STRATEGIES FOR SHOWING

STRATEGIES FOR SHOWING

Women, Possession, and Representation
in English Visual Culture
1665–1800

MARCIA POINTON

OXFORD UNIVERSITY PRESS

1997

Oxford University Press, Great Clarendon Street, Oxford OX2 6DP

Oxford New York
Athens Auckland Bangkok Bogota Bombay
Buenos Aires Calcutta Cape Town Dar es Salaam
Delhi Florence Hong Kong Istanbul Karachi
Kuala Lumpur Madras Madrid Melbourne
Mexico City Nairobi Paris Singapore
Taipei Tokyo Toronto

and associated companies in
Berlin Ibadan

Oxford is a trade mark of Oxford University Press

Published in the United States by
Oxford University Press Inc., New York

British Library Cataloguing in Publication Data
Data available

Library of Congress Cataloging in Publication Data
Data available
ISBN 0-19-817411-x

1 3 5 7 9 10 8 6 4 2

Typeset by Selwood Typesetting
Printed in Great Britain on acid-free paper by
Butler and Tanner Ltd,
Frome and London

For My Sisters
Susan Collin and Clare Pomposo

ACKNOWLEDGEMENTS

I HAVE benefited in inestimable ways in researching and writing this book from the advice, help and constructive criticism of many friends and colleagues. Several chapters originated in invitations to give papers at particular events like the 'Allegory and Gender' symposium in Essen in 1992 (Ch. 2), the Angelica Kauffman conference in Brighton in 1992 (Ch. 4), the Society for Eighteenth-Century Studies annual conference 1993 (Ch. 5). All chapters have been delivered as research presentations on at least one occasion, and some have had a number of airings. The opportunity to receive the kinds of critique that such events offer is of unequalled value and I would like to thank not only those who invited me but also those who attended and those who questioned, challenged, and commented. The staff of the many libraries and archives in which I have worked as this book slowly came to completion are owed a great debt of thanks. In particular—as I have taxed their patience on so many occasions—I would like to thank the staff of the John Rylands Library of the University of Manchester (Deansgate), the Heinz Archive at the National Portrait Gallery, the Witt Library, the Print Rooms at the Victoria and Albert Museum and the British Museum, and the British Library. I would also like in particular to thank Peter Burton and Michael Pollard not only for their own photographic work, but for encouraging me to believe that I too could do it, and Andy Fairhurst for cheerfully rescuing me from many a computer crisis. The University of Manchester generously provided me with a grant for a research assistant; not only did Emma Chambers and Lucy Peltz give me invaluable research assistance, they were also amusing company and provided much-needed distraction to a harassed Head of Department.

I would like to thank the following individuals who generously took time to respond to my questions: David Alexander, Malcolm Baker, Tim Barringer, Maxine Berg, Paul Binski, Chloe Chard, Deborah Cherry, Helen Clifford, John Coleman, Fintan Cullen, Gisela Ecker, Richard Edgcumb, Elizabeth Einberg, William Griswold, Robin Hamlyn, Gerald Hammond, Revd Peter Hammond, Mr and Mrs Christopher Harley, Eileen Harris, John Hayes, Konrad Hoffman, Tim Ingold, Bill Jackson, Anna Kerr, Charlotte Klonk, Robert Lacey, Christopher Lloyd, Stephen Lloyd, Jennifer Montagu, Kate Nicholson, Frank O'Gorman, Gill Perry, David Peters Corbett, John Pickstone, Ann Pullan, Aileen Ribeiro, Margaret Richardson, Hugh Roberts, Michael Rosenthal, Susanne Rosing, R. C. Roundell, Gill Saunders, Sigrid Schade, Simon Shaw-Miller, Susan Siegfried, Jacob Simon, Mrs D. A. Staveley, Roey Sweet, Dorcas Taylor, the Hon. R. Turton and Mrs R. Turton, Silke Wenk.

Ludmilla Jordanova and Karen Stanworth read and commented on five chapters in an early draft. That they found the time in their own exceedingly busy schedules to do this for me was an act of great generosity. I am immensely grateful to them both. I am also grateful to Anne Ashby for her consistent encouragement and to the anonymous readers who helped me put this work into its final shape. Any omissions are my own.

M.P.

CONTENTS

List of Illustrations x

Introduction 1

1. Purchasing and Consuming: Elizabeth Harley . . . and Others 15

2. Marriage and its Boundaries: The Montgomery Sisters Adorning a
 Term of Hymen 59

3. Abundant Leisure and Extensive Knowledge: Dorothy Richardson
 Delineates 89

4. Working, Earning, Bequeathing: Mary Grace and Mary Moser—
 'Paintresses' 131

5. Portraiture, Excess, and Mythology: Mary Hale, Emma Hamilton,
 and Others . . . 'in Bacchante' 173

6. Protestants and 'Fair Penitents': With Special Reference to St Cecilia 229

Appendix: An Anthology of Wills Relating to Women's Property
1739–1760 307

Bibliography 401
Index 423

LIST OF ILLUSTRATIONS

1 Sir Joshua Reynolds, *Three Ladies Adorning a Term of Hymen*, Tate 62
Gallery, London

2 J. Bacon, design for Hymen candlesticks, *Coade's Lithodipyra or Artificial* 66
Stone Manufactory, 1777–8

3 *Sacrifice to Priapus,* from F. Colonna, *Hypnertomachia Poliphili,* Venice, 68
1499

4 Peter Paul Rubens (and Bruegel), *Nature Adorned by the Graces,* Glasgow 68
Museums: Art Gallery & Museum, Kelvingrove

5 Richard Cosway, *A Group of Connoisseurs,* Towneley Hall Art Gallery 73
and Museums, Burnley Borough Council

6 P. H. d'Hancarville, *Recueil d'antiquités étrusques, grèques, et romains,* 75
Paris, 1766–7, ii, pl. 97

7 Santi Bartoli, *Admiranda Romanorum antiquitatum,* Rome, 1693, iii, tab. 75
57, pl. 75

8 B. de Montfaucon, *L'Antiquité expliquée, et représentée en figures,* Paris, 76
1719, ii, part I, pl. 1

9 B. de Montfaucon, *L'Antiquité expliquée, et représentée en figures,* Paris, 76
1719, i, part II, pl. clxxxi

10 Dorothy Richardson, *Hack Fall near Ripon,* pen, ink, and wash, Ryl. Eng. 92
MS 1122 (between fos. 214–15), John Rylands University Library of
Manchester

11 Dorothy Richardson, *Richmond Friary,* watercolour, Ryl. Eng. MS 1125 93
(between fos. 184–5), John Rylands University Library of Manchester

12 J. C. Bentley after C. Cousen, *Bierley Hall,* from J. James, *The History* 95
and Topography of Bradford, London, 1841

13 Dorothy Richardson, *The Bit of a British Bridle Found at Silbury Hill,* pen, 99
ink, and wash, Ryl. Eng. MS 1123 (between fos. 229–30), John Rylands
University Library of Manchester

14 Dorothy Richardson, *Plan of Bridlington Quay,* pen and ink, Ryl. Eng. 112
MS 1126, fo. 59, John Rylands University Library of Manchester

15 Dorothy Richardson, *Mr Yorke's Folly at Bewerley,* pen, ink, and wash, 116
Ryl. Eng. MS 1125, fo. 106, John Rylands University Library of
Manchester

16 Dorothy Richardson, *Danesfield,* pen, ink, and wash, Ryl. Eng. MS 1125, 117
fo. 155, John Rylands University Library of Manchester

17 Dorothy Richardson, *St Patrick's Chapel near Heysham*, pen, ink, and 122
 wash, Ryl. Eng. MS 1122, fo. 257, John Rylands University Library of
 Manchester

18 G. Bestland after H. Singleton, *The Royal Academicians Assembled in their* 132
 Council Chamber, pub. 1802, British Museum, London

19 Mary Grace, *Self-Portrait*, engraving, 'Mrs Grace, Paintress', publ. 1 136
 August 1785 by C. Taylor, Holborn, British Museum, London

20 Mary Moser, *Self-Portrait*, Museum zu Allerheiligen, Schaffhausen. 137
 Sturzenegger–Stiftung

21 J. Spilsbury after Mary Grace, *The Revd Thomas Bradbury*, British 140
 Museum, London

22 Alken after Emma Crewe, *Flora at Play with Cupid*, frontispiece to E. 149
 Darwin, *The Loves of the Plants,* 1789, vol. ii of *The Botanic Garden*

22a Anchor Smith after J. H. Fuseli, *Flora Attired by the Elements*, frontispiece 151
 to E. Darwin, *The Economy of Vegetation*, 1791, vol. i of *The Botanic Garden*

22b F. P. Nodder after anon. artist, *Meadia*, E. Darwin, *The Loves of the Plants*, 153
 vol. ii of *The Botanic Garden*, London, 1789, p. 6

23 M. Moser, *Vase of Flowers*, Victoria and Albert Museum, London 155

23a M. Moser, *Study of a Tulip*, Victoria and Albert Museum, London 158

24 M. Moser, The Mary Moser Room, Frogmore 163

25 Sir J. Reynolds, *Lady Sarah Bunbury Sacrificing to the Graces*, The Art 174
 Institute of Chicago

26 Harewood House, Yorkshire, interior of the Music Room 180

27 *Plantation House, near Guisborough*, sketch by member of the family, 182
 probably Mary Hale

28 Harewood House, Yorkshire, north front 182

29 J. Watson after Sir J. Reynolds, *Mrs Hale as Euphrosyne* 184

30 Interior of Harewood House, plan of the ground floor showing Music 185
 Room

31 J. H. Fuseli, *Euphrosyne*, Kurpfälzisches Museum der Stadt Heidelberg 187

32 C. Burney, *A General History of Music*, London, 1776 188

33 C. Grignion after R. Hoare, frontispiece to R. Graves, *Euphrosyne: or,* 189
 Amusements on the Road of Life (1776), London, 1780

34 A. Kauffman, *Self-Portrait (?) as a Bacchante*, Staatliche Museen zu Berlin 191
 Kulturbesitz Gemäldegalerie

35 S. Woodforde, *A Bacchante*, Christie's, 11 October 1993 192

36 L. Bartolini, *Reclining Bacchante*, Devonshire Collection, Chatsworth 192

37 G. Romney, *Emma Hamilton (?) as a Bacchante*, Sotheby's, 17 February 1988 · 193

38 Emma Hamilton performing her 'Attitudes', engraved by T. Piroli, in *Drawings Faithfully Copied from Nature at Naples and with Permission Dedicated to the Right Honourable Sir William Hamilton . . . by his Most Humble Servant Frederick Rehberg. Historical Painter in his Prussian Majesty's Service at Rome*, London, 1794 · 200

39 Emma Hamilton performing her 'Attitudes', engraved by T. Piroli, in *Drawings Faithfully Copied from Nature at Naples and with Permission Dedicated to the Right Honourable Sir William Hamilton . . . by his Most Humble Servant Frederick Rehberg. Historical Painter in his Prussian Majesty's Service at Rome,* London, 1794 · 201

40 Sir J. Reynolds, *Lady Worsley*, Earl of Harewood · 203

41 G. Romney, *Emma Hamilton as a Bacchante*, Tate Gallery, London · 206

42 J. R. Smith after Sir J. Reynolds, *A Bacchante,* British Museum, London · 207

43 G. Romney, *Emma Hamilton as a Bacchante*, Sotheby's, 29 November 1978 · 209

44 E. Vigée Lebrun, *Lady Hamilton as a Bacchante*, Lady Lever Art Gallery · 210

45 F. Wheatley, *A Bacchante*, British Museum, London · 211

46 Sir J. Reynolds, *Thaïs,* The National Trust: Waddesdon Manor · 212

47 T. Dempster, *De Etruria regali libri*, Florence, 1723, VII, i, tab xi, p. 78 · 214

48 J. Grozer after Sir J. Reynolds, *The Death of Dido*, pub. 19 May 1796, British Museum, London · 216

49 Sir J. Reynolds, *The Ladies Waldegrave*, National Gallery of Scotland, Edinburgh · 217

50 A. Kauffman, *A Bacchante*, British Museum, London · 219

51 T. Walton after F. Wheatley, *Thaïs*, pub. 10 March 1779, British Museum, London · 220

52 G. Romney, *Emma Hamilton*, Christie's, 7 November 1980 · 232

53 A. Le Grant after M. W. Peters, *An Angel Carrying the Spirit of a Child to Paradise*, British Museum, London · 239

54 W. Dickinson after M. W. Peters, *The Resurrection of a Pious Family*, pub. 1 February 1790, British Museum, London · 240

55 F. Bartolozzi after M. W. Peters, *The Spirit of a Child Arrived in the Presence of the Almighty*, pub. 21 May 1787, British Museum, London · 241

56 E. F. Burney, *The Waltz*, Victoria and Albert Museum, London · 253

57 M. W. Peters, *Lydia*, Tate Gallery, London · 255

58 M. W. Peters, *Sylvia*, National Gallery of Ireland, Dublin · 256

59 R. Dunkarton after M. W. Peters, *Belinda*, British Museum, London · 260

60 W. Dickinson after M. W. Peters, *Lydia*, British Museum, London 265

61 J. Houghton after J. H. Fuseli, *The Power of Fancy in Dreams*, from E. 269
 Darwin, *The Temple of Nature*, London, 1803

62 Sir J. Reynolds, *St Cecilia*, Los Angeles County Museum of Art 274

62a Detail of Sir J. Reynolds, *St Cecilia*, no. 62 275

63 Sir J. Reynolds, *Mrs Billington as St Cecilia*, The Beaverbrook Art Gallery, 277
 Fredericton, NB, Canada

64 G. Romney, *Emma Hamilton as St Cecilia*, Christie's, 21 November 1975 278

65 Emma Hamilton in the 'Attitude' of a Vestal Virgin, engraved by T. 279
 Piroli, in *Drawings, Faithfully Copied from Nature at Naples and with
 Permission Dedicated to the Right Honourable Sir William Hamilton . . . by
 his Most Humble Servant Frederick Rehberg. Historical Painter in his Prussian
 Majesty's Service at Rome,* London, 1794

66 Sebastiano Conca, *St Apollonia Surrounded by Putti*, Sotheby's, 280
 17 February 1982

67 P. Mignard, *St Cecilia*, Louvre, Paris 281

68 P. Tanjé after M. Rocca (Il Parmigianino), *St Cecilia,* British Museum, 282
 London

69 Sebastiano Conca, *St Cecilia*, location unknown 283

70 C. Grignion after J. Bruce, *The Theban Harp*, from C. Burney, *A General* 291
 History of Music, London, 1776

Introduction

IN 1757 a young woman aged 17 named Hester began the year's entries in her Daily Journal by recording what she did in the first week of the new year. This young woman would, after marriage in 1763 to the wealthy brewer Henry Thrale, become famous as the intimate of Dr Johnson. Following her second marriage, Hester Thrale Piozzi would acquire a reputation as a literary figure in her own right. The jottings of this young woman in her journal give little indication of literary promise. But the apparent randomness of these quotidian recordings serves well to introduce the concerns of my study:

2 Jan Nothing happen'd that I thought worth mentioning in this Book

4 Jan Miss Stapleton drank Tea with us dress'd up for a fine Lady

5 Jan Went with Miss Wyon to sit for her Picture
 call'd on Mrs Butler in our way home

6 Jan Mrs. Jones brought several things. I bought a Pompon w ch cost 1s & a Ruf w ch cost 18d to give Coz Phil besides a washbath for my own use

Mon 10th–Sat 15th at Finchley
 playing shuttlecock & goose
 Win 1s, lost 1s

Wed Nobody came, nor nothing done but playing

Thurs, Fri, Sat ditto

Sun Went to Church & to see Mrs. Miller[1]

We might be tempted to conclude from these entries merely that Hester's days were as tedious as those of other young women of the gentry and nobility, afflicted with compulsory idleness and victims of a life of imposed inertia. What interests me about these entries is, however, their very ordinariness. Unheroic events are noted in economic prose with a discipline that requires the writing down of the fact that nothing has happened, or nothing worth

mentioning, a clear indication of a self-conscious sifting of personal happenings to discover what is and what is not worthy of record. What is inscribed is—in all its brevity—a representation of a sequence of rituals that make up a paradigm of the everyday relationship of a young woman with her environment. In this brief space, a space in which very little *happens*, are recorded tea-drinking, the evaluation of another woman's appearance and dress in terms of class, a portrait sitting, the visit of a female pedlar or merchant and the purchase of a range of priced goods (some for the author but one as a gift for a relative), games played with others away from home involving placing of bets, and a visit to church. 'Dress'd up for a fine Lady' and 'for my own use' are evaluative enunciations. They state things about the relationship of the subject to her world. They are representations of daily rituals that are themselves ritualized through inscription within the pages of a leather-bound commercially produced journal that came complete with sections for accounts, appointments, and memoranda.

The origins of my book lie in a curiosity about the relationship of women to the world of possession and representation. If, as has been claimed, 'it is necessary to search out and analyse the allocation of roles and identities between the genders in order to understand the dynamics of any social system',[2] it must equally be true that the instrumental nature of representation as systematic and ideological, as well as affective, must be examined if we are to make sense of that social system. In what follows I do not address directly the development of parliament or the functioning of court in eighteenth-century England. I do not consider the rise of commerce or the importance of the navy. The workings of the Royal Academy are scarcely discussed and, while some of the paintings of its first President, Sir Joshua Reynolds, do have a part in my account, I have in no way attempted any coherent analysis of the work of this or any other eighteenth-century artist. None the less, those things which I do consider are, I suggest, central to a proper understanding of eighteenth-century cultural history.

Focusing on particular situations in which women are representers and represented makes it possible to scrutinize the contradictions within which women were caught as subjects and as individuals in eighteenth-century culture. By emphasizing representation, I wish to draw attention to the capacity of art forms to construct and mediate meanings within specific historical circumstances. What may be functional and factual may also be imaginative; finding ways that trace the linkages between recording and inventing is one of the things I seek to do. Thus this book covers a range of disparate cases chosen because they lend themselves to this purpose; for example, I shall argue that the writing of wills is an imaginative as well as a

legal act, permitting women to delineate objects they held dear and to name people for whom they had particular feelings. They are thus forms of representation spoken with a female voice albeit within a patriarchal system. As Amy Erickson has argued in her magisterial work on women and property, the use of wills as a historical source is not straightforward. The size and nature of bequests in wills 'may have been shaped by many factors: "convention, affection, guilt, need, duty"'.[3] Inventories written after the death of the owner have always been regarded as more reliable indicators of personal wealth precisely because they are impersonal; they list rather than describe and because they are produced without the intervention of the possessor they are regarded as more historically reliable. Erickson acknowledges, however, that 'wills do reveal personal intentions, as opposed to the impersonal operations of the law' and Maxine Berg argues that wills reveal different attitudes among men and women to their possessions[4] and recognizes them as suggestive documents. My aim is precisely to problematize the idea of 'intention' by exploring the forms of representation that are at work in wills concerning not land but the personal possessions of women. I do not wish to suggest that we can 'hear' the voices of women from the past speaking through these legal documents; on the other hand, the often idiosyncratic nature of the language used, the sometimes extraordinary degree of detail with which objects are delineated, and the cumulative effect of the representation, *en masse*, of valued artefacts cannot be ignored. It is, I believe, reasonable to assume that the owners themselves played some part in the ways in which their possessions were described for posterity since they had the greatest personal and emotional investment in ensuring that no ambiguities ensued. Readers will be able, to some extent, to judge these matters for themselves by referring to the Anthology of Wills printed at the end of this book.

Debates about luxury were pressing and influential in eighteenth-century England. Notions of property were based on a general conception of natural law derived from Locke and his predecessors,[5] but the success of England as a mercantile nation, particularly after the end of the war with France, brought new problems that could not be resolved by reference to laws and theories that related to land rather than goods. These problems were perceived as acute. Commercial success required high levels of consumption but in the hands of the lower orders this consumption of luxury goods was believed to breed corruption. Some argued that licentiousness was the prerequisite to a healthy economy but there was massive concern about the balance of payments crisis produced by the importation of luxury goods (like silks) from countries to which Britain was not exporting.[6] The fine arts were seen as particularly

vulnerable to corruption and were regarded as an indicator of the threat to a republic of taste. In the words of one commentator:

Nothing is a greater Indication of Luxury, the For-runner of Poverty, than the Degeneracy of the polite Arts into useless Ostentation. The Poets, Painters and Sculptors have of late almost forgot what gave rise to, and ought to be the end of their Labours. Those noble Designs in which Athens gloried more than in all her Military Exploits, are now little regarded; and those servants of Virtue, the ARTS, which formerly gave Instruction not only to the young and unexperienced, but to the old and learned, are most slighted and often prostituted to adorn Vice, and flatter human Vanity. [7]

The authors of those debates are men, but for all their protestations women, as well as men, continued enthusiastically to imagine, represent, acquire, and consume luxury goods. The history of consumption must take account not only of trade and commerce but also of seduction, of the relationship between people and things as one of desire. In my first chapter, therefore, I explore how the need to represent objects desired and things possessed led to the production of texts which tell us much not only about the availability of consumer goods but, equally importantly, about the articulation of desire around this question of possession. The will to represent is, in the case of Elizabeth Harley, tied to the desire to maintain a bond between city and country, husband and wife, parliament and home. A discourse constructed around desire emblematized through representations of goods and chattels, property and children, is a self-consciously produced strategy. Letters are demands for reciprocation and a form of self-portraiture; they are also in their own way political. There is nothing marginal about such matters; to understand the particular is not to suggest that from this a general view be extrapolated but it is to suggest that an understanding of the exercise of power in England in the eighteenth century requires not only an increasing knowledge of the relationship of court to parliament, of the institutions of the state, of changes in the ownership of land and wealth, but also knowledge about the history of manners, religion, ritual, and feeling. And questions of gender are central to that history.

Like so many moral debates, discussions about commerce, liberty, and luxury both used women as a yardstick for the relative health or degeneracy of the nation and required the idealization of the female subject as a means of representing the model state. As Sylvana Tomaselli has pointed out, there was a widespread view that women were the barometers on which every aspect of society, its morals, its laws, its customs, its government, was registered.[8] Women's physical appearance was equally highly invested; while eighteenth-century letter-writers perpetually describe how people look, the legibility of

faces being widely promoted, women's appearance was doubly significant for, as Robert Jones has recently claimed, in eighteenth-century England 'to be beautiful is not only to possess an engaging physical presence, but also to be positioned in relation to a series of moral injunctions, which on the one hand raise and endorse women's public presence, while on the other hand damn the beautiful as a source of enervating femininity'.[9] Women (and to a much lesser extent men) were also assessed as human beings within the economic system that was propelled by expenditure: discussions of dowries and marriage settlements became increasingly pressing as the range of goods and entertainments on which money could be spent increased. Among the luxury goods that were purchased, circulated, given away, sold, were paintings. Imagery was instrumental in increasing the desire for goods and in promoting emulation. From an art-historical point of view, the issue of luxury thus becomes part of a question of the power of visual imagery and of its capacity to generate copies and imitations. I consider in this book two types of paintings from the point of view of the gender of the owners, viewers, and subjects, and the ways in which these interact to produce particular public and private meanings across extended fields of consumption. One is allegorical portraits and the other is religious paintings. The first is a genre which in this period is almost exclusively confined to the female subject; the other is a more general category but within this I have focused upon the phenomenon of paintings of female saints. The question I have asked is, what did it mean within Protestant England, where imagery in churches was largely proscribed, to commission and purchase imagery of female saints for domestic consumption? And how did such commodities fit into a visual economy that included licentious images of women?

Artists and writers were part of public life. They were thinking citizens with moral responsibilities. Women were, for all the notoriety of the Blue Stocking circle, regarded as unthinking and economically unproductive. As Katharine Shevelow has pointed out, just as women were becoming visible as readers and writers, as leading consumers of print culture, the literary (and one might also include the visual) culture was producing an increasingly restrictive model of femininity.[10] Included in my account are, therefore, two discussions of the work of particular women who were conventionally productive in the non-biological sense. Whether paid or unpaid, they worked. These women represent themselves through a range of conventions—travel-writing, flower and portrait painting—and consideration of their lives and their work permits me to pose questions about women as active participants in the process of representation as a part of the gender system. The will to cognizance through delineation (a consequence of the notion of seeing things clearly) can be

charted as a claim not only to be part of the public domain (and thus enter discourse) but to possess knowledge and exercise power.

As I move from the real to the represented with great frequency in the course of this book, I should perhaps establish that I view the real historical bodies of my subjects as also involved in representation. This is not to ignore the lived life—indeed this is very much part of my project—it is rather to assert the self-consciousness, the ritual nature of all human communication so that the very act of recording is also a representation. As such it is productive of myth. I can best explain this by citing, for example, the hanging of a painting, the viewing of a site of historical interest, or the writing of a description of an artefact in terms formulated by Huizinga who, in exploring the nature of play, invokes the *dromenon*. This is something acted, an act or an action. That which is enacted, or the stuff of the action, is, as Huizinga says, a *drama*, which again means act, action represented on a stage.

Such action may occur as a performance or a contest. The rite, or 'ritual act' represents a cosmic happening, an event in the natural process. The word 'represents', however, does not cover the exact meaning of the act, at least not in its looser, modern connotation; for here 'representation' is really *identification*, the mystic repetition or re-presentation of the event. The rite produces the effect which is then not so much *shown figuratively* as *actually reproduced* in the action. The function of the rite, therefore, is far from being imitative; it causes the worshippers to participate in the sacred happening itself. As the Greeks would say, 'it is *methectic* rather than *mimetic*'. It is a 'helping out of the action'.[11]

Clearly there are significant differences between a drama that enacts something on a stage and, say, a woman writing about an ancient castle in antiquarian mode, or a patron discussing with Sir Joshua Reynolds the way in which his fiancée and her sisters should be depicted. What I wish to convey, however, is the quality of ritual, ceremony, and social engagement that is germane to acts of this kind, actions all of which require the person representing to place themselves (self-consciously or not) within a pre-existing script and which require consumers also to play the part of helping out the action.

The overarching thesis of this book is therefore that an important and highly constructive relationship exists between women as producers and describers and women as subjects of representation or objects of discourse in eighteenth-century England. Inspired by Michel de Certeau's challenge to recognize and take account of the power of everyday practice in the formation of grand historical (and by extension art-historical) narratives, this book takes as its focus women as a constituency and explores the overlapping and interdependent nature of the everyday (objects, dress, journal-writing) with

universalizing public discourses in which the feminine is frequently invoked as ideal, thereby pointing up connections and contradictions which serve to cast new light on our understanding of the ways in which gender functions in eighteenth-century culture. Issues such as marriage, death, sexuality, and religion are addressed through the products that they generated—images, objects, and writings. Our historical knowledge of individual and collective identities is accessed through languages both visual and verbal. In this book a series of case studies centred on an individual or group of individuals illuminates the ways in which use of artefacts (buying, inheriting, giving, destroying) produces meanings. Thus it is possible to understand aspects of the position of women in eighteenth-century England that cannot be apprehended through quantitative methods. These are aspects that are beyond legislature—areas characterized by myth, belief, aspiration, and superstition. But they interact with legislated facets of society's activities and this interaction is central to my project.

Paintings—and this book focuses in part on portraits and on portrait-like fictional images of women—are not only images but also artefacts which are described and consumed, located, dislocated. Descriptions (portrayals) are not only factually informative but imaginatively invested by those who read them as well as those who write them. By bridging acts of representation and objects represented or delineated, this book offers an account of the importance of artefacts and of the delineation of seen objects in the creation of individual identity. This book extends the study of portraiture as a defining social practice that I undertook in *Hanging the Head* (1993). There I examined the ways in which portraits were deployed and circulated as well as the ways in which they represented individuals ideologically. Here I focus on women's differentiated role in the world of labour and knowledge as constituted in discourse and in practice. I consider the portrait as one component in a wider and encompassing practice of delineation through which women are constructed in that world but within which women also construct a position, a voice, an identity through their own acts of portrayal and delineation.

There has been for some time now a well-established tradition for studies of social and portrait images in which woman connotes 'to-be-looked-at-ness'.[12] Woman as representation is often split from woman as historical individual. The strategies of interpretation that feminist writers have drawn from psychoanalytic and semiotic theory and from discourse theory have informed an analysis based upon the relationship between representation and power. The stress on language, convention, and ideology has permitted us to understand some of the ways in which gender (which is defined but not circumscribed by our understanding of human beings as male or female)

structures forms of visual representation, whether film, painting, photography, print, or any other medium. Another strand of feminist work on history and culture has addressed how women lived. The notion of a constituency that is 'hidden from history', to use Sheila Rowbotham's trend-setting term,[13] has been replaced by the conviction that nothing is hidden; it is simply a matter of asking the appropriate questions of the relevant body of material. Thus the assemblage of data on women's lives and work has ranged from ostensibly straight biographies of wealthy and outstanding women, like Frances Harris's study of Sarah, Duchess of Marlborough,[14] to Catherine Hall's and Leonore Davidoff's classic study of the middle class with its subtle examination of the lived lives of individuals—women and men—situated between domesticity, business, and religion.[15]

The first of these strands concentrates on discourse at the expense of the empirical and ignores the undeniable truth that, though we may not have access to their lives (and how much do we know, after all, of anyone's life, even of those closest to us?), there have, indeed, been historical individuals who ate, drank, made love, did business, owned things, moved around, and died often leaving possessions behind them. The other strand neglects the importance of representation and, however apparently close to the individual and the everyday is the evidence on which it draws (and I am thinking here of enormously influential, and justly admired, studies which focus on material culture inspired by writers like Norbert Elias and Fernand Braudel),[16] neglects to take account of the fact that such historical writing is predicated upon interpreting descriptions (verbal and visual) which are always conventional and ideological.[17] Michel de Certeau has vividly described our fascination with the past as the construction of a stage on which we place a cast of dead actors. Writing history, for de Certeau, can be specified under two rubrics: on the one hand it is a burial rite (exorcising death by inserting it into discourse) and on the other hand it possesses a symbolizing function, allowing society to situate itself by giving itself a past through language and thereby opening to the present a space of its own.[18] The stage is by no means remote from the theatre and the theatre, let us remember, is artifice and not nature. Why we look to the past rather than just getting on with our lives while looking to the future is not a question that resolves itself by appeals to pragmatism, logic, or morality, but one that speaks desire and fascination, fantasy and subjectivity, identity and identification.

For art historians, the 'narrative itinerary' through which the dead are represented involves the pictorial and the visual with their iconicity and connotativeness. Thus, although the work of anthropologists like Marcel Mauss, Mary Douglas, and Arjun Appadurai[19] has been not merely important

but often germane to the development of an analytic for dealing with material culture, the historical importance attached to genres and the possibility of recognizing the capacities of objects to communicate imaginatively in specific historical circumstances marks a major difference between the anthropological enquiry and the art-historical examination. Moreover, the notion of 'the life of things' is problematic when divorced from questions of representation and meaning. Questions that are asked of historians and anthropologists are also, however, asked of art historians. In addition, there is the question of what, precisely, is being addressed. A human subject clothed and shod is an art-work as is a table laid with crockery and food. If these are to be regarded as generically different from, say, a Rembrandt painting, it must be on account of a difference in function, since a laid table may give as much (or more) pleasure as a representation of a laid table. I make the point not in order to engage with Platonic arguments about mimesis but merely to suggest that distinctions between art as fine art and artefacts as craft, and between permanent values and transient effects, may be constricting either to a discussion of eighteenth-century artistic production or, indeed, to twentieth-century visual culture in which the temporary and passing is so frequently foregrounded in three-dimensional works that are made up of the everyday and the familiar. What makes the laid table seem different from the Rembrandt is that while the laid table appears to invite demolition, the painting (paradoxically) appears to offer both permanence and authenticity. It hangs in a museum, it can be taken from the wall, the reverse can be examined. Our knowledge of the outfit worn or the table laid relies on description, whether visual or verbal. Because our access to the object, a painted canvas, is immediate, what is represented on that canvas seems, by extension, historically graspable. In fact, in both cases the referents are culturally determined formations mediated by conventional languages and interrelated as signifying systems (the Rembrandt painting depends on representations of things like a table laid or an outfit worn and the laid table and clothing are known to us as described or depicted by artists like Rembrandt).[20] In one sense this is merely to draw attention to the familiar tautologies of realist aesthetics, but in another, it is to comment upon the constraining effect of notions of genre and of the aftermath of academic theory in historical analysis.

The practice of history often works on the basis of an assumption that description is access, whereas description is, of course, representation. The apparent difference, outlined above, evaporates if we consider not only what the painting images but how it has been deployed as an object. With some exceptions, paintings in the west have been largely portable objects, often

relatively small in dimensions; for their owners they were part of a three-dimensional arrangement of furnishing and partook in the rituals of exchange whether for commodity or for symbolic value. Thus, in this book, I have thought it important to consider the paintings made by Reynolds for music rooms at Harewood and St James's Square (in Chapters 4 and 6) in relation to their contexts and to interrogate the Revd Matthew William Peters's work of a religious and of an erotic nature as part of a pattern of production and consumption. Art history, like other 'criticism-based' disciplines (music and English), has been shaped by genre. Religious art has not been understood as important in England. It has been a neglected genre, and genre is a powerful if unacknowledged determinant in academic discourse. Even supposedly new areas of study like film and media carve their activities into genres. If we examine paintings not only as images but also as objects, the notion of genre appears as a form of taxonomy that has more to do with historiography than with the production and meaning of artefacts.

This book is by inference also about men. As a symptomatic examination of a range of knowledge fields and the necessity of representation in the formation and social dispersal of those knowledges, it concerns the male subject, whether producer or consumer, as much as the female. Subjectivities are invented in a relational way and discourse is, in the terms of this study, social. There are undoubtedly many possible counter-narratives to the ones I have told; these might foreground a Luke Gardiner (husband), a Sir William Hamilton (lover), or a Queen Charlotte (patron). The social constituency explored in the following pages is necessarily defined by those who were literate and who had the power to acquire and dispose of property. This is, however, no monolithic élite; my aim is to offer representative accounts of the ideologies that informed life-styles of individuals whose habits and ways of representing the world crossed boundaries between the aristocracy (for example, the Lascelles) and the gentry (for example, the Richardsons), and between patrons and artists (thus complicating the notion of the commission, as with Mary Moser and Queen Charlotte or Sir Joshua Reynolds and Luke Gardiner). This is a fractured élite body, if such it is; it is a class that crossed regional boundaries and the country/city divide. Polite society is, perhaps, one thing to which all the individuals here discussed might have aspired. Whether or not the category of 'ordinary women' established in Erickson's work has any relevance here is a moot point. Clearly the legal documents and correspondence discussed in Chapter 1 have little to do with the women who have been so effectively 'put in the picture' by Erickson for a somewhat earlier period.[21] On the other hand, Mary Grace appears to have been a woman of humble origins, and the kinds of images discussed in other chapters reached a

very wide market. The point is that the situation of women may change in the course of a lifetime and, particularly in metropolitan eighteenth-century culture, aspirations to politeness probably mean exposure to a range of representations not necessarily characteristic of a particular group classed simply by wealth and possession. Recent work has brought a degree of recognition of the importance of politeness in discourse but what it meant in terms of production and consumption has been much less clear.[22] Politeness, as we see in the case of a Dorothy Richardson or an Emma Hamilton, can be deployed and managed in the interests of ideas about social change and individual identity. The force of imagination in eighteenth-century life has long been recognized in respect of its literary manifestations (as with discussions of the cult of sentiment) and, to a much lesser extent, in respect of painting and sculpture (which have tended to be viewed primarily as grounded in class and economic interests).

This book has four shaping principles: it takes as its time-scale a long English eighteenth century running from the 1680s through to the early years of the nineteenth century; its 'dead actors' are women first and foremost; the art forms it addresses are ostensibly mimetic in function (that is, they work with discourses of the real world); the issue of ownership and possession—whether of people, knowledge, or property—underpins each chapter. Within this framework my account offers many disunities: it examines genres as distinctive as flower-painting, allegorical portraiture, letter-writing, and journal-writing; it treats paintings not only as images but also as artefacts; it places such paintings as objects within an economy encompassing consumables of a wide and necessarily arbitrary range; it deals with the celebrated (Sir Joshua Reynolds) and the wholly unknown (Mary Grace). Above all, this book seeks to map the mythological onto the everyday and to recognize 'speech' as well as discourse. It is predicated, therefore, on the conviction that the theoretical and the empirical are mutually reinforcing rather than mutually exclusive modes of historical study.

To recognize the ideological nature of language employed to delineate an individual and her or his physical and material attributes is not, in my account, to ignore the actual physical nature of the life as lived. Certainly what is enunciated may function discursively in ways that signify meanings contrary or in antithesis to declared intention, but human subjects individually and collectively have an extraordinary aptitude for transmuting the functional into the mythological, by engaging in, or colluding with, the production of discursive formations. Portraiture has played an important part in this process—what may initially have been understood as no more than a likeness (though that in itself is a problematic enough concept) may in the process of

possession, a process in which physical inertia may be equalled by psychic dynamism, work to produce or enforce myths that situate the individual subject in overarching narratives. According to this model, myth (the creation of fictions that have a widespread currency and a capacity to signify at the level of the symbolic) is the product of individual human action that is in some degree conscious, whereas discourse is outside human agency and works across those boundaries that myth serves to establish.

It is for this reason that two chapters of this book address some of those female subjects who, through portraiture of an allegorical kind such as was extremely popular in eighteenth-century England,[23] become in some way *representative*. Named human female subjects become the site of fantasy and desire that is not personal to the artist who painted them but pertinent to a cultural and social class. The identity of these portrait subjects as individuals who lived particular lives in the past (an Elizabeth Montgomery or a Mary Hale) is assimilated in the mythologizing process. Art is undeniably more powerful than life and these two chapters are, therefore, an attempt not to discover the 'real' people behind the paintings but rather to understand the processes whereby these subjects are—through a relatively mundane act of sitting for a portrait—woven into a complex web of discourses.

Notes

1. Hester Thrale's *Daily Journal or the Gentleman's Complete Annual Accompt-Book*, 1757, MS John Rylands University Library, Manchester, R 71063 (616). There are many testimonies to the imposed passivity of women, most notably Daniel Defoe, who wrote in *The Complete English Tradesman*, 'the tradesman is foolishly vain in making his wife a gentlewoman, forsooth; he will have her sit above in the parlour, receive visits, drink tea, and entertain her neighbours, or take a coach and go abroad; but as to business, she shall not stoop to touch it; he has his apprentices and journeymen, and there is no need of it.' D. Defoe, *The Novels and Miscellaneous Works of Daniel De Foe*, xvii: *The Complete English Tradesman* (1726; Oxford, 1841), i. 219. Hester Thrale in fact later in life not only helped her husband in his business but was largely responsible for saving the brewery from financial disaster.
2. E. Fox-Genovese, 'Placing Women's History in History', *New Left Review*, 133 (May–June 1982), 15.
3. A. L. Erickson, *Women and Property in Early Modern England* (London, 1993), 32.
4. Ibid. 33; M. Berg, 'Women's Consumption and the Industrial Classes of Eighteenth-Century England', forthcoming. M. Berg, 'Women's Property and the Industrial Revolution', *Journal of Interdisciplinary History*, 24 (1993–4).
5. Locke's *Two Treatises of Government* (1690) soon became the standard for theories for which the slogan was 'Life, Liberty, Property'. There is a huge literature on the subject of property in the 18th cent. but a useful overall introduction is R. Schlatter, *Private Property: The History of an Idea* (London, 1951). See, however, also the observation that 'in the eighteenth century and up to our own time, defining property generates major questions about the nature of human personality in social, psychological, and legal terms: who could be a legitimate

person, what justified ownership, and whether or to what extent women were things, a form of property, or persons, proprietors in their own right', C. Blum, 'Of Women and the Land', in J. Brewer and S. Staves (eds.), *Early Modern Conceptions of Property* (London, 1995), 161.

6. See I. Kramnick, *Bolingbroke and his Circle: The Politics of Nostalgia in the Age of Walpole* (Cambridge, Mass., 1968); J. Sekora, *Luxury: The Concept in Western Thought, Eden to Smollett* (Baltimore, 1977); C. Berry, *The Idea of Luxury* (Cambridge, 1994). I am indebted to all these studies for knowledge of the commercial imperatives in English 18th-cent. society.

7. J. G. Cooper, *Letters Concerning Taste* (London, 1755; 3rd edn. 1757), letter viii, p. 49.

8. Sylvana Tomaselli, 'The Enlightenment Debate on Women', *History Workshop Journal*, 20 (Autumn 1985), 114.

9. R. Jones, '"Such Strange Unwonted Softness to Excuse": Judgement and Indulgence in Sir Joshua Reynolds's Portrait of Elizabeth Gunning, Duchess of Hamilton and Argyll', *Oxford Art Journal*, 18:1 (1995), 30.

10. K. Shevelow, *Women and Print Culture: The Construction of Femininity in the Early Periodical* (London, 1989), 1.

11. J. Huizinga, *Homo Ludens: A Study of the Play-Element in Culture* (1944; London, 1949), 14–15.

12. J. Berger, *Ways of Seeing* (London, 1972); L. Mulvey, 'Visual Pleasure and Narrative Cinema', in L. Mulvey, *Visual and Other Pleasures* (London, 1989).

13. S. Rowbotham, *Hidden from History: Three Hundred Years of Women's Oppression and the Fight against it* (London, 1973).

14. F. Harris, *A Passion for Government: The Life of Sarah Duchess of Marlborough* (Oxford, 1991).

15. L. Davidoff and C. Hall, *Family Fortunes: Men and Women of the English Middle Class* (London, 1987).

16. See F. Braudel, 'The Structures of Everyday Life: The Limits of the Possible', in *Civilisation and Capitalism*, i (1979), trans. S. Reynolds (London, 1984), and N. Elias, *The Civilizing Process: The History of Manners*, trans. E. Jephcott (1939; New York, 1978).

17. Note, for example, how Elias in ch. x writes of the drawings in the House-Book.

18. See M. de Certeau, *The Writing of History*, trans. T. Conley (1975; New York, 1988), 99–100. 'Writing places a population of the dead on stage—characters, mentalities, or prizes' (p. 99).

19. M. Mauss, *The Gift: The Form and Reason for Exchange in Archaic Societies*, trans. W. D. Halls (1950; London, 1990); M. Douglas and B. Isherwood, *The World of Goods: Towards an Anthropology of Consumption* (1978; London, 1979); A. Appadurai, *The Social Life of Things: Commodities in Cultural Perspective* (Cambridge, 1986).

20. To quote the succinct formulation given in Douglas and Isherwood, *The World of Goods*, 72, 'Goods that minister to physical needs—food or drink—are no less carriers of meaning than ballet or poetry. . . . All goods carry meaning but none by itself.'

21. Erickson, *Women and Property*.

22. S. Copley, 'The Fine Arts in Eighteenth-Century Polite Culture', in J. Barrell (ed.), *Painting and the Politics of Culture: New Essays on British Art 1700–1850* (Oxford, 1992), points out that, although the exercise of polite taste depends on economic production and consumption, effort is expended in defining politeness outside of commerce altogether (p. 16). He also draws attention to deep distrust over low genres, though it is notable that all the passages he quotes in this section refer to portraits (p. 28).

23. And not merely among the aristocracy (see, for example, the satirical description in Goldsmith's *The Vicar of Wakefield* concerning Dr Primrose's family portrait, and Cosway's portrait in the Tate Gallery, *A Gentleman and his Wife and Sister in the Character of Fortitude Introducing Hope as the Companion of Distress*).

1

Purchasing and Consuming: Elizabeth Harley . . . and Others

ROBERT HARLEY (1661–1724) was one of the major activists in English politics from 1689 to 1714. The survival of his political correspondence, much of it published by the Historical Manuscripts Commission in the late nineteenth and early twentieth centuries, has resulted in a detailed understanding of his engagement with the post-Revolution parliament and government. The tense period between the 1688 Revolution and the accession of the House of Hanover is the arena for Harley's activities which were complex, often secretive, and highly influential with regard to constitutional and financial management of the English State.[1] Harley married twice: on 14 May 1685 he married Elizabeth Foley, the daughter of Thomas Foley of Witley Court in Gloucestershire, and after her death on 30 November 1691 from smallpox, he married Sarah Middleton, daughter of a city merchant. The second of these marriages was childless but three of Elizabeth's four children survived to adulthood. I am concerned with the first of these marriages, a marriage that united the offspring of two wealthy and influential county families with common political interests.[2]

Thomas Foley had stood alongside Sir Edward Harley in all three exclusion parliaments and like him had been defeated in the elections of the Tory Parliament of 1685. Both had a Puritan background.[3] Moreover the alliance was cemented by further intermarriages to the effect that the Foleys and Harleys acted as one group in parliament.[4] The financial arrangements pertaining to Robert Harley's marriage to Elizabeth Foley are not known but, as the eldest daughter of a man whose fortune was founded on ironmongery (including guns, cannon and ball, locks and hinges, axes and pitchforks), Elizabeth was undoubtedly a most desirable match for economic as well as political reasons.[5] Robert Harley and his son Edward collected one of the most remarkable libraries of books and manuscripts ever accumulated, now in the British Library, where their portraits hang in the vestibule to the Manuscripts Dept.[6] While Robert Harley's correspondence has been extensively drawn

upon in accounts of his life,[7] the copious number of letters written to him by his first wife have never received much notice, perhaps because they have never been transcribed and are written in a free and sometimes barely legible script. It is, therefore, on the testimony of one party that Robert's marriage to Elizabeth is described as 'a happy one, a match of love as well as a momentous family alliance',[8] and as 'an especially intimate affair'.[9] The long letter written by Robert on receipt of news of Elizabeth's death is often quoted not only as evidence of 'the man of strong passions struggling to control them, trying to reconcile himself to overwhelming loss' but also as testimony to the hold of religious rhetoric of a Presbyterian kind on English discourse.[10] The benefits of extended family life at Brampton, the Harley family home in Herefordshire, are unquestioned.

The object of this chapter is not, as it were, to put the record straight. Rather, it is to examine the case of two individuals who lived hundreds of miles apart for most of their short six-year marriage in terms of the ways in which a discourse of material culture—of objects and artefacts pertaining to the everyday—became the bridge to maintain an affective connection. None the less, one effect of this examination is to question the relationship between what might appear ostensibly as the political and what primarily the personal, to see the domestic as a part of the public. What, we may ask, did it mean to have to negotiate the compelling but competing demands of pregnancy and parliament, parturition and legislation?

The Harleys' life was complex. When Robert Harley fought for, and won, a parliamentary seat, it was a moment of transition from a parliament that met intermittently to one that sat more or less full time for most of the year. Defending parliament as a representative body was immensely time-consuming and Robert Harley could not have known in 1689 that he would be one of a new breed of full-time politicians rather than a gentleman of substance who occasionally met with his kind in parliament.[11] It was this momentous change that kept Robert in London and provoked the extended correspondence between him and his wife between 1688 and 1691. While the overt expression of affection or exasperation may offer a frame in which to understand the relationship between these two people in history, that relationship is individualized, placed outside rhetoric and within a different set of conventions, by the discourse of possessions. The punctuation that renders the declarations of devotion meaningful is the description and exchange of goods.

Robert Harley was resident in King Street, London, for virtually the entire year from 1688 onwards; his wife remained at Brampton, an arrangement that caused unhappiness to both. It was not, however, a simple matter. Elizabeth continually begs Robert to return to Brampton; in the late days of her preg-

nancy with her third child in June 1689, she is distressed at the apparent pro-
crastination of his visit: 'I am very glad to hear that the Parliament is like to
adjourn; I hope then you will cum the sooner down. . . . I do not think I shall
go my time. I hope you will cum down before I begin or else it will be a great
troubel to me.' Six days later she writes to him complaining of a terrible pain
in her leg. Robert consulted Sir Thomas Millington about her condition and
sent her laudanum for the treatment of cramp but did not leave London.[12] On
22 May she complains that he has quite forgot her and hopes 'you will rite to
me when I do ly in'. The baby, Edward, was born at Brampton on 2 June in
Robert's absence. Two days later, still ignorant of the baby's birth, Robert
writes to Elizabeth: 'the House never rises until three or four, & then com-
mittees sit until 9 or 10 this examination of ye miscarriages of fre land take up
much time we are in hopes of getting down every one is weary of staying & I
am sure noone more desires than I do to come down to your self, we had talk
of being adjourned next week, if business could be finished we should be first
down.'[13] By 6 June, the news of his wife's confinement has reached him and he
writes:

Tho I cannot tel yf my (Dearest) wil be able to read this I cannot slip this post wth out
joying in praise <tear> our most Gracious God for his great mercy & loving kindness,
as it is no smal troble to me I am not with you, al our prayers are yt God would gra-
ciously sanctifie this mercy persue it in restoring your self to strength, & in making the
little one his child purged from yt corruption it receives from us: Desire it may be ded-
icated to God—Father, Son & Holy Spirit in Baptism by ye name of Edward, I hope it
is already done for you knew my mind. The God of mercy strengthen you in soul and
body & in his good time bring us together . . . Pray God bless ye two little ones & ye
little stranger.[14]

Two days later he writes again, telling his wife that she is continually in his
thoughts, referring again to the significance of baptism, and averring that little
Edward with grace 'may not only carry ye name but virtues of his grand-
father', and praying God to bless Betty and Abby.[15] Elizabeth (Betty) had been
born in 1686 and Abigail (Abby) in 1687. A second son, Robert, born fit and
well in June 1690,[16] died a month later.[17] It seems that Elizabeth gave birth on
this occasion without a midwife. Her husband, who was not present either,
found Christian solace in both lacunae, writing to her on 14 June:

Pray read not this your self, but let it be read to you. I came but just now from <?> it
was a joyful surprise to find the news of your safe delivery—I heartily bless God for it,
tho I am greatly trobled I am not with my Dearest. . . . I am sorry your midwife was
not with you but desire you wil keep her some time, & again I beg you wil not be ven-
turing but keep yourself orderly and quiet. . . . It is a great affliction to me I am not
with you, but God hath been better to you when you were most helpless.[18]

Throughout this period, Robert's letters are full of excited news of court and parliamentary affairs, of threats in Ireland and the prospect of invasion from France. The letters Robert Harley writes to his wife are not, however, to be understood as a distraction, or as a subordinate theme in the heroic narrative of statehood. The commitment to an ideology of the free-born Englishman that drives the relentless labour in the metropolis is predicated upon the preservation of the personal, the familial, and the rural that is inscribed and kept alive in this series of letters. Robert's grandfather had rebuilt Brampton Bryan Manor House after the famous siege of 1643 in which Brilliana Harley held out against royalist attack and, in addressing his letters to Elizabeth at Brampton Bryan, Robert must have had an image of the castle ruins that stand to this day adjacent to the manor house, a vivid reminder of the democratic rights he sought to enshrine in parliamentary procedures. While Elizabeth and other members of the household made decisions on the day-to-day running of the estate, letters were a medium which linked town and country and through which control could be exercised at the linguistic and symbolic level. 'I hope great care is taken of ye clock & nobody meddles w^th it until I come back', he tells Elizabeth in a phrase which evinces not only the material value laid upon a clock but also the need for a mastery of time which (for both personal and political reasons) was pressing.[19]

Elizabeth Harley's views of political life are nowhere explicitly stated, but when Robert was appointed Commissioner of Accounts his young wife wished him 'much joy of your troublesome plase, I am afraid it will be to you; and I am a fraid it will hinder your cuming in the country . . . Pray my dear write . . . whether it will; which I do humbly hope it will not.'[20] Alongside the exasperation and the eagerness to receive at least a letter, if not a visit, are frequent expressions of keenly felt love. Robert's are couched in literary conceits: 'Should I have written abt my thoughts with truest affection I should have wanted a Secretary with a hundred hands continually to have accompanyed me, & you would have stood in need of more eys than are in a peacocks trayne to have dyspatched ye reading.'[21] Elizabeth is more direct: 'I have a good mind to Love my Dear as you Love me: thus not right a brief one letter in a fortnight or 3 weake: if you do not come to night to me I do come to night to you; you cannot thinke how much it trouble me that you right so seldom to me . . . prey me Dear if you have any kindness for me pray rite often.'[22] She combines threats with persuasion and touching assertions of affection: 'I thank you for your Last most Lovd Letter. I do not know how I do deserve such great expression of Love from you. I cannot express mine to you they are so great. I am [word illegible] & do much Delight in your company & in no one else:—it leys in yor pours [lies in your powers] that we may be more together: it is a

great mercey there is love between us—& I trust God will continue it; I wish you did but ymagine how soroful I am without you. I trust we shall meat eare long with much comfort.'[23]

In 1691, the question of Elizabeth visiting Robert in London is under discussion. As early as March, a reference in one of Robert's letters to an accusation of insincerity and the supposition that Elizabeth 'would come up with my aunt Bromfield' indicates a controversy.[24] Having written in mid-April, 'I hope you will let me cum to London . . . I do much long to be with my Dearest. I am sure it is my great trouble to be so much from you,'[25] Elizabeth then goes quiet on the matter for a while. It seems to have been a subject of disagreement, for she writes on 12 May: 'If you are not desirous of my cuming I shall not cum up; for non hear will forward my cuming to you: if you have not a mind to have me cum I will not presse my self upon you; for I would not be a burden to you.' On 23 May Robert is in hopes 'to have heard of your coming up'[26] but now Elizabeth claims the children prevent her: 'I long to be with you, nedey cannot tolerate to hear of my going to London—he takes a great delight in being in your Studey with my brother ned & never was any one fonder of a child than my brother ned is of your Littel Nedey.'[27]

The one recorded attempt physically to close the gap between husband and wife foundered, suggesting perhaps that it had become, for all their protestations to the contrary, necessary to them in some way. Doubtless the longer Elizabeth was away from London with small children, the more daunting may have seemed the prospect of metropolitan life. It may also, however, have been the case that the relationship had come to depend on this dynamic of longing, on the articulation of unfulfilled wants and desires. Once acknowledged, the psychic dimension begins to explain the significance, at a level more than that of mere convenience, of the litany of requests for commodities that punctuates the correspondence. Bearing this in mind, Elizabeth's letter to Robert of 17 July 1688, which opens with many complaints about his failure to write but then develops into something of a shopping list, may be understood as a discourse as much upon preserving love as upon preserving fruit. Unwilling to believe her husband has really forgotten her, Elizabeth can none the less articulate that fear in her irritation that he has forgotten to send her Queen of Hungary water:

I hope you will not for git to by me the <???> . . . I hope you will send some powder shuger & <???> shuger for I have not one bit to preserve with; indeed if you do not send the preserving things I am not able to preserve any thing. I hope you will send some quene of hungry water for I have not a quarter of a bottel. . . . I have discusd these things before but I am afraid you have for got them & <tear> I make bould to remember you of them.[28]

One of the unforeseen effects of the circumstances that kept Robert in London was the difficulty experienced by the family in Herefordshire in gaining access to luxury commodities not available outside the capital. While he worried about the Jacobite succession, Elizabeth worried about sugar and coffee; while he relentlessly pursued corruption in public expenditure, she ran up bills and instructed him (as was her right) to pay her debts;[29] while he was so busy he had not even time to write to his wife and children, she made sweetmeats knowing full well how much they were enjoyed in London, and sent them south with messages which, in their visualization, asserted a degree of physical intimacy with those from whom she was separated: 'I have sent a paper of dried plums and chips of oring [orange] cakes for Sr Edward, I wish he may like them: I thought he mite be glad of such a thing to cary in his pocket.'[30] Among the frequent requests are coffee, oil, vinegar, chocolate, olives, lemon, orange, and above all sugar.[31] One letter contains two characteristic postscripts. The first reads, 'When I do begin to rite to you I do not know how to leaf off', and the second merely states: 'No shugar no sweatmeats.'[32] The two 'goods', love and comestibles, are interwoven and defined through each other. Children, by extension, are a further 'good' that may be mobilized in this struggle to control the discourse and hence to ensure the survival of the relationship.

The traffic was not entirely one-way and, though he found little time to write, these commissions were evidently regarded by Robert as of sufficient importance to require the attention even of one with his national responsibilities. Robert entertained his political associates with venison, bacon, and woodcock from Herefordshire[33] and regularly received beer and game from Brampton.[34] In return he supplied the requested commodities when they were available. Discussions and explanations concerning these commodities and luxury items are often juxtaposed with expressions of love and affection, explicitly demonstrating the connection between the exchange of goods and the protestations of sentiment. Robert tells his wife, 'I returne my (Dearest Heart) thanks for your most kind letter & ye Bacon. I have not sent you oreng better being expected but have sent coffee, ye Roll for neddy was promised but is not ready: you can never I am sure take so much contentment & satisfaction in my company as I do in yours.'[35] At the time this was written Robert was, actually, in his wife's company for only a fraction of the year. It would, I suggest, be a mistake, however, to regard these matters as trivial. They are, in essence, the language that knits together the two separate lives of the Harleys and makes possible the bond of communication between them.

The Harleys' arrangements were part of an institutionalized structure that is inscribed in conduct manuals of the period. John Evelyn recommended his

grandson and heir in 1704 not to spend time in London 'unlesse you have an Office to support the charge' since London life will 'alienate your wife and daughters from domestical things more necessary and virtuous'. A 'Regular Oeconomy in the Country is the best condition, at least after a little experience, unlesse I say some publique Employment be such as does not totally devower your Time, and even in that case what an Advantage is it to have your country Oeconomy with a discreete and faithfull Wife whom you will always find worthily Imploy'd and at home.'[36] Robert Harley's office entitled him to expect his wife to maintain his country economy. In separating Elizabeth from London, the institutionalized structure also established the conditions for the play of fantasy and desire. Distance separated Elizabeth not only from her husband but also from luxuries that she desired and the two are inextricably intermingled in her letters. London may, as Evelyn warned, have alienated women and men from domestic things, but removal from London may have emphasized rather than diminished the desirability of those things that were only available in London. Defoe, among others, writing in 1720, reported on the fact that everywhere, in the smallest towns or even villages, people wanted goods from other parts, and Braudel has argued that by the early eighteenth century an elaborate retail network was already in existence.[37] Lack in Elizabeth Harley's life is articulated therefore around goods desired—and this she shares with other wealthy dwellers in the shires—as well as around human relations. And the lack of goods, being easier to control than the lack of a husband, became one vehicle for the articulation of her sense of desertion.

Elizabeth Harley's correspondence with her husband between 1688 and 1691 indicates not only luxury food items that had to be sent from the capital, but also those consumer durables that were valued by a well-established family and which were often purchased for or on behalf of children. Present-giving was an important ritual, especially associated with the birth of a baby. Gifts are a useful index to luxury spending, being part of a social practice of potlatch, instrumental in the maintenance of a self-perceived position in society.[38] Among the items that Elizabeth requests between 1688 and 1691 are: a silver spoon and plate for 'bebye and Abeye' (Edward and Abigail)[39] and 'some silver things to give the littel uncle & neace' (this in response to a gift to Abigail and Edward of a cornelian ring and half a guinea each by cousin Foley and aunt Foley respectively).[40] The Ludlow courier was used frequently to send goods back and forth. Thus on 28 October 1691, Elizabeth thanks her husband for sending for her inspection 'gould fring gloves' which she wishes to keep. At the same time she sends to London two boxes in which are, besides her husband's flannel waistcoat, '112 pearls which will make bebey and babay a necklise. I desire you will get them bord & sent down in the box with my tasell; I could

not find nor hear of your hatt case. I hope your hatt . . . have no harm; pind to one of your handkerchiefs is the account of all your library that you have; I desire the faver of you to get my bibel new bound, I have sent it up in your box.'[41] The precise delineation of these objects—poised in language just as they are understood to be suspended in transit somewhere between Ludlow and London—is the concretization of the need to maintain a relationship. The items described are of the most personal order: a much-loved and lost hat case; a much-used and broken bible; a list of books pinned to a piece of personal linen (the bringing together of two of the most distinctive outward signs of the gentleman); ornaments for the children who are their own flesh and blood and, in seventeenth-century terminology, the pledge of their love.

What, then, of the thin thread of representation with which Robert Harley maintained *his* connection with Brampton Bryan? The letter he wrote after Elizabeth had died of smallpox has become celebrated for the passion of its religious expression; this also bears closer examination. While there is no doubt that a man of Harley's education and unusually wide reading may well have used a rhetorical stance as a medium for genuine pain, the religious sentiments also provide for the containment of personal remorse. While we would agree, in all likelihood, that Elizabeth's death was a 'terrible blow' to Robert,[42] that blow may well have been exacerbated by the knowledge that his wife had paid a high price for his political successes. His prolonged absence was unwelcome to her and, for over a hundred substantial letters in the period of their marriage, she had received in return significantly fewer and briefer communications, in many of which Robert apologizes for being in 'so great a Hurry' and confesses frankly 'my failing of short letters'.[43] The timing is also interesting. Robert received news of Elizabeth's illness on 28 November and immediately sought the advice of his aunts. On 1 December it was thought in London that the symptoms suggested a mild form of the disease. Two days later, on 3 December, he heard of her death which had occurred on 30 November (she was buried the same day), but it was not until 5 December that Robert wrote to his father at Brampton the much-quoted religious sentiments. There is never any suggestion of his travelling to Brampton.[44]

This brief look into the domestic correspondence of Robert Harley indicates that the notion of a 'happy marriage' is too simple even by the standards of a modern historian working with assumptions about the precedence of political careers over domestic obligations. There seems to be a desire on the part of historians to construct marriages as 'happy', thereby creating a binary structure in which one unproblematic part of the life-story acts as ballast for the place where serious conflict takes place, that is in the public and political arena. Similarly, the myth of an extended family is useful in so far as it permits

the assumption that the wife in the country is supported in some way. Scrutiny of Elizabeth's letters also suggests that this was more complicated than historians have allowed. Nor is the idea that she was sickly (thereby perhaps making Robert's absences of seven months and more in each year seem reasonable) at all convincing;[45] a visit to Tunbridge Wells to take the waters in the months after their marriage was probably connected with questions of fertility since Robert reported to his father on 12 March 1686 that Elizabeth was better and 'hath, thanks be to God, a certainty of her breeding'.[46] Her letters are robust and energetic; whilst they contain the usual list of physical ailments familiar to the period these are no more than those that Robert himself appeared to suffer, and her letters also contain discussions about the management of the estate (the disposal of hay in 'Brockley feald'[47] and instructions in 1691 about hiring a coachman for Robert in London[48]). Elizabeth was a woman of independent spirit and when, in the autumn of 1689, she is travelling around visiting friends and relatives accompanied by her three small children, she provokes from her husband something approaching a reprimand. Complaining that he does not know where his letter will find her and that the floods and bad weather have made him anxious on her behalf, Robert remarks: 'I see nothing is to[o] hard for a female resolution yet I believe if your concern were as great for yourself as mine you would not have ventured.'[49] Hearing that she has arrived safely but plans to travel on, he writes: 'methinks you ride Post about the Country. It is a wonder my Letters can meet wth you, you talk of so speedy a remove from Chavenage, I know not where this wil overtake you—I could wish you would remember me & your little ones.'[50] The expressed unhappiness with this travelling speaks of the threat it poses to the equilibrium between rural/domestic/personal, and metropolitan/parliamentarian/public upon which Robert Harley's world view was predicated.

The remark to Robert that 'non hear will forward my cuming to you', made by Elizabeth on 12 May 1691, suggests that the extended Brampton family may not have been as supportive as we, with a late twentieth-century nostalgia for what we think of as the diverse sociability and intimacy of the past, might like to think. This is borne out in a series of letters in which Elizabeth asks guidance on the matter of the Brampton housekeeping. Elizabeth's first letter on this topic written on 11 April 1691 is worth quoting in full:

I am joyfull to hear that my Dear is in Health. I pray good continuance to you. nedey is trobled with a could in his teath; I do understand by my sister & brother that they do intend that I should take the house keeping which I am not very desirous of & especially now you are not at home. That I might have your direktion about it I desire that you will be so kind as to write me soon so that I know best what to do in this matter. I am sure I do always need your direktion but in particular in this matter I desire that

you will not take and notice . . . anyone. I desire that when you write to me about this that it may be in a littel peese of paper & put in with your other letter to me . . . Let me know your mind in all these things. I have no one in the world that I can speake freely to but your self nor no one that will direkt me but your self so I hope you will not be angry with me that I put you to the troble of desiring your direktion for me.[51]

The use of the word 'intend' to describe the pressure being put upon her to take on the arduous task of managing this large household (which included besides herself and three children, her brother, Robert's unmarried sister, her father-in-law, and her sister-in-law Martha Hutchins) as well her request to Robert to reply secretly suggests a less than idyllic situation.[52] Robert had still not given the desired direction by the end of the month and she wrote again therefore: 'by all I hear that I must take the Housekeeping upon me which I am not very desirous of but all that I can say is that I shall be willing to be direkted by Sr Edward & yourself & will do my utmost to please you both.'[53] The survival of a book of 'disbursements' containing items of personal expenditure from the months immediately after her marriage (including the visit to Tunbridge Wells) to 1688 written in Elizabeth's hand does not suggest that bookkeeping was one of Elizabeth's skills. The same book was used by her sister-in-law Martha Hutchins for household expenses from 1691 so presumably Elizabeth died before the family had a chance to persuade her, and Martha took over, using Elizabeth's book.[54]

Elizabeth Harley's disbursements offer a microcosmic view of 'consumption' on the part of the wife of a young, ambitious, and highly successful courtier. While examination of these data cannot establish what proportion of income was spent on any particular item (as we do not know what the income was) it can indicate patterns in spending, from which the relative value of material goods for this individual and her immediate family may be inferred. The young Robert Harley and his new wife visited London and Tunbridge Wells, which was fast beoming a popular spa at this period;[55] otherwise Elizabeth was in the country and Robert in town.[56] During this four-year period 1685–8 Elizabeth made thirty-one separate acts of charity totalling £5 8s 4d. Included in this category are all gifts listed where no service has been rendered (such as 'given to a pour boy'). The individual gifts range from £1 1s. 6d. 'given to Mrs. Housemans sone' to the more usual 6d. to 1s., though 'a pour wooman that cut her [illegible]' at Tunbridge Wells got 5s. More charity, at least in this instance, is given in the country than in the city, when expenditure on luxury items increases and gifts to the poor decrease, suggesting perhaps that the obligations of landowning were taken seriously and that the urban poor were a less recognized category. Payment to named individuals, including servants, amounted to a total of £40 5s. This excludes coach hire

but includes servants' wages: Priceilla, Jone, and Non Long receive 2s. 6d. each and Margis and Nan Bate get 2s. and 3s. respectively in June 1687/8. These may have been bonuses rather than wages. A clearer indication of wages paid to servants is provided in an entry for 28 July when Jone Cate receives 16s. for twenty-five days' work. A memorandum with signed receipts at the front of the account book and written in Martha Hutchins's hand indicates that a little later, in 1703, a servant named Mary Lloyd received £2 per annum and Ann Angeuyn in 1710 received £4 in wages. Mrs Hopkins was paid £1 'for looking after bebbey [baby] 2 mounth'. Most of the sums spent on service by Elizabeth Harley were in the region of 1s. to 10s. and they were paid for services such as 'a boy going to Kidderminster', 'for bringing a basket of od things at tunbrgwells', 'given to the buchers boy', 'coleman and woudman for bringing it in', 'pd the choremen', 'given to nurses to guard children ' (2s.), 'given to a pour man that brout frout from witley' (Witley Court, Worcestershire—home of Elizabeth's father Thomas Foley), and 'given to the gardnr at Witley'. Costs of laundry amounted to the not inconsiderable sum of £6 19s. 3d. (13 entries) with additional sums for the purchase of soap, isinglass and brimstone. The doctor, on the other hand, cost £1 1s. 6d. and the chimney sweep 1s. each for one visit.

Pin-money, as Susan Staves has so effectively demonstrated, was a deeply serious matter both in law and in practice. Pin-money could mean a substantial private income for a woman during marriage and failure to pay it could lead to litigation. Staves has repudiated the view that pin-money is a manifestation of the greater liberalization of relations between spouses in the eighteenth century, arguing that such arrangements were also to the benefit of men and, moreover, that it was not inconsistent with a patriarchal view that women should be kept contented. There was widespread debate in the late seventeenth and early eighteenth centuries over the proper use of pin-money: could it, for example, be saved and used to purchase a cottage or bank stock, and if such purchases were made, did they belong to the wife or to the husband?[57] Elizabeth Harley seems to have had full control over her pin-money; in Tunbridge Wells she frequently lost at cards ('Lost at C & other things') and 'rafild away' small but, given her overall budget, significant sums of money. In what cannot have been more than a few weeks, she raffled away £11 8s. 9d. and lost £1 7s. 8d. at cards. Whether she ever won anything at cards is not recorded. It also seems to have been Elizabeth who kept a ready supply of petty cash. Her husband frequently 'borrowed' sums from her when they were in London: the entire amount recorded under 'Mr Harley had of me' or 'Mr H' was an astonishing £79 6s. 6d. mostly made up of sums between £1 and £2 but including one payment of 8 guineas and one of 7. Interestingly, in the

case of sums paid to her husband, Elizabeth Harley broke with her practice of not troubling to put down dates on which sums were paid out; presumably the fact that he received sums from her on 16, 18, 20 January, 19 February, two payments on 20 February, 22, 23, and 25 February began to cause her concern and made her wish to record not only the sums but also the frequency with which they were issued.

To understand what Elizabeth Harley's disbursements might mean historically, it is necessary to recognize the widespread and compelling arguments about luxury that were a feature of political thinking in the early modern period. Precisely what constituted luxury was hard to define since, as Sekora remarks, 'from at least Cato onward, writers had devoted much attention to elaboration, little to definition'. As an idea, luxury ensured the division of mankind into a virtuous 'we' against a corrupt 'them' and proved the existence of the lower orders. As Sekora puts it, 'the concept of luxury can be seen as much as a cluster of symbols as it can a cluster of ideas, sustaining one type of code while rejecting another'. The 1688 Revolution unleashed a new economic order and a new financial culture that produced artificial wealth—bank notes, paper money, stocks and shares, speculation and investment, profit and loss on an unprecedented scale. The natural order, it was feared, was being subverted and the constitution, the people, the morals and manners of the nation were at risk.[58] We have relatively little material, as opposed to textual, evidence as to what, at the everyday level of experience, contributed to these fears and how they were interpreted by individuals. As Berry states, 'the crux of the matter is the "relativity" of luxury; one person's luxury can be another's necessity'. Rather than Mandeville's highly influential *The Fable of the Bees*, which was not published in its expanded form until 1723, *England's Treasure by Forreign Trade*, written by Thomas Mun, a director of the East India Company, and published in 1664, is a more appropriate indicator for the period of the young Harleys' marriage. Mun does not wholly endorse frugality as a social principle because it would make it impossible for the nation to sell abroad. Central to Mun's treatise is, however, the theme of the vices of feasting, fashion, and idleness. Livy had blamed the import of foreign luxuries for the deterioration of standards in Rome from an earlier, more virtuous era. Mun scarcely uses the word luxury but he adopts this concept and refers to silks, sugars, and spices as unnecessary wants. Things that are imported, excessive, superfluous to basic needs, and things that are fashionable are all luxurious. Whereas Elizabeth Harley could have fruit from her parents' garden brought from Witley to London, the olives which she evidently loved, the oranges and lemons that she purchased in great quantities, and the fashionable new drinks of tea, chocolate, and coffee would all have counted as luxuries. Her respon-

siveness to fashion can be adjudged simply from the shoes that she bought—many pairs all different.[59]

By far the largest three categories of expenditure in Elizabeth Harley's accounts in terms of frequency of demand, if not always of financial outlay, are luxury foodstuffs (not to be confused with overall housekeeping expenditure),[60] small items connected with the maintenance of apparel (not including major items of clothing which are not covered in this account), and small consumer durables. Sugar, sugar candy, olives, flummery, cheesecake, peaches, preserved nutmegs, coffee, tea, oysters, pickled oysters, French plums, lemons and oranges, strawberries and raspberries, orange peel and orange chips, apples, chocolate, chocolate almonds, quinces, bird seed, orange flower water, Queen of Hungary water,[61] butter, macaroons, a pomegranate, bitter almonds, violets, cowslips, vinegar and oil, brandy, white bread, custard and mince pies, roast nuts, sweetmeats, syrup of rhubarb appear to have been the most desired foodstuffs and medicines. Regular sums are disbursed for postage and for carriage of the boxes destined for Robert and Sir Edward Harley in London. Two entries (2s. 6d. each) for 'cuting my hair' appear and there are many entries listing expenditure on 'fring for my peticoat', lace, black silk and thread, 'sating ribing' (satin ribbon?), a variety of fabrics such as holland, muslin, and calico, gloves and stockings for Elizabeth herself and also for Robert. A tippet and a muff at £5 and black silk stockings for Robert at 12s. are among the more expensive items. Elizabeth pays several times to have her stays altered, whether for fashion or as a result of pregnancy is not clear. Pairs of Spanish leather shoes, 'glase' shoes, 'plane shous', 'lase shoos', 'black clauth shous', and slippers are also purchased. The precision with which these are listed—the distinction between 'plane' and 'lase' is evidently an important one—evinces a degree of emotional investment in the objects themselves. The period in London includes frequent references to the purchase of 'nuse books' (newspapers) at 6d. or 1s. a time. The Licensing Act expired in 1695, opening the way to a free press. Robert Harley would be the chief impetus behind the development from 1704 of the first unofficial ministerial press organ, Defoe's *Review*, which served such an important function as a parliamentary propaganda instrument. He would be crucially involved in resisting later attempts to reinstitute press censorship. At the beginning of 1695 only one newspaper was being published regularly—the official *London Gazette*. Three other papers soon began to be published three times a week but there was no daily newspaper until 1702.[62] There is the occasional reference to books purchased (though only a copy of the *Cries of London* is listed by title as costing 2s.) but a number of entries are in payment for the carriage of books, perhaps those purchased by Robert or brought from the country up to the town for his use.

The Harleys evidently did not have their own coach in London and paid frequently for hiring a vehicle.

Distinctions perceived between luxury items and everyday necessities are clearly marked in Elizabeth Harley's account and usefully underline Weatherill's distinction between 'frontstage' and 'backstage' in households of substance during this period.[63] 'Earthen things' and 'Wouden things' indicate everyday vernacular (earthenware utensils) and utilitarian objects (wooden). Fashionable and tasteful purchases are itemized in detail. Thus it seems that Elizabeth Harley was an early devotee of the tea-drinking that was to become such a rage in the eighteenth century.[64] She purchased '6 tee dishes' for 1s. and then 'a 12 of tee dishese' for 2s., a 'tee table' and 'tee pot' for £2 15s. and £1 each all at about the same time; later a further two purchases of twelve tea-dishes and '6 chancy tee dishes & plates to them' (10s.), amounting to forty-eight in all. Pleasure may have been derived, as with 'lase shoos', 'plane shous', etc., from the very act of representing these items. All chinaware was imported from the Far East prior to the 1740s and entered the British markets through auctions at the East India Company warehouse in London. Ownership was concentrated at this period in London and one or two other large centres. It is hard to overestimate its importance as a status symbol and as the central focus of a highly evolved series of competitive social rituals. Paintings of the period celebrated the tea-table, as did novels and poems. Tea-drinking is a paradigmatic case of a cultural phenomenon in which economics and performativity are inextricably bound up with representation and self-presentation.[65]

Elizabeth Harley was, if not profligate, certainly a keen spender. In the category of personal material objects that she acquired either for herself, or to give away, during this period are listed, besides all the tea-dishes and other sundry 'choncy dishes': '2 screans [screens]' 6s. 6d., 'a shuger thing' 5s., gumwork flowers 2s., 100 marbles at 1s., a 'necklis' 1s., 2 lockets £2, 2 fine box combs 2s., '100 neadels' and 500 pins (1s. and 4s.), a silver thimble 1s., a 'maske' 1s. 3d., 'toys for mis Let & mis Lety' 12s., 'a tin coufey pot' 1s., 'a claspe for my bibel' 1s. 6d. and a further 1s. in connection with the same purchase, 'a candel stick' 5s., 'a botel to hang by my nack' 4s., and 'things to hang the botel on' 2s. 6d.

Few of these purchases added up to anything like the amount spent on what must have been grand and elaborate clothes, perhaps worn to the tea-drinkings. The 'lase shoos' mentioned above cost a guinea and 'flowered persian for a manto and peticoat' purchased at the same time in July 1687 cost the substantial sum of £5, twice the annual wages of Mary Lloyd as listed by Martha Hutchins in 1703. Bed linen was also very costly with 'a pare of sheats and pilifors' costing £4 19s. Nel's quarter wages, at around the same time,

amounted to 15s. Children's clothes were also costly: '2 pare of worsted for bebey' cost 2s. 6d. in July 1687 and 'a night goine for her' cost 16s., a silk coat and petticoat for the baby cost £1 12s. 0d., leading strings were 1s. 6d. By comparison, 3 pounds of cherries cost 5s. and Mrs Hopkins received £1 in wages for looking after the baby for two months.

It is significant that all the evidence I have adduced so far in this chapter is of a verbal, not a visual, nature. Given that artefacts like those purchased by Elizabeth Harley were valued personal and household possessions, how is it that they do not feature more visibly in paintings? Why was there no tradition for the resplendent display of goods in paintings in England in this period consonant with that in northern Flemish and Dutch imagery? One reason must surely be that paintings—and perhaps especially portraits—were understood themselves to be a part of that world of household possessions. To make them mirrors of household goods, as with Dutch or Spanish still-life paintings, would have necessitated seeing them as different or 'other'. Of course, there are images that contain lovingly depicted arrays of objects and there are portraits in which the owner is represented wearing jewels and clothes he or she is known to have possessed. But the discourse of things occurs in descriptions that, to use Susan Stewart's terms, speak 'to the cultural organisation of the material world' and do so 'by concealing history and temporality' and engaging in an illusion of timelessness.[66] Paintings were a part of that world, not outside it. Our access to that world is through language, and through representation, and this would be true even had more than the sparse quantity of goods from this period survived. Those that have survived, whether in homes or in museums, are no longer in the relational environment for which they were valued by their owners, and I mean relational in the sense of the relation of objects to the human body, and relational in the sense that all objects participate in an economy to which other objects also belong.

The otherwise interesting work that has been done on the history of possessions fails to acknowledge the importance of language. Descriptions, as Stewart points out, must rely upon 'an economy of significance which is present in all of culture's representational forms, an economy which is shaped by generic conventions and not by aspects of the material world itself'.[67] The organization of information in realistic genres like 'the inventory', 'the will', or 'the account book' is not mimetic of the material world itself, but of values embedded in the social world and in its forms of hierarchization. Because of the history of the word as utterance in lived social practice, significance, in Stewart's account, attaches not to the object but to the description of the object. The fascination of historians with inventories is, arguably, due to the fact that they speak of the unattainable actual and authentic. The will, the

account book, the inventory thus represent a site of desire to escape from discourse into actuality. Moreover, conventions mean that the representation of the world of things produces categories of objects that are alike—spoons, coffee-pots, gold watches—whereas history desires the individual and craves the particular. In the account book, significance is *assigned* to objects because they exist. In the letter they are woven into narrative culminating in closure and are understood to offer a definition of the writer's progress through the world of things.

Accumulations of objects, and forms which represent those accumulations, are connotative of death because artefacts are culturally tied into ownership, they speak possession. Hence the appeal of 'lost property' art installations like those of the contemporary artist Christian Boltanski. Lost property is a contradiction in terms; an item separated from its owner is no longer property in anything other than the strictly legal sense. It is no longer part of the relationship self/object that fuels so much imaginative representation from Proust to the shopping catalogue and from the Christmas tree to the concentration camp. Memory, and nostalgia, are tied to objects and objects once owned are linked to our attempts to envisage death. When Freud in *Beyond the Pleasure Principle* formulated his celebrated description of the *fort da* game in which the baby Ernst enacts the loss he experiences by throwing the cotton reel and drawing it back again, he not only discovered a fundamental truth about the human subject's capacity to deal with loss, he also unwittingly demonstrated how functional objects have multiple uses, and how they become invested with particular meanings by particular individuals and so serve transcendent purposes. Nor is this an invention of the late nineteenth century. In *An Analytical Inquiry into the Principles of Taste* (1805), Richard Payne Knight set out the preconditions needed to spark a chain of imaginative association that would lead to aesthetic appreciation. One of these was the ownership of property which, of course, immediately establishes Picturesque Taste as an exclusive matter. In speaking of this, however, Knight lists the kinds of objects to which human beings form attachments, attachments of an intensity that go beyond the grave:

Love may be extinct, and friendship buried in the grave with deceased contemporaries: but, nevertheless, both will be replaced by habitual attachment to inanimate objects:— to the trees we have planted or protected:—to the lands, that we have purchased or improved:—to the books, that we have studied or admired:—to the curiosities, that we have collected or valued:—and even to the money, that we have amassed.[68]

If the inanimate objects amassed carry the burden of sentiment through time, representing those objects serves only to enhance their intensity. An

eighteenth-century reader would have understood the special nuance of Pamela's epistolary delineation of objects owned, their unique properties, their histories, and their symbolic as well as their actual importance for the heroine's new life. The framing of possessions within a declaration of religious faith would also have been wholly familiar. Here is how Richardson's heroine describes her transformation from a servant whose virtue is under siege to lady of the house:

> He was pleased afterwards to lead me up-stairs and gave me possession of my lady's dressing-room and cabinet, and her fine repeating watch and equipage; and, in short, of a complete set of jewels, that were hers; as also of the two pair of diamond earrings, the two diamond rings, and necklace, he mentioned to me in his naughty articles, which her ladyship had intended for presents to Miss Tomlins, a rich heiress, who was proposed for his wife, soon after he returned from his travels, had the treaty been concluded . . . He presented me also with books, pictures, linen, laces, and everything that was in my late lady's apartment; and bid me call that apartment mine. Give me, give me, good God, an increase of humility and gratitude.[69]

The belief that property determined power extended to every area of eighteenth-century English law and social practice. Liberty was understood to be meaningless without property and, as Blackstone expressed it, 'Whatever . . . hath a value is the Subject of Property.'[70] Susan Staves draws a distinction between real property (land and buildings) and chattel property (movable things) and suggests that in the eighteenth century conceptualizations could move from one to the other. My concern in this chapter is with the second of these definitions, though some of the women discussed were also owners of real property, even though it was rare for women to have possession of land and buildings.[71] The law offered overriding protection to the male property owner and most discussions of the relationship between property and power centred on one form of property above all others—land. None the less, in everyday life, property increasingly included commodities and personal possessions of an ever wider range and greater degree of complexity. Houses, furniture, paintings, clothes, jewels, carriages, servants were the visible signs of success. As Richardson's Pamela discovered, the comely appearance of a servant was an asset to the master of the same kind as the fine binding of a beautiful book: it/she could be brought out and displayed to guests, discussed and evaluated. Clothes and small-scale material objects of value that could be readily transported from house to house, from city to country, from home to watering place, played a particular role in the eighteenth-century economy of display. Pamela is given pictures along with the linens, laces, and other valuable items that had belonged to Mr B's mother. In this book, pictures—and they are almost exclusively portraits—will be examined for the images that

they represent. They will also, however, enter into the discussion as material objects, part of the world of things.

Landed property tended to be controlled by men (though the importance of widows and other legally empowered groups of women, as well as women like Elizabeth Harley to whom responsibility was accorded by circumstance, should not be underestimated), while women participated in the purchase and control of commodities and personal possessions.[72] In the case of domestic goods, as Amanda Vickery has shown, women of the gentry and middle ranks often had complete control and management.[73] This seems to have been true of Elizabeth Harley. The eighteenth century was identified by McKendrick, Brewer, and Plumb with the birth of a consumer society based on the principle of emulation and competition with women forming the chief impetus to consumption.[74] Vickery has effectively challenged this model of woman as pathological consumer and pointed out that inventories of goods do not establish what meanings individuals attached to artefacts.[75] Others have questioned the notion of the early eighteenth century as sluggish in consumer terms by comparison with mid-century.[76] It has also been pointed out that, whereas in modern-day society goods are cheap and people expensive, the reverse was the case in eighteenth-century England, when goods were expensive and employment of a servant was one of the basic criteria for something approaching middle-class status.[77] Moreover, purchase and acquisition may not be the only meaningful criteria for assessing the role that possessions played in the formation of social structures; we know, for example, from the evidence of Parker and Wakelin, the silversmith and jeweller which eventually became Garrard's, that even extremely wealthy families spent regular sums over long periods on the repair of basic household items (candlesticks, punchbowls, etc.).[78] None the less, the purchase of goods was a matter of intense personal importance and this was so from at least the end of the seventeenth century rather than the mid-eighteenth century as McKendrick and Plumb suggest. The purchase, giving, and receiving of jewels, for example, marked important moments of transition in an individual's life, a practice that survives in a residual form even in the late twentieth century with gold watches and rings marking rites of passage.

We may gain some sense of the affective as well as the economic value of such transactions by referring briefly to one particular but probably not atypical instance. In September 1735 Grace Boyle, aged about 15, wrote to her friend Anne Strafford: 'Many things have happened to me since I came here [i.e. to London] viz: the borring of my Ears, Papa's giving me a pair of £100 Earrings, a pink Diamond ring, & a pair of gold buckles . . . with 4 guineas for my pocket. Mama is giving me a pair of star Errings, a set of stay buckles, & an

Ermine muff. So I think I came to town to some purpose.'[79] The record of gifts received from her parents marks Grace Boyle's entry into adult life and into London society. They are gifts of property and are specifically intended for the adornment of this young woman's body; they are valuable gifts calculated for public display in a ritual of ostentation which will mark out the girl as marriageable and her parents as powerful. Whereas the low-born Pamela acquired such objects after marriage, Grace is given them before. They are also gifts of lasting value and they are small in size; unlike a horse they will not grow old and die; unlike an estate or a piece of land they can be held in the hand and they are intended specifically to be seen and understood as extensions and enhancements of the natural body. Moreover, they can be described using a set of vocabularies—fiscal, biological, and technical.

Great time and effort was devoted to the purchase of jewellery and to the commissioning of bespoke items, testifying vividly to the commercial vitality of London as consumer capital. Jane Cockburn, another friend and errand-runner of Anne Strafford, reported that she had been 'at Dear Lady Anne's commands' to Mrs Shanays and acquired the buckle which would be delivered by her father. She could not, on the other hand, find a necklace such as Lady Betty desired ready strung but she had ordered one to be made which would be ready the following Tuesday and would cost about 7s. She reports having sought for 'night earrings' (presumably what are now known as 'sleepers') at seven shops 'but I can meet with no such thing for they make none but with drops'. There is, however, a wide range of choice if she has the tops without the drops, 'set in gold for fifteen & the garnett sort in gold for twelve or thirteen shillings: and in silver gilt for six shillings'.[80]

It was not only the daughters of wealthy aristocratic families that acquired, wrote about, and wore expensive items of jewellery. Towards the end of the century, when anxiety about policing class boundaries was intense, the vision of a tradesman's wife wearing a diamond bracelet bearing a portrait in miniature aroused great hostility: 'And many a good Woman, whose arms are marked with an eternal red, from the industry of less prosperous days, considers the Bracelet, with the Miniature-Painting, as an ornament necessary to her Station in Life.'[81] What is incongruous, to this writer, is the body with its marks of past labour united with a form of adornment that signified leisure and the freedom from labour.[82] In both cases, the property is described not only as belonging to the individual but as affirming her body as a socialized organism.

This coming together of property and the female body moves from a momentary drama (whether of pleasure in ownership or self-righteous disapproval) into an extended narrative at the moment of the subject's death. 'I also

give my said daughter these jewells following (vizt) a pair of diamond earrings with three drops to each of them and my solitair and girdle buckle my hoop ring and my b<r>illiant diamond ring.'[83] This testatrix, Dame Sarah Humble, exercises control over her own property, defining in material detail those items that had adorned her own body which she determines should now become the property of her daughter. Each item of adornment stands in metonymic relation to the biological body whose decease is the pre-text for this declaration: rings for fingers, ear-rings for ears, girdle buckle for the waist. On a scale from the extremely modest to the very lavish, according to the extent of those *things* that were *theirs*, to use Stewart's self-consciously everyday vocabulary, women wrote their bodies thus into a narrative of timeless continuities.

Making a bequest implies rights of ownership. Women's right to own and dispose of property was no simple matter. Once a woman married she was considerably disadvantaged with regard to her legal status since common law regarded her as feme covert. The doctrine of unity of person meant that her interest in property, personal and real, passed under her husband's control. In return, however, the wife had certain rights to both personal and real property (goods and estates) after his death. Yet this is only half the story, because the law administered in the Court of Chancery, known as equity, afforded married women considerable legal status, especially through marriage settlement and through mechanisms that ensured that when a married woman was bequeathed an estate, it was bequeathed to her for her sole use.[84] Discussions about the relative dependence or independence of married women during the eighteenth century have also focused on pin-money. Lawrence Stone, at one extreme, proposed that the institution of pin-money constituted an independent fixed income at a wife's exclusive disposal while Susan Moller Okin at the other argued that it was not hers to spend or save as she chose but was explicitly 'intended to be spent so as to keep up her appearance and that of the household consistent with her husband's economic and social position'.[85] The case of Elizabeth Harley suggests both may have been true.

This chapter is not concerned with examining the legal ramifications of marriage settlements, nor with questioning the overall position of women financially from the end of the seventeenth and through the eighteenth century. While it is true that women lost the right to control their own property with marriage, it is also the case that marriage offered their most likely means of acquiring property —directly and indirectly—if they were not born to it. The real-life example of Sarah, Duchess of Marlborough, whose marriage did not make her wealthy but (along with her position at court) enabled her to work independently of her soldier husband to build up her own as well as their joint fortunes so that when she died in 1744 she was by any measure the wealthiest

woman in England, is a testimony to marriage as an enabling institution in the acquisition and control of women's property.[86] It may be argued that Sarah Churchill was a highly exceptional case. On the other hand, female virtue in Samuel Richardson's best-seller is quite explicitly rewarded by the acquisition of property. Happiness, for the exemplary Pamela, who originally owns nothing but her chastity, is conferred in the form of itemized goods. The value of an equipage such as that which Mr B gives Pamela after their marriage along with laces, linens, and other goods is measurable in a variety of ways. In the first place, it constitutes a calculable financial investment, and whilst it is not clear that control of this property is legally made over to Pamela, the fact that it is linked to Mr B's mother, who clearly did have control of it (the words 'that were hers' are not used idly), suggests that in receiving the contents of the lady's apartments Pamela steps into command of her own acquisitions. Jewels and fine clothes are also—as throughout the novel—ways of marking out differences of class; what would have been improper before marriage is necessary after, as Pamela must be seen as an appropriate ornament to her husband's position.

Consumption implies that objects are assimilated by the individuals that acquire them and the interest of historians is often more in the selling and so-called consumption of material goods than in the uses that they served. The corollary to the repair economy of the eighteenth century which we have already mentioned is the degree of importance attributed to individual objects, often small or apparently insignificant in themselves. It is clear, from the testimony of women's wills and correspondence (as well as from the fictitious case of Pamela), that possession of material goods was esteemed not only for their use value and for their symbolic exchange value but also for their economic exchange value. In the case of Pamela, just as Mr B's mother had intended to give his prospective bride a set of diamond jewels, so the married Pamela herself now has the power to make gifts. Her first act, on receipt of her annual pin-money, is the disbursement of charity and the making of gifts to her former fellow-servants.

To make a gift is to exercise power in ways that are not calculable merely by reference to the financial value of the gift. As Baudrillard points out, a gift is a very particular kind of object: 'it is inseparable from the concrete relation in which it is exchanged, the transferential pact that it seals between two persons'. A gift, he states, 'has properly speaking neither use value nor economic exchange value. The gift is unique, specified by the people exchanging and the unique moment of exchange.'[87] To pursue this idea a little, we might say that, while an object that is given away may, by conversion, be assimilated into an exchange economy (diamond ear-rings could, for example, be sold

though they might still be identifiable with their original owner, being unique-
ly designed and made for that person), the act of giving places the giver and
the receiver in a relationship of dependency. The gift is a sign of that relation-
ship. At the same time, there is much evidence from the writings by and on
behalf of women in the eighteenth century that property was acquired and
given away in a systematic exercise of power that blurs Baudrillard's cate-
gories. Thus, for example, a silver coffee-pot, used daily by a particular woman
and bequeathed to another woman, was freighted with associative values: it
was a souvenir (an object invested with memory) that linked two people. The
same object might also confer on the receiver symbolic value simply because
the possession of a silver item was indicative of social class. When Jane
Cockburn recounted to her friend Anne Strafford her visit to Mrs Foreman's
London home, she made a point of stating not only that she viewed medals
and prints but also that she 'drunk coffee out of the silver pot which is vastly
fine'.[88] Furthermore, because silver could directly be exchanged for money
with which basic commodities like food could be purchased, the bequest of a
silver coffee-pot produced economic exchange value. It also, of course, pos-
sessed use value, especially if the person to whom it was given did not already
possess such an object. Men as well as women could, and did, make gifts but
it is also clear from, among others, the case of Elizabeth Harley that women
were socially positioned as givers of material items of value not only on their
own behalf but also on behalf of husbands who met the bill.

Women realized capital and disposed of personal possessions at particular
moments in their lives; the disposal of jewels and other effects often marks a
rite of passage. Horace Walpole left an interesting account of how the
Duchess of Portland dealt with her possessions during her own lifetime. The
Duchess of Portland's mother had been 'a prodigious collector of portraits of
her Ancestors, & had reserved <sic> the fine Miniatures, Enamels, & Vases of
crystal & all which she left as Heirlooms to her Daughter & her Descendents'.
As readers of Anthony Trollope's novel *The Eustace Diamonds* will know, an
heirloom is family property left in trust for perpetuity, the current owner
having no right to dispose of it. But the Duchess of Portland also inherited
from her mother the considerable income of £8,000 per annum. With this she
'gratified her taste for Virtu', bought pictures which, according to Walpole
whose opinion should be treated with caution, 'she did not understand', and
went 'deeply into natural history'. Her most famous purchase was, of course,
the Barberini Vase (which subsequently became known as the Portland Vase).
In 1786 the Duchess ordered her fabulous collection to be sold for the benefit
of her children. She must have been aware that the thirty-eight-day sale would
further enhance her celebrity by demonstrating her to be not only a consum-

mate collector but also a generous parent. She did not, however, include every-
thing in the sale and in many ways the interest of Walpole's account lies in
what he tells us of those items that were kept behind. The enamels and minia-
tures were entailed to the Duke and her most valuable jewels she had dis-
tributed between her daughters and granddaughters on their marriages.
These included 'a pair of solid Emerald drop-earings to her Daughter Lady
Weymouth, & a toilette of gold Filigraine to her Granddaughter the Countess
of Aylsford. To her friend Mrs. Delany She had bequeathed an exquisite
portrait of Petitot in enamel by himself which her Grace had bought in
Ireland for forty guineas as a Grandson of that Painter & also Raphael's
Mice from the Royal Collection, two Mice (different) in water-colours, also
called by Raphael, but certainly not, and an enamelled snuff box.' The
Duchess's son received pictures, china, and furniture as well as the cabinet of
rarities which contained 'the pearl earring worn by Charles Ist at his
Execution'.[89]

Seeking, locating, acquiring, transporting, and owning constitute a disci-
pline that interweaves and folds into other kinds of disciplines, including those
(for example) of political life. Wills, on the other hand, mark a self-conscious
moment of decision-making which is more or less public in nature. Moreover,
since writing a will requires a particular visualization of the material (in the
inventory the generic may suffice but the will demands the particular and
specified) and that visualization is translated into words by the objects' owner,
the very language of wills is imaginatively invested. It has been suggested that
many eighteenth-century men made their wills only when they were
approaching death. It would appear that this was not necessarily the case with
women whose wills, in the sample on which the remainder of this chapter is
based, are often dated some years before they are proved.[90] Legal formulations
notwithstanding, the vocabulary used to identify particular objects is often
clearly that of the owner, not that of a clerk, a lawyer, a bailiff, or a house-
keeper. Thus typically we read of 'my straw coloured damask elbow chair',[91]
'a wrought bed that was my mothers with the damask to line it and my own
picture at half length . . . my diamond buckles for my stays my lockett set with
diamonds with her [the testatrix's daughter] ffathers hairs a mohair bed that
was my mothers and my own picture in little'.[92] While the discourse of the
will is apparently impersonal like the law, the personal, which perpetually
erupts therein, is all the more striking.[93] Affirmations that the testatrix has
always 'lived hand to mouth' and never laid anything up lend a resonance to
the descriptions of satin cloaks and silver snuff boxes that follow[94] and the sub-
stantial provision of £50 per annum for life to 'my melancholly daughter Judith
Lady Dowager Coningsby Baroness of Clanbrazil in the kingdom of Ireland'

on the part of Elizabeth Halpenn (commonly called Lady Lawley) speaks of a complicated history of bereavement and hardship.[95]

So far this chapter has highlighted the case of Elizabeth Harley in order to establish the patterning of objects and emotions, the one punctuating and marking the expression of the other. For the remainder, I shall look at the world of things as generically represented. The aim here is not a quantitative assessment; I have looked for material that could be qualitatively evaluated and this has necessitated the selection of wills in which women have elaborated upon their possessions. If the reason for this was that no mistake should be made in identifying those objects, I do not regard that as in any way precluding an emotional relationship with things possessed. Indeed, one might argue that only someone with a major investment in the uniqueness conferred by ownership upon what was in most cases a far from unique object would have gone to this trouble. In other words, I do not believe that economic value exists independently of sentimental attachment. The sample is considerable if not exhaustive: a total of eighty-nine wills signed by women between 1711 and 1760 and proved between 1739 and 1760. Only women who left substantial property are included. The aim was to include five wills for each year during the period covered. In most cases this was achieved, though for one or two years there were only four of sufficient interest to meet the criteria (see Appendix). In this sample, seven marriage settlements or legal entitlements by inheritance are specifically mentioned. The status of the women at the time of writing the will is as follows:

widow	57
widow & wife	3
wife	6
spinster	12
unspecified	11

Among the sample are women of the wealthy merchant class as well as landed gentry and titled aristocracy. The former are characterized by a degree of detail with regard to the description of individuals and goods, and a willingness to direct possessions to be sold rather than retained. Thus Dame Phyllis Langham, a widow writing her will in 1754, names as her executors two male friends (a lawyer [?] and a gunsmith) and her daughter, wife of a Spitalfields silk dyer. She directs that all her household goods, plate, jewels, watch, gold equipage, linen, wearing apparel be sold within three months of her death. After payment of debts and funeral expenses, an elaborate series of small bequests to relatives such as her brother (described as a necklace maker) are to be arranged; chief beneficiary is her granddaughter, for whom a trust is

set up to permit her £15 per annum until she is 21 when £500 shall be transferred to her for her own use and benefit.[96] The fastidious approach to household economy, which Amanda Vickery has so well described in the case of Elizabeth Shackleton, extends to management of goods after the individual's decease. The Dowager Viscountess Gage, for example, in a will drawn up in 1757, leaves to her companion (provided she be living with her at the time of death)[97] all her clothes 'except those that have gold or silver in them' and except a white satin gown. These items are reserved 'to make use of for church stuff'.[98]

Dame Sarah Langham's provision for her granddaughter is typical of a range of formulations designed to protect women's interests. The language of these stipulations is extremely specific and self-conscious. Elizabeth Halpenn, drawing up her will on 27 January 1739, having left her husband 1s., leaves Mrs Powell 'ffive pounds to be paid into her own hands separate from and exclusive of her husband and he to have nothing to do therewith but her receipt to be sufficient for the same'.[99] Dame Mary Jones, on 13 November 1739, refers to her daughter Mary, who is married to the Hon. Major-General Howard, and three grandchildren. Mary gets her mother's gold repeating watch and 'all things thereto affixed' except for the seals that go to a grandson and all the grandchildren get lump sums. Dame Mary also, however, gives elaborate instructions to ensure that the dividends and interest on stock she is leaving will be solely for her daughter's use. This money shall be delivered 'unto the proper hands of my said daughter . . . and wherewith her said husband notwithstanding her coverture is no ways to intermeddle nor is the same to be subject to his debts power or controul but the receipt or receipts of my said daughter . . . shall be sufficient discharge or discharges for the same'.[100] Arrangements such as these for female friends and relatives were common.[101] The term 'intermeddle' seems to have been peculiar to bequests to women as it also appears in wills written by men when women are the beneficiaries.[102] It is also more or less standard for women to provide in some way for their servants, sometimes simply with gifts of clothes and linen (presumably with a second-hand market value) but also more lavishly. In this sample of wills, the most interesting arrangement is that whereby Lady Ann Harvey made provision for 'my black girl Lovey Longwell' by leaving £100 for her in trust, under the control of Mrs Elizabeth Courtney, Lady Harvey's granddaughter. 'Lovey Longwell may receive the interest therof as it shall yearly grow due and the said principal sum of the hundred pounds I order to be payd her whenever she shall marry to an advantage and to the good liking of my said granddaughter.'[103]

The power of widows in the management of estates prior to their sons'

majority, and the efficacy of marriage settlements and jointures in enabling women to have control of their own money, are well known. What also emerges from this sample of wills is evidence of the significance of gifts and bequests—often of a very modest kind—in the conduct of social relations between women. It is not merely a matter of women leaving small legacies to women friends; it is a question of the naming of women as individuals, the precise delineation of these individuals and their status, the selection of the items appropriate to the person, and the description of those items in a text that functions both as permanent legal record and as declaration of sentimental attachment. These gifts and bequests may have been useful to the individuals who received them though we can never ascertain this to have been the case. What is apparent is the process of inscription wherein the testatrix—at an important ritualized moment and before witnesses—inscribes a personal history of friendships and marks them with a gift. To state, as does Diefendorf, that 'if a man's last will and testament was a "mirror of his life and actions", a woman's, too, was her self-portrait' is only half the truth;[104] the will is at one and the same time a script for a staging that will take place after the author's death and a set of rhetorical recollections concerning the author's relations with her world during her life.

The will as personal inscription is typified by Dame Anna Maria Shaw who leaves her 'good ffriend Mrs Mary Bridges' a substantial annuity and also significant tokens of remembrance: 'my new ring set with diamonds which I made in remembrance of my late dear daughter my silver saucepan engraved with my widows arms my yellow damask bed with the bedstead and ffeather bed curtains blanketts bolster pillows quilt and worked counterpain and the window curtains and chairs thereunto belonging and also my stone shoe buckles'.[105]

Another interesting case is the Hon. Lady Catherine Jones, third daughter of Richard Earl of Ranelagh. She died unmarried in 1740 after an interesting life during the course of which she corresponded with Dean Swift, entertained George I to supper at Ranelagh House, and, most interestingly, took into her home Mary Astell, who dedicated several books to her.[106] Lady Catherine opens her instructions for the disposal of her property by requesting that the portrait of 'my dear ffriend Mrs Kendall' which stands over the door of her bedchamber be given to Mrs Ann Mudiford of Windsor if she be living and, if not, to Mrs Oldfield and her sister. The portrait of Miss Squire, deceased, is to go to Mrs Narcot, her executrix. The sense of a network of women articulated through gifts and bequests is reinforced when it comes to the distribution of the proceeds of the sale of land Lady Catherine has inherited from her father. A thousand pounds is to go to her sister the Countess of Kildare and the same sum to her niece Lady Frances Hanbury Williams. Smaller bequests are provided as follows:

To Lady Colliton the widow of Sir Theodore Colliton the sum of one hundred pounds as a small remembrance of her friendship to me & Thomas Read my godson son of Mrs Read who is daughter of Doctor Langford fifty pounds to Mrs Mary Green of Westminster spinster one hundred guineas as a small token of my regard and gratitude to her to Mrs Braithwaite of Piccadilly spinster to whom I have always been obliged one hundred pounds to my good friend and old acquaintance Mrs Crawford now of Blackheath near Greenwich one hundred pounds and to her two daughters who are now unmarried ffifty pounds each and my godson William English grandson of my said ffriend Mrs Crawford fifty pounds to Mrs Angel Butler spinster my long acquaintance and ffriend one hundred pounds . . . [107]

Thereafter Lady Catherine provides for her servants and leaves a bequest to Chelsea Hospital. The extent to which an estate is dispersed in the interests of friendship is notably counter to received wisdom about the management of property. In other cases, the naming of individuals with a declaration of the nature of the relationship which we see in Lady Catherine's will is replaced by an exuberance, an excess, of descriptive prose. It is as though the owner of the goods seizes this moment to celebrate the particularity of these loved objects, legitimizing the material world by the process of description at the very moment when she contemplates leaving that world. The Law legitimizes here what Protestant ethics forbids and the virtues of thrift and good management are translated into a poetry of the everyday.

The discourse of the personal and the domestic that is found in these wills is anti-taxonomic and characterized by plenitude and excess. The listings defy the kinds of classification recommended by Evelyn and replicated in the ordering of his own account where he advises on household management room by room.[108] The plethora of adjectives that aim to distinguish this particular item as personal to its owner, the repetition of the possessive pronoun, the rapid movement from jewels to clothes to household goods to silver, speak not merely sufficiency but excess. Provision and adequacy are surpassed in a discourse that refuses the taxonomic in favour of a biblical profusion. I will take merely one example—in its entirety—to illustrate this tendency:

I give to the Right honourable the Lord Chedworth my brothers picture which I had of his ffather I also give the right honourable the Lady Shaftesbury my wrought bed. Item I give to Mrs Letitia Juge wife of Edward Juge of Brook Street in the parish of St George Hanover Square afore said gentleman my tea table six china cups & six saucers my china tea pott and saucer my china sugar dish and cover my china slop-bason and saucer two china muggs and my six silver tea spoons my four large damask table cloths and nine damask napkins and my two little damask table cloths my velvett gown and pettycoat my ffrench brocaded handkercheif my two long laced hoods my black laced handkercheif my ffringed work pettycoat my white satten laced mantelett and pilgrim

the same my velvett muffels my emerald ring set round with rubys and diamonds my stone shoe buckles and my girdle buckle both set in silver my green earings with three white drops my garnett earings with three drops and all other my earrings and stones therto belonging my black broad small bead necklace my white ffrench necklace three rows my hook my white ivory ffan my gold stuff my little canvas ffire screen my two gold tassells my whiite sattin stumacher and my silk cover for the tea table and my book of receipt in cookery. Item I give to Miss Letitia Barbara Juge the daughter of the said Edward Juge my twezer case and chain to my watch and seals and my little amythist ring. Item I give to the said Edward Juge my gold watch but in case he shall happen to die in the lifetime of his daughter the said Letitia Barbara then I will and order the said watch to be delivered to her and immediately upon his death I give the said watch to her the said Letitia Barbara. Item I give to the said Edward Juge my green doublett stone ring. Item I give to Mrs Arbrough my landlady at Kensington a ring of one guinea value. Item I give to Mrs Hesse Nugent of Westminster six of my best shifts and two old fine ones six of my best cambrick tuckers four of my best holland aprons my two fflowered aprons two broad hem'd cambrick aprons one flowered lawn pinner and quoif six handsome mobbs one suit of plain drest night cloaths two suits of my best night mobbs two of my best plain short hoods one pair of single fflowered lawn ruffles one pair of double plain cambrick ruffles one double lawn handkerchief one single fflowered lawn handkerchief my coarsest singled edgd handkercheif three single coarse cambrick handkercheifs two fine cambrick pocket handkercheifs four new coarse cambrick handkercheifs two white dimity stomachers two dimity under pettycoats one dimity waist coat and one callico waistcoat one callico half sack work't and long dimity pettycoat two pair of cotton sleves one pair of fine holland sheets and six pillow cases one printed callico bed gown one pair of dimity pocketts two pair of my best cotton stockings one plaid gown one plaid pettycoat two new peices of plaid my white gown workt my tabby gown and tail and my fflowerd cotten gown my blue silk quilted petticoat and white silk quilted pettycoat my scarlet and black under pettycoat my best pair of stays my white silk stomacher and waist hoop my velvett mantelett and pilgrim and short hood two india silk handkercheifs two pair of new kid gloves my everlasting ffan and french muff my black enamelled gold ring one pair of worsted stockings my biggest pair of shoes my hair pormantua with a trunk at the <word illegible> my two large silver spoons and the sum of ten pounds in money. Item I give and forgive the same Mrs Hesse Nugent all moneys now due to me by virtue of her bond & jointly with Mrs Goles. Item all the rest residue and remainder of my ready money . . . and all my goods chattels and estates of what nature or kind soever whereof I shall be in any ways possessed or intitled unto at the time of my decease and not by me herein before given or disposed of after payment of my said just debts ffuneral expences and all charges touching the proving of or otherwise concerning this my will I give and devise unto the said Edward Juge.[109]

If we are tempted to regard this outpouring as merely functional, we might contrast this form of utterance with that of Anne Legge, spinster, who around the same time stated tersely: 'I give and bequeath all and singular my goods

chattels ready money plate household ffurniture and estate of what kind or nature soever after paying my just debts and legacys unto my dear and loving sister Elizabeth Legge of the parish and county aforesaid who I do hereby make ordain constitute and appoint full and sole executrix of this my last will and testament.'[110]

Ownership is a question of symbolic investment; the fact of possession endows an artefact with characteristic virtues that are denied apparently identical objects. The artefact has a maker, a seller or donor, and a user. By dint of having been used by an individual it acquires an aura and an identity which qualify it to function discursively. This relationship is enunciated in wills both by inference and also overtly through description such as: 'the three pronged ffork I commonly eat with, and my smallest two handled silver cup which hold as near as I can guess about a pint or not so much'[111] or 'a gold snuff box with a peice of enammel on the top given me by Queen Caroline when I was one of the Ladys of her Bedchamber'.[112] The role of women as guardians of family history is evinced in the process of endowment that is enacted through the medium of wills. Lineages are established and maintained through the handing on of possessions; while children may fall sick and predecease the owner, artefacts in English society at this time offered a kind of permanence and could thus represent (through description) a longed-for continuity. The watches, jewellery, paintings, satin cloaks, silver spoons, and other possessions written into these wills may have been made by celebrated goldsmiths, exceptional artists, gifted silk-weavers, and so on. Reversing the customary preoccupations of art historians, my concern is not with the makers but with the value acquired through use. In this process all identity is subsumed within that of the owner and speaker—the testatrix herself. Thus the Dowager Marchioness of Vannevelle returns 'to Mrs Passar the cups which she made me a present of' and leaves to Mrs Ebers 'my straw coloured damask elbow chair as a token of my friendship'.[113] Lady Ann Paul leaves to her chambermaid, Mrs Hannah Vaughan, £50 a year for life and a lump sum of £200 as well as all her wearing apparel, laces, linen and the furniture in her bedchamber and household linen. But she retains within the family as an exception from this bequest 'the fine old damask linnen that was my mothers the pattern of boys turning a wine press'.[114]

Dame Sarah Cotton, determined there should be no doubt as to the identity of the objects she is describing, states that she gives to Mrs Bowdler, a granddaughter of her late husband, 'a large shagreen case containing twelve knives and twelve forks with silver handles and twelve silver table spoons and a large seal set in gold with a mans head engraven on a stone and four small r's engraven at the bottom of the head in this manner *rrrr* '.[115] Mothers' jew-

ellery is usually passed on to daughters, granddaughters, or nieces.[116] The Dowager Viscountess Ashbrook leaves very specific instructions: her daughter is to have 'my watch with a blue enameled case with the steel chain and trinkets belonging to it and also my two bracelets one of her ffather my late lord Ashbrook and the other of her brother the present Lord'. The latter is to have discretion as to whether his two sisters be permitted 'to wear and have the use of my brilliant diamond earrings my seven brilliant roses for the stays my brilliant sprig for the hair and my brilliant diamond egret untill the marriage of my said son or daughters or either of them'. Her son is to have her silver teatable and 'the old ffamily silver watch which belonged to <word illegible> Temple'.[117]

The formal recognition of kinship was enacted through the bequest of a sum of money to buy a mourning ring and these are mentioned as a matter of course in virtually every will. They range from standard mourning rings that cost on average £10 to 'an hundred pounds for a diamond ring to wear for my sake' willed by Lady Anna Elinora Shirley, who had been her sister's sole heir, to her nephew.[118] The idea that surfaces in Lady Ashbrook's will, that possessions (especially jewels) might be made available but not actually given, is also common. The Dowager Viscountess Cobham gave the Countess of Westmoreland (sic) her diamond girdle buckle but she also gave Dame Jane Lambert 'the use of my large pearl necklace for her life and after her decease the same to be returned'.[119]

Division of labour was a pronounced feature of domestic life in eighteenth-century England. While the library was the responsibility of the husband, pictures and 'curious cabinet pieces' should be 'under the custody' of the wife.[120] Paintings, and particularly portraits, constitute the most frequently itemized artefact after jewellery, appearing in 24 out of the total number of 89 wills read. But books are mentioned with surprising frequency (6 times in all), ranging from passing references in which books are simply mentioned among other goods[121] to books described in such a way as to convey their particularity and the value they held for the owner. Lady Elizabeth Harris invites one of her sons to pick one or two French and English authors from among her books 'to keep for my sake', leaving the library in its entirety to her other son.[122] The Dowager Duchess of Somerset gives instructions for the disposal of 'my quarto bibles printed by ffield [Richard Field fl. 1579–1624] and 4 volumes of sermons octavo by Dr Mason' along with a bookcase with glass door and the drawers under it standing in her closet at Percy Lodge to Mr George Lomas.[123] The Dowager Viscountess Cobham leaves to Mr Rawlins 'my old harpsicord that is at Stoke and all my musick books'.[124] Libraries may have been ideologically construed as the spatial province of husbands and

their contents their concern but it is clear that women also owned and valued books and that in some cases their collections were of sufficient significance to merit the name library.

Family portraits, whether full-size or miniature, are often mentioned with jewels, watches, and other precious non-utilitarian items (as opposed to household linen and wearing apparel).[125] Lady Frances Colepeper, who bene-fited from a marriage settlement, leaves her house which she names 'Stone Stepps' to John Spencer Colepeper along with all her plates, jewels, linen, and 'my pictures my father and my mother and my dear husbands my lords pictures'.[126] The desire that family portraits should remain *in situ* is very strong. Lady Catherine Gardeman instructs that ' the picture of my said late husband Baltazar Gardeman may always remain at the vicarage house in Coddenham aforesaid to which living he hath been so great a benefactor'.[127] Dame Margaret Conyers desires that her daughter Henrietta Maria Wollacot (who is also her executrix) 'keep and preserve all family pictures which I am now pos-sessed of or intitled to and not to sell or dispose of the same or any of them'.[128] If portraits are to be removed, strenuous efforts are made to ensure they will be cared for, reinforcing the suggestion made elsewhere in this book that portraits may be understood by their owners not only as representations of individuals but as representative of individual bodily presences.[129] Anxiety that depictions of family may fall into unsympathetic hands converts Margaret Gouijon's legal prose into a discursive account which combines assertions of family ties with instructions to tradesmen: ' I leave my little picture in minia-ture to the sister of the Marquis de Tomars her father and my late husband were first cousins it will be a remembrance of their ffamily as for the great picture which is in my hall it is that of my elder sister and the other of my younger sister I desire that a case may be made for both of them and that they be sent to Mrs de la Colle at Mantz and let them be diverted to Mr Samvagett merchant at Mantz to be forwarded to her. She is my half sister and it is better that they should not go out of the ffamily or to my nephew.'[130]

The Howard of Effingham family portraits were evidently regarded as the property of the Dowager Baroness[131] and, like precious necklaces, could be lent rather than given. Writing her will in 1740, she gives her grandson, the Earl of Effingham, 'the whole length picture of his ffather and also the half length picture of his mother and two whole length pictures of my late lord and myself all which pictures are at Estwick and I do direct that the said Earl of Effingham shall have the use of the said pictures during his life and at his death give the same unto his son the Right honourable the Lord Howard'.[132] A reading of wills testifies to the ways in which owners identify portraits not through the naming of artists but by identifying subjects and by detailed

descriptions of framing, medium, and location, descriptions which constitute, in the context of will-writing, distinct acts of royalist or familial piety. The naming of paintings can be, as is suggested by Margaret Gouijon's testimony, a way of producing metaphorically a family tree. This is certainly the case with Lady Elizabeth Spelman, a widow with large numbers of portraits to dispose of:

ffirst I give the right honourable James Hamilton Lord Viscount Limerick of the kingdom of Ireland the following pictures vizt the first picture of King Charles the second when a child Queen Ann of Bullen Henry Lord Hunsden Mary of Bullen his lady Henry Lord Leppington only son to Henry Earl of Monmouth but dyed before him Lady Herbet her first husband was the honourable Thomas Carey these last five are small paintings the large ffamily peice containing Robert Earl of Monmouth and his countess Henry Lord Carey afterwards Earl the honourable Thomas Carey and the Lady Philadelphia Carey their younger children this is a large fine painting[133] Martha Countess of Monmouth wife to Earl Henry the Lady Ann Carey Countess of Clanbrazil[134] the Lady Elizabeth Carey who dyed unmarried the Lady Martha Carey Countess of Middleton with that of John Earl of Middleton her husband the Lady Viscountess Mordant daughter of the honourable Thomas Carey these last six paintings are half lengths the Lady Elizabeth Spelman daughter to John Earl of Middleton[135] and Martha his countess these two last paintings are quarter lengths. Item I give to the right honourable the Earl of Orrery a picture of the right honourable the Lady Martha Cranfield when a child[136] afterwards Countess of Monmouth likewise a small picture of the right honourable Lady Margaret Cranfield who dyed unmarried both elder sisters to the right honourable Lady ffrances Cranfield afterwards Countess of Dorsett. Item I give to the right honourable the Lord Hardwick Lord High Chancellor of Great Britain one picture as directed for him on the back thereof. Item I give to my two cousins Mrs Ann and Mrs Elizabeth Byerley my bed of my own working with what work remains belonging thereto and my own picture in a red coat when a child[137] the picture of the learned Sr Henry Spelman sitting in a chair[138] and one of Philip Lord Wharton these three paintings are half lengths a picture of Henry Earl of Monmouth two others of Lady Elizabeth Carey and Mrs Windsor these last paintings are quarter lengths.[139]

The death of a testatrix like Lady Spelman must, at a conservative estimate, have involved very considerable upheaval and expense in the locating and redistributing of named objects.

It would be wrong to infer that where artists are not named the authorship of works was not known, or that they were not highly respected. Moreover, there are some exceptions to the general practice of identifying portraits (and other paintings) by subject rather than by artist. Among the artists named in this group of wills are both the famous and those for whom no records survive. Not surprisingly, it is the Dowager Duchess of Somerset—member of

one of the nation's most powerful and long-established dynasties—who iden-
tifies most paintings by artist.[140] Indeed her will suggests extensive and detailed
knowledge of the historical value of her possessions. They include: 'one
picture of the inside of a cabinet painted by old ffranks', 'the two pictures of
Windsor castle and Syon House both painted by Caneletti',[141] 'an original
picture of Peter the ffirst Emperor of Russia painted by Clinsted', a 'small
enamell'd picture' of her husband, a collection of 'watercolour'd and enam-
el'd pictures', portraits of Thomas Lord Weymouth[142] and Elizabeth Countess
of Northumberland[143] by unnamed artists, a portrait of her late husband by
Richardson,[144] 'Lady Mary Brook with a garland in her head painted by Sir
Godfrey Kneller',[145] portraits of Lady Mary's parents by Hoare, and, finally,
'one picture of cattle with a man woman and boy bought for me at Brussels
by Andrew Mitchell'.[146] Dame Sarah Cotton, widow of Sir Robert Cotton,[147]
with a much more modest estate, names among several family portraits an
anonymous subject—'the picture of a young gentleman set in a black and gilt
frame with a glass before it and drawn by Mr Hussey'.[148] The only other artists
mentioned are Mr Cooper (responsible for a portrait of the Earl of Suffolk)[149]
and Mr Doll (presumably a descendant of the seventeenth-century engraver
William Dolle) who is described as having drawn (i.e. painted) the Dowager
Viscountess Harcourt with her first husband Sir John Walter, a work which she
leaves to William Aislabie of Studley Hall.[150]

The location of portraits is an important means to identification and, unlike
the information offered by inventories, wills are sometimes very specific in
their descriptions. At the same time, statements about location are a poetic
means of invoking the interior space inhabited by the testatrix and are thus a
rare form of testimony. Even the briefest reference can offer a vivid glimpse of
how family portraits, cared for by women, were hung in organized interior
spaces. Dowager Baroness Trevor's 'great family picture of Sir Robert
Bernard', her late husband, hangs at the time of writing (1730) in the dining
room at Peckham.[151] Dame Frances Chester, listing all the valuable objects she
is giving to her daughter Frances (laces, clothes with gold and silver on them,
tea-spoons, diamond ear-rings), includes 'the pictures that are between the
windows in my dressing room except the large picture in a gold frame and all
my japan the books that are on the shelves and in the escrutore in my dress-
ing room',[152] while the Dowager Viscountess Cobham identifies those family
portraits she intends for Mrs Gyfford as 'in the White Parlour at Stoke'.[153]

It seems reasonable to infer that the kinds of specifications to portrait
painters known to have been issued by women such as the Countess of Kildare
were by no means unusual; she told Ramsay to paint her husband in a coat of
a particular colour because it accorded with the décor of her dressing room

and she wanted a particular French frame for the portrait which would fit above the chimney in her blue dressing room and not be attached to the chimney because she wanted to display her fine china on the white marble mantelpiece.[154] This chapter has been concerned with what de Certeau calls 'the secondary production hidden in the process of utilization'.[155] Consumption is, as de Certeau argues, not a passive state but a process of production apart from the making of an object. It has not been my aim to convey how women used household goods, clothing, and precious luxury objects in practice though the material with which I have been dealing might justify certain inferences on that count. Nor have I been concerned to establish change or regional difference. My interest has been precisely with the question of individual need, a question encompassing the psychic as well as the economic. My project is, therefore, distinct from that of social historians such as Weatherill, from whose work I have none the less learned much. How possessions generate discourses, how utilization (as a process distinct from manufacture or employment) produces forms of representation—letters, account books, wills—are important elements in my account. Representation is a process of empowerment and, although I do not argue that this form of production is exclusive to women, it is clear that it operates according to a highly gendered set of conventions. In the case of Elizabeth Harley, the method of analysis is to examine the data from the inside out, to situate a particular subject historically and to examine the web of representations which she wove in writing and in which she herself is also represented. In the second half of the chapter, I have changed tack deliberately to examine the rhetorical strategies in the representation of the everyday at a highly unusual moment, the moment of writing a will. In my examination of Elizabeth Harley's relationship with her surroundings, consumption as represented is a metaphor for negotiating difficult personal relationships and something has, therefore, to be said about those relationships in so far as we know of them from empirical sources. In my examination of wills, the descriptions of objects that are desirable and desired are treated as historical texts open to investigation and to qualitative assessment as acts of communication analogous to those of portraits and novels. And we might remind ourselves that the word 'pourtraiture' was used until very recently, to describe any material body rather than to represent a human being. What is of interest here is common languages, common strategies of representation, common narrative formulations. This is not to lose sight of the individual women who are, indeed, sometimes startlingly invoked by these seemingly functional and legalistic formulations. I make no claim that they are representative or typical, though the apparent proliferation of these intense and highly nuanced delineations in this period

might give food for thought. What I have demonstrated is the way in which, as texts (multifaceted and open to interpretation), these documents permit a new understanding of the affective aspects of possession, of how women felt about the things they owned, and how they employed the fact of their possession in the expectation of exercising influence.

Notes

1. Harley was the son and heir of Sir Edward Harley of Brampton Castle, Herefordshire; he assisted his father in raising a troop of horse for the Revolution in 1688; he became Sheriff of Hereford in 1689; major in the Hertfordshire militia in 1696; MP for Tregony 1689–90 and for Radnor in 9 parliaments before 1711; Commissioner of Public Accounts 1690–7; Speaker of the House of Commons in 3 parliaments 1701–5; Chancellor and Under Treasurer of Exchequer 1710–11. He was created Baron Harley of Wigmore 23 May 1711 and was dismissed by Queen Anne on her death-bed.

2. Robert's brother, Sir Edward Harley, Auditor, married Elizabeth's sister Sarah Foley (1675–1721), who is commemorated by a lavish wall monument in Brampton Bryan parish church, erected by her husband in 1724. The facts that their children had names in common with Robert's and Elizabeth's offspring, that both families lost sons named Robert in infancy, and that Sir Edward's son (also Edward) succeeded Robert Harley's son Edward as 3rd Earl creates a situation in which considerable caution is needed in the reading of documents.

3. For the early history of the Harleys, see J. Eales, *Puritans and Roundheads: The Harleys of Brampton Bryan and the Outbreak of the English Civil War* (Cambridge, 1990).

4. See B. W. Hill, *Robert Harley: Speaker, Secretary of State and Premier Minister* (New Haven 1988), 9.

5. The Foley family home of Witley Court was built by Elizabeth's grandfather and transformed by her brother, who succeeded in 1683. It was transformed into an elaborate palace in the early 19th cent. and burnt down in 1937. The ruins are in the care of English Heritage. The remarkable rococo church (James Gibbs?) was begun in 1732 and contains Rysbrack's distinguished monument to the 1st Baron Foley and his family (see M. Baker, 'Rysbrack's Terracotta Model of Lady Foley and her Daughter and the Foley Monument at Great Witley', *Stadel Jahrbuch*, NS 2 (1987), 261–8).

6. Sir Godfrey Kneller's portrait shows Robert Harley in his robes as Lord High Treasurer. The portrait was copied many times (e.g. National Portrait Gallery) and also engraved by George Vertue.

7. Largely, it has to be said, through transcripts published by the Historical Manuscripts Commission rather than from the originals.

8. Hill, *Robert Harley*, 9.

9. A. McInnes, *Robert Harley, Puritan Politician* (London, 1970), 178.

10. See e.g. S. Biddle, *Bolingbroke and Harley* (1973; London, 1975), 19–20.

11. See Hill, *Robert Harley*, 17.

12. Robert Harley to Elizabeth Harley, London, 11 May 1689, BL Add. MS 70270.

13. Robert Harley to Elizabeth Harley, 4 June 1689, BL Add. MS 70270.

14. Robert Harley to Elizabeth Harley, 6 June 1689, BL Add. MS 70270.

15. Robert Harley to Elizabeth Harley, 8 June 1689, BL Add. MS 70270.

16. See Elizabeth's reference in her letter of 8 July 1690 to 'Neday' being 'very fond of his littel brother' and on 1 July 1690 to 'Littel Roben' doing very well and being 'a very hartey sucker'.

17. See Elizabeth Harley to Sir Edward Harley, 24 July 1690, transcribed and published in *Historical Manuscripts Commission 14th Report,* Appendix, part II, Portland MSS, vol. iii (London, 1894), 449.

18. Robert Harley to Elizabeth Harley, 14 June 1690, BL Add. MS 70270. A letter to Elizabeth dated 30 July 1690 offering consolation and, on one side of the double folded sheet, a letter to Betty dated 26 May 1698, is inscribed 'My Father's Lett to my Mo after ye death of my Bro Ro . . . And from my Grand to my Bety.' This letter is not, however, in Robert Harley's writing and it would appear that both letters were written by Sir Edward Harley. The inscription must have been incorrectly inscribed by either Edward or Abigail Harley. BL Add. MS 70270. The entry in the Brampton Bryan church record reads 'Robert ye Son of Robt Harley Esq. and Elizabeth his Wife was baptiz'd June 10th. The said child was buried July 28th.' I am most grateful to Mr Christopher Harley for providing me with this information.

19. Robert Harley to Elizabeth Harley, 9 Aug. 1690, BL Add. MS 70270.

20. Elizabeth Harley to Robert Harley, Brampton, 30 Dec. 1690, BL Add. MS 70238.

21. Robert Harley to Elizabeth Harley, 13 June 1688, BL Add. MS 70270.

22. Elizabeth Harley to Robert Harley, Brampton, 17 July 1688, BL Add. MS 70238.

23. Elizabeth Harley to Robert Harley, Brampton, 14 Mar., no year, BL Add MS 70238.

24. Robert Harley to Elizabeth Harley, 24 Mar. 1690/1, BL Add. MS 70270.

25. Elizabeth Harley to Robert Harley, Brampton, 14 Apr. 1691, BL Add. MS 70238.

26. Robert Harley to Elizabeth Harley, London, 23 May 1691, BL Add. MS 70270.

27. Elizabeth Harley to Robert Harley, Brampton, 28 May 1691, BL Add. MS 70238.

28. Elizabeth Harley to Robert Harley, Brampton, 17 July 1688, BL Add. MS 70238.

29. e.g. Elizabeth Harley to Robert Harley, Brampton, 30 Apr. 1689, PS: 'You promised me to pay all my dets I have sent you a note of all my dets: I do desire that Mrs. Pye may be paide first', BL Add. MS 70238.

30. Elizabeth Harley to Robert Harley, Brampton, 27 Jan. 1689/90, BL Add. MS 70238.

31. L. Weatherill, *Consumer Behaviour and Material Culture in Britain 1660–1760* (London, 1988) discusses the distinctions between town and country living. The Harley correspondence makes clear first that it was expected that certain items would be available and secondly that it was not expected that they would be available outside London.

32. Elizabeth Harley to Robert Harley, Brampton, 25 Jan. 1689, BL Add. MS 70238.

33. 'I desire you wil by the next carrier send me two [tear] of venison or 3 a flitel[?] of Bacon if ready, should [tear] a pot of wood cock I have some friends it wil [tear] very acceptable to & necessary I should gratifie', Robert Harley to Elizabeth Harley, 29 Nov. 1690, BL Add. MS 70270.

34. 'The beer is received & paid for one bottle was broke: we all thank you. Mr. Richardson promises to take al care to send ye sugar down, yr note for the Apothecary came too late to have any thing this week', Robert Harley to Elizabeth Harley, 7 June 1690, BL Add. MS 70270.

35. Robert Harley to Elizabeth Harley, 14 Mar. 1690/1, BL Add MS. 70270. See also 21 Mar. 1691: 'I have sent oranges & lemons. I would not send too many least hot weather should come but you shal have as many more when you wish. There is also a Roll for Neddy & 2 pounds of coffee, 1 pound of chocolate for Aunt B'.

36. *Memoires for My Grand-Son by John Evelyn,* transcribed and furnished with a preface and notes by Geoffrey Keynes (Oxford, 1926), 70–2.

37. D. Defoe, *The Complete Tradesman,* quoted by F. Braudel in 'The Perspective of the World', *Civilisation and Capitalism,* iii (1979), trans. S. Reynolds (London, 1984), 367.

38. On this topic see J. Huizinga, *Homo Ludens: A Study of the Play-Element in Culture* (1944; London, 1949), 62 and C. Berry, *The Idea of Luxury* (Cambridge, 1994), 31.

39. Elizabeth Harley to Robert Harley, Brampton, 17 July 1688, BL Add. MS 70238.

40. Elizabeth Harley to Robert Harley, Stoke Court, 25 Oct. 1689, BL Add. MS 70238.

41. Elizabeth Harley to Robert Harley, Brampton, 28 Oct. 1691, BL Add. MS 70238.

42. McInnes, *Robert Harley*, 179.

43. Robert Harley to Elizabeth Harley, 30 Nov. 1689, BL Add. MS 70270.

44. This series of letters is transcribed and published in *Historical Manuscripts Commission 14th Report,* iii. 483–4. No will is recorded for Elizabeth in the PRO. Her burial is recorded in the Brampton Bryan church register on 30 Nov.

45. See e.g. E. S. Roscoe, *Robert Harley, Earl of Oxford* (London, 1902), 13: 'Always delicate, she was the victim of smallpox'; Hill, *Robert Harley*, 28: 'her constitution weakened by grief over the death of their son'.

46. Robert Harley to Sir Edward Harley, 12 Mar. 1685/6, Oxford, *Historical Manuscripts Commission 14th Report,* iii. 395.

47. Elizabeth Harley to Robert Harley, Brampton, 30 July 1690, BL Add. MS 70238.

48. Elizabeth Harley to Robert Harley, Brampton, 30 Apr. 1691, BL Add. MS 70238.

49. Robert Harley to Elizabeth Harley at Chavenage, near Tedbury, Gloucestershire, 9 Nov. 1689, BL Add. MS 70270.

50. Robert Harley to Elizabeth Harley, 12 Nov. 1689, BL Add. MS 70270.

51. Elizabeth Harley to Robert Harley, Brampton, 11 Apr. 1691, BL Add. MS 70238. The fullest account of the responsibilities and duties of women in relation to household labour concerns, though dealing with a slightly later period, is to be found in B. Hill, *Women, Work and Sexual Politics in Eighteenth-Century England* (Oxford, 1989). See also R. Bradley, *The English Housewife in the Seventeenth and Eighteenth Centuries* (London, 1912).

52. See Weatherill, *Consumer Behaviour,* ch. 7, 'The Domestic Environment' for an interesting and informative discussion of household management.

53. Elizabeth Harley to Robert Harley, Brampton, 28 Apr. 1691, BL Add. MS 70238.

54. BL Add. MS 70348. The section of the book used by Martha Hutchins is readily distinguishable by the more discursive style of writing as well as by differences in the script and the mode of laying out the figures. Martha's section includes dates but the section used by Elizabeth Harley has no dates except at the very end, where daily entries for 1687–8 appear. However, it is clear from references to a first visit to London after her marriage and to Tunbridge Wells that the account book was used by Elizabeth regularly from 1685 to 1688.

55. On Tunbridge Wells, see P. Hembry, *The English Spa 1560–1815: A Social History* (London, 1990), ch. 6.

56. As the book of 'Disbursements' was used by more than one person and not consecutively, and as the writers seldom name the year, it is difficult to be precise about the time spent in London and Tunbridge Wells. Judging by the nature of purchases, it seems to run as follows: first half-column general purchases, remaining page and next half-page headed 'laid out at London', remainder of this page and onto the next half-page Tunbridge Wells, a gap, then eight columns headed 'laid out London', gap. Thereafter the accounts are spasmodic and do not appear to relate to city purchases. It seems, therefore, that following the marriage the Harleys visited London and travelled thence to Tunbridge, returning for a prolonged stay in London before Elizabeth went to Brampton.

57. See S. Staves, *Married Women's Separate Property in England 1660–1833* (Cambridge, Mass., 1990), 131–2 and the whole of ch. 6.

58. J. Sekora, *Luxury: The Concept in Western Thought, Eden to Smollett* (Baltimore, 1977), 49, 51, 68–9. For an interesting discussion of reactions to fashion and luxury in the late 18th cent., see J. Raven, *Judging New Wealth: Popular Publishing and Responses to Commerce in England, 1750–1800* (Oxford, 1992), ch. viii.

59. I am indebted to Berry, *The Idea of Luxury* for information about Mun. See pp. 33–4 and 103–4. On the introduction of fashionable drinks and on food in general, see J. C. Drummond and A. Wilbraham, *The Englishman's Food* (1939; London, 1991).

60. A further useful discussion of the term 'luxury' (e.g. the consumption of costly high-quality foods) is provided by Weatherill, *Consumer Behaviour*, 15 and there is an excellent discussion about contemporary writing on luxury in J. Raven, 'Defending Conduct and Property: The London Press and the Luxury Debate', in J. Brewer and S. Staves (eds.), *Early Modern Conceptions of Property* (London, 1995).

61. This was an infusion of rosemary used medicinally. Queen Elizabeth of Hungary is supposed to have left a recipe dated 1235 which she had been given by angels and the name was exploited by commercial pharmacists (rosemary was also associated with the Virgin Mary as indicated by Wotton in his *Chronicles of Pharmacy*). It was an international preparation involving a lengthy process and was both expensive and highly valued. I am grateful to Bill Jackson for this information. Elizabeth Harley consumed a regular quantity and it features in her requests to her husband to send goods from London, e.g. 17 July 1688: 'I hope you will send some quene of hungry water for I have not a quarter of a bottel', BM Add. MS 70238.

62. The three newcomers were *Post Boy*, *Flying Post*, and *Post Man*. See J. A. Downie, *Robert Harley and the Press* (Cambridge, 1979), introd.

63. Weatherill, *Consumer Behaviour*, 28.

64. For the import and purchase of china, see ibid. 86.

65. For imports of china, see ibid. For tea-drinking and representation, see D. H. Solkin, *Painting for Money* (New Haven, 1993), ch. 2 and K. Stanworth, ' "Pictures in Little": The Conversation Piece in England', Ph.D. thesis (University of Manchester, 1994). The pathbreaking work of McKendrick, Brewer, and Plumb by concentrating on Wedgwood may give a misleading picture. Moreover, it seems clear that 'consumerism' was well under way at least as early as the 1680s. See N. McKendrick, J. Brewer, and J. H. Plumb, *The Birth of a Consumer Society: The Commercialization of Eighteenth-Century England* (London, 1982).

66. S. Stewart, *On Longing: Narratives of the Miniature, the Gigantic, the Souvenir, the Collection* (1984; Durham, 1993), 29.

67. Ibid. 26.

68. R. Payne Knight, *An Analytical Inquiry into the Principles of Taste* (London, 1805), 462. I am grateful to Anne Bermingham for including this in her book *Landscape and Ideology: The English Rustic Tradition 1740–1860* (Berkeley and Los Angeles, 1987), 71, and to Ann Pullan for pointing it out to me.

69. S. Richardson, *Pamela: or, Virtue Rewarded* (1740; Harmondsworth, 1980), 488. 'Equipage' was a much-used word and had many meanings; it could mean 'all that was needed' or 'get up' in almost any context—military, naval, or domestic. The *OED* cites this quotation as meaning 'articles for ornament or personal use'. In this case they would certainly have been silver. I am indebted to Dr Helen Clifford for a fascinating discussion about silverware, its sale and purchase, in 18th-cent. England.

70. Quoted in P. Langford, *Public Life and the Propertied Englishman 1689–1798* (Oxford, 1991), 3.

71. Staves, *Married Women's Separate Property*, 29, 61. There is a large and significant literature on ownership of real property in this period, starting with H. J. Habakkuk's 'English

Landownership 1680–1740', *Economic History Review*, 10: 1 (1940) and running through H. J. Habakkuk, 'Marriage Settlements in the Eighteenth Century', *Transactions of the Royal Historical Society*, 4th ser. 32 (1950); C. Clay, 'Marriage, Inheritance, and the Rise of Large Estates in England, 1660–1815', *Economic History Review*, 2nd ser. 21 (1968); P. Roebuck, 'Post-Restoration Landownership: The Impact of the Abolition of Wardship', *Journal of British Studies*, 18: 1 (Fall 1978); and L. Bonfield, 'Marriage Settlements and the "Rise of Great Estates": The Demographic Aspect', *Economic History Review*, ser. 2, 32: 4 (1979). I am grateful to Frank O'Gorman for advice on this topic.

72. For an interesting discussion of the representation of a widow in charge of her deceased husband's estate, see Shelley Bennett's essay on Francis Cotes's portrait of Thomas Crathorne and his wife in the Huntington Library, San Marino, Calif., in G. Sutherland (ed.), *British Art 1740–1820: Essays in Honor of Robert Wark* (San Marino, Calif., 1992). Bennett in my view underestimates, however, the influence that widows were able to exercise over property in the second half of the century.

70. A. Vickery, 'Women and the World of Goods: A Lancashire Consumer and her Possessions, 1751–81', in J. Brewer and R. Porter (eds.), *Consumption and the World of Goods* (London, 1993), 274–301. I am indebted to Vickery's work for the ways in which it focuses on behaviour and attitudes to material things rather than upon the process of marketing or the bare facts of possession.

74. McKendrick, Brewer, and Plumb, *The Birth of a Consumer Society*.

75. Vickery, 'Women and the World of Goods'.

76. See e.g. Weatherill, *Consumer Behaviour*, 23. Despite caveats, Weatherill tends to use pictorial material as unmediated evidence in this otherwise excellent study. A similar account by the same author appears in Brewer and Porter, *Consumption*. Weatherill's work is based on probate inventories and she is concerned with the need to distinguish between necessity and luxury in 'middle-rank' families. She does not allow for representation, fantasy, or imagination in the portrayals of goods in the texts she cites.

77. Langford, *Public Life*, 10.

78. See Garrard ledgers, microfilm, National Art Library, V. & A., London.

79. Strafford Papers, BL Add. MS 22,256 (36). I am grateful to Karen Stanworth for drawing my attention to this passage. For an excellent history of jewellery and how it was worn in 18th-cent. England, see D. Scarisbrick, *Jewellery in Britain 1066–1837: A Documentary, Social, Literary and Artistic Survey* (Norwich, 1994), chs. 7–10.

80. Undated letter from Jane Cockburn to Lady Anne Strafford, Strafford Papers, BL Add. MS 22,265 (33), c.1735. There is no goldsmith named Shanay in Heal's directory, but William Shayler, 44 Lombard St. was in business 1752–75. See A. Heal, *The London Goldsmiths 1200–1800: A Record of the Names and Addresses of the Craftsmen, their Shop-Signs and Trade Cards* (Cambridge, 1935), 241.

81. *A Poetical Epistle to Sir Joshua Reynolds* (London, 1777), introd.

82. See T. Veblen, *The Theory of the Leisure Class: An Economic Study of Institutions* (1925; London, 1957).

83. Dame Sarah Humble, Prob. 11/700 quire 12, fos. 91–3, will signed 26 Apr. 1737.

84. See J. Greenberg, 'The Legal Status of English Woman in Early Eighteenth-Century Common Law and Equity', *Studies in Eighteenth-Century Culture*, 4 (1975); S. M. Okin, 'Patriarchy and Married Women's Property in England: Questions on Some Current Views', *Eighteenth-Century Studies*, 17: 2 (Winter 1983); A. L. Erickson, 'Common Law *Versus* Common Practice: The Use of Marriage Settlements in Early Modern England', *Economic History Review*, 2nd ser. 43: 1 (1990), 21–39; A. L. Erickson, *Women and Property in Early Modern England* (London, 1993).

85. L. Stone, *The Family, Sex and Marriage in England 1500–1800* (New York, 1977), 330; Okin, refuting Stone, 'Patriarchy', 136.

86. At her death she possessed 27 estates in 12 counties with a capital value of more than £400,000 and an annual rent roll, after outgoings, in excess of £17,000 p.a., almost all of them of her own acquiring. In addition she owned well over £25,000 in capital and a further £12,000 in annuities as well as huge quantities of jewellery. See F. Harris, *A Passion for Government: The Life of Sarah Duchess of Marlborough* (Oxford, 1991), 349 and BL Add. MS Althorp Papers D15 (3).

87. J. Baudrillard, *For a Critique of the Political Economy of the Sign* (St. Louis, Miss., 1981), 64.

88. Jane Cockburn to Lady Anne Strafford, no date but *c.*1735, BL Add. MS 22,256 (21).

89. H. Walpole, *The Duchess of Portland's Museum*, introd. W. S. Lewis (New York, 1936), 3–10.

90. Staves, *Married Women's Separate Property*, 112.

91. Rt. Hon. Claude Margaret Gouijon, Marchioness Dowager of Vannevelle, Prob. 11/712 quire 264, fos. 246–7, signed 13 June 1739.

92. The Rt. Hon. Ann Baroness Dowager Trevor, Prob. 11/751 quire 367, fo. 318, will signed 3 Aug. 1730.

93. J. P. Zomchick in *Family and the Law in Eighteenth-Century Fiction* (Cambridge, 1993) points out that family law is a major theme in fiction of the period. On p. 61 he draws attention to the fact that family strife among the Harlows in Richardson's *Clarissa* was the result of the grandfather's will. For a discussion of funerals see P. Earle, *The Making of the English Middle Class* (London, 1989), part III, section 11 (ii).

94. See n. 91, above.

95. Prob. 11/702 quire 144, fos. 249–50, will signed 27 Jan. 1739.

96. Prob. 11/813 quire 17, fos. 137–8, signed 15 June 1754.

97. This was a common condition and one which served to ensure that servants remained in service.

98. Prob. 11/833 quire 301, fos. 152–3, signed 26 July 1757.

99. Prob. 11/702 quire 144, fos. 249–50, signed 27 Jan. 1739.

100. Prob. 11/725 quire 119, fos. 185–7, signed 13 Nov. 1739.

101. See e.g. Dowager Viscountess Dillon (Prob. 11/791 quire 305, fos. 39–40, signed 11 Aug. 1749. Viscountess Duppelin (prob. 11/803 quire 201, fos. 76–7, signed 20 June 1753), Dame Phyllis Langham (Prob. 11/813 quire 17, fos. 137–8, signed 15 June 1754), Lady Barbara Leigh (Prob. 11/813 quire 17, fos. 38–40, signed 18 Aug. 1750), Dame Anna Maria Shaw (Prob. 11/819 quire 328, fos. 335–6, signed 24 May 1753), Dame Margaret Conyers (Prob. 11/835 quire 7, fos. 57–8, signed 4 May 1756).

102. I am grateful to Jacob Simon for drawing this to my attention. He cites the case of Joseph Goupy leaving the residue of his estate to his mistress's sister, as reported in *Apollo* (Feb. 1994), 16.

103. Prob. 11/715 quire 17, fos. 131–2, signed 11 Nov. 1737.

104. In Brewer and Staves (eds.), *Early Modern Conceptions of Property*, 182.

105. Prob. 11/819 quire 328, fos. 335–6, signed 24 May 1753.

106. For details of this relationship see R. Perry, *The Celebrated Mary Astell* (Chicago, 1986) (many references). For Lady Catherine Jones's pedigree, see *The Complete Peerage*, iii (London, 1913), 734.

107. Prob. 11/702 quire 147, fos. 276–8, signed 7 June 1730.

108. Evelyn, *Memoires*.

109. The Hon. Margaret Mugge, Prob. 11/754 quire 103, fos. 39–40, signed 21 Nov. 1744.

110. Prob. 11/752 quire 14, fo. 108, signed 13 May 1746. For other examples of the itemization of property largely bequeathed to women, see Dame Frances Chester (Prob. 11/792 quire 7, fos. 51–2, signed 24 Oct. 1747) and the Dowager Viscountess Preston (Prob. 11/843 quire 30, fos. 238–9, signed 15 June 1751).

111. Dame Cecilia Garrard, Prob. 11/803 quire 205, fos. 108–10, signed 4 July 1753.

112. Dowager Duchess of Somerset, Prob. 11/810 quire 211, fos. 80–2, signed 13 Dec. 1753.

113. Rt. Hon. Claude Margaret Gouijon Marchioness Dowager of Vannevelle, Prob. 11/712 quire 264, fos. 246–7, signed 13 June 1739.

114. Prob. 11/773 quire 293, fos. 212–13, signed 9 Mar. 1748.

115. Prob. 11/803 quire 225, fos. 270–1, signed 18 June 1753.

116. See e.g. Dame Elizabeth Collett, Prob. 11/835 quire 7, fo. 57, signed 26 June 1757.

117. Prob. 11/843 quire 44, fos. 346–8, signed 27 Nov. 1758.

118. The Rt. Hon. Lady Anna Elinora Shirley (Prob. 11/810 quire 211, fo. 75, signed 7 Apr. 1754).

119. Prob. 11/854 quire 140, fos. 346a–348, signed 8 Oct. 1759.

120. Evelyn, *Memoires*, 55–6. In *Pamela*, Mr B's library is clearly defined as masculine space and reading books (as opposed to novels) as his prerogative.

121. e.g. Dame Rebecca Dixie, Prob 11/737 quire 10, fos. 75–6, signed 29 Sept. 1744. Dame Dorothy Every, Prob. 11/771 quire 181, fos. 4–5, signed 11 Dec. 1746, leaves her library to Mr George Gretton of Jesus College, Cambridge. Lady Catherine Gardeman leaves her grandson all her books 'desiring that he will dispose of those relating to divinity according to the directions which I shall have for that purpose' (Prob. 11/828 quire 50, fos. 26–7. signed 27 Sept. 1756).

122. Prob. 11/731 quire 40, fos. 321–2, signed 12 July 1743. The son who is asked to choose the books also gets 'my ffathers picture set in gold also my medal of my grandffather also my saphire ring with the velvet christening mantle'.

123. Prob. 11/810 quire 211, fos. 80–2, signed 13 Dec. 1753.

124. Prob. 11/854 quire 140, fos. 346a–348, signed 8 Oct. 1759.

125. For general references of this kind see: Lady Ann Harvey (Prob. 11/715 quire 17, fos. 131–2, signed 11 Nov. 1737); Dame Mary Jones (Prob. 11/725 quire 119, fos. 185–7, signed 13 Nov. 1739); Elizabeth Lady Compton (Prob. 11/723 quire 35, fos. 280–1, signed 16 May 1741): 'a little picture in watercolours of my grandfather Northampton'; Hon. Margaret Mugge (Prob. 11/754 quire 103, fos. 39–40, signed 21 Nov. 1744); Dowager Viscountess Irwin (Prob. 11/754 quire 129, fos. 249–50, signed 19 Apr. 1736): a series of miniatures set in gold; Dame Elizabeth Hare (Prob. 11/776 quire 46, fo. 402, signed 1 Dec. 1742); Dame Cecilia Garrard (Prob. 11/803 quire 205, fos. 108–10, signed 4 July 1753): several portraits including 'my small picture of Charles the ffirst set round with small diamonds'; Dowager Baroness Bingley (Prob. 11/828 quire 74, fos. 223–4, signed 25 July 1737); Lady Barbara Leigh (Prob. 11/813 quire 17, fos. 138–40, signed 18 Aug. 1750, codicil).

126. Prob. 11/708 quire 83, fos. 323–4, signed 31 Aug. 1738. Her affection for the house is enunciated in the frequency of naming in this will and in the codicil in which she gives instructions for what is to be done with the livestock and pasture.

127. Prob. 11/828 quire 50, fos. 26–7. signed 27 Sept. 1756.

128. Prob. 11/ 835 quire 7, fos. 57–8, signed 4 May 1756.

129. See my discussion of the portraits of Lady Worsley and Emma Hamilton in Ch. 4.

130. Prob. 11/712 quire 264, fos. 246–7, signed 13 June 1739.

131. Elizabeth, widow of Sir Theophilus Napier, married (Jan. 1721/2) 6th Baron Howard of Effingham as his second wife. He died in 1725 aged 43 (will signed and dated 1725). His

widow married (settlement 11 Sept. 1728), as his second wife, Sir Conyers Darcy who died Dec. 1758. She died 1741 aged 51.

132. Prob. 11/715 quire 17, fos. 133–4, signed 10 Jan. 1740. A similar arrangement is made by Lady Mary Petre: 'I give to my nephew John Petre esquire all the ffamily pictures at Bellhouse excepting my own in my dressing room upon condition that William Edmondson shall have the use of them during his lease of one and twenty years' (Prob. 11/823 quire 174, fo. 92, signed 10 Sept. 1747).

133. This is the portrait attributed to Paul Van Somer, in the collection of the National Portrait Gallery (no. 5426), 227 × 216 cm, on loan to the National Trust, Montacute House.

134. This is the portrait by Van Dyck in the Frick Collection, New York, 212.1 × 127.6 cm.

135. A portrait corresponding to this description, in the collection of Earl Roder, is recorded in the National Portrait Gallery Archive (CI neg. B69/1599).

136. This portrait, by Daniel Mytens, was sold at Christie's, 28 July 1978 (247), 112.3 × 69.8 cm, National Portrait Gallery neg. 28998.

137. This portrait was sold by Lawrence of Crewkerne, 26 Oct. 1989 (98), as circle of Lely, 127.1 × 101.6 cm, photo National Portrait Gallery Archive.

138. Sir Henry Spelman (1562–1641) was a famous historian and philologist. This portrait, by an anonymous artist, was part of the Clarendon collection. A copy by Henry Bone (1821) was sold at Sotheby's Colonnade 22 and 24 Sept. 1992 (598).

139. Prob. 11/759 quire 27, fos. 211–12, signed 2 Nov. 1745. A comparable, but rather shorter, list of portraits of members of the family of the Earl and Countess of Scarborough is found in the codicil to the will of Lady Barbara Leigh (Prob. 11/813 quire 17, fos. 138–40, signed 18 Aug. 1750).

140. Born at Longleat, she was the eldest daughter of Hon. Henry Thynne and married Algernon Seymour, Earl of Somerset 1714/15. He died 1749/50 and she died four years later, aged 55. She was Lady of the Bedchamber to Caroline both when Princess of Wales and when Queen Consort.

141. One of these must have been *A Panorama of Windsor Castle*, painted for Sir Hugh Smithson, 1st Duke of Northumberland in 1747 and now in the collection of the Duke of Northumberland. The view of Syon House hangs at Syon.

142. Possibly a portrait by William Wissing at Longleat (CI neg. B54/634). The Heinz Archive in the National Portrait Gallery also records a portrait of Lord Weymouth by Lely.

143. Perhaps this was a version of Ramsay's 1739 portrait of the Duke.

144. The National Portrait Gallery archive offers a number of unidentified male sitters by or attributed to Richardson but nothing that appears to correspond to this particular portrait. Portraits at Syon and Petworth (attributed to Knapton and Vanderbank) are recorded.

145. No Mary Brook is listed by Douglas Stewart in his monograph on Kneller and there is no portrait in the National Portrait Gallery Kneller file corresponding to this description.

146. Prob. 11/810 quire 211, fos. 80–2, signed 13 Dec. 1753.

147. She herself is portrayed in a work attributed to Thomas Murray (inscribed Hester S. Cotton 1708), 74 × 61 cm, Sotheby's, 14 July 1993 (136). She was sister of Sir John Salisbury and wife of Sir Robert Cotton.

148. Prob. 11/803 quire 225, fos. 270–1, signed 18 June 1753. Giles Hussey (1710–88). Glass was expensive and thus merits particular mention.

149. Hon. Dorothy Howard, Prob. 11/858 fo. 212, signed 28 Feb., dated 1748.

150. Prob. 11/763 quire 204, fos. 117–18, signed 13 Feb. 1747. See also Lady Elizabeth Wentworth (Prob. 11/712 quire 248, fos. 116–17, signed 19 June 1739) for mention of 'a small picture of a Magdalen done by Solimene' among several family portraits.

151. Prob. 11/751 quire 367, fo. 318, signed 3 Aug. 1730. A portrait of the testatrix and one of her children, both attributed to Charles D'Agar (125.5 × 100.2 cm. and 59 × 60 cm.), hang at Glynde Place. I have not located the family portrait named here.

152. Prob. 11/771 quire 210, fos. 235–6, signed 5 Feb. 1748.

153. Prob. 11/854 quire 140, fos. 346a–348, signed 8 Oct. 1759.

154. N. Penny (ed.), *Reynolds* (Royal Academy of Arts, London, 1986), 28.

155. M. de Certeau, *The Practice of Everyday Life* (1984), trans. S. Rendall (Berkeley, 1988), p. xiii.

2

Marriage and its Boundaries: The Montgomery Sisters Adorning a Term of Hymen

MARRIAGE in eighteenth-century England was, for families of substance, an occasion for drawing up settlements for the protection and increase of property for both parties. Marriages, and engagements to be married, were also occasions for portraiture. In common with other eighteenth-century artists, Sir Joshua Reynolds was frequently commissioned to paint portraits of women about to be married, or recently wed. As Nicholas Penny has pointed out, men were seldom portrayed at the moment of this rite of passage. Rather their portraits would celebrate their Grand Tour or, later in life, some moment of special achievement whether civil or military.[1] Moreover, as I have established, portraits, once executed, framed, and delivered, became part of a parcel of property with a history and a future, an object to be bequeathed, disposed of, stored, or displayed in a particular place.

In this chapter I shall frame questions about allegory and female portraiture in relation to a particular portrait painting by Reynolds, read within a historical agenda that is both general and very specific. The 1753 Hardwicke Marriage Act (which prescribed that marriages should take place in churches preceded by banns or licences designed to prevent clandestine unions) provoked several decades of debate about marriage and its different interpretations and applications for women and for men. The population controversy precipitated in 1755 by Revd William Brackeridge and growing concern about divorce are interconnected issues.[2] These were national concerns, as the author of *Hymen: A Poem*, published in 1794, makes clear: 'Detest the Harlot's prostituted kiss | And flee the Brothel, for domestic bliss; | then might we hope to see firm Patriot's rise, | Bound to their country by the strongest ties.'[3] This chapter

A short version of this chapter appeared in S. Schade, M. Wagner, and S. Weigel (eds.), *Allegorien und Geschlechter-differenz* (Vienna, 1994). I would particularly like to thank Sigrid Schade, Gisela Ecker, and Conrad Hoffmann for their helpful contributions towards the writing of this chapter.

focuses on one portrait by Sir Joshua Reynolds. I shall propose not that Reynolds managed brilliantly to re-work the allegorical conventions for the representation of women, welding them to the commissioned portrait, nor that the allegorical portrait is primarily a novel means of communicating character (both familiar lines of argument),[4] but that it was the very instability, the very undecidability produced by the irresolvable tension of portrait and allegory that made this format peculiarly appropriate for the representation of young women—marriageable, recently married, or about to be married—at this particular period. I shall be asking why this particular portrait mode satisfied ambiguous and contradictory responses to the question of marriage in relation to the female subject in the second half of the eighteenth century. At a theoretical level, this study is informed by questions concerning the nature and effect of quotation (a device recommended by Reynolds and used by him to great effect), and questions about how visual imagery can be reconciled to the demands for sequentiality of allegorical narrative. I shall argue that the issues of boundaries, barriers, and blockages that are raised by the forms of narrative sequence upon which allegory is predicated are figuratively staged in the subject matter of Reynolds's paintings. I shall in particular demonstrate that narrative blocked by portraiture comprises a strategy that serves to define sexual difference in a historically specific moment.

The terms 'allegory' and 'portrait' appear to be contradictory. How can a portrait that represents a known individual also be an allegory the whole purpose of which is to represent something other than itself? Yet portraits in which the subject—usually a woman—appears as a figure in some mythological narrative are familiar in eighteenth-century English art. *Mrs Hale as Euphrosyne* of 1764 (Pl. 29; the subject of a later chapter) and *Lady Sarah Bunbury Sacrificing to the Graces* of 1765 (Pl. 25), both by Sir Joshua Reynolds, leading portrait painter and first President of the Royal Academy, are cases in point.[5] Reynolds sanctioned the combination himself, declaring:

The variety which portraits and modern dresses, mixed with allegorical figures, produce, is not to be slightly given up upon a punctilio of reason, when that reason deprives art, in a manner, of its very existence. It must always be remembered that the business of a great painter is to produce a great picture; he must therefore take special care not to be cajoled by specious arguments out of his materials.

What has often been said to the disadvantage of allegorical poetry—that it is tedious and uninteresting—cannot, with the same propriety, be applied to painting, where the interest is of a different kind. If allegorical painting produces a greater variety of ideal beauty, a richer, a more various and delightful composition, and gives the artist a greater opportunity of exhibiting his skill, all the interest he wishes for is accomplished; such a picture not only attracts, but fixes the attention.[6]

It is significant that Reynolds introduces this discussion by reference to Rubens's *Life of Marie de' Medici* series in the Luxembourg Palace in Paris, as we would readily recognize that the combination of allegory and portraiture in this sequence of paintings has very particular gendered political meanings. It is the relation of gender to this pairing of the allegory and portrait that is addressed in this chapter.

Three Ladies Adorning a Term of Hymen (Pl. 1) was exhibited at the Royal Academy in 1774 (no. 216), where portraits of women of rank were customarily displayed without their proper names though the identities of the sitters were commonly known by the time the work appeared in the exhibition. In this case a reviewer under the pseudonym 'Guido' identified the three women by name in the *Public Advertiser* at the time of the exhibition and furthermore described them as 'the Irish Graces'.[7] They were the three daughters of Sir William Montgomery: Elizabeth (1751–83) (centre), Anne, Lady Townshend (1752–1819) (right), and Barbara (?1757–88) (left).[8] The painting was commissioned by the Rt. Hon. Luke Gardiner, member of parliament for Co. Dublin and member of the Privy Council of Ireland. He paid for the work the very considerable sum of £450, the kind of sum Reynolds normally charged only for history paintings.[9]

Three Ladies Adorning a Term of Hymen shows three adult female figures disposed across the canvas, all on the same plane, their figures creating a rising curve from the kneeling figure at the left through the central figure who rests one knee on a stool, to the right-hand figure who raises her arms above her head. The stool is covered with an oriental carpet and a crimson drapery billows in the background. In addition to flowers—some of which are in a basket at the left-hand side but most of which form a lengthy swag held by the women in preparation for the adorning—the accoutrements for this staging include a vase and an altar, both in the antique style. The statue—or term (a pilaster surmounted by a torso and head)—of Hymen with sightless eyes and holding a torch at an almost horizontal angle, which gives the painting its name, looms up in the background shadows between Elizabeth and Anne. There is smoke and flame coming from the altar at the right but the painting's light sources are the bright daylight from behind and a theatrical front lighting that falls on the women's faces and the upper parts of their bodies, resulting in a curious effect in respect of Barbara's dress, which is crimson apart from the shoulders which are white. This is a very cluttered painting and it is easy to miss the fact that the vista at the left encompasses a landscaped garden: a pool is just visible behind Elizabeth's left foot, and just above, between the two trees, is the base of a garden statue or a fountain.

Luke Gardiner was involved in two important pieces of parliamentary legislation: in 1778 he introduced the Catholic Relief Bill into parliament and four

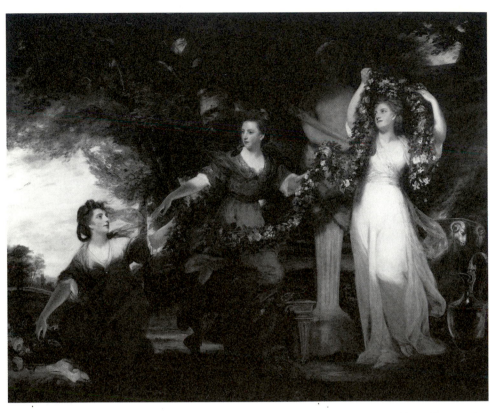

1. Sir Joshua Reynolds, *Three Ladies Adorning a Term of Hymen*, oil on canvas, 236.6 × 291, 1773, Tate Gallery, London

years later was instrumental in the passing of a further bill, one consequence of which was the tolerance of intermarriage between Catholics and Protestants. This second Bill provoked Edmund Burke's *A Letter from a Distinguished English Commoner to a Peer in Ireland*, written to Viscount Kenmare on 21 February 1782 and published in 1783.[10] Gardiner's focus on further religious toleration was regarded by Burke as a distraction from the major issue of the franchise. His letter testifies to the ways in which marriage as an issue in eighteenth-century politics was locked into a complex web of controversy, civil and ecclesiastical. Marriage was on Gardiner's agenda in these years in more ways than one.[11] At the time of his marriage and the portrait commission (1773–4), Gardiner would have been engaged both in thoughts about the political implications of intermarriage and in attempts to introduce measures to enable Catholics to testify their loyalty to the crown at a time when there were real fears of an insurrection among Irish Catholics sympathetic to France. In describing Elizabeth Montgomery (who by the time the painting was on show at the Royal Academy was Mrs Gardiner) and her sisters as 'Irish Graces', the reviewer was not only paying a commonplace compliment but also drawing on popular collective knowledge and recollection of the vexed history of Anglo-Irish relations. The Irish Graces were the concessions won from King Charles I by the Irish in return for heavy subsidies; the two principal articles of these concessions were withdrawn by Wentworth in what has been described as 'one of the most shameful passages in the history of English government in Ireland'.[12] In short, this pastoral portrait was embedded in Anglo-Irish history through its commission and through its theme. On completion it was taken to Dublin where it hung in Ranger's House (built by his father, also Luke Gardiner) in Dublin's Phoenix Park.[13]

Gardiner himself had sat to Reynolds in February and March 1773 and the commission for *Three Ladies . . .* was sent to Reynolds from Gardiner via his fiancée Elizabeth Montgomery, in May of the same year. Reynolds was still working on the painting at the beginning of July when the couple were married, so the painting as exhibited shows—in progression—two sisters married and one unmarried. The commission is well documented by Reynolds's assistant and biographer James Northcote. The letter that Elizabeth Montgomery carried to Reynolds's studio stated:

This letter will be delivered to you by Miss [Montgomery], who intends to sit to you with her two sisters, to compose a picture, of which I am to have the honour of being the possessor. I wish to have their portraits painted together at full length, representing some emblematical or historical subject; the idea of which, and the attitudes which will best suit their forms, cannot be so well imagined as by one who has so eminently distinguished himself by his genius and poetic invention.[14]

In other words, this was a conventional request for a portrait of three related female sitters elevated into the grand style by mythological allusion, a portrait type upon which Reynolds had built his reputation. The particular format of young women performing sacrifices and making libations at altars was, in all likelihood, as Robert Rosenblum has pointed out, drawn from images by Vien exhibited at the Salon in the early 1760s and immediately circulated through engravings.[15] At the first exhibition of the Royal Academy in 1769 Reynolds's exhibits were all female allegorical portraits[16] but by 1774 he was by no means alone in presenting portraiture in this form. Richard Cosway, for example, had exhibited at the Royal Academy in 1771 *A Lady and her Two Daughters in the Characters of Wisdom, Virtue and Beauty,* a composition to which Reynolds's portraits bears a more than superficial resemblance.[17] By the time it reached the National Gallery, Reynolds's painting had become transmuted from *Three Ladies* to *Three Graces Adorning a Term of Hymen,* perhaps a consequence of a simple association of three female figures in a pastoral setting (which, as we have remarked, was picked up by at least one reviewer at the time of its exhibition) or perhaps, more precisely, on account of a lingering recollection of Mr Gardiner's assertion to Reynolds that he would acquire honour 'in conveying to posterity the resemblances of three sisters *so distinguished for different species of beauty'.*[18] The process does, moreover, demonstrate a period tendency to translate actual women into quotations, a process which may be defined as allegorical if we think about allegory as that which draws attention not only to the descriptive surface but also to more abstract, comparative, and explanatory levels of meaning. James Clifford describes this allegorical process as 'mapping descriptions of the other onto what is familiar', and relates it particularly to the constructed, imposed nature of representational authority around questions of gender.[19] Allegory, let us remind ourselves, comes from 'allos' (other) and 'agorenein' (to speak). We can see this process at work in this specific historical instance. Thus, for example, when Reynolds exhibited his portrait of the Waldegrave sisters in 1781 (Pl. 49), a reviewer invoked the feminine 'other' by suggesting the sisters be styled 'Graces' by contrast with a male portrait by Reynolds hanging above. The latter is 'sublime' and, as a consequence of the hanging arrangements at the Royal Academy, is here literally as well as symbolically 'above' the feminine:

If this [Reynolds's portrait of Lord Richard Cavendish] partakes of the sublime so largely, the three ladies Waldegrave under it, no. 187, are beautiful; indeed, without any impropriety they might have been stiled Graces, on account of their own personal perfection, as well as the skill of the Master.[20]

Reynolds, for his part, wrote to Gardiner on 3 July 1773 saying that the picture

was the 'great object' of his mind at present and that the subject 'affords suf-ficient employment to the figures, and gives an opportunity of introducing a variety of graceful historical attitudes'.[21]

Three Ladies Adorning a Term of Hymen can already be demonstrated to have borne some of the classic characteristics of allegory. This is not only a ques-tion of reading but also a question of history. The gentleman who commis-sioned the painting specified 'some emblematical or historical subject'. This, we may assume, suited Reynolds since, as a child, his formative learning expe-rience, we are told, was derived from the study of the plates in Plutarch's *Lives* and Jacob Cats's book of emblems.[22] Emblem and history may be the raw material through which allegory works but ultimately allegory is a question of interpretation so I will now look in more detail at how this image functioned allegorically. It has been remarked that 'though allegory may be intended to reveal, it does so only after veiling a delayed message which it would rather keep from any very ready or facile interpretation'.[23] If my reading of the Irish connotations of the three Graces is correct, Reynolds's image belongs in a central tradition of English allegory, that of pastoral in which the process of veiling which the allegorical mode necessarily entails serves to protect the interests of the subject from political exposure. It thus belongs with Spenser's *Faerie Queene* and Milton's *Lycidas*. In the case of the Montgomery sisters' por-trait, however, the 'something that cannot be said' is not only the political but also, as I shall argue, the sexual.[24]

Contemporaries identified Reynolds's portrait as allegorical also in other respects. Walpole remarked that the thoughts were old, a familiar accusation to be levelled at allegory which plays on the shared knowledge of a commu-nity.[25] Everyone knows, as Todorov demonstrates, the real meaning of a euphemism. However, if it is not to become useless and thus unusable it is necessary that the presence of the literal meaning be attested, however tenuous it may be.[26] Thus everyone recognized the Montgomery sisters were Graces. The audience for the Royal Academy exhibition knew what to look for: 'The *allegorical* part is agreeably handled, and is perfectly intelligible', wrote a reviewer, 'which is not always the case in allegorical pictures, many of which are, as Shakespeare expresses it *"too cunning to be understood"*.'[27] An awareness of, and interest in, allegory may have been stimulated by the publi-cation in 1766 in Dresden of Winckelmann's essay on allegory in which he pro-poses in a sweeping definition that allegory is the expression of ideas by means of images and is, therefore, a universal language principally for artists. Among the modern subject matter that Winckelmann suggests lends itself to allegor-ical treatment are a series of marriage-related themes.[28]

Classical mythology—the narrative content of much that is allegorical—

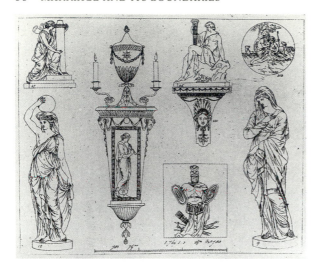

2. J. Bacon, design for Hymen candlesticks, *Coade's Lithodipyra or Artificial Stone Manufactory*, London, 1777–8, Guildhall Library, London. Photo: author

had long been a familiar part of the interior of the English country house and educated audiences expected to be surrounded not only by allegorical portraits but also by tapestries, plasterwork, ceramics, and metalwork with allegorical themes.[29] Votive rustic scenes similar to *Three Ladies Adorning a Term of Hymen* appear on Meissen and Sèvres porcelain from the 1760s and the figure of Hymen, god of marriage, features in many media as, for example, with John Bacon's Psyche and Hymen candlesticks, produced by Coade (Pl.2).[30] As marriage was the chief means through which estates and property were enhanced and family fortunes aggrandized, it was a popular allegorized topic in many media;[31] educated viewers would, therefore, have been wholly at ease with the ways of reading explored in this chapter.

Allegory is traditionally understood as what happens when a single metaphor is introduced in continuous series.[32] This sequential character might be perceived as problematic in relation to visual imagery. At the same time, more recent considerations of allegory have drawn attention to the way it allows 'language to say the other while speaking of something else', it permits 'the possibility of always saying something other than what it gives to be read'.[33] If we turn to another review of *Three Ladies Adorning a Term of Hymen*, we may recognize how contemporary reading foregrounds the act of garlanding, adorning (one might, indeed, say 'veiling') the statue of Hymen which the painting stages and which, also, replicates the very process by which allegory works. Thus a reviewer in the *Morning Chronicle* describes the sisters as 'wreathing' the statue of Hymen. Allegory likewise wreathes portraiture, thus making it obscure, difficult, and, therefore, pleasurable.[34] It is this 'speak-

ing of itself' to which the reviewer responds. The requirement for a continuous series is also endorsed in this review where we are told of each sister's social status after which, intriguingly, the reviewer proceeds to extend the narrative to encompass one of Reynolds's other contributions to the exhibition, *Portrait of a Lady in the Character of Miranda in 'The Tempest'* (no. 217).

[*Three Ladies Adorning a Term of Hymen*] besides the exhibition of mere portraits, has an elegant design and fancy—it represents Lady Townshend and her two sisters wreathing the term of Hymen with flowers; the married Lady has the principal employment; the second (who was then going to be married, and is since Mrs. Gardner) is assisting her at a distance, and the other supplying them with flowers: from so pleasing a disposition, from such fine subjects in nature, and from the creative power of Sir Joshua's pencil, nothing can be conceived, in the portrait way, more grand and natural; . . . No. 117 is a portrait of one of the above ladies in the character of Miranda in The Tempest, a part she played in a private party some time ago.[35]

The sitter for this was Mrs Tollemache but the reviewer misrecognizes her portrait as a further image of one of the Montgomery sisters, thus demonstrating the way allegory creates relays of narrative. It is a minor and understandable error caused in all probability by the fact that Mrs Gardiner was renowned as an actress in private theatricals.[36] However, it also illustrates the ways in which allegorical modes transmute and interact with real-life situations creating simulations that are also interpretations.

Robert Rosenblum has interestingly noted how Reynolds provided a means for Warburgian expatriate scholars to integrate their old and their new lives during the war years by identifying Reynolds's European borrowings.[37] Among the publications produced by this group is an article published in 1942 by Ernst Gombrich in the *Burlington Magazine* entitled 'Reynolds's Theory and Practice of Imitation: Three Ladies Adorning a Term of Hymen'. It has over the years become a *locus classicus* and was reprinted unamended in *Norm and Form* in 1966.[38] In this short but succinct account of a painting[39] Gombrich argues that by disentangling the threads of (iconographic) tradition which Reynolds has woven into 'a perfect texture' we can watch the artist apply his own principle of imitation in his work and thus we can 'narrow the rift which for many observers still exists between Reynolds the teacher and Reynolds the artist'.[40] The 'rift' referred to here is that perceived between the powerful arguments adumbrated in his *Discourses* delivered to the students and members of the Royal Academy that an artist should leave out particularities and retain only general ideas in the interests of presenting an image of ideal human nature and Reynolds's own practice as a portrait painter, a practice which of necessity required at least some attention to particularities and verisimilitude.

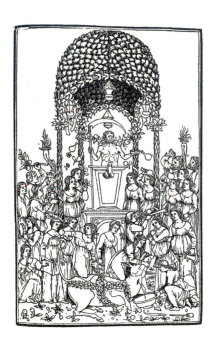

3. *Sacrifice to Priapus*, from F. Colonna,
Hypnertomachia Poliphili, Venice, 1499.
Reproduced by courtesy of the
Director and University Librarian, the
John Rylands University Library of
Manchester

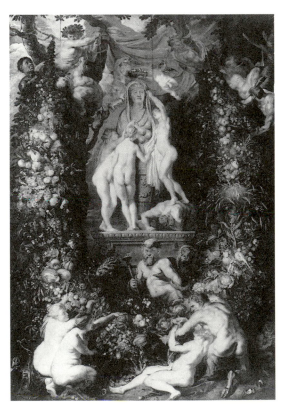

4. Peter Paul Rubens (and Bruegel),
Nature Adorned by the Graces, oil on
wood, 106.7 × 72.4, *c*.1615, Glasgow
Museums: Art Gallery & Museum,
Kelvingrove

Gombrich demonstrates how the poetic invention requested by Gardiner was brought into play to produce a mythological portrait which succeeded, apparently, in synthesizing a Priapean rite (Pl. 3)[41] (via Poussin) with the pleasing notion of the three Graces. 'By replacing Rubens's Nature—a female genius of fertility in the shape of the Ephesian Diana—[Pl. 4] by her male counterpart, Reynolds fused the two iconographic motives into one graceful idea.'[42] Gombrich goes on to trace prototypes for the individual poses of each young woman, arguing that they provide an illustration of the powerful case made in the *Discourses* for imitation. It is, Gombrich claims, 'this deliberate display of the "quotation" rather than the practical use of traditional types and formulae that distinguishes a work like Reynolds's Three Ladies . . . from earlier cases of adaption'.[43] Gombrich concludes that in this image 'the two worlds of portraiture and of history, of realism and imagination are held in perfect, if precarious balance'.[44]

In his essay Gombrich curiously makes no mention of Edgar Wind's work on eighteenth-century portraiture, first published in German in 1932.[45] Wind labels portraits that partake of other genres 'composite portraits'. Speaking of Reynolds's child portraits he points out that 'the difference between the genre-like children's scene for which an individual child sat, and the child portrait with genre features, inevitably disappeared—a principle which mutatis mutandis also applies to historical or mythological portraits of adults'.[46] Where Gombrich sees an inventive artist deftly and successfully putting into practice a theory of imitation, Wind sees a practice which contradicts or disrupts the very theory that is intended to underpin it. For Wind there is no brilliant solution to the problem of the inherent contradiction between mythologizing history painting and the specifics of portraiture for, while the representation of a lady as a goddess (in this instance he is discussing *Lady Blake as Juno*, RA 1769) was intended as a compliment, to maintain the complimentary mode inevitably involved forgetting what followed in mythological narrative since Juno had asked for the cestus from Venus in order that she could seduce and then deceive her husband.[47] This is, claims Wind, a limitation characteristic of all Reynolds's allegories. We are invited to accept a personification but required to refuse a comparison. Thus the Montogomery sisters should not be understood to be either ladies *or* Graces (a matter of debate that has exercised biographers)[48] but ladies *as* Graces.[49] We would now recognize the Montgomery sisters in this explanation as an iconic sign that cannot be split into its constituents of signifier (ladies) and signified (Graces) but can only be apprehended as sign.[50]

Gender enters into these discussions of mythology and portraiture at two points. Gombrich argues that the inevitable social impropriety that would

attach to a representation of society ladies adorning a female fertility cult statue is accommodated by substituting the male god of marriage for the abundantly endowed female Nature. Wind, on the other hand, notices (though he does not explore) the fact that the mythologizing and allegorizing portrait is a type that belongs chiefly to female subjects in the eighteenth century.[51] Furthermore, Wind's identification of the element of refusal, of impasse, of blockage—the point beyond which the personification of the portrait subject may not pass without loss of the identity of the sitter—has, I shall argue, particular resonances in relation to the construction and regulation of the representation of femininity in *Three Ladies Adorning a Term of Hymen.*

More recently David Solkin has pointed out that historical portraiture— that is the casting of contemporary subjects in the roles of historical individuals from the past (like Hector taking leave of Andromache)—was not widely adopted in eighteenth-century England and that by and large it was restricted to the occasional portrayal of women and children, where it functioned 'as a witty sort of game'.[52] Because, Solkin argues, it implicitly admitted the inadequacy of modern virtue by comparison with its ancient counterpart, 'such role playing could never match up to the sterner requirements of male portraiture'. Two observations are in order. The first is that witty games—and allegories involve witty game-playing—are ritualized forms of social organization and control and, as such, deserve our attention. The second observation relates to the distinction between historical and allegorical (or emblematical) subjects which, as we have seen, contemporaries tended to link. While the literary sources for these paintings may be shared (Homer, or Ovid, for example), in so far as historical portraiture defines contemporary subjects in terms of mortals from the past, it differs from mythologizing portraits which constitute subjects as supernatural. Both forms are in a literal sense historical and are also historical in the sense that they aspire to the genre of history painting. Moreover, both forms are allegorical because they invite us to enter into a visual narrative (Trojan history or Bacchanalian rite) which represents simultaneously something *other* than itself, that is, a particular living human subject. Historical and mythological portraiture thus have in common the fact that they stage irreconcilable opposites—the past and the present, the then and the now—but mythological portraiture is additionally intensely liminal since it depends upon the apprehension of the actual in terms of the mythic, the natural in terms of the supernatural, and the particular in terms of the general. It is this very liminality that determined the application of this portrait mode to female subjects in particular. It is a mode predicated upon the assimilation of human subjects into the lives of goddesses

or, at the very least (as with *Lady Sarah Bunbury sacrificing to the Graces*) into the world of pagan religion as handmaids, priestesses, etc.

These arguments have been outlined in some detail because the issues that are raised demand further investigation. The act of quotation so brilliantly identified by Gombrich cannot, I suggest, be explained merely by reference to a strategy that is 'deliberate'. The function of quotation is very varied, although in terms of eighteenth-century academic painting, the assumption is that it enables men of education to recognize a set of familiar classical allusions and thus to be united in public taste.[53] From the point of view of portraiture, visual quotation has always been understood also to have served the function of elevating the genre, rendering it closer to history painting while at the same time complimenting a contemporary sitter and therefore satisfying the demands of the contract. But quotation is a complex process of grafting, a cultural and linguistic act that unites texts of divergent origin. I shall look at this question of quotation at a theoretical level working from the principle that the removal of a text from one site to another is not, as it were, like transplanting a shrub, it is more like mixing a colour. Traces of the original context inevitably accompany the transfer and both transplant and trace are transformed by the site that receives them. The act of quotation may be deliberate but intentionality cannot account for the consequences; Reynolds's painting rather demonstrates the tendency of quotation to be accompanied by unforeseen or unintended traces of earlier sites than manifests the kind of invention and control identified by Gombrich. Such traces spill over and disrupt the very decorum which classical allusion is supposed to superimpose onto portraiture.

How the process of quotation is effective may furthermore be determined by the gender of the subject. In the case of Viscount Keppel posed as the Apollo Belvedere (1752) the public character is anterior to the portrait and the quotation merely serves to enhance that character. For female subjects who were young ladies (rather than, say, actresses) the process was clearly different. That woman is excluded from the discourse of femininity that is about her is now a convention of feminist discourse.[54] In this instance where quotation does not merely serve as a device to render interesting a portrait of an individual whose status is an a priori given, we may recognize how the discourse of femininity transfixes the historical female subjects. The equipoise, the precarious balance identified by Wind between the individual sitter and the mythology invoked, is an equipoise that prohibits the narrative of the sitter's life just as much as it prohibits the unfolding of the mythological narrative. The Montgomery sisters as historical subjects, as individuals in history, are effectively, as a consequence of the mechanism of quotation, excluded from the discourse about them. That Elizabeth is known to have been an excellent

actress endorses this process.[55] Of course, there is no 'real subject', no person to whom the portrait were it constructed differently might permit us access. However, the very illusion that this might be possible is here doubly repudiated. The idea of the performative skills of the Montgomery sisters (which might have remained part of the historiographic relay—a sequence of anecdotes that 'frame' the painting) is foregrounded in an image which celebrates the portraiture as artifice, as acting.[56] Mr Gardiner sent his fiancée as a messenger to Reynolds with his instructions penned in Dublin on 27 May 1773. She is the bearer of the letter (a theatrical role) as well as its subject and she has no voice of her own in the historical narrative. Elizabeth Montgomery is, therefore, medium between artist and patron both in the sense that she carries letters and in the sense that her body is constituted as medium of communication in the work of art. Although Reynolds referred in his reply to 'the subject we have chosen' the description is worded in such a way as to suggest that it was exclusively the idea of Reynolds who had, in any case, earlier painted a similar theme.

Reynolds's theory proposed that, since the burden of meaning in a painting was carried by form, not by its subject matter or fable, it was important to employ a set of visual and narrative references that everyone was familiar with and thus to ensure the minimum of distraction from the general idea.[57] The question here, then, is what has happened in the interstices of Reynolds's mosaic of quotations from iconographically familiar sources? If this is a matter of imitation, of quotation, then what of the residual traces of the originary text which cling to the grafted passage whether in the collective consciousness (or unconscious) of an eighteenth-century audience, in the intention of the artist, or in the thematics of reading in the late twentieth century? And what are the implications of this for the power relations of gender? These relations are peculiarly visible in a portrait of three young women, commissioned from an artist who possesses more authority than any other artist in Britain at that time by a man who, in marriage, is to become possessor not only of the symbolic body of the painting but also of the carnal body of one of the women through ecclesiastical and legal authority. When Elizabeth Gardiner (née Montgomery) died in childbirth ten years later, her death was an outcome of the second of these acts of possession.[58] The portrait which, as portraits usually do, survived all its sitters, was (as we have observed) identified as allegorical at the time of its exhibition. But we are dealing here not with just any allegory (a fable, or a Christian story) but with the world of classical mythology. It is to the connotative and figurative power of this work that I shall now turn.

Mythology does not only threaten portraiture with social impropriety (as

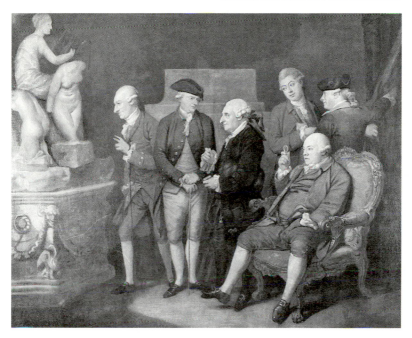

5. Richard Cosway, *A Group of Connoisseurs*, 1771–5, oil on canvas, 85.1 × 110.5, Towneley Hall
Art Gallery and Museums, Burnley Borough Council

Wind affirms), it unsettles socially constructed gender differences and thereby
creates a discursive terrain of competing interests. Pastoral myth and allegory
such as Reynolds invokes are licentious and voluptuous discourses, not least in
eighteenth-century English culture. Classical learning, it was acknowledged,
had its underside. As one scholar has remarked, 'it was in the eighteenth
century that serious allusions to myth began to fail regularly'.[59] While the
researches of Towneley, d'Hancarville, and Richard Payne Knight into the reli-
gious cults of antiquity (and particularly into Priapean rites)[60] were serious
and scholarly in intent, the examination of the goddesses of classical mythol-
ogy was, for contemporaries, a double-sided activity. Learning, as Cosway's
counter-portrait of Zoffany's famous patron Charles Towneley demonstrates
(Pl. 5), could also be licentious.[61] And classical mythology could allude to the
low as well as the high. For example, *The Graces: A Poetical Epistle from a
Gentleman to his Son* (1774), typical of a genre which uses classicizing language
to treat bodily functions, recommends strict attention when in the shrine of
ease (i.e. the privy) for fear of offending the goddess: 'The Ease of Nature asks
the Ease of Grace.'[62] The hazards of comparing contemporary society ladies
with figures from the pages of Ovid were greater, perhaps, than Gombrich

recognized. Visual eclecticism in Reynolds's painting may therefore be a deliberate process of veiling, a practice that ensures that visual references are dispersed and fragmented in the interests of preserving intact the notion of chastity in the dangerous territory of mythology. But chastity's very precariousness, I suggest, refuses this management through iconographic substitution.

While the supplicants or celebrants remain female throughout the various transmutations from Renaissance *Hypnertomachia Poliphili* to Rubens, the gendered object of their pleasurable address in Reynolds's painting changes from the male to the female principle and back to the male, or so it seems. So what of Hymen, the substitute, who is discreetly present only in the form of a sightless and shadowy term (*Terminus*), a device used in land organization to signal closure of a passage or mark a boundary?[63] Reynolds's Hymen has, we may presume, lit the flaming altar at the far right of the painting but his torch is now discreetly lowered. A familiar figure in masques and nuptial poems, the god of marriage has had a chequered history and his intervention is not invariably benign. As we read in Ovid's *Metamorphoses*:

Orpheus's invitation to the God to attend his marriage was of no avail, for though he was certainly present, he did not bring good luck. His expression was gloomy, and he did not sing his accustomed refrain. Even the torch he carried sputtered and smoked, bringing tears to the eyes, and no amount of tossing could make it burn.[64]

Even if he could be relied on to attend, Hymen's antecedents were by no means clear and unsullied and, more important, nor was his gender unambiguous (unlike that of Priapus, god of generation for both the sexes and the most commonly represented in the form of the term) as he spent considerable time in women's clothes pretending to be female.

The idea of Hymen, upon which Reynolds alighted in his efforts to produce what Gombrich describes as a balance of realism and imagination, embodies the very quality of precariousness that is the characteristic of chastity. Moreover the *form* by which Hymen is represented in this particular image is highly problematic.[65] Gombrich's argument that the Priapean iconography is overwritten by the more socially acceptable imagery of Hymen is hermeneutically and historically unsustainable. To begin with, the relegation of Hymen to the shadowy background in Reynolds's painting does not obscure the erect and phallic presence of this garden god. Blind, and therefore symbolically castrated, the repressed Priapus returns in the form of a term that stands in its completeness *as* phallus in this garden of nubile females. If Reynolds thought that he had erased Priapus by substituting Hymen, he would merely have been following Zoffany, who carefully occludes Priapus in his painting of Charles

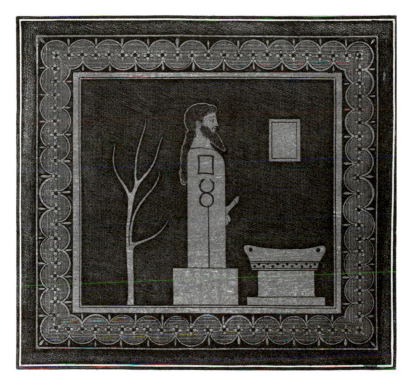

6. P. H. d'Hancarville, *Recueil d'Antiquités étrusques, grèques, et romains,* Paris, 1766–7, ii, pl. 97, by permission of The British Library, London (688.i.3–6)

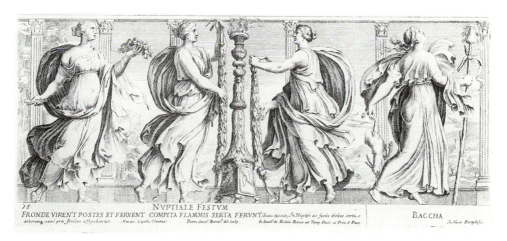

7. Santi Bartoli, *Admiranda Romanorum antiquitatum,* Rome, 1693, iii, tab. 57, pl. 75, by permission of The British Library, London (3 Tab 57)

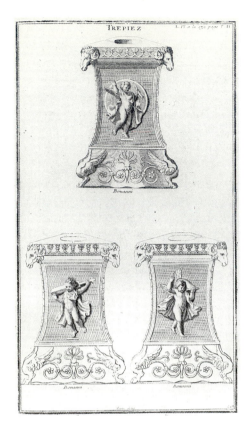

8. (*left*) B. de Montfaucon, *L'Antiquité expliquée, et représentée en figures*, Paris, 1719, ii, part I, pl. ı, by permission of The British Library, London (740.i.20)

9. (*below*) B. de Montfaucon, *L'Antiquité expliquée, et représentée en figures*, Paris, 1719, i, part II, pl. clxxxi, by permission of The British Library, London (740.i.20)

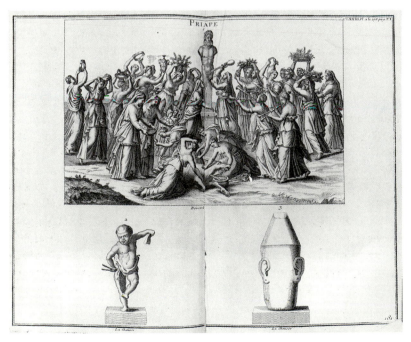

Towneley's Gallery.[66] But this is to disregard the phallic form of this kind of statue, whatever god it represents.[67] Moreover, Reynolds's most immediate sources in Montfaucon's *L'Antiquité expliquée* (1719) and d'Hancarville's *Receuil* (1766–7)[68] suggest that contemporaries would immediately have associated a term not with Hymen but with Priapus. This is one of the 'garden gods and not so decent either' mentioned by Byron in *Don Juan*[69] as part of a long tradition of garden eroticism that enjoyed particular favour in Italy in the sixteenth and seventeenth centuries and which was readily available to later generations of European artists[70] through suites of engravings (by followers of Giulio Romano).[71] The term is, in general, in the form of a Priapus (even if the erect penis is veiled) rather than in the form of a Hymen (Pl. 6); it is, for example, in this form that it appears in the exedra designed by William Kent for Lord Burlington's garden at Chiswick. The sisters individually may be modelled on relatively innocuous female figures from Bartoli (Pl. 7)[72] or Montfaucon, who also provides the source for the garden furniture Reynolds includes in his painting (Pl. 8), but the Priapean rite (complete with those ubiquitous baskets of flowers that Reynolds liked to give female sitters) remains the major point of reference for the composition (Pl. 9). A further endorsement might be offered by Poussin's drawings of Priapean celebrations which were also readily available to Reynolds.[73] What, we might ask parenthetically—and psychoanalytically—are the Montgomery sisters doing with their veiling garlands? Priapus was a cipher for sexual licentiousness. Nor was the Royal Academy as a site seen as immune from this. Quite the contrary, it was described in 1781 by a critic who disapproved of imagery of this sort as a 'Temple of Priapus'.[74] Quotation, then, does not lend itself to authorial control of the kind suggested by Gombrich. Priapus refuses to lie down.

If Priapus refuses to leave the text, Hymen is also present and Hymen is associated with happy marriage. It is through Hymen's association with happy marriage that his name became connected in medical discourse with the membrane that closes the vagina. It is to this other, associated hymen that we must now turn, as factual and as figurative. The hymen's cultural significance consists in its role in legal definition; it has been understood to be the seal which guaranteed to the male marriage partner that his partner had not been 'de-flowered' and that his issue would therefore be legitimate.[75] But the hymen has a confused and complicated history. It is, as Esther Fischer-Homberger claims, a great, important theme from the Middle Ages onwards, one whose history is shrouded in darkness.[76] She identifies the eighteenth century as one of the eras in which the hymen (the existence of which had been challenged by Soranos and others since the second century AD) became again the crucial test of virginity.[77] A popular eighteenth-century medical

dictionary describes the hymen clearly. It is 'a circular folding of the inner Membrane of the Vagina: and this being broke (in primo Coitu) its Fibres contract in three or four Places, and so form the Glandulae Myrtiformes.' Moreover, when breached, the hymen 'is generally accounted the Test of Virginity'.[78]

From Shaftesbury to Reynolds, and from Reynolds to Lessing, the theory of history painting is concerned with the peak narrative moment or, to draw attention to the feminized discourse operative here, the so-called 'pregnant moment', and its before and after. The moment the artist chooses to represent must imply both what has preceded and what will succeed. Shaftesbury's 1712 treatise on the subject of the Judgement of Hercules was a canonical text and was parodied by Reynolds in *Garrick between Tragedy and Comedy* (1761).[79] Perhaps the most powerful of such moments is that which relates to the social regulation and mythologization of gendering in western societies: the before and after of virginity, implicated as it is in primogeniture. The hymen stands physiologically and symbolically at that threshold, it is the part of the female body that served to authenticate both virginity before marriage and loss of virginity in marriage. The breaking of the hymen is an act of profound symbolic as well as of physical significance and was recognized as such in eighteenth-century medical discourse.[80] The powerful hold of loss of virginity on the eighteenth-century English imagination, a matter of sociological as well as of moral importance, runs through the novels of Fanny Burney (with whom Reynolds socialized in the 1770s) and through imagery as diverse as Dr Johnson's *Rasselas,* in which Imlac, desperate to break through the boundaries that keep him in the enchanted valley, feigns 'an orphan virgin robbed of her little portion by a treacherous lover, and crying after him for restitution and redress',[81] and Hogarth's intentionally ambiguous *Before* and *After* (1730–1). *Three Ladies Adorning a Term of Hymen*, as Gombrich points out, represents the Montgomery sisters at varying temporal stages in their relationship to marriage as represented by the stone statue. The presence of Hymen (here being veiled in flowers) raises also the before and after of that most important and precious of boundaries, the veil or membrane of the hymen. This idea is underscored by the fact that the name 'term', adopted for a statue made of a head and shoulders surmounted upon an architectural base, is etymologically connected with the idea of term as boundary. In other words, *Three Ladies . . .* thematizes marriage at levels other than the polite and celebratory.

The difficulty of allying mythology with portraiture in a composite image, a difficulty everyone agrees on from eighteenth-century theorists to twentieth-century art historians, is staged around the need to curtail or arrest in their narrative unfolding those very associations between contemporary women

and ancient goddesses (whether Graces or not) that have been assembled so laboriously through quotation. Just as the hymen symbolically and physiologically constitutes the boundary that may not improperly be traversed (or may only be so at the price of social cohesion), so the portrait may not cross into the history painting nor history into portraiture. *Three Ladies Adorning a Term of Hymen* is—at least in one sense—a painting about barriers and impasses. The hymen is, in Derrida's words, 'an operation that *both* sews confusion between opposites *and* stands *between* the opposites "at once"'.[82] It thus stages thematically the theoretical problems of the genre of composite portraiture in relation to the genres of academic discourse. And it does so through a representation that at one and the same time offers to view the particular female body and the mythicized feminine presence. It is thus no accident that such portraits are confined largely to images of women. By imaging explicitly Hymen and also implicitly the hymen, the question of the permissible limits of representation is foregrounded.

The hymen that shares the name of the god Hymen—whose statue the Montgomery sisters adorn with their flowers—can represent at a theoretical level the impasse that Wind identifies in the attempt to elide portraiture and mythology. The membrane that provides evidence of the status of the female subject serves also to define the boundaries between reality and mythology. The question remains as to how it is possible that at the historical level a portrait could be commissioned and shown publicly that carried from the carnal world of classical myth traces so unmistakably associated with sex and procreation. One answer is that our admiration for Reynolds as an inventive imitator has allowed us to partition off certain works as scholarly and therefore to expunge from them the capacity for innuendo they may have carried for some contemporary audiences. This is, after all, an age when bawdy spills over into heroic couplets. Why should Reynolds have differed so absolutely from Swift, Sterne, or Pope in his avoidance of sexual innuendo and *double entendre*? We know, after all, that he was friendly with Sterne and Boswell, both men fascinated by the sexual and cultural 'underside'. The sisters are situated not merely in a landscape but in a garden, as the presence of a fountain or piece of garden statuary visible in the background between Barbara and Elizabeth makes clear. Reynolds thus chose to paint three young women in a garden setting in fulfilment of a commission from a gentleman named Gardiner suggesting he was not, himself, incapable of enjoying a pun. Gardiner was an educated gentleman who had been on the Grand Tour with his brother William between 1770 and 1772, and who was elected a member of the Society of Dilettanti on his return. He was an amateur architect of great proficiency who developed ambitious plans for Mountjoy Square including a castellated house

for himself, and his serious interest in neo-classicism is evinced in the commission he gave Gavin Hamilton for a painting of *Priam Pleading with Achilles for the Body of Hector* which may have hung opposite *Three Ladies Adorning a Term of Hymen* in Gardiner's house, in which case heroic masculinity and antique tragedy would have faced modern femininity and classical pastoral. Gardiner, as John Coleman has established, was also an enthusiast of the theatre and wrote the prologue to *The Count of Narbonne: A Tragedy* acted by Robert Jephson at the Theatre Royal, Covent Garden in 1782. Interestingly this poem suggests a man who was aware of, indeed intrigued by, questions of interpretation. He describes the need to stand at a distance to apprehend things as they are (his example significantly is a ponderous statue) and to receive pleasure from them:

> Yet such are we, that objects ever new,
> Passing in bright succession to our view,
> Delight us not, till they at a distance stand,
> Remov'd by sacred Time's mysterious hand.
> The pond'rous statue, if beheld too near,
> Would but a huge, misshapen mass appear;
> Yet plac'd aloft on the high temple's brow,
> The rugged rock is graceful Venus now.
> What odours the Arabian coasts dispense,
> Which, breath'd too near, o'erpower and pall the sense.[83]

Landscape, wild and untrammelled or tamed into a garden (and both aspects are present in Reynolds's painting), had complex female connotations in eighteenth-century England.[84] Moreover, 'rustic' imagery was commonly invoked euphemistically in descriptions of female genitalia. The following 'landscape poem' with its references to 'limitary bounds' (though not marked by terms) offers a *double entendre* to the knowing reader:

> In close recess, hid from curious eyes,
> Beneath a shade the blissful region lies;
> A rising eminence the vale surrounds,
> And justly marks the limitary bounds
> On ev'ry side:—beneath cool fountains flow,
> Which water all the fertile fields below . . .
> The various mazes you with pleasure trace,
> While lovely streams irriguate all the place.[85]

Pastoral allegory—the medium for Reynolds's portrait—seems precisely to have been the site for public and widespread discussion of sexual practice. The idea of a gentleman and the idea of sexual innuendo were by no means incompatible.

In *The Oeconomy of Love: A Poetical Essay*, published first in 1736 and reissued in a new edition by Tom Davies, bookseller to the Royal Academy, in 1774, the year *Three Ladies . . .* was exhibited, John Armstrong, Physician to His Majesty's Army and author of several popular books, offers advice in heroic verse to young men on the matters of sexual practice. Invoking the Muses ('tho Virgins'), Cupid, and Hymen, Armstrong sings 'how | Best to improve the genial joy, how shun | The snakes that under rosy pleasure lurk'. After dealing with wet dreams, masturbation, and menstruation ('from Love's Grotto now | Oozes the Sanguine Stream thro' many a rill, | Startling the simple Lass'), he moves to love-making and to the moment of defloration. 'Stretch'd on the flow'ry turf' the man is advised that though his 'manly Pride', 'throbbing with Desire', will find obstacles in its way, these can easily be overcome. Once 'her lovely limbs' are on view, he should 'Forthwith discover to her dazzled sight | The stately novelty, and to her Hand | Usher the new Acquaintance'. The woman may show some reluctance and when her lover tries 'The sweet Admission' she may resist. None the less, he should 'pursue | The soft Attack' until he overpowers her, but penetration should not be forced.[86]

> On the Brink at last
> Arriv'd at giddy Rapture, plunge not in
> Precipitant, but spare a Virgin's Pain;
> Oh! spare a gentle Virgin! spare yourself!
> Lest sanguine War Love's tender Rites profane
> With Fierce Dilaceration, and dire Pangs
> Reciprocal. Nor droop because the Door
> Of Bliss seems shut and barricaded strong;
> But triumph rather in this faithful Pledge
> Of Innocence, and fair Virginity
> Inviolate.[87]

There follows a long and detailed set of recommendations to young men for recognizing the 'subtle wench' whose 'Virgin Honours' may have been 'in evil hour unseemly torn'. These women will have had resort to a variety of extraordinary natural remedies (thorn, dock, plantain, etc.) from 'The Sylvan store' for a powerful lotion to 'contract the shameful breach'. The pastoral setting of the garlanding of Hymen is here understood to reveal its underside—the source of a reconstituted hymen through which men will be deceived. The man should look out for counterfeit hymens: 'the corrugated parts, | With ill-dissembled Virtue (tho' severe, | Not wrinkled into Frowns when genuine most) | Relapse apace, and quit their borrow'd Tone.' On the other hand he is advised to judge the variety of Nature's work with charity since 'the Purple Stream' of the young woman's menstrual flow may have left her parts 'flexible and lax'. If we

were left in any doubt of the enormous significance of the hymen, Armstrong's final words on the subject would dispel it:

> But hapless he,
> In nuptial Night, on whom a horrid Chasm
> Yawns dreadful, waste and wild; like that thro' which
> The wand'ring Greek and Cythera's Son,
> Diving, explor'd Hell's adamantine Gates:
> An unessential Void; where neither Love
> Nor Pleasure dwells, where warm Creation dies
> Starv'd in th'abortive Gulph; the dire Effects
> Of Use too frequent, or for Love or Gold.[88]

In this account the paradox of the hymen is apparent: it is an inconvenient obstacle to the attainment of masculine pleasure and a treacherously deceptive—but necessary—condition, the absence of which offers up a conceptual void.[89] In conclusion, we might observe that Reynolds's 'quotation' was deliberate not only in the scholarly sense intended by Gombrich. Hymen/hymen links the practice of academic imitation with another tradition which also is rooted in narratives of antiquity—that of sexual and social mastery. The position of the female subject is always more complicated than that of the male subject in the dialectic of enlightenment because it is the mater/materia (mother/material) which has to be mastered and rationalized in the struggle for self-preservation.[90] John Armstrong's verses may be taken as an exemplum of 'a delightful if peculiar genre of sex guide . . . written in verse'.[91] They are also, however, symptomatic of the cultural dialectic in which woman's body is—via mythology—apprehended, made visible, and thereby controlled. Woman's body is a natural waste, it is *materia* for the organization and hence the rationalization for which the hymen offers the index and measure. Mythology provided a mechanism for constituting the body of woman in portraiture in ways that were dialectical. Mythology permitted full play to the articulation of the female reverse of enlightenment denied by the socially controlled conventions of a polite (and fundamentally mimetic) portrait tradition, a tradition in which the imagery of woman was contained within the parameters of her prescribed social role as man's other and his possession. The allegorizing combination of portrait and mythology opened up the dangerous and threatening questions of what might not be known, the *materia* (wasteland) of woman's nature. At the same time it also preserved, through the particularity of the portrait subject, the 'wandering Greek and Cythera's son' (the humanist subject Ulysses as sexual explorer) from the horrors of 'an unessential void'. Reynolds's *Three Ladies Adorning a Term of Hymen* is precarious in ways that neither Gombrich nor Wind may have suspected.

Notes

1. N. Penny (ed.), *Reynolds* (Royal Academy of Arts, London, 1986), 29.
2. The population controversy began in the 1750s when the Bill for taking the census (1801) was being discussed; among the concerns were levels of illegitimacy and the fashion for men to remain unmarried. For an account of publications in this period, see D. V. Glass, *Numbering the People: The Eighteenth-Century Population Controversy and the Development of Census and Vital Statistics in Britain* (Farnborough, 1973).
3. *Hymen: A Poem* (London, 1794), 27.
4. See e.g. Gill Perry's interesting essay 'Women in Disguise: Likeness, the Grand Style and the Conventions of "Feminine" Portraiture in the Work of Sir Joshua Reynolds', in G. Perry and M. Rossington (eds.), *Femininity and Masculinity in Eighteenth-Century Art and Culture* (Manchester, 1994); R. E. Moore, 'Reynolds and the Art of Characterization', in H. Anderson and J. S. Shea (eds.), *Studies in Criticism and Aesthetics 1660–1800: Essays in Honor of Samuel Holt Monk* (Minneapolis, 1967).
5. Harewood House, Yorks. and Chicago Art Institute.
6. Sir J. Reynolds, Discourse VII, in *Discourses on Art*, ed. R. Wark (London, 1975).
7. *Public Advertiser* (1774), newscutting, Courtauld Institute Press cuttings.
8. Penny (ed.), *Reynolds*, no. 90.
9. Gardiner became Lord Mountjoy, and the 1st Earl of Blessington. He was killed at the head of his regiment at the battle of New Ross in the 1798 rebellion. See W. E. H. Lecky, *A History of Ireland in the Eighteenth Century* (new edn. London 1892), iv. 390 and C. R. Leslie and T. Taylor, *Life and Times of Sir Joshua Reynolds: With Notices of Some of his Contemporaries* (London, 1865), 5 n. Gardiner was a distinguished parliamentarian, Deputy Vice Treasurer, and property developer 'who made a useful well connected marriage'. See T. W. Moody and W. E. Vaughan (eds.), *A New History of Ireland*, iv: *Eighteenth-Century Ireland 1691–1800* (Oxford, 1986), 69–70, 273, 503. On prices, see *The Works of Sir Joshua Reynolds, Knt. Late President of the Royal Academy . . . to Which is Prefixed an Account of the Life and Writings of the Author, by Edward Malone, Esq.* (London, 1797), p. xxxvi.
10. It is collected in Burke's *Works* but most readily available in S. Deane (ed.), *Field Day Anthology of Irish Writing*, i (Derry, 1991), 816–22. I am grateful to Fintan Cullen for drawing this to my attention.
11. On 20 Feb. 1782 Gardiner proposed that the Catholic Bill should include indulgences: enjoyment of property, free exercise of religion, education, marriage. *The Parliamentary Register: or, History of the Proceedings and Debates of the House of Commons of Ireland, 1781–2* (2nd edn. Dublin, 1784), 249–50. I am grateful to Fintan Cullen for pointing me in the direction of this publication.
12. Lecky, *History of Ireland*, 30. The Graces were an analogue to the Petition of Rights. The most important was the ruling that undisturbed possession of sixty years should secure a landed proprietor from all older claims on the part of the crown. The Graces were agreed on condition that the Irish gentry raised a large sum for the English crown. The subsidies were made but Wentworth violated the King's solemn promise by withdrawing the two principal articles of the Graces, the limitation of the crown claims mentioned above and the legislation of the Connaught titles.
13. I am extremely grateful to John Coleman for permitting me to read his M.Litt. thesis, 'Images of Assurance or Masks of Uncertainty: Joshua Reynolds and the Anglo-Irish Ascendancy, 1746–1789' (Trinity College, Dublin, 1993), in which he establishes the location of the painting in Gardiner's lifetime.

14. J. Northcote, *Memoirs of Sir Joshua Reynolds, Knt.* (London, 1813), 185.

15. See R. Rosenblum, 'Reynolds in an International Milieu', in Penny (ed.), *Reynolds*, 48–9.

16. No. 89 *A Portrait of a Lady and her Son, Whole Lengths, in the Character of Diana, Disarming Love* (a portrait of the Duchess of Manchester); no. 90 *A Portrait of a Lady in the Character of Juno Receiving the Cestus from Venus* (Lady Blake, formerly Miss Bunbury); no. 91 *Portraits of Two Ladies, Half Lengths: Et in arcadia ego* (Mrs Bouverie and Mrs Crewe); no. 92 *Hope Nursing Love* (Miss Morris).

17. The whereabouts of this portrait is not known though there is a copy of an engraving in the Witt Library (Royal Academy index). However, the Tate Gallery, London owns Cosway's *A Gentleman and his Wife and Sister in the Character of Fortitude Introducing Hope as the Companion of Distress.*

18. Northcote, *Memoirs*, 185. My italics. On the differentiation of different beauties, see R. Jones, 'The Empire of Beauty: The Competition for Judgement in Mid-Eighteenth-Century England', Ph.D. thesis (University of York, 1995).

19. See J. Clifford, 'On Ethnographic Allegory', in J. Clifford and G. E. Marcus (eds.), *Writing Culture: The Poetics and Politics of Ethnography* (Berkeley and Los Angeles, 1986), 98–101.

20. 'Candid', *Morning Chronicle*, 5 May 1780. I am grateful to Karen Stanworth for drawing my attention to this review.

21. Northcote, *Memoirs*, 186–7.

22. F. W. Hilles (ed.), *Portraits by Sir Joshua Reynolds* (London, 1952), 20–1; Malone, *The Works of Sir Joshua Reynolds*, p. v.

23. A. Fletcher, *Allegory: The Theory of a Symbolic Mode* (1964; Ithaca, NY, 1965), 330.

24. For an interesting discussion of allegory and the political, see J. Fineman, 'The Structure of Allegorical Desire', in S. Greenblatt (ed.), *Allegory and Representation: Selected Papers from the English Institute, 1979–80* (Baltimore, 1981), 28 ('Allegory seems regularly to surface in critical or polemical atmospheres when for political or metaphysical reasons there is something that cannot be said').

25. 'The thoughts old and flowers too neglected', quoted in A. Graves, *The Royal Academy of Arts: A Complete Dictionary of Contributors* (London, 1906).

26. S. Todorov, *Symbolism and Interpretation*, trans. C. Porter (London 1983), 56.

27. *Public Advertiser* (1774), quoted Witt Library RA Index.

28. J. J. Winckelmann, *Versuch einer Allegorie, besonders für die Kunst* (Dresden, 1766). I have used the French translation in H. Jansen (trans.), *De l'allégorie ou traités sur cette matière, par Winckelmann, Addison, Sulzer etc.* (Paris, 1799) (see pp. 21, 326). The view that allegorical figures are more suited to literature than to the plastic arts was still being strongly maintained when Erasmus Darwin composed the first interlude to *The Botanic Garden*, part II, published in 1789 (E. Darwin, *The Botanic Garden, Containing the Economy of Vegetation: A Poem with Philosophical Notes* (London, 1791)).

29. For an interesting survey, see G. Jackson-Stops, 'A British Parnassus: Mythology and the Country House', in G. Jackson-Stops *et al.* (eds.), *The Fashioning and Functioning of the British Country House* (Washington, 1989).

30. *Lithodipyra* (1777–8), a set of illustrations of the factory's products, is reproduced in *Country House Lighting 1660–1890*, Temple Newsam House Studies 4 (Leeds, 1992), pl. 84.

31. Including music, see e.g. *Hymen: A Serenata Composed by Mr. Handel* (London, 1742).

32. Quintilian, *Institutio oratoria*, 8. 6, 14–15.

33. J. Derrida, *Memoirs for Paul de Man*, trans. C. Lindsay, J. Culler, and E. Cadava (New York, 1986), 11.

34. Medieval theory argued for a calculated obscurity which elicited an interpretative response in the reader, see Fletcher, *Allegory*, 234–5. This is in contradistinction to Winckelmann (who is often actually discussing symbol rather than allegory) who insists, *Versuch einer Allegorie*, 22, that every image should have a clear and accessible meaning.

35. *Morning Chronicle*, 27 Apr. 1774.

36. See her obituary notice, *Gentleman's Magazine*, Nov. 1783; according to C. Maxwell (*Dublin under the Georges 1714–1830* (London, 1936), 99) Luke Gardiner had a private theatre in Ranger's Lodge.

37. Rosenblum, 'Reynolds in an International Milieu', 43.

38. E. H. Gombrich, 'Reynolds's Theory and Practice of Imitation: Three Ladies Adorning a Term of Hymen', in *Norm and Form: Studies in the Art of the Renaissance* (Oxford, 1966), 129–34.

39. Bequeathed by the Earl of Blessington, transferred from the Tate Gallery to the National Gallery in 1968, no. 79.

40. Gombrich, 'Reynolds's Theory', 129.

41. This image was subject to frequent censorship; see H. K. Szépe, 'Desire in the Printed Dream of Poliphilo', *Art History*, 19: 3 (Sept. 1996).

42. Gombrich, 'Reynolds's Theory', 131.

43. Ibid. 132–3.

44. Ibid. 133.

45. 'Humanitätsidee und heroisiertes Porträt in der englischen Kultur des 18. Jahrhunderts', in *England und die Antike,* ed. F. Saxl, Vorträge der Bibliothek Warburg 1930–1931, 9 (1932), 156–229; amplified from Wind's papers by J. Anderson and published in *Hume and the Heroic Portrait: Studies in Eighteenth-Century Imagery* (Oxford, 1986), 1–52. All references are to the English text.

46. Ibid. 26.

47. Ibid. 43.

48. Leslie and Taylor, *Life and Times of Sir Joshua Reynolds*, 69.

49. Wind, 'Humanitätsidee und heroisiertes Porträt', 44: 'The fact that the girls had reason to crown Hymen, whereas the Graces had not, once again shows the internal problems of the allegorical style'.

50. Joel Feinstein's article 'Mrs. Siddons, the Tragic Muse, and the Problem of As', *Journal of Aesthetics and Art Criticism*, 36: 3 (Spring 1978), 317–22 is relevant to this discussion but I cannot agree with Feinstein's initial proposal that the 'portrait as' is alienating. Nor am I convinced by Feinstein's philosophical preoccupation with a conflict between the diachronic and the synchronic. His article is, none the less, essential reading for anyone interested in portraits in character.

51. Ibid. 29: 'There are, it is true, many degrees of heroic effort in the portraits of men. But on the whole a man is glorified in the social position he has attained.' It might be argued that the example of James Barry contradicts this argument (*Barry and Burke in the Characters of Ulysses and a Companion Fleeing from the Cave of Polyphemus*, 1776) but it does seem generally that there are more female than male mythologizing portraits in England in the 18th cent.

52. D. Solkin, 'Great Pictures or Great Men? Reynolds, Male Portraiture and the Power of Art', *Oxford Art Journal*, 9: 2 (1986), 43–4. A more nuanced but similar line of argument is presented by Solkin in relation to portraits of male members of the Shaftesbury family in *Painting for Money: The Visual Arts and the Public Sphere in Eighteenth-Century England* (New Haven, 1993).

53. J. Barrell, *The Political Theory of Painting from Reynolds to Hazlitt* (London, 1986).

54. See e.g. M. A. Doane, 'Film and the Masquerade: Theorizing the Female Spectator', *Screen* (Sept.–Oct. 1982).

55. 'Mrs Gardiner had the most remarkable fine theatrical talents and performed most of Shakespeare's tragic characters, it was said, even better than Mrs. Crawford. Her Lady Macbeth was the finest piece of acting ever exhibited on any stage. Mr. Gardiner, to gratify his beautiful lady's taste, fitted up a theatre at his lodge in the Phoenix Park', obituary, *Gentleman's Magazine*, 54 (Dec. 1783), 1064. Coleman, 'Images of Assurance', 263 states that Elizabeth was involved in theatrical activities in Dublin and was responsible for the decorations of the Crowe Street Theatre for a performance of Addison's *Cato*.

56. On the performative in portrait commissions, see H. Berger Jr., 'Fictions of the Pose: Facing the Gaze in Early Modern Portraiture', *Representations*, 46 (Spring 1994).

57. See Barrell, *Political Theory of Painting*, 100.

58. Her death was announced in the *Gentleman's Magazine*, 54 (Nov. 1783), 978, 'At Dublin, in child-bed, Lady of rt. Hon. Luke Gardiner'.

59. J. Engell, 'The Modern Revival of Myth: Its Eighteenth-Century Origins', in M. W. Bloomfield (ed.), *Allegory, Myth and Symbol* (Cambridge, Mass., 1981), 251.

60. For Payne Knight, see A. Ponte, 'Architecture and Phallocentrism in Richard Payne Knight's Theory', in B. Colomina (ed.), *Sexuality and Space* (Princeton, 1992).

61. For a detailed account of the 'sexual exoticism' of this circle of scholars, see G. S. Rousseau, 'The Sorrows of Priapus: Anticlericalism, Homosocial Desire, and Richard Payne Knight', in R. Porter and G. S. Rousseau (eds.), *Sexual Underworlds of the Enlightenment* (Manchester, 1987).

62. *The Graces: A Poetical Epistle from a Gentleman to his Son* (London, 1774), 3.

63. 'In geometry . . . the extreme of any magnitude, or that which bounds and limits its extent', C. T. Watkins, *A Portable Cyclopaedia* (London, 1810). The *OED* makes clear that a term is not only a space of time and a boundary but also (now obsolete but common in the 18th cent.) a point of origin.

64. *The Metamorphoses of Ovid,* trans. M. M. Innes (Harmondsworth 1955; 1983), 10. 1–28.

65. A list of literary (and some visual) instances of Hymen figures is provided in J. Davidson Reid (ed.), *The Oxford Guide to Classical Mythology in the Arts 1300–1990s* (Oxford, 1993), vol. i.

66. Towneley's celebrated collection was housed at his London home, 7 Park St. (now Queen Anne's Gate).

67. It is interesting to note, in this connection, that Aubrey Beardsley represented himself (?) as Bacchus tethered to (enthralled by) a herm—a form of sculpture almost indistinguishable from a term. In this drawing (*A Footnote*, published in *Savoy* (Apr. 1896)), the herm stands as detached phallus to the body of the author. I am grateful to David Peters Corbett for a helpful discussion about Beardsley. Vincent Crapanzano in an essay on Hermes in Clifford and Marcus (eds.), *Writing Culture*, 52 points out that the 'stone heap', Hermes, became a head and phallus on a pillar and replaced the heap of stones as boundary marker. Finally, Mikhail Bakhtin (*Rabelais and his World* (1965), trans. H. Iswolsky (1968), Bloomington, Ind., 1984), 318 groups terms with towers and subterranean passages as architectural equivalents of the grotesque body.

68. B. de Montfaucon, *L'Antiquité expliquée, et représentée en figures* (Paris, 1719); P. Hugues d'Hancarville, *Recueil d'antiquités étrusques, grèques et romains* (Paris, 1766–7).

69. *Don Juan* (1819), canto i.

70. Goya, for example, painted a *Sacrifice to Priapus* in 1771 which belongs within this tradition

(private collection, Barcelona). See A. E. P. Sanchez and E. A. Sayre (eds.), *Goya and the Spirit of Enlightenment* (London, 1989), no. 2.

71. The associations between gardens and 'defloration' and the notions of young women gaining sexual satisfaction with statues of Priapus are often made explicit in such works.

72. Santi Bartoli [G.P. Bellori], *Admiranda Romanorum antiquitatum* (Rome, 1693).

73. As well as examples in the royal collection, a fine drawing now in the Musée de Bayonne was first in Richard Cosway's collection and then in Sir Thomas Lawrence's. See W. Friedlander and A. Blunt, *The Drawings of Nicolas Poussin: A Catalogue raisonné* (London, 1953), vol. iii, no. 191, pl. 151. It is interesting to note that there has been confusion in the identification of Hymen and Priapus in paintings by Poussin who, Friedlander suggests, elided different accounts of the god. See W. Friedlander, 'Hymenaea', in M. Meiss (ed.), *De artibus opuscula XL: Essays in Honor of Erwin Panofsky* (New York, 1961).

74. *Morning Post* (15 May 1781), 4. I am grateful to Karen Stanworth for this reference.

75. Its importance in this respect has recently been revived as a result of widespread concern over child abuse, in the definition of which the state of the hymen often plays an important part. I am grateful to Anna Kerr for discussing this with me.

76. E. Fischer-Homberger, 'Hebammen und Hymen', in E. Fischer-Homberger, *Dies Krankheit Frau* (Bern, 1979), 85.

77. Soranos was writing in AD 150: 'On pense parfois qu'une mince membrane, qui s'est développée en travers du vagin, l'obstrue; que la rupture de cette membrane intervient au cours de la défloration et cause une douleur, ou qu'elle a lieu en cas d'apparition des règles avant défloration; que si la dite membrane demeurant en place, prend consistance et durcit, elle est à l'origine de l'état pathologique nommé atrésie: tout cela n'est que mensonge. D'abord, la dissection ne révèle pas semblable membrane; ensuite, chez les vierges, on ne devrait buter sur elle en explorant le vagin à la sonde: or la sonde entre profondément.' Sorane d'Ephèse, *Maladies des femmes,* trans. P. Burgière, D. Gourevitch, and Y. Malinas (Paris, 1988), i. 14.

78. J. Harris, *Lexicon technicum: or, An Universal English Dictionary of Arts and Sciences: Explaining Not Only the Terms of Art, but the Arts Themselves,* 2 vols. (London, 1708–10; 5th edn. 1736), i; on sex guides and sexual quackery, see P. Wagner, *Eros Revived: Erotica of the Enlightenment in England and America* (London, 1988).

79. A. Ashley Cooper, 3rd Earl of Shaftesbury, Treatise VII, 'A Notion of the Historical Draught or Tablature of the Judgement of Hercules, According to Prodicus, Lib. II Xen. de Mem. Soc.', in *Characteristicks of Men, Manners, Opinions, Times* (1st pub. in France, 1712; 2nd edn. corrected, 3 vols., London, 1713–14), vol. iii.

80. It is also worth noticing that the term hymen seems to have become generically a word for membrane as Linnaeus used it to define one of the orders of his class of Hexapoda, the Hymenoptera, in his *Systema natura* of 1735.

81. Dr S. Johnson, *Rasselas*, in *The Works of Samuel Johnson,* ed. G. J. Kolb, vol. xvi (New Haven, 1990).

82. J. Derrida, 'The Double Session', in J. Derrida, *Dissemination* (1973), trans. B. Johnson (London, 1981), 212.

83. *The Count of Narbonne: A Tragedy as it is Acted at the Theatre Royal in Covent Garden by Robert Jephson, Esq.* (4th edn. Dublin, 1782), quoted by Coleman, 'Images of Assurance', 221–3. The play is a dramatized version of Walpole's *The Castle of Otranto.* The first edition, published in London in 1781, has a different prologue, spoken by Mr Wroughton.

84. See e.g. discussions in C. Fabricant, 'Binding and Dressing Nature's Loose Tresses: The

Ideology of Augustan Landscape Design', *Studies in Eighteenth-Century Culture*, 8 (1979); James D. Turner, 'The Sexual Politics of Landscape: Images of Venus in Eighteenth-Century English Poetry and Landscape Gardening', *Studies in Eighteenth-Century Culture*, 11 (1982).

85. *The Joys of Hymen: or, The Conjugal Directory* (London, 1768).
86. J. Armstrong, *The Oeconomy of Love: A Poetical Essay* (London, 1736; 1774), 2, 4, 5, 13.
87. Ibid. 14–15.
88. Ibid. 16–18.
89. See also Derrida, *Dissemination,* on Mallarmé, 212–13.
90. See S. Weigel, 'Body and Image Space: Problems and Representability of a Female Dialectic of Enlightenment', *Australian Feminist Studies,* 11 (Autumn 1990), 3.
91. P. Wagner, 'The Discourse on Sex or Sex as Discourse: Eighteenth-Century Medical and Paramedical Erotica', in Porter and Rousseau (eds.), *Sexual Underworlds,* 49. Wagner misunderstands the gist of this poem by suggesting it is directed at a young man about to marry. In fact it contains a long passage about avoiding marriage and the necessity of providing for bastards if a man is to avoid embarrassment after marriage.

3

Abundant Leisure and Extensive Knowledge: Dorothy Richardson Delineates

TO DELINEATE
1. To trace out by lines, trace the outline of, as on a chart or map
2. To trace in outline, sketch out (something to be constructed); to outline; to make the first draught of
3. To represent by a drawing, to draw, portray
4. To portray in words; to describe

(Oxford English Dictionary)

O f the five senses, sight lends itself most richly to multiple meaning and metaphor. The biblical cadences of 'Have ye not eyes to see, and ears to hear' place upon us a responsibility to use that precious faculty of sight in both the physical and the spiritual sense. Sight links the external with the internal and, in a post-Lockeian world, the relationship between what Blake would call the inner eye and its outer counterpart was matter for speculation and interest. If a person is blinded, they lose their sight, which is to underscore that the faculty of being able to see is a possession. For all its fragility and vulnerability, sight is largely taken for granted. The exceptions to this—and I omit the prime issue of science and medicine—are in the genre of travel literature which is predicated upon the notion of an authentic sight or view relayed through representation to third parties. If it is true that to see is to *possess* sight, then the question of *who* possesses that faculty and *how* they re-present in delineations the seen world needs to be addressed. This is, moreover, a historical question.[1] Travel-writing could be epistolary or in the form of a journal though writings that were too autobiographical were often condemned. The role of the travel writer was 'to describe the various objects that successively present themselves to his view, to communicate anecdotes of the company he is introduced into, and to relate incidental occurrences that offer themselves to

notice'.[2] Travel-writing was, however, much more than this. In eighteenth-century England travel literature, antiquarianism, and local history formed, as R. H. Sweet has stated, 'a complicated nexus of works which drew upon and inspired each other, and generated in turn another large mass of summaries and abridgements'.[3]

Travel literature can be roughly divided into those texts that offered accounts of foreign travel and those which described journeys undertaken in the British Isles. Works in the latter category often encompassed elements of other genres of writing: antiquarian, natural history, urban history. A further, important, distinction should be made between those works that were published and those that remained in manuscript. Of the thousands of travellers of the nobility and especially the gentry who undertook what came to be called tours in the eighteenth century, many recorded their travels. A circuitous journey embracing the principal places of the country or region mentioned—this is how the *Oxford English Dictionary* defines a tour (literally a revolution, a circular movement or a turn, a meaning in which the French origins of the word are evident). This usage evidently became common from the second half of the seventeenth century, an etymology that reveals the close links between surveying, seeing, and an inductive view of the world. For the most part such works (usually single volumes which often give little more than an itinerary, and which often commence conscientiously but falter as the tour proceeds) lie unread among personal papers in archives and county record offices. Those that have seen the light of day such as Celia Fiennes's celebrated travels (written 1685–1703, published in an incomplete version in 1888, and finally published in full in 1947) have attracted attention as fascinating repertoires of data concerning the appearance of England in earlier times. Fiennes was an outstanding and rare example of what became, within the next hundred years, a cultural commonplace. It is with commonplace matter, therefore, in one sense that this chapter is concerned. But the questions I wish to ask of this commonplace are particular. The fact that touring was common and that women were frequently tourists must not obscure the fact that for each subject a tour was a unique experience. For a young woman—and particularly for an unmarried woman—to set off on a tour was for her to strike a note of independence, whether accompanied or not, since it meant exposing herself to the excitement and stimulation of new sights. Elizabeth Bennet, the heroine of *Pride and Prejudice*, takes such a tour at the crucial moment in the narrative of her life. Jane Austen recognized that enabling her female character to escape from the oppressive company of her foolish mother in this way would strike a chord with female readers. Possession of sight and the ability to travel, and to represent how sight had been exercised by delineating those

sights to which the tour gave access, was a means to empowerment that women even of the middling classes were able to employ. Few, however, possessed the learning of Dorothy Richardson, the subject of this chapter, who undertook a series of tours in England between 1761 and 1801. I shall examine the unusually detailed and structured sequence of travel writings produced by Dorothy Richardson with the prime objective of establishing not so much *what* is seen as *how* things are delineated—in words and images—as having been seen.[4]

The time-frame for this chapter is precisely that period when the traveller in all but the most remote areas of Britain could enjoy improved roads, itineraries, and maps;[5] it was a period that fell precisely between the era when hardship was a deterrent to pleasure and the era in which, to use Schivelbusch's phrase, space was annihilated by railway technology.[6] Until the outbreak of the Napoleonic wars, travel on the Continent was the apogee of a fashionable education for young men. Picturesque touring in the British Isles, inspired by the publications of William Gilpin, Uvedale Price, and Richard Payne Knight, encouraged the less wealthy or adventurous to explore the Wye valley, Derbyshire, the Lake District, and other areas which thereby became identified as tourist locations, conceptualized via a network of structured mechanisms for viewing and apprehending.[7] The simultaneous emergence of natural history as a structure of knowledge, and what has been described as the momentum towards interior as opposed to maritime exploration, are conditions not only for economic expansion and territorialism but also for the consolidation of bourgeois forms of subjectivity and power.[8] In the first part of this chapter I will examine the conditions, both individual and cultural, in which Dorothy Richardson lived and worked. In the second part I will conduct a detailed examination of her writing.

Dorothy Richardson (b. 1748) recorded where she went and what she saw on her tours in five volumes.[9] Her delineations fall neither into the category of picturesque travel, nor are they Grand Tour literature—she never left England. In their relentless assemblage of historical and economic data they are deeply nationalistic; genres like genealogy, antiquarianism, the aesthetics of picturesque travel, agronomy, county histories, and reportage that seem to be at the same time both discrete discourses and highly generalized categories in eighteenth-century cultural production are brought together in her accounts. I have used the term England but this is perhaps a misleadingly unitary category; Richardson maps areas of the north of England (predominantly) and London and its periphery: these are territories that are regional in the empirical (geographical) sense and also highly differentiated as imaginatively invested topographies. Thus Hack Fall (Pl. 10), represented by Dorothy in August

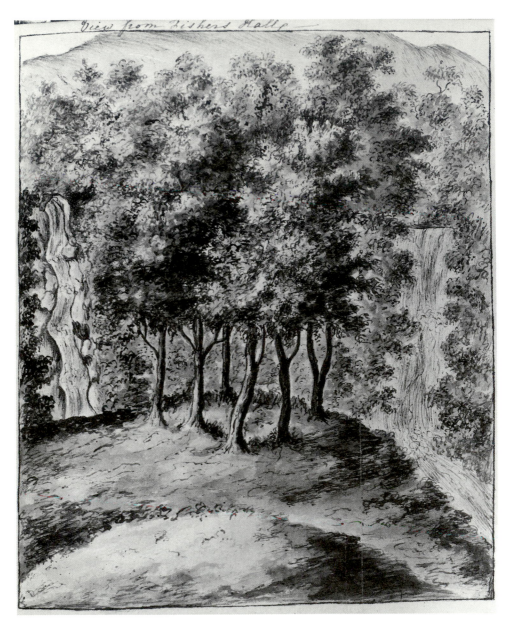

10. Dorothy Richardson, *Hack Fall near Ripon*, pen, ink, and wash, Ryl. Eng. MS 1122 (between fos. 214–15). Reproduced by courtesy of the Director and University Librarian, the John Rylands University Library of Manchester

11. Dorothy Richardson, *Richmond Friary*, watercolour, Ryl. Eng. MS 1125 (between fos. 184–5). Reproduced by courtesy of the Director and University Librarian, the John Rylands University Library of Manchester

1771 with a description and an image,[10] would be one of the views included on Wedgwood's agate-ware service for Empress Catherine of Russia. Images and descriptions at many levels and in many media were producing reservoirs of topographical locations to be marvelled at literally without leaving home. Wonder was not the exclusive property of the alpine passage, the discovery of South Sea islands, or an experience unique to the artist sent to draw the ancient ruins of Palmyra, but could be experienced by a female traveller like Richardson witnessing the awesome organization of labour in the Soho Works in Birmingham or the ancient friary in Richmond, Yorkshire (Pl. 11). Each centre of habitation in Richardson's tour-writing is defined not only by its present appearance but also by its history which demands—and justifies— a narrative of high seriousness rather than sensation. Surveying the life of the place—when the place is England and not the Continent—is a form of quali- tative statistics; this kind of statutory viewing (that which is authorized by the State) is most typically represented in the period by Arthur Young.[11]

Unlike travellers commissioned by the Society of Dilettanti or the Board of Agriculture, Richardson was female. None the less, she lays claim to an edu- cated process of viewing and recording that is characteristically masculine. It has been remarked that while the publication of urban histories flourished in the second half of the eighteenth century and women not only read them but also subscribed to them, the authorship is exclusively male.[12] As an educated woman independent of child-care, Richardson could make use of such publi- cations; her consumption of urban histories transformed into production: when passing through Leeds in 1770 she is able to cite specific historical facts, and visiting Knaresborough in 1801 she merely refers her reader 'to Hargrove's History of the Castle Town and Forest of Knaresborough 4th edition'.[13] Although history was regarded as a suitable subject for women to read, they were not expected to write it.[14]

Women were also positioned in particular ways with regard to the politics and poetics of observation. The change from a commentary of scholarly com- pilation to a commentary of viewing which, according to Chloe Chard, took place between the seventeenth and the eighteenth centuries with regard to foreign tours allowed women the authority of the eye-witness. As Chard establishes (quoting Mary Wollstonecraft's declaration of 1796: 'At supper my host told me bluntly that I was a woman of observation, for I asked him men's questions'),[15] a variety of concepts of masculinity and femininity are employed in order to reinforce the traveller's authority to describe and comment. European travel-writing was characterized by a model of (male) spectator and (feminized) spectacle whether the narrator is male or female. Moreover, territorial metaphors (commonplace, for example, from the

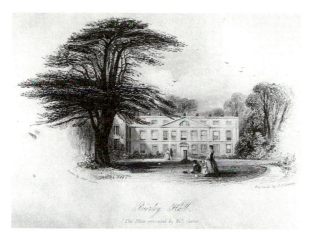

12. J. C. Bentley after
C. Cousen, *Bierley Hall*, from
J. James, *The History and
Topography of Bradford*,
London, 1841. Photo: author

naming of states such as Virginia and Philadelphia, through metaphysical
poetry, colonial travel literature, and imagery of mother countries like Ireland)
which have constituted woman as a terrain to be explored, penetrated, and
possessed render the positionality of the female traveller/writer peculiarly
problematic. My account, however, addresses the topography of England and,
while difference and 'otherness' will be seen to play their part in the produc-
tion of pleasurable experiences, these tours define England as a topography
demanding a serious, masculine approach. While the genre in which
Richardson wrote is commonplace in eighteenth-century English culture, her
claim to knowledge, and particularly to antiquarian knowledge, is not.
Antiquarianism was, like urban history, a masculine practice but, by reason of
parentage, Dorothy Richardson had access to knowledge and expertise which,
while perhaps not so rare for a woman as used to be supposed, are none the
less unusual. In short, therefore, I am concerned with how a woman might lay
claim to a field of knowledge and a set of languages defined as exclusively
masculine in the period in which this woman lived, looked, and recorded.

Dorothy Richardson was born on 3 October 1748 at Bierley Hall just outside
Bradford (Pl. 12). This was the home of her grandfather Richard Richardson
(1663–1741), Oxford- and Leiden-trained doctor, member of the Royal Society
from 1712, eminent antiquarian, and close friend of Hans Sloane, who is said
to have provided the seed from which the cedar tree which was a Bierley
landmark grew after being nurtured in Richardson's greenhouse (said to be
only the second hothouse in England).[16] Dr Richardson's son (1708–81), also
called Richard, died childless after enhancing the already distinguished library
and picture collection and developing the estate.[17] He, perhaps with the help
of his brother William, was responsible not only for the fine chapel built

nearby by William Carr of York in 1766 (consecrated in 1824) but also for remodelling the house and developing the grounds, which were probably completed by 1751. Here, according to one account, he dammed a stream to create a rustic cascade and a series of ponds, he constructed a grotto, and, most interestingly in view of the curiosity about stone circles evinced by Dorothy's tours, he built a druidical circle from enormous stones brought from Wibsey Slack, an area of moorland two or three miles west of Bierley.[18] William and a fourth son, John (who took the name of Currer), were members of the Society of Antiquaries.[19] Richard was an active collector of paintings and engravings, which he acquired from the dealer Van der Gucht between 1747 and 1756, on one occasion buying the dealer a horse in exchange for a companion for his *St John* by Guido (a *Madonna and Child and St Joseph* by 'Morillo' (sic) 'in a style between Titian and Van Dyck and very little inferior to either'), on another occasion buying works attributed to Veronese and Titian and a variety of prints all of which he had sent up to Yorkshire on approval.[20]

Dorothy was the third child of Dr Richardson senior's third surviving son, Henry, who became Rector of Thornton in Craven, and elder of two daughters. She lived her entire life in Yorkshire. Her sister Mary married the Revd William Roundell, who also came of a family with connections with the Society of Antiquaries.[21] Dorothy appears to have spent much time at Bierley since her tours in general commence and conclude there. The Bierley Library was regarded as one of the great eighteenth-century libraries. No correspondence and no personal family papers have, to the best of my knowledge, survived to give an idea of life at Bierley but it is reasonable to infer (given the evident knowledge displayed in her writing) that Dorothy enjoyed the benefits of the Bierley Library. The Richardson family appear to have encouraged their women to educate themselves; the Bierley Library was left to Dorothy's niece Frances Mary Richardson Currer (b. 1785) together with the Currer family library. At Eshton Hall near Skipton, not far from Dorothy's home at Gargrave, Frances Richardson Currer added to these collections, which eventually amounted to 15,000 volumes, filling both drawing room and library. T. F. Dibdin described Eshton Hall's 'amiable and intellectual owner' as 'head of all the female collectors of Europe' and 'as a good scholar'.[22] She never married and is remembered today on account of her library. A catalogue was printed in 1820 but the library continued to grow to the extent that a further catalogue was necessary by 1833.[23]

Only one published work by Richardson survives and that is the memoir of Richard Richardson, MD, her grandfather, compiled in 1815 and published under her own name in J. Nichols's *Illustrations of the Literary History of the*

Eighteenth Century (London, 1817, vol. i). This is signed with the date 23 December and the place at which it was written, Gargrave, which is also the place where Dorothy Richardson died. It is a scholarly and professional piece of discursive genealogy, economical in format and foregrounding accurately transcribed data in a long time-frame which does not mask the overlapping and confused nature of family history, full of false trails and dead ends. It is worth pausing for a moment over this. The only person, apparently, able to write the authoritative account of the distinguished Dr Richardson, Dorothy, his granddaughter, skilfully tackles the problem of her own presence in the text as subject (author) and as object (part of the family being described). She includes herself in the genealogy only by indirect reference. She describes her father having two sons and two daughters and, although she later enumerates the lives of the sons, the only mention of herself is in the form of two quotations, one from the monument erected at the death of her mother in 1800 aged 82 at Gargrave in Craven ('Dorothy, now living unmarried')[24] and one in a footnote quoted from Dr Whitaker's *History of Craven* (first edn.) where the author expresses

grateful remembrance of a lady and friend, whom abundant leisure, and extensive knowledge, have enabled to procure more information, than any other person on the subject of this Work, and whose good wishes for its success have allowed her to withold no efforts which could promote it. This benefactress is Mrs. Dorothy Richardson.[25]

It is thus by default that Dorothy Richardson finds a place in that great compendium of eighteenth-century life and letters compiled by Nichols. But it is also by design. Excluded from the main text except as a quotation, she stages her own memoir through the voice of a third party in a footnote. This might be all that could be said about Dorothy had not a series of accounts of tours undertaken between 1761 and 1801 mainly in the north of England (and a collection of transcriptions from antiquarian publications[26]) survived. Each of the five volumes is indexed and in some cases cross-referenced. I do not take these to contain private utterances by contrast with the fragmentary public statements of the official historian of the family; I shall argue that handwritten though they be, these texts are also concerned with conscious disclosure in a dialogue with the world of public affairs.

 Membership of the Society of Antiquaries was open exclusively to men. As late as 1901 a statute had to be amended to include the phrase 'Ladies are not admitted' after Mrs Evans, an Oxford graduate and archaeologist in her own right, had had the temerity to accompany her elderly husband to a lecture. Papers had been accepted for publication from women since the late eigh-

teenth century, but it was only in 1919, when the Solicitor-General ruled that learned societies which refused to elect qualified women members would be acting in opposition to the will of the House of Commons, that women were admitted.[27]

The means by which antiquarians and natural scientists communicated at this period was primarily the letter. 'We have in Northampton a Society of Gentlemen that are very much addicted to all manner of Natural Knowledge . . . There belongs to it some Gentlemen of the best fortunes of any in Northamptonshire. . . . The Gentlemen of this Society, not content with examining into Nature themselves, are also desirous of having the opinions of the Curious on the subject. They correspond with many eminent Gentlemen in several parts of this kingdom.'[28] This is how William Shipley, founder of the Royal Society of Arts, described one such network in 1747. As a woman, Dorothy Richardson was excluded from such relations. Shipley, apart from undertaking frequent tours into different parts of the country and using the standard method of the antiquarian and naturalist (noting things of interest he encountered), urged in 1782 that parties of young gentlemen should travel about Great Britain and visit places where there were phenomena of natural history, 'important manufactures and trades, well-conducted systems of poor relief', and interesting 'Antiquities' such as 'Abbeys, Roman Roads, Camps and Barrows' or gentlemen's seats with 'capital collections' of paintings and sculpture. The youths should learn drawing 'which will be very useful for them to take perspective views of any Machines, Buildings, or Pieces of Antiquities'.[29] It was this programme that Dorothy Richardson adopted; the categories of interest are precisely those with which she works and the records of her tours are illustrated with occasional depictions designed primarily to elucidate written data (Pl. 13). Shipley's programme is designed for young gentlemen and, in following it, Dorothy traversed a gender boundary. Just how bold an act this was may be estimated by turning to an incident she recorded on 14 March 1775 during a visit to Dr Hunter's Museum in Windmill Street, London on a 'private day'.

Dorothy's method was to take what she refers to as 'Minutes' *in situ*. These notes are then written up at leisure in neat handwriting and backed up with information from published sources where appropriate. As honoured guests—she was in the company of her brother-in-law William Roundell—the party was shown round by the keeper, Dr Coombes. For Dorothy this posed a problem: 'I am unable to give much account of this museum as we were join'd by some of Dr. Coombes learned friends; & I had not the courage to take out my Pocket Book to make Minutes'.[30] A further remark about this famous medical collection (now housed in Glasgow

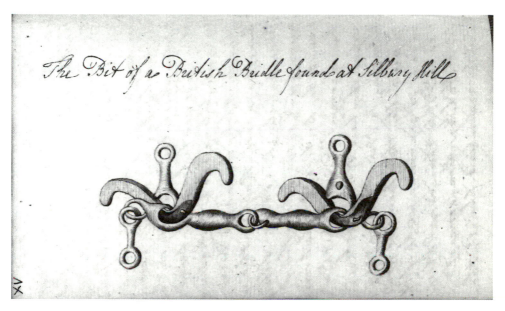

The Bit of a British Bridle found at Silbury Hill

13. Dorothy Richardson, *The Bit of a British Bridle Found at Silbury Hill*, pen, ink, and wash, Ryl. Eng. MS 1123 (between fos. 229–30). Reproduced by courtesy of the Director and University Librarian, the John Rylands University Library of Manchester

University) suggests other boundaries that were culturally constructed across gender lines:

In cases in the Galleries adjoining the walls, but almost all of them closed, except a very few that were not disagreeable are I am told the finest collection of Anatomical preparations in the kingdom, perhaps in the world—but I was happy they were out of sight, indeed I made this enquiry of Dr. Coombe before I ventur'd.[31]

Antiquarian knowledge—dates of invasions and buildings; identification of material objects from earlier times; family history and genealogy—were (unlike anatomy) territory that a curious woman could traverse more freely, provided, that is, no male guide was present to render improper the visible sign of accumulating knowledge—the taking of notes.

Dorothy Richardson's travelling companions were in the main members of her immediate family: parents, uncles and brothers, and brother-in-law. A group, sometimes including wives, set out by chaise but the actual exploration of sites was often undertaken by Dorothy and a single male companion on foot or on horseback.[32] Considerable distances were covered and even the roughest terrain presented small impediment to the pursuit of knowledge:

We laid ourselves down one by one in a shallow boat Tub. I was pushed by a Man over the Water. in one place the rock was so low as almost to touch the Tub; here we were left, while the man went round the Rock, thro a shallower place;—Upon Landing we were astonished with a very grand open [sic] 70 yards over & 20 high, from this we walk'd 60 yards to the Second River, which we cross'd in a Tub standing upright.[33]

The last recorded tour, based in Bridlington, was undertaken in 1801 with only her maid, obliging her to fall back on other women as companions. This proved extremely unsatisfactory in practice ('Parties were every day going to sea in boats, & I often wished to be with them but as I could not prevail upon Mrs. Brisco & Miss Brooke to accompany me, I did not care as I have never been at sea, to intrude into any other party, lest sea-sickness might have made me a troublesome companion'[34]) but, in terms of the written record, it also permitted a textual space in which Dorothy Richardson as author could mark her difference from other women and reaffirm for a putative reader the seriousness of her enterprise. On 28 August 1801 she set off from Bridlington for Flamborough Head in a chaise with Mrs Smyth and Mrs Brown, two 'Hull ladies'. Richardson wanted to go right to the lighthouse as she 'had been told it commands a very noble sea view, & particularly what Gilpin calls a variety of outline'. However, 'to this Mrs. Smythe put an absolute negative saying that the walk was too long for a hot day & that the road was impassable for a carriage'. Later Richardson learned this 'was absolutely false' and, as she put it: 'I believe the real truth was that she was in haste to get back to an afternoon card

party.'[35] The next time she wished to go exploring, Richardson took her maid with her in a gesture which in 1767, when she was 18, and recorded her first serious tour, would have been unthinkable but which by 1801 (when she was 52 and a new world order was being heralded) must have seemed libertarian. This outing proved liberating and led to encounters not only with antiquities but with people of other classes in a degree of proximity that occurs nowhere earlier in her recorded experiences.

The adventure took place on 4 September when Richardson 'set out betwixt 4 & 5 in the morning in a chaise to Scarborough' unaccompanied but for her maid. She was thrilled with Scarborough: 'It was nearly full tide, the sands almost cover'd & the bathing houses conveying company into the sea or returning; here are 96 bathing houses but not near that number employed.'[36] She remarked on the zig-zag walk to the beach, on the 'romantic scenery' and the 'shipping in the bay' which made it, for her, 'the most striking coup d'oeil I ever beheld'. She covers many pages with a detailed history of the town and castle, the fishing economy, the events of the Pilgrimage of Grace, the construction of the church and barracks. The day is very showery and eventually they are driven by rain into an inn where they dine. After dinner they again ventured out, 'and passing through a close dirty part of the town & descending an immense flight of steps we reached the sands at the head of the bay'. Commenting on the difficulty of walking on wet sand even when firm, Richardson remarks, surely with irony considering her own intrepid excursions on foot, 'noone has any business at Scarborough without they possess a carriage'. The sight that provokes this observation is as follows:

We beheld a very gay scene sociables, coaches, chaises, phaetons & gigs, driving along at a great rate, a number on horseback, with a crowd of common people men, women & children who were assembled to see a horse race upon the sands; as I was dressed in a morning gown I mixed with the mob & crossed the sands to the spaw.[37]

There follows a very detailed description of the spa and how it operates, but this is also the location for viewing a race upon the sands and, characteristically, we are given a very precise topography onto which is mapped a description of class:

The area is guarded by a railing with a bench before it, & below it is a walk also faced with a railing & I think benched—Both were filled with company to see the race, Ladies, Gentlemen, Sailors & the mob men women & children all crowded together without any distinction of persons, but before the race began, a most violent shower fell, & the whole posse ran for shelter; we happened to be nearest a long shed on the north west side of the spaw house which is covered with tile open in front & has a bench along the back & ends; upon which we were so lucky as to get seats but here I

remained for an Hour among the mob the smart people being in the spaw house but as they crouded to the front to see the race which was in the heaviest part of the shower I was the less incommoded & a good deal amused with the conversation of two vulgar well-dressed country women who sat next to me, & who from their own account were farmers wives come to Scarborough for an out.[38]

In discussing Dorothy Richardson, I am engaging with a series of writings which are neither confession nor fable but which lie somewhere between autobiography and chronicle, history and inventory.[39] In reading her tours we are engaged in interpretation.[40] As Ricoeur puts it, 'understanding knowledge through signs of another mental life, thus provides the basis in the pair under-standing–interpretation, the latter element supplies the degree of objectifica-tion, in virtue of the fixation and preservation which writing confers on signs'.[41] Dorothy Richardson, however, is a *woman* in 'the world of things in which men move, which physically lies between them'.[42] Felicity Nussbaum suggests that, as women become the subject and object of their own scrutiny, they assume stances often situated in contradiction, in the ideology of gender.[43] The issue of gender demands a series of hermeneutic strategies. In so far as we are concerned with a written narrative of things seen, those strate-gies must take *time* into account for narrative structures produce a dialectic of time (the specificity of human experience compared to the ordinary represen-tation of time as a line linking events).[44] They must also allow for the deploy-ment of rhetorical strategies for the articulation of pleasure. For example, the episode in which Dorothy and her maid shelter from the shower in Scarborough is recounted in terms of series of boundaries: a specific time (one hour), a location that is fenced in, a construction of the social that permits the recognition of difference and hence the experience of pleasure.

Abundant leisure is a female attribute of time whereas knowledge is assigned to masculinity. As Katharine Shevelow has pointed out, the leisured woman became a figure both idealized (because of the class status it implied) and carefully constrained (lest uncontrolled leisure lead women to vice).[45] Dorothy's case demonstrates a refusal of feminine leisure, of the confessional mode fostered by eighteenth-century print culture, and of a life devoted exclu-sively to the traditional occupations of women. In this, she shares a common purpose with other educated women of her century such as Elizabeth Elstob, the Anglo-Saxon scholar, who claimed that the studious woman 'neglects not domestic duties, but "the Theatre and long sittings at Plays, or tedious Dressings, and visiting Days and other Diversions, which steal away more time than are spent at study"'.[46] The works of Mary Astell, Mary Wortley Montagu, Catherine Macaulay, and others were increasingly discussed and the

publication in 1752 of G. Ballard's *Memoirs of Several Ladies of Great Britain* drew attention to women's achievements in the field of learning over a long period of time.[47] Leisure could be put into service to achieve knowledge. So how could this be represented? Periodization devices are heuristic; they are social facts rather than part of the natural order (days, weeks, etc.).[48] As social facts, periodization devices are also gendered. Thus what an eighteenth-century male writer describes (in the only published reference to Richardson located) as 'abundant leisure' is clearly quite other to the female writer who is constructed as possessing it. Moreover, times of the day, days of the week, and seasons of the year may have resonances that are particular to gendered experience. Richardson, for example, separates herself from conventions of femininity in her pleasure at early rising and (arguably) also from conventions of masculinity in her disregard for when, where, and what she eats. But we should none the less be clear here that these are discursive formations rather than factual truth: statements and utterances are subject to laws and dynamics that are social as well as individual. Thus the tours (as texts and as material objects) reproduce time as well as place as a series of controlling devices establishing continuities and hiatuses, sequences and disruptions in which dates, days, and times of day are forms of punctuation. Moreover, just as the epicentre of Richardson's production is provincial (rather than metropolitan), so also in speaking the language of natural philosophy and antiquarianism in an age of sensibility and associationist aesthetics, she constructs for herself a deliberately archaic time-frame. Leisure is not, in this analysis, a uniform and homogeneous entity: it is dispersed, fragmented, and individualized. In approaching tour-writing in this way, I am distinguishing my approach from that of Esther Moir who writes of 'the simplicity and spontaneity of their writings [which] stand in refreshing contrast to much other tourist literature, and when other travellers' tales grow tedious it is good to turn again to these eye-witness accounts of the English countryside which they knew and loved'.[49]

Richardson's tours record what she sees, or claims to see, and what she knows from having either read it or been told it by another person. Vision is also a gendered activity (as we have remarked in the case of the Hunterian collection) and what is written is the result of an evidently self-conscious sequence of actions: noting, recollecting, recording, correcting, indexing. I have chosen not to measure what is recorded against what remains of the things she saw (there are no comparative photographs in this chapter) because this would be to suggest two static moments—a then and a now—across which some bridge could be built. As I indicated in opening, such links are symbolic—they operate at the level of trace and myth, not at the level of

material. There is, however, no doubt as to the historical importance of ten separate recorded tours, bursting with closely observed and recorded data.[50]

The analysis of eighteenth-century travel has been, to date, sporadic and rather unsatisfactory.[51] Among art historians, there is a recognition that artists like Dayes or Turner were participatory in a wider interest in travel, the concern of Jane Austen and other novelists of the period with picturesque travel and the acquisition of taste is explored, and illustrated tours such as Celia Fiennes's are reproduced as coffee-table books. Fiennes at the turn of the seventeenth and eighteenth centuries, Defoe, the Torrington diaries, Arthur Young, and Cobbett's *Rural Rides* are extensively drawn on by historians but the genre of touring as such has received relatively little attention.[52] One of the few publications on eighteenth-century travel that adopts a critical and historical position rather than merely describing or surveying is Carole Fabricant's essay of 1987 which draws on Raymond Williams and Dean MacCannell.[53] While much of what she says, with regard to the examples cited, is convincing, Fabricant places in one category travel books, tour guides, estate poems, and other discursive texts of place which fulfil very different functions and work within different sets of conventions. She constructs a relationship of viewer to viewed in terms of class, privacy, and ownership in which tourists are understood to be victims of class conspiracy, and in which tourist literature is part of an economy of competition and display. I agree that ownership of land and buildings provides a hierarchical and geographical narrative structure for tour writers but they, as ambulant scrutinizers, also engage in interactive imaginative dialogue with their objects of vision. They are not defined as passive objects by what they see but are empowered as writing subjects. And these objects of vision—seen in the arbitrary sequence of a journey (palace followed by hovel)—can disrupt class hegemony by their very propensity to invoke chaos. The accidental can disrupt the best-laid itinerary and sight is not altogether to be controlled by a previously agreed programme for education and knowledge.

As an example of such meaningful disruption, we might turn to an episode in Richardson's well-planned London itinerary in 1785. Visiting Mr Edward's in Pall Mall where they examined a Persian manuscript, she and her companion were 'detain'd by Mr. Fox passing by in procession to take up his seat for Westminster; his carriage was drawn by the Populace & he was attended by numerous croud but chiefly of the lowest order of citizens; his friends the Butcher's distinguished themselves, with their Marrow bones & Cleavers'.[54] Equally the viewing tourist could construct—at one glance, as it seems, as in this description of Harrow—the very structure of society, encompassing it in a sentence: 'The common Houses are some of them Brick; but in general,

wood and Plaster. Sir John Rushout has a large, old seat, of Wood and Plaster, which stands near the Church with Pleasure Ground down the side of the hill—and Mr. Hearne an elegant new Stucco House at the other end of the Town—near which are the Butts, where the silver arrow is shot for by the young Gentlemen every year, the first Thursday in July'.[55]

Writing empowers; the discipline of seeing, organizing, and composing is a way of laying claim to knowledge and of inserting the individual self into history. Travellers had been advised in manuals how to organize their findings from the late seventeenth century in works like W. Davison's 'Most Notable and Excellent Instructions for Travellers' which Richardson may have known, though the better-known *An Essay to Direct and Extend the Inquiries of Patriotic Travellers*, published in 1789, would have come too late for her.[56] Class is an issue both for Richardson and for us reading Richardson but it is not, as Fabricant suggests, a question of the tour reinforcing the distance between the powerful landowner and the curious fleetingly engaged visitor. The very mobility of the traveller—and especially of the woman traveller—puts class into flux: inns with shared bedrooms; hotels and their rituals; watering places; labour and its regional differences; transport and its practicalities; the acquisition of basic necessary information; all serve to confuse class boundaries if, indeed, they ever existed in actuality as strictly as Jane Austen would have us believe. Hazlitt certainly recognized the capacity of travel to blur or erase the distinctions of class, stating in his essay 'On Going a Journey': 'the *incognito* of an inn is one of its striking privileges—"lord of one's self, unencumbered with a name", oh ! it is great to shake off the trammels of the world and of public opinion—to lose our importunate, tormenting, everlasting personal identity in the elements of nature . . . to be known by no other title than *Gentleman in the Parlour!*'[57] It is this very class confusion which Smollett and Fielding turn to good account in their 'progress' novels, where class misrecognition is often a turning point in a plot. The titled are certainly listed by Dorothy when she encounters them (at Buxton in 1767 the Duchess of Portland heads the list of seventy-six guests from as far away as Ireland, Petersfield, and Gloucester[58]) but so are old women living in smelly huts ('There are about half a dozen poor looking Houses at Sunderland for the accommodation of sailors, & one we enter'd was so dirty that we were glad to drink tea upon a bench at the Door').[59] Moreover, both are listed as part of an economy that includes other 'objects': fossils, unusual land formations, Anglo-Saxon remains, new buildings.

John Byng, author of the Torrington diaries, Dr Pococke, Arthur Young, or Celia Fiennes are the most obvious points of comparison for Dorothy Richardson. Like them, she benefited from improved roads, the publication of

gazetteers, and updated editions of Ogilby's road books. But her writing resembles that of none. Unlike Fiennes, Richardson is not a pioneer traveller covering uncharted territories. She is an observer in a tradition of natural history that aspired to extend common understanding to a vast range of phenomena, both natural and 'man-made', travelling in a relatively narrow region, often in a group, and concerned with testing out received knowledge against the evidence of her eyes as well as hypothesizing on the basis of accumulated evidence. Richardson differs from Fiennes also in her avoidance of personal anecdote and in her scholarly invocation of published writings. Unlike Fiennes and unlike Defoe, who stated, 'matters of antiquity are not my inquiry; but principally observations on the present state of things',[60] Richardson was as interested in antiquity as she was in contemporary Britain.[61] Unlike Young, her main concern was not with agriculture, and her writing is self-conscious to a degree rarely found in Young, whose reputation depended upon his farming origins. John Byng visited Derbyshire but most of his tours were undertaken in the southern counties, while Richardson travelled mainly in northern England. Country houses were one of many interests of Dorothy Richardson and she corrected guidebooks rather than marvelling at contents.[62] Moreover, while all forms of industry attracted meticulous attention from Richardson, for Byng they were often a cause of irritation in their 'rattlings and twistings'.[63] The period of Pococke's travels is roughly the same as Dorothy's but he lacks her passion for antiquarian sites, confining himself to odd inscriptions and minor observations.[64] In coverage and in tone, as well as in its inclusion of lavish visual material, Dorothy may well have taken as an example Spencer's *The Complete English Traveller,* which covers Yorkshire and Derbyshire, though this publication does not match her own writings for detailed attention to particularities.[65]

An unmarried woman with a high degree of education, and ample leisure, Richardson's project is characterized by a seriousness of intent and a profound respect for knowledge. Her corrections and cross-referencing suggest a passion for accuracy and indicate that she had engaged with 'thorny researches' which women were recommended to avoid for fear they blunt their wit. Women were exhorted to eschew 'entering into any of those minutiae . . . which make their study dry to themselves, or occasion its becoming tiresome to others'.[66] Byng's anecdotes and confessional digressions would have been anathema to Richardson, who states, 'I rarely record private anecdotes',[67] and in whose tours conversation, recorded speech, and accounts of dinners consumed or the vicissitudes of travel are almost wholly absent. While none of her tours constitutes a survey in the sense that Aubrey or Stukeley would have understood, her seriousness of intent and her concern with learning and tax-

onomy set her apart from the generality of tourism.[68] Sharing a classificatory language permitted, it has been argued, artisans and their social superiors to exchange scientific information without class getting in the way.[69] Antiquarian language did not provide Dorothy with an entrée into the networks of the Society of Antiquaries but it may, for her, have had the attraction of an apparent neutrality of gender.

Artisans and gentlemen wrote to each other in the nineteenth century on topics concerning natural history. Dorothy Richardson, however, appears to have been writing for herself. For whom was she writing? Whom was she addressing? It should be borne in mind that virtually all of the substantial number of published travel accounts written by women appeared after 1800 and the numerous unpublished travel journals that lie, often unread, in county record offices are (as I have indicated) neither as extensive nor as detailed as Richardson's, tending rather to consist of brief, one-off, picturesque tours.[70] Richardson's volumes are inscribed in the front cover with her own name and with that of Eleanor Roundell, daughter of Dorothy's sister Mary and her husband William, who was often Dorothy's travelling companion. It seems likely that the tours were privately circulated to friends and family—a riposte to the practices of the Society of Antiquaries from which she was excluded. The fact that they have survived, and in excellent condition, suggests the extent to which they were valued. Historian of her family and author of an official genealogy which gives her, the author, *no* life history, her tours stand as testimony to a cultivated stance in which mobile reportage, and the textual registering of accumulated knowledges (over hundreds of years), vigorously assert this woman's right to a place in 'matters of the world'. Antiquarian time—the *longue durée* of chronicle and genealogy—is appropriated in Dorothy's texts and integrated into a self-consciously ordered articulation of present time; through this appropriation that episodic time which is domestic and culturally defined as feminine is evacuated from the text. Dorothy's accounts commence when she leaves home and conclude when she returns. Feminine space, and time, is thus narratively negated. In this sense the tours are epic and heroic—voyages of discovery in which existing knowledges are tested and new knowledges acquired. They do not, therefore, share what have been described as the characteristics of travelogues.[71] In her concern with knowledge, Dorothy engages in a recognizably modern process involving the transformation of time and space. Genealogies which represent time through graphic spatial schemata are mapped onto geographies that are contemporary but none the less structured in a dialogue with past spatial dispositions. Whether we take Foucault's total institutions, Giddens's concern with time–space separation of different sectors of social life (the journey to school or to work), or Weber's arguments about the importance of double-entry bookkeeping for the development of rational

capitalism, the control of time is a characteristic of entry into the modern world.[72] Richardson's travels are less haphazard than those of Fiennes or Byng, her texts establish scrupulous records of time and place, and her reasoning is inductive.

Dorothy Richardson began the habit of writing up tours at an early age. The first volume in the series opens: '26 March 1761 <?> I went along with Miss Fenton of Bank Top near Barnsley to see Wentworth House, the seat of the Marquis of Rockingham.' The following day in the same company she visited Wentworth Castle, 'the seat of the Earl of Strafford'. She records paintings hanging in the gallery, livestock and exotic plants in the grounds, the architectural features (the house 'has fifteen windows & is three stories high; but being built in the French taste is too much ornamented to look handsome'), and the situation ('the house stands almost upon the top of a very high hill, commanding an extensive view down a Rich valley; which is terminated by Wombell Woods on one side & the village and church of Worpsborough make a Picturesque appearance & opposite to that is a Ruin Ld. Strafford built upon Barnsley Common').[73] Later the same year she records a tour from Crofton on 24 July 1761 'with Mrs. Traviss etc. to see Nostal the seat of Mr. Rowland Winn'. The discipline of writing, using the correct vocabulary (prospect, elevation) and accurate unembroidered statements of fact about ownership, suggests the 12-year-old Dorothy practising a deliberately taught and acquired art of writing in the genre. She demonstrates a precocious aptitude for matters of antiquarianism and architectural history, remarking that the monastery of St Oswald formerly stood at Nostell (the modern spelling) and that she therefore imagines 'a large Gothic window, in the Old House (which is still standing below the new one) is some remains of it'. Only very occasionally is the taxonomic ordering interrupted with the sense of a moment of personal identification as when, having listed all the hangings, paintings, and wallpapers, she comes to the nursery at Nostell and remarks: 'there is a chest of drawers, a trunk full of very nice Child cloaths & a Nurse & child standing—There are Brass Locks to all the Doors.'[74]

What we might term the fully developed tours commence in August 1767, using the same volume used for the visits to Wentworth and Nostell. From now on it is periods away from home lasting several weeks that are recorded, primarily in solitary mode.[75] Always accompanied by at least one other person, Dorothy none the less hardly ever refers to her companions after the initial statement of the mode of travel, destination, and company. An independent space is constructed in these texts which privileges individual sight; the dialogue recorded is that which takes place first between the viewer and

the objects viewed and secondly between the viewer and the authorities she has read. The objects viewed may be listed non-hierarchically in the manner of an inventory, the order being the order in which they were seen as the body moves along a course preordained by architectural design and the organization of space. Dorothy Richardson's preference for using the dash (—) strengthens the sense of a concatenation of apparently disconnected facts. Here, for example, she is in Benjamin West's studio in Newman Street in 1785:

[We] were conducted down a long Gallery furnish'd with drawings into a large square Room lighted from the Roof & fill'd with paintings. Over the Chimney two very fine figures which the Servant call'd Harriet & Joseph—The Transfiguration with Isaiah on one side and Jeremiah on the other—[list of paintings] . . . The Door into an inner Room being left a little open, Mr. Webber who was with Mr. West heard our voices, came to us, & introduced us into Mr. West's Painting Room. Here we saw a very large Landscape with a view of Windsor Forest in the Foreground a Hut & a wood cutters Family with Pigs &c . . . Mr. West was painting a very large Picture for the King's Chapel there, the subject St. Peter preaching, the audience large; a harsh featur'd Man was sat by the fire almost smother'd with woollen drapery from whom Mr. West was painting one of the figures. Mr. West has lost the bricky hue he gave his pictures some years ago; the colouring is now rich & the drawing delightfull. This Room is also lighted from the top.[76]

We might notice the authoritative view of West's development as an artist and the understated way in which the servant's error is recorded; by these means the writer's superior knowledge is underscored. The framework for these items is, however, that of the ordered inventory such as Dorothy began with when listing paintings at Wentworth House and Nostell Priory in 1761. When it seems necessary to add information procured from a source other than her own observation and knowledge it comes in anonymous form: 'I was told there is a very fine Family Picture of Sr Thos More & his Children in the House by Hans Holbeins [sic], but we did not see it' (Nostell, 1761). Sources of supplemental information of this kind are usually nameless in Dorothy's text, maintaining the secure boundaries of her own authority. When she has recourse to antiquarian publications, they are usually cited following her own observations, not as a prelude and legitimization for them: a description of Castleton in 1767 is followed by the remark that Camden says 'near this place elephants bones had been dug up';[77] at Fountains Abbey in 1771 Camden and Dugdale are mentioned as 'the best account I can meet with of the Foundation of this Monastery'—a remark that constitutes a claim to a degree of discernment in the literature on monastic foundations;[78] in later volumes she is increasingly critical of even recently published antiquarian literature, stating, of Bolton Abbey in 1779,

the Antiquarians I take my account from are Dugdale, Buston, Grose &c but they differ so much in their accounts of the Romeli, Meschines, FitzDuncan, & Le Gross Families that I know not what to make of them; I leave it to better Antiquarians to reconcile them if they can, for I cannot.[79] The building of Skipton Castle & foundation of Bolton Abbey is a direct contradiction—& as I cannot know the truth of any, I give the different accounts. Some of the possessions of Bolton Abbey I have from Deeds, which must be authentic, & I am sure Cecilia de Rumeli gave Hildwick to Emesey as I have seen the Deed.[80]

By comparison, Pococke, for example, merely states of this monument which he visited in 1750, 'we went to see the remains of the old abbey which was first founded at Emesy, by William Meschines and Cecilia his wife in 1120 and removed to this place by Alicia Rumelee their daughter in 1151'.[81] Dorothy evidently had access not only to the Bierley library but also to muniments. She must have been able to read Latin and also have possessed palaeographer's skills.[82] She was thus able following a tour to add notes to her account based on subsequent reading. The status of these additions to the text is always made clear.[83] The second half of the eighteenth century has been identified as a period marked by the decline of serious fieldwork and the advent of dilettantism in antiquarian studies.[84] Richardson's antiquarian accounts are not frivolous; nor are they pedantic and cumbersome, laden with genealogical detail and Latin footnotes as were many of the antiquarian county histories of the day.

The only 'voices' apart from her own that enter the text are those of particular and superior authorities. Meeting John Webber, an artist who had accompanied Captain Cook's last voyage, Dorothy reports: 'He told me that he was an unfortunate spectator of Capt. Cook's untimely end, for happening to be upon the deck & seeing a bustle on shore he caught up a Telescope & saw the death stroke given: he spoke of the affair with great emotion but would not say what caus'd the quarrel with the Natives, nor I am told will any of the officers talk of it.'[85] Dorothy's position as a third-generation member of a family of antiquarians is apparent from her discriminating remarks about British Museum keepers: 'We were shewn it by Mr. Planta one of the keepers; but he was either very ignorant, or extremely inattentive for he would scarce answer a question we asked him; & hurried us thro' the rooms as fast as possible—I greatly regretted the Death of Dr. Solander, from whom I had met with the utmost attention & who seemed to have particular pleasure in communicating a knowledge to those who shew the least curiosity.'[86]

The lament for what may not be seen is rare—the only complaint about access is in relation to the royal collection ('We went . . . to see the Queen's Palace after making great interest & being several times disappointed; it being

strictly commanded not to be shewn; there is no way of getting into it, but by the under servant & as I was not allow'd to take any minutes, my account will be very imperfect'[87]). Perfection of particularized data—a virtual reification of what is seen—is what the text aspires to. Consequently the kinds of generalizations commonplace in Byng or Cobbett are rarely found. Identifying regional difference near St Albans in 1770, she risks the comment that 'in this part of the country they burn faggots & have Dogs instead of Gates'[88] and in 1775 she dismisses the area around Newark as 'a dull country'.[89] By and large however (as we shall shortly see) the economy of an area assessed through the heterogeneity of its appearance is atomized in the same way as a collection in a museum.

The structure of telling is normally either in the form of an impersonal narration ('The warehouse made a very beautiful appearance'; 'people were . . .') or a generalized collective ('We staid all night at Lovetts the new Bath in Matlock'),[90] through which authorial control is exerted through distance. Thus on the rare occasion that a first person pronoun enters the text, it is striking. Sometimes for example 'I' is used to remind the reader that there is, indeed, an authorial presence, and to distance that presence from the generality of (uneducated) human beings ('Having now finished all I can recollect as to the Buildings [of London] &c I must not omit the shews strangers are generally carried to').[91] Perhaps the most amusing instance of this strategy occurs in the final tour of 1801 when Dorothy and her maid rented lodgings (belonging to an absent sea captain and his wife and described in great detail) on Bridlington Quay (Pl. 14). Overall there is considerably more latitude in this final volume; scholarly precision remains but pleasure in her own independence is more evident. Dorothy is entranced by the moonlight on the sea[92] and on 27 August she and her maid 'were upon the Pier by half an hour after four in the morning to see the Sun rise from the sea'. Not normally given to superlatives, Dorothy concludes: 'tho' this was the most splendid scene I ever witnessed & tho' I returned home enraptured with it, Mrs Brisco & Miss Brooke never could be prevailed upon to leave their Beds to witness it.'[93]

Equally interesting are the occasions when the first person appears in the text as a mark of a moment of special pleasure related to acquisition of a precious object—a fragment of the material world that has been classified and described is now possessed, in the hand. Visiting the lead mines near Matlock in 1767, she writes: 'The sides & top of the mine, made a most Glittring appearance by Candle Light; being lead ore spar & congeal'd water; I took a Pick-ax, I help'd myself to some ore.'[94] At Heysham in 1775, a similar moment occurs, related to discovery and ownership—the pleasure of the collector: 'I

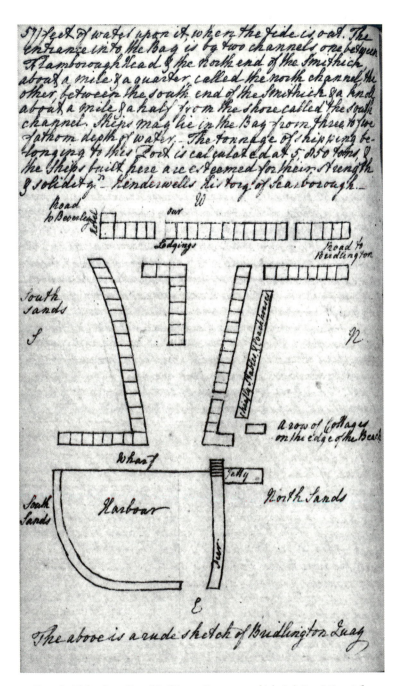

57 feet of water upon it when the tide is out. The entrance into the Bay is by two channels one between Flamborough Head & the north end of the Smithick about a mile & a quarter, called the north channel, the other, between the south end of the Smithick & a knoll about a mile & a half from the shore called the south channel. Ships may lie in the Bay from three to five fathom depth of water. — The tonnage of shipping belonging to this Port is calculated at 5,050 tons, & the Ships built here are esteemed for their strength & solidity." Hinderwells History of Scarborough. —

Road to Beverley

out

W

Lodgings

Road to Bridlington

South Sands

S

N

Theatre, Markets, & Courthouse

A row of Cottages on the edge of the Beach

Wharf

Harbour

Jetty

Pier

South Sands

North Sands

E

The above is a rude sketch of Bridlington Quay

14. Dorothy Richardson, *Plan of Bridlington Quay*, pen and ink, Ryl. Eng. MS 1126, fo. 59. Reproduced by courtesy of the Director and University Librarian, the John Rylands University Library of Manchester

picked up a few shells, tho' none of any beauty, and gather'd variety of sea weeds, which having steep'd in fresh water changing it often, I dried between pieces of flannels, opening ev'ry branch with the point of a needle.'[95] In such passages as these, we have exemplified the role of curiosity as a source of pleasure; the kinds of striking singularity that explorers and Grand Tourists sought are here located small-scale and in such form as might be seized and possessed, perhaps examined through a microscope, as well as explained in a pleasurable narrative of sensations.

The Mrs Briscos and Miss Brookes are generic types, women unlike Dorothy Richardson, women who want to play cards, socialize, have tea, or just stay in bed at 4 a.m. Gender is constituted in Dorothy's text by the recording of incidents such as the sunrise at Bridlington. Gender and class distinctions implicitly underpin her account and, from time to time, emerge as explicit within a narrative. For example, in 1775 she joins a party to visit Sunderland travelling 'in two Turf carts which are the usual vehicle for the ladies: & that I was in was driven by a woman, who entertained us with stories of Ghosts, but apprised us that none had ever power to appear upon the sands'.[96] The word 'usual' leaves open the possibility that she, Dorothy Richardson, might not do what is usual for the ladies; these ladies are distinct from women who are labourers and drive carts but they, like Dorothy, have a voice and can recount stories even if those stories are fiction and do not have the status of history. When she encounters female accomplishment (dining in Hayes, she admires feather-work that she takes at first to be painting[97]), and when she encounters female eccentricity, they are recorded. In the latter instance, it is again a case of the female subject (this time a lady and not a woman) behaving in an independent manner:

Lady Norton's economy is a fund of amusement to the neighbourhood, among many stories told of her one I cannot omit, as I am assur'd of the truth of it—when she is in the country, she usually goes to Ripon Market in her Coach & six late in the afternoon to buy the refuse of the Butcher's meat cheap & as they kill their own mutton, she takes the Tallow & skins, these my Uncle Dr. Richardson has frequently seen taken out of the coach; after parting with her greasy companion, she fills the coach with the market Basket, pots, mops, Brooms, & what ever is likely to be wanted in the House for the ensuing week.[98]

Dorothy Richardson sometimes travelled on her own with a single male companion—uncle, brother, or brother-in-law. Despite her confession of reluctance to take minutes before the learned male company at Dr Hunter's museum, she seems to have been tolerated if not accepted as an equal among the educated male élite with whom she mixed. One example will suffice. Arriving in Oxford in early May 1770 in the company of her uncle John

Richardson (whom she later described as a solicitor living in Lincoln's Inn with a taste for topography and heraldry and owner of a voluminous collection of pedigrees[99]) Dorothy dined with the Principal of Brasenose College (albeit in his lodgings rather than at high table) and was later conducted by him to see the chapel and the library.[100]

The early tours contain a number of predictable set-piece picturesque descriptions revealing a familiarity with an ekphrastic tradition and with the aesthetics of the picturesque. The later tours, however, suggest a greater concern with the specific conditions of landscape; descriptions are formulated with geological and botanical precision in order to convey the precise nature of the terrain. Thus in 1779, touring Niddersdale on horseback with her brother-in-law and passing through the village of Wath, she 'met with a Landscape worthy the pencil of Poussin, a large group of thatched cottages with a stately picturesque & steep hanging wood rising immediately behind them, & beyond taking a bold projection into the valley with scatter'd cotts at its very summit'.[101] A little later, however, they descended the south side of the hill and, putting their horses in a barn near a little stone bridge which crosses Houstean Gill, proceeded on foot along a 'rocky water course from 20 to 30 yards deep':

We explored it as well as we were able, but being entirely hung with wood (chiefly elm) we could only here & there get a transient view, & that with difficulty; the sides of the Gill are form'd by mossy rocks, intermixed with shrubs, the water tumbled down its rocky channel, but it being a very dry season the stream was trifling; in a flood it must be tremendous—many parts of the Gill are so narrow that a Man might leap over it—we scrambled upon a ledge of rocks on the northern brink of the Gill, intending to reach a cavern call'd Tom Taylor's Hall, but were intercepted by a fall of water, turn'd from ditches down the rock, which was impossible to pass.[102]

By comparison with writing on picturesque landscape from the 1760s and 1770s, this is remarkably direct and unadorned. One might, for example, compare it with Thomas Gray's description of Grasmere of 1769 with its relatively elaborate tropes: the eminences that 'vary the figure of the little lake they command', 'meadows green as emerald', 'steep smooth lawn embosom'd in old woods', the whole being described as a 'little unsuspected paradise . . . [where] all is peace, rusticity, & happy poverty in its neatest most becoming attire'.[103] The moral tone of much published picturesque writing is absent in Dorothy Richardson's tours: there are no appeals to Nature's great purpose. Moreover, while pleasure (her own pleasure) is clearly a part of the project, it is pleasure in viewing, assessing, and writing. The notion of aesthetic pleasure as a guiding principle which informs so much of Gilpin's and Price's writing plays no part.

Fashionable absurdities attract Dorothy's opprobrium and her sardonic but acute criticisms of the excesses of landscape gardening and extravagant fanciful building (with new industrial money) strike an Austenesque note. There is pleasure in writing about what (she claims) is unpleasant to look upon. Mr Yorke's house near the village of Bewerley, seen the same day as the attempt on Tom Taylor's cavern, is described with devastating precision:

Mr. Yorke's house is close to the road, on the right hand side; the front towards it, has a door at the side of the center part & two strange kind of Gothic windows; at each end a round Tower, with three windows, battlements upon the top, & each terminated by a trifling lead spire . . . the front towards the east has two square top'd Venetian windows one over another glaz'd in the Gothic taste, & so near each other that I conclude the upper window goes to the floor . . . No praise can be given to the architecture of this house, variety it certainly can boast of, in a greater degree than I ever saw before in a place of that size. This Front stands upon a small lawn bounded by a shrubbery, it commands a view of the side of a beautiful wooded Hill crown'd with cliffs, & upon its very summit Mr. Yorke has built an object in the true sense of the word which I was told cost him 300, one of the buildings is strikingly like a gallows; below is a sketch of them. [The sketch is annotated 'Light and shade cannot with propriety be thrown upon a streight line of walling, therefore I have attempted none'; Pl. 15].[104]

Here Dorothy constructs a language of precision and criticism—the gloss to her drawing proclaims a commitment to a high degree of accuracy—which empowers her and endows her with command over the viewed estates of foolish men. Contemptuous of ignorance, she is openly impatient of men with money and no knowledge. Mr Aislabie, owner of Fountains Abbey in 1771, intending to beautify the site 'has greatly defac'd it . . . it was formerly almost coverd with Joy and Shrubs; these venerable relics of Time are now all cut down; & where the stones were moulder'd new ones are put in, so that this Grand Ruin which equals if not exceeds any in the kingdom, is now a piece of Patchworks.' Richardson finds further evidence of insensitive and ignorant restoration as she enters the choir 'in the middle of which Mr. Aislabie has set the Trunk of a Woman, which he calls Anne Bullen upon a square Roman Mosaic Pavement of different colour'd Tiles raisd upon two half paces; where everything else is in Ruins, this has a very bad effect, & seems to have no connection with the place; here it is said was the sanctum sanctorum'.[105]

The knowledgeable tourist was not confined to evoking scenery and describing the distasteful 'improvements' of landowners. With her brother-in-law and Heneage Ilsley, Dorothy explored an ancient camp on Thornborough Moor on 5 June 1779 (Pl. 16). She describes it in detail, attempts to identify it, then compares her own observations with the conclusions of the celebrated antiquaries:

106) Venetian, but have round tops; no praise can
be given to the architecture of this house, variety it
certainly can boast of, in a greater degree than I
ever saw before, in a place of that size. This front
stands upon a small Lawn bounded by a shrubbery,
it commands a view of the side of a beautiful wooded
Hill crown'd with Cliffs, & upon its very summit Mr
Yorke has built an object in the true sense of the word
which I was told cost him 500, one of the buildings is
strikingly like a Gallows; below is a sketch of them

Light & shade cannot with propriety be thrown upon
a straight line of walling, therefore I have attempted
none. — The wooded Hill ascending towards Gra-
vington which I mention'd having seen from the
opposite side of the Valley, has here a pretty effect.
For a considerable way we had a wood to the
left which descends to the River; to the right,
enclosures with hanging woods & cliffs beyond
them. — The opposite side of the Valley from
Pateley to Brimham is call'd Wilsell, there is a
Village & a few scatter'd Houses but not much
wood: Brimham Rocks with their descending
woods, have a fine effect from this side of the
Valley, two Hills from thence push into it, with
beauteous detach'd woods, & upon the summit of
the lower stands the village of Braisty. Our road
lay alternately thro' fields & woods, the river

15. Dorothy Richardson, *Mr Yorke's Folly at Bewerley*, pen, ink, and wash, Ryl. Eng. MS 1125,
fo. 106. Reproduced by courtesy of the Director and University Librarian, the John Rylands
University Library of Manchester

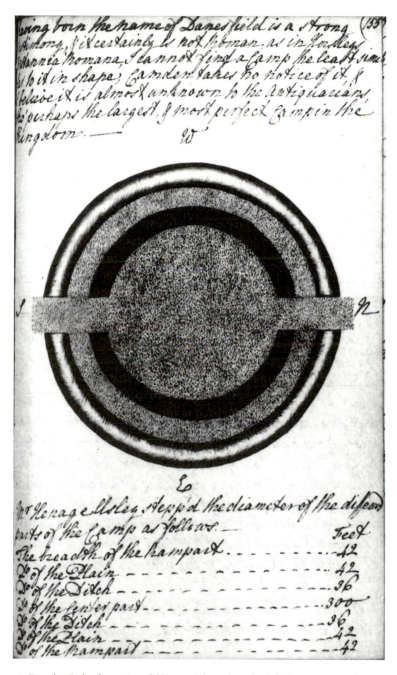

ering bore the name of Danesfield is a strong (155)

Camp, & it certainly is not Roman, as in Yorkley Prannea Romana, I cannot find a Camp the least similar to it in shape; Camden takes no notice of it, & believe it is almost unknown to the Antiquarians, & perhaps the largest, & most perfect Camp in the Kingdom. ——

Mr Henage Illsley stepp'd the diameter of the different parts of the Camp as follows. ——

	Feet
The breadth of the Rampart	42
Do of the Plain	42
Do of the Ditch	36
Do of the Center part	300
Do of the Ditch	36
Do of the Plain	42
Do of the Rampart	42

16. Dorothy Richardson, *Danesfield,* pen, ink, and wash, Ryl. Eng. MS 1125, fo. 155. Reproduced by courtesy of the Director and University Librarian, the John Rylands University Library of Manchester

The Camp is at the west end of the common in a flat situation & it is of great extent, the Ramparts very high & quite perfect on the eastside; the west side is broken; the Plain (which is the 2nd circle) the deep ditch (which is the 3rd circle) & the plain in the middle are quite entire, in this last there is no elevation in the Center for the General's Tent. That the camp is Danish, I think there can be no doubt, the neighbouring village of Fairfield having born the name of Danesfield is a strong testimony, & it certainly is not Roman as in Horsley's Britannia Romana, I cannot find a Camp the least similar to it in shape, Camden takes no notice of it, & I believe it is almost unknown to the Antiquarians tho' perhaps the largest, & most perfect camp in the kingdom.[106]

This enthusiasm contrasts markedly with William Gilpin's comment when passing in 1770 the magnificent stone circle of Avebury in Wiltshire that 'we could not but admire the industry, and sagacity, of those antiquarians who can trace a regular plan in such a mass of confusion'.[107]

If a passage such as this shows Dorothy Richardson concerned with a past remote in time, other sections of the tours reveal an equally critical and methodical engagement with a specific moment and set of conditions in her present. We tend to think of women of good education in the second half of the eighteenth century participating in highly structured social rituals, and if awareness of the industrial revolution impinges upon those rituals it is through the woman's role as landowner, employer (or wife to an employer), or disburser of charity. The highly structured social rituals of her own class—and the division of labour in manufacturing industries—are, however, atomized by Dorothy in a series of passages that are valuable not only for the information they provide but also as examples of the assured sociological procedures of writing that a woman (given adequate means and freedom from wifely and maternal obligations) could adopt in this period. Among the notable passages in Richardson's tours is a visit in 1771 to Harrogate which, she says, is 'frequented by so great a concourse of company' and 'consists chiefly of Inns, standing upon a very wild common'. She first describes the comparative reputations of the Salutation and Granby's Head ('the former has a neat Long Room & is a Genteel House; the Latter has lately been built by Mr. Collins of Knaresbro' & has scarce established its reputation') and then proceeds to the Green Dragon and the World's End. The former has the worst Long Room but is frequented by the most genteel company on account of the 'Elegant Accomodations' while the World's End has 'a very elegant Long Room fitted up with Ornamental Stuco & a handsome staircase up to it: But the House is now quite out of Repute, owing to their having so few Bed Chambers.'[108]

These comments suggest the changing priorities in so far as private bedchambers are rated more important than good public rooms. The Richardson party stayed at the Green Dragon, and as well as listing all her fellow guests

Dorothy atomized with the scrupulous and self-consciously distanced eye of an early ethnographer the social rituals of this Harrogate inn:

The Company generally rise early, upon account of going to the Wells, & Breakfast in the Long Room in different Parties from eight to eleven, each finding their own Tea & Sugar—From Breakfast to Dinner they work, Ride, or Walk out; In general they take their Places at Dinner as they come & each Family have their own Wine with their name upon the Bottles & if any is left, the waiter takes care of it for the next time— The Ladies seldom Dress till after Dinner & particularly of a Ball Day; & they wear Hats in a morning. All the Ladies treat the Company with Tea & Coffee in an after-noon in their turns; & cards of Invitation with the Ladys name who gives Tea, are thrown upon the Tables after Dinner,—From tea to Supper they walk about, or Play at Cards: on a Common Night the Ladies retire out of the Dining Room into the Great Room soon after supper, & the Gentlemen following, they walk about or play at cards till Bed time. There are Public Balls twice a week on Mondays & Fridays; when the Green Dragon, the Salutation, the Granby & the Queens Head, take it in their turns; there is only about one Ball in a season at the Worlds End; Printed Cards of Invitation are sent to all the Houses & the chief part of the Company generally meet, they never begin till after Supper—Private Balls are sometimes made for the Ladies at their own Houses, the night before they leave the place, but then no Minuets are Danc'd. The Ordinary at the Dragon is Half a Crown a Day, each finding their own Tea & Sugar, & paying for all the Liquor. The Servants pay a shilling a Day & have a Pint of Ale allow'd. The Vails to the Servants at coming away are about Two Guineas but some give more and some less.[109]

The ability to identify the significant features that structure an economy and to record them from a position constructed as outside of that economy (prices agreed, avoidance of competition between establishments, rituals like tea-parties and walking which require the employment of printers and the personnel that service clothing and appearance) that Dorothy displays here is also applied in the inspection of other economies. Here, for example, is Dorothy's delineation of Niddersdale in 1779:

The cottages & small Frame Houses in this Valley are chiefly thatch'd with Ling which when well laid on will last thirty years without repair, slate being very dear, as it is brought from Woodall Hills near Bradford. There is a quarry of slate above Pateley, but it is so rough & heavy that the Timber must be very strong to bear it—A little worsted is spun in this neighbourhood, but the chief manufacture is lime of which coarse cloth is made call'd Knaresbro Linnens. Coals are brought from Leeds; the poorer people burn wood and Turf upon Hearths, & it is a capital House that pos-sesses a Grate—No more corn is grown than supplies the Families, the Farmers make up their rents by Dairys. In the beginning of the summer they firkin Butter for sale & bring up calves with the Blue Milk; in Fog time, they make great quantities of cheese.[110]

This is a far cry from William Gilpin's preoccupation with concealing the productive detail of the landscape in the interests of representing the general view; he was prepared to dismiss a large tract of the Thames valley, for example, on account of the fact that 'the woods are frequent; but they are formal copses: and white spots, bursting everywhere from a chalky soil, disturb the eye'.[111] Dorothy is less concerned about 'correct' vistas and more concerned to identify, define, and describe the features of a micro-economy, enabling her to command an authority over the discourse of labour; as a gentlewoman excluded from the necessity of labour, Dorothy Richardson inserted herself into a discourse of labour through the process of identifying and naming. The authority lent by this procedure is particularly evident in relation to the various industries she visited. Here, again, sight is paramount. Travel permits access, and access permits sight, and sight allows for identification, and identification establishes ownership of the inventory or the material of knowledge. In 1770, for example, Dorothy visited Birmingham and saw Bedford's Japanry warehouse, Soho (which she describes in detail listing thirty-nine rooms—'I believe we did not see half'—and describing the division of labour), and Baskerville's Printing Works.[112] Nine years later, staying near Oldham, she visits the different manufactures in the neighbourhood and is most impressed by Clegg's hat-making factory.[113] His warehouse is 'a large Pile of Building' and 'of the extent of his business some judgement may be form'd by his paying 100 p. ann for the article of paper alone, used for packing the Hats'.[114]

The concern with naming that is a feature of genealogical and antiquarian procedures is here brought into play for the analysis of industrial process ('a piece of iron or copper, bent for the purpose, & call'd a stamper').[115] Eschewing any notion of 'feminine' interest, Dorothy stresses her concern with eye-witnessed operation and with economy: 'I was present at the whole process of making a Hat, & am surpriz'd how a low priz'd one can be afforded, it goes thro' such a number of hands':

> 1st the weighing the Beaver, down, wool &c which is done for every Hat seperately, & the better kind of Hats are made of five or six different kinds; 2nd the Bowing; the different materials are mix'd together & laid upon a flat Table with long chinks cut thro' it, to let out the dust; upon this they have a Bow, resembling that belonging to a violin but larger whose string is work'd by a little bow stick & thus made to play upon the furs till they are mix'd in the nicest manner & form two gores of an oval form ending in an acute angle at the top; this is the most difficult operation as it requires great justness of the hand, to make the stuff fall together, so that it may be every where the same thickness, with what stuff remains they strengthen the thin places, & designedly make them thickest in the brim near the crown.[116]

As Hayden White has pointed out, narrative closure seems only possible in the passage from one moral order to another; no sequence of real events can be said actually to come to an end. 'There is no other way that reality can be endowed with the kind of meaning that both displays itself in its consummation and withholds itself by its displacement to another story "waiting to be told" just beyond the confines of "the end".'[117] I have argued that Dorothy Richardson invokes 'reality' by a variety of writing strategies designed to position her as author in a relationship of power and control over the seen world and its past. Narrative closure is effected at the end of each tour when she records a return. But her practice of employing the same book for a sequence of tours allows the reader a sense that this is not the end and more may come. The overall effect of this for an individual reading of these volumes—and I am concerned with the actual volumes as material objects of leather and paper—is that of a particular management of time. Travel is movement and movement provides a narrative framework. Everything outside that framework is silence; this is no diary, for days of the week are not recorded and not every observation is dated, but it none the less works with notions of time. I shall conclude by examining how Dorothy Richardson's text invokes time.

The far distant past of the Danish or Norman occupation of Britain belongs in the antiquarian time-scale of history as 'long ago'. Dorothy Richardson pays critical attention also to the past of her own day, to recent events and institutions within living memory. She admires, for example, the monument in Chipping Wycomb church erected after the death of Shelburne in 1751.[118] Visiting Lichfield in 1770, she notices the house in Bird Street where Garrick was born but makes no mention of the town's other famous son, Samuel Johnson. At a later date, presumably on the occasion of Johnson's death, an additional note is appended: 'Dr. Samuel Johnson was born at Litchfield on [blank] he died 13 Decr 1784 @ 75 His Father was a Bookseller.'[119] Changes are noted in the appearance of buildings and other locations when she revisits them. In 1801 the Green Dragon in Harrogate 'is much enlarged since I saw it before & many Lodging Houses & shops are built on each side of the road' whereas York she found 'very little altered since I was there in 1787'.[120]

Given the pre-eminence of sight—of what is seen over what is heard or read—it is interesting to observe how means are devised to record the passage of time and the movement from place to place when nothing is seen because the author is travelling at night. Leaving Bierley on 26 June 1775, Dorothy and her relatives pick up the new London Fly at the King's Arms in Leeds:

Travell'd from thence to Sheffield in the night, the only disagreeable circumstance attending this conveyance but as the weather was extremely fine we suffer'd no inconvenience except losing a view of the country which we saw in our return & which I shall mention in this place putting the account between hooks to avoid confusions.[121]

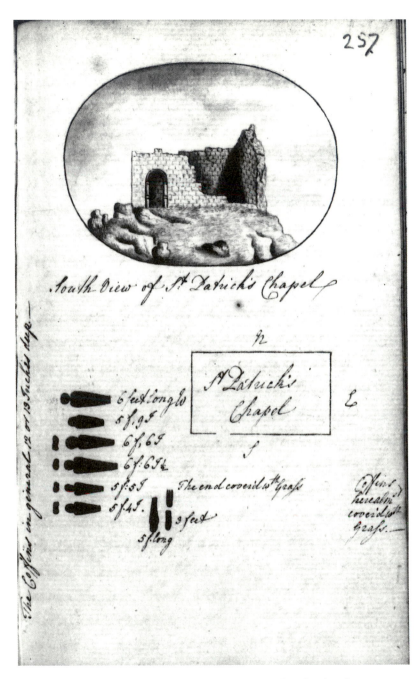

17. Dorothy Richardson, *St Patrick's Chapel near Heysham*, pen, ink, and wash, Ryl. Eng. MS 1122, fo. 257. Reproduced by courtesy of the Director and University Librarian, the John Rylands University Library of Manchester

In her tours, Dorothy Richardson demonstrated a highly developed competence in all the branches of learning on which institutions like the Royal Society of Arts and the Society of Antiquaries were founded: genealogy, archaeology, ancient history (Pl. 17). She appears to have been little interested in botany (which was generally the branch of natural history most closely associated with women), but geology and all aspects of commerce and manufacture were objects of profound fascination. Equipped with the necessary vocabulary, she was capable of discoursing upon limestone caverns or the production of japanned tables. The pleasure in measurement, inventory, identification, and dating are such as would have been readily recognized by any gentleman of learning of her own age and her rigorous empiricism would have been a match for the most punctilious natural philosopher. The question remains as to why this form of knowledge should be gathered in this particular form. Seeing and witnessing—and conveying to others what has been witnessed—is a form of discourse that pervades eighteenth-century writing whether imaginative and fictitious or positivist and documentary.

To have seen something remains an empowering experience (did you see the Colosseum, the football match, the film, the accident in the street?). The texts discussed in this chapter are ostensibly non-fictional and non-autobiographical. Yet dealing in the actual (the material world) they offer a (perhaps deceptively) concrete set of connections. How, and by what strategies, we have asked, is the subject Dorothy Richardson produced in the format of tours in which sight and place are of paramount importance? In texts written over a period of time (1767–1801) spatiality and temporality work as powerful discursive formations, and both are manifestly inflected by gender. Many men, it has been pointed out, wrote as women in the eighteenth century. 'Ascription of imagination to women as a specifically female rather than human power then leads to its peripheralisation onto the edge of power patterns.'[122] If this is so, how would it be for a woman who disavowed imagination and who wrote like a man? What when a woman sought to enter in her own name a discursive field of knowledge that was defined and institutionalized as exclusively masculine? While she did not adopt a man's name in her writing, Dorothy Richardson none the less engaged with discourses that were specifically masculine, those of topography and of antiquarianism.

In reading Dorothy Richardson, we have been reading a past which, for all that it has the anchorage of fixed dates, will always be bursting beyond chronological boundaries and reminding us that this past is also present in our present. Moreover, we will recognize that the past of which Dorothy writes when she describes antiquities is linked in an analogous relational structure to

her present. The spatial dimension of Dorothy's account is determined by topographical boundaries—private estates, counties, parishes—and also by the spatial relations that are set into play by class and gender producing proximity or distance between subject and object.[123] The conventions of topographical and antiquarian travel provide the framework for Dorothy Richardson's narratives. In so far as they are rhetorical devices, they may be interrogated, thus permitting inferences concerning representation of space and representational spaces.[124]

It seems clear that, at a personal level, Dorothy's project was profoundly concerned with the disavowal of those qualities of sentiment and recorded speech that were understood in the period to be particular to the female sex. It is, therefore, both paradoxical and highly significant that her obsessive interest in detail and her highly developed but seldom publicly visible practice of note-taking is shared with one of the century's most fascinating and powerful fictitious heroines, Samuel Richardson's Pamela (*Pamela*, 1740–1). For Pamela, writing (the format is the letter rather than the journal though the intended recipients are more of a pretext than a plausible destination) produces an archive that is united with her body, at one stage literally by being sewn into her clothing. One function of Pamela's detailed note-taking is that it serves as investment, as capital that can be transformed by symbolic exchange, in her case eventually into marriage with her would-be seducer. Dorothy's tour-writing, with its indexes, its corrections and updatings, and its preoccupation with taxonomies, represents an investment in time and space independent of, as well as belonging to, socially constructed norms. Recording social practices is, for Dorothy, ambiguous and transitional, since it serves to situate her outside those practices that would define her as female and dependent. We will never know what function Dorothy Richardson's archive may have served in her existence as a private individual. As a historical body she is constituted exclusively by those writings. What they offer to us is a paradigmatic case of disciplined recording that challenges received notions of travel, pleasure, gender, and knowledge in England in the second half of the eighteenth century.

Notes

1. Linked to this is the issue of curiosity which has been discussed by Barbara M. Benedict in 'The "Curious Attitude" in Eighteenth-Century Britain: Observing and Owning', *Eighteenth-Century Life*, 14 (Nov. 1990).

2. *Critical Review*, 47 (1779), 417, quoted in C. L. Batten Jr., *Pleasurable Instruction: Form and Convention in Eighteenth-Century Travel Literature* (Berkeley and Los Angeles, 1978), 39.

3. R. H. Sweet, 'The Writing of Urban Histories in Eighteenth-Century England', Ph.D. thesis (Oxford University, 1994), 87.

4. What follows was presented as a research paper to the Women's Studies network seminar at the University of Manchester, to the 18th-cent. seminar at the University of York, and to the Society for Eighteenth-Century Studies (North West). I am grateful for the many helpful comments I received on these occasions.

5. The intensity of publication can be usefully gauged from the entries in the *Gentleman's Magazine Library*, 'English Topography', ed. G. L. Gomme (1893). J. Ogilby's *Britannia* was first published in 1675; it was pirated by W. Gent as *The Infallible Guide to Travellers* (1682). Leland's itinerary was augmented in 1785 by publication of Paterson's *British Itinerary* by Carrington Bowles.

6. W. Schivelbusch, *The Railway Journey: The Industrialization of Time and Space in the Nineteenth Century* (1977; Leamington Spa, 1986), ch. 3.

7. On the picturesque tour, see M. Vale, *The Gentleman's Recreations: Accomplishments and Pastimes of the English Gentleman, 1580–1630* (Cambridge, 1977), ch. x and especially Ian Ousby, *The Englishman's England: Taste, Travel and the Rise of Tourism* (Cambridge, 1990).

8. See M. L. Pratt, *Imperial Eyes: Travel Writing and Transculturation* (London, 1992), 9.

9. John Rylands Library, University of Manchester, *c.*160 × 110 mm quarter vellum bindings. The volumes entered the library from a descendant of the author's brother-in-law Revd W. Roundell.

10. Ryl. Eng. MS 1122, fo. 213.

11. Young's first tour (*A Six Weeks' Tour through the Southern Counties of England, 1768*) postdates Richardson's earliest tours and was written in an attempt to earn money to support his family. Young's preoccupations are primarily those of the farmer and his best-known reports were drawn up for the Board of Agriculture and Internal Improvement, of which he was secretary.

12. See 'Writing of Urban Histories', 3, 9.

13. Ryl. Eng. MS 1123, fo. 3 and Ryl. Eng. MS 1126, fo. 2.

14. See Sweet, 'Writing of Urban Histories', 9. Catherine Macaulay is, of course, the exception that proves the rule.

15. C. Chard, *Pleasure and Guilt on the Grand Tour* (forthcoming). I am most grateful to Chloe Chard for her advice on this chapter.

16. See J. James, *The History and Topography of Bradford* (London, 1841), 316–19; R. Thoresby, *Ducatus Leodiensis: or, The Topography of the Ancient and Populous Town and Parish of Leedes* (London, 1715), 9; J. Nichols, *Illustrations of the Literary History of the Eighteenth Century* (London, 1817; Krauss reprint, 1966), i. 225–53; *DNB*. Both hall and tree survived into the present century but were destroyed in the 1960s, when the present (lamentably designed) hospital was erected on the site and took the name.

17. James, *History and Topography*, attributes responsibility to William, the second son, but other sources state it was Richard. See G. Sheeran, 'The Richardsons and their Garden at Bierley Hall', *Bradford Antiquary*, 3rd ser. 4 (1988–9), 3–10.

18. See Sheeran, 'The Richardsons', who points out that Burlington's chief gardener, George Knowlton, visited the Richardsons. Some vestiges still remain in the hospital grounds but the destruction of this garden, which was still fairly intact in the 1950s (see G. Bernard Wood, 'Bierley Hall', *Yorkshire Life Illustrated* (Oct. 1956), 37–8), is a matter of great regret. For a discussion of Bierley in the context of contemporary interest in the druids, see S. Smiles, *The Image of Antiquity: Ancient Britain and the Romantic Imagination* (New Haven, 1994), ch. 8.

19. A List of the Members of the Society of Antiquaries of London, MS Society of Antiquaries.

20. Nichols, *Illustrations*, 356 *passim*.

21. John Rownall is listed alongside J. Richardson, see above, n. 8.

22. T. F. Dibdin, *Remininscences of a Literary Life* (London, 1836), ii. 949–56.

23. According to the *DNB* the first catalogue was privately printed and limited to fifty copies. The second was also privately printed but more widely circulated. See C. J. Stewart, *A Catalogue of the Library Collected by Miss Richardson Currer at Eshton Hall* (London (for private circulation), 1833). This catalogue indicates a library extremely strong in history.

24. Nichols, *Illustrations*, i. 243.

25. Ibid. 245.

26. Also held by the John Rylands Library, Ryl. Eng. MS 1127–8 (transcriptions from the texts of antiquarian writers) and Ryl. Eng. MS 1129, a transcript of the memoirs of Sir Henry Slingsby, Bart., an important Yorkshire royalist in the civil war.

27. J. Evans, *A History of the Society of Antiquaries* (Oxford, 1956), 196, 352, 388–9.

28. D. G. C. Allan, *William Shipley: Founder of the Royal Society of Arts: A Biography with Documents* (London, 1968).

29. Ibid. 24–5.

30. Ryl. Eng. MS 1124, fos. 336–7.

31. Ibid.

32. e.g. 29 May 1779, Ryl. Eng. MS 1125, fo. 93. For the history of roads and conveyances, see E. Moir, *The Discovery of Britain: The English Tourists 1540–1840* (London, 1964).

33. 8 Sept. 1767, Ryl. Eng. MS 1122, fo. 43.

34. Aug. 1801, Ryl. Eng. MS 1126, fo. 64.

35. Ibid. 85 *passim*.

36. Ibid. 164.

37. Ibid.

38. Ibid. 167–8.

39. For the distinctions between chronicle and history, see H. White, 'The Value of Narrativity in the Representation of Reality', in W. J. T. Mitchell (ed.), *On Narrative* (Chicago, 1981; originally published in *Critical Inquiry*, Autumn 1980).

40. 'The art of understanding applied to such manifestations, to such testimonies, to such monuments, of which writing is the distinctive characteristic', P. Ricoeur, 'What is a Text? Explanation and Understanding', in *A Ricoeur Reader: Reflection and Imagination*, ed. M. J. Valdés (Hemel Hempstead, 1991), 45.

41. Ibid.

42. H. Arendt, *The Human Condition* (Chicago, 1958), 182–3. The full passage is as follows: 'Action and speech go on between men, as they are directed toward them, and they retain their agent-revealing capacity even if their content is exclusively "objective", concerned with the matters of the world of things in which men move, which physically lies between them and out of which arise their specific, objective, worldly interests. These interests constitute, in the word's most literal significance, something which inter-est, which lies between people and therefore can relate and bind them together. Most action and speech is concerned with this in-between, which varies with each group of people, so that most words and deeds are about some worldly objective reality in addition to being a disclosure of the acting and speaking agent. Since this disclosure of the subject is an integral part of all, even the most "objective" intercourse, the physical, worldly in-between along with its interests is overlaid and, as it were, overgrown with an altogether different in-between which consists of deeds and words and owes its origin exclusively to men's acting and speaking directly to one

another. This second subjective in-between is not tangible, since there are no tangible objects into which it could solidify ; the process of acting and speaking can leave behind no such results and end products. But for all its intangibility, this in-between is no less real than the world of things we visibly have in common. We call this reality the "web" of human relationships, indicating by the metaphor its somewhat intangible quality.'

43. F. Nussbaum, 'Heteroclites: The Gender of Character in the Scandalous Memoirs', in F. Nussbaum and L. Brown (eds.), *The New Eighteenth Century: Theory. Politics. English Literature* (New York, 1987), 150.

44. Ricoeur, *A Ricoeur Reader*, 100.

45. K. Shevelow, *Women and Print Culture: The Construction of Femininity in the Early Periodical* (London, 1989), 55.

46. Ballard MSS, xliiii. 8, Bodleian Library, quoted in M. Ashdown, 'Elizabeth Elstob, the Learned Saxonist', *Modern Language Review*, 20: 2 (Apr. 1925) 130. I am grateful to Lucy Peltz for drawing this article to my attention.

47. G. Ballard, *Memoirs of Several Ladies of Great Britain Who Have Been Celebrated for their Writings or Skill in the Learned Languages, Arts and Sciences* (Oxford, 1752). Ballard opens with Juliana of Norwich and concludes with Mary Astell and Constantia Grierson. I am grateful to Lucy Peltz for this reference. There is now a considerable and rapidly growing scholarly literature on 18th-cent. women of learning. See especially the work of Bridget Hill, *Eighteenth-Century Women: An Anthology* (London, 1984); ead., *The First English Feminist: Reflections upon Marriage and Other Writings by Mary Astell* (Aldershot, 1986); ead., *The Republican Virago: The Life and Times of Catherine Macaulay, Historian* (Oxford, 1992).

48. See M. Erben, 'Editorial Introduction', *Sociology*, special issue 'Auto / Biography in Sociology', 27: 1 (Feb. 1993), 3.

49. Moir, *The Discovery of Britain*, 1.

50. Had they carried a male rather than a female signature, they would undoubtedly have been extensively mined by social and economic historians and by art historians rather than, as is the case, overlooked and ignored.

51. *Pace* Batten, *Pleasurable Instruction* (who does not distinguish between foreign and home-based travel), Ousby, *The Englishman's England* and Robinson (see n. 70). W. G. Rice (ed.), *Literature as a Mode of Travel* (New York, 1963), only deals with foreign travel, as does Chloe Chard's recent work which will, none the less, bring light to this subject. See n. 15 above.

52. The standard text remains Moir, *The Discovery of Britain*. Moir is concerned with the picture that emerges from the tourists' accounts of what a gentleman of taste in the 18th-cent. liked and admired in natural scenery and in the arts (p. xiv). For the antiquarians, see also S. Piggott, *Ruins in a Landscape: Essays in Antiquarianism* (Edinburgh, 1976), 103–7. This is not to disregard the importance, in terms of documentation, of John Harris's 'English Country House Guides, 1740–1840', in J. Summerson (ed.), *Concerning Architecture: Essays on Architectural Writers and Writings presented to Nicholas Pevsner* (London, 1968).

53. C. Fabricant, 'The Literature of Domestic Tourism and the Public Consumption of Private Property', in Nussbaum and Brown (eds.), *The New Eighteenth Century*, 150. R. Williams, *Marxism and Literature* (Oxford, 1978) and D. MacCannell, *The Tourist: A New Theory of the Leisure Class* (New York, 1976).

54. Ryl. Eng. MS 1124, fo. 308.

55. Ryl. Eng. MS 1123, 1770, fo. 31.

56. Davison's essay is appended to R. Essex, P. Sidney, and W. Davison, *Profitable Instructions: Describing what Special Observations Are to Be Taken by Travellers in All Nations* (London, 1633).

L. Berchtold, *An Essay to Direct and Extend the Inquiries of Patriotic Travellers* (London, 1789). I am indebted to Batten, *Pleasurable Instruction*, 88–9 for both these references.

57. W. Hazlitt, 'On Going a Journey', in *The Complete Works of William Hazlitt*, ed. P. P. Howe (London, 1931), viii. 185. I am grateful to Chloe Chard for this reference.

58. Ryl. Eng. MS 1122, fos. 33–5.

59. Ibid. 271, 1775.

60. D. Defoe, *A Tour through the Whole Island of Great Britain* (1724–63), ed. G. D. H. Cole (London, 1935), i. 69.

61. *The Journeys of Celia Fiennes*, ed. C. Morris (London, 1969) (1685–1705); Defoe, *Tour*, ii. 62.

62. For guidebooks, see Harris, 'English Country House Guides'.

63. Hon. J. Byng, *The Torrington Diaries* (London, 1935), ii. 62.

64. Dr R. Pococke, *The Travels through England of Dr. Richard Pococke . . . during 1750, 1751, and Later Years*, ed. J. J. Cartwright (Camden Society, NS 42, 1888).

65. N. Spencer, *The Complete English Traveller: or, A New Survey and Description of England and Wales* (London, 1771).

66. From *The Lady's Museum* (1760), quoted in Shevelow, *Women and Print Culture*, 185–6.

67. Ryl. Eng. MS 1125, 1775, fo. 225.

68. A published text from a private journal that is similar to Dorothy Richardson's is found in S. Markham, *John Loveday of Caversham 1711–1740: The Life and Tours of an Eighteenth-Century Onlooker* (Salisbury, 1984).

69. A. Secord, 'Corresponding Interests: Artisans and Gentlemen in Nineteenth-Century Natural History', *British Journal of the History of Science*, 27 (1994), 383–408. I am grateful to John Pickstone for drawing this article to my attention.

70. J. Robinson, in *Wayward Women: A Guide to Women Travellers* (Oxford, 1990), lists works by Lady Anna Miller (1776), Marianna Stark (1800), and A Lady (1798) but most published accounts by women appeared in the second half of the 19th cent. The extent of unpublished accounts is extremely difficult to assess.

71. See Benedict, ' "Curious Attitude" ', 65.

72. See A. Giddens, *The Constitution of Society* (Cambridge, 1984), 152–5.

73. Ryl. Eng. MS 1122, fos. 1–7.

74. Ibid. 11, 17. We may conjecture that the 'nurse and child standing' were models installed for tourists.

75. Vol. i (Ryl. Eng. MS 1122): 'Derbyshire and Nottinghamshire (my Uncle and Aunt Richardson, my Father, Mother and I in two Chaises)', 29 Aug. to 19 Sept. 1767; 'Harrogate, Ripon and district (my Father, Mother, Sister, Brother & I in two Chaises)', 12 Aug. to 28 Aug. 1771; 'Heysham and Manchester (my Brother Richardson & I)', 21 Aug. to late Sept. 1775. Vol. ii (Ryl. Eng. MS 1123): 'Kildwick to Oxford via Harrow and Birmingham (my Uncle John Richardson & I in a chaise)', 29 Apr. to ? May 1770. Vol. iii (Ryl. Eng. MS 1124): 'London (my Uncle & Aunt Richardson, Mr., Miss, Masr Worthington & I)', 26 June to ? 1775; 'London (alone but joined by Mr. Roundell)', 4 Mar. to 14 Mar. 1785. Vol. iv (Ryl. Eng. MS 1125): 'Hartwith and the North Riding of Yorkshire (Mr. Roundell, my sister and I)', 27 May to *c*.6 June 1779; 'Oldham (my mother and I)', 20 July to ? Sept. 1779. Vol. v (Ryl. Eng. MS 1126): 'East Riding of Yorkshire (my maid and I)', 16 Aug. to *c*.16 Sept. 1801.

76. Ryl. Eng. MS 1124, fo. 311.

77. Ryl. Eng. MS 1122, fo. 42. Camden's *Britannia* was published in 1586; the edition most probably used was the improved version of 1695 or the 1722 major text revised by Edmund Gibson.

78. Ryl. Eng. MS 1122, fo. 185.

79. Francis Grose, *The Antiquities of England and Wales, Antiquities of Scotland* (London, 1773–91).

80. Ryl. Eng. MS 1125, fo. 84.

81. Pococke, *Travels through England*, 28 Aug. 1750.

82. Sweet, 'Writing of Urban Histories', 48 suggests that antiquarians needed Latin, Anglo-Saxon, and a knowledge of the law.

83. e.g. Ryl. Eng. MS 1123, fo. 261 *passim*.

84. See Piggott, *Ruins in a Landscape*, 50.

85. Ryl. Eng. MS 1124, fo. 305.

86. Ibid. 309.

87. Ibid. 83.

88. Ryl. Eng. MS 1123, fo. 25.

89. Ryl. Eng. MS 1124, fo. 21.

90. Ryl. Eng. MS 1123, fo. 231; Ryl. Eng. MS 1122, fo. 63.

91. Ryl. Eng. MS 1124, fo. 162.

92. Ryl. Eng. MS 1126, fo. 56.

93. Ibid. 62.

94. Ryl. Eng. MS 1122, fo. 64.

95. Ibid. 266.

96. Ibid. 270.

97. Ryl. Eng. MS 1123, fo. 32.

98. Ryl. Eng. MS 1125, fo. 117.

99. Nichols, *Illustrations*, i. 244.

100. Ryl. Eng. MS 1123, fo. 53.

101. Ryl. Eng. MS 1125, fo.99.

102. Ibid. 102.

103. Thomas Gray, letter of 3 Jan. 1770, quoted by M. Andrews, *The Picturesque: Literary Sources and Documents* (Mountfield, 1994), i, introd. p. 13.

104. Ibid. 105–6.

105. Ryl. Eng. MS 1122, fos. 179–82.

106. Ryl. Eng. MS 1125, fos. 154–5.

107. W. Gilpin, *Observations on the River Wye in the Summer of 1770*, section xi, repr. in Andrews, *The Picturesque*, 276.

108. Ryl. Eng. MS 1122, fos. 151–2. The popularity of Buxton, Harrogate, and Bridlington as spa towns in the 18th cent. (all visited by Richardson) is discussed in E. Hughes, *North Country Life in the Eighteenth Century: The North-East, 1700–1750* (1952; London, 1969), 400–1.

109. Ibid. 153–5.

110. Ryl. Eng. MS 1125, fo. 99.

111. *Observations on the River Wye in the Summer of 1770*, section i, repr. in Andrews, *The Picturesque*, 243.

112. Ryl. Eng. MS 1123, fos. 205–18.

113. Clegg Hall Mill, Milnrow.

114. Ryl. Eng. MS 1125, fos. 205–6.

115. Ibid. 207.

116. Ibid. 206.

117. White, 'The Value of Narrativity', 22.

118. Ryl. Eng. MS 1123, fos. 36–8. Henry Petty, Earl of Shelburne is celebrated in an elaborate monument by Peter Scheemakers with many figures, erected 1754.

119. Ibid. 219, 224.

120. Ryl. Eng. MS 1126, fos. 2, 16. This evidence is directly contrary to Girouard's arguments about changes at York, see M. Girouard, 'The English Country House and the Country Town', in G. Jackson-Stops *et al.* (eds.), *The Fashioning and Functioning of the British Country House* (Washington, 1989), 305–28.

121. Ryl. Eng. MS 1124, fos. 3–4.

122. G. Beer, 'Representing Women: Re-presenting the Past', in C. Belsey and J. Moore (eds.), *The Feminist Reader: Essays in Gender and the Politics of Literary Criticism* (London, 1989), 65–6.

123. In attempting to present Dorothy Richardson, I am concerned both to acknowledge the fact that Richardson is constituted as an author function by the texts which bear her name and to recognize the reality of a life that was lived between 1748 and 1819. The entity 'Richardson' that I construe is, therefore, in a sense conceptually analogous to the appropriated, transformed, and reconstructed location of Bierley Hall. Richardson's evidence does not open up an unmediated past; it constitutes a set of interpretations of seen experiences. My reading of that evidence is the result of a hermeneutic engagement between my present and a series of seized textual moments from other times.

124. The terms are Henri Lefebvre's, see *The Production of Space* (1974), trans. D. Nicholson-Smith (London, 1991), 38–9; I adhere to the cognitive and symbolic idea of the ordering of space rather than to what Tim Ingold has proposed as the notion of a 'dwelling perspective' according to which the landscape is constituted as an enduring record of, and testimony to, the lives and works of past generations (special issue of *World Archaeology*, ed. R. Bradley, kindly communicated by the author).

4 Working, Earning, Bequeathing: Mary Grace and Mary Moser— 'Paintresses'

*O*UR VIEW of the situation of women artists in London in the eighteenth century has been very much coloured by the high-profile example of the internationally renowned Angelica Kauffman. Nor is this situation new: Maria Hadfield (later to marry Richard Cosway) was described by James Northcote in 1778/9 as following in the footsteps of Angelica Kauffman.[1] And it was Kauffman who was chosen to appear as one of the *Nine Living Muses of Great Britain* in Richard Samuel's painting of that title, engraved and published in (Joseph) *Johnson's Ladies New and Polite Pocket Memorandum for 1778.*[2] While Kauffman, recently the subject of a substantial exhibition,[3] has maintained a place in a general view of the eighteenth-century art world, the same cannot be said of her companion in Zoffany's and Singleton's celebrated portraits of members of the Royal Academy. In the former, painted in 1772 and in the Royal Collection, Angelica Kauffman and Mary Moser, founder members of the Academy, are represented through portraits on the walls, a form of exclusion that has been frequently noted.[4] The latter, showing the Royal Academicians assembled in their Council Chamber to adjudge the medals to the successful students, engraved and published in 1802 (Pl. 18), represents the two women members standing side by side in a highly prominent position, behind the chair of the President. So one way of correcting this view is to ask, in the first place what happened to Mary Moser, in the second place were these two women so very unusual in pursuing professional careers as artists, and in the third place how might the work of an artist (such as Mary Moser) who made her reputation as a flower painter (a genre perceived as particularly female) be better understood within a historical context (Pl. 24).

I shall, therefore, be focusing in this chapter on the lives and work of two Marys: Mary Moser and her contemporary, the completely unknown Mary Grace. A number of premises frame this chapter. First I want to suggest that

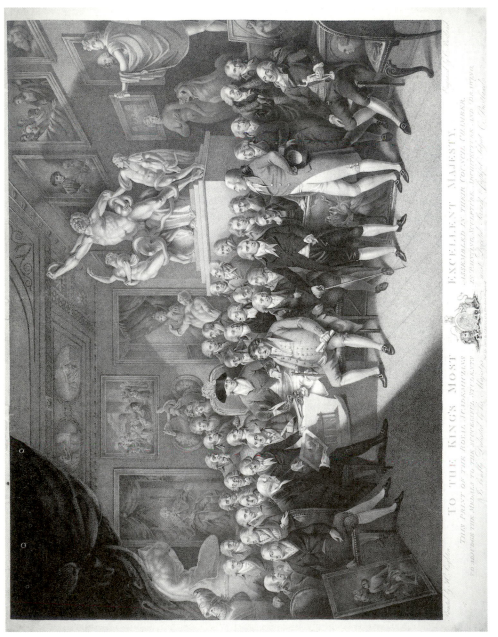

18. G. Bestland after H. Singleton, *The Royal Academicians Assembled in their Council Chamber*, pub. 1802, British Museum, London

the supremely powerful (and overweening) position allotted to the Royal Academy in accounts of eighteenth-century art might be challenged; a historical account that privileges the literary and institutional document, and the published theoretical text, and which accepts unquestioningly an essentially top-heavy explanation of artistic production, may not now be a wholly convincing one. On the question of the genres most commonly practised by women, it has been proposed that paintings of flowers and still life were overdetermined by the tendency to identify women with nature.[5] Parker's and Pollock's evidence comes from literary descriptions published in the nineteenth century and I shall show in this chapter that the situation was more complex than they suggest. There is evidence to suggest that flower painting, which is of particular interest in this chapter on account of Moser's *œuvre*, was regarded in the eighteenth century as part of a broadly defined and highly regarded design discipline practised by men as much as by women. Moreover, both men and women were active in the field of botanical illustration which was not always a discrete specialism separated from decorative flower painting.

One might cite, for example, in support of this contention, Richard Earlom, who produced hand-coloured mezzotints after flowerpieces by Van Huysum, Thomas Green, who worked after Verelst, as well as Simon Verelst himself, who worked in England from 1669 to 1721, Richard Anthony Salisbury, who published *Icones stirpium rariorum descriptionibus* in 1791, Peter Brown, botanical painter to the Prince of Wales, and, somewhat later, the Revd Alexander Dyce, who produced flower and insect paintings.[6] These productions are linked both to the Dutch and Spanish traditions of flower painting and to the new taxonomies of the eighteenth century. It is, moreover, possible to see such work less as appearing at the bottom of an academic hierarchy of genres than as forming an interface with textile production, interior decoration, ornament, and so on. It is clear that the kinds of enquiry that would offer explanations of how flower paintings by Mary Moser and her contemporaries signified has scarcely begun.[7]

Mary Moser's origins place her firmly in the commercial sector of the decorative arts as she was the only daughter (and only surviving child) of George Michael Moser, an immigrant gold chaser and painter in enamel. She was born in 1744 and died in 1819.[8] As a result of her family connections, we know considerably more about Mary Moser than we do about Mary Grace. Born in Schaffhausen in 1706, George Michael Moser became a leading member of London's art world: he belonged to the group that met in Slaughter's Coffee House, he was appointed drawing master to George III before his accession to the throne and designed the Great Seal for him, he had rooms in Somerset

House and socialized with men like Goldsmith and Johnson.[9] Through her father, who was a founder member of the St Martin's Lane Academy, a founder and director of the Incorporated Society of Artists, and founding member and first Keeper of the Royal Academy, Mary was well situated for her entrée as a professional first into the Society of Artists and then into the Royal Academy.

Moser's début took place, however, in neither of the above-named institutions but in the competitions organized by the Society for the Encouragement of Arts, Manufactures, and Commerce (usually known as the Royal Society of Arts). The constitution, functions, and membership of this organization were distinctly different from those of the Royal Academy and its precursor the Society of Artists. In one of his invaluable accounts, the Royal Society of Arts' archivist and librarian D. G. C. Allan lists the members of that body in 1764 and draws attention not only to the multifariousness of an organization whose membership comprised clergymen, naval personnel, medical men, merchants, booksellers, brokers, haberdashers, and so on, but also to the instability of the designation 'artist'. In a group of 812 members entitled 'Mister' without an additional occupational description, 378 admitted to a trade or craft and of these 46 used designations associated with 'Polite Arts'.[10] There were 14 'engravers' and 10 'painters'—small numbers compared with linen drapers and mercers—but equally interestingly, there were variations in the styles adopted by the artist members. Robert Edge Pine and Richard Cosway called themselves 'artist', Francis Cotes and Benjamin West used 'painter', J. H. Mortimer called himself 'history painter', and Hudson called himself 'portrait painter'.[11] In this listing, the occupation of a man concerned with pictorial art was a professional practice linked to commerce rather than an elevated avocation.

In the light of this, it is interesting to turn to the self-portrait by the second Mary of this chapter, Mary Grace, known only from an anonymous brown stipple engraving, published 1 August 1785 by C. Taylor, Holborn, and to notice that it is titled 'Mrs. Grace, Paintress' (Pl. 19).[12] Though her date of birth is unknown (since she began exhibiting in the early 1760s it is unlikely to have been later than 1740) this inscription identifies her profession unequivocally even though her image is one of generalized gentility (jewels around the neck and in the ears) rather than professional specificity. Mary Moser's recently rediscovered self-portrait (Pl. 20)[13] is a more robust affair; she depicts herself at work on a flower painting, glancing round to engage the viewer with a direct look. It is very much in the tradition of Artemesia Gentileschi's well-known *Self-Portrait* of c.1630 (Hampton Court) or Giulia Lama's *Self-Portrait* of 1725 (Florence, Uffizi). It is, however, the engraved self-portrait of Grace that the author or editor of *The Artists' Repository* (1770–80) chose to reproduce in

volume iv of his work where, under the heading 'Miscellanies by a Correspondent', is printed a defence of women artists which, in its rhetorical strategies, endorses the precedence of *praxis* over *theoria* that we have noticed in the self-naming of the members of the Society of Arts.

The writer wonders first why there are 'so few female names of eminence' in the annals of art. The possibilities either that the arts are too difficult of attainment, or that the 'female mind is destitute of the requisite predispositions', are dismissed. On the contrary, the author argues, the 'seeds of taste are general among mankind' and 'the female part possesses an ample share' especially in the qualities of 'sprightliness of imagination' and 'impressive sensibility' which are characteristics of the female sex. This passage is undoubtedly reiterating the gendered definitions of taste of late eighteenth-century England but it must be recognized that it is also urging a positive engagement in artistic practice on the part of women.

History painting is described as a 'too barren, though laureated rock' which is reached only through a 'steep and rugged' road. The implication is clear—who would want to sit on a barren rock? The writer proceeds to situate his observations in a self-declared pragmatic account which we may see as a deliberate rejection of academic theory, adapting his or her observations 'to the level of general life, as at present maintained among this nation' since it is preferable to 'be thought vulgar than unintelligible'. There have been, we are told, long and frequent complaints about the 'exclusion of the female sex from many employments and occupations, which might contribute to their comfortable subsistence in life!' The conduct connected with this idea is, it is argued, unaccountable and, furthermore, the indifference of parents to the education of their daughters is not only unaccountable but 'unquestionably extremely criminal'.[14]

This utilitarian account of female education and the need to earn a living might, I suggest, be construed as an overtly anti-academic position which, while it leaves women artists within a definition of gender-specific creativity, none the less recognizes art as a particular, designated area in which women should be expected to earn a living. And it does this in language which is pragmatic rather than condescending, its discourse leaving many openings for interjection and enquiry.

Directly addressing the female readership of *The Artists' Repository*, the writer exhorts women to cultivate a more intimate acquaintance with the arts. 'I do not say to every one "become a professor"; but I think I may justly say, "become a proficient".' In order to help these female readers turn their innate principles of taste into a 'right channel', an account is offered of the 'several abilities of those whose reputations are most honourable'. Heading the list are

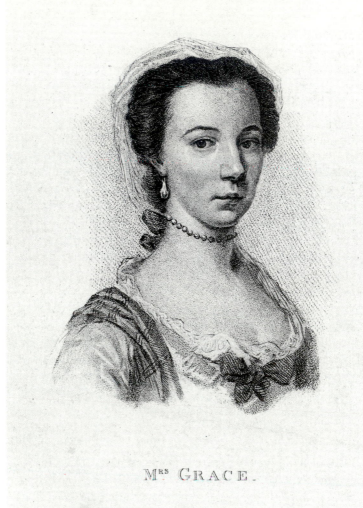

MRS GRACE.

Paintress.

London, Publish'd Aug.st 1, 1785, by C. Taylor N.o 10 near Castle Yard, Holborn.

19. Mary Grace, *Self-Portrait*, engraving, 'Mrs Grace, Paintress', pub. 1 August 1785 by C. Taylor, Holborn, British Museum, London

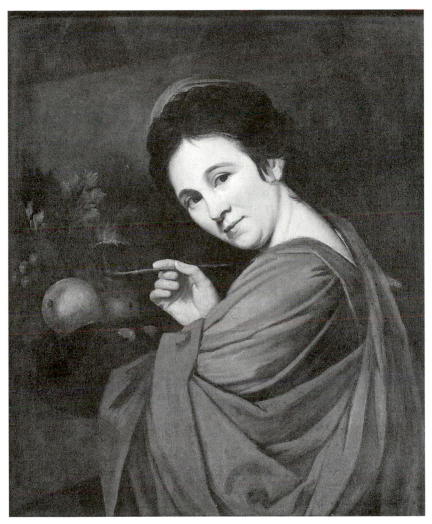

20. Mary Moser, *Self-Portrait*, oil on canvas, 73 × 61, c.1780, Museum zu Allerheiligen, Schaffhausen. Sturzenegger–Stiftung

Angelica Kauffman and Maria Cosway.[15] Close behind comes Mary Grace whose self-portrait 'is an instance of merit attained by application and industry, without any material regular tuition'. The only teaching she ever received, we are told, was from 'a person whose office it was to clean the pictures, &c in Somerset House, and elsewhere'. Somerset House was a royal residence and was treated as both a store and a restoration studio in this period prior to Sir William Chambers's restoration. There are records of pictures being moved from there in 1757 to make room for a battalion of guards but payments for restoration work there continue. The Surveyor of the King's Pictures from 1745 to 1765 was Stephen Slaughter who, apart from painting portraits, also undertook the restoration of pictures in the Royal Collection.[16] Slaughter's own work has been described as exhibiting 'a dry linear style, fussiness over small features and the humps and bumps of a face, a somewhat naive sense of perspective, combined with meticulous attention to detail'.[17] Slaughter, if it was indeed he, may have been well disposed to train Mary Grace as he is known to have lived in Kensington with his widowed sister Judith Lewis, who (Elizabeth Einberg has established) was also an exhibiting professional artist,[18] and his daughter Mary, who is described in 1763 as a 'modeller of portraits in wax'.[19] Slaughter travelled frequently between England and Ireland in the 1740s. Mary Grace (presumably at this time living under her maiden name, Mary Hodgkiss) is known to have been of Irish origins. Perhaps it was through Slaughter that she came to London. At any rate she learned from him, we are told, the nature and use of colours and the principles of the art. Grace is described here as responsible for many portraits 'whose management, as well as likeness, do her great honour'. It is suggested that she is rather well off financially and that this is the result of her artistic practice, not of an advantageous marriage ('the advantage of possessing thousands is not grudged to those whose Industry is rewarded with them').[20]

In case we should be tempted to dismiss the evidence of *The Artists' Repository* as a marginal counter-blast within a dominant ideology and practice, we should note that Mortimer's commercial directory for 1763 lists nine female artists at London addresses.[21] We might also just cast a glance at the exhibition catalogues of the Society of Artists of Great Britain. At its first show in the exhibition rooms of the Royal Society of Arts in 1760, only two works out of 130 were by women (a flower piece by Moser and a portrait by Catherine Read).[22] The following year, however, Catherine Read had four works on display (all figure studies) and Miss Anning showed a flower painting. There were also several other women exhibiting, in the sections covering drawings, engravings, and needlework. In 1763 Catherine Read showed four works.[23] At the second annual exhibition of the Society of Artists of Great

Britain at Spring Gardens in 1761, Moser is joined by Mrs Carwardine and Miss Charpin, while the following year, in addition to Moser and Grace, Benwell had four works, Carwardine two, and they were joined by a Miss Toddereck.[24] Grace exhibited every year from 1762 to 1769—a total of fifteen works. Moser exhibited almost every year from 1760 to 1768, a total of eleven works. At the Royal Academy (where Grace did not exhibit), Moser showed from 1769 to 1802 a total of thirty-six works.

The practice whereby women of the gentry were classed as amateurs even before marriage and nearly all women were given that status after marriage makes it difficult to ascertain the extent of working women artists, earning money from their practice, in eighteenth-century London.[25] It is, for example, known that Susannah Highmore continued to work after her marriage to John Duncombe in 1761. She wrote a poem from her home in Canterbury, explaining to her female friends that she had given up poetry and painting in favour of motherhood.[26] But she did continue to produce designs for book illustrations and frontispieces to her husband's published work.[27] At her death, her unmarried only daughter Anna Maria left family pictures, including a St Cecilia by Susannah.[28] It has been pointed out that although growing up in England in the middle of the eighteenth century meant being moulded, sometimes with subtlety, more often with unquestioning demands, to the requirements of society, there was leeway for developing interests and initiatives in particular cases. The status of a family, the interest of an educated father, and the presence of brothers being educated were major factors in the ability of women to establish themselves intellectually and professionally.[29] Myers is referring primarily to literary pursuits but what she says also applies to painters. There is no doubt that being the daughter of an artist made it very much easier for a woman to enter the profession. The supportive environment of a family was, however, not without problems as Frances Harris's recent work on Mary Black has shown. The young Black painted a portrait of Dr Messenger Monsey in 1764 and was commissioned also to paint a number of copies. A serious dispute ensued when the sitter declined to pay the requested fee and expected the copies to be done for almost nothing. She was regarded as her father's assistant and this fine portrait was for many years regarded as his work.[30] It is, however, clear even from these fragments of evidence that women were not an ephemeral presence in London's art exhibitions; their work was consistently visible, often over a considerable period of time. Nor was a Kauffman or a Moser quite the exception that we may have thought.

Much of our ignorance about these paintresses stems from loss of their work. The only work by Mary Grace that I have been able to uncover, apart from her self-portrait, is a portrait of Thomas Bradbury, the celebrated

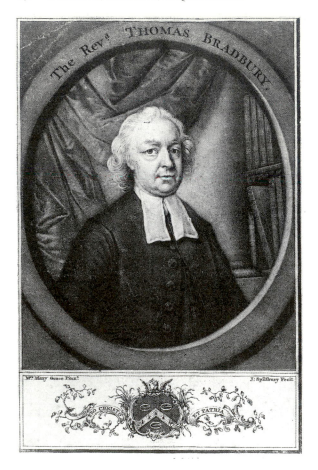

21. J. Spilsbury after Mary
Grace, *The Revd Thomas
Bradbury*, British Museum,
London

Dissenting minister, known from an engraving by Jonathan Spilsbury of 1769
(Pl. 21). J. H. Anderdon (in his grangerized set of exhibition catalogues now in
the British Museum) describes it as the only engraving of any of Grace's work
he has ever met with and gives a date of 1767. Bradbury, however, died in 1759,
so either Grace was already established as a portrait painter by that date or her
portrait of Bradbury was posthumous.[31] The evidence of the Society of
Artists' exhibition catalogues suggests an artist of much more diverse talents.
As well as portraits, there are *A Ballad Singer* (1762, no. 33) and *Beggars* (1763, no.
45), which Walpole described as 'A woman holding a little girl in her lap, who
is crying, and has got hold of a boy's coat, that is running away with a por-
ringer of broth, and spilling it and laughing—the woman is angry'. The paint-
ing that gets the longest transcript from Walpole and which it would be most
interesting to see is, like the last, a contemporary narrative low-life subject,

with six figures, *Pea-Pickers Cooking their Supper* (1764, no. 40). The description suggests a pictorially complex work which, perhaps along the lines of Wheatley, Morland, or Bigg, combined a vernacular narrative with suggestions of the erotic:

Six figures. On the right hand a man standing by, a woman sitting. The man is kissing her and putting his hand on her bosom, which she struggles to prevent. Opposite, on the left, is a pretty girl sitting on a hassock, stirring something in a small wooden bowl, and laughing at the man and woman. Close to her is a girl about 13, cooking the kettle, close to a man and a little boy with his back towards you. In front a little girl about five years old, stooping down and blowing a bit of lighted wood.[32]

It would appear that Grace was not deterred by the kinds of obstacles identified by Parker and Pollock from making interventions into the field of history painting.[33] In 1765 she exhibited *The Death of Sigismunda* (no. 38), an extremely popular subject at the period, and in 1767 what we might guess to have been her most ambitious work, *Antigonous, Seleucus and Stratonice* (no. 62). It is worth observing that, while Plutarch's story was popular in France in the seventeenth century as a result of a series of literary presentations culminating with Corneille's *Antiochus, fils de Seleuchus* of 1666, and while versions are known by Pietro da Cortona, Gerard de Lairesse, and a number of other artists, the most celebrated pictorial renderings of this theme by eighteenth-century artists (works like Benjamin West's painting of 1772 and David's painting of 1774) all postdate Mary Grace's exhibited work.[34]

According to Samuel Redgrave, Grace retired to Homerton on the death of her husband in 1769.[35] This turns out to be not quite true. The church rate books for Homerton, then a rural parish in Hackney in a locality renowned for its Nonconformist chapels, reveal that Thomas Grace paid the rate of 3s. 4d. in 1770. The rate book for 1771 is missing but by 1772 the rate, now 6s. 8d., is paid by Mary Grace herself. Rate books do not give actual street locations but the property appears to have been close to what was known as Wick Farm. Mary Grace continued to pay the rate up to and including 1799. In September 1800 she is recorded as 'late Mary Grace'. She therefore died in late 1799 or early 1800, some thirteen years after the date given in Redgrave.

Forms of historical evidence are readily overdetermined; the vision of a quiet retirement for the widowed artist in rural Hackney, a location to which she may have been drawn by an interest in Nonconformism if we interpret the commission for a portrait of Revd Bradbury as significant,[36] seemed plausible enough until Grace's will was located. The date of probate, 28 May 1800, enabled a firmer date to be proposed for her decease. Wills, as we observed in Chapter 1, are very particular forms of documentation in which the living will

their desire for power from beyond the grave. Written by the living for perusal after their death, at ceremonial readings where power resides with the absent guest, they enmesh the personal and individual with the legal and the statutory (of the State) around the crucial issue of accumulated wealth and property. If women in the eighteenth century are perceived generally as legally passive, the reading of wills like Mary Grace's swiftly counteracts such an impression.

When she died, Grace was living not at Homerton, a property which she presumably let, but in Weymouth Street in the parish of St Mary Le Bow. Her shoemaker father[37] we may now be fairly certain was Irish since she refers to the possibility of her death taking place in Dublin, expressing the wish in this eventuality to be buried next to her father, rather than next to her husband. The upshot of Mary Grace's will (dated 20 September 1793) is that, apart from small bequests (£10) to her servant and her executors, her property is to be divided between her children Richard and Clara Louisa. The former is given 1 guinea but confirmed in the will is transfer of Mary Grace's property in Ireland to her son Richard. What is of particular interest is the way in which Mary Grace bequeaths the remainder of her substantial property to her daughter, wife of William Middleton, as it indicates the kind of carefully developed strategy we remarked in Chapter 1 to ensure that a daughter retains control over her own property. The interest on £1,300 invested by Grace in various bonds is to be enjoyed by Clara Louisa 'free from the Controul or intermeddling of any late, present, or after taken husband'. Clara Louisa 'should have full power and authority to dispose of the said sum . . . in such shares and proportions and in such amounts to her children' as she deems fit. Moreover, the executors are instructed to assemble all her plates, linen, household furniture together with plate and silver lent to Clara Louisa and her husband on their marriage and place it 'in Trust for my Said Dear Daughter . . . in order that she may enjoy & possess that same fully and absolutely free from that interference or controul of late present or any after husband'. The real estate in England is likewise designated.[38]

Mary Moser's will is dated 22 August 1801, eighteen years prior to her decease. She had married Capt. Lloyd of Seymour Place, Little Chelsea on 26 October 1793[39] but at the time of writing her will she was living in John Street, St Pancras. Childless and widowed but surrounded by friends, she left most of her fortune to her cousin Joseph Moser. But there were substantial bequests to a female cousin (Elizabeth Graham), to Mary Nollekens (wife of the sculptor and executor of the will), Juliet Moser (her cousin's wife), Conradt Habbick of Schaffhausen (her father's nephew), her cousin Rachel Schweier, and Elizabeth West (wife of Benjamin West). There were also gifts for Charlotte Harward, Frances Ellis, and Maria Cosway. Richard Cosway, Joseph Nollekens, and

Benjamin West were to receive prints and books from Mary Moser's collection, and her servant got the usual bequest of £10.[40] Under the terms of Moser's will, Elizabeth Graham (wife of John Graham the history painter and Head of the Edinburgh Trustees Academy) received substantial benefits in her lifetime and her children would benefit after her death. She was also the main beneficiary of Joseph Moser's will, in which he left her the enormous sum of £7,000.

It is interesting to note that Moser provides for so many women: relatives, friends, and wives of fellow-artists. These women are regarded here as independent of their husbands. Moser's will, published by Nollekens in 1828, has long had the status of a public document. The difference, not only in the way property is allocated but also in overall structure and language, between Grace's will and Moser's is notable. Moser's will comprises a discourse of friendship—of power through naming and human proximity—to which money and property are subsidiary.[41] Whereas Grace's constitutes a declaration of goods and capital won and conserved, Moser's offers a declaration of reputation earned and won. While Grace's will may be read as constructing a defence against predatory men—a means of securing financial independence for her female child in a social environment unsympathetic to female financial independence—Moser's might be interpreted as endorsing marriage since she provides for the wives of so many friends. Other forms of evidence, however, militate against any such ready conclusions.

An indication of Moser's views on gender relations may be inferred from a letter to a female friend on the subject of divorce which, as we have seen in Chapter 4, was a topic of considerable interest. Having given the correct Christian position on divorce ('a vow solemnly to which we have calld God to witness can never be made void by Legislative Powers'), Moser then permits herself to 'speak like a Heathen & according to the sentiments of the world':

know—My Dear freind that as men have not to much either of religion [*replacing* Vertue] nor vertue [*replacing* religion] devorce is necessary . . . for if a weak woman should swerve from Honour what Saint in the Calendar of your Acquaintance would shave his Head, & not lift his Armed Hand against the Life of the Adultress were there no other way found out to set him free . . . it is in the Power of any Jade of a wife to send her Poor man to the divil whenever she pleases, if he sues a devorce his broken vow condemns him, if he commits an outrage on humanity he is lost that way, & if he retaliates adultery crys out against him & he sinks erecoverable, the worst of all is madam bears him Company.[42]

Without suggesting that they were necessarily typical of women working as artists in London towards the end of the eighteenth century, a comparison of the circumstances of Grace and Moser suggests a wide range of possibili-

ties. Both women worked initially under their maiden names and adopted their husbands' names at marriage without apparent professional disadvantage; both were children of immigrants; neither of them married artists. If Grace suffered a disadvantage of birth and education, Moser came from a family of artists working in the applied and decorative arts. Women artists clearly benefited, as I have indicated, from belonging to a family dedicated to one of the artistic professions. One way of measuring the conditions for women who invariably worked at home is to read what they have to say about their control of their own space. Another professionally successful Mary, Mary Delany, who made a reputation in flower- and shell-work, left a vivid description of her arrangements in a letter to a friend. The final apologia suggests how, even when writing to another woman, the professional had to justify not giving up space and time to pursuits regarded as more conventionally womanly:

I am going to make a very comfortable closet; to have a dresser, and all manner of working tools, to keep all my stores for painting, carving, gilding, &c; for my own room is now so clean and pretty that I cannot suffer it to be strewed with litter, only books and work, and the closet belonging to it to be given up to prints, drawings, and my collection of fossils, petrifications, and minerals. I have not yet set them all in order yet; a great work it will be, but when done very comfortable. There is to my working closet a pleasant window that overlooks the garden, it faces the east, is always dry and warm. In the middle of the closet a deep nitch with shelves, where I shall put whatever china I think too good for common use, but trifling and insignificant is my store-room to what yours is! Mine fits only an idle mind that wants amusement; yours serves either to supply your hospitable table, or gives cordial and healing medicines to the poor and the sick.[43]

Mary Moser does not disavow the worth of her own profession as Mary Delany feels it necessary to do, but she does, in one of her letters, offer an ironic and poignant insight not only into the general difficulty of purchasing a commodity for another person, especially when that person is one's father, but also into some of the restrictions of movement and independence suffered even by a very successful woman artist of mature years:

Unfortunately for me this morning I went to a sale, where alack & a well a Day I bid for an India Cabinet thinking it would serve my Father to lay his Shells in when it came home he did not like it & insisted on its being placd in my room to hold my linnin this my provoking vexatious wretch of a Cousin declares is omineous & that I have nothing more to do but provide myself with a Parrot, lap dog and monkey. If you know of any charm to avert the fatality of the above incident send me word with good speed.[44]

Moser launched herself upon her career in 1759 at the age of 15 when, entering for the second time in the competitions held for young people of different ages by the Royal Society of Arts, she won the silver medal in the class of Polite Arts for a watercolour and gouache study of flowers which hangs today in the Society's rooms. She had already, in 1758, won the first premium of £5 in the class of Drawings of Ornaments by Girls under Eighteen.[45] The Society, whose first meeting had been held in 1754, was the brainchild of William Shipley. Unlike other comparable bodies (for example, the Dublin Society for Promoting Husbandry and other useful arts, founded in 1731) and unlike learned societies such as the Society of Antiquaries (from which Dorothy Richardson was excluded) and the Royal Society, the Society of Arts provided for the inclusion of women and for the award of medals as honorary premiums.[46] In 1759 four boys and five girls won premiums in the Polite Arts section.[47] The Polite Arts was, as D. G. C. Allan has pointed out, the category that enjoyed a spectacular rise in the Society between 1758 and 1764.[48] In order to understand what the Polite Arts encompassed in this context, we need to recognize first that the other categories were Agriculture, Chemistry, Colonies and Trade, Manufactures, and Mechanicks, and secondly that very specific criteria applied in terms of both the assumed class of participants and the kinds of work they would produce. Within Polite Arts were a number of classes covering life drawing, landscape, cast copies, etc. The Society's premium list for 1758 designates class 58 as being 'for the best drawings or composition of ornaments, consisting of Birds, Beasts, Flowers, and Foliage, fit for Weavers, Embroiderers, or any Art or Manufacture, by Girls under the Age of Eighteen . . . to be coloured or not coloured at the option of the candidate'.[49]

The same members who drew up the terms for Polite Arts decided the criteria for the award of the silver medal. These criteria suggest a deliberately targeted constituency that would cross the boundaries between commerce and fine art:

As an Honourable Encouragement to Young Gentlemen and Ladys of Fortune, or Distinction, not exceeding 16 years of Age, who entertain or Amuse themselves with Drawing, the Society proposes to give a silver medal for the best performance in Drawing of any kind; And also a Silver medal for the 2nd best, such young Gentlemen and Ladies are not expected to draw at the Society's Office unless Agreeable to themselves but are expected to give sufficient proof that the Drawings produced are their own performance.[50]

After the foundation of the Royal Academy in 1768, Moser withdrew from the Society of Arts. This action, that of transferring allegiance totally from the space of the Society of Arts to that of the Academy, is symptomatic of Moser's own personal ambition for recognition according to the criteria of academic

idealism and not merely those of craftsmanship and competence; it is also indicative of the shifts in views about the relative values of the different fine arts and their place in a commodity economy. As Stephen Copley has pointed out, in this period the hierarchy of artistic forms and the model of artistic context that are proposed within the civic tradition of aesthetics are far removed from the prevailing conditions of production, distribution, and reception of art in the period. Moser had received her first accolades as a professional in the Polite Arts, so designated by the Society of Arts. Polite taste, Copley argues, is in large part instruction in discriminating consumption, the fundamental qualification for which is leisure, which will enable the polite to acquire standards of taste to guide their manners and their social and economic behaviour. The domain of politeness, while it depends upon economic production, is carefully constructed as outside commerce but (unlike the discourse of civic humanism) it celebrated 'feminized values' and allowed for the existence of made objects.[51]

There are some historical subjects among Moser's list of exhibited works (though these may have been variants on flower painting which was the genre in which she predominantly worked) and a signed life drawing in a classicizing pose suggests that she had aspirations in this direction.[52] In signing her flower paintings Moser frequently used her full name, the Latin 'fecit' (as did her father), and the date. Sometimes she added 'R.A.'. In other words, she declared her allegiance to an academic tradition independent and separate from the tradition for competency and skill in which she first trained. It seems likely that Moser gave lessons to Queen Charlotte and her daughters; Farington claims that Moser was Drawing Mistress to the royal princesses for many years and that they were so eager in their studies that in summer they often got up at four o'clock in the morning to pursue them.[53] We might treat this with circumspection. It is, however, certain that the royal family were keen on the arts; the *Morning Post* in 1783 noted that in London art was more fashionable than ever before 'and the practice of painting, modelling and design attracted amateurs of all ranks from the King and Queen downwards'.[54] Princess Elizabeth, who later married the Landgrave of Hesse-Homberg, was particularly serious in her practice; a large number of her engraved works are on display at Frogmore House and, in an undated letter to Mary Moser sent to accompany the gift of a (cast-off?) gown, she affectionately says, 'though out of sight you are not out of mind', and assures her that she has 'a sincere old friend in Elizabeth'.[55] It is also certain that the Queen greatly admired Mary Moser's flower paintings and awarded her a major commission (Pl. 24).[56]

During the nineteenth century botany acquired markedly feminine connotations; the trend began, however, as early as 1749 when the great botanical

artist G. D. Ehret first commenced giving lessons in flower painting to the Duchesses of Norfolk and of Leeds and to the daughters of the nobility.[57] In 1766 publication of *The Young Lady's Introduction to Natural History* precipitated a wave of popular botany. In the next thirty years, publications on botany in English with women as their target audiences proliferated. But, as David Allan points out, women were not merely passive and amateurish recipients of knowledge gathered and articulated by men. Hostesses like Mrs Ord and Mrs Montagu in the 1750s organized learned conversations and salons.[58] Moreover, a significant number of women were serious botanists.[59] The Duchess of Beaufort developed gardens at Badminton and Chelsea and advised the leading botanists of the day; Lady Margaret Cavendish Bentinck, a great collector of all kinds of things, built up a huge natural history collection.[60] The accession of George III in 1760 placed at the nation's head, for a brief space, a trio of enthusiastic botanists. The Queen was knowledgeable and sufficiently seriously interested to persuade the King to buy her Lightfoot's herbarium as a present;[61] the King's mother (Princess Augusta) was an active horticulturalist whose hobby laid the foundations for what is now the Royal Botanical Gardens at Kew. Keenest of all was the Earl of Bute, then the King's chief minister.[62] Women were encouraged not only in botany but also in flower painting by specialist literature extolling their skills and advising them on how to attain excellence. One such text, echoing the tone of the *Artists' Repository*, declares:

The general taste for painting flowers that prevails, and the great progress that some ladies have made in painting, is a convincing proof, that taste or genius for painting is not confined to the other sex; on the contrary, I am inclined to think that ladies would make much greater progress than men, were they first taught the proper rudiments.[63]

In total disregard for the teaching of Reynolds and the hierarchy of the genres, the author goes on to say that although improvements in the nation's art have occurred in the past fifty years, 'so great is the barrenness of genius in painting among English artists' that he is sure there is good reason to hope that the times will produce female artists to support the national interest.[64] Even allowing for the hyperbolic compliments and extravagant conceits expected in popular publications, the content of this statement and the seriousness of tone are remarkable.

All this was not without a politics. It has been pointed out that commending systematic natural philosophy was a way of ratifying the prevailing status quo.[65] Priscilla Wakefield, a Quaker, published *An Introduction to Botany* in 1796 in which she claimed that the study of botany made women rational creatures worthy of employment and that botany could be an antidote to the aristocratic maladies of levity and idleness. Women's moral exertions were on trial

in the 1790s when the sex was relied upon to ward off republicanism that threatened to disrupt the quietude of hearth and home. As the domestic idyll extended to the garden, botany became the most loved of moral sciences. However, the shift in the eighteenth century from a medicinal interest in botany to a search for abstract and universal methods of classification, which produced a scientization of botany as the Linnaean system was widely adopted, also had as a consequence a sexualized discourse of plants. There were, as Londa Schiebinger points out, two levels of sexual politics in early modern botany: the implicit use of gender to structure botanical taxonomy and the explicit use of human sexual metaphors to introduce plant reproduction into botanical literature. Linnaeus's taxonomy, built on sexual difference, imported into botany traditional notions about sexual hierarchy.[66] As commentators and moralizers came to identify the licentiousness of language which described the 'nuptials' of living plants (marriage metaphors were predominant), botanical study was seen as dangerously liberal and immodest and women were, by 1798, being advised to study chemistry, which was unlikely to inflame the imagination.[67]

New interests in exotic plants as part of a luxury and commodity-conscious culture merged with the old interest in physick. Wealthy members of society supported sumptuous publications like John Martyn's *Historia plantarium rariorum* (1728), illustrating plants newly introduced into the Chelsea Physick Garden. Not until after 1737 did the English take serious cognizance of the Linnaean system.[68] Martyn's work was illustrated with plates by Jacobus Van Huysum. This Amsterdam-born artist and copyist, son of Justus Van Huysum and brother of the famous Jan Van Huysum, lived and worked in England from 1721 and died in London in 1740. He is exemplary of the network of professional, familial, stylistic, and generic characteristics that tie together the great flower-painting traditions of seventeenth-century Holland with eighteenth-century representational developments in the field of natural history.

As the daughter of a Swiss immigrant, Mary Moser had every reason to be informed not only of the pre-eminence of botany as a developing science in England in the 1760s but also of the distinguished artistic traditions of northern Europe. The claim that 'her name is unknown to fame except as a flower painter'[69] is true enough but what such a statement—more a measure of the theoretical preoccupations of the Royal Academy than an introduction to a successful artist—masks is the centrality of flower painting to important areas of English cultural life in the second half of the eighteenth century: natural history, gardening, decoration and ornament, consumerism predicated upon luxury, changing ideas of nature, an interest in classification, debates about beauty. Erasmus Darwin's *The Botanic Garden*, published in two parts (*The*

22. Alken after Emma Crewe, *Flora at Play with Cupid*, frontispiece to E. Darwin, *The Loves of the Plants*, 1789, vol. ii of *The Botanic Garden*. Reproduced by courtesy of the Director and University Librarian, the John Rylands University Library of Manchester

Loves of the Plants, which is part II, appeared in 1789, and *The Economy of Vegetation*, which is part I, in 1791), brings many of these concerns together. It is Darwin's work that most richly illustrates the multifaceted attractions of plant analysis and representation in the last two decades of the eighteenth century. Darwin elaborately, even extravagantly, weaves an imaginative narrative informed not only by detailed botanical study but also by Freemasonry, mythology, archaeology (part I canto iv includes a detailed discussion of the Portland Vase), and the technologies of viewing (in part II he describes the workings of camera obscuras and mechanisms for viewing prints), aesthetics, and biography. Each part carries a frontispiece with a representation of Flora. It is worth pausing to look closely at these images. Alken engraved the frontispiece to part II after Emma Crewe (Pl. 22).[70] It depicts Flora as a seductive female figure reclining on a garden seat having relieved Cupid of his bow and arrow and sent him off with rake and spade to do some gardening. Flora bears many of the attributes of the luscious young women represented by Matthew

William Peters and discussed in my final chapter. Cupid is a near cousin to Reynolds's *Link Boy* with a similar degree of phallic suggestiveness.[71] There are no identifiable botanical specimens in this image; the floral swags around the oval frame containing the scene are merely conventional. But the frontispiece is none the less consonant with Darwin's declared intentions. Whereas, says Darwin, Ovid transmutes men, women, and even gods and goddesses into trees and flowers,

I have undertaken by familiar art to restore some of them to their original animality, after having remained prisoners so long in their respective vegetable mansions; and have here exhibited them before thee, which thou may'st contemplate as diverse little pictures suspended over the chimney of a Lady's dressing room, connected only by a slight festoon of ribbons. And which, though thou mays't not be acquainted with the originals, may amuse thee by the beauty of their persons, their graceful attitudes, or the brilliancy of their dress.[72]

In this proem, Darwin uses the fashion for sticking so-called furniture prints onto the walls of domestic interiors and connecting them one with another by means of commercially produced cut-outs as a way of identifying his audience (female) and establishing the eclecticism of his method. His statement also, however, connects the idea of transformation (as with Graves's poem with which I open Chapter 5) with that of representation. And the representations he proposes link botany with human beings in a decorative scheme. The frontispiece to part I, *Flora Attired by the Elements*, engraved by Anchor Smith after the Swiss-born artist Henry Fuseli, takes up the theme of love (Pl. 22a). Here Flora is a tall and powerful seated figure surrounded by female personifications of the four elements—Air has a particularly fetching butterfly hat and Fire holds up a mirror merging the iconography of Flora with that of Venus— while from the grass at her feet bursts a gnome bearing gifts of rings set with gem stones.[73] The scene is enclosed in an oval frame surmounted by swags of mixed flowers. The looking glass conveys the idea not only of vanity but also of self-knowledge while the process of adornment suggests traditional amorous narratives. Pleasure and celebration are the dominant discourses with botany suggested in a merely conventional way. Nor should this be attributed to incompetence as Fuseli was well practised in illustrating scientific treatises.

I do not propose any direct connection between Darwin's poem and Mary Moser's flower painting, though I shall suggest in due course that the particular combination of botany, decoration, and allegory associated with Frogmore where Moser worked is very much part of the same cultural disposition. On the other hand, it is unlikely that a highly educated woman like Mary Moser could have avoided knowing about *The Botanic Garden*. My main purpose in

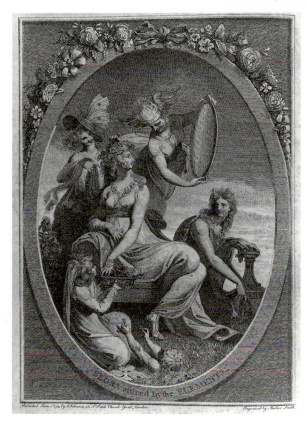

22a. Anchor Smith after J. H.
Fuseli, *Flora Attired by the
Elements*, frontispiece to
E. Darwin, *The Economy of
Vegetation*, 1791, vol. i of *The
Botanic Garden*. Reproduced by
courtesy of the Director and
University Librarian, the John
Rylands University Library of
Manchester

citing Darwin is, however, to indicate that the depiction of flowers in general
at this period in England is tied up with issues of generation and representation
as well as with celebration and mythological decoration. Moser executed two
types of flower imagery: elaborate arrangements of diverse flowers in vases on
flat surfaces and representations of single specimens. It would be wrong imme-
diately to conclude that the first belong to a fine art tradition, where the single
vase of flowers developed as an image in its own right from the detail in devo-
tional and religious paintings in the Renaissance, as with, for example, Daniel
Seghers and Erasmus Quellinus II, *Flower Piece with the Madonna and Child*,[74] and
the second to a newly developing botanical concern. The example of John Van
Huysum is instructive here. When Matthew Pilkington published his *Dictionary
of Painters* (originally written in 1770) in a new edition in 1810, he devoted a long
passage to a description of Van Huysum's flower painting, describing how
flower-growers would bring him their most prized specimens and from them
he would create an image that rendered every object 'more beautiful, if

possible, than even nature herself'. The importance in Van Huysum's practice of painting everything after nature is stressed. Thus, although the final outcome is understood to epitomize artifice, the ingredients are single botanical specimens identified and selected by specialist horticulturalists. Flower pieces are arrangements of flowers that would never have flowered at the same time; each painting is, therefore, a utopian challenge to the passage of time. A structural relationship thereby exists between scientific and ideal discourses. Contemporary publications support this contention. *Twelve Months of Flowers*, published in 1730, with a large number of influential subscribers many of whom are women, offers an elaborate flower still life for each month designed by Peter Casteels from the collection of Robert Furber, gardener at Kensington, and engraved by H. Fletcher. Every spray is numbered and a key beneath the image identifies each botanical specimen with its common name. At the same time, the format is that of the flower piece arranged in an elaborate vase on a table. As far as consumers were concerned it probably functioned both as sales catalogue and as flower piece.[75]

Still lifes now regarded as easel paintings were often let into the wall or placed in front of fireplaces in summer.[76] They are part of the decorative tradition in which three-dimensional space is the medium, and illusionistic techniques coalesce with flat arabesque and pattern. Moser's work at Frogmore is, as we shall see, a clear demonstration of this. Similarly, if we take the well-documented example of tulipmania in the seventeenth century when the passion for new breeds of tulips in Holland produced something akin to a stock market crash, it is impossible when addressing Moser's seven tulip studies in the Victoria and Albert Museum to separate out notions of scientific accuracy, formalist preoccupations with beautiful objects, and commodification.[77] Gill Saunders's suggestion that anything not isolated on a ground was deemed unscientific is to adopt too narrow a definition of 'science' for this period. If we take, for example, the plate illustrating Meadia (American cowslip) in Darwin's *Botanic Garden*, we have an image that appears precisely to fall within the herbalist's conventions as defined by Saunders (Pl. 22b). The text which this image accompanies is, however, a mixture of the scholarly and the fantastic:

> Meadia's soft chains five suppliant beaux confess,
> And hand in hand the laughing belle address.
> Alike to all, she bows with wanton air,
> Rolls her dark eye, and waves her golden hair.[78]

The accompanying note tells us: 'The uncommon beauty of this flower occasioned Linnaeus to give it a name signifying the twelve heathen gods (Dodecatheon); and Dr. Mead to affix his own name to it.'

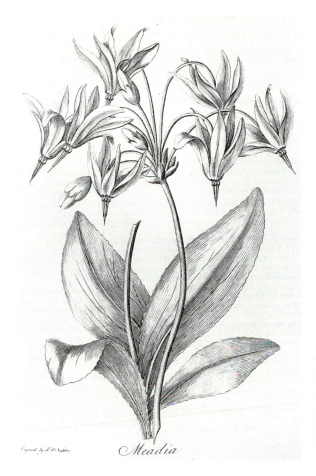

Engraved by F. P. Nodder

Meadia

22b. F. P. Nodder after anon. artist, *Meadia*, E. Darwin, *The Loves of the Plants*, vol. ii of *The Botanic Garden*, London, 1789, p. 6. Reproduced by courtesy of the Director and University Librarian, the John Rylands University Library of Manchester

The apparent resistance of flower painting to hermeneutic strategies has been acknowledged not least by those who have devoted a lifetime to its study. Sterling finds the conclusion that 'fascination induced by the beauty of flowers' unites Vases of Flowers all over Europe seemingly banal but none the less deep. Arguing for a 'sensitive and precise analysis of pictorial language' as the art historian's chief tool, Sterling insists, finally, on the exact evaluation of a work of art 'as a visual fact'.[79] We are left, however, with the problem of what a visual fact is and how it signifies. A clue to at least one area of meaning generated by flower painting in the eighteenth century is provided by Brown, the drawing master, when he states: 'There is a secret pleasure in copying minutely this part of the creation, which none but those who are capable of doing it feel.'[80] An aristocracy of copyists who, through acquisition of com-

petence, earn private pleasures is rather different from the concept of a pan-
global fascination with the beauty of flowers, about which Brown has little to
say.

A close examination of one of Moser's elaborate large-scale flower paint-
ings may help to advance the argument.[81] The first thing we might observe is
that flower paintings work iconically; their titles (while they may refer to a par-
ticular specimen like a rose) by and large are wholly generic: 'Flower Piece',
'Vase of Flowers', 'Flowers in a Basket'. They thus refuse the relay of signifi-
cation that operates between catalogue entry, image, spoken title, reputed
description, (mis)titling in review, catalogue raisonné, and so on. Reviews of
flower pieces engage with colour and with material. Those seeking a language
in which to be pejorative find themselves captive within the genre's own par-
ticular economy; Horace Walpole's catalogue for the Free Society exhibition
of 1763, for example, contains the following ripostes after John Heather's two
flower pieces: 'A Weed', 'A Thistle'.[82] The economy of flower painting
demands that it be critiqued on its own terms; denigration of a flower paint-
ing can only effectively be accomplished by describing it as a sub-species.
Moser's Vase of Flowers (Pl. 23) is identifiable in distinction from all her other
Vases of Flowers first by reference to its number (377—1872) in the Museum and
secondly in relation to its provenance; dated 1764 (on the back), painted in
tempera on paper measuring 61 × 44.5 cm, it was formerly in the collection of
Queen Charlotte.

Elaborately worked tempera produces a flat, chalky grey background over
a terracotta ground against which flowers are depicted variously, brilliantly
contrasted against this background or literally merging into it. The back-
ground is laid in after the flowers have been individually painted and it is pos-
sible, on close scrutiny, to see how the spaces in between flowers have been
filled in.[83] Gum arabic is employed to establish depth in the shadows and chalk
and chinese white are used to add lights. This image immediately raises flower
painting's most fundamental challenge: how to account for the joint presence
of the arabesque and the trompe-l'œil.[84] In fact, Moser's work is not trompe-l'œil
(the xenion of antiquity)—it lacks the additions of illusionistically painted
beetles, dew drops, and so on that characterize the genre—and would not
have been understood as such by an eighteenth-century audience for whom
such works were 'deceptions'.[85] None the less, flower pieces in the Dutch tra-
dition like those of Moser invite a detailed reading of familiar objects imit-
ated from originals in the natural world. The question of mimesis is thus
foregrounded in these works. So, also, is the question of drawing (and discur-
sivity) as opposed to colour (and eloquence).[86] The ornamental and design
elements invite the viewer to understand the image as a flat surface upon

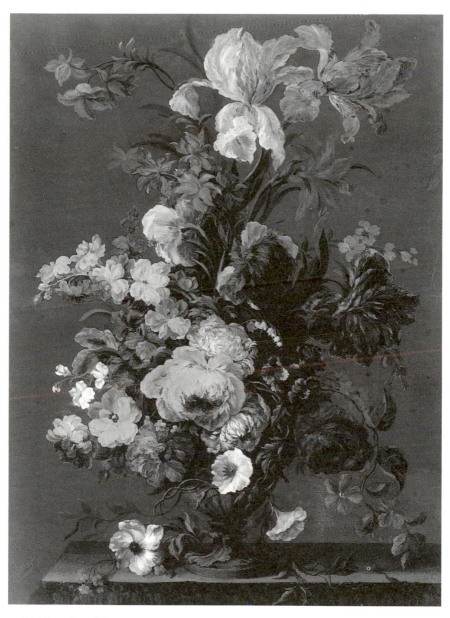

23. M. Moser, *Vase of Flowers*, tempera on paper, 61 × 44.5. By courtesy of the Board of Trustees of the Victoria and Albert Museum, London (377—1872)

which a pattern has been applied. In the case of 377—1872 flatness and pat-
terning are insisted on in the following ways: the vase 'exists' only in residual
and rudimentary form but it reiterates the natural theme with the
shell/foliage shapes at its base, a bulbous organicism of form above its 'stem',
earthy in colour; the entire image field is worked over with tendrils and leaves
reaching to the frame; the arrangement whereby the largest blossom (the iris)
surmounts the bouquet reinforces the sense that this is utterly implausible as
a gathering of cut flowers supporting themselves in a container of water; the
variegated hues ranging from highly saturated tones to shades barely dis-
cernible from the background are dictated by the demands of pattern and
effect, not by the requirements of naturalism; the table, the edge of which is
also decorated with a flowing naturalistic pattern, is reduced in depth and ren-
dered almost one-dimensional in order not to detract from the flatness. The
advice offered to flower painters 'to darken all but the Windows you sit at, the
different Lights produced by many Windows making a Variety of Lights and
Shades' is calculated to ensure maximum effect of colour rather than precise
imitation of a natural effect.[87] Moser's image accordingly speaks of artifice
over nature and of the unifying function of image-making in relation to the
chaos and disorder of the natural world. Linnaeus might encourage a predis-
position to classification that thrived on an ability to represent so precisely the
uniqueness of every natural form. But despite, or because of, this the object of
paintings like this image by Moser remained the representation of a plenitude
that epitomized long-standing views of nature.

If, as is generally claimed, vases of flowers in images derive from a religious
tradition (the Virgin Mary with a single vase containing lilies) it is significant
that the genre to which Moser's work belongs is so successful in a Protestant
market-place (where actual religious imagery was problematic) and that it was
executed for a Queen of German birth. At Frogmore we shall find garlands
surrounding a royal insignia instead of a biblical icon, as in *Garland of Flowers
with the Virgin, Infant Jesus and Angels* by Jan Bruegel and Rubens (Madrid:
Prado). Belief in the revelation of the divine plan in the particulars of natural
history was widespread. It was articulated at its most sophisticated level by
William Paley, whose *Natural Theology* (1802) drew upon an earlier tradition, as
exemplified by John Ray's *The Wisdom of God Manifested in the Works of
Creation* of 1691. Paley's view that 'the contrivances of nature surpass the con-
trivances of art in the complexity, subtlety, and curiosity of the mechanism',
and that this is the surest demonstration of God's greatness, received
widespread acceptance at the end of the century and offered a licence for sci-
entific investigation.[88] At a popular level it is exemplified in this fictive conver-
sation between a Chevalier, a Countess, and a Prior:

Cheval I freely confess it never entered into my Thoughts to seek for any Design in
Flowers; but if I may judge of them by the delight they afford me, they were cer-
tainly created to please us.

Countess That seems to be a flattering Thought: But is it nothing more? And must we
really take it for an illusion of Self-Love?

Prior I am far from entertaining that Opinion: There is a manifest Connexion in all
Nature; and though each Object has its particular End in that System or may
happen to correspond with some other, we see that all of them have an ultimate
Relation to Man. They are united in him as their Proper Centre; he is the End of all,
since he alone has a Use for the whole.[89]

It is this theological viewpoint that underpins the aesthetic morality of Dr
Johnson's recommendations to the poet in his celebrated discourse in *Rasselas*
(1759) invoking the delineation of a flower. Imlac states in this discourse that
the business of the poet

is to examine, not the individual, but the species; to remark general properties and
large appearances: he does not number the streaks of the tulip, or describe the differ-
ent shades in the verdure of the forest. He is to exhibit in his portraits of nature such
prominent and striking features, as recall the original to every mind; and must neglect
the muter discriminations, which one may have remarked, and another neglected, for
those characteristics which are alike obvious to vigilance and carelessness.[90]

Johnson's assertion is analogous to Reynolds's insistence that the ideal is
won at the cost of particularity but his choice of the tulip as an example is sig-
nificant because tulips were man-made hybrids and were consequently con-
tentious. Naomi Schor has drawn attention to the way in which not only in
Reynolds, but across a whole range of treatises on taste in this period, Dutch
art and art of ornament (Venetian) are understood as feminine in opposition
to the manly style of the Roman School, thus forming part of a sexual and aes-
thetic hierarchy.[91] The identification of ornament with the feminine, and the
use of the tulip by Johnson as an example of what should not be described,
defined, and delineated by the poet in search of the ideal, offers a dynamic dis-
course within which to understand Moser's representations of tulips. Seven of
these are in the Victoria and Albert Museum (100–6—1879, each 48.3 × 33.7
cm.) (Pl. 23a). These utterly unoriginal depictions (they can be matched by
countless single tulip representations drawn, painted, and engraved by artists
like, for example, Judith Leyster) may have been executed for teaching or for
botanical purposes; they contrast markedly with the elaborate flower pieces
by the same artist.

A number of things need to be taken into account in considering these
works. Tulips were, unlike roses, not endemic to northern Europe but had

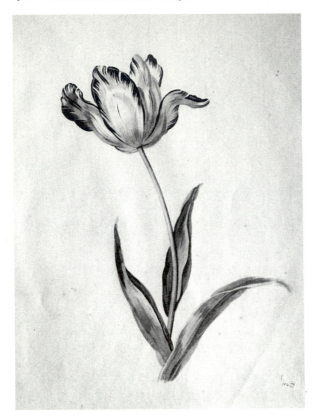

23a. M. Moser, *Study of a Tulip*, watercolour on paper, 48.3 × 33.7. By courtesy of the Board of Trustees of the Victoria and Albert Museum, London (104—1879)

been introduced from Turkey and were part of a luxury trade. In England any representation, any portraiture, of tulips in the eighteenth century needs to be understood as part of the passion for gardens, Delftware, and other things Dutch following the Glorious Revolution. The tulip is an object of extreme rarity that became vulgarized through popular mass distribution. Through visual representation of high technical competence it might again become rarefied and stand as an exemplum of the feminized and the particular.

Moser shows us the cut flower without the bulb (which would be required for full botanical knowledge). Thus it approximates to a pressed flower and the question arises as to why, when flower presses were available and commonly used, images like this were needed. One answer might be that the discipline of describing—and through description transforming an impermanent manifestation of nature into an object that might be viewed, hoarded, shown, given away, bequeathed in a will—was part of the process of symbolically knowing and controlling the world. Such objects fall within the category of those things

to be wondered at. The language with which Erasmus Darwin describes the tulip belies the apparently unemotive delineations of artists like Moser. And yet Darwin's work was eagerly received, suggesting an audience ready and willing to make these associations.[92] Another answer must be that, as an emblem of beauty, its mediating function in representation is to separate and preserve the idea as distinct from the material, the dried and dead specimen. What Moser represents in her tulip depictions is, therefore, like the Vase of Flowers, essentially an urban image. And here we return to Sterling's concern with 'beauty' and the 'visual fact'.

Jacques Derrida has drawn attention to the significance in Kant's *Critique of Pure Reason* (1781) of the wild tulip. Neither Kant nor Derrida is concerned with a particular representation of a tulip. Kant's choice (taken from Saussure, Derrida tells us) is odd since tulips were highly cultivated and the notion of a wild tulip in 1781 is almost perverse. The tulip, it might be argued, was a useful commodity; Kant's insistence (via Derrida) is that it is the lack of use that is important. Derrida identifies in the third *Critique* a 'paradigmatics of the flower'. Kant's search for a beauty without end, without goal or outcome and without the concept of an end, is located in the tulip:

Everything about the tulip, about its form, seems to be organized with a view to an end. Everything about it seems finalized, as if to correspond to a design (according to the analogical mode of the as if which governs this whole discourse on nature and on art), and yet there is something missing from this aiming at a goal—the end. The experience of this absolute lack of end comes, according to Kant, to provoke the feeling of the beautiful, its 'disinterested pleasure'.[93]

I do not wish to imply that Moser had any knowledge of Kant, though it is not impossible that she could have known of his work; it is much more likely that she was demonstrating her skill in a familiar genre of single-stem, cut plant, image. But Derrida's meditations upon, and explication of, Kant, for all that they are unconcerned with historical conditions, serve to remind us that Johnson's choice of the tulip is not accidental; the tulip represents singularity and, above all, beauty as artifice. The requirements of a tulip are, furthermore, measurable by strictly geometric standards. The streaks might, indeed, be numbered. The cup should form, when expanded, from half to a third of a hollow ball, the six divisions of the perianth being broad at the end, and smooth at the edges, so that the divisions may scarcely show on the indenture.[94] Therefore, the tulip might be said to stand for complete precision, accountability, and calculability on the one hand and, on the other, the 'finality without end, of this useless organisation, without goal, gratuitous, out of use'.[95]

Derrida's account of the contradictory nature of the tulip might well extend to the paradox of decoration. I shall conclude this chapter by looking at what must arguably be regarded as Moser's most distinguished work and one of the late eighteenth century's most significant surviving decorative schemes, the room at Frogmore House, Windsor painted by Mary Moser for Queen Charlotte. I want to suggest that an understanding of the achievement of women artists in eighteenth-century England, as well as an accurate recognition of how they were regarded in their own time, requires us to move outside the Royal Academy, away from the frame in the literal as well as the metaphorical sense, and to substitute a lateral for a vertical model of artistic production, a synchronic for a diachronic view of history. The Moser room is an extension and summation of the artist's accomplishment as a painter of flower pieces, a three-dimensional excursion in what, when writing to a friend, she terms the 'rural style'. This letter, with its self-conscious artifice and self-mocking, ironic tone, is an apt introduction to an art form that turns inside out and outside in:

I am just returned from Hampton Court where I have spent the last fortnight very agreeably. I only deferd writing in hopes that dimpling Brooks, flowery Vales, noding wispering Groves would have inspird me with new Ideas to furnish out an Epistle in the rural stile, but I was mistaken the Delights of the Country were not among those which I enjoyd, for from the day I left London to the evening I returnd it raind incessantly there was not sunshine enough to aford us even a rainbow, however the wet without doors did not damp our spirits within, we sported dancd & sung sometimes we pouted & for variety now and then we quarrelled.[96]

The first mention of Moser by Queen Charlotte appears in a letter to the Duke of Sussex in 1792 when she mentions a room to be set aside for the 'flower pieces painted by Miss Mosert [sic]' in connection with a design for a new Gothic cottage that Wyatt was preparing to build for her on the site of Amelia Cottage.[97] This dates Moser's employment to a period prior to the purchase of the adjacent Frogmore and suggests that the Mary Moser room at Frogmore, as Queen Charlotte designated it,[98] was in some sense an extension of an already well-established relationship between Queen Charlotte as patron and Moser as artist. The Moser room decorations consist of a combination of easel paintings and decoration applied to the walls. So we may assume that existing easel paintings were incorporated into the scheme at the Queen's request.

Nollekens alleged that Moser was paid over £900 for the flower room at Frogmore which she executed in the mid-1790s and that Queen Charlotte 'took particular notice of Miss Moser, and for a considerable time employed her at Frogmore'.[99] If this is so, it might explain the story recorded in

Farington's diary for 10 December 1794, according to which Mrs Lloyd (Mary Moser worked under her husband's name after her marriage), along with three other outsiders, received one vote in the election which brought Benjamin West into the President's chair. After a discussion, her name was omitted from the minutes since it was 'evidently intended as a joke, and if seriously she was not eligible'.[100] This form of ritual humiliation was, we may assume, reserved for upstarts (two of the others named are Catton, a coach painter, and Copley, an American) and women. The male club having a joke at the expense of its vastly outnumbered female minority is familiar enough but the particular form of this joke—the elevation in order to demote—may have been provoked by the considerable success Moser was enjoying at this time in the employ of Queen Charlotte.

Frogmore was purchased by the Queen in 1792 and became her favourite residence. The house was remodelled by James Wyatt and Major William Price, Uvedale Price's brother, was employed to lay out the ornamental lake. The Queen kept her botanical collections here and part of her very substantial library which included many botanical works.[101] In among the exotic trees and shrubs, garden buildings—a Gothic temple, a ruin, a hermitage, a barn— were erected. The hermitage was constructed from a drawing by Princess Elizabeth.[102]

Frogmore was the location for a series of sumptuous fêtes which even the very partial biographer of Queen Charlotte cannot help contrasting with 'the scarcity and distress which the war with the revolutionists of France had occasioned at this time'.[103] Indeed, the very strong sense of Frogmore as a female royal space, which queens and princesses participated in designing and where they spent their leisure, invokes immediate associations with Versailles where, we may recall, Louis XIV had hung some sixty fruit and flower paintings by Monnoyer and almost as many by Jean Belin de Fontenay.[104] Queen Charlotte's biographer, Oulton, was writing in 1819 when the easy accommodation of luxury within the natural order was being increasingly questioned. Moser's work for Queen Charlotte spans a range of interests from the botanical to the decorative that could still (at least in a garden house) be theologically justified. As the fictitious Countess, whom we have already encountered, tells her companions:

The Festivals in the Country are never celebrated without Garlands, and the entertainments of the Polite are ushered in by a Flower. If the Winter denies them that Gratification, they have recourse to Art. A Young Bride in all the Magnificence of her nuptial Array would imagine that she wanted a necessary part of her Ornaments, if she did not improve them with a Sprig of Flowers. A Queen, amidst the greatest Solemnities, though she is covered with Jewels of the Crown, has an inclination to this

rural Ornament; she is not satisfied with mere Grandeur and Majesty, but is desirous of assuming an Air of Softness and Gaity by the Mediation of Flowers.[105]

The room that Moser decorated on the south side of the house mingles themes of pastoral pleasure with loyalist patriotism, and its organization reiterates the careful simulacra which turned the gardens into a ballroom and the house into a garden. It contains framed canvases let into the wall and painting on panels *in situ*. In simulating on the ceiling a space open to sky with cords across which an imaginary awning might be drawn, Moser was following the conventions of seventeenth-century decorators (such as Robert Streeter at the Sheldonian Theatre, Oxford, 1668–9) who based their designs on a conviction about how the architects of Roman amphitheatres organized protection from the weather. The painting is executed entirely in oil and offers an alternating rhythm between mirror surfaces of the expensive pier glasses and densely painted panels. The richly coloured garlands of flowers stand out from a pale background. The wall facing the French windows which lead into the garden is most elaborate and is taken up with a painting that celebrates Great Britain and the Order of the Garter (Pl. 24): a large urn, supported by the lion and unicorn on its base showing the escutcheon with the crown, is framed with 'entre-lacs'. This kind of design was imported from France into England during the last decade of the eighteenth century[106] and constitutes a declaration of loyalty in a period of republican revolution. On the urn, which is overflowing with flowers, appear the Garter insignia with the words 'Honi soit qui mal y pense'. The golden collar of the Order is suspended by two white silk bows, like those which are worn on the shoulder of the Order's mantle. To the collar is attached the 'Lesser George', a golden medal showing St George and the dragon. The flowers surrounding the urn are equally patriotic, symbolizing the various parts of the kingdom which is represented by the figure of Britannia (oak leaves and rose for England, thistles and lilies for Scotland, a harp for Ireland).

The way in which the design of the panels assumes an ability to move between flat pattern and three-dimensional space reiterates the dialectic of figurative and abstract representation which we have already remarked as characteristic of the *Vase of Flowers*. This feature links in to other forms of pattern-making in luxury consumables in the second half of the eighteenth century: the weaving of patterned silks in Spitalfields, for example. These were known as 'flowered' silks and their designs changed every season. The transitory beauty of flowers is thereby enshrined as an idea in a material form which speaks of a short time-span; the season of fashion is thus analogous to the horticultural season. Women in flowered silks walked and sat in rooms decorated with flowers set in gardens planted with flowering shrubs.[107] There

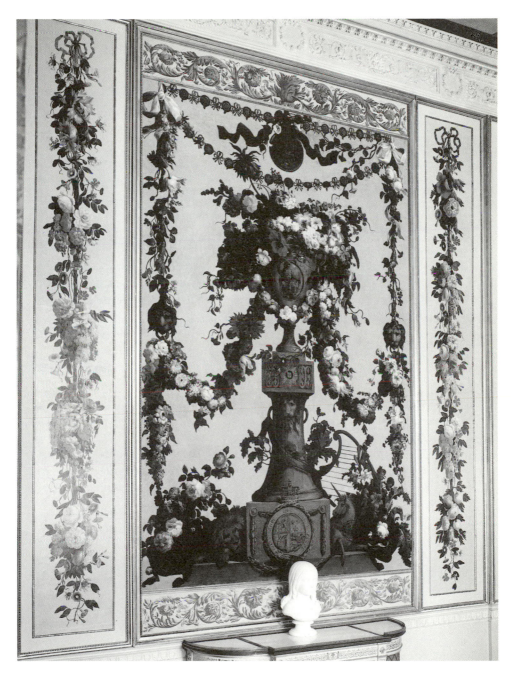

24. M. Moser, The Mary Moser Room, Frogmore, c.1792–5, The Royal Collection.
By gracious permission of Her Majesty the Queen

is talk of one of Moser's flower paintings being embroidered for the new throne room at Windsor Castle in 1782[108] so it may well have been her intention to draw such visual comparisons.

Women did not only purchase and wear flowered silks, they also designed them and wove them. This was an area, commensurate with flower painting and portrait painting, where women professionals worked; Anna Maria Garthwaite is one named textile designer working at this time with garlands and flowers very similar to those that appear in Moser's work. The decorative is part of a signifying practice, and one of major importance in this period. Ornament is conditioned, as Joan Evans pointed out, by the perceptions of the aristocracy of the time, whether it be an aristocracy of taste, learning, birth, or mere wealth.[109] The fact that a Royal Academician engages in work of this kind on the eve of the French Revolution is interesting enough and suggests the healthy survival of an ancient lack of distinction between the fine and the decorative arts despite the foundation of the Royal Academy in 1768. But Frogmore was not unique. Only the fact that it was part of the Windsor estate ensured its survival; of comparable decorative schemes little remains apart from odd panels reassembled in museums.[110]

So what was the significance of Moser's decoration within the wider scheme of royal leisure? In eschewing human figures and confining herself to abstract and botanical forms, Moser permitted a space for the viewer to enter and established a sense of continuum between house and garden. The oscillation between permanence and impermanence (architectural forms and flowers that decay) seems to have been part of an elaborate overall scheme in which aristocrats could also be peasants and in which art could vie with nature in an economy that the organizers of the entertainments of Queen Elizabeth I would have understood. This is underscored in textual references. Here, for example, is a description of a fête at Frogmore in 1799 to celebrate Princess Amelia's recovery from illness:

A heavy rain kept the visitors in the house till seven in the evening, when their Majesties and the company went to the ball-room. A long covered awning, illuminated with lamps, similar to that in Vauxhall, was erected from the house to the place allotted for the sports. The enchanting place to which they were conducted was the entire design of Princess Elizabeth, as already observed: the middle space was allotted to the dancers, and the two sides to the company. The pillars were covered with bay leaves and artificial flowers, wreathes of flowers decorating the intermediate spaces at the top: the chandeliers suspended from the ceiling were in the shape of a bee-hive: at the upper end of them [sic] formed the tassel; between each row of lamps were interwoven ears of corn, blue bells, violets, lilies of the and valley [sic]. For the accommodation of the company rush chairs were provided, and the place altogether formed a

most delightful scene. Pavilions adjoining the rooms were erected for serving the company with tea and refreshments. The ladies all appeared in white.

At the conclusion of the ball the Princess Elizabeth reconducted her company back to the house to supper. The Princess Amelia leaned on the arm of the Prince of Wales. In the supper room a beautiful transparency was displayed in compliment to the Princess Amelia; on the tablet were the words 'the offering of Gratitude for restored health'.[111]

The reference to Vauxhall, where Mary Moser's father had been responsible for designing decorative items, must by this date have been nostalgic, recalling the now faded beauties of that archetypal pastoral pleasure ground, replete with its promise of social and erotic intercourse. A place of enchantment made of artificial and natural flowers, rustic seats, and women dressed in white; this is a royal version of Richard Graves's vision of the Graces and a fantasy that readers of Erasmus Darwin's *The Botanic Garden* would have recognized in its mingling into one fecund confusion flowers natural and artificial, insects, and nubile female figures. It is, however, new technology that provides the *tour de force*; the illuminated emblem (echoing the heraldic paintings by Mary Moser) serving to set the stamp on a theatre in which nature is processed as self-conscious artifice.[112] Moser's work at Frogmore must have provided a permanent reminder—in winter as well as summer—of the fêtes held there and lent *gravitas* to those celebrations which, with their stress on emblem and ritual, likewise establish the medium in which Moser's work overall may best be understood.

Notes

1. S. Lloyd, *Richard and Maria Cosway: Regency Artists of Taste and Fashion* (Edinburgh: National Galleries of Scotland, 1995), 42.
2. The other muses are: Elizabeth Montagu, Elizabeth Carter, Charlotte Lennox, Catherine Macaulay, Anna Barbauld, Elizabeth Griffith, Elizabeth Sheridan, and Hannah More. For a discussion of this work see S. H. Myers, *The Blue Stocking Circle: Women, Friendship and the Life of the Mind in Eighteenth-Century England* (Oxford, 1990), 276–7. The representation is, of course, highly conventionalized and it would be erroneous to imagine that any such meeting ever took place.
3. See Wendy Wassing Roworth, *Angelica Kauffman: A Continental Artist in Georgian England* (London, 1992).
4. See e.g. R. Parker and G. Pollock, *Old Mistresses: Women, Art and Ideology* (London, 1981), 28. As women Kauffman and Moser were not admitted to the Life Class. However, caution is needed in discussions of both women artists and academies (the most reliable account of which is to be found in I. Bignamini and M. Postle, *The Artist's Model: Its Role in British Art from Lely to Etty* (Nottingham, 1991)). It should also be noted that these portraits fall within a long tradition for the representation of absent but venerated members of a body through *imago clipeata* (see M. Pointon, *Hanging the Head: Portraiture and Social Formation in Eighteenth-Century England* (New Haven, 1992), 65–6).

5. Parker and Pollock, *Old Mistresses*, 58.

6. For Simon Verelst, see drawings in the V. & A. 263–7—1876; for Richard Anthony Salisbury, see nine vols. of drawings in Natural History Museum and a series of drawings in the V. & A. dated 1786–1820 (7890.2, 4, 5, 18, and 19); for Alexander Dyce see *Vase of Flowers* (signed and dated 1820), V. & A. 974–8.

7. Exceptions are G. Saunders, *Picturing Plants: An Analytical History of Botanical Illustration* (London: Victoria and Albert Museum, 1995), and C. Klonk, whose Ph.D. ('Science and the Perception of Nature: British Landscape Art in the Late Eighteenth and Early Nineteenth Century', University of Cambridge, 1992) will be published shortly by Yale University Press. W. Blunt and W. T. Stearn, *The Art of Botanical Illustration* (rev. edn. London, 1994) is an excellent general account.

8. George Michael Moser and his wife were painted by Carl Michael Tuscher around 1742–3; oil on canvas, 72 × 73 cm, Jeffrey Museum, London.

9. I am grateful to Richard Edgcumb whose work on George Moser will shortly be published for discussing with me the Moser family. He tells me that Mary was baptized 22 Nov. 1744 (register in Victoria Library, Buckingham Palace Rd.) and points out that Moser's only known book illustration, a title-page vignette, appeared in *Fables for the Female Sex,* which was published the same year as his daughter's birth. For literature in print on Mary Moser, readers must still turn to M. Zweig, 'Mary Moser', *Connoisseur Year Book* (1956), 104–10.

10. For definitions of the polite in relation to private and public see S. Copley, 'The Fine Arts in Eighteenth-Century Polite Culture', in J. Barrell (ed.), *Painting and the Politics of Culture: New Essays on British Art 1700–1850* (Oxford, 1992).

11. D. G. C. Allan, 'Studies in the Society's History and Archives: Artists and the Society in the Eighteenth Century', *Royal Society of Arts Journal,* 132 (1983–4), 271.

12. British Museum, Anderdon, Catalogue, vol. iii, facing p. 703; Whitworth Art Gallery, University of Manchester.

13. The portrait was identified in the Museum zu Allerheiligen, Schaffhausen by Susanne Rosing, who has kindly allowed me to read her dissertation, 'Mary Moser: The Discovery of an Extraordinary Woman and the Development of her Work' (Christie's Education Dept. and the Royal Society of Arts, London, 1992). The portrait (A 1668) is oil on canvas, 73 × 61 cm.

14. *The Artists' Repository and Drawing Magazine Exhibiting the Principles of the Polite Arts in their Various Branches* (4th edn. London, 1788), preface, iv. 137–9.

15. For Maria Cosway, see Lloyd, *Richard and Maria Cosway.*

16. I am extremely grateful to Christopher Lloyd, Surveyor of the Queen's Pictures, for this information.

17. E. Einberg, ' "The Betts Family": A Lost Hogarth that Never Was and a Candidate for Slaughter', *Burlington Magazine* (July 1983), 416. This article reattributes a Hogarth to Slaughter. It would be interesting to know whether Grace's lost work has found its way into the Slaughter canon. I am grateful to Elizabeth Einberg for a helpful conversation about 18th-cent. women artists.

18. Ibid. She died 6 Apr. 1781 aged 70.

19. Mr Mortimer, *The Universal Director; or, The Nobleman and Gentleman's True Guide to the Masters and Professors of the Liberal and Polite Arts and Sciences . . .* (London, 1763), 26.

20. *The Artists' Repository,* 137–41. Other artists mentioned are Miss Read, Miss Benwell, Miss Moser, and the engraver Caroline Watson.

21. *The Universal Director.* The artists listed are: Miss Benwell, Mrs Carwardine, Miss Hooper, Mrs Jones, Mrs Lewis, Miss Moser, Miss Read, Miss Slaughter. *The Diary of Joseph Farington,* ed. K. Garlick and A. MacIntyre (New Haven, 1978), ii. 599 mentions a grant to Pris Todderick of 6 guineas by the Royal Academy among grants to needy dependants.

22. *A Catalogue of the Pictures, Sculptures, Models, Drawings, Prints, &c. of the Present Artists. Exhibited in the Great Room of the Society for the Encouragement of Arts, Manufactures and Commerce, on the 21st April, 1760.* Strictly speaking, this grouping formed itself into a society only as a result of this exhibition and called itself the Society of Artists of Great Britain only at its exhibition the following year.

23. *A Catalogue of the Pictures, Sculptures, Models, Drawings, Prints, &c. Exhibited by the Society of Artists of Great Britain at the Great Room in Spring-Gardens, Charing Cross, May the 9th, 1761 (Being the Second Year of their Exhibition).* Catherine Read is also a very interesting example of a highly successful 18th cent. female artist. Born in Scotland in 1723, she studied in Paris under Quentin de la Tour, and visited Italy, where the Abbé Grant (who seems to have kept an eye on her) allegedly said: 'were it not for the restrictions her sex obliged her to be under, I dare safely say she would shine wonderfully in history painting [as well as portraits].' She was patronized by royalty between 1761 and 1765 and concluded her career in India in 1779. See Lady Victoria Manners, 'Catherine Read: The "English Rosalba" ', *Connoisseur* (Dec. 1931), 376–86; (Jan. 1932), 35–40; (Mar. 1932), 171–8. Mildred Archer adds to this material in her chapter on Read in *India and British Portraiture 1770–1825* (London, 1979). She quotes (p. 120) Fanny Burney's observation that Read was 'a very clever woman, and in her profession, has certainly great merit'.

24. Mary Benwell is listed in S. Redgrave's *A Dictionary of Artists of the English School* (1878; Bath, 1970), where it is stated that she purchased the promotion of her officer husband and retired. She is described as having been an aspirant for Royal Academy honours.

25. The work of Dorcas Taylor, who is writing an M.Phil. thesis on this subject, University of Manchester, should help to rectify a situation in which Carwardine (Cawardine?) is given variously as Miss J, and as Mrs Ann. We should not, however, assume that women in this period were not breadwinners. As Amy Erickson has pointed out, 'women's work was certainly "supplementary" in the sense that their wages were lower than those of men, that they worked overwhelmingly in the service trades, and that as wives they adapted their labour to assist their husband's trades [one might add daughters *vis-à-vis* fathers in the case of the artistic professions]. But the terminology of "by-employments" reflects a later historical development—the assumption that a man "supported" his wife and children and that any contribution that they made to the family economy was incidental.' A. L. Erickson, introd. to A. Clark, *Working Life of Women in the Seventeenth Century* (1919; London, 1992), p. xx.

26. See Myers, *The Blue Stocking Circle,* 120.

27. She drew, for example, four designs for John Duncombe's *Horace* in 1767 as well as for later publications. See W. Mild, 'Susannah Highmore's Literary Reputation', *Proceedings of the American Philosophical Society,* 122: 6 (1978), 383. On the Highmore family see W. Mild, *Joseph Highmore of Holbein Row* (Ardomore, Pa., 1990).

28. Anna Maria Duncombe, Prob. 11/1702 quire 424, proved 20 Aug. 1825. See also the so-called Highmore scrapbook in the Tate Gallery.

29. Myers, *The Blue Stocking Circle,* 16.

30. F. Harris, 'Mary Black and the Portrait of Dr. Monsey', *Burlington Magazine,* 135 (Aug. 1993).

31. The death of the Revd Mr Bradbury, Dissenting minister, is announced in the *Gentleman's Magazine* as occurring in Aug. 1759 (vol. 29, p. 442).

32. H. Walpole, transcribed by Anderdon and also by Algernon Graves, *The Royal Academy of Arts* (London, 1906).

33. Parker and Pollock, *Old Mistresses*.

34. Pietro da Cortona's painting is in the Camera Veneris at the Pitti Palace; Gerard de Lairesse's painting of Seleuchus is in the Kunsthalle, Karlsruhe; a version of the subject by Pittoni is in the Museum of Fine Arts, Springfield, Mass.; a painting of this subject by Benjamin West was sold at Christie's in 1985 (signed and dated 1772) and another version is in the Worcester Art Museum, Mass.; David's painting won him the Grand Prix.

35. Redgrave, *A Dictionary of Artists of the English School*.

36. Hackney was a known centre for Baptist worship. *The Origin of the Church of Christ of the Particular Baptist Denomination, Shore Place, Hackney*, dated 13 May 1798, has an introduction signed by, among others, J. Hodgkin or Hodgkiss (Hackney Archives Dept., D/E 232 MAR 2/1), but since Grace's father seems to have been Irish it seems more likely that she was Roman Catholic.

37. See n. 35.

38. Prob. 11/1342 quire 366, proved 28 May 1800, will signed 20 Sept. 1793, MSS, Public Record Office.

39. *Gentleman's Magazine* (Oct. 1793), ii. 957. Moser's obituary, *Gentleman's Magazine* (May 1819), i. 492 refers to 'Mrs Lloyd, late Miss Moser, by which name she was best known to the public as a very eminent artist in flower painting.' I have taken my cue from this and refer to Mary Moser throughout.

40. Moser's will (PRO Prob. 11/1617 quire 283) was proved on 5 June 1819. The main body of the will was printed in J. T. Smith, *Nollekens and his Times* (1829), ed. W. Whitten (London, 1920), i. 284–6. The will contains several codicils not printed in *Nollekens*. From these it is clear that Nollekens and Joseph Moser were to be executors, but Joseph Moser died in May 1819 before Mary Moser's will was proved so Joseph Nollekens was the sole executor. The will was verified under oath by two neighbours acquainted with Moser and with her handwriting. Joseph Moser's will was signed on 10 Apr. 1817 and proved on 17 June 1819 (Prob. 11/1617 quire 286). It makes no mention of his wife Juliet, who presumably therefore predeceased him.

41. Nollekens described Moser as 'somewhat of a precise woman . . . at times a most cheerful companion'. He also states that she was very near-sighted. Smith, *Nollekens*, i. 55, 282.

42. Mary Moser to Mrs Lloyd, no date, MS private collection. Moser married the recipient's husband after he had been widowed. It is not helpful to speculate upon Moser's grounds for the views expressed in her letter but, like many women artists, she was sometimes the subject of gossip and her flirtatious correspondence with Fuseli in 1770–1 (MSS, private collection) suggests that she may have enjoyed an amorous relationship with this distinguished libertarian.

43. Mary Delany to Mrs Dewes, 6 Oct. 1750, *The Autobiography and Correspondence of Mary Granville, Mrs. Delany*, ed. Lady Llanover (London, 1861), ii. 600–1. For a discussion of Delaney, see Myers, *The Blue Stocking Circle*; for a consideration of female friendships in this period, see B. Rizzo, *Companions without Vows: Relationships between Eighteenth-Century British Women* (Athens, Ga., 1994).

44. M. Moser to Mrs Lloyd, 21 Oct. [1770], MS private collection.

45. Dr Templeman's transactions, ii. 124, MS Royal Society of Arts (Dr Templeman was the Society's third secretary, 1760–9); *A Register of the Premiums and Bounties Given by the Society* (London, 1778).

46. D. G. C. Allan, *William Shipley: Founder of the Royal Society of Arts: A Biography with Documents* (London, 1968), 48.

47. R. Dossie, *Memoirs of Agriculture and Other Oeconomical Arts,* iii (London, 1782).

48. Allan, *William Shipley,* 275. The most useful discussion of the far-reaching notion of politeness in 18th-cent. England is to be found in L. E. Klein, *Shaftesbury and the Culture of Politeness: Moral Discourse and Cultural Politics in Early Eighteenth-Century England* (Cambridge, 1994), especially introduction.

49. *Premiums by the Society, Established at London, for the Encouragement of Arts, Manufactures, and Commerce* (London, 1758), 15.

50. Dr Templeman's transactions, i. 15 and 16.

51. See Copley, 'The Fine Arts' 15, 16, 25, 27.

52. Female nude whole length, black and white chalk on paper, 49 × 30.2 cm, Fitzwilliam Museum, Cambridge. Attribution to Mary Moser of a portrait of Joseph Nollekens (Yale Center for British Art) has been questioned (*'The Pursuit of Happiness': A View of Life in Georgian England* (Yale Center for British Art, New Haven, 19 Apr–18 Sept. 1977), no. 78.

53. Quoted Zweig, 'Mary Moser', 105.

54. Quoted ibid. without a specific reference.

55. Whiteley Papers, MS British Museum Print Room, quoted in Smith, *Nollekens,* i. 286 and by Zweig, 'Mary Moser', 105.

56. I am informed by Hugh Roberts, Deputy Surveyor of the Queen's Works of Art, that the only reference to Moser in the Royal Archive refers to the commission for the flower room at Frogmore (personal communication of 30 Apr. 1993).

57. D. E. Allen, *The Naturalist in Britain: A Social History* (London, 1976), 28. On Ehret, see G. D. Ehret, 'A Memoir of Georg Dionysius Ehret . . . Written by Himself', *Proceedings of the Linnean Society* (1894–5), 41–58.

58. Allen, *The Naturalist in Britain,* 48–9.

59. See Ann B. Shteir, 'Linnaeus' Daughters: Women and British Botany' in B. J. Harris and J. A. McNamara (eds.), *Women and the Structure of Society* (Durham, NC, 1984).

60. Allen, *The Naturalist in Britain,* 28–9.

61. Ibid. 43.

62. Ibid.

63. G. Brown, *A New Treatise on Flower Painting: or, Every Lady her Own Drawing Master* (3rd edn. corrected and enlarged, London, 1799), 1.

64. Ibid. 4.

65. I am much indebted here to M. Benjamin (ed.), *Science and Sensibility: Gender and Scientific Enquiry, 1780–1945* (London, 1991), ch. 1. I am grateful to Ludmilla Jordanova for drawing my attention to this work.

66. L. Schiebinger, 'The Private Life of Plants: Sexual Politics in Carl Linnaeus and Erasmus Darwin', in Benjamin (ed.), *Science and Sensibility,* 123–9.

67. Benjamin, ibid. 35–6.

68. C. Linnaeus, *Species plantarum* was published in 1753 and extensively reviewed in the *Gentleman's Magazine* in 1754. Ibid. 42. By 1788 it had become a standard point of reference even for popular instruction manuals. See e.g. *An Easy Introduction to Drawing Flowers According to Nature by James Sowerby Originally Designed for the Use of his Pupils* (London, n.d. (plates dated 1788)). The text under plate vi advises readers to familiarize themselves with the structure of the flower by consulting Curtis's ingenious illustrations to the Linnaean system.

69. J. E. Hodgson and F. Eaton, *The Royal Academy and its Members 1768–1830* (London, 1905), 90.

70. She is listed in E. Bénézit, *Dictionnaire critique et documentaire des peintres* (3rd edn. Paris, 1976) simply as a painter of costumes.

71. *Cupid as Link Boy, c.*1773, Albright-Knox Art Gallery, Buffalo, NY.

72. E. Darwin, *The Botanic Garden* (London, 1791), part II, proem.

73. Darwin adopted the Rosicrucian doctrine of the elements that had also fascinated Pope and other earlier 18th-cent. writers.

74. Ghent, Museum voor Schone Kunsten. For a discussion of this tradition, see C. Sterling, *Still Life Painting from Antiquity to the Twentieth Century* (1952; 2nd rev. edn. New York, 1981), 49 and J. Goody, *The Culture of Flowers* (Cambridge, 1993), ch. vi.

75. Robert Furber, Peter Casteels, and Henry Fletcher, *Twelve Months of Flowers*, dedicated to Frederick Prince of Wales and the Princess Royal (London, 1730).

76. Sterling, *Still Life Painting*, 110; see also Saunders, *Picturing Plants*, 106.

77. For an account of tulipmania in English, see S. Schama, *The Embarrassment of Riches: An Interpretation of Dutch Culture in the Golden Age* (London, 1987), 350–7 and S. Schama, 'Perishable Commodities: Dutch Still-Life Paintings and the Empire of Goods', in J. Brewer and R. Porter (eds.), *Consumption and the World of Goods* (London, 1993).

78. Darwin, *The Botanic Garden*, ii. 6, ll. 62–5.

79. Sterling, *Still Life Paintings*, 23.

80. Brown, *A New Treatise on Flower Painting*, 2.

81. V. & A. 377—1872.

82. Nos. 90 and 91, 'Notes by Horace Walpole . . .', *Walpole Society* (1938–9), 68. Walpole frequently comments on flower painting.

83. This is the standard recommended practice. See e.g. J. June, *The Delights of Flower Painting: In Which is* [sic] *Laid Down the Fundamental Principles of that Delightful Art. To Which is Annexed a Curious Description of the Manner in Which Fifty . . . Flowers are now Finished by the Several Masters in that Branch* (2nd edn. London, 1756): 'Having first outlined you [sic] Flowers upon fair Paper or Vellum, proceed by laying on a proper wash, which must always be very slight, in order to preserve a natural Tenderness that is found in all Flowers, and in working it up, to bring it to its proper Effect' (p. 7). This book takes much of its material direct from the section on flower painting in C. Boutet, *Traité de mignature pour apprendre aisément à peindre sans maître* (3rd edn. Paris, 1684).

84. Sterling, *Still Life Painting*, 110.

85. As, for example, with works exhibited at the Free Society by the Revd Spooner in 1768, 1769, and 1770.

86. For a fascinating recent account of the 17th-cent. debate over line and colour in relation to linguistic theory, see J. Lichtenstein, *The Eloquence of Colour: Rhetoric and Painting in the French Classical Age,* trans. E. McVarish (1989; Berkeley and Los Angeles, 1993).

87. June, *The Delights of Flower Painting*, 8.

88. W. Paley, *Natural Theology* (London, 1802) in *The Works of William Paley DD . . . in Five Volumes* (London, 1821), quoted in F. Ferre (ed.), *Natural Theology: Selections* (Indianapolis, 1963), 13.

89. Abbé Pluche, *Spectacle de la Nature or Nature Display'd Being Discourses on Such Particulars of Natural History as Were Thought Most Proper to Excite the Curiosity and Form the Minds of Youth,* trans. Mr Humphries (3rd edn. London, 1736), ii (1740), 14.

90. *Johnson: Prose and Poetry*, selected by M. Wilson (London, 1950; 1963), 410.

91. N. Schor, *Reading in Detail: Aesthetics and the Feminine* (New York, 1987), ch. 1.

92. 'So tulip-bulbs emerging from the seed | Year after year unknown to sex proceed; | Erewhile the stamens and the styles display | Their petal curtains, and adorn the day. | The beaux and beauties in each blossom glow | With wedded joy, or amatorial woe.' E. Darwin, *The Temple of Nature: or, The Origin of Society: A Poem with Philosophical Notes* (London, 1803), canto ii.

93. J. Derrida, *The Truth in Painting*, trans. G. Bennington and I. McLeod (Chicago, 1987), 85–6.

94. *Encyclopaedia Britannica* (11th edn. Cambridge, 1911).

95. Derrida, *The Truth in Painting*, 87.

96. MS Sept.? 1775?, private collection.

97. Information contained in a letter from Hugh Roberts, Deputy Surveyor of the Queen's Works of Art, 30 Apr. 1993.

98. Smith, *Nollekens*, i. 60.

99. Ibid.

100. *The Diary of Joseph Farington* (10 Dec. 1794), i. 272.

101. *A Catalogue of the Genuine Library, Prints, and Books of Prints, of an Illustrious Personage, Lately Deceased, Which Will be Sold by Auction, on Wed. 9th June 1819 and the following days by Mr. Christie at his Rooms in Pall Mall* (9–23 June) (London, 1819).

102. See D. Watkin, *The Royal Interiors of Regency England* (London, 1984); W. C. Oulton, *Authentic and Impartial Memoirs of her Late Majesty, Charlotte Queen of Britain and Ireland* (London, 1819), 340.

103. Oulton, *Memoirs*, 341.

104. Sterling, *Still Life Painting*, 107, quoting Michael Fare.

105. Pluche, *Spectacle de la Nature*, ii. 19.

106. I take the heraldic information from Zweig, 'Mary Moser', 105.

107. Rosing, 'Mary Moser', 32–3 compares the Mary Moser room with Sèvres porcelain and the work of Grinling Gibbons.

108. Zweig, 'Mary Moser', 105 quotes a review of the RA exhibition in the *Public Advertiser*.

109. J. Evans, *Pattern: A Study of Ornament in Western Europe 1180–1900* (Oxford, 1931), p. xxxiv.

110. See e.g. fifteen painted panels by Andien de Clermont from the Scaramouche Parlour at Belvedere, Kent, executed for the 5th Lord Baltimore, 1742, and now in the V. & A. P13–28—1985.

111. Oulton, *Memoirs*, 356–7.

112. Simon Schaffer has pointed out in his fascinating article 'Natural Philosophy and Public Spectacle in the Eighteenth Century', *History of Science*, 21: 1 (1983), no. 1 that the theatrical image as an analogy for the world to be investigated was common and that Linnaean disciples cultivated the idea of astonishment, and wrote of the 'theatre of this life' (pp. 14–150).

5

Portraiture, Excess, and Mythology: Mary Hale, Emma Hamilton, and Others . . . 'in Bacchante'

I N 1776 Richard Graves, author of *The Spiritual Quixote*,[1] published a collection of poems called *Euphrosyne: or, Amusements on the Road of Life*.[2] Included in this collection is 'The Love of Order' addressed to William Jones, Esq. of Denford, Berkshire. In a section of this poem entitled 'The Cottage Garden', Graves (who was by this time celebrated for his humorously subversive and anti-heroic version of pastoral) describes himself reclining beneath his 'rustic grott | the cares of life awhile forgot'. As he sits there 'wrapt in a deep, poetic trance' he sees advancing the three Graces 'by ancient Bards so often seen'. They are not, however, clothed in 'their antique Grecian dress | the genuine charms of nakedness | But such as now-a-days one sees, | In gauze, and lace and negligees'. Fixed in rapture and surprise, he then observes that they are followed by Apollo, who turns out on closer scrutiny to be Graves's neighbour and friend. An explanation of the 'heavenly vision' is then offered by his neighbour. It is none other than his own wife and daughters: 'In her own work my wife has deck'd her | Not one of us e'er tasted Nectar.'

In this delightful narrative of a reverie, Graves articulates the fantasy of a continuum between classical mythology and present-day humanity. It was a continuum that provided, for eighteenth-century writers, a wealth of conceits and a rich vocabulary in popular parlance. Young women are addressed as

A shorter version of this chapter was published in *British Journal of Eighteenth-Century Studies* (Spring 1994). I am grateful to the British Society for Eighteenth Century Studies for an invitation to address its annual meeting in 1993, and to Leeds University Fine Art Dept. for the opportunity to present my ideas there in the same year. The spelling of 'Bacchante' varies greatly across a range of 18th-cent. visual sources; Romney, Reynolds and other artists, as well as authors like Charles Burney, employ different spellings. I have standardized the spelling throughout.

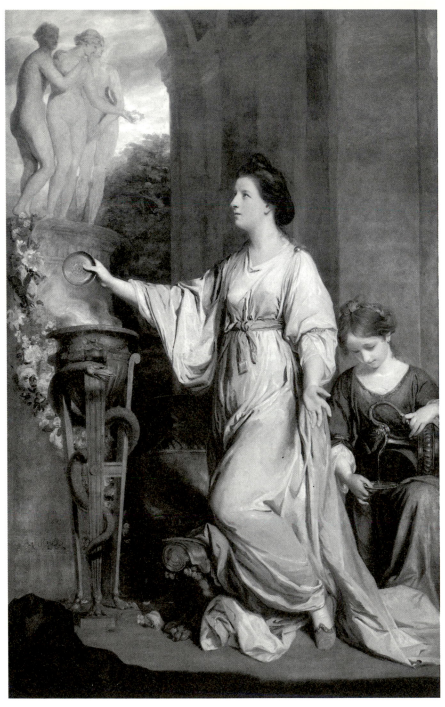

25. Sir J. Reynolds, *Lady Sarah Bunbury Sacrificing to the Graces*, oil on canvas, 1765, 242 × 151.5, The Art Institute of Chicago, Mr and Mrs W. W. Kimball Collection, 1922.4468. Photograph © 1966, The Art Institute of Chicago. All rights reserved.

goddesses by their suitors in popular novels and, as we have seen in Chapter 2, portrayed in painted images as vestal virgins making sacrificial offerings. At the level of the social, this notional continuum offered at one and the same time the opportunity for graceful compliments and the occasion of ribald comment based on antithesis. Faced, for example, with *Lady Sarah Bunbury Sacrificing to the Graces*, Reynolds's famous portrait (Pl. 25), Mrs Thrale remarked that the sitter 'never did sacrifice to the Graces; her face was gloriously handsome, but she used to play cricket and eat beefsteaks on the Steyne at Brighton'.[3] Graves's poem underlines, moreover, the propensity of readers and viewers in the late eighteenth century to switch instantly from one mode to another: one moment there are three Graces; the next moment there are his neighbours 'all plain folks—of mould terrestrial'. There is a capacity for irony at work here but, over and above that, there is a mechanism through which different sides of the same coin can be held in the mind simultaneously, like the facets of an emblem.

Richard Sennett has argued that the upper classes in the eighteenth century were literally disembodied bodily imagery—wigs, coats, hats, vests attracted attention to the wearers by the quality of these adornments as objects in themselves and not as aids to setting off the peculiarities of face or figure. He describes the surfaces of the body as backgrounds on which to inscribe ideograms.[4] It is possible to regard portraiture in much the same light—to interpret the paintings of Reynolds as offering mannequins (albeit more life-like than the previous century's) upon which insignia of wealth, gender, and status are hung. Such an approach, in so far as it makes no allowance for Reynolds's recognized skill in capturing a likeness or conveying character, would probably generally be regarded as over-reductive. On the other hand, physical appearance and character as referents are impossible not only to quantify but even to speculate upon or guess at. Sennett's example is, interestingly, male and my concern here is chiefly with female portraits which, I suggest, present a different case. None the less, Sennett's model offers a useful paradigm for recognizing the capacity of bodies in history to signify, to produce meanings in excess of definitions of individual identity. This chapter takes a cue from Richard Graves and addresses what I will call the transformative capacities of Reynolds's female portraiture, that is, its potential for re-presenting social order whilst simultaneously providing a site of fantasy. In particular I shall trace the presence of Bacchic and orgiastic elements in polite and socially harmonious female imagery based on particular human subjects.

First some explanation of my approach to Reynolds's work in relation to other more familiar lines of argument about the portrait paintings produced by this most loved and distinguished of English eighteenth-century artists. Portrait

representations appear to underpin the social ordering of eighteenth-century society; men are men and women are women in a mass of canvases from the glittering and original to the dull and prescriptive, from viscounts and marquesses to bishops, judges, and an ever-increasing flow of doctors, manufacturers, country squires, and small tradesmen. Wedgwood fitted his sitting for Stubbs in between frenetic activity in Barlaston and London, and Stubbs's painting (incorporating a sample of his manufacture prominently displayed on the bench next to him) serves to celebrate Wedgwood not merely as paterfamilias and a member of the landed gentry but also as successful inventor and producer of black basalt.[5]

It is tempting for historians of eighteenth-century culture to view the portraiture of the period as a window onto society, offering vivid and tangible access to the players on a stage. Great caution is needed here. Not only, as we have seen in previous chapters, are portraits of individuals known to have lived in the past unverifiable visual documents representing one party, commissioned and paid for (espcially in the case of female subjects) by a second party, and produced by a third party, they are also physical objects. As material property they may participate in ceremony and ritual to the meaning of which the identity of the subject portrayed may be arbitrary, incidental, or relative. Merely moving a portrait from one wall of a room to another, for example, or putting it in a different frame, will change its meanings as they are bound— since it is a material object—to be produced contextually.

Furthermore, our sense that eighteenth-century portraiture offers an unmediated view of eighteenth-century society must be understood as an inheritance from biographical accounts of eighteenth-century artists published in the second half of the nineteenth century; these biographies are themselves determined by the publication of anecdotes, journals, and letters published in the same era. Works like *The Life and Times of Sir Joshua Reynolds* by C. R. Leslie and Tom Taylor, published in 1865, are shaped by the publication of Fanny Burney's diaries, by the Thrale–Johnson correspondence, and by other similar collections. Mid- to late-Victorian society retrieved Hogarth, Reynolds, and Gainsborough as salutary and respectable representatives of an age that had earlier been dismissed as hopelessly immoral and marked by absurd clothing and dissolute manners; the retrieval took place in written and in visual form.[6] Suffice it here to affirm that our perception of Reynolds and his art is bound up with this historiography and it is a historiography that stresses the patriarchal and ordering role of Reynolds as an artist.

We should also register that by the third quarter of the eighteenth century portraiture as an art form was regarded by contemporaries as highly conflicted and contentious in terms of propriety, in its reliability as a means of expressing social truths and its ability to signify in ways that were meaningful

and desirable. 'This seems to be a Portrait-painting Age!'[7] declared one writer in an epistle to Sir Joshua Reynolds published in 1777. His protests are by no means unique.[8] He goes on to ask the cause of 'the present universal employment of the Artist in this line of Painting'. It may, he suggests, be fashion, the increase of sentiment 'which some suppose to have now attained its utmost refinement', the spirit of luxury 'which pervades all ranks and professions of men'; or it may be a union of them all. The debasement of portraiture from an aristocratic to a bourgeois art form is a common complaint at this time. The writer puts it like this:

In former times, Families of Distinction and Fortune alone employed the Painter in this line of Profession. But in these days, the Parlour of the Tradesman is not considered as a furnished room, if the Family Pictures do not adorn the wainscot. . . . But, perhaps, the ingenuity of the Artists themselves has been a very co-operating cause in diffusing this branch of Painting to so wide an extent, as it at present occupies.[9]

It would be wrong, I suggest, merely to see such complaints as the outrage of an élite at the appropriation of their favourite art form by the lower ranks; it represents a genuine crisis in meaning, in how representations of individuals are to be read. It is a crisis which the author of *A Poetical Epistle* regards as resolved by the detachment of the portrait from the original—that is the separation of the issue of portraiture from questions of likeness and identity. Thus allegorical and fancy portraits—representations of individuals enhanced by narrative interest—have rescued portraiture from its confinement to the specifics of individual likeness:

This addition of Character, whether Historical, Allegorical, Domestic, or Professional, calls forth new sentiments to the Picture; for by seeing Persons represented with an appearance suited to them, or in employments natural to their situation, our ideas are multiplied, and branch forth into a pleasing variety, which a representation of a formal Figure, however strong the resemblance may be, can never afford.[10]

Reynolds was painting allegorical female portraits a good decade before this was published and it is therefore not the case that portraits of women in historical and mythological characterizations are a simple reaction to a perceived debasement, an attempt to notch portraiture up to a higher register. None the less, the female portrait (and significantly it is the female subject that the writer of the epistle to Reynolds selects to illustrate this debasement) carried a symbolic role that had to be specially and energetically defended against this popularization.[11] This would, for example, help to explain the emergence in the last years of the century of Emma Hamilton's portraits—produced *en masse* by a variety of artists from Romney and Reynolds to Vigée Lebrun and Kauffman (Pls. 37, 41, 42, 43, 44). As the author of the epistle remarks:

Portraits, unless they were produced by the Pencil of a very eminent Master, have, from the insipid and uninteresting style in which they were generally painted, been considered as mere Trash and Lumber by all who were ignorant of the Originals. But, by the Genius of many modern Professors of Eminence, that Insipidity is vanished; and, by their Hands, a Portrait is now interesting even to the stranger, and, where its colours are of a lasting nature, will be interesting to future Ages.[12]

In other words, a conceptual split is possible by the 1770s between the original (that is the portrait subject or individual sitter) and the notion of the portrait painting as an aesthetic experience. The problematic identity of Emma Hamilton (courtesan or wife of Sir William; serving girl of humble origins or embodiment of the classical ideal through her 'attitudes')[13] facilitated this split and was celebrated through it. Emma Hamilton's very public and problematic identity precisely demanded an extreme solution: a pictorial staging in which artists collectively participated and to which audiences collectively responded, a staging through which the portrait of the low-class person was demonstrably transformed into a site of collective fantasy. Through such transformations, as the author of the epistle makes clear, portraiture could slough off its associations with tradesmen's parlours and low-class aspirations. It had stood the test of extremes: a female subject known to be of the lowest class was transformed by art into the highest ideal. Just as Amy Lyon, daughter of a Cheshire blacksmith, could be transformed first into Emma Hart and then into Emma Hamilton, so the subject's 'picturesqueness'—the propensity of her features and body to be metamorphosed—demonstrated the power of art to transform the dross and material into magic. And it was in and through female portraiture that this transformation took place.[14] We will return to Emma Hamilton in due course.

The female portrait subject is, then, an unstable signifier and, as such, is fundamentally implicated both in changing definitions of the proper functions of the portrait as art form, and in the creation and endorsement of a legitimized discourse of excess. In this chapter, I adopt as a hypothesis the idea that far from providing an ordering process reflecting social structures of eighteenth-century England, there is in Reynolds's work a strand of female portraiture that serves precisely the opposite function; these are images that provide for the expression of disorder, that establish a site of excess, of unruly passion and disequilibrium. They invite viewers, while beholding fashionable ladies, to glimpse Graces, which while they may at one level symbolize harmony, also threaten disorder, pose choice, incite sexual envy and desire for gratification.

I use the word 'Graces' here as a generic type—Reynolds's repertoire in mythological quotation was in one sense, as we have seen in Chapter 2, nar-

rowly defined by popular literature and the plates of Montfaucon and d'Hancarville.[15] But it was also much wider than a simple reference to 'Graces' would imply. I shall also be emphasizing the symbolic importance of clothing and its relation to different parts of the body, rather than viewing it either as studio prop or part of someone's actual wardrobe, though it may, of course, be those things as well. Furthermore, I shall take up some of the themes explored in Chapter 1 by positing an analogy between the material object (the canvas in its frame) and the woman represented in paint upon that canvas. I shall suggest that there is a connection between the way in which a painting of a female subject is commissioned, purchased, owned and discarded, lent, given away, or otherwise disposed of and the way in which the woman repre-sented was positioned in social and political terms. I wish to suggest, there-fore, that just as portraits of young women prior to, at the moment of, or during the years immediately succeeding marriage image individuals caught up in the contradictory legal and social framework of marriage and divorce, so they also serve as exchange objects, items which may be bartered for.

It is impossible, Lawrence Stone claims, to advance a plausible functionalist interpretation of the twists and turns of the law of marriage in England from the sixteenth to the nineteenth centuries. 'It was the product of a complex his-torical evolution in which law, ethics, and social behaviour were continually at loggerheads.'[16] The portrait in some instances literally served as a material component, the production of which ritually marked the union and which when dispensed with served, inversely, also to mark its dissolution. At the same time I shall argue that, considering marriage as a framework of legiti-mate sensuality,[17] portraits of marriageable or recently married women stage the permitted violation that is constituted by the individual act which marks entry into marriage. Society's orgiastic and aggressive vectors can be negoti-ated and contained within an imagery that stages the fantasy of the Bacchic within the celebratory mode of female society portraiture.

I shall turn first to Harewood House in Yorkshire, built by John Carr of York for Edwin Lascelles. Begun in 1759, Harewood was first inhabited in 1771. Its owner was an active Whig politician who corresponded with Rockingham in the 1760s. It was he who commissioned the particularly fine Adam interiors to the house.[18] The Music Room is one of the finest of these interiors (Pl. 26). Central and integral to its décor is Reynolds's portrait of Mary Hale. Mary Chaloner married Colonel Hale of the Light Horse on 11 June 1763.[19] She was 19 and he was 31. She died in 1803 after having given birth to twenty-one chil-dren.[20] Mary's sister Anne married Edward Lascelles, who in 1796 would become Baron of Harewood on the death of his cousin Edwin without an heir. Mary and Anne Chaloner were daughters of William Chaloner of

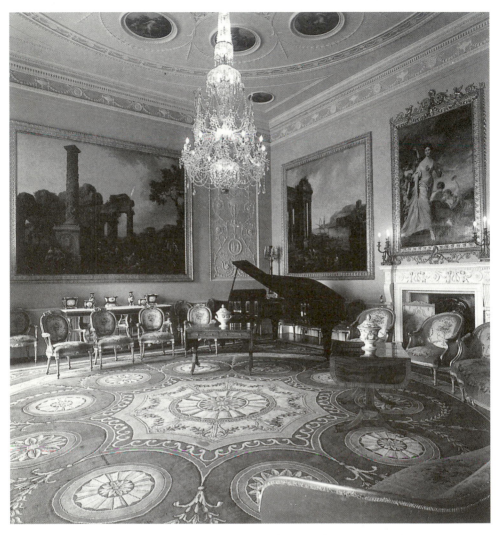

26. Harewood House, Yorkshire, Interior of the Music Room. Photo: Royal Commission on the
Historical Monuments of England

Guisborough, owner of an alum mine north of York. Anne had married
Edward Lascelles on 12 May 1761 at the fashionable church of St George's,
Hanover Square (1724) and gave birth to her first child on 10 January 1764.[21]
Edward Lascelles, like his five siblings, had been born in Barbados, where his
father was the Collector of Customs who had married in 1732 the daughter of
Guy Ball, Esq., member of the Council of Barbados. The Lascelles originated
in Northallerton in Yorkshire and Edward was elected Burgess for that con-
stituency in the same year as he married Anne Chaloner.

The Chaloners were long-established Yorkshire gentry whose wealth was
sustained on trade. They lived at Guisborough Hall and the survival of Mrs
Chaloner's account book for the years of her widowhood until her son's
majority (1754–71) give an idea of a carefully but fairly modestly run house-
hold. Anne and Mary received £10 per annum allowance but in 1760 they
received for two years an additional allowance each. This was presumably to
enable the sisters to enjoy the London season in the period when they were
looking for eligible husbands.[22] A letter of 1766 from Mary Chaloner (signed
with her maiden name though by this time she was married) to Mrs Readshaw
indicates only that she knew how to write the customary polite language of
well-bred young ladies. Having apologized for not having written earlier to
congratulate her friend on her change of situation (marriage), she goes on to
describe the pleasures of a great ball given by Miss Chudleigh on the Prince of
Wales's birthday. The Hales evidently moved in elevated circles:

We often make little excursions into ye country, ye most agreeable way in my opinion
of spending ones time this part of ye season. On Monday we dined at Lord
Widdringtons, at Turnham Green, & did not return home till ten o'clock. We have
likewise dined at Richmond, have been to see the Duke of Argyle's & Mr. Garricks
seat so that tho' the diversions of this place are partly over, yet we find amusements
enough to employ our time.[23]

The Hales set up home at Plantation House in the parish of Guisborough,
once a farm on the site of an ancient hall which Colonel Hale extended and
adorned with plantations of trees (Pl. 27). John Hale had made a considerable
reputation as a soldier in the Quebec campaign in 1759 and in serving as sec-
retary to the Earl of Albemarle on the expedition to Havana in 1762. The
speech that he delivered at the time of his nomination and election as a
member of parliament for Yorkshire in 1785 suggests that he was a liberal and
an abolitionist even though the Chaloners' business interests involved the slave
trade.[24] Bringing up twenty-one children must have imposed considerable
financial burdens but it is none the less a significant marker of the social dif-
ference between the household of Mary Hale and that of her sister Anne, who

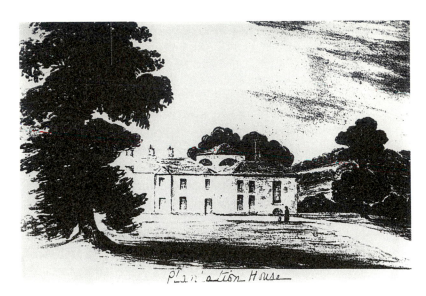

27. *Plantation House, near Guisborough*, sketch by member of the family, probably Mary Hale, North Yorkshire County Council, CRO, ZFM (Mic 1415)

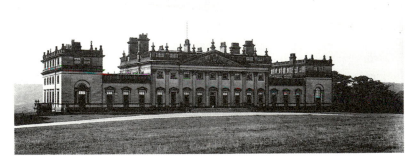

28. Harewood House, Yorkshire, north front. Photo: Royal Commission on the Historical Monuments of England

by this time was resident at Harewood House (Pl. 28), that when Mary wrote her last will and testament in 1803, she made provision for her sons Vicisimus and Edward 'to be placed with my son Francis Hale for the purpose of being instructed in the trade or business of a clothier'.[25] Another of Mary's sons, Richard (b. 1773), became Vicar of Harewood presumably under the patronage of his uncle and aunt.

If at first we seemed clearly to be dealing with a case of two eligible sisters making good marriages within three years of one another and the portrait of the younger sister providing a substitute for her presence at the home of the elder, the facts suggest otherwise. As we have seen, the social circumstances of the Chaloner sisters were different and Anne must always have had far greater expectations of wealth than Mary. Moreover, the circumstances of the commission of Reynolds's portrait of Mary Hale further dispel this idea. It was commissioned not by her brother-in-law Edward Lascelles, but by his cousin Edwin.

Pre-dating the foundation of the Royal Academy, Reynolds's portrait of Mrs Hale was exhibited at the Society of Artists in 1766 (136, *A Lady*; whole length) and it was engraved by James Watson in 1768 (Pl. 29).[26] Edwin Lascelles paid 150 guineas for the painting around 1770–1; it is not clear from Reynolds's account books precisely when it was executed but, given the exhibition date, the payment seems to have been late.[27] Adam drawings for the Music Room have survived and, although the plan with laid-out elevations is undated, the ceiling plan has a date of 1765. The chimney-piece elevation in Adam's drawing includes a large framed painting; the frame appears very similar to that which now contains Reynolds's portrait of Mrs Hale. However, the image in Adam's drawing bears no relation, indicating a static composition involving two figures at a (?) tent.[28]

So, to sum up, an image of a young woman was commissioned by a powerful landowner and political figure who had only a remote connection with her; it became, in its Chippendale frame, a focal point of an interior that was being planned between 1765 and 1771 (Pl. 30) but in all likelihood not executed until after the completion of the painting.[29] The inequality in station between Mary, the subject of the painting, and Anne, who lived with it in her music room, may have permitted a degree of freedom with subject matter that would have been unlikely in a more conventional portrait commission. Or, to push the argument further, we might be inclined, knowing these historical circumstances, to see this as more of a fancy picture than a portrait and to understand Mary Hale as more the subject of appropriation than a woman honoured by a distinguished portrayal.

As a consequence of the subsequent publication of an engraving which

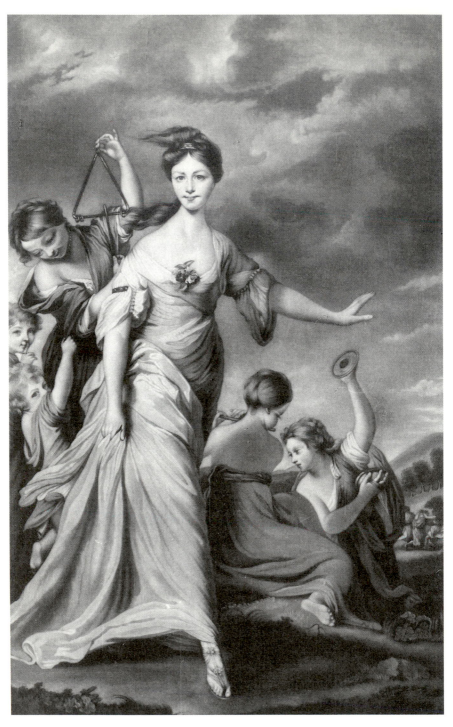

29. J. Watson after Sir J. Reynolds, *Mrs Hale as Euphrosyne*, 1768. Photo: Witt Library, University of London

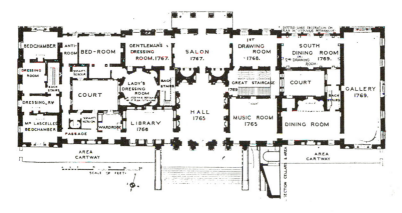

30. Interior of Harewood House, plan of the ground floor showing Music Room, completed *c.*1765

incorporates a quotation from Milton's 'L'Allegro', the painting has become known as *Mrs Hale as Euphrosyne.*[30] The guidebook currently on sale at Harewood appears to recognize the evident oddity of this image, stating: 'the picture, appropriately if surprisingly, is a family portrait, of Mrs. Hale, sister-in-law of the first Earl of Harewood, painted as Euphrosyne in Milton's "L'Allegro" with some of her children.' This is a narrative that seeks to accommodate a difficult picture into an easy framework of family and heritage. It should alert us to discrepancies and contradictions.

The pictorial origins of Mrs Hale's portrait are vividly and unequivocally Bacchanalian.[31] The dancing figure of Mrs Hale, hair streaming, sandalled foot pointed, surrounded by piping and dancing children (whom the guidebook misguidedly invites us to understand as her own), belongs in the mythological world we invoked in Chapter 2. Mrs Hale's peers are the priestesses and votaries of Hymen and Priapus familiar from the publications of Montfaucon and Bartoli,[32] and from the paintings (and even more the drawings) of Bacchanalian rites by Poussin.[33] The streaming hair and swinging clothing constitute what Lemoine-Luccioni calls the radical language of 'l'organisation pulsionnelle'; the body cannot move as well as clothing can move, thus the body only speaks through the compulsive vision of pulsation ('pulsion'). Indicating a scopic economy in which the moving clothed body is a symptom as well as a language of desire, Luccioni allows us to identify the dancing, draped, and asymmetrical figure as one that speaks more than the portrayal of the individual historical subject.[34]

Commentators on this work have tended to interpret it as part of a repre-

sentation of harmony and good cheer. They point to the lyres woven into the pattern of the carpet in the room where the painting is installed as an over-mantel (Pl. 26). Lyres, pipes, and trumpets are carved on the marble chimney, and the central ceiling panel by Antonio Zucchi depicts Midas presiding over a musical contest between Apollo and Marsyas. Music is not, however, associated only with restful harmony. If we allow for a moment the notion that the painting, like the engraving, represents Euphrosyne as invoked in Milton's 'L'Allegro', and turn to the poem, we may remark that the goddess is described as having been carried by Venus to 'Ivy-crowned Bacchus'. As she advances on 'light fantastick toe', she is invited to bring with her 'sweet liberty' and Mirth with whom the poet longs to live 'in unreproved pleasures free'.[35] The interpretation of Milton's Euphrosyne as a licentious figure is borne out in Fuseli's rendering at the end of the century for the Milton Gallery (Pl. 31).[36] The portrait of Mrs Hale is the centrepiece of an ensemble comprising caprices in which the gods, goddesses, and the imagined mortals of ruined civilizations sport with abandon, dance, play instruments, and make amorous dalliance. The wall and ceiling panels by Angelica Kauffman and Antonio Zucchi reinforce this licentious theme. In *The Ruins of Dalmatia*, for example, one of Zucchi's large wall panels, a young woman plays a triangle, echoing Mrs Hale's attendant, in accompaniment of a male companion on the lute. Lightly clad women and swarthy men dance beside a ruined archway.

Richard Leppert has drawn attention to the defensive tone adopted by popular dance collections and etiquette books, signalling the potentially subversive nature of dance as a social practice. Seventeenth-century Puritans were deeply opposed to theatre, music, and dance and, although dancing was a popular and legitimate pastime among respectable people in mid-eighteenth-century England, it was still recognized to carry with it potential dangers. These dangers were understood to be sexual. As Leppert puts it, dance and music were 'twin components of immoral leanings which together—and through women—contrived to destroy men's virility. . . . Dance was dangerous to the spiritual purity of men who might be (even physically) polluted by women in physical motion.'[37] We shall return to this question of movement and its representation.

If the Harewood Music Room thematizes sound in a context which offers the possibility not only of order (in Adam's synchronized design of roundels and stuccoed borders) but also of abandonment of order, the portrait of Mrs Hale places sight and vision as pre-eminent in a composition which daringly invokes disorder. Prominently situated to Mrs Hale's right is a female figure who has just clashed her cymbals; these are of an antique type commonly seen in the hands of fauns and satyrs on Greek vases and reproduced in the history

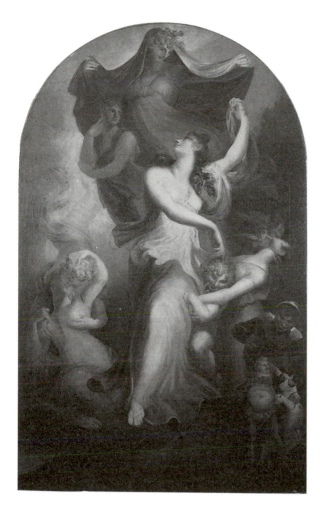

31. J. H. Fuseli, *Euphrosyne*,
oil on canvas, 1799–1800,
55.3 × 24.3, Kurpfälzisches
Museum der Stadt Heidelberg
(Leihgabe des Ministeriums
fur Wissenschaft und Kunst)

of music that Reynolds's friend Dr Burney published in 1789 and to which Reynolds subscribed.[38] As Burney's text makes plain, the cymbals are unmistakably Bacchanalian:

The Cymbalum, or Crotalo. This instrument is frequently to be seen in the Bacchanalian sacrifices and processions represented in ancient sculpture. It is still in general use in eastern countries, and has lately been introduced among the troops of almost all the princes of Europe, on account of its utility in marking the steps of the soldiers, with force and precision during their march. The present engraving was made from an ancient painting at Portici, in which it is placed in the hands of a Baccante, who beats time upon it to her own dancing.[39]

32. C. Burney, *A General History of Music*, London, 1776, iv, pl. 4, by permission of The British Library, London (557*f12)

The Bacchanalian origins of musical instruments are pictorially established in Burney's account in plate iv, where a series of male and female minstrels playing a variety of wind and string instruments are interspersed with antique masks (Pl. 32).[40] Moreover, in a passage which specifically links the story of Orpheus with Sir Joshua Reynolds's *The Infant Hercules* (1788), Burney identifies Politian's *Orfeo* as the world's first attempt at musical drama. Act V, 'Baccanale', stages 'Orpheus, one of the Menades (not Thracian women), and a chorus of Menades, who tear him to pieces'.[41] As Burney states, 'the whole of this drama which, from its brevity seems chiefly to have been sung, is admirably calculated to impassioned Music of every kind'.[42] Menades or Maenades are Bacchantes— priestesses of Bacchus under a different name. They are traditionally represented 'at the celebration of the Orgies almost naked with a thyrsus and dishevelled hair. Their looks are wild, and they utter dreadful sounds and clash different musical instruments together.'[43] Reynolds had in his own possession representations by earlier artists who had been inspired by Bacchanalian themes: two attributed to Rubens and one each to Crespi and Jordaens.[44] In the manner of mythic ancient literature, Bacchantes are shifting and unstable signs whose other manifestations are maenads and furies. The origins of the words 'manic' and 'mania' lie unequivocally with these female figures. The irresistible attraction, sexual freedom, and artistic inspiration of the Bacchanals is amply conveyed in Euripides' *The Bacchae*. So, too, is the commonsensical pragmatism of civic responsibility in the person of Pentheus, whose palace is destroyed by Dionysus when he refuses to worship him like a god.[45]

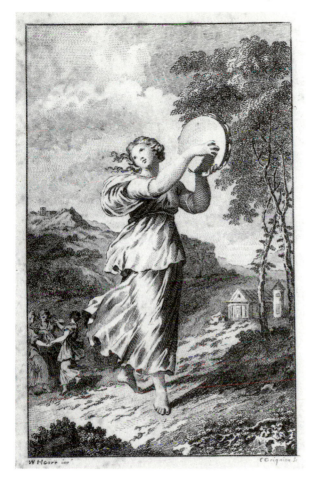

W. Hoare inv. C. Grignion Sc.

33. C. Grignion after
R. Hoare, frontispiece to
R. Graves, *Euphrosyne: or,
Amusements on the Road of Life*
(1776), London, 1780, by per-
mission of The British Library,
London (11661. bb. 3)

Euphrosyne, with whom Mrs Hale is identified in the engraving after
Reynolds, is one of the three Graces and represents good cheer.[46] The fron-
tispiece to Richard Graves's *Euphrosyne*, with which I opened (Pl. 33),[47] offers
us a near contemporary Euphrosyne, but we should notice that while Mrs
Hale herself plays no instrument, here Euphrosyne plays the tambourine, an
instrument that also has powerful Bacchanalian associations, as we shall later
observe. The pose of Euphrosyne and the relationship between the main
subject and the figures in the far background is similar, if reversed. In so far as
Mrs Hale is not semi-nude or naked, she is not overtly 'in bacchante'.
However, in the engraving in particular her looks are 'wild', her hair is cer-
tainly dishevelled as many contemporary and subsequent critics noticed, and
she is surrounded by different musical instruments. The triangle just being

struck, the black storm clouds, the piping and apparently 'topless' girl immediately to Mrs Hale's right, and the extraordinary orgiastic group of grappling, tumbling figures in the background all serve to point up the Bacchanalian theme. Taking the cue from the Guercino-like child with its fingers to its lips, we engage with Mrs Hale's inexorable advance. There can be scarcely any other work by Reynolds that displays such asymmetry: arms flail in space, of the nine figures in the composition only Mrs Hale is seen entire, and she is pushed into the left-hand half of the picture space in such a way as to produce an effect of extreme struggle for balance and for mastery of space. Her left hand points back to the orgiastic mêlée in the background, her right foot, with its cloven, satyresque appearance, extends into the viewer's space. The result is a precarious tension and a dynamic disequilibrium, rather than any form of classical resolution such as a male portrait based on a classical source like the Apollo Belvedere might have offered.[48] Nor has all this gone unnoticed: though criticism tends to be formulated within the bounds of an aesthetic language, discomfort with the latitude of the image is unmistakable. Tom Taylor, for one, says: 'I cannot but class the Euphrosyne among [Reynolds's] few ungraceful pictures. . . . The disposition of the hair, streaming upwards, is singularly unlovely, and this is the stranger with a painter who has made even the yard-high "fetes" and yard-wide "frissures" of his own time tolerable to us by the exquisite taste of his treatment.'[49]

Later in the century, the 'cloven-footed' dancing female figure as Bacchante, sometimes full-length with cymbals, tambourine, or musical accompaniment, sometimes head and shoulders, became a standard fashionable type. There is a tendency of modern-day commentators to identify all these images with Emma Hamilton but that is certainly incorrect. Angelica Kauffman painted a striking image in 1785 (which, probably apocryphally, is called a 'self-portrait') (Pl. 34), one of a pair with *Ceres*, Samuel Woodforde's 1788 *A Bacchante* (Pl. 35) is described as 'thought to be Lady Hamilton',[50] Elizabeth Vigée Lebrun produced a portrait of a dancer with a tambourine (now in the Musée Cognaq Jay), and at Chatsworth there is a sculpture by Lorenzo Bartolini (1777–1850) of a reclining Bacchante whose tambourine is inscribed with a wine goblet, vine leaves, and grapes (Pl. 36). A reclining figure of Emma Hamilton at the mouth of a cave on the coast of Naples (?), holding a goblet and leaning on a leopardskin, by Elizabeth Vigée Lebrun (with a copy by Henry Bone, now in the Wallace Collection), seems to have set the reclining type, which became popular in the nineteenth century when it rapidly lost its potential to shock. Indeed, a painting by Charles Rossiter (1827–90) that recently passed through the sale room showed a Bacchante with tambourine and leopardskin with a baby and bore the title *Teatime*.[51] There is, however, no doubt that the associ-

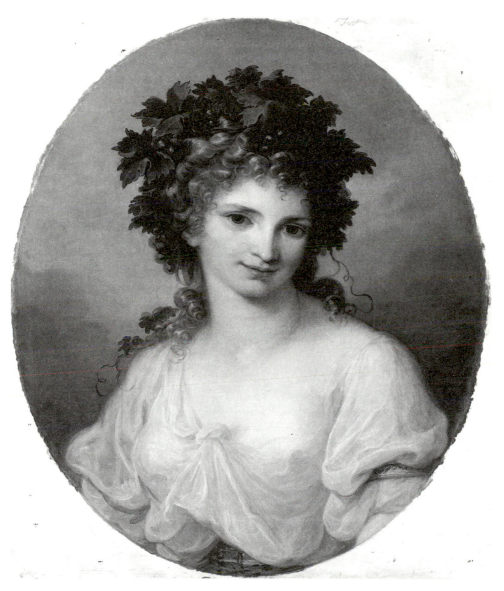

34. A. Kauffman, *Self-Portrait (?) as a Bacchante*, oil on canvas, 1775, 74 × 61, Staatliche Museen zu Berlin Kulturbesitz Gemäldegalerie

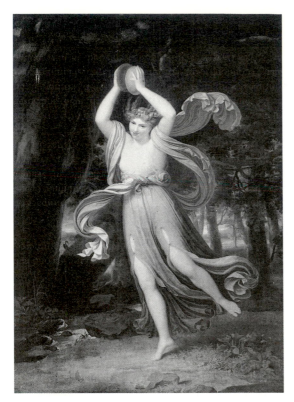

35. (*left*) S. Woodforde, *A Bacchante,*
oil on canvas, 1788, 137 × 99,
Christie's, 11 October 1993

36. (*below*) L. Bartolini, *Reclining
Bacchante*, Devonshire Collection,
Chatsworth. Reproduced by
permission of the Chatsworth
Settlement Trustees. Photo:
Courtauld Institute of Art

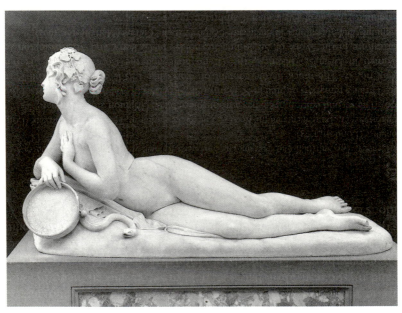

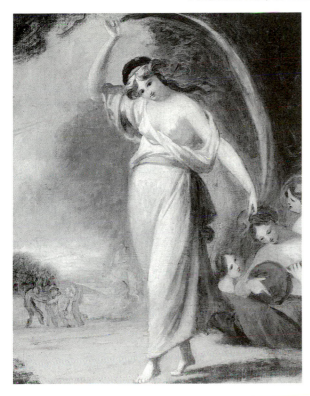

37. G. Romney, *Emma Hamilton (?) as a Bacchante*, oil on canvas, 38 × 30.5, Sotheby's, 17 February 1988

ation of the subject with Emma Hamilton gave it a certain excitement in the last decades of the century. Nor did Romney, in his variations on this theme, neglect to refer back to *Mrs Hale as Euphrosyne,* suggesting that an artist of Reynolds's own generation perceived clearly that this portrait was, indeed, 'in bacchante'. One of the versions painted by Romney (an engraving by R. Sayer shows the main figure only) allegedly shows Emma Hamilton dancing in a landscape with movements not unlike those of Mary Hale while to her left and slightly to the rear is a group of musicians and, in the distance, a Bacchanalian dance (Pl. 37).[52]

Reynolds's portrait of Mrs Hale pioneered a way of representing female subjects that became, by the end of the century, familiar as a generalized image. Male figures were never shown in Bacchanalian pose nor are there, to the best of my knowledge, any portraits of male subjects as classical gods. Quintilian explicitly forbids 'tossing or rolling the head till the hair flies free' in his recommendations to orators and actors because such movements are associated with ecstatics and with maenads.[53] To eighteenth-century audiences, images of women represented in energetic and ecstatic dance, like Mrs Hale

in Reynolds's portrait, must have signalled the very reverse of the figure of the male orator which, as Solkin has shown, was much favoured for masculine subjects.[54] They thus provided a counterpoint to, and an assurance of, the credibility of civic masculinity. Reynolds's portrait of Mrs Hale, in its physical setting, exemplifies therefore the artist's capacity to produce icons of uncertainty, images of Bacchanalian disorder that could, through their context in an ordered interior arrangement, and through their link to a particular socially established family, anchor and secure that disorder in ways which permitted the pleasurable contemplation of excess without its attendant miseries. Reynolds's *Discourses* are usually read as purveyors of immutable truths, rigid regulations, and canonical prescriptions. If, however, we engage with them as texts and contexts, that is as something that is not totally opaque, refusing to be brought to light, nor totally transparent and appearing in some kind of referential purity,[55] we might draw attention to two instances in which a reading against the grain of the *Discourses*, a symptomatic reading, might yield evidence.

In Discourse II (1769) Reynolds allows for excess in imagination. Provided disciplined study has taken place, the artist may attain 'a sort of sovereignty over those rules which have hitherto restrained him'. Having thoroughly established his judgement, the artist may now 'without fear try the power of his imagination'. The words Reynolds uses here are strong and resonant in an era that produced also Burke's *Enquiry* and James Parsons's *Passions*:[56] 'The mind that has been thus disciplined, may be indulged in the warmest enthusiasm, and venture to play on the borders of the wildest extravagance.' In Discourse III, delivered the following year (1770), Reynolds states that the way to the ideal is via recognition of the grotesque. Only by 'discovering what is deformed in nature . . . what is particular and uncommon' can the artist attain the abstraction of ideal beauty.

However circumscribed this assertion (reiterated in a number of different ways throughout Discourse III) Reynolds here not only authorizes but actually insists upon identification and contemplation of perfection. There is, says Reynolds, no attaining perfection without thoroughly knowing, by experience, the nature of imperfection. It is, therefore, reasonable to conclude that Reynolds's *Discourses*, the first two of which were delivered around the time that Mrs Hale was being painted, enshrine an interest in grotesque and imperfect forms and in excesses of imagination. Admittedly these were supposed to be tempered or discarded in the artist's final product but this is hardly germane if one takes the *Discourses* as texts in which contested and conflicted ideas about the role of representation and the function of the artist are simultaneously present.

'The borders of the wildest extravagance', to take up Reynolds's phrase, 'the warmest enthusiasm', were conditions of mind that were frequently invoked also by writers on marriage in this period, from the moralistic to the hedonistic. A common language predicated upon ideals of rationality and temperance articulates, in the process, a fascination with excess and uncontrolled desire. In considering the outward and legislative conditions for this intersection of discourses we might cite again the Hardwicke Marriage Act of 1753 that sought to curb clandestine marriages and which gave rise to what Stone describes as a pamphlet war.[57] But this stream of literature, much of it from the pens of the clergy, is by no means the only or the dominant discourse of marriage in the period of the late 1750s to 1770s. The royal marriage of 1761 generated in the pages of the *Universal Magazine* and the *Gentleman's Magazine* a vast euphoric outpouring of nuptial verse. [59] Moreover, the topic of divorce was vigorously and passionately debated by members of both sexes in novels like Henry Fielding's *Amelia* (1751), in essays, poems, and private correspondence.[59] For example, Mary Moser gave both the orthodox Christian view, and her own pragmatic worldly view, of divorce in a letter to her intimate friend Mrs Lloyd some time during the 1770s.[60] Furthermore, we need to take into account the huge body of literature, semi-medical, semi-mythological, semi-pornographic that was published to provide sexual advice to young men, and to which reference was made in Chapter 2.

Stone offers an account of the 1753 Marriage Act which, correctly, stresses its origins in the desire of ruling-class parents and landowners to ensure their children and heirs did not make secret marriages that would result in the dissipation of their property. He likewise draws attention to the widely acknowledged need to establish a means of absolute and secure universal legal proof of marriage. But if we read some of the literature generated by the Act as imaginative (rather than primarily legal), it may be seen to inflect aspirations and desires much wider and more complex than have perhaps been allowed. Under the influence of the Commonwealth, it was argued that a wealthy man who did not marry was at fault because 'his want of Posterity is a Loss to the Poor whose maintenance is deriv'd from those Employments, which they obtain from the Rich'.[61] In the mid-eighteenth century, by contrast, arguments about marriage centre on questions of natural law and civil liberty ('There must be a fixed time in society when Men are to begin to act like free Men').[62] Henry Stebbing, Chancellor of the Diocese of Sarum and Chaplain in Ordinary to His Majesty made one of the most effective interventions:

When the question is asked, what Power the state has to deny Protection to Marriage Contracts; it is supposed that Marriage has a natural Existence of its own, antecedent to, and abstracted from, all the Laws of Civil Society. And there is in fact nothing more

certain. Marriage there was before Civil Societies began; And Marriage there would be again if all Civil Societies in the world should be destroyed.[63]

Responses to Stebbing's argument express deep anxiety about parental control—'who in a state of nature is to judge thereof?', to use the words of Joseph Sayer, a sentiment with which many late-twentieth-century parents would feel in accord.[64] But issues of control rapidly lead to questions of licence and questions of licence to processes of procreation and the passions engendered therein. The state of perfection in women for producing fine children is not, it is argued, reached until the age of 21. 'The same although not quite so obviously holds as to men: for so exstatick and transporting is the conjugal caress, that human nature in its most vigorous state can but just bear it.'[65]

The problem of bastardy and the nation's foundlings had been energetically brought to public attention since the 1720s and 1730s.[66] The legal term for adultery was 'criminal conversation', suggesting a subversion of that most valued eighteenth-century commodity, the easy communication between gentlemen of education and taste, especially as many cases of 'crim. con.' were demonstrated to result from prior agreements in the financial interests of one party.[67] A husband could, in other words, recover damages from the other man if he could prove 'criminal conversation' with his wife's body, pointing up the belief in a husband's legal possession of his wife's body as manifest through exclusive physical ownership.[68] Adultery, divorce, and prostitution were topics debated in all the literary media with anguish and with a passionate conviction.[69] Women are exhorted when faced with a disagreeable man to 'smooth your brow; compose your temper; and try to amend it by chearfulness and good nature'.[70] Woman's power to disrupt social order is to be feared and her temper must, therefore, be held in check:

Happily for men, the generality of women do not know their own power, or how much mankind would be their slaves, were they constantly to exert those tender and endearing arts, which nature has so long lavishly bestowed on them. Anger, violence, and rage deform the female figure, and a turbulent woman disgraces the delicacy of her sex.[71]

It now seems unsurprising that the idea of Euphrosyne, or Good Cheer, should have been attached to Mrs Hale's portrait when it was engraved (Pl. 29). The lyres which are woven both literally and metaphorically into the fabric of the Music Room at Harewood House could all too easily—when juxtaposed with a portrait redolent of Bacchanalian associations—recall the fate of Orpheus who had the misfortune to encounter a group of wild maenads who tore his body to pieces limb by limb. An image of the young and vivacious Mary Hale that inflected notions of untrammelled liberty, of human

nature verging on Bacchanalian excess, was doubtless extremely exciting as a visual experience for educated viewers soaked not only in the classics but also in the published debates on marriage and sexuality. Health, vigour, energy, and procreation were seen to belong in a logical sequence leading to the production of a 'nobler breed' to bless the earth. *The Joys of Hymen* makes this connection explicit:

> Let the deform'd avoid the rites of love
> And none but beauteous limbs the raptures prove:
>
> For only those whom health and vigour bless
> Are fit for love, and proper to caress.[72]

Recommending morning sex for more certain procreation of male heirs, the author predicts after-dinner copulation as likely to produce a feeble offspring:

> Fresh from the festal board, if thus you meet,
> Not long the transport, nor the bliss complete,
> While Love's warm balm in vain you seek to pour,
>
> An unconcocted, tepid, drizzling show'r:
> For hence no males replete with gen'rous fire
> Shall spring; no beauteous damsels call you sire.[73]

Hung in a public room as part of a major decorative project, Reynolds's painting of Mrs Hale signifies as an icon of licensed sexual excess: health and vigour, beauteous limbs, good cheer, can all be accommodated in an image that is at one and the same time an object of desire and a portrait of a neighbour, just as Graves's vision was of celestial Graces and ladies visiting him from next door. The Bacchic wildness—with its dangers to the male subject—is contained and controlled by the genre of portraiture and the regime of exhibition.

What I have raised here is the possibility that a portrait, hanging in a particular ensemble, might be a calculated and recognized site of fantasy for its viewers. But this painting prior to its inclusion in the Harewood décor was exhibited in London. When Mrs Hale's portrait was shown at the Society of Artists in 1766, it was presented merely as 'A Lady'. This was the usual practice. At the moment of ritual entry into the public domain—the moment of display—the portrait posed a question; the image invited the viewer to guess, to speculate, and to fantasize. Admittedly there is also evidence that portraits were seen as unproblematic. As a typical Royal Academy reviewer in the *London Chronicle* puts it: 'As to portraits, landscapes, conversation pieces, and the like, whose meaning and merit must be obvious at first sight, I shall pass

them over unnoticed. I shall confine myself chiefly, if not entirely, to history pieces.'[74] But a disclaimer like this might well be read equally as evidence precisely of the powerful hold of portraiture, a hold that generated the necessity for public disavowal. For certain it is that the exhibition rooms were full of portraits.[75]

As Lacan established, there is always a lure in looking. The dialectic of the eye and the gaze is such that they do not coincide so that all looking interposes objects which fail to satisfy because identity starts with a prior lack—the loss of the mother.[76] I am suggesting here that a portrait of an unidentified female sitter in this arena staged this moment of desire in a particular way. Seeing was itself increasingly difficult as the century progressed. Mary Hale's portrait now enshrined at Harewood had appeared before the public in the overcrowded environment of the Society of Artists. Somewhat later a reviewer at the Royal Academy described his task as 'to tear away the gauze and the glitter, which are nothing; and to point out a few good performances . . . As a celebrated writer said "he could not see the wood for the trees", so here it is difficult to discover the pictures for the frames.'[77] Here the process of mediating images to a public is presented as a process of unveiling, of tearing away the gauze and the glitter. But portraits (and particularly portraits of women) were markedly unstable iconic signs and, while a reviewer might tear away the gauze and, for example, reveal a subject's identity, equally portraits could generate narratives that would not necessarily enhance anyone's reputation though they might engage the fantasies of viewers. Thus, following the popular tradition of Peter Pindar, humorous and offensive epigrams were published to accompany exhibited portraits; these epigrams demonstrate the structural relationship that allows mythological referencing to provide a demonized reverse side to social propriety both for women and for men. Lycurgus, for example, writing in the *Gazeteer and New Daily Advertizer* on a sitter identified only as Lord C—y (Coventry?) declares:

> The crown of Venus binds his ample brow;
> What was Priapus once, is C—y now.

Nor does the female sitter rendered as part of a family group emerge unscathed:

> She ends a Saint, a Sinner did begin;
> That groupe would hide a multitude of Sin.[78]

Quotations such as these, typical of extensive press coverage of exhibited portraits in the second half of the eighteenth century, demonstrate the dialectical nature of portraiture. This view is endorsed if we consider a poem of 1777

dedicated to Reynolds which suggests an imaginative engagement with the female portrait as an object allowing in effect transference of the properties of the woman onto the physical attributes of the canvas. The portrait described here is specifically a mythological or 'fancy' painting of the type to which Mrs Hale's belongs. The passage opens:

> Painter, thy Pencil well may trace
> A Juno's awful, heavenly grace;
> Upon your Canvas may be seen
> Chaste Beauty's fair, imperial Queen.[79]

The poet, his commissioned portrait complete, bears it home and 'smiling, view'd it o'er and o'er'. When the subject, Maria, was away, he 'gaz'd on it all the live-long day', hoping her cheeks would continue to bloom for years to come. If she died, he thought, all his hopes would centre on this portrait. However, as he looks he sees the paint fading, the vivid colours melting away, and the lively tints decayed.

> And ere twelve fleeting months were o'er
> The lovely Charmer blush'd no more

It seems at this point that we are contemplating the physical decay of Maria herself. Indeed, the portrait and its subject are elided to the extent that either reading is possible. The poet rescues the reader from this ambiguity by an attack on the ephemeral quality of a painting which deteriorates so much that only when the mezzotint after the painting is shown do people recognize it as Maria.[80] The failure of fantasy—so closely tied to the material existence of the painting—suggests that culturally portraits of women were invested by male viewers with qualities proper (albeit imagined and idealized) to actual women. Portraits were construed in accounts like this as objects which could fill the gap between the ideal world of Venus and passionate love and the real world of marriage legislation and 'criminal conversation'. Of course, in effect, they failed to do this but the expectations of what they might do were powerful in legitimizing collective fantasy. It is the appeal to collective fantasy that helps to explain the metamorphosis of Mary Hale (née Chaloner) into Euphrosyne and the translation of a portrait of a remote relative by marriage into the centrepiece of Edwin Lascelles's elaborate Music Room in his newly built mansion at Harewood.

The separation between image and actuality blurs in the case of Emma Hamilton. History offers us many narratives, many representations of the poor girl who as a result of her personal charm and appearance advanced herself in life and eventually made an impressively advantageous marriage.

38. Emma Hamilton performing her 'Attitudes', engraved by T. Piroli, in *Drawings Faithfully Copied from Nature at Naples and with Permission Dedicated to the Right Honourable Sir William Hamilton . . . by his Most Humble Servant Frederick Rehberg. Historical Painter in his Prussian Majesty's Service at Rome*, London, 1794, University of London, Warburg Institute Library

The theme may have lent itself particularly to the fantasy we have identified: that which elides the distinction between subject—in this case Emma Hamilton—and the material object of the painted canvas on which her image appears. The oscillation between representation and subject that permitted the poet to speak of the canvas as though it were the woman (the dangerous Platonic trope of mimesis that has fascinated western viewers since the writings of antiquity and which reaches its summation in the Pygmalion story as told by Ovid) was suspended in the performances of Emma Hamilton in which she was seen as a moving, ambulant, work of art. This performance is now known chiefly through the drawings produced by Rehberg (Pls. 38, 39).[81] Goethe also left a description which testifies to the attraction of Emma's attitudes as creating an illusion of static imagery come to life. Goethe's inclusion of the Apollo Belvedere is, perhaps, not only an indication of the sexual nature of Emma's performance (venturing into cross-sexual transgression) but also a reason for questioning the apparently unproblematic nature of this statue as a model for masculine portraiture in eighteenth-century England:

39. Emma Hamilton performing her 'Attitudes', engraved by T. Piroli, in *Drawings Faithfully Copied from nature at Naples and with Permission Dedicated to the Right Honourable Sir William Hamilton . . . by his Most Humble Servant Frederick Rehberg. Historical Painter in his Prussian Majesty's Service at Rome*, London, 1794, University of London, Warburg Institute Library

Sir William Hamilton, who is still living here as English ambassador, has now, after many years of devotion to the arts and the study of nature, found the acme of these delights in the person of an English girl of twenty with a beautiful face and a perfect figure. He has had a Greek costume made for her which becomes her extremely. Dressed in this, she lets down her hair, and with a few shawls, gives so much variety to her poses, gestures, expressions etc., that the spectator can hardly believe his eyes. *He sees what thousands of artists would have liked to express realized before him in movements and surprising transformations*—standing, kneeling, sitting, reclining, serious, sad, playful, ecstatic, contrite, alluring, threatening, anxious, one pose follows another without a break. She knows how to arrange the folds of her veil to match each mood, and has a hundred ways of turning it into a head-dress. The old knight idolizes her and is enthusiastic about everything she does. In her, he has found all the antiquities, all the profiles of Sicilian coins, even the Apollo Belvedere. This much is certain: as a performance it's like nothing you ever saw before in your life.[82]

Emma Hamilton (and her promoter) offered her body as a picture to an audience (which, if Goethe is to be relied upon, seems to have been exclusively male), as a representation which bridged the gap between actuality (perfor-

mance) and fantasy (representation). In Goethe's account Emma is a picture come to life. It is interesting therefore to set this alongside Elizabeth Vigée Lebrun's description of the event she orchestrated for the benefit of the duc de Berry and the duc de Bourbon. In her account, Emma is a performer tranformed into a picture: 'Je plaçai au milieu de mon Salon un très grand cadre, enfermé, à droite et à gauche, dans deux paravents. Je posai une énorme bougie . . . afin qu'elle éclairât Lady Hamilton comme on éclaire un tableau. Elle prit dans ce cadre diverses attitudes avec une expression vraiment admirable.'[83]

In this account Emma Hamilton *is* the picture. The desire to close the gap between representation and reality has taken an ultimate turn in a spectacle organized for two male viewers. Presumably Emma Hamilton thus positioned offered that much-sought-after paradoxical form of representation—the image of a subject more like herself than herself.[84] On the other hand a *tableau vivant* like this could not serve so well as a painted canvas in the patterns of substitution that were involved in the psychic play of desire. We shall return to Emma Hamilton. Meanwhile another Harewood portrait by Reynolds will illustrate how the viewer's investment worked at the level of fantasy and desire, an irrational practice of viewing which served to elide the object (painting) with the subject (sitter).

Reynolds's portrait of Lady Worsley (Pl. 40) is described by David Mannings as one of the artist's 'most spectacular female portraits'.[85] Lady Worsley is dressed in a riding habit which, even allowing for the fashion for women's riding dress to be modelled closely on masculine attire, is stridently male. A jacket distinguished by military revers, fastened by hooks and eyes at the chest, is worn over a waistcoat fastened from left to right (the man's side) and with an officer's gorget at the neck. Lady Worsley is wearing the colours of her husband's regiment, the Hampshire militia (of which he became colonel in 1779),[86] and she carries a whip. To later observers, it seemed clear that Lady Worsley was wearing her husband's uniform.[87] Exhibited at the Royal Academy in 1780 as 'Portrait of a Lady', the painting remained in Sir Richard Worsley's possession for only a relatively short time. The Worsleys' seven-year marriage came abruptly to an end in 1782 when Sir Richard, controller of the royal household, sued Major G. M. Bissett for £20,000 for eloping with his wife. At the trial for 'criminal conversation', which (according to Stone) would have been decided by a special jury of gentlemen in a matter of minutes, Lady Worsley having no right to speak,[88] it emerged that Worsley had encouraged Bissett's interest in his wife by raising him up on his shoulders so that Bissett could peer through an upper window and see Lady Worsley naked as she washed herself. This was a revelation which gave much ammunition to caricaturists.[89]

Lady Worsley allows us to apprehend how an image of a female subject

40. Sir J. Reynolds, *Lady Worsley*, oil on canvas, 1781, 236 × 144, Earl of Harewood.
Photo: Royal Academy Library

could be at one and the same time private property and public icon, a relationship that had to be negotiated via the same tangle of ambiguous allegiances that caused such an expensive and scandalous sequence of events in the real-life narrative of the subjects involved. Since Lady Worsley is represented wearing an outfit that replicates her husband's military colours at the time of acute fears of a French invasion, her portrait offers her body as a national icon. In other words, superimposed on the identity 'Lady Worsley' is a more powerful and collective identity, 'Hampshire militia', signifying at this time the defence of the realm. As many writers have demonstrated, actual women have often been translated into symbols in this way.[90] The fact of cross-dressing, however, also enhances Lady Worsley's image as an object of desire, making her a kind of transgressive eighteenth-century cabaret figure. The events (exciting events) of a threatened invasion might temporarily license women to wear men's clothes, and the contemporary fashion for women's riding habits might authorize society women to dress in masculine clothing,[91] but enshrined in portraiture such acts of collective fashionable daring become individual and permanently embodied records of transgression. The long-established notion that painting makes one love reality all the more lent such icons as *Lady Worsley* the authority of theory and history.[92]

Like the Bacchic, cross-dressing unsettles categories and threatens social disorder. In the words of Marjorie Garber, 'transvestism is a space of possibility structuring and confounding culture: the disruptive element that intervenes, not just a category crisis of male and female, but the crisis of category itself.'[93] Clothing and dress allowed people to recognize who a person was, to what rank they belonged, and to which sex. Dislocations caused by servants dressing as masters or mistresses and by all forms of cross-dressing were highly dangerous, and eighteenth-century novels testify to the seriousness of this matter. In marriage, the period demanded openness and honesty just as there had to be no dissembling either in gesture or dress between husband and wife. 'When persons are married, they should have no secrets; each should reveal their thoughts and actions to the other . . . Disguise, either in disposition or dress is unpardonable.'[94] Yet, as a number of writers have established, women clad in an approximation of male attire but not fully disguised as men are objects of desire (and we only have to think of principal boys in pantomimes, bunny girls with bow ties, and Liza Minnelli in the film *Cabaret* to recognize the truth of this). The reverse is not the case.[95] So Lady Worsley's portrait invites spectators at the Royal Academy in 1780, the British Institution in 1851, the Manchester Art Treasures exhibition in 1857, the Royal Academy in 1875, and the Grosvenor Gallery in 1884 to view a female subject seductively transgressive but not so disguised as to be improper.[96]

To turn now to the material presence—the painting—given away by Lord Worsley shortly after the legal hearing described above. Just as Reynolds's image of Lady Worsley functioned as a sign of elements other than Lady Worsley herself—defence of the realm, symbol of nationhood, object of fantasy and desire—so the actual object, the painted canvas, functioned as a body analogous to the physical body of the woman re-presented upon it. Lady Worsley's body, owned by her husband in marriage, was represented in paint on canvas dressed in his clothes. Ownership is thereby doubly underlined. In marriage he made the sight of that body available to a third party; in the ritualized world of commodity ownership and exchange, he gave away the symbolic body of his wife at the moment she ceased to be his property. He gave away a representation of her body clad in masculine clothes which were not uniquely his in design but his as member of a regiment. The portrait of Lady Worsley by Sir Joshua Reynolds was thus given to Mr Lascelles (Edwin Lascelles had married Lady Worsley's mother Jane Fleming) and that is how it comes today to hang at Harewood House.

It was not unknown for women, as well as their portraits, to be items of exchange value in eighteenth-century England. The best-documented case is probably that of Emma Hamilton, to whom we will now return to take a look at how a young woman, without her knowledge, came to be given away. The story of Amy Lyon, born on 26 April 1765, the daughter of a Cheshire blacksmith, is well known. In the spring of 1781 Amy was installed by Sir Harry Fetherstonhaugh in his house at Uppark. In November the same year, the pregnant Amy was thrown out by her protector. One of his friends, Charles Greville, then aged 35, took her in and became her lover and educator. Charles Greville was nephew of the childless Sir William Hamilton, manager of his affairs and estates in England, and his assumed heir. I say 'assumed' because it is clear from correspondence of 1785 that Sir William had not, up to this date, been explicit with regard to his intentions.

I draw attention to this because the notorious episode in which Charles Greville handed over his unknowing young lover to Sir William brings together a number of themes related to property transactions that are worth examining closely, as they suggest a conceptual frame encompassing different categories of possession and, implicit within this, various possibilities for dealing, bartering, and exchanging goods. Women, and portraits of women, are locked into this system. Sir William Hamilton had met his nephew's mistress in London and on his return to Naples he wrote, in February 1785, in reply to an offer from Greville to acquire paintings for him. After mentioning a Salvator he wants 'as it is the exact companion to my landscape',[97] he begs Greville to send 'those at Romany's [Romney's] with Emma's picture'. He

41. G. Romney, *Emma Hamilton as a Bacchante*, oil on canvas, c.1786, 48.3 × 40.1, Tate Gallery, London

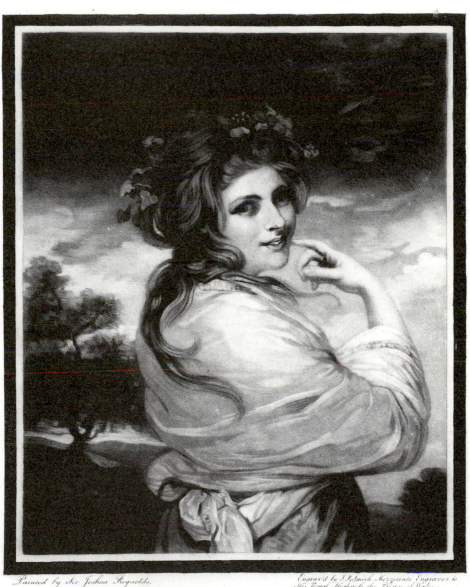

Painted by Sir Joshua Reynolds.

Engrav'd by J.R.Smith Mezzotinto Engraver to
His Royal Highness the Prince of Wales.

A BACCHANTE

42. J. R. Smith after Sir J. Reynolds, *A Bacchante*, British Museum, London

instructs Greville to 'tell Emma even Reynolds's consumptive Scots' woman is a cons[olation] to me as it is like enough to [tear in paper] one of her' (see Pls. 41, 42).[98] The next time Sir William writes, on 1 June 1785, he is responding to an enquiry from Greville concerning his will (Greville's side of the correspondence has not survived) and his plans for Emma. Sir William's interest in Emma had already been aroused and sustained via the provision and promise of representations of her, portraits by Romney and Reynolds which were either already in Sir William's possession or to be sent to him in Naples. Now, having been sent the portraits, he is offered the portrait subject; having contemplated the symbolic body and perceived it as inadequate (Reynolds's 'consumptive Scots' woman'), he is invited to enjoy the actual body. Running alongside and simultaneous with this negotiation is a much larger negotiation about property into which the deal involving the unknowing and objectified Emma is absorbed.

Sir William, on 1 June 1765, finally declares unequivocally his intention to leave his estate to Greville and then, responding to the bait which Greville has used to bring his uncle to this declaration, states: 'As to E. was I in England & you was to bring your present plea to bear & she would consent to put herself under my protection I would take her most readily for I really love her & I think better of her than of anyone in her situation.' But Sir William is sensible not only of Emma's situation (her low birth and status as kept woman) but also of the huge age difference between them.

But my Dear Charles, there is a great difference between her being with you or me for . . . she may love you when she could only esteem me and suffer me—I see so many difficulties in her coming here should you be under the necessity of parting with her that I can never advise it—tho' a Great City Naples has every defect of a Province and nothing you do is a Secret.[99]

Sir William offers to settle £50 a year on Emma if Greville chooses to send her to the country to leave him free to marry but Sir William, despite his earlier caveats, also leaves open the possibility of his own capitulation to desire at the expense of good judgement:

I do assure you when I was in England tho' her exquisite beauty had frequently its effects on me it never would have come into my head to have proposed a freedom beyond an innocent kiss whilst she belonged to my friend—& I do assure you I should like better to live with you both & see you happy than to have her all to myself for I am sensible I am not a match for so much youth and beauty.[100]

As is well known, Charles Greville did get his way; Emma was sent to Naples to 'belong' to Sir William. The conclusion of the transaction involved not only Emma the person but also portraits of her. Whether Emma was the

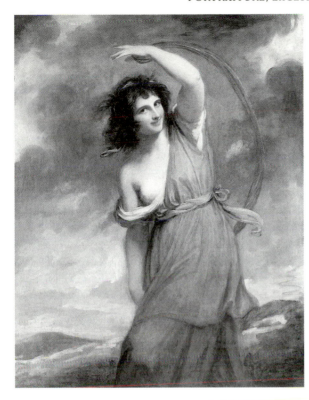

43. G. Romney, *Emma Hamilton as a Bacchante*, oil on canvas, 151 × 119.5, Sotheby's, 29 November 1978

price paid for his assured inheritance (an inheritance that was ironically threatened when Emma succeeded in persuading Sir William to marry her) is hard to say. What cannot be in doubt is that the protracted negotiations over the inheritance were inextricably intertwined with a deal over Emma as a person and that this deal was accompanied and marked by the symbolic exchange of portrait representations of Emma. The discourse of the early exchanges between Greville and Hamilton references portraits by Romney and Reynolds. Furthermore, having relinquished her person, Greville proceeded to discard Emma in representation. The famous portrait of Emma Hart as a spinstress was commissioned by him. It was unfinished at the time Greville sent Emma to Naples and when he relinquished his claim on it it was purchased from Romney's studio by Christian Curwen.[101]

In representing Emma Hart as a Bacchante in the 1780s, artists like Reynolds (Pl. 42), Romney (Pls. 41, 43), and Elizabeth Vigée Lebrun (Pl. 44) were explicitly playing on the ambiguity about those kinds of associations female portraits could invoke, associations which had implicitly attached to Reynolds's portrait of Mrs Hale as Euphrosyne from twenty years earlier.[102] Ainsworth's

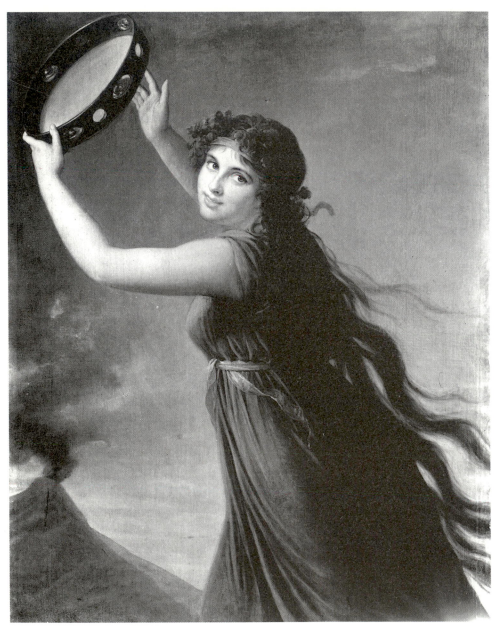

44. E. Vigée Lebrun, *Lady Hamilton as a Bacchante,* oil on canvas, 132.5 × 105.5, Board of Trustees of the National Museums and Galleries on Merseyside (Lady Lever Art Gallery)

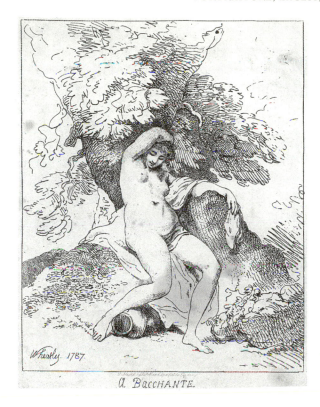

45. F. Wheatley, *A Bacchante*, etching, 1787, British Museum, London

Thesaurus of 1746 gives two definitions for Baccha: a she-priest of Bacchus or, quite simply, a courtesan. A Bacchanal is, similarly, 'the place where the feasts of Bacchus were solemnized' or, quite simply, 'a bawdy house'. Bacchans means, it is stated, 'raging mad'.[103] The ambiguities are clearly manifest in an etching by Francis Wheatley (Pl. 45) in which a Bacchante suggestively reclines at the foot of a tree accompanied by a large vessel.[104] Raging madness is an attribute attached to another portrait of a Baccha, or woman of easy virtue, associated with Charles Greville and exhibited at the Royal Academy in 1781, the year Greville took Emma Hart into his protection. This is a painting, always understood to be a portrait, known as *Thaïs* (Pl. 46). Just as 'Portrait of a Lady' obscured the identity of a sitter and invited interrogation, so mythological names like Thaïs incited discussion about the subject who was similarly known to have been a particular person. Paid for some time between 1781 and 1783, *Thaïs* also belonged to Charles Greville, who sold it around about that time.

 Thaïs generated a mass of narratives at the time of its exhibition and has

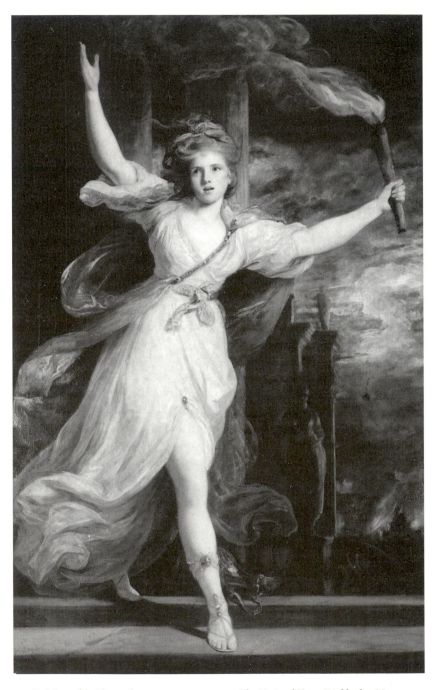

46. Sir J. Reynolds, *Thaïs*, oil on canvas, 229.2 × 144.2, The National Trust: Waddesdon Manor. Photo: Courtauld Institute of Art

continued to arouse speculation since.[105] Like all the images I have been discussing—apart from the portrait of Lady Worsley—*Thaïs* is well known from an engraving.[106] According to (the not very reliable) William Hickey, Reynolds had 'painted her portrait many times and in different characters'.[107] He gives an account of the subject as Emily Pott, or Emily Warren, the mistress of his friend Bob Pott. A scurrilous contemporary newspaper, the *Earwig*, identifies the face as painted from the famous Emily Bertie and states that the painting remained long in the artist's studio after the first sitting. This account suggests that Emily Bertie commissioned a portrait but was unable to complete the payments, whereupon Reynolds turned her into a raging pyromaniac, setting fire to the Temple of Chastity.[108] Northcote calls the sitter Emily Coventry and says that the head only was painted in 1776 on a whole-length canvas.[109] Graves and Cronin summarize the various accounts and also quote from contemporary reviews which described *Thaïs* as 'a woman of the town' and as being too 'masculine' in appearance.[110] The speculative and fantastic narratives woven around the painting suggest that it touched a rich vein of imaginative association for late-eighteenth-century audiences.[111]

At this point we may reintroduce Reynolds, the artist, and turn back to his portrait of Mrs Hale as Euphrosyne (Pl. 29) to establish a series of connections which will help to explain both how Mary Hale came to be represented implicitly 'in bacchante' and how *Thaïs,* not a depiction of a Baccha but certainly wild, fits into this patterning through which a dangerous femininity is constructed and controlled. Attention has been drawn recently to two oil sketches by Reynolds, both depicting a flimsily clad and mischievously laughing female figure with outstretched hands poised to clash together a pair of cymbals of the sort we have identified in Mrs Hale's portrait at Harewood.[112] These two sketches have been linked to a life study (chalk on paper on loan to the Royal Academy) of a nude female figure holding an arrow. While the oil sketches are extremely close in composition, the chalk drawing, presenting a figure facing the other direction, seated, and with her head at a quite different angle to her body, appears not to belong to this group. Martin Postle has related all three studies to Reynolds's *Garrick between Tragedy and Comedy*, hence the dating of 1762. Drawing a connection between the painting and Shaftesbury's famous essay on the Judgement of Hercules in *Characteristicks*, he identifies the figure of Comedy towards whom Garrick is inclining as Shaftesbury's 'Pleasure', or Euphrosyne.[113] If, indeed, this is Euphrosyne, then it would suggest that in Reynolds's imaginative repertoire of types (and we know well how frequently he repeated and adapted motifs) the Grace who represents good cheer and happiness is part of a feminine repertoire that includes Bacchic figures clashing cymbals. In other words, far from there being

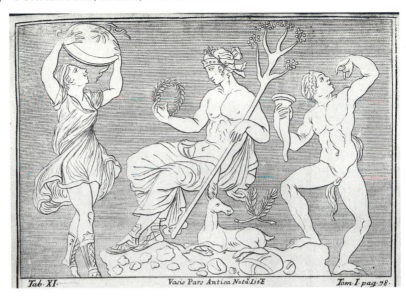

47. T. Dempster, *De Etruria regali libri*, Florence, 1723, VII, i, tab xi, p. 78, by permission of The British Library, London (622.11)

any contradiction between Euphrosyne and the maenads they are, in the peculiarly eighteenth-century reinvention of classical mythology as a field of psychic play, very much one and the same. Nor was this repertoire unique to Reynolds. A comparison between the frontispiece to Graves's *Euphrosyne* and, for example, the figure of a Baccha dancing and playing the tambourine from Dempster's *De Etruria regali* (Pl. 47) suggests that Euphrosyne is here, also, understood to have Bacchic connotations.[114]

A closer look at the three-quarter-length oil sketch reveals that this figure is close in many respects to that of Thaïs. Indeed, in the details of her dress, she is closer to Thaïs than to Pleasure/Comedy in *Garrick between Tragedy and Comedy*. The figure in the Garrick painting wears a full-length gown but Thaïs wears a garment that is slit at the knee and fastened with a jewel identical to that in the oil sketch. All this goes to show that Reynolds never wasted a good idea but, more than that, it offers evidence of the slippage between virtue and vice, between an exemplary femininity and a dangerous sexuality. It suggests that the kind of ambiguity that makes Reynolds's portrait of Mrs Hale so appropriate for a music room (music having the power both to soothe and to incite to excess) threads through a variety of work across a long period of the artist's career. It suggests that clothing and other material items in Reynolds's female portraits are neither mere decorative ballast nor particular personal

attributes but comprise a language of allusion which is highly nuanced. Thus, while Thaïs (Pl. 46), like Mrs Hale, possesses no cymbals or tambourine and instead carries a flaming torch, her very pose and garment indelibly connect her to the maenad class of female. However, the exposed knee and thigh to which attention is drawn by a well-placed jewel, which we have already remarked, is a feature which tends to be reserved in eighteenth-century painting for representations of Venus. We may observe it in, for example, Angelica Kauffman's 1768 *Venus Showing Aeneas the Way to Carthage*.[115] Similarly Mrs Hale's escaping locks of hair and wild gestures are unmistakable signs which connect her to the Bacchic figures that share the picture space. At the same time she remains Euphrosyne—one of the Graces, and the respectable and virtuous wife of Colonel Hale.

Music is also the medium that is thematically central to *Thaïs*. Mistress to Alexander the Great, Thaïs is said to have persuaded him to burn the Palace of Persepolis. In 1753 Handel's *Alexander's Feast* had been performed in London to a text based on Dryden's poem of 1697, in which recitatives in praise of Bacchus 'ever Fair, and ever Young' are sung but in which Thaïs does not herself burn down the temple but leads the King towards the 'glitt'ring Temples' of the Persians' 'hostile Gods'. Thaïs here is likened to Helen, and is described as 'firing another Troy'.[116] The link with Helen underscores the connections between sexual desire and potential social destruction. The orgiastic imagery of Emily Bertie/Pott makes vividly present the dilemma of an age which produced not only *Serious Thoughts on the Miseries of Seduction and Prostitution* (1783) but also countless works with titles like *The Blessings of Polygamy Displayed* (1781).

In the same Royal Academy exhibition at which *Thaïs* was presented, Reynolds also exhibited *The Death of Dido* (Pl. 48).[117] I merely want to draw attention here to the fact that Dido's tragic and dramatic suicide is the consequence of her desertion by the desired Aeneas. The triumphant courtesan or Baccha, Thaïs, and despairing Dido were seen by Fanny Burney in Reynolds's studio in 1781. Also being prepared for exhibition was what has become one of Reynolds's most famous and much-loved portraits, 'the three beautiful Lady Waldegraves', as Burney describes it, 'Horatia, Laura and Maria' (Pl. 49).[118]

One of the questions that a consideration of paintings like *Thaïs* or *The Death of Dido* brings to the fore is how eighteenth-century audiences negotiated the boundaries between portraits of society ladies and portraits of courtesans and actresses. It is important to remember that Reynolds's mythological paintings, which often seem an embarrassment to scholars of today, were not only hung alongside Reynolds's portraits in the Royal Academy exhibitions but often aroused a more enthusiastic response than his portraits.[119] Slippages

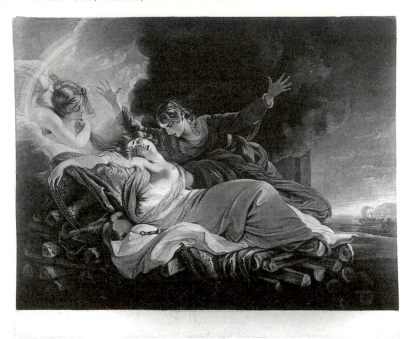

48. J. Grozer after Sir J. Reynolds, *The Death of Dido*, pub. 19 May 1796, British Museum, London

between portraiture and mythology echoed ambiguities in real life. Actresses were often understood to be potentially, if not actually, courtesans but celebrated actresses also not infrequently made very good marriages. An unstable continuum from the stage, to being the mistress of one or more distinguished and wealthy man, to an economically beneficial marriage is inflected in the instabilities of the range of references upon which artists like Reynolds and Romney drew in their portrayals of women whether ostensibly 'respectable', like Mrs Hale, or evidently licentious, like Emma Hamilton.

I began by identifying in *Mrs Hale* elements in the image and in the history and circumstances of its location that suggested that boundaries between courtesans and society ladies, if indeed they clearly existed, were blurred in actuality and deliberately ambiguous in ideology. The liminal spaces occupied by women represented in poses and settings with Bacchic connotations were consciously provocative. Rather than being a question of a choice between femininity in its married or marriageable state and licentious objects of sexual desire exhibiting Bacchanalian excesses, it was much more a question of a structural relationship between these two possible conditions, an axis or continuum in which one mode is never clear-cut or independent of the other.

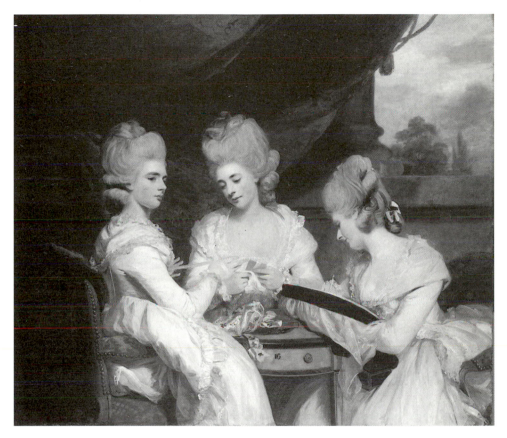

49. Sir J. Reynolds, *The Ladies Waldegrave*, oil on canvas, 1781, 143.5 × 168, National Gallery of Scotland, Edinburgh

Marriage, divorce, and prostitution are, I have suggested, in the second half of the eighteenth century, social and medical discourses which governed the representation of women in portraits. Female portraiture thereby is understood to function promiscuously, a major public genre heavily invested as a site of collective fantasy, and an arena for the articulation of desire. What, then, of Reynolds's apparently straightforward, non-mythological, non-allegorical portraits? Do these contradict the argument I have mounted?

When Fanny Burney visited Reynolds's studio, she saw there a portrait (Pl. 49) which we might think the antithesis of *Thaïs* (Pl. 46). The sitters are titled ladies, not courtesans. They work at their embroidery, rather than flourishing flaming torches. They are shown seated and dressed in the height of fashion, rather than whirling with tambourines in flimsy drapery. Shown in three-quarter length, their legs and thighs are invisible. But the portrait of the Ladies Waldegrave, for all this contemporaneity, for all these signifiers of the actual, was instantly interpreted in ways that constructed it as part of a common language of classical allusion. Richard Graves, author of *Euphrosyne*, allowed his vision to slip from Graces to actual women, from a fantasy of sexual gratification to the reality of social intercourse. Horace Walpole, the Waldegrave sisters' uncle and commissioner of the portrait, commented (possibly ironically) that he had wished 'to have them drawn like Graces adorning a bust of the Duchess [their mother]' but his idea had not been adopted.[120] But women as images were infinitely open to appropriation and the deflection of Walpole's declared intention did not prevent visitors to the Royal Academy from immediately associating the three young women with the three Graces. One critic, contrasting this portrait with that of Lord Richard Cavendish, also by Reynolds and hung above it, says 'without any impropriety they might have been stiled Graces, on account of their own personal perfection, as well as the skill of the Master'.[121]

There is a further respect in which we may recognize the portrait of the Ladies Waldegrave as participating in, rather than being marked by separation from, the licentious world of classical mythology. Thaïs bears a flaming torch but her pose (as well as her persona as narratized in contemporary texts) is that of a Baccha or Bacchante. The distinguishing feature of the Baccha for eighteenth-century audiences is the tambourine; the maenad in Dempster's copy of an antique urn flourishes one (Pl. 47), Emma Hamilton waves one aloft before a view of Mount Vesuvius in Vigée Lebrun's portrait (Pl. 44), in a drawing by Angelica Kauffman (engraved by Bartolozzi in 1780) the Baccha holds both thyrsis and tambourine (Pl. 50).[122] In *The Bacchae*, Pentheus declares he will keep the women in his own household to work the looms, 'and that will stop their fingers drumming on tambourines!'[123] Tambourines were, like

50. A. Kauffman, *A Bacchante*, pencil and chalk on grey paper heightened with white, British Museum, London (1886-10-12-5-4-1)

the similarly Bacchanalian cymbals that feature in Mrs Hale's portrait, very ancient instruments, known to have been used in Rome, familiar from Poussin's Bacchanalian scenes, and associated in the eighteenth century also with salacious orientalist settings.[124]

So Thaïs is a Bacchante without her tambourine (though, as we have seen, there is a thematic linkage through oil sketches to the idea of music), as well as an Alexandrian courtesan, and a beautiful Helen, dangerous inflamer of sexual passion, destroyer of cities and cultures. Wheatley's image of Thaïs, engraved in 1779, presents her as a bare-shouldered Bacchante with flowers in her tangled locks and a torch in place of a tambourine (Pl. 51). The Ladies Waldegrave (Pl. 49) are not Bacchantes but they may be Graces—so one of

THAIS.

Painted by F. Wheatley. *Engraved by T. Watson*

London, Published March 10th 1779, by Watson & Dickenson No 158 New Bond Street.

51. T. Walton after
F. Wheatley, *Thaïs*, pub. 10
March 1779, British Museum,
London

them might be Euphrosyne and thus dangerously close to drifting into the Bacchanalian mode. They are goddesses rather than priestesses but none the less they are dangerously suggestive of passion. Propriety, the commissioner, the social status of the sitters holds the Bacchanalian in check, masks it, and makes it invisible. Yet does it? As Fanny Burney noticed when she saw the portrait of the Ladies Waldegrave in Reynolds's studio, and it was the only thing she did notice, these beautiful young women are 'at work with the tambour'.[125] The tambour, like the tambourine, is a kind of drum (or tabor), a circular frame within which is a second frame which stretches taut the cloth to be embroidered. It was a device which fashionable young women employed in order to embroider gowns but, particularly, to produce the immensely popular flowered waistcoats worn by men in this period. The language of the period links female labour, mythology, and giving favours to the male sex. Horace Walpole received a gift of a waistcoat from Lady Ossory at New Year 1775 and wrote: 'The present I saw came from no mortal hand . . . Venus had

chosen the pattern, Flora painted the roses after those at Paphos, Minerva worked the tambour part.'[126] Tambours, sometimes of large dimensions, feature in the female portraits of Reynolds and Angelica Kauffman.[127] The wild and mystic festival of Bacchus, held in secret and attended by women only, re-enters the text. The duality of vision that enabled Graves to see Graces and female neighbours informs also this most discreet of portrait representations of young marriageable females and reminds viewers of the possibility of licentious excess at the heart of English metropolitan society.

Notes

1. R. Graves, *The Spiritual Quixote: or, The Summer's Ramble of Mr. Geoffrey Wildgoose: A Comic Romance* (London, 1773).
2. *Euphrosyne: or, Amusements on the Road of Life by the Author of The Spiritual Quixote* (London, 1776). The second edition, 1780, has a frontispiece by C. Grignion after W. Hoare.
3. Mrs Thrale's remark is quoted in N. Penny (ed.), *Reynolds* (Royal Academy of Arts, London, 1986), no. 57. The mock heroic content of works like this is discussed by Gill Perry in 'Women in Disguise: Likeness, the Grand Style and the Conventions of "Feminine" Portraiture in the Work of Sir Joshua Reynolds', in G. Perry and M. Rossington (eds.), *Femininity and Masculinity in Eighteenth-Century Art and Culture* (Manchester, 1994).
4. R. Sennett, *The Fall of Public Man* (Cambridge, 1974; 1977), 69, 70.
5. G. Stubbs, *The Wedgwood Family*, 1779–80, the Wedgwood Museum, Barlaston.
6. See P. Barlow, 'The Backside of Nature: The Clique, Hogarthianism and the Problem of Style in Victorian Painting', Ph.D. thesis (University of Sussex, 1990) and K. Diggens, 'The Influence of Reynolds and Gainsborough on Nineteenth-Century Portraiture', Ph.D. thesis (University of Manchester, 1995).
7. *A Poetical Epistle to Sir Joshua Reynolds* (London, 1777), introd.
8. See e.g. *Catalogue of the Portraits and Pictures in the Different Houses Belonging to the Earl of Fife* (n.p., 1798), dedicated to Benjamin West, preface.
9. *A Poetical Epistle*, introd.
10. Ibid.
11. For a most perceptive discussion of the difficult definitions of femininity in the second half of the 18th cent., see Harriet Guest, 'A Double Lustre: Femininity and Sociable Commerce, 1730–1760', *Eighteenth-Century Studies*, 23: 4 (Summer 1990).
12. *A Poetical Epistle*, introd.
13. These were the classical poses she adopted in *tableau vivant* that made such an impact on Neapolitan society and which were drawn by many artists. See *Drawings Faithfully Copied from Nature at Naples, and with Permission Dedicated to the Right Honourable Sir William Hamilton . . . by his Most Humble Servant Frederick Rehberg. Historical Painter in his Prussian Majesty's Service at Rome* (London, 1794), engraved by Thomas Piroli; G. Chazal, 'Les "Attitudes" de Lady Hamilton', *Gazette des beaux-arts*, 6th ser. 94 (1979), 219–26.
14. There are a number of sensational biographies of Emma Hamilton and, recently, a novel by Susan Sontag based on her life. See e.g. Flora Fraser, *Beloved Emma* (London, 1986) and Susan Sontag, *The Volcano Lover* (London, 1992). On Sir William Hamilton, see B. Fothergill, *Sir William Hamilton, Envoy Extraordinary* (London, 1969). For images of Emma Hamilton, see *Lady Hamilton in Relation to the Art of her Time* (Iveagh Bequest, Kenwood, 18 July–16 Oct.

1972) and O. E. Deutsch, 'Sir William Hamilton's Picture Gallery', *Burlington Magazine*, 82 (1943), 36–41. Portraiture also, arguably, was able to endow courtesans and actresses with crucial qualities of class and elegance, sustaining the magic of their performance into a fantasy of real life through the mode of portraiture. This accounts for the preponderance of subjects from this class of person in the *œuvres* of major 18th-cent. portrait painters.

15. P. V. d'Hancarville, *Collection of Etruscan, Greek and Roman Antiquities from the Cabinet of the Honble Wm. Hamilton* (London, 1766–77); B. de Montfaucon, *L'Antiquité expliquée, et représentée en figures* (Paris, 1719).

16. L. Stone, *Road to Divorce* (Oxford, 1992), 137.

17. The term is George Bataille's. See *Eroticism* (1957), trans. M. Dalwood (London, 1962; 1987), 109.

18. Letters to the 2nd Marquess of Rockingham are among the Wentworth Fitzwilliam Papers in the Sheffield archives (NRA 1083). The foundation stone was laid on 23 Mar. 1759. See J. Jewell, *The Tourist's Companion or the History and Antiquities of Harewood in Yorkshire* (Leeds, 1819), 18, 20. On 30 Sept. 1766 Edwin Lascelles entertained the Duke of York and on 22 Sept. 1767 he held an elegant 'Turtle Feast'. His wife died 11 Sept. 1764. See 'Extracts from the Leeds Intelligencer 1763–67', *Thoresby Society*, 33 (1930–2), nos. 544, 656, 741.

19. *Gentleman's Magazine*, 23 (June 1763): 'Marriages'; her address is given as New Bond St.; Reynolds also painted a portrait of Colonel Hale (oil on canvas, 126.4 × 101 cm), University of Western Ontario, Canada.

20. Chaloner family papers, annotations and notes, MSS N. Yorks. County Record Office.

21. See Jewell, *The Tourist's Companion* for a family tree including details of the place of marriage; the birth of Anne's first child is recorded in the *Gentleman's Magazine*, 34 (1764).

22. Mary Chaloner's account book, MS N. Yorks. County Record Office (MIC 1415 ZFM 84–9).

23. Mary Hale (née Chaloner) to Mrs Readshaw, 11 Jan. 1766, MS N. Yorks. County Record Office (MIC 2050, 2270 ZFM).

24. Testimonies signed by Maj.-Gen. W. Kepple and Maj.-Gen. James Murray, MS; 'The Speech of Lt. Gen. Hale . . . 1785', both N. Yorks. County Record Office (MIC 1419 002029 ZFM).

25. Last will and testament of Mary Hale, 20 Sept. 1803, MS N. Yorks. County Record Office (MIC 1419 002029 ZFM).

26. See David Mannings's entry in Penny (ed.), *Reynolds*, no. 75.

27. Ibid., no. 61.

28. I am grateful to Mrs Margaret Richardson, Assistant Curator at the Soane Museum, for providing me with information concerning the Adam designs for the Harewood Music Room.

29. The designs by Adam for the interiors are dated 1765–71, ibid. Michael Rosenthal has pointed out (personal communication) that Mrs Hale's dress matches the colour of the ceiling, raising the question of whether the colour scheme was devised to accord with the portrait.

30. According to A. Graves and W. Cronin, *A History of the Works of Sir J. Reynolds* (London 1899–1901), ii. 414, *Mrs Hale* was engraved four times: by J. Watson, R. Purcell, Lambertine (in an oval), and S. W. Reynolds. J. Chaloner-Smith, *British Mezzotint Portraits* (London, 1883), iii. 36 and 37; iv. 69 and 70.

31. I am unconvinced, for reasons that will become apparent in the course of this chapter, by Nicholas Penny's suggestion of Raphael's *St Margaret* as a source for this image. See Penny (ed.), *Reynolds*, 228. It is important to take not only the figure but also the environment into account. A more suitable canonical comparison would be with Claude's *Marriage of Isaac and Rebecca (Landscape with Mill)* which includes a dancing female figure.

32. See Montfaucon, *L'Antiquité* and Santi Bartoli [G. P. Bellori], *Admiranda Romanorum antiquitatum* (Rome, 1693).

33. Most notable are *A Bacchanalian Dance*, *A Bacchanalian Festival*, and *The Nursing of Bacchus* in the National Gallery, London but note also a number of drawings that were in English collections in the 18th cent. in which the theme is more adamantly stated. See A. Blunt, *The Drawings of Nicolas Poussin* (New Haven, 1976).

34. See E. Lemoine-Luccioni, *La Robe: Essai psychanalytique sur le vêtement* (Paris, 1983), 29.

35. J. Milton, 'L'Allegro', ll. 14–16, 39–40, in *Milton: Complete Poetry and Selected Prose*, ed. E. H. Visiak (London, 1952).

36. Now in the Heidelberg Art Gallery, *Euphrosyne umschwebt von Phantasie und Massigung* (1799–1800), no. 45 in the Milton Gallery. See G. Schiff, *Johann Heinrich Füssli 1741–1825* (Zurich, 1973), i. 520, cat. 907.

37. R. Leppert, *Music and Image: Domesticity, Ideology and Socio-cultural Formation in Eighteenth-Century England* (Cambridge, 1988), 73.

38. C. Burney, *A General History of Music* (London, 1776), iv, pl. v, engr. Malevre. Reynolds's name is listed among the subscribers at the front of vol. i. Malcolm Baker has kindly pointed out to me that figures with cymbals of this kind are commonplace in 18th-cent. sculpture (see e.g. Clodion).

39. Ibid., description to vol. iv, pl. v.

40. Ibid., vol. iv, pl. iv, engr. Grignion.

41. Ibid., vol. iv. 14–15.

42. Ibid. iv. 15.

43. J. J. Lemprière, *A Classical Dictionary* (preface dated 1788, 2nd edn. 1792; new enlarged edn. 1839).

44. Reynolds's studio sale (13 Mar. 1795) is reprinted in Graves and Cronin, *Works of Sir Joshua Reynolds*, iv. The attributions, even at the time, were regarded as very doubtful, but the subjects are not in doubt. They include: Rubens, *Bacchanalian Nymphs and Satyrs in a Landscape* and *Baccanti Head*; Crespi, *A Bacchanalian Offering*; and Jordaens, *Bacchanalian Nymph and Satyr*.

45. Euripides, *The Bacchae and Other Plays*, trans. P. Vellacott (Harmondsworth, 1973).

46. Robert McCubbin has mounted an interesting argument about the iconography of Thalia and Euphrosyne in 18th-cent. art and literature, research paper, 1995, publication forthcoming.

47. Graves, *Euphrosyne*, engraved by Grignion after W. Hoare.

48. The Hon. Lady Jane Halliday (in Reynolds's portrait at Waddesdon Manor) has a similar pose but she lacks Mrs Hale's attendants and the wildness of her hair and dress and thus presents a far more decorous figure.

49. C. R. Leslie and T. Taylor, *Life and Times of Sir Joshua Reynolds* (London, 1865), ii. 261.

50. Christie's, Sacombe Park, Herts., 11 Oct. 1993 (255).

51. Sotheby's, 30 Mar. 1994 (60). See also Daniel Gardner's *Portrait of an Actress* and Romney's *The Gower Family* at Abbot Hall, Kendal.

52. The engraving, badly damaged, is BM 1874-7-11-849. The painting (or a copy after it) was sold at Sotheby's, 17 Feb. 1988 (255).

53. Quintilian, *Institutio oratoria*, 71, quoted in F. Graf, 'Gestures and Conventions: The Gestures of Roman Actors and Orators', in J. Bremmer and H. Roodenberg (eds.), *A Cultural History of Gesture from Antiquity to the Present Day* (Oxford, 1991), 48–9.

54. See D. Solkin, 'Great Pictures or Great Men? Reynolds, Male Portraiture and the Power of Art', *Oxford Art Journal*, 9: 2 (1986).

55. I take this useful formulation from A. Jardine, 'Opaque Texts and Transparent Contexts: The Political Difference of Julia Kristeva', in N. K. Miller (ed.), *The Poetics of Gender* (New York, 1986), 96–7.

56. E. Burke, *A Philosophical Enquiry into the Origin of our Ideas of the Sublime and the Beautiful with an Introductory Discourse Concerning Taste and Several Other Additions* (London, 1756); J. Parsons, *Human Physiognomy Explained in the Crounian Lectures on Muscular Motion for the Year MDCCXLVI Read before the Royal Society* (London, 1747).

57. Stone, *Road to Divorce*, ch. v.

58. See e.g. *Universal Magazine* (Nov. 1761), 266–7.

59. Stone, *Road to Divorce*, 46–7 points out that divorce in the 18th cent. could mean either full legal severance of a marriage by a judicial body, allowing both spouses to marry again (something only parliament could grant prior to 1857), or separation from bed and board by an ecclesiastical body without permission to marry again. In *The Road to Hymen Made Plain, Easy, and Delightful: In a New Collection of Familiar Letters, Pleasing Dialogues, and Verses . . . by Benedict the Married Man* (London, 1790), 54–5, a fictitious woman writes to her friend, 'You must know then that whatsoever your husband proves, there is no means of changing. Of old, indeed, there was a thing in use, for a remedy in this case, called a divorce: but authority hath abrogated that custom. There is now no remedy, for better or worse, during life.' See also F. Nussbaum, 'Heteroclites: The Gender of Character in the Scandalous Memoirs', in F. Nussbaum and L. Brown (eds.), *The New Eighteenth Century: Theory. Politics. English Literature* (New York, 1987), 156.

60. Mary Moser to Mrs Lloyd, unpublished MS, private collection ('but if you would hear me speak like a Heathen & according to the sentiments of the World know—My Dear freind that as men have not to much either of religion [*replacing* virtue] nor vertue [*replacing* religion] devorce is necessary according to my <word illegible> Opinion'). See p. 143.

61. *Marriage Promoted in a Discourse of its Ancient and Modern Practice both under Heathen and Christian Common-Wealths: Together with their Laws and Encouragements for its Observance* (London, 1690), 19–20.

62. J. Ibbetson, *Some Observations on Two Pamphlets . . . by James Ibbetson, DD* (London, 1755), 24.

63. H. Stebbing, *A Dissertation on the Power of States to Deny Civil Protection to the Marriages of Minors . . . by Henry Stebbing DD* (London, 1755), 1.

64. J. Sayer, *A Vindication of the Power of Society to Annull the Marriages of Minors* (n.p., 1755), 24.

65. Ibid. 37.

66. There is a large literature on the subject and the London Foundling Hospital was the most substantial outcome. See e.g. Thomas Man, *The Benefit of Procreation Together with Some Few Hints Towards the Better Support of Whores and Bastards* (London, 1739).

67. For a discussion of the nuances of the term 'conversation' in this period, see K. Stanworth, ' "Pictures in Little": The Conversation Piece in England', Ph.D. thesis (University of Manchester, 1994).

68. The best discussion of this question, together with particular cases, is to be found in S. Staves, *Married Women's Separate Property in England 1660–1833* (Cambridge, Mass., 1990).

69. As an indication of the range, see 'An Essay on the Passions of the Ancients', *London Chronicle*, 22–4 Mar. 1774, in which there is a discussion of what the Greeks thought of marriage; *Hymen: A Poem* (London, 1794); and a letter from 'Wretched Julia', married for eight years to a man fifteen years her senior, in *Morning Post and Daily Advertiser*, 1 Mar. 1774. What Reynolds's view of marriage might have been can only be speculation.

70. 'Benedict, the Married Man', *The Road to Hymen Made Plain, Easy, and Delightful*, 2.

71. Ibid. 8.

72. *The Joys of Hymen, or the Conjugal Directory* (London, 1768), 17.

73. Ibid. 36.

74. 26–28 Apr. 1774.

75. See M. Pointon, *Hanging the Head: Portraiture and Social Formation in Eighteenth-Century England* (New Haven, 1993), ch. i. ii.

76. See J. Lacan, 'Of the Gaze' in *The Four Fundamental Concepts of Psycho-Analysis* (1973), trans. A. Sheridan (London, 1987), ch. 6.

77. 'Candid', writing in *Morning Chronicle,* 4 May 1780.

78. 16 May 1780.

79. *A Poetical Epistle.*

80.
> Nor will the curious Crowd believe
> That 'tis my Lady now alive
> But when the Metzotinto's shewn,
> They all a strong resemblance own.

81. See n. 13 above.

82. J. W. Goethe, *Italian Journey* (1768–88), trans. W. H. Auden and E. Mayer (1962; Harmondsworth, 1982), 208. My italics.

83. Quoted with no source given by Chazal, 'Les "Attitudes" de Lady Hamilton', 222. 'I placed in the centre of my Salon a very large frame, enclosed on left and right by two curtains. I positioned an enormous candle so that it illuminated Lady Hamilton as one illuminates a painting. She adopted in this frame diverse attitudes of a truly admirable expression.'

84. There are a number of classic formulations of this conundrum. See e.g. Erasmus' statement: 'Who could portray me better than I can myself—Unless, of course, someone knows me better than I know myself' (Erasmus, *Praise of Folly*, trans. B. Radice (London, 1971), 65).

85. See Penny (ed.), *Reynolds,* cat. no. 118.

86. Ibid.

87. See e.g. *Athenaeum*, 3037 (9 Jan. 1886), 74: 'Sir Joshua's Lady Worsley (157) is in her husband's uniform.'

88. Stone, *Road to Divorce*, ch. ix.

89. See Penny (ed.), *Reynolds,* cat. no. 203 and Stone, *Road to Divorce,* pl. 32.

90. See e.g. M. Warner, *Monuments and Maidens: The Allegory of the Female Form* (London, 1985) and my own essay on Delacroix's *Liberty on the Barricades* in M. Pointon, *Naked Authority: The Body in Western Painting 1830–1906* (Cambridge, 1990).

91. See D. Mannings in Penny (ed.), *Reynolds,* cat. no. 118 and, for another example of a woman dressed in a riding habit, Pointon, *Naked Authority,* ch. v.

92. A view articulated by, among others, Castiglione. For a discussion of this concept and of the philosophical arguments about the dangers of simulation, see J. Lichtenstein, *The Eloquence of Colour: Rhetoric and Painting in the French Classical Age* (1989), trans. E. McVarish (Berkeley and Los Angeles, 1993), ch. 1.

93. M. Garber, *Vested Interests: Cross Dressing and Cultural Anxiety* (1992; Harmondsworth, 1993), 17.

94. *London Chronicle,* 30 Apr.–4 May 1774.

95. See M. A. Doane, 'Film and the Masquerade: Theorizing the Female Spectator', *Screen* (Sept.–Oct. 1982).

96. The very frequency of exhibition is testimony to the iconic status of *Lady Worsley.*

97. A list of Hamilton's pictures compiled in 1798 included three works by Salvator Rosa: *Democritos,* and a pair: *A Storm by Sea* and *A Tempest by Land.* It was presumably one of these last two paintings that he sought from Greville. See Deutsch, 'Sir William Hamilton's Picture Gallery'.

98. Sir William Hamilton to the Rt. Hon. Charles Greville, 22 Feb. 1785, BL Add. MS 42071, Hamilton and Greville Papers, vol. iv. Reynolds exhibited *A Bacchante* at the Royal Academy in 1784 (342), which is often described as 'Emma Hamilton as a Bacchante' (e.g. in E. K. Waterhouse, *Reynolds* (London, 1941), 75) even though the sitter was at this stage known as Emma Hart. It was engraved in mezzotint by J. R. Smith, engraver to His Royal Highness the Prince of Wales.

99. Sir William Hamilton to the Hon. Charles Greville, 1 June 1785, BL Add. MS 42071, Hamilton and Greville Papers, vol. iv.

100. Ibid.

101. Iveagh Bequest, Kenwood House, no. 14.

102. H. Ward and W. Roberts in *Romney: A Biographical and Critical Essay with a Catalogue raisonné of his Works* (London, 1904) state that the earliest appearance of Emma Hart's name in Romney's diary is 8 July 1782 (ii. 179–80). They list as many as twelve different versions of Emma as a Bacchante suggesting that the originary image was that painted in 1784, a half-length, and sent to Sir William Hamilton. See also *Lady Hamilton in Relation to the Art of her Time*. Vigée Lebrun's canvas (132.5 × 105.5 cm) was one of four renderings of the subject (1790–2) two of which belonged to Sir William Hamilton. At least one other version is known, see Lady Lever Art Gallery, Port Sunlight, *Catalogue of Foreign Paintings, Drawings, Miniatures, Tapestries, Post-Classical Sculpture and Prints* (Liverpool, 1983), 23.

103. *Thesaurus linguae Latinae compendiarius: or, A Compendious Dictionary of the Latin Tongue, Designed for the Use of the British Nations by R. Ainsworth* (London, 1746).

104. British Museum, 1860–1–14–258.

105. These are summarized in Penny (ed.), *Reynolds*, cat. no. 124.

106. According to Graves and Cronin, *Works of Sir J. Reynolds*, ii. 762–3, *Thaïs* was twice engraved, by Bartolozzi and by S. W. Reynolds. The painting is in the Rothschild collection at Waddesdon Manor.

107. W. Hickey, *Memoirs*, ed. A. Spencer (London, 1913–25). i. 276.

108. *Earwig or An Old Woman's Remarks on the Present Exhibition of Pictures of the Royal Academy Preceded by a Petit Mot Pour Rire, Instead of a Preface, Dedicated to Sir Joshua Reynolds, RA* (London, 1781), 3.

109. J. Northcote, *Memoirs of Sir Joshua Reynolds, Knt* (London, 1813), 280–1.

110. Graves and Cronin, *Works of Sir J. Reynolds*, ii. 762–3. They report a Miss Pott in a Grecian dress, sold at Greenwoods, 15 Apr. 1796, bt. Inchiquin.

111. *Thaïs* was engraved also by T. Watson in mezzotint and published 10 Mar. 1799 by Watson Dickinson.

112. M. Postle, 'Reynolds, Shaftesbury, Van Dyck and Dobson: Sources for Garrick between Tragedy and Comedy', *Apollo*, 132 (Nov. 1990), 307–11. The sketches, dated by Postle *c*.1762, are in the Art Museum, Stockholm and in a private collection. In the case of the second—a three-quarter length figure—the cymbals are clearly visible. The first is a half-length figure and although it is hard to decipher the instruments, the pose is the same.

113. Anthony Ashley Cooper, Earl of Shaftesbury, Treatise VII 'A Notion of the Historical Draught or Tablature of the Judgement of Hercules, According to Prodicus, Lib II, Xen. de Mem Soc', in *Characteristicks of Men, Manners, Opinions, Times* (2nd edn. corrected, 3 vols., London, 1713–14), vol. iii.

114. T. Dempster, *De Etruria regali libri*, vii (Florence, 1723), i. 78, pl. xi. This represents a type familiar from Roman carving and painting.

115. This painting was a pendant to *Penelope taking down the bow of Ulysses*, painted for Lord

Boringdon and engraved by Ryder, pub. B. B. Evans, 1 July 1791. See D. Alexander, 'Kauffman and the Print Market in Eighteenth-Century England', in W. W. Roworth (ed.), *Angelica Kauffman* (London, 1992).

116. *Alexander's Feast: or, The Power of Musick. An Ode Wrote in Honour of St. Cecilia by Mr. Dryden. Perform'd on Friday the 2nd of March, before the Presidents, Vice-Presidents, and Governors of the Small-pox Hospital. Set to Musick by Mr. Handel* (London, 1753).

117. The painting is now in the Royal Collection. The pose of Dido also suggests Reynolds participating in a common vocabulary of the erotic, see for comparison Angelica Kauffman's *Cupid's Parting,* published as an engraving in 1785. M. Postle, *Sir Joshua Reynolds: The Subject Pictures* (Cambridge, 1995) offers a range of material relevant to this discussion.

118. *Diary and Letters of Madame d'Arblay,* ed. C. Barrett, i. (London, 1781), 329.

119. Reynolds's subject paintings were given hardly any coverage in the Royal Academy exhibition in 1986. For a contemporary response, we might notice Dorothy Richardson's observation when she visited Reynolds's studio in 1775. She lists a number of portraits without comment and then states: 'A Sleeping Venus & Cupid in the stile of Titian, this is call'd Sir Joshua's Masterpiece & is indeed a wonderful Picture: I was disappointed with his Portraits; I have been told he has particular pleasure in taking children, & in those I think he most excels', the journal of Dorothy Richardson, Ryl. Eng. MS 1124, John Rylands Library, University of Manchester. The painting seen by Richardson was *Venus Chiding Cupid,* which Reynolds exhibited first in 1771 (Iveagh Bequest, Kenwood); the second version which was exhibited in 1776 (Lady Lever Gallery, Port Sunlight) would have been in the artist's studio in 1775. Postle, *Sir Joshua Reynolds,* goes some way towards redressing the imbalance.

120. H. Walpole to W. Mason, 28 May 1780, quoted in Penny (ed.), *Reynolds,* cat. no. 122, where Penny rightly suggests that Walpole's remarks were in the spirit of mock heroic.

121. 'Candid', *Morning Chronicle* (5 May 1781). See also p. 64. I am grateful to Karen Stanworth for drawing my attention to this passage.

122. See Dempster, *De Etruria regali libri;* for Vigée Lebrun, see n. 74 above; Kauffman's drawing is in the British Museum (1886-10-12-541).

123. Euripides, *The Bacchae,* ll. 425–6.

124. Gloria Flaherty in *Shamanism and the Eighteenth Century* (Princeton, 1992), 11, 15, discusses the tambourine as one important feature of shamanism as explored in 18th-cent. culture.

125. *Diary and Letters of Madame d'Arblay.*

126. *The Autobiography and Correspondence of Mary Granville, Mrs. Delany,* ed. Lady Llanover (London, 1861), iii, quoted in A. Buck, *Dress in Eighteenth-Century England* (London, 1979), 181.

127. For examples by Kauffman, see *Morning Amusement,* 1774 and *Mary, 3rd Duchess of Richmond,* engraved by Ryland in 1775.

6

Protestants and 'Fair Penitents':
With Special Reference to St Cecilia

> Antiquity, how poor thy Use!
> A single Venus to produce?
> Friend Eckhardt, antient story quit,
> Nor mind whatever Pliny writ;
> Let Felibien and Fresnoy declaim
> Who talk of Raphael's matchless Fame,
> Of Titian's Tints, Corregio's Grace,
> And Carlo's each Madonna Face,
> As if no Beauties now were made
> But Nature had forgot to Trade . . .
> In Britain's Isle observe the Fair,
> And generous chuse your Models there;
> Such Patterns as shall raise your Name
> To rival sweet Corregio's Fame.[1]

*I*N this chapter, I shall consider how in England, in the period from the 1740s to around 1800, ideals of femininity were instrumental in the formation of national cultural identity. Through a self-consciously construct-ed frame of reference that drew upon the pleasures of Italian religious paint-ing, pleasures that were both associated with aesthetic merit and also indelibly stamped with ideas of corruption, the female subject as saint offered to an audience of travelled and educated connoisseurs the possibility of a trans-gressive engagement with an object of desire whose otherness was mediated through a discursive practice of recognizing, collecting, appreciating, and describing. Roman Catholicism, the narratives of the lives of female saints, and the visual vocabularies of Italian art, not only of the admired sixteenth-century masters but also of the late seventeenth- and early eighteenth-century baroque, provided a legitimizing network of cultural references.[2] Anchored in gentlemanly pursuits and patrician spaces (libraries, galleries, clubs), the very questions of superstition and propriety in image-making that had exercised

seventeenth-century English theologians and churchmen became a rich terrain for pleasurable engagement. Not only images of saints but all forms of imagery remained highly problematic for those responsible for the building and maintenance of churches—and Hogarth's frequent references to the failure of the Church of England in its doctrinal and pastoral roles match the opprobrium with which he treats both Roman Catholicism and the Dissenting religions[3]—but religious imagery was eagerly acquired and, moreover, commissioned from contemporary artists by private individuals. Old Masters and modern works hung side by side in the great houses whose owners were avid collectors of Italian and Flemish painting.

One such contemporary artist was the Revd Matthew William Peters, whose work was recognized in his lifetime to encompass a range of subject matter expressive of sentiments both religious and secular. By reassessing Peters's work, and then by examining a group of images of St Cecilia, I shall propose that the representation of 'saints' was part of a process of appropriation and secularization that served to disempower the non-English and non-Protestant other by asserting the pleasures of the Beauties of Britain's Isle. I use the word 'saint' to describe both figures designated within the Roman Catholic canon and figures identified by analogy as 'saints' within contemporary parlance, a form of language that draws attention to the exceptional and 'beautiful' qualities of an individual. The platonic connection between beauty and goodness is an underlying assumption but one which is also, as we shall see, open to subversion. One important way in which the fascination of the Fair of Britain's Isle (actual portrait subjects, as well as abstract ideal types) could most effectively be articulated was through the language of the religious other. This paradox offers an opportunity to begin to reassess the importance of religious imagery in eighteenth-century England (in painting and engraving but also in glass) and also indicates paradigmatically how crucial is the question of gender to any such discussion. But first, as so little attention has hitherto been paid to the question of religious painting in England, some consideration of wider issues is called for.

We might begin by going back to 1725. In that year, William Kent's altarpiece was installed in the church of St Clement Dane's in the Strand. Crowds came to see it and it was lampooned by Hogarth for its incompetence.[4] But when the altarpiece was removed, it was not on grounds of artistic inadequacy. The painting, now destroyed, depicted St Cecilia surrounded by angels with a harp and an organ in the background (judging from Hogarth's lampoon); one of the angels was thought to possess identifiable features, to be in short a portrait. The subject it was thought to resemble was none other than Clementina Sobieski, who had married the Roman Catholic Pretender to

the English throne, James III (James VIII of Scotland), in a service performed in Rome by the Bishop of Montefiascone on 1 September 1719.[5] William Kent himself was suspect because of the time he had spent at 'the Court of Rome'.[6] His altarpiece was seen as part of an attempt 'on the Peace of our Truly Apostolic Church by Popish Emissaries, non-Jurors, and other its Open and Secret enemies'. The power of a painting of a saint to inspire consternation and fascination is evinced in the reports that the church was 'thronged with spectators'.[7] The Bishop of London, who had it removed, was applauded for this 'last Injunction to remove that ridiculous superstitious piece of Popish Foppery from our Communion Table'.[8]

Fifty years later the President of the Royal Academy was enhancing his reputation by exhibiting portraits of high-born female subjects posing as saints from the Roman Catholic canon. In the Royal Academy exhibition of 1772, Reynolds showed *Mrs Crewe as St Genevieve* (no. 206) and *Mrs Quarrington as St Agnes* (no. 209). Neither sitter was an actress and both were well born. It would be wrong to suggest that these saintly identities are merely a pretext for a meditative pose. As Martin Postle has pointed out, Reynolds had attempted a somewhat more moderate pose for Mrs Quarrington slightly earlier and the 1772 painting, with its uplifted and swivelled head, is expressive in the manner advocated by Le Brun for the visual representation of ecstasy. Moreover, it was known simply as *St Agnes*, the name of the sitter only appearing at an 1859 sale.[9] In around 1775 Reynolds painted *St Cecilia* (with an unnamed sitter) for Sir Watkin Williams-Wynn's Music Room (Pl. 62) as well as a portrait of Mrs Sheridan as St Cecilia (*A Lady in the Character of St Cecilia*, RA 1775 no. 222). Mrs Sheridan was eminently respectable; indeed not only was she the wife of the premier playwright but she was, in her own right, included as one of the nine living muses in Richard Samuel's painting of 1778.[10] In the last year of his life, when he was almost blind, Reynolds exhibited a further and final *St Cecilia*; this also was a portrait, executed between 1786 and 1789 perhaps with the help of studio assistants, this time of the singer *Mrs Billington* (Pl. 63).[11]

These images represent a drop in the ocean of Reynolds's extraordinary output in these years but there were also images of angels (RA 1782 no. 73 and 1786 no. 396) and several versions of the child St John and the infant Samuel. Nor was Reynolds alone in executing such subjects; his contemporaries were also able to find a market for ostensibly religious subjects. During the same period James Northcote painted *A Lady in the Character of St Catherine* (RA 1774 no. 195, three-quarters, a portrait of Miss Chatfield), Matthew William Peters exhibited the enormously popular *An Angel Carrying the Spirit of a Child to Paradise* (RA 1782 no. 31), a portrait of Mary Isabella, wife of the fourth Duke of Rutland, and Charlotte Dundas, the deceased child of Sir Thomas Dundas.

52. G. Romney, *Emma Hamilton*, oil on canvas, 736 × 61, Christie's, 7 November 1980

St Cecilia and *A Magdalen* were among copies Romney executed from prints and which he sold by lottery *c*.1760. In 1765 he exhibited *The Head of a Lady in the Character of a Saint* at the Free Society and among the many guises in which he painted Emma Hamilton were a nun (cf. Pl. 52), St Cecilia (at least three times, Pl. 64), and the weeping Magdalen, the latter reportedly for the Prince of Wales.[12] Francis Hayman and Benjamin West exhibited biblical subjects regularly during the 1770s and a recent analysis of exhibitions in London in 1774 has established that among the shows of fashionable china and flower collections was Mr Jervais's exhibition of stained glass which included 'a Saint Cecilia after Domenichino, nearly as large as life, calculated for either a church or music room'.[13] In the annual Royal Academy show, even before Macklin's project for an engraved Bible began to stimulate the production of biblical subjects in the 1780s, religious and biblical paintings were regularly on display by Italian expatriate artists like Cipriani, Zuccarelli, and Biagio Rebecca, as well as by British contributors like Hayman, Barry, and West.[14] Illustrated bibles with plates sometimes derived from Old Master paintings and sometimes after contemporary artists (Samuel Wale was particularly prolific) were

popular throughout the century but Boase places the Revd Francis Fawkes's 'family bible'—a serial publication 1761–2—as a watershed for generously illustrated volumes.[15]

The century had opened with anxieties about the Protestant succession colouring cultural and religious debates. It is interesting to compare the confident and competitive tone of the 1740s, exemplified in my opening quotation, with a discourse upon a similar topic published in 1705. This offers a long description of the artistic merits of Italy while asserting that tyranny reigns there and that the people are wretched. By contrast, thanks to the Queen and the British constitution, Britons are happy. Nor need they envy Bernini, Guido, and Raphael because British learning and British laws constitute the national arts:

> Their Beauteous *Sculpture's* but an Art design'd,
> The poor unthinking Multitude to blind.
> Their *Paintings* too the *Priesthood's* cheats describe,
> To make Men Bigots, and enrich the *pamper'd Tribe*,
> We envy not such Arts; but boast our own,
> Our *Learning* and our *Laws*. . . .
>
> To guard our Liberties from Lawless Force,
> And curb Usurpers in their Dangerous Course;
> To answer each Insulted Nation's Pray'rs;
> These are our *British* Arts, these our Gen'rous Cares.[16]

David Solkin has argued that, outside an ecclesiastical setting, biblical paintings retained only a vestige of religious significance, and that they were open to basic exercises in connoisseurial technique and tasteful discrimination. 'The whole question of a spiritual dimension may simply have been irrelevant', suggests Solkin.[17] I do not disagree with this, at least not with regard to the paintings exhibited at the Foundling Hospital in the 1740s, which are the focus of Solkin's subtle analysis of exhibition and reception. On the other hand, we know precious little about the *process* of aestheticization, or secularization, and what may have been true in the 1740s almost certainly was not true in the 1760s. Margaret Aston has instructively demonstrated the capacity of English patrons in the first half of the seventeenth century to use a secular genre such as portraiture for devotional purposes.[18] The situation in the eighteenth century is at least as problematic. Even among historians, eighteenth-century religion has been relatively neglected (an untidy hiatus between the 1689 Act of Toleration and the advent of the High Church movement) and among cultural historians the situation (with a few notable exceptions) is even more marked. *The New Oxford Book of Eighteenth-Century Verse*[19] contains very few

poems that eighteenth-century readers would have recognized as religious even though most literate people read religious material. Linda Colley's magisterial work on this period of British history stresses convincingly the powerful groundswell of anti-Catholic Protestant feeling.[20] My argument, on the other hand, addresses the attraction of the élite and the middling classes to the affective aspects of Rome. In focusing on the relationship between religious representations and the construction of female imagery, this chapter cannot redress any wider imbalances, but it is my hope that it will suggest further avenues of enquiry.

The most highly publicized incidence of the proscription of religious imagery in eighteenth-century England was the ill-fated proposal by a group of Royal Academicians in 1773 to complete the work of Sir James Thornhill by painting the interior of St Paul's Cathedral with scriptural histories at their own expense.[21] It is, however, important not to see this event in isolation. The recently founded Royal Academy had a major investment in establishing a public visibility and access to the mechanisms of publicity. The high-profile nature of the event meant that it was taken up by writers like Valentine Green and William Carey and informed a nineteenth-century polemical view of the production of religious imagery.[22] The earlier dispute over the parish church of St Margaret Westminster that occurred in 1757, at a crucial time in the history of the Royal Society of Arts and the prehistory of the Royal Academy, was in many ways both more symptomatic and more significant in so far as it resulted in a most detailed and reasoned argument in defence of imagery in churches.

What happened was roughly as follows. In 1757 £4,000 was allotted by the House of Commons for the repair of its parish church which, nestling under Westminster Abbey, remains to this day the church for members of both Houses. The whole of the east end, it turned out, needed rebuilding and, whilst this was happening, the parishioners were notified that 'an ancient Window of Stained Glass', originally intended as an ornament for Henry VII's chapel, would be disposed of. 'The COLOURING, the EXPRESSION, and the GENERAL BEAUTY of this Piece . . . were universally admired by the most critical Judges; and from the historical Representation of our Blessed Saviour's Crucifixion contained in it, the greatest Propriety was deemed to arise for placing it over the Communion Table.' What the parishioners did not know, however, was that 'some Persons of considerable rank [we may guess they were members of the Society of Antiquaries] had been disappointed in their Desires of purchasing this Window for adorning their Private Chapels'. As soon as it was installed accusations of superstition and popery were levelled against the churchwardens who none the less won their case and, with it,

struck a blow for the rights of parishioners to make decisions about their churches. In this case, the parishioners being mainly well educated, the matter was aired 'very publicly' and the prosecution in the Ecclesiastical Court was a 'Topick of popular discourse in our capital'.[23] Having worked through various scriptural points in defence of paintings and sculpture in churches, Thomas Wilson, author of a substantial work on church decoration, chose to refute accusations of blasphemy by presenting an argument about the nature of representation, namely that imagery is a system that works by analogy or by signs. Religious imagery could thus not only be tolerated but could paradigmatically open up the question of the relationship between the signifier and the signified that proved so fascinating to men of letters from Locke to Lessing.[24] Painting and sculpture, states Wilson, 'may be considered as Languages, which like all others, have two Methods of conveying Ideas, the Descriptive and the Allegorical':

The latter, if one may be allowed the Expression, is the Poetry of Painting, the first is the Historical. Things which are not immediately the Objects of our Senses can not otherwise be represented than by others which do not directly excite the Ideas intended to be raised, but are a kind of arbitrary Signs which are Selected for the Purpose; I say a *kind of arbitrary Signs*, because they are not entirely so, some supposed Resemblance was the Reason for their being fixed on.[25]

As the century neared its close, masonic artists like de Loutherbourg were producing apocalyptic scenes, many of which would reach wide audiences through Macklin's Bible, a large-scale publishing enterprise under way in the 1780s, Benjamin West was turning out altarpieces (at Rochester Cathedral, St Stephen's Walbrook, Trinity College Cambridge, and Winchester Cathedral), Mortimer's *Raising of the Brazen Serpent in the Wilderness* painted on glass by Pearson was installed in the great west window of Salisbury Cathedral, where Turner incorporated it into his view of the nave in 1797.[26] There was also an altarpiece for All Souls, Oxford commissioned from Mengs and one for the Sardinian Embassy Chapel from Rigaud.[27] This was a volume of activity that would surely have scandalized those who repudiated Kent's altarpiece in 1725 and surprised Hogarth in his pioneering large-scale paintings of forty years earlier. Nor was it confined to the metropolis. Evidence is hazy because nineteenth-century reformers reorganized the interiors of English parish churches and Pevsner's heroic enterprise in our own century excludes free-standing paintings.[28] None the less, there are signs that parishes were prepared to spend considerable sums, not only on glass which was often imported from Germany and Flanders, but also on paintings. One example is the splendid church of Louth, in Lincolnshire, associated with the Pilgrimage of Grace,

which contains not only a convincing enough 'School of Tintoretto' *Deposition* but also three grand figure paintings that may have been part of a reredos and which are attributed to William Williams, the teacher of Benjamin West.[29]

Turner's watercolour of Salisbury Cathedral nave transcribes the Gothic tracery of the fine fifteenth-century interior in subtle shades of grey. The contemporary (eighteenth-century) glass provides a brilliant splash of colour and a clear indication of human forms. The contrast between these two elements is underlined by the manner in which Turner has juxtaposed his signature with the name of the first foundation at Salisbury. This appears on the tomb slab in the foreground, 'Turner | Sarum', and helps illustrate one of the lines of argument about religious painting: that modern art-works in ecclesiastical settings were visible declarations of modern rationalism in its triumph over 'Gothic' superstition. Fashionable antiquarian practice sought to establish links between modern Christianity and ancient pre-Christian religious beliefs in ways that claimed an English ancestry for all biblical history.[30] By the eighteenth century iconoclasm was associated with the mob and with witchcraft, pre-Reformation ignorance, and irrationality. It is, for example, significant that the Societies for the Reformation of Manners (organizations of moral rearmament popular in the early part of the century) list among the 'fleshly lusts' to be overcome: heresies, idolatry and witchcraft, as well as sabbath-breaking, cursing, adultery, and many more.[31] Classically inspired imagery, by mid-century, was being claimed as the antidote to pre-Reformation barbarism. It was on these grounds that Thomas Warton celebrated Reynolds's painted window at New College, Oxford in 1783 (now destroyed). He describes himself as lured by elfin sculptors who had 'oer the long roof their wild embroidery drew', creating 'phantoms of my fairy dream, | phantoms that shrink at Reason's painful gleam!' But Reynolds' 'powerful hand' has 'broke the Gothic chain, | And brought my bosom back to truth again'. Grecian groups have, for Warton, replaced the 'Kings, Bishops, Nuns, Apostles, all alike!'[32] For Valentine Green, also, looking back over the last half of the eighteenth century, it is adherence to 'Gothic barbarisms' that has obstructed the development of a national policy on art in churches and other public edifices.[33] It was, however, also that very 'Gothic chain' which Romney invoked when he painted Emma Hamilton as a nun; it was that 'wild embroidery' which in 1815 would grip the young Coleridge as the most powerful metaphor for the imagination when he was writing *Biographia literaria*.[34]

A look at Reynolds's designs for windows, Cipriani's full-scale figures of St Cecilia and St Anne painted for Holkham Hall in 1764,[35] or Peters's large *Annunciation* in Lincoln Cathedral (painted in 1799 for the Essex reredos of 1769),[36] all of which appear markedly derivative, might seem merely to

confirm rather than belie the notion that the fiasco of the St Paul's project marked the end of serious attempts at religious art at least until George III employed West for the Chapel of Revealed Religion at Windsor in the 1780s. But it might be worth asking whether the not altogether effective, but none the less continuing, resistance to imagery in churches licensed its transformation and realization in highly personalized—and sometimes explicitly eroticized—terms within secular spaces. It may be that the female saintly subject could be explored in full here precisely because it had been excluded from church imagery, such as it was.

England in the eighteenth century, long before the sale of the Orléans collection in 1792,[37] was awash with biblical and religious imagery in the private spaces frequented by the gentry and nobility. Sales at Langford's and Christie's processed quantities of foreign religious works. And those sales were hugely popular. When the fictitious Lady Maria Modish tells her friend Lady Belinda Artless in 1778 not only that 'Auctions, Belinda, so common are grown, | That each Day we may view them, or let them alone', but also that 'Religion no Person of Fashion regards, | Sundays pass now in Walking, in Scandal, and Cards',[38] she was unwittingly testifying to the secularization of life and also of religious subject matter since that is what those very auctions frequently contained. The attributions may have been incorrect but the subject matter was unmistakable.[39] Valentine Green, aware of the quantities of religious art that had found its way into his countrymen's homes, drew attention in 1782 to the apparent anomaly:

If Scriptural Subjects in Painting be unfit for our Churches, they are less suitable to our domestic habitations, and ought therefore to be wholly suppressed: for it is incompatible with our reverence of the duties they inculcate, that we should suffer their examples to be pourtrayed for the decoration of our houses, if they are capable of such dangerous violences to our faith, and modes of worship, as are ascribed to them, when found in our Churches, in the proportion the evil complained of in public, being so much multiplied in their being found in almost every house we enter.[40]

Collectors in the first half of the eighteenth century had demonstrated a marked tendency to purchase works of the Italian baroque, with French seventeenth-century and Flemish painters also popular choices. Nor was such collecting by any means confined to Catholic families whose sons were educated abroad as, for example, with the Towneleys of Burnley. Sir Joshua Reynolds's own studio sale contained an impressive list of religious subjects attributed optimistically to sixteenth- and seventeenth-century artists: a *Magdalen* by Domenichino, a head by Correggio for the cupola of the Duomo at Parma, a *St John* and a *Martyrdom with Saints* by the same artist, a *St Theresa* and *An*

Angel's Head by Guido Reni, Le Brun's *Ecce Homo*, Parmigianino's *Marriage of St Catherine,* and, by one of Reynolds's Italian contemporaries better known for his portraits, a *Magdalen's Head* by Batoni.[41] Ian Pears has pointed out that Robert Walpole's single painting by Guido Reni cost the equivalent of the yearly wages of 500 labourers and that the Earl of Egremont, buying on the London art market to build up his collection of some two hundred works, favoured Maratta, Guercino, and Bassano.[42] In 1758, Earl Spencer was prepared to pay 2,000 guineas for a Guido and an Andrea Sacchi.[43] Indeed, it is clear that apart from Correggio, Guido Reni was the most popular painter among the travelled class of collectors.

The Grand Tour had led wealthy young men, like Thomas Coke of Holkham, to Rome where (in Coke's case at the age of 15½) serious acquisitions were made. Coke bought his first paintings by Pietro da Cortona and others in Rome in 1714. Two years later he returned to the city and began buying from living artists: Francesco Bartoli, Procaccini, Luigi Garzi, and an artist who seems to have been particularly popular with English visitors, Sebastiano Conca.[44] Men of Coke's generation could, it must be remembered, buy works in Rome direct from the pupils of the most admired seventeenth-century artists. Conca, for example, was a pupil of Solimena, who established himself in Rome in 1706. The collection of the Marquess of Exeter at Burghley (already well established as a tourist attraction in the eighteenth century) contained a stupendous collection of paintings by Italian and Flemish artists, chiefly of biblical and religious subjects, acquired by the fifth Earl (1648–1700) during at least four long visits to the Continent and by his great-grandson, the ninth Earl (1725–93). Nor was knowledge of these works confined to an élite circle; not only were visits to great houses an established part of the kind of tour undertaken by Dorothy Richardson and described in Chapter 3, old and modern masters were engraved and widely distributed. Boydell, for example, engraved the entire Houghton collection. Ancient and modern hung side by side in these collections, and copies were ordered to fill gaps. Just as bibles were illustrated with a mixture of engravings after Raphael and after Hayman or Wale, collectors did not hesitate to hang Italian originals alongside modern paintings. Matthew William Peters's *An Angel Carrying the Spirit of a Child,* which hangs today at Burghley surrounded by genuine works by Italian masters and copies by his hand of works his patrons were unable to acquire, was one of a group of eighteenth-century paintings commissioned by the ninth Earl.[45] Looking at Peters's paintings at Burghley, it is hard to agree that 'there is sparse evidence that the Baroque of a Maratti, or the Rococo of a Masucci, or a Giaquinto exerted any decisive influence on English painting' (see Pls. 53, 54, 55).[46]

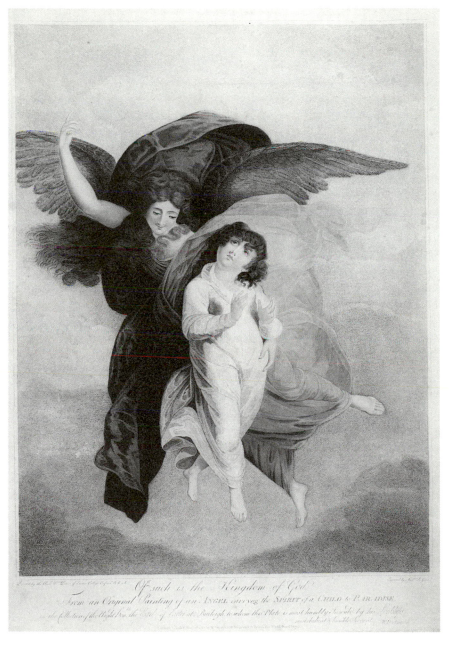

53. A. Le Grant after M. W. Peters, *An Angel Carrying the Spirit of a Child to Paradise*, British Museum,
London

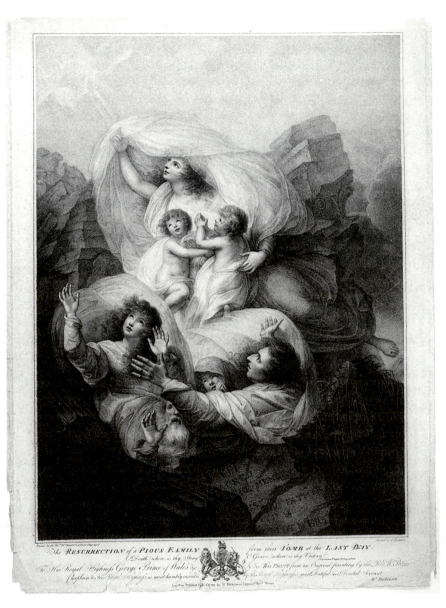

54. W. Dickinson after M. W. Peters, *The Resurrection of a Pious Family*, pub. 1 February 1790, British Museum, London

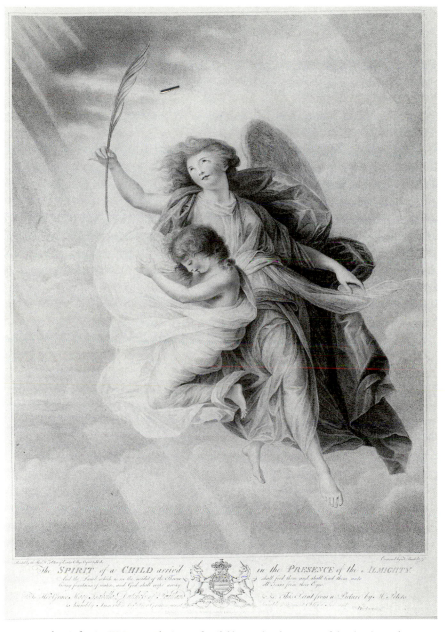

55. F. Bartolozzi after M. W. Peters, *The Spirit of a Child Arrived in the Presence of the Almighty*, pub. 21 May 1787, British Museum, London

Throughout the century, contacts could be made through English artists who were themselves installed in Italian cities sometimes for lengthy periods.[47] Thus, for example, Matthew William Peters, who was copying Raphael, Titian, Correggio, and Parmigianino [48] in Venice, Florence, Parma, and Rome in 1762–5, and was again in Rome in 1775–6, was available in 1771 to show the Duke of Gloucester paintings in the Pitti Palace and the Royal Gallery as well as taking him to see the Duomo and the studio of Francis Harwood.[49] Peters, who would take Anglican orders shortly after his return from Italy, is perhaps a good example of an English artist with an undoubted affiliation to Protestantism (he would make his career ultimately in the Church) at ease with a Roman Catholic tradition and with patrons from both sides. Freemasonry, within which Peters became a leading figure in the 1780s, offered a network which transcended religious difference and Peters enjoyed the patronage of the prominent Roman Catholic peer Lord Petre (whose entertainment of the King and Queen at Thorndon in 1778 marked official recognition of the Catholic Relief Bill) as well as that of the Duke of Manchester.[50]

Ian Pears has drawn attention to the formation of the eighteenth-century collection as 'a triumphant act of enclosure'.[51] Arguing that we should not overlook the importance of a shift from the church as an open access site for viewing works of art in the Middle Ages—through the desecration and removal of images from churches—to the privatization of art as a commodity to be enjoyed behind locked doors, Pears has pointed out that the practical privatization of art was accompanied by a re-evaluation of painting. Thus the purpose of a picture was less its value as a religious aid and more an intellectual end in itself. 'The picture increasingly took on many aspects of being an intellectual fetish: from having a function as an illustration of, or commentary on, religious devotion and worship . . . the picture itself became the object of commentary and discussion.'[52] It is certainly true that access to works of art and an ability to discourse upon them became not only the condition for membership of an élite but also the yardstick by which individuals and groups measured themselves. However, this account needs qualifying in a number of ways.

In the first place it is possible for a religious painting to provide the pre-text for a discourse independently of that painting's subject matter but none the less for the subject matter—saints, angels, madonnas—to offer the occasion of an imaginative engagement. In other words, paintings are very much the kinds of objects with regard to which viewers may talk of style, chiaroscuro, modelling, and at the same time absorb and be moved by the figurative nature of the work. In fact, viewers had long been quite explicit about the emotional

excitement that the religious subject matter of work by Raphael, Guido, Correggio and others generated. Indeed, it was the ability to distinguish the difference in the quality of spiritual 'lift' in the faces (and the emphasis is on faces, which eighteenth-century audiences expected to read)[53] that marked out the real connoisseur. Although Addison concludes his 'Letter from Italy' written in 1701 with the declaration that 'T'is Britain's care to watch o'er Europe's fate, | And hold in balance each contending state', his own seduction by Italian art is frankly charted:

> From theme to theme with secret pleasure tost,
> Amidst the soft variety I'm lost.[54]

It is the 'heavenly figures' which 'flow' from the pencil of Raphael that produce this confession of ecstasy; the language in which the experience is conveyed is, however, unequivocally erotic. And the same goes for the much less excitable, and phlegmatic, Richardson father and son who, having found various faults with a Madonna by Correggio (thus suitably demonstrating a degree of discernment and connoisseurship), burst out: 'But the Beauty! the Morbidezza! the Thought and Expression! Good God!'[55]

In the second place, paintings were infinitely disposable and the circumstances in which they were disposed of might (as we have seen in Chapter 4 in the case of Charles Greville and Sir William Hamilton's dealing over portraits of Emma) be significant in ways not explicable by the economics of collecting. In the third place the parameters established in England by the last quarter of the century to allow for discussion of paintings were often grounded very precisely in a set of gender attributes. We might take as an example James Barry's advice to students of the Royal Academy, when Professor of Painting, to which he was appointed in 1782. Recommending the 'absolute necessity of making a judicious selection in the objects of your imitation, and of directing your attention to the species in each walk of character, rather than to the individual, because in this consists the very essence of design', Barry instructed his listeners in the recognition of the true, the beautiful, the good, and the great in the objects that surround us. Beauty, which 'makes so essential a part in the design of a great artist, is, and must be, founded on the unalterable nature of things, and independent of all particular dispositions'. It is in the fitness of male and female forms for their distinctive functions that Barry (in common with his generation) locates the paradigm of beauty:

Man, as a totality, comprehends a greater variety of visible parts than the female, and yet surely he is not more beautiful. We should not increase the beauty of the female bosom by the addition of another protuberance; and the exquisite undulating transitions from the convex to the concave tendencies, could not be multiplied with any

success. In fine, our rule for judging of the mode and degree of this combination of variety and unity, seems to be no other than that of its fitness and conformity to the designation of each species.[56]

The competing claims to the site of absolute beauty which Barry pragmatically passed over were a source of trouble to Winckelmann who, as Alex Potts has pointed out, wished not to be seen as asserting an illegitimate preference for the beauty of the male body to the exclusion of the female body, but rather to protest against a narrowly limiting identification of beauty with the feminine. [57]

In the fourth place, we should not forget that the nature of religious imagery and its capacity to inspire devotion continued to fascinate the English as is testified by the numerous accounts of travellers both published and unpublished. Paintings purchased by a Thomas Coke may finally have found their way into a niche at Holkham Hall where they would be the object of informed discussion by the owner and his friends, but by the last three decades of the eighteenth century, in the imagination (and sometimes also in actuality), it was easy to blur the boundaries between the secular and the religious. When Sir William Hamilton invited guests to view his wife performing a series of 'attitudes' based on works of art he (and she) were responding to a process of cultural slippage that had already powerfully influenced the possible ways of consuming not only artefacts but also other cultural experiences. One of her attitudes (if Rehberg is to be believed[58]) was that of St Cecilia; the main point to be made is, however, that confusion was deliberately sown between what was material or physical and what was representation. Not only could people enact art, they could also be ambulant images. Hester Thrale Piozzi, for example, notes with great interest how the lazzaroni of Naples go around with the angel of Raphael or the Blessed Virgin Mary delineated on one brawny sunburnt leg, the Saint of the town on the other: their arms representing the Glory or the Seven Spirits of God, a brass medal representing their favourite martyr round their neck. [59] In Milan, on the other hand, a young woman is herself 'a beautiful figure of the Madonna, dressed from a picture of Guido Reni'. [60] The very privilege and enclosure of the English picture collection with its Marattas, Renis, Dolcis, and Domenichinos fostered a climate of fascination which made it possible for the wives, children, and mistresses of these collectors (though not them themselves—for the gender boundary is strict) to pose as saints and angels before the canvases of leading portrait painters.

One reason the gender boundary was so strict was that religious practice for Protestants was perceived as a gendered affair. In their remarkable study of the English middle class 1780–1850 Leonore Davidoff and Catherine Hall estab-

lished the importance of the intertwining of the religious with the economic and the social, with the establishment and maintenance of class loyalties and spheres of influence. Women—and particularly women of Nonconformist households—were guardians of the collective family spiritual well-being. What they find true of the period post-1780 may also be seen earlier in the century. Domestic piety was, it has been argued, an important (if unre-searched) feature of Georgian England. [61] Religion was understood as the practical province of those subservient to the head of the household, as we learn from the case of a gentleman writing (probably to Dr. T. Wilson) on 30 July 1738:

Having sometime ago made a Purchase of an Old House where there is a fine Chapple and not being yet old Enough to stand in need of ye Assistance of a Chaplin for ye use of my Maids and female Neighbours, I have resolv'd to pull it down, and knowing right well that you are a great dealer in Virtu I thought propper to Acquaint your holy-ness that there is one of ye finest large Windows of Painted Glass in England wch I desire you will make know to ye good People of your Colledge that they may Depute you to take a View of it, if they like it they shall in honour to you have it for less than any else.[62]

The desire of Mr Olmins to dispose of religious furniture profitably, and his knowledge of how to go about it, is striking. But so too is his clear sense that he has no use for a chapel because he is as yet unmarried. Women's link with religion was expressed in physical terms: not only was church attendance and religious education of children (and servants) their responsibility but, as we have noticed in Chapter 1, women often made provision in their wills not only for bequests of money to the Church but also for the Church to receive such apparel as contained gold and silver thread and might, therefore, be adapted for ecclesiastical use. From the second half of the eighteenth century and through the nineteenth, countless advice manuals for women, many of them published by the Society for the Promotion of Christian Knowledge, founded in 1699, rehearse their obligations as mothers and as wives to ensure a God-fearing family disposition. Hannah More, berating fashionable London on its lax morals, rhetorically asks: 'Is there any degree of pecuniary bounty without doors which can counteract the mischief of a wrong example at home; or atone for that infectious laxity of principle, which spreads corrup-tion wherever its influence spreads?'[63]

For Roy Porter, writing in 1982, eighteenth-century English religious life was characterized by an easygoing pluralism in which religion did not inter-fere too much with anyone's pleasures and 'piety was to be natural, common-sense, easy, the workaday world in Sunday suits'. Anglican privilege still held sway but 'less stigma was attached to those who sported their minority

religion like gentlemen'.[64] Porter cites Lord Petre and Sir Henry Arundel as examples of Catholics who enjoyed full and rich lives and proclaimed their sense of freedom. The Anglican Church was an immensely wealthy institution but fewer and fewer people attended services. It is symptomatic of the Church's preoccupation with aesthetic and historical value that when, in 1711 following the Tory landslide, the London Churches Act set aside money for a projected fifty churches for over-populated suburban parishes, only ten were actually constructed, largely because the trustees opted for high standards of originality in architectural design and building.[65]

For J. C. D. Clark, on the other hand, the Church in eighteenth-century England is the site of a highly invested debate on the divine right of kings, an intellectual and spiritual force vital in strengthening the ideology of Hanoverian patriotism.[66] Where these two very different authors agree is over the survival of popular superstitions and folk rituals including witchcraft. Neither, however, poses the question of how the religious impacted—through antiquarian and connoisseurial mediation—upon the imaginative life of the powerful élite classes of England in the later years of the eighteenth century. Other historians have emphasized the reformist aspects of eighteenth-century religious teaching and practice as a prelude to social reform, focusing on figures like Hannah More and William Wilberforce, and on evangelical organizations like the Society for the Promotion of Christian Knowledge and the Proclamation Society.[67]

A more cautious account is offered by Walsh, Haydon, and Taylor, who take a long view which encompasses eighteenth-century memories of the traumas of the previous century, when Calvinism and Roman Catholicism had both been major threats. They see an eighteenth-century Church which gained strength from classical and Enlightenment ideals of balance and harmony, and which drew on the powerful cultural notions of politeness. The metaphor of Anglicanism as a golden mean was useful, they suggest, in a wide variety of contexts.[68] By far the most interesting study of religion in eighteenth-century England in a cultural context is Linda Colley's analysis of the patriotic Protestantism of the English and the Welsh.[69]

It would be easy to speculate that the assignment of responsibility for the family's spiritual well-being to the wife and 'other' left men free to indulge in transgressive fantasies. But this is a particularly class-based issue. The classes of which Davidoff and Hall write are not those who commission suggestive images of nuns or scantily clad women fingering stringed instruments in angelic company. For men, and perhaps also for women, of the educated classes religion offered a site for sexual encounter in fantasy and fiction and probably also in reality. The repudiation of church-going in bawdy literature

as well as in the lives of fashionable people suggests an ambivalence or even an endorsement of the religious as a site of fascination. Hogarth's work mid-century, so carefully researched by Paulson,[70] demonstrates not only a profound hostility both to popish (foreign) superstition and to Nonconformist enthusiasm, but also a degree of fascination with the religious as a site of corruption. Prints like *The Sleeping Congregation* of 1728 and *Enthusiasm Delineated* of 1768 are not only occasions for criticism but also opportunities for prurient sexual voyeurism. Religion provided, as Peter Wagner has pointed out, a language for popular eroticism and pornographic publications.[71] The Female Rake, in the poem of that title (1735), uses the familiar tag of the 'saint' to indicate corruption beneath the surface of society:

> Cou'd we but see the World, without Disguise,
> What number shou'd we find of living Lies!
> What wanton female Saints, what praying Knaves,
> What Coward Heroes, and what Virtuous Slaves.[72]

The ambiguities of Hogarth's *Morning* might usefully be set alongside such observations. It contrasts early-morning spinsterish religious devotion with secular and sexualized pleasures of the street, but which of the two is counterfeit and hypocritical is a moot point.[73]

The utterances of female rakes notwithstanding, the Church was one of the great stages of Georgian England. Box pews not only permitted the perpetuation of family power and a degree of personal comfort that may have been at odds with Christian doctrine, they also offered opportunities for drama. In 1656, George Fox, the founder of Quakerism, had averred that 'many People go to the Steeple-house [i.e. church] on the first day [i.e. Sunday] to see Fashions, and shew their Fashions; and doth not many Tradesmen go thither to see the Fashion, that they may please their Customer with that Fashion that they have seen at Church, as they call it, and the People have seen it likewise'.[74] The situation a hundred years later may not greatly have differed. Readers of eighteenth-century novels expected the drama occasioned by the appearance of protagonists in church. The triumphant entry of the married eponymous heroine at the end of Richardson's *Pamela* is described in detail:

I was dressed in the suit I mentioned, of white flowered with silver, and a rich head-dress, and the jewels I mentioned before: Mr. B. had on a fine laced silk waistcoat, of blue Paduasoy; his coat was a pearl-coloured fine cloth, with silver buttons and button-holes, and lined with white silk. He looked charming indeed. . . . The neighbouring gentry, it seems, had expected us; and there was a great congregation; for (against my wish) we were a little of the latest; so that, as we walked up the church, to his seat, we had abundance of gazers and whisperers.[75]

Following the service, Pamela is told that she has 'charmed the whole congregation'. The success is repeated during the afternoon service with an even larger congregation, those who had stayed away in the morning being tempted forth by the expectation of a glimpse of Pamela.

The fact that both Pamela and Clarissa, incarcerated by their libidinous admirers, are prevented from attending divine service through most of a narrative of Christian virtue (exemplified in the chaste figures of the heroines) serves to enhance their very desirability. Clarissa, whom Lovelace habitually addresses as an angel ('Let me worship an angel, said I, no woman'),[76] dies a martyr's death. The imprisonment of Richardson's erotic heroines comprises a Protestant and ostensibly moralized version of the narrative of sexual passion or rape in the sequestered confines of a religious house that had interested Aphra Behn[77] and Voltaire and would so preoccupy de Sade later in the century. 'Altars', 'shrines', and other religious terminology are commonly deployed in describing the orifices of bodies, and the pseudo-religious rituals of courtly love are transposed and reinvented through western culture in a continually transmuting preoccupation with the connections between sex and religion in their simultaneous dependence upon the body and the transcendence of the body. These connections would preoccupy Freud, Bataille, and Foucault and no one, perhaps, formulates the nature of this fascination more cogently than Bataille when he states: 'Le fondement de l'érotisme est l'activité sexuelle. Or, cette activité tombe sous le coup d'un interdit. Il est inconcevable! il est *interdit* de faire l'amour! A moins de le faire en secret. Mais si, dans le secret, nous le faisons, l'interdit transfigure, il éclaire ce qu'il interdit d'une lueur à la fois sinistre et divine: il l'éclaire, en un mot, d'une lueur religieuse.'[78] Whilst the literature of courtly love possessed its own decorum, the late eighteenth century invented new representational strategies for dealing with the intertwining themes of sex and religion. In France, as Kate Nicholson has demonstrated, the cult of Roman vestals 'was a mixture of archaeology and fantasizing that at one and the same time evoked women's virtue and its erotic opposite'.[79] In England, the Gothic novel, with its view of the old religion as steeped in mysterious and carnal possibilities, was one strategy. The imaging of nubile young women as angels and saints was another. Such images represented beautiful women and, as Robert Jones has shown, debates about 'beauties' became increasingly, as the century progressed, debates about desire.[80]

What I will term a politics of beauty—typified by my opening quotation with its popularized rendering of the ancients versus moderns debate—stipulated national precedence through a recognized and reproducible form of female beauty. This politics depends upon presenting a Pantheon of Italian

painters, producers of images of Venus, saints, and the Virgin Mary, which is then discarded in favour of a native model. The verses in this regard display a profound ambivalence. Put simply, Correggio is the yardstick without which female beauty cannot be judged. But the fact of Correggio's being Italian and a 'Papist' must be negotiated. The same ambivalence is apparent in academic writing in the second half of the century. In Discourse VIII Reynolds admires Correggio's laying in of a ground in order to produce relief but in Discourse IX he accuses Correggio and Parmigianino of incorrectness in their depiction of figures ('very little attention will convince us, that the incorrectness of some parts which we find in their works, does not contribute to grace but rather tends to destroy it'). In short, that which Reynolds can endorse is technical and relatively uncontroversial, that which he must reject concerns representational methods: long necks and fingers spoil an otherwise graceful image. Barry, on the other hand, is characteristically less measured in his assessment (of the same *Madonna dall' collo lungho* by Parmigianino now in the Uffizi), stating that the painting 'would stand unrivalled for a masterly precision of drawing, divine beauty, character, elegance, and graceful action, were it not that some of those pefections are a *little* overcharged, to the prejudice of the simplicity of nature and truth'. However, Barry continues, 'its excellencies are so great that *my heart smites me* when I pass this censure on those particular exuberances, for they cannot be considered as affectations, which would imply assumed qualities, not really felt'.[81] James Barry was described by his detractors as a Romanist. The truth is more likely to be that he was committed to Catholic reform allied to a belief in Republicanism. None the less, he cannot have failed to be aware of the implications of expressing such emotion before a devotional image while addressing a group of English students in an institution patronized by the Protestant monarch. The success of academic and aesthetic discourse in annexing questions of religion does not obscure their actual importance or the emotive associations. The very invocation of Italian art in eighteenth-century England is a cue for a parody of sensibility. Thus when, in 'The Beauties: An Epistle to Mr. Eckhardt, the Painter' with which I opened, Walpole parades the names of the Italian 'greats', it is an inevitable consequence that their attributes settle upon and colour the never specified native model.

Such was the intense fascination with (and desire to repudiate) this self-imposed measure that, typically, an Italian correspondent is invented by the *St James's Chronicle* to write about English good looks. This is, of course, the familiar trope of the hypothetical traveller—the distancing device that enables us to view ourselves:

The ladies appear to me to be the best production of this Island, and the most beautiful. They tell many Stories here of the Origin of this Nation, but I believe nothing of it, for the Women are more beautiful than any northern Beauties; they are neither like the Grecian nor the Roman Beauties but have something of Originality which is not easy to explain. For my Part I believe them to be like Venus, a Chymical Mixture of Celestial Substance, with the Foam of the Sea.[82]

It may be objected that I have elided biblical and religious painting and assumed beauty (as national and female) to be also sexual. In the first place it is the case that within the Protestant culture of eighteenth-century England there was no strict demarcation between biblical and religious subjects. The conventions of Renaissance art situated saints within New Testament narrative scenes while Old Testament iconography was extensively drawn upon for sermons. Moreover the spirit in which Evelyn had himself portrayed in saintly posture by Robert Walker in 1648 survived among High Church loyalists; the grand church of Charles the Martyr in the fashionable watering place of Tunbridge Wells was begun in 1682 but continued to be aggrandized with private subscriptions through the eighteenth century. At a rhetorical level, of course, female beauty is not presented as sexual. None the less, discursively, the production of the female body is invariably erotic, not least in the context of that religious art from which connoisseurs drew such sustenance. We might, in illustration of this point, cite just one example. The conventions and circumscriptions of Royal Academy reviewers, writing in limited spaces for short-lived publications that promoted 'news', are forms of rhetoric, the smooth façade of which sometimes fractures under pressure of a face-to-face encounter. That such engagements took place in the public and heterogeneous space of a Royal Academy exhibition intensified anxiety and produced admonishments more urgent and intense than familiar iconographies might reasonably warrant. In 1772 an artist called Olivier, described as 'Painter to the King of France, belonging to his Royal Academy of Painting; first painter to His Royal Highness the Prince of Conti', exhibited *The Massacre of the Innocents*, with figures about 2 feet high (no. 172).[83] Walpole was dismissive but the *Middlesex Journal*, a newspaper with a radical reputation, was worried about the propriety of showing such explicit violence, finding 'the circumstance, particularly, of the soldier having his foot upon the throat of a child, and squeezing it to death' especially affecting. 'Is it not even shocking and horrid, and as such improper?'[84] The critic of the *Morning Chronicle* expressed even more doubt but on account of another more disturbing feature:

There is a boldness, an unity and fidelity in this . . . piece which claims a capital reputation and makes us the more lament the painter has been so unfortunate in his subject. *The act of the woman's tearing out the soldier's eyes* (who is the principal figure)

and wantoning her fingers in the sockets, is too horrible even for men to look at and may be productive of much mischief for the female sex.[85]

These reviews are interesting for the degree to which they permit us to infer the boundaries of the permissible in visual imagery.[86] To read the utterances of Reynolds or Barry to students of the Royal Academy is one thing; framed in historical and cultural narratives, academic discourse, with its particular professional audience and its private space of delivery, could disavow concerns with the *affect* of religious art viewed in the public arena. Describing paintings in galleries and churches in Italy was safe enough, permitting a synoptic approach and the situating of religious subjects in a historicized discourse of aesthetics and instruction.[87] However, reviewers confronting a religious painting in the annual show occupied a distinct textual space in which, as Andrew Hemingway has pointed out of a slightly later period, several types of discourse came together.[88] It is hard to see how the representation of the Massacre of the Innocents could be anything but horrible and violent and the over-painting of Bruegel's famous scene testifies to the troublesome nature of the subject.[89] Since Olivier's painting is unlocated, we cannot read the comments of the critics alongside the image. In what way then could this painting have been improper? Surely not in the representation of a massacre as violent? Biblical painting itself must have been what was improper, though it was difficult to be explicit about this given the requirements of history painting and the grand style. The second review focuses its anxiety upon the imaging of women and the dangerous capacity of art to destabilize society ('productive of much mischief'). The production of images of female saints and angels becomes more explicable when we recognize the sexualized language deployed by the reviewer in transmitting to a wide metropolitan public his impressions of what was certainly a standard and conventionalized theme in European painting. Through the use of the word 'wantoning', he has transformed a retaliatory act of violence or self-protection into an image of castration so horrible that it is a direct threat to men and, presumably because women's latent violence may be unleashed by viewing it, also a potential disaster for women. By comparison, images of saints and angels connoted female suffering and resignation, passivity and soulful unworldliness.

For reviewers, a representation of the Massacre of the Innocents involving violent acts by female subjects comprised a dangerous threat to the stability of social relations in a society structured through a gendered distribution of power. Moments such as this should alert us to the fact that, whatever the apparent continuities, stabilities, and imperviousness of major eighteenth-century institutions (the Law, the Court, Parliament) to notions of the disruptive possibilities of gender, in the cultural arena there are high levels of anxiety,

at least from mid-century. And furthermore this anxiety is staged around the sexual nature of certain forms of imagery on display to metropolitan publics. The Royal Academy was described by one reviewer, as we have remarked, as a 'Temple of Priapus'.[90] Some time around 1800, E. F. Burney produced two extraordinary watercolours that display the dismemberment—literal and metaphorical—of the body politic as a consequence of the corruption of social institutions. As Richard Leppert has remarked of *The Waltz* (Pl. 56), 'this is a world come apart, the reasons for which are not of course dancing but which, in Burney's hyperbolic representation, are nevertheless perfectly reflected therein'.[91] Both *The Waltz* and its pendant *The Lady's Academy* (the central figure of which is posed in Bacchic posture) are replete with texts. In *The Waltz*, written fragments spill over into every available space packed with official forms of language: 'Laws and Rules for the Assembly', advertisements for matrimony, quotations from Shakespeare and Milton, and a list of lost property in which the staccato nature of the torn text echoes the dysfunctioning and dispersal of fragments of a body which was always, in any case, pure simulation: 'To be raffled for. Unclaimed articles in Assembly Rooms incl. A pair of waxen Br[easts] | a cork Rum[p] | A Good Time | An Under | A Heart set in | A Cupid | A Glass eye | leather | Good. A True Lover | Temper. A Row of Tee[th] | A Night to tedious to mention.' In this Assembly, where musicians fall asleep over instruments with broken strings, sexual relations as imaged in the ceremonial of the dance have fallen into anarchy. Here the chaotic nature of gender relations is staged as part of a discourse about the failure of institutions. As with Rowlandson's frequently reproduced images of art exhibitions, the sheer anarchy, physicality, and celebration of disorder suggest some of the ways in which anxieties about the operations of institutions set up to monitor and govern taste were threatening to disrupt those very imperatives that had determined their foundation. Conventions of politeness are here parodied, shown to be mere semblance. Politeness, by contemporary definition, was situated in 'company' and involved the dextrous management of words and actions.[92] Burney's drawings show the dismemberment, and the emasculation, of that polite body.

The contradictory and intertwined cultural interests and imaginative investments that kept religion, sexuality, gender, and social order as an area of acute interest and sensibility in the period from the 1760s are exemplified in the work of Matthew William Peters. Born in 1742 of Irish parents on the Isle of Wight, and trained in Dublin and with Thomas Hudson, Peters began exhibiting in London in the mid-1760s. He took orders at Exeter College, Oxford in 1781 but (despite some accounts to the contrary) did not abandon painting. He

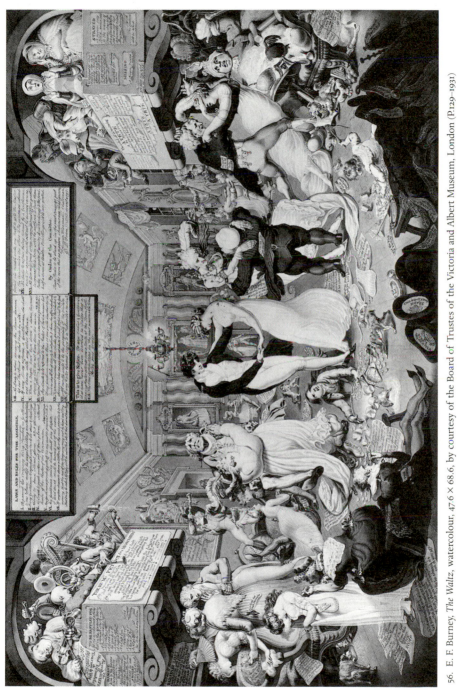

56. E. F. Burney, *The Waltz*, watercolour, 47.6 × 68.6, by courtesy of the Board of Trustes of the Victoria and Albert Museum, London (P.129–1931)

resigned from the Royal Academy (to which he had been elected in 1777—and for which he was also chaplain) in 1788 and took up a series of livings under the patronage of the Duke of Rutland. He was an active Freemason and, by the time of his death in Kent in 1814, he had amassed a considerable fortune. Much of his work was engraved—often several times—which offers a clear indication of his popularity.[93] E. K. Waterhouse astutely pointed out that Peters has a stronger link with France than other painters of genre since he was there in 1775 and again in 1783–4 when he became friendly with Vestier and Boilly.[94] He also draws attention to the similarities between Greuze and Peters but, ultimately, Waterhouse is uncomfortable with Peters's 'swimmy facial expressions' derived from Correggio and his *risqué* subjects and concludes that paintings like *An Angel Carrying the Spirit of a Child to Paradise* (see Pl. 53) 'belong to the curiosities of the history of taste rather than to the history of art'.[95]

With the exception of Lady Victoria Manners (and Whitley who connects Peters with an abortive plan to establish a painting academy in Oxford in 1786 and with de Loutherbourg's scenery for a pantomime of Omai),[96] writers have steered clear as far as possible of Matthew William Peters. Hodgson and Eaton remarked in 1905, 'few have seen his pictures, and fewer remember them'.[97] What have been remembered are the satiric lines of the poet Peter Pindar (Dr Wolcot):

> Dear Peters! who, like Luke the Saint,
> A man of Gospel, art, and paint,
> Thy pencil flames not with poetic fury;
> If Heav'n's fair angels are like thine,
> Our bucks, I think, O grave Divine,
> May meet in t'other world the nymphs of Drury.

And referring to *An Angel Carrying the Spirit of a Child to Paradise*:

> The infant soul I do not much admire:
> It boasteth somewhat more of flesh than fire;
> The picture, Peters, cannot much adorn ye.
> I'm glad, though, that the little red-fac'd sinner,
> Poor soul! hath made a hearty dinner
> Before it ventur'd on so long a journey.[98]

The attention of Pindar testifies to the widespread popularity of Peters's work which lasted at least until the early years of this century. Thereafter he virtually disappeared from view even though two of his paintings were at one time a jewel in the crown of the Pierpont Morgan Collection. Two major public collections have purchased paintings by Peters since 1970 though in

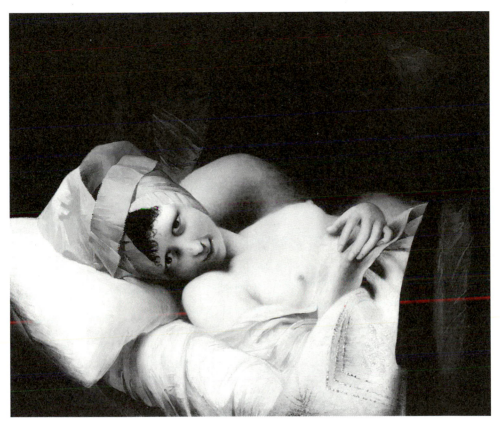

57. M. W. Peters, *Lydia*, oil on canvas, 1777, 64 × 76, Tate Gallery, London

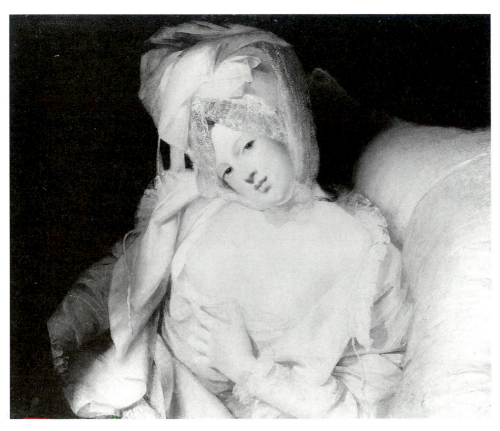

58. M. W. Peters, *Sylvia*, oil on panel, 1777, 63 × 76, Reproduction courtesy of The National Gallery of Ireland, Dublin

neither case have the paintings been much out of the store. A glance at *Lydia* (Tate Gallery, Pl. 57) or *Sylvia* (National Gallery of Ireland, Pl. 58) perhaps explains the reluctance of modern scholars to engage with Peters's genre paintings. None the less, there are a number of things about Peters which are exceptionally interesting. He was particularly well connected and, although he quarrelled with Opie, he had a large number of influential colleagues and patrons.[99] He was one of the most European artists of his generation; he made two visits to Paris, returning on one occasion with a finely crafted female lay figure which was much admired,[100] and he spent extended periods of time in Florence, Rome, and Parma.[101] His command of painting techniques was superb and, unlike many of his contemporaries (including luminaries like Reynolds), his paint surfaces were not only richly executed but non-fugitive. *An Angel Carrying the Spirit of a Child to Paradise* (RA 1782), which hangs in the Second George Room at Burghley in a suite of rooms containing an exceptional series of works by and after Guido Reni, Carlo Dolci, Correggio, and Raphael, makes its effect with high tonalities and a willingness unusual in an English artist to situate the figures in a large vacant area, enabling virtuoso treatment of the blue and pink clouds. The pink feet stand out against the blue background and the garments are painted with meringue-like impasto. The pretty pink feet and hands, together with the contemporary nightdress worn by the child and the overall evocation of maternal sentiment, establishes the kind of humanized dialogue with the supernatural with which Flaxman and Westmacott made their reputations in stone-carving, and Cosway through print, some thirty years later.[102] The Burghley painting was engraved several times (sometimes in colour) from 1784 with appropriate accompanying text (one version, for example, is labelled 'For of such is the Kingdom of God', Pl. 53). Indeed, Whitley quotes an account in the *Morning Post* in 1786 according to which a travelling showman was earning a 'comfortable livelihood, by shewing at a shilling each copy, from the print only, of the Angel and Child painted by him and now in the possession of Lord Exeter'.[103] Purchased together with *The Resurrection of a Pious Family* (engraved by W. Dickinson, dedicated to the Prince of Wales, 1790, Pl. 54), *The Three Holy Children,* and *The Spirit of a Child Arrived in the Presence of the Almighty* (Pl. 55), with their respective biblical texts, it could be hung by consumers of the middling sort in an arrangement of images to provide a narrative of redemption mediated through gobbets of biblical text that did not demand engagement with difficult issues like transubstantiation and which permitted a high degree of empathy.[104] Peters's subject matter thus spans an axis from the erotic icon of the sort that was to beome increasingly popular through Keepsake literature to large-scale religious painting. That the body of his engraved work

includes many religious subjects suggests a market for such images in Hanoverian England.[105] Moreover, while it was clearly not easy to negotiate across these various genres, the fact that Peters made a reputation by so doing should alert us to the possible structural relationship between religious and secular (erotic) subjects in the context of English art patronage and display. While Reynolds advanced his reputation by painting ladies posed as saints, Peters established his by painting not only human beings bound for paradise, but also angels who were understood to be ladies, and courtesans who were understood to be courtesans.

Peter Pindar's merriment was not universally shared. When Peters exhibited *A Woman in Bed* at the Royal Academy in 1777 the reviewers were prepared to be jocular but also devoted serious attention to Peters's performance. Although not formally identified, Manners suggests this must have been *Sylvia*, reproduced in mezzotint in 1777.[106] The appellation 'woman' as opposed to 'lady' and the reference to 'bed' indicates clearly that this was a painting of a courtesan. Moreover, the pastoral 'Sylvia' had by this time transformed into something very different in eighteenth-century culture; the playmate of Corydon and Thyrsis was now, in the counter-world of bawdy with its propensity for parodying revered high art forms, to be found in the bagnio. The conspicuous luxuriance of paint, the delicacy of handling, the control of the figure in its setting, and the elaborate impracticality of clothing all announce this as an essay in a genre that was widely respected by educated audiences familiar with Titian's *La Bella* and other Renaissance courtesan images. Peters's model offers almost exposed breasts for viewing. Imagery of this sort provided a pre-text for virtuoso painterly performance.

Such a work thus offers a clear example of the way in which the unique painting which was justified among an élite class on account of an apparent fusion between technique and content—the sensuousness of the handling was necessary for the fleshy subject and the fleshy subject required the intensity of painting—was transformed through stipple engravings into an image popular because of its subject alone. The ability to appreciate paint remained the exclusive property of the aristocratic patron for whom the image was painted and by whom it was owned. Through this appreciation, the work itself was legitimized as a refined work of art worthy of being hung in a gallery of historic paintings. The popular print, based on the image but divested of those elements that required an educated view, and often with a suitable narratizing and moralizing text attached to it, entered the popular domain as icon; not only was the original without text, left as it were intact, but the knowledge that there was an original enhanced the allure of the print as commodity. The owner of the painting authorized this transformation. Thus the letterpress for

Sylvia reads: ' Engraved from an original painting in the collection of the Right Honble. Lord Melbourne by J. R. Smith. O Woman lovely woman, Nature made you to temper Man: We had been Brutes without you. Published Decemr. 28, 1778, by J. R. Smith.' The inference is that the original of woman, as well as the original of the painting, lies with Lord Melbourne who, God-like, may authorize an endless series of replicas. Through the collective solidarity of the male 'we', encompassing all viewers, print thus conspires in the commoditization of femininity and, simultaneously, in the preservation of the aura of the feminine. This ideological process is reinforced by the historiography in which anecdotes, like that according to which Lord Grosvenor, for whom another version of *Sylvia* was produced (possibly in crayon), kept the picture veiled. Manners is sceptical, arguing that the susceptibilities of society were unlikely to have been so delicate as to demand this. But this is, of course, to miss the point. Leaving aside the evidence that this anecdote provides of an intense interest in the idea of veiling an image of a woman, as with other paintings of women we know to have been veiled (a case in point would be Courbet's erotic paintings of women), the covering would have been a ritualized act of possessiveness. The ceremonial unveiling of the painting replicates the act of undressing the female subject and endorses the power of ownership. The right to unveil, to control the revelation, lies with the painting's owner.

Peters produced a series of images of this type, the titles consisting simply of women's names, and suggesting therefore both an intimacy and an anonymity, a technique adopted in our own century by 'girlie' magazines such as *Playboy*. Like 'Sylvia', the names of Lydia (of which at least two versions are known)[107] and Belinda (engraved by Dunkarton and published 1777, Pl. 59) were frequently used for heroines of *risqué* novels and as fictitious diarists and confessional letter-writers. Belinda is, of course, celebrated as the subject of Pope's *The Rape of the Lock*, the first illustrated edition of which (1714) included a frontispiece featuring Belinda in bed,[108] but she also features in popular novels such as *The Woman of Fashion: A Poem: In a Letter from Lady Maria Modish to Lady Belinda Artless*[109] and *Belinda: or, The Fair Fugitive*, a novel by Mrs C. In the former, Lady Maria tells Belinda of the necessity of marrying money:

> What—marry for Love! Oh! I die at the thought!
> With Money alone must old Hymen be fraught.
> Thus when at the Altar much Nonsense we say,
> (For we promise to honour, respect, and obey)
> Our Hearts, at the Moment we utter each Word,
> Confess that the Book and the Priest are absurd.
> Nay, what signifies Love?—We barter our Hand,
> O'er Coaches and Diamonds to have the Command.[110]

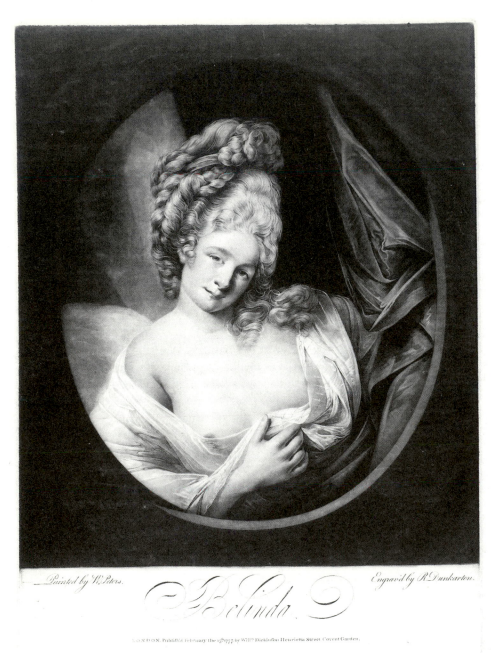

Painted by W. Peters.

Engrav'd by R. Dunkarton.

Belinda.

LONDON, Publish'd February the 15th 777 by Will.m Dickinson Henrietta Street Covent Garden.

59. R. Dunkarton after M. W. Peters, *Belinda*, pub. 15 February 1777, British Museum, London

The latter is rather different in tone. Dedicated to Her Grace the Duchess of Marlborough, it opens with two wealthy gentlemen discussing an arranged marriage and settlement between their children who have not been consulted about the match.[111]

Sylvia was especially popular as a name for fictional heroines: *Sylvia's Revenge*, published as a response to *The Folly of Love: A New Satyr against Woman* (1701), which reached its twelfth edition in 1720 and continued popular through the century, offers the reader a sequence of quintessential female names as generic of particular feminine attractions:

> Now he dyes for *Sylvia's Charming Eyes,*
> Till Caelia's Singing did his Soul surprize;
> His *trifling* heart she for a while possest,
> Till 'twas remov'd to *Rosalinda's* Breast.[112]

This poem is not, of course, in any serious sense a defence of the female sex; quite the contrary it is a pretext for enumerating the possible variant relations a man may have with a woman. Sylvia is also the recipient of an epistle from a friend called Libertina in 1735 ('Till Time had stol'n the Light'ning from her Eyes | Sylvia, was never known to Moralize'),[113] the heroine of a long novel in which the orphaned Sylvia goes to work and wards off frequent rape attempts before finally being reunited with her sweetheart,[114] and the 'Delicate Edinburgh Belle' in *The Entertaining Amour of Sylvander and Sylvia*.[115] Lydia, the name of Lady Lydia Languish, heroine of Sheridan's *The Rivals,* is, if anything, still more popular and, by the time Jane Austen used it as the name for the flighty youngest Bennet sister in *Pride and Prejudice*, seems to have acquired distinctly non-classical associations with loose living and bawdy. *Lydia: or, Filial Piety* by John Shebbeare appeared in 1755, Maria Robinson's *Celadon and Lydia* in 1777, and *Lydia: ou, Mémoires de Milord d'——, imité de l'anglais par M. de la Place* in 1772. Lydia is invariably an innocent beauty discovered by a male raconteur. In Maria Robinson's tale we are told that

> Secluded from the world's ignoble strife,
> By storms unruffled, and unknown to Care,
> Fair Lydia pass'd a solitary life,
> Stranger to Poverty and sad Despair.[116]

In the *Mémoires* of the anonymous Milord, a book dedicated to David Garrick, published in London and Brussels, and evidently intended for an educated English audience since it concerns the adventures of a libertine in the company of his friends Merrill and Sir Henry Burr, the eponymous heroine is described at first sight:

Une robe, très-blanche, une ombre de coeffure devenue presque imperceptible à travers une abondance de cheveux naturellement bouclés, qui descendoient par de là la ceinture; un grand fichu de mousseline, qui cachoit une gorge dont les mouvemens sembloient répéter ceux de mon coeur: tel étoit le déshabille de Lydia; ou, la propreté, & la noble simplicité, triomphoient de tout ce que l'art de la parure a de plus recherché.[117]

Although some of these poems and novels have ostensibly moral overtones, they all purvey an imagery of sexually available and compliant femininity. They are some few of the hundreds of novels and poems on the theme of seduction published especially during the second half of the century.[118] It would clearly be rash to suggest any precise correlation with Peters's images of young women *en déshabillé*. None the less, these narratives can help us to establish the conditions of readership for Peters's work. The notion of retirement and seclusion is clearly important and so is the idea of lack of adornment. Lydia, in the last passage quoted, offers charms that are finer than those of the most expensive 'parure' ('get-up', a term that usually means a set of matching jewels). Peters's *Lydia* (Pl. 57) and *Sylvia* (Pl. 58), by contrast, present subjects dressed in extremely elaborate day headgear. The situation in which they are found (in bed or reclining on a sofa) and their ostensible nakedness is set off by the sheer elaboration of their caps.[119] This item of female apparel, foreshadowing the fantastic female heads of some of Fuseli's drawings, was the focus of a great deal of attention; the erotic charge, we may guess, was derived from the contrast between a high degree of sophistication and artistry in the framing of the face, and the remainder of the body left simply attired (or unattired). Stubbs's *Haymakers* of 1775 (Tate Gallery, London), in which women working in the hayfield are dressed in similarly elaborate caps surmounting plain attire, may have been calculated to produce the same kind of *frisson*. It was evidently a combination that provided a historically specific sexual nuance. The pseudo-Italian visitor writing in the *St James's Chronicle* offers insights into the immense importance of what went onto the head:

Their high Head-Dresses with loose curls are very proper and beautiful; Feathers, to a moderate Degree, very becoming; but their Caps are horrid, and I find them to be a French fashion: Indeed, they are very Insignificant, and I can compare them to nothing but an Ornament which the French have in their Gardens, called *Treillage*, raised to an amazing Height, which neither shelters you from the Rain, nor shades you from the Sun. So are the caps of the Ladies, without the least apparent Use; and what increases the Ridicule of it is, that they stick them on in a Perpendicular Form, so that from the Chin to the Top of the Cap makes exactly Half the Length of the Body. [120]

The satirists of the 1770s who mounted a vigorous critique not only of macaronis but also of the elaborate piled high hair-styles of women were also much

interested in caps which were often of equal extravagance. Maria Cosway, who was always abreast of fashion, is said to have favoured elaborate caps which curtained the face and tied under the chin with strings.[121]

Belinda and *Lydia* share a format that captures the figure in a frame (oval or almost square) which permits the semi-exposed breasts of the subject (whose hand holds together—or releases—her clothing) to project forward attracting the eye to the just-revealed nipples. Lydia and Sylvia—and this is common to many of Peters's female sitters—wear immensely elaborate caps while Belinda has the huge curled coiffure mentioned above. Their drapery, unlike the models of Reynolds or Romney, is very definitely in the form of clothing— Sylvia's draw-strings are visible and Belinda's off-the-shoulder garment sug- gests a sleeve construction—and they lean back on their sofas and beds with their heads tilted forward like broken flower heads waiting to be picked, looking hazily and invitingly through half-closed lids.

In these images women are packaged and wrapped. The veiling of a picture merely adds one more layer to a process the artist has already commenced. Indeed, in *Lydia*, a curtain appears to have been drawn back to reveal the model. One further feature in this set of images by Peters is worthy of remark: in each case we see only one hand. The suggestiveness of this pose consists in the fact that it implicitly leaves open the question of the position of the subject's other (right—though in the engraved version left) hand. In the case of *Lydia*, for example, the model's visible left hand holds something hidden beneath the gauzy sheet, a something which may be her other hand, but is sufficiently indecisive to leave the matter open to interpretation. Like religious icons or revered relics, the object of desire is covered and swathed; it is also— like religious images—replicated and marketed to a popular audience. Moreover each original painting is in some sense a replica of its fellows. *Belinda* (Pl. 59) is, for example, a vertical variant of *Lydia* (Pl. 57) with masses of hair instead of an elaborate cap. Such works were, therefore, done to order, with variations in dress and accoutrements just as the fashionable Roman por- trait painter Batoni produced images of milordi on the Grand Tour with minor variations.

In at least some instances the identity of the sitters for these paintings was known. The sitter for *Hebe* was the sister of John Hamilton Mortimer (engraved by J. R. Smith, 1779), a Miss Bampfylde sat for Belinda,[122] and *Love in her Eyes Sits Playing* (formerly in the Pierpont Morgan Library, engraved by J. R. Smith, 1778) is said to be a portrait of the actress Mrs Jordan.[123] Admittedly, while clearly seductive, these paintings did not show the sitters in quite such a state of swooning acquiescence as Sylvia and Lydia. They may perhaps be regarded as an interim stage between the images of young women in bed and

the portraits of young women which Peters exhibited under their own names. All these paintings were, however, being produced at the same time for the same group of patrons. Not only was there apparently not a problem about the artist of *Sylvia* being commissioned to paint the Hon. Mrs O'Neill (engraved J. R. Smith, 1778) or Elizabeth Stephenson, daughter and heiress of Henry Stephenson of East Burnham, Buckinghamshire (engraved J. R. Smith, 1778), Peters's reputation seems positively to have been enhanced by his perceived accomplishments in this sensational field of image-making. We may also deduce that the body of named portraits probably licensed speculation about the identities of the models for the semi-clad images, even if no one model existed.

The unusually square format and the enveloping of the female form in cushions, curtains, caps, and laces in *Lydia, Sylvia,* and their companions gives the sense of opening a gift box, or looking into the petals of a large artificial flower. In this sense the image stages the spectacle of the female genitals. The pillows, cushions, and bedding are treated like flesh with their shadowy hollows and protruberances. This effect of padded symmetry is carried through into the less *risqué* paintings like the pendant panels formerly in the Pierpont Morgan Collection.[124] Lydia in the painting of that name is arranged in the picture space in such a way that she may be viewed from any angle: the spectator is invited by the pose to revolve the image, to view it from every way up. Indeed, it is imperative that the viewer either turn his head, or turn the painting, to engage with the direct and solicitous gaze of the female subject. Turn it whichever way you will, the feline eyes and pneumatic breasts are still there for the taking. Sylvia is produced, one might say, by tipping over Belinda, or Belinda, by swivelling Sylvia. The letterpress to the engraving after *Lydia* by W. Dickinson (1824, Pl. 60) includes the quotation attributed to Dryden which the Royal Academy Council declined to permit to be printed in the catalogue when the painting was exhibited.[125] This quotation positions the viewer as Creator and possessor, asserting that the woman's 'no' effectively is countermanded by the unspoken message of the eyes: a classic defence:

This is the Mould of which I made the Sex, I gave them but one Tongue to say us nay,
And two kind eyes to grant.

The feline qualities of these models—their sharp chins, narrow dark eyes with large iridescent pupils, small shiny mouths, and high cheek-bones—suggest that Peters was familiar not only with Vestier but also with Greuze.[126] The suggestion of animality in the female face seems to have been a key component in the imaging of sexual availability in the period for it appears prominently in Reynolds's fantasy child subjects. *Muscipula* (which Reynolds

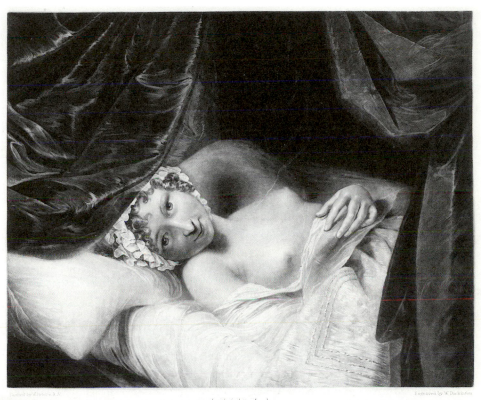

60. W. Dickinson after M. W. Peters, *Lydia*, pub. 10 July 1824, British Museum, London

exhibited in 1785 as a fancy picture of a girl with a mouse trap) and *Robinetta* (*c.*1786), for example, possess, a decade later, very similar features to Peters's *Lydia* in the head and shoulders version.[127] Martin Postle draws attention to the Flemish painters as a source of inspiration for this group of images of children[128] but the facial type owes much to the Parmigianino *Madonna* and accompanying figures that James Barry found so irresistible. The exaggeration of eyes and chins to produce the feline effect links these images to the traditions of physiognomy that were familiar from Della Porta through Le Brun (who mapped human faces onto those of cats and other animals) to the newly fashionable treatises of Lavater[129] and to popular notions of women as shrews and bitches. The first English translation of Buffon's *Natural History*, which appeared in 1775, describes cats as having 'gentleness especially when they are young' but also possessing 'an innate cunning, and a perversive disposition, which age increases and which only education hides'.[130]

Sylvia reclines against cushions on a sofa, an item of fashionable furniture with connotations of the Orient and of leisured, if not luxurious behaviour. As Cowper expressed it in *The Task* (1783):

> Thus first necessity invented stools,
> Convenience next suggested elbow chairs,
> And luxury the accomplished sofa last.[131]

Lydia, on the other hand, is definitely in bed: the counterpane with its very specific patterning appears in all versions.[132] The reclining posture of these models would have been, in itself, sufficient to invite salacious interest. An acknowledgement of this aspect of Peters's work helps to explain the insistent verticality of female portrait subjects of Reynolds, Cotes, and, to a lesser extent, Romney and other late-eighteenth-century artists, whose long bodies are disposed in elegant lines on large canvases in compositions which stress height, and whose clothing appears free-flowing and devoid of draw-strings, seams, and apertures. And when seated, these portrait subjects never loll but sit straight-backed and composed. It also goes some way towards explaining the overwhelming preference for maintaining outdoor landscape settings for the portrayal of female subjects through the eighteenth century. By contrast, all is compressed in Peters's images—indoors, oppressive, wrapped, and hot-house. Peters was often compared with Reynolds as a technician, but Reynolds's female sitters have free-moving limbs in *plein air* settings. While Peters's imagery speaks luxury, Reynolds's enunciates politeness.

Confronted with *Woman in Bed*, the reviewer of the *Public Advertiser* admired the richness and warmth of colouring which he relates to the Florentine and Venetian Schools. 'This must be allowed', says the reviewer, 'to

be a good Piece, and has the Effects of a good Piece on By-standers.'[133] The measure of the work's success seems here to be its effect on an audience. It is, however, clear from a second review (in the *Morning Chronicle*) that effect was not merely a matter of appreciating the extent to which an artist had learnt the lessons of Italian colourists. Effect might also mean arousal and, more specifically, sexual arousal:

Mr Peters, who has the manner of Sir Joshua in his colouring, seems to have been determined that, the exhibition should have something to charm the Bucks as well as the Belles of the age. His Woman in Bed is a good picture, and makes every gentle-man stand for some time—and gaze at it. We cannot however, help thinking that the inviting leer of the lady, and her still more inviting bosom, ought to be consigned to the bed-chamber of a bagnio, where each would doubtless provoke a proper effect; in the present situation they serve to prevent the pictures around them from being so much seen and admired as their merits demand. For every man who has either his wife or his daughter with him must for decency's sake hurry them away from that corner of the room.[134]

Here the bystander is a person—and more particularly a man—who stands for some time and gazes. The audience for the Royal Academy show is assumed to comprise women as well as men but certain paintings in the show are properly viewed only by men. The seductive nature of this picture impinges upon other pictures hung nearby. If the commentary on *Woman in Bed* offers an extreme example of the ineffectual hold of the President's teaching on the productions displayed by the Royal Academy's members, it also provides an insight into the typically complex intertwining of genres, themes, and viewing positions in the exhibition arena of late-eighteenth-century England. Malcolm Baker has affirmed that Walpole's declaration in 1770, that the rage to see exhibitions in London is sometimes so great one cannot pass through the streets, is borne out in the 1770s by the extraordinary range and variety of shows available to London audiences.[135] This range and variety also extended to the viewing possibilities within particular exhibitions themselves. Thus, picking your way around the Royal Academy, especially if accompanied by your wife and daughter, was not exactly a cause for complaint (there is little evidence of indignation about Peters's painting) but required some alertness.

The fact that Peters is capable of what the reviewers call 'a good picture'—that is, good by reference to colour and facture—does not disguise the fact that when it comes to content, the rules that governed have well and truly broken down. The advent of an ever-growing female readership for literature and, especially through print, for art[136] accentuated the question of viewing as a gendered activity. As the editor of the *Freemason's Magazine, or General and Complete Library* for July 1793 declared, his objective was to provide readers

with 'superb engravings' and 'nor will the Ladies . . . be forgotten'.[137] Rules and assumptions about politeness that prevailed earlier in the century did not provide adequate guidance for visitors to the Royal Academy in 1777. The *Sentimental Magazine* (first published 1773) and other similar publications appealed to 'chastity of sentiment'[138] and to the choice of modesty rather than wit because the boundaries between politeness and salaciousness were so blurred. It was this kind of confusion that was exposed in E. F. Burney's mordant drawings of the musical and educational establishments discussed earlier.

The texts introduced to anchor the imagery in the prints after Peters's work—both religious and secular subjects—with the purpose of mediating the subjects for a wide audience, are themselves ambivalent with their connotations of élite patronage, use of apparently spurious quotation, and biblical tags. They function as a pre-text much in the same way as the texts of sermons which could relate in detail a series of lewd events from the Old Testament, doubtless to the delectation of the congregation, as a prelude to a moral diatribe about adultery.[139] One writer has referred recently to the astonishing market for devotional literature in the eighteenth century.[140] This literature covered not only Bible commentary which was extensive and popular[141] but also semi-secular moralizing narratives. Irony and inversion were used by sermon-writers. Thus, for example, in a popular series called *Sermons to Asses*, James Murray goes to great lengths to describe the Moabites as dirty, feckless, and fornicating and then rhetorically asks, could such things ever be said of England?, knowing full well that his readers will recognize contemporary society in his descriptions from the Old Testament. The language used for a sermon on luxury and dissipation, even when framed by moral rectitude, was calculated to offer entertainment to an audience accustomed to move easily between the secular and the religious.[142]

The sensual and erotic discourse of saintly and angelic femininity was well established in eighteenth-century visual culture, legitimized through a long tradition that linked the visual and the verbal and brought 'Beauties' who could vie with Correggio's saints on their own ground onto the public stage. In the previous century, Lely had painted subjects such as *Susannah and the Elders* (Tate Gallery, London) and *Mary Magdalen*[143] within the context of a portrait practice and Kneller's *Lady Elizabeth Cromwell as St Cecilia* of 1703[144] is merely the first in a long line of nubile young women posed as early Christian saints. When George Eliot chose to define the peculiar susceptibility of English Protestantism to the sensuousness of Rome in the person of Dorothea Brooke, with her sublimated sexuality and her impulsion to martyrdom, she

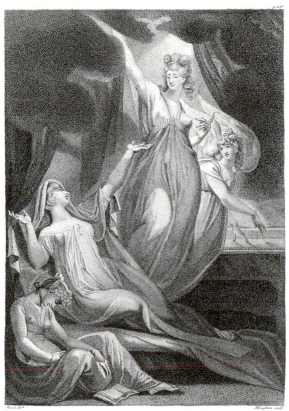

THE POWER OF FANCY IN DREAMS.

So holy transports in the chaste a shade
Bay round thy roses running mind
Charmed are thy lost celestial voice sing
And Seraphs hover in enamoured wing

Pub. 1803 April 1 by J.J. Johnson London

61. J. Houghton after J. H.
Fuseli, *The Power of Fancy in
Dreams*, from E. Darwin, *The
Temple of Nature*, London,
1803, c.1786, Reproduced by
courtesy of the Director and
University Librarian, the John
Rylands University Library of
Manchester

drew upon a rich vein of English fantasy. Richard Crashaw's ecstatic poems to
St Mary Magdalen ('Eyes! nests of milky doves | In your own wells decently
washt. | O wit of love! that thus could place | Fountain & Garden in one face')
and to St Teresa ('Thou art Love's victime; & must dy | A death more mysti-
call & high') may have been out of fashion with the Protestant literati of
Johnson's circle but lives of saints and the notion of angelic companies
remained an area of mental excitement as with the subversive activities of
atheistical groups like the Hell Fire Club and Sir Francis Dashwood's
Medmenham monks.[145] Whether the latter group did or did not indulge in the
excesses of which Wilkes and others accused them is not the point here;[146] the
fact is that converted abbeys were becoming pleasure grounds. Peter Wagner

describes the class of imagery with which these groups engaged as 'anti-religious erotica';[147] he addresses the effectiveness of the erotic for parodying and exposing the Church (and particularly the Roman Catholic Church), but whatever religion may have contributed to the eighteenth-century erotic, and to the question of what this might mean when the imagery comes not in the form of popular print but as an Italian Old Master painting, is not his concern. Admiration of artists for the painted saints of Correggio, for example, is articulated in ways that suggest an engagement with the minutiae of bodies that approaches the fetishistic. Romney in Genoa in 1773 is by no means atypical when he enthuses: 'the beauty of the features, the angelic sweetness of the countenances, and the elegant disposition of the hair, make them divine beyond conception.'[148]

At a popular—but not necessarily overtly bawdy—level stories of nuns in Gothic seclusion were associated, it seems, at the end of the eighteenth century with a particular form of explicit sexuality. When Fuseli illustrated Erasmus Darwin's *The Temple of Nature*, published in 1803 (Pl. 61), he or the publisher Joseph Johnson chose to provide a plate for canto iv illustrating the power of fancy in dreams. Fuseli's design relates to a metaphor not to the substantive point of the canto, and shows a swooning nun-like figure with a prominent cross on her breast.[149] The life of Louise de la Vallière, who became mistress of Louis XIV in 1661 and who, after being supplanted, eventually retired to a Carmelite convent in great style in 1674, was seemingly a source of great fascination to the English aristocracy.[150] Matthew William Peters was sent by the fourth Duke of Rutland in 1782 to copy Le Brun's portrait of de la Vallière in her habit in the Carmelite Church in Paris.[151] Although this copy was destroyed by fire at Belvoir Castle, two copies survive at Burghley, suggesting a particular interest in this subject.[152] Edward Moore, famous for his *Fables of the Female Sex* (1748), wrote a 'cantata' called 'The Nun' (with a structure that alternates between a recitative and an air) which was collected in Bell's popular *The Poets of Great Britain*.[153] This poem invites readers to imagine a beautiful recluse and, as it brings together a cluster of ideas which are the leitmotif of the second half of this chapter—song and music, religious devotion, and female seductiveness—it is worth quoting at some length. The poem opens with a recitative:

> Of Constance holy legends tell,
> The softest sister of the cell;
> None sent to heav'n so sweet a cry,
> Or roll'd at mass so bright an eye.
> No wanton taint her bosom knew,
> Her hours in heav'nly vision flew,

> Her knees were worn with midnight prey'rs,
> And thus she breath'd divinest airs.

To this 'sacred pile' which 'echoes but to holy songs' comes predictably the monk Francis, whereupon the nun sings the following air:

> Alas ! how deluded was I
> To fancy delights as I did,
> With maidens at midnight to sigh,
> And love, the sweet passion, forbid !
>
> O Father! my follies forgive,
> And still to absolve me be nigh;
> Your lessons have taught me to live,
> Come teach me, O teach me! to die.
>
> To her arms in a rapture he sprung,
> Her bosom, half naked, met his,
> Transported in silence she hung,
> And melted away at each kiss.
>
> Ah Father! expiring, she cry'd
> With rapture I yield up my breath!
> Ah daughter! he fondly reply'd
> The righteous find comfort in death.

Situated in Bell's popular household collection between 'The Lover and the Friend' and 'Solomon: A Serenata in Three Parts Set to Music by Dr. Boyce', this lightly pornographic poem, with its punning around death and orgasm and its *double entendres* over religious dedication and sexual abandonment, narratizes the very constituents that educated taste in a more elevated language dwelt upon in paintings by Italian and Flemish artists and sought to replicate in modern art: virginity and seclusion in a picturesque setting redolent of Roman Catholicism and its rituals, a cultivation of the transcendental through the medium of music which, as we shall see, is the key to St Cecilia's appeal, seduction leading to sexual rapture. The banality of this mildly *risqué* poem notwithstanding, its constituents are those that de Sade would develop to such brilliant excesses in the narrative of Thérèse in her encounters with the libertine Dom Severino in *Justine*.[154] It also helps to explain the cultural context for the consumption of a painting of Emma Hamilton as a nun in Sir John Fleming Leicester's Gallery and his images of the same subject as Magdalen, Madonna, and vestal (cf. Pl. 65).[155] Antiquarians, as we have seen in the case of Dorothy Richardson, during this period were assiduously investigating the pre-Reformation history of the English nation. The corollary to such scholarly undertakings (which were themselves not lacking in emotional affect) was the

production of a pleasurable site of transgression whether in the form of a hermit in a garden grotto, a nun seduced in a poem, or an image of a saint tinged with the corruption of an Italianate tradition.

At a somewhat more elevated level than the readership of 'The Nun', the widespread demand for Bartolozzi's engravings after Guercino and for a large number of, often imported, engravings after Domenichino testifies to the capacity of a generalized religious imagery (often avoiding the Old Testament and featuring numerous angels) to fulfil a national need. The immense popularity of these and other seventeenth-century artists (Carlo Dolci, Carlo Maratta, Guido Reni, Murillo, and others) in the second half of the eighteenth century—the pre-eminence of Raphael notwithstanding—is largely a matter of the triumph of pleasure over improvement. Though Hazlitt is of a later generation, in viewing after a gap of twenty years the paintings at Burghley— he first visited the house in 1792—he self-consciously inserts himself into a narrative of continuity, contrasting the change and decay manifest in his own person with the 'deathless works' within the house. Phrases like 'pulpy softness', 'tender grace', and 'expression unutterable' are used of Guido's *Head of an Angel*. Does not art like this, Hazlitt rhetorically asks, offer us 'glimpses of Paradise'?[156] But the question of whether it is earthly or heavenly paradise is left hanging like a Correggio cherub suspended mid-canvas. Angels, theologically speaking, are ungendered but there is little doubt that in eighteenth-century England the angel imaged in sixteenth- or seventeenth-century Italian art was tacitly understood to provide a paradigm of female perfection. 'There is a sweetness in Guido's heads, as there is also a music in his name': Hazlitt's language for ekphrastically engaging with this imagery is calculated to invoke an intensely corporeal experience.

The immense popularity (and subsequent obscurity) of an artist like Peters is altogether more credible if we think of the cumulative effect of a collection like that at Burghley or at the home of another of Peters's noble patrons, the Duke of Rutland at Belvoir. The third Duke of Rutland was a good gentleman painter and a keen collector and, even after the devastating fire of 1816, Belvoir offered a dazzling array of religious art. There were major works by Parmigianino, Dolci, Guido, the Carracci, Murillo, Veronese, and Correggio. Peters (who acted as curator of paintings to the Duke and was unfortunately allowed to meddle in restoration) possessed the ability to approximate the quality of 'sweetness' so admired; the inclusion of his work ensured a contemporary gloss on the products of Italian culture so avidly accumulated.[157]

One saint from the Roman Catholic canon occupied a special position in post-Reformation English culture. St Cecilia, the patron saint of music, is a familiar

figure through poetry, imagery, and through the importance attributed to the saint's day, 22 November, as an occasion for sermons, concerts, and festivals. While it is certainly true that 'St Cecilia' provided a convenient complimentary tag to attach to the portrait of any young woman with musical aspirations, and permitted a rare opportunity to show female subjects active but none the less decorous, I shall propose that Reynolds's St Cecilia paintings typify a process through which particular sitters could be displayed in works that connoted the religious and sexual qualities we have already established as part of the culture of Roman Catholicism and the visual arts in eighteenth-century England. In Chapter 4, I considered the Bacchanalian associations of Reynolds's portrait of Mrs Hale as Euphrosyne, painted for the Music Room at Harewood House, and drew attention to the similarities between the figures of Mrs Hale (Pl. 29) and Thaïs (Pl. 46). The story of Thaïs, it will be recalled, was told by Dryden in 1687 in his *Alexander's Feast*. This work was written for, and performed upon, St Cecilia's day and was preceded by a poem to St Cecilia. It was revived and set to music by Handel in 1710. This juxtaposition of a dedicatory poem to a Christian martyr and the wild story of Alexander's mistress as destroyer points up the slippage between genres and the interplay between secular and Christian themes with which this chapter is concerned.

Reynolds's large *St Cecilia* (now in Los Angeles, Pl. 62) was also painted for a music room. Sir Watkin Williams-Wynn was a precocious collector: by the time he was 26 he had purchased a major collection of paintings (including Poussin's *Landscape with a Snake*, National Gallery, London, for which he paid in 1773 the then astonishing price of £650). He was a leading member of the Society of Dilettanti among whom he was portrayed by Reynolds, presiding over the meeting in 1777 at which his friend Sir William Hamilton was introduced as a new member.[158] He was also a great patron of music: he was a key figure in the Handel Commemoration Festival of 1784 and Mrs Sheridan, the subject of a further version of *St Cecilia* by Reynolds (c.1775), sang to him on his death-bed. Williams-Wynn commissioned Reynolds to paint *St Cecilia* c.1774 for his new town house in St James's Square. It was a companion-piece to a painting of *Orpheus Lamenting the Loss of Eurydice* by Nathanial Dance (unlocated). The paintings were to hang on either side of the chimney-piece while over the doors on each side of the organ were to hang heads of musicians with an image of the Muses honouring the tomb of Orpheus over the door at the end. Stucco ornaments with lyre girandoles were to be introduced into the panels that did not have paintings.[159] Thus the pagan personification of music and the Christian martyr and patron saint of music hung as pendants in what must certainly have been a carefully rehearsed and self-conscious duet.

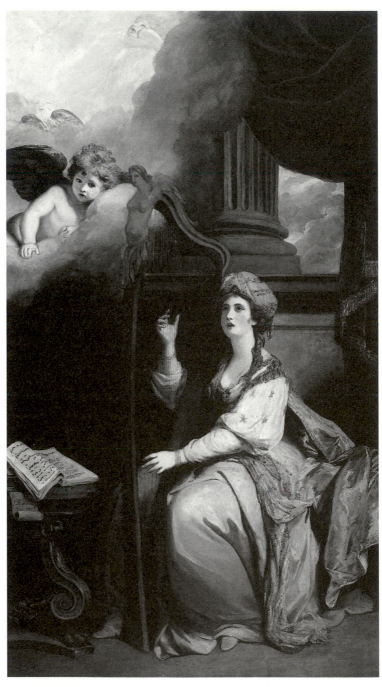

62. Sir J. Reynolds, *St Cecilia*, oil on canvas, 280 × 160 cm, Los Angeles County Museum of Art (49.17.28), William Randolph Hearst Collection (49.17.28)

62a. Detail of Sir J. Reynolds, *St Cecilia*, no. 62

Precisely how this arrangement was arrived at is less certain. An annotated drawing by Adam in the Soane Museum shows two panels on either side of the fireplace; in the right is sketched a figure of a woman playing the organ with putti overhead and a single putto at her feet. The left panel is blank but for the inscription 'St. Cecilia'. Eileen Harris has suggested that the images served to counterbalance what she has described as Robert Adam's 'spectacular organ'.[160] She has, moreover, proposed that although it is possible that Adam and his patron planned to have two St Cecilias, this was unlikely and the image on the right was perhaps intended to represent Music as a generality while Reynolds's image of St Cecilia playing a harp, an instrument associated with Wales, would appear on the left.[161] The organ-playing figure sketched in by Adam is, however, so unambiguously a St Cecilia that this seems unlikely. Had there been two figures, one with a harp and one with an organ, the problem of whether to show St Cecilia with the traditional organ or with a harp would have been resolved. At some stage it must have been decided to extend the thematic range thereby abandoning one St Cecilia and introducing an Orpheus.

At first sight *St Cecilia* impresses the viewer by its dimensions; when compared with the Harewood painting, it also appears ostensibly decorous.[162] St Cecilia (for whom unusually no model has ever been suggested[163]) is seated and plays on her harp music so heavenly that a rapturous cherub is lured into peeping over his cloud to listen. This decorum is a little shaken when we look at this painting in sequence. Reynolds did not exhibit it at the Royal Academy,

preferring perhaps not to risk detracting from the relatively modest *Mrs Sheridan in the Character of St Cecilia* exhibited 1775, when the artist may still have been working on the Williams-Wynn painting.[164] Mrs Sheridan is shown in profile, seated at an organ—the instrument most usually associated with the saint—while the celestial references are confined to two small children with song books who might pass as putti. The strict classical profile forbids the kind of baroque licence in which Reynolds indulged for Sir Watkin Williams-Wynn, in whose painting the uplifted eyes and parted lips of St Cecilia, the turbanned head and exotic clothing (the subject wears full mauve skirts with gold highlights, an oriental turquoise scarf and a turban from which braids bound with green ribbons can be seen to descend, her sleeves are embroidered with stars, and she wears bangles on both wrists),[165] the billowing curtains, carved music stand containing an open volume of manuscript music, and the heavenly sky full of cherubs speak of a determination to match the rococo charm and drama of Michele Rocca (Parmigianino) or Sebastiano Conca. The facial type—which Reynolds had already explored in *Mrs Quarrington as St Agnes* of 1772—approximates to that in Conca's *St Apollonia* (Pl. 66).[166] Romney's *Emma Hamilton as St Cecilia* painted in 1785 (Pl. 64), on the other hand (which must have been known to Reynolds), turns the subject around to face the viewer with rapt expression, hands joined in prayer, while her discarded instruments lie in the background. Harping was adopted as a pose for Jane Countess of Eglinton by Reynolds in 1777 and by Gainsborough for Louisa Lady Clarges in the same year, while Angelica Kauffman's equally secular St Cecilia plays the more traditional organ.[167] It was perhaps to redress this sliding sensuousness with an injection of moral purpose that, in representing *Mrs Billington as St Cecilia* in 1786–9 (Pl. 63), Reynolds reverted to an upright figure in the manner of Kneller's *Lady Cromwell as St Cecilia* of 1703.

The choice between seated and standing figures followed a long tradition with Raphael's erect figure (Bologna, Pinacoteca) establishing one prototype and a series of seated St Cecilias becoming increasingly popular in the late sixteenth and seventeenth centuries.[168] When Reynolds came to paint this major commission for a leading collector of European painting, it is hard to believe that he was unaware of some if not all of a series of paintings of this subject by artists practising earlier in the century.[169] Among these are the seated *St Cecilia* by Mignard (Pl. 67), that attributed variously to Rocca and to Conca in the Academia di San Lucca in Rome (Pl. 68), a version by Solimena,[170] and that attributed to Conca that appeared recently at a London dealer's (Pl. 69).[171] All three are very similar in composition with full-scale seated figures at instruments accompanied by musical cherubs, clouds, and elaborate billowing draperies. In the first and the last above-mentioned works, St Cecilia wears a

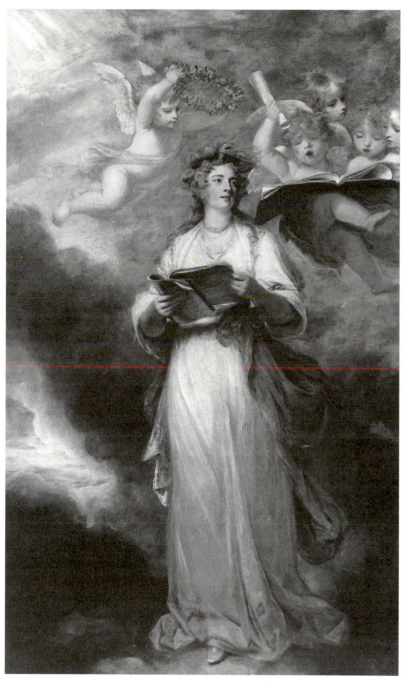

63. Sir J. Reynolds (1723–92), *Mrs Billingon as St Cecilia*, oil on canvas, 1786–89, 239.7 × 148, Gift of Lord Beaverbrook, The Beaverbrook Art Gallery, Fredericton, NB, Canada

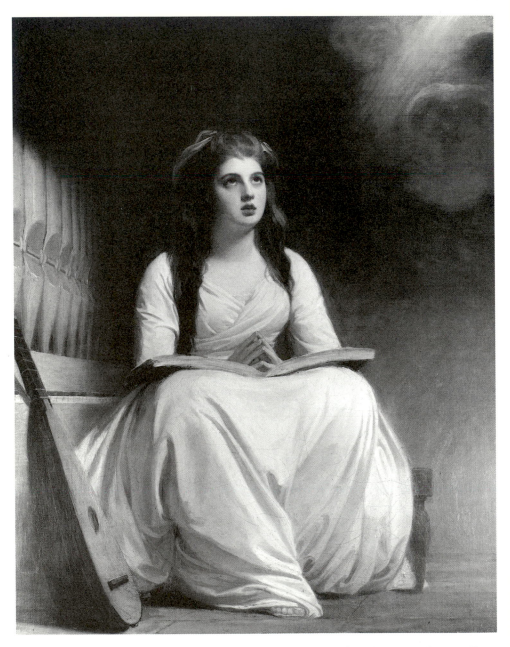

64. G. Romney, *Emma Hamilton as St Cecilia*, oil on canvas, 152.4 × 101.6, Christie's, 21 November 1975. Photo: Courtauld Institute

65. Emma Hamilton in the 'Attitude' of a Vestal Virgin, engraved by T. Piroli, in *Drawings Faithfully Copied from Nature at Naples and with Permission Dedicated to the Right Honourable Sir William Hamilton . . . by his Most Humble Servant Frederick Rehberg. Historical Painter in his Prussian Majesty's Service at Rome*, London, 1794, University of London, Warburg Institute Library

turban and is playing a harp decorated with elaborate carving rather than the more familiar organ. It was Leslie and Taylor who first suggested that Reynolds's *St Cecilia* was no more than a plagiarism from Domenichino, meaning from the Old Testament *David* of Domenichino (Louvre), not from his *St Cecilia,* who does not play a harp.[172] There are similarities between Reynolds's figure and the *David* of Domenichino but the attribution of a harp to the female saint was well established by the time Reynolds received his commission from Sir Watkin Williams-Wynn.

Harps appear to have been very fashionable in London in the decade from around 1775. The Welshman Edward Jones, who had worked in Paris and who in 1783 would become Harper to the Prince of Wales, introduced a 'Merlin harp' with a pedal action into London and performed on one at the Burneys' in May 1775. A number of such harps made in Paris in the 1780s are on display in the Victoria and Albert Museum. They incorporate images of heavenly musicians and are ornamented with carved putti. Judging by his trade card the harp Jones played was not dissimilar to that Reynolds chose for St Cecilia.[173] There are, however, more particular reasons why Reynolds chose to show St

66. Sebastiano Conca, *St Apollonia Surrounded by Putti*, oil on canvas, 80 × 68, Sotheby's, 17 February 1982

Cecilia with a harp. Not least, hung next to Orpheus, whose lyre is a primitive version of the harp, Reynolds's painting would have conveyed values of harmonious modern civilization in contrast to the pagan melodies of Orpheus. The harp also echoes the lyre of Apollo, situating St Cecilia thus within an Apollonian, as opposed to a Dionysiac, tradition, remote from the tambourine-shaking Bacchantes I have discussed in Chapter 4.[174] There was, of course, also already an English precedent in Kent's ill-fated altarpiece for St Clement Dane's.

Pan pipes were savage and, like all blown flute-like instruments, were thought to distort the face. It is precisely thus that they are shown being played in the illustrations to Dr Burney's *A General History of Music* (1776–89). The organ, on the other hand, was the civilized version of Pan's pipes, the most rational of instruments, its construction visibly conveying an ordered progression in which sound is not only large and public but also controlled. In playing an organ St Cecilia (or Mrs Sheridan) is the agency for the production of sound, the ordered pipes determining to a large extent what is heard. The strung harp also makes visible the mathematics of music but an image of a female performer—fingers plucking strings—furthermore suggests an elision

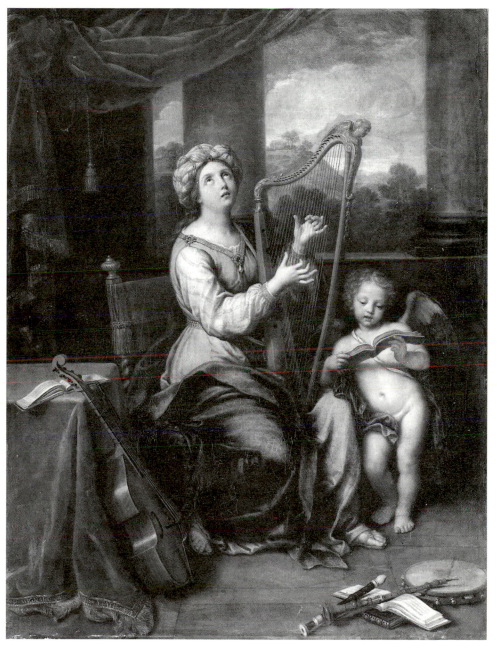

67. P. Mignard, *St Cecilia*, 1691, oil on canvas, 74 × 56, Louvre, Paris. Photo: Réunion des Musées Nationaux

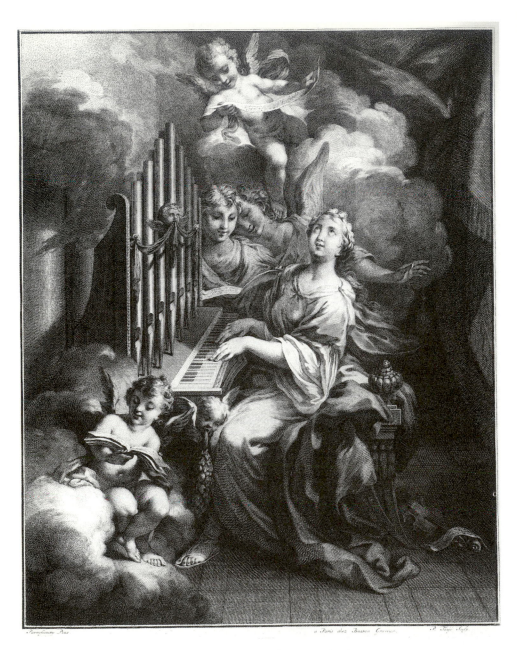

68. P. Tanjé after M. Rocca (Il Parmigianino), *St Cecilia*, British Museum, London

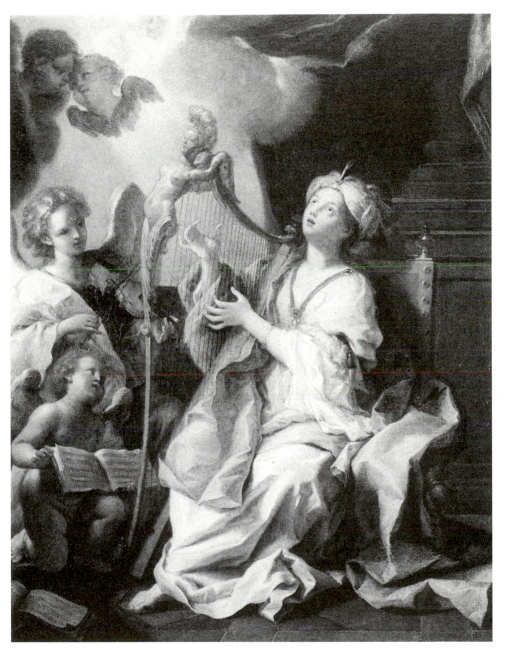

69. Sebastiano Conca, *St Cecilia*, oil on canvas, 47.6 × 36.7, location unknown

between woman and nature. Like the wind in an Aeolian harp, woman making music is principle as well as agency. The human voice, on the other hand, is its own instrument so that a combination of harp and voice suggests a particularly direct and unmediated form of music. In moving from the organ which Mrs Sheridan plays, to St Cecilia's harp in the painting for Williams-Wynn (Pl. 62), and finally to Mrs Billington singing (Pl. 63), Reynolds constructs a progression from instrument as played by subject to subject as instrument. This evolution replicates the elision between sitter and subject in the allegorizing female portrait I have examined in earlier chapters. The trajectory comprises a series of attempts to represent the oscillation between control and abandonment which is widely recognized as characteristic of the listening state;[175] the female subject is, as we shall see, thus germane to the articulation of an aesthetics of artistic autonomy, for it is a trajectory that also encompasses the notion of painting as superior to music in its ability to evoke both sight and sound.[176] If painting is to convey genius, how better than by thematizing music which is understood, through Neoplatonic traditions (however debased), merely to imitate a divine, autonomous, and supreme sound unheard by human ear. The Platonic tradition also, however, posits music as more elevated than the visual arts. By staging sound through the medium of paint, Reynolds not only plays upon a paradox (seeing sound) but also, as a painter, challenges that tradition.

The alliance of music with figures of femininity has a wide cultural history, from the seductive and threatening songs of Circe to the nurse's indoctrinating rhythms in Plato's *Republic*.[177] It is also most neatly instantiated in the life of St Cecilia as popularly told.[178] The story of Cecilia (or Cecily) is that of a young Christian girl of patrician rank in the second or third century who was betrothed to Valerius, a young pagan. On her wedding day she told him she had consecrated her virginity to Christ and that she was watched over by a guardian angel who would protect her and also defend him if he respected her chastity and became baptized. This he did, as did his brother. Eventually all three were condemned to death and died for their faith. Cecilia did not become a patron saint of music until relatively late and her representation as a musician dates only from the fifteenth century. It is significant that in Butler's *Lives of the Saints* of 1756, almost certainly the source for Reynolds's knowledge, St Cecilia is the patron saint of specifically church music. But the secularization process to which Reynolds himself contributes in this work is of long standing and Butler himself stresses the human side of St Cecilia, saying 'Divine love and praise are the work of the heart, without which all words or exterior signs are hypocrisy and mockery.'[179] The origin of her patronage lies in a passage from the account of her life which runs: 'while Cecilia was being

led into the house of her betrothed on her wedding day to the sound of musical instruments (*cantatibus organis*) she invoked only God in her heart, asking him the favour of keeping her soul and body without stain.'[180] The point of the reference to musical instruments here is precisely to contrast the sound of heavenly harmonies heard only by the blessed with the dross of worldly devices for producing sound. Indeed, early versions of the subject depict St Cecilia with broken instruments and even in Raphael's painting of *c.*1512 discarded and broken instruments lie at St Cecilia's feet and she does not play the portable organ she holds in her hands but looks up to heaven.[181] In Bernstein's words: 'in Raphael's painting, the painted figure of Cecilia stands visibly as the conduit between the literal musical instruments and that metaphoric music of which earthly music is but a distant and feeble echo or shadow. One might say the painting represents allegory itself, opening the corridor from the wreckage of material signs to their invisible transcendent counterparts. But part of the scene's character as a painting is precisely that the invisible is indeed visible; the transcendent music is given visible form in the angelic choir.'[182] 'Organum' can mean any instrument but in the sixteenth century this was interpreted as meaning the contemporary or portative organ.[183] The contradiction between heavenly sound (produced spontaneously without the aid of instruments) and earthly music lingers in the images of eighteenth-century artists in the abandoned pages of music, the eyes raised to heaven, and (as with the late version by Romney) the turning away from the organ.

Richard Leppert has, in two fascinating studies, established that each musical instrument was associated with one sex or the other (Roger North at the end of the seventeenth century specified 'espinnett', harpsichord, lute, and 'gitarr' as well as the voice for women) and also that music-making, as long as it was in private, could greatly enhance a woman's beauty.[184] Robert Jones has persuasively argued, furthermore, that music was not simply the social context for licensed *rapprochement* between the sexes, but that it was construed as the medium through which beauty in the abstract could be grasped and apprehended. In other words, beauty could be translated into sexuality through music. Certain it is that the musical instrument features importantly in the narrative unfolding of eighteenth-century novels[185] and that women and girls were often portrayed with musical instruments. There has, not surprisingly, also been much speculation on the sexual symbolism of musical instruments.[186] This is based on analogies between the shapes of instruments and wombs and penises; on metaphoric associations deeply embedded in cultural forms around the idea of 'playing', 'touching', 'performance', and other ritual acts; on the social tradition in which music and dance are ceremonial subli-

mations or enactments of sexual union ('If music be the food of Love, play on . . .'); and on cultural traditions in which music is understood to be intoxicating and dangerous.[187]

In psychoanalytic theory music is interesting because of its temporal nature; musical accomplishment requires practice and while repetitive acts may be the prerequisite for art they may also be totemic or obsessional. Musical passages are auditory triggers which are widely understood to bring into language traces buried in the unconscious. Music, in other words, has psychic dimensions. As Leppert puts it, music, as a phenomenon that acts through time, when heard contemplatively stops all other actions. As such it is an exercise of power, a political act.[188] In a characteristically astute statement, Leppert conveys the unique relationship between music and the body:

The body produces music, often from the depths of its interiority, as with singing and the exhalation of breath into wind-driven instruments. Whatever else music is 'about', it is inevitably about the body; music's aural and visual presence constitutes both a relation to and a representation of the body. Nonetheless, the connection between music and the body throughout Western history is highly problematic and contradictory, the product of deep socio-cultural anxieties and antagonisms.[189]

Music has also long and deeply respected associations with sacred rites. If these were articulated in a displaced mode through paintings of music-playing saints in the late eighteenth century rather than through church services, this vividly demonstrates something of the way in which religious practice is reinvented in secular contexts. The abstract and mathematical potential of music ensured for monastic communities in medieval Europe a highly developed tradition and a complex discursive practice. In Gregorian chant, however, the element of control was absolute and the notes as performed were addressed to God. The difficulty in modern times (as in eighteenth-century England) was the inability to stabilize and predict with any certainty the meanings of music as a discursive practice. Sacred music was more approved than secular but foreign music (French or Italian) was potentially seditious.[190] The destruction of musical instruments by Quakers in the late seventeenth and early eighteenth centuries[191] may seem extreme cases but they signal the complexities of music's discursivity in Protestant England. The St Cecilia story, with its insistence on a music produced through the female form but with divine assistance and with an angelic rather than a human audience, might *seem* to answer a need for an ostensibly 'natural', 'chaste' idea of music that reserved to the player the essentially seductive sexual presence that music conveyed while cleansing it of overt connections with what we have recognized as Bacchanalian. But in the experience of musical performance, one is presented not only with a completed work but with artistic production itself. Hegel

wrote of the subject's fear of losing control when at the receiving end of music.[192] Anxiety about the rhetorical manipulation and the erotic seduction of music are evinced in a text of 1778 which advises women:

Our Music has become so totally changed. It is not now sought as a repose for the mind after its fatigues, but to support its *Tumults*,—not to impress the *Delights* of *calm reason*, or prevail on us to *listen* to the *charmer*; but she must leave the purity of her *own Nature*, and by divesting herself of *Simplicity*, force us to *admire*, not *feel*, and yield to *astonishment* and *absurdity*, instead of *chaste Beauty* and delight.[193]

Reynolds could rely on his audience's familiarity with the idea of St Cecilia. The name was popular (witness Fanny Burney's novel *Cecilia*, 1782) and St Cecilia's day remained an important cultural occasion at least until the 1750s. The fact that the popularity of the theme in painting seems to have accelerated at just the moment when the festival was becoming less important further suggests the process of secularization and the appropriation of the theme for visual rhetoric.[194] Indeed, there is even a record of a satirical English engraving of St Cecilia with a chorus of cats, dated 1782.[195] Chaucer's account of the life of St Cecilia is contained in the Second Nun's Tale, part of *The Canterbury Tales* which never lost favour. Addison had written an 'Ode for St Cecilia's Day' which was set to music by Purcell to be performed in Oxford in 1699. It was revived on St Cecilia's day in 1740 with music by Michael Festing[196] and provided the frontispiece for *The Poetical Works of Joseph Addison* in Bell's *Poets of Great Britain* in 1807.[197] As told by Addison, the St Cecilia story clearly manifests its capacity to evoke the sexual fascination with sainthood and the potential for religious imagery to articulate desire that I have discussed earlier. Cecilia's 'charming tongue', in Addison's account, transforms her betrothed's 'smother'd passion' (whether for Christ or Cecilia is left open) into devotion of a higher calling:

> The love-sick youth, that long suppress'd
> His smother'd passion in his breast,
> No sooner heard the warbling dame,
> But, by the secret influence turn'd,
> He felt a new diviner flame,
> And with devotion burn'd.
> With ravish'd soul, and looks amaz'd,
> Upon her beauteous face he gaz'd;
> Nor made his amorous complaint:
> In vain her eyes his heart had charm'd,
> Her heavenly voice his eyes disarm'd,
> And chang'd the lover to a saint.[198]

Pope, who was Roman Catholic, wrote a poem in 1708 (published 1713) which also provided a frontispiece for Bell's collection;[199] neither set to music nor performed it tells the story of Orpheus and Eurydice and thus explicitly raises the question of violence that the great classical narratives (the death of Marsyas in particular) invoke. As Leppert and others have pointed out, instruments of music can become weapons or instruments of torture, and music has the capacity to suck the subject into a heavenly hole, rendering him blind and castrated.[200] Pope's account, however, also employs the trope of the overthrow of the pagan world by the advent of Christianity, following Milton's 'Ode on the Morning of Christ's Nativity'; Cecilia personifies that triumph and offers a guarantee of music's capacity to restore and elevate.

> Music the fiercest Grief can charm,
> And Fate's severest Rage disarm:
> Musick can soften Pain to Ease,
> And make Despair and Madness please:
> Our Joys below it can improve,
> And antedate the Bliss above.
> This the divine *Cecilia* found,
> And to her Maker's Praise confin'd the Sound . . .
> Of *Orpheus* now no more let Poets tell,
> To bright *Cecilia* greater Pow'r is giv'n;
> His Numbers rais'd a Shade from Hell,
> Hers lift the Soul to Heav'n.[201]

The celebrations on St Cecilia's day that were a feature not only of Lincoln's Inn Fields but also of Oxford, Winchester, and other towns may have been in abeyance after 1750.[202] In imagery, however, the idea of St Cecilia flourished at a time when the Georgian Church rested its credentials on the idea of a *juste milieu*. The possibilities for nuance and allusion, for containing contradiction, and for lasting forms of public exposure through engraving go some way to explaining the prevalence of this imagery in late eighteenth-century England. The heroine of a Christian story, set in Roman times and bringing together the religious and the sexual, ancient and modern, the figure of St Cecilia seems ideally suited to the temperament of the 1770s and 1780s to which Reynolds responded with his impressive canvas for Sir Watkin Williams-Wynn. Weaving together these contradictory elements was no mean task; the large St Cecilia was not, as we have remarked, exhibited but discomfort about the alliance of feminine sensuality and religious themes surfaced at the time of the exhibition of *Mrs Billington as St Cecilia* despite the relative rectitude of its treatment. Reynolds allowed himself a greater degree of latitude with the *St Cecilia* for a room designated for the purposes of music and commissioned by a sophisti-

cated cosmopolitan. At the same time he may have decided not to exhibit this work precisely because it displayed what—a critic of the later painting remarked—the Bishop of London would find 'an improper mixture of the sacred and the profane'.[203]

It seems unlikely that Reynolds, as a friend of Charles Burney, would have been unaware first of the significance of St Cecilia's day (an occasion for sermons as well as for poems and performances) as an affirmation not only of the legitimacy of church music against the criticism of the heirs to Puritanism, but also of its associations with musical antiquarianism. Sacred music was, as Weber points out, High Tory and royalist and, whereas St Cecilia's day was less celebrated publicly after 1750, the tradition of religious music (including of course references to heavenly choirs such as are suggested by Reynolds in his paintings) was regarded as a moral counterblast to the immorality, showiness, and luxury of the age.[204] The heroic moral and political connotations of Handel's oratorios have been recognized as part of a national cultural agenda for high seriousness.[205] The foundation of the Concert of Ancient Music in 1776 marked an organized effort not only to understand the music of Greece and Rome but also to lend authority to English music of the Elizabethan age.[206] Given the date of the Williams-Wynn *St Cecilia*, it is worth speculating that the music that lies carefully arranged for the viewer to scrutinize is intended to be understood as 'ancient'. This is not a single sheet of music but a codex and what is written upon its pages—and it is turned outwards so the viewer may inspect it—appears to be not a psalm (as one might expect especially if the image is derivative from *David*). The visible pages contain words in Latin and notes and suggest a particular noted missal (Pl. 62a).[207] It seems possible that this was intended to represent a particular ancient book in the collection of Sir Watkin Williams-Wynn.[208] At all events it signals a commitment to the idea of continuity and of the rights of late eighteenth-century secular musicians to the liturgical music of a national past.

It was appropriate that Reynolds should challenge the clamorous claims of music, claims traditionally made most insistently upon St Cecilia's day, by painting a series of splendid images of the patron saint of music. If popular opinion reiterated the old 'Paragone' view that 'other Arts shall pass away; | Proud *Architecture* shall in Ruins lie, | And *Painting* fade and die, | Nay Earth and Heav'n itself in wastful Fire decay, | MUSICK alone and *Poesy* | Triumphant o'er the Flames shall see | The world's last Blaze', educated opinion, especially from the 1760s with Reynolds himself as a leading spokesman, would insist on the power of the visual arts to convey moral values.[209] Underpinning this view was the example of Raphael, and central in the work of that artist was his painting of St Cecilia. In the words of Daniel Webb: 'The most courtly

imagination cannot represent to itself an image of a more winning grace, than is to be seen in [Raphael's] Sta. Caecilia. Indeed, an elegant simplicity is the characteristic of his design; we no where meet in him the affected contrasts of Mic. Angelo or the studied attitudes of Guido.'[210] According to Webb, even more important than grace and beauty (of which character is a part) is expression of mind which is conveyed 'in the air of the head, and the intelligence of the countenance'.[211] The disposition to 'read' faces and heads in these terms among late-eighteenth-century *cognoscenti* drew them to the face of Raphael's *St Cecilia*. At the same time an anonymous account of a second version of Raphael's famous painting in Bologna, published in 1770, is remarkable as a testimony to the mental rather than performative discipline of close-looking, the interpretation of represented faces, and the insistence that the spectator educated in 'nature' needs no prior education in painting:

It was not the intention of Raphael to render this his principal figure the most perfect in all respects; but, as the effect of music is chiefly perceived in the countenance, he has exerted his sublime genius and superior art in the air of St. Cecilia's head, in the expression of her mouth; in the attention that marks her judgement, in the triumphant pleasure of her sentiments, produced by her skill in musical composition; in the refinement of her sentiments of devotion, unmixed with passion, unmixed with imagination, and joining in the harmony of angels with seraphic piety.

Raphael requiring little of the spectator of his picture, suddenly seizes him with sublime enthusiasm, if his dispositions are suitable. Every spectator who possesses such kind sensibility, feels the effect of the picture. Nor is it needful that the spectator bring along with him skill in painting; such dispositions as are susceptible of the impressions of the beauties of original nature, will produce the same effects.[212]

St Cecilia was superficially a subject that offered at one and the same time the chance to demonstrate the brilliance of effect of which the modern world was capable while acknowledging its ancient lineages and the values of antiquity, to create an exotic and sexually provocative female image without challenging licensed boundaries, and to demonstrate the capacities of visual art forms and mental processes over and above performative values of music and poetry.

Taking these things into account, we may now return to Reynolds's painting for Williams-Wynn's Music Room (Pl. 62). The image is divided into four roughly equal sections with St Cecilia occupying the lower right quarter. The organization of light within the painting emphasizes the subject's hands. Hers is no discarded instrument. Nor is it disregarded as sanctioned in the 'Life', like that of Raphael's St Cecilia. Reynolds's subject raises her eyes heavenward, her lips are parted in song and her fingers still rest on the strings. The listening cherub is a synecdoche for what is heard. Of Mrs Billington, Reynolds is alleged to have said, when upbraided with failing to fulfil expectations: 'I

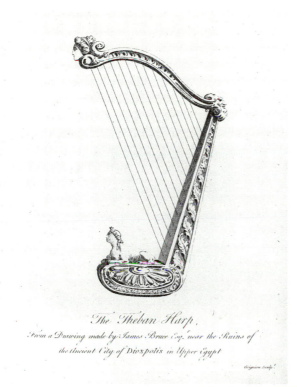

The Theban Harp,
from a Drawing made by James Bruce Esq. near the Ruins of
the Ancient City of Diospolis in Upper Egypt

Grignion Sculp.ᵗ

70. C. Grignion after J. Bruce,
The Theban Harp, from C.
Burney, *A General History of
Music*, London, 1776. By per-
mission of The British Library,
London (557. * f12)

cannot help it—how can I paint her voice?' (Pl. 63).[213] At one level the cherub
(and its more distant companions) are mere adjuncts borrowed from Mignard
and Conca.[214] But the entire lighting scheme leads the eye from St Cecilia's
hands to the listening cherub, linking heavenly sound and human agency and
providing therefore a variant on the theme of genius without labour, art
without artifice.

Reynolds chose to sign his work prominently on a scroll of paper that can be
seen tucked under the music book (Pl. 62a) and which, like the music, extends
beyond the assumed front plane of the picture into the viewer's space. This
divergence from the traditional iconography—in which either the music is
placed before St Cecilia's eyes (though she disregards it) or else the music (a
heavenly score) is held up for her by angels—is particularly interesting. The artist
(through his signature as marks on a canvas) not only aligns himself with ancient
Christian music and with careful labour and artistic intelligence—all things
endorsed in his *Discourses*—but also constructs the painting's viewers as arbiters,
in short as subjects. The fruit of that labour—Reynolds's representation of the

divine St Cecilia—occupies the facing quarter. The cherub is a signifier not only of artistic pedigree (linking Reynolds to the European baroque) but also of innocent childishness. It suggests the very antithesis of the head of the sphinx that adorns the harp and which nestles so close by. It is to that carving, and to the instrument Reynolds chose to depict, that we must now turn. Sebastiano Conca's St Cecilia plays a harp topped by a prominent and distinctly lascivious female caryatid. This is followed by Reynolds (who does, however, reduce the flamboyant headdress of the figure). The important position occupied by this carved figure—midway between the cherub and St Cecilia—should not be overlooked. It would doubtless have been immediately recognizable to Reynolds's patron and his friends when he entertained them in his new Music Room in St James's Square as a Theban harp known from a drawing made by James Bruce near the ruins of the ancient city of Diospolis in upper Egypt. This find was illustrated by Charles Burney in volume i of his great *History of Music* (Pl. 70).[215] It is described by Burney as 'the most curious and beautiful of all ancient instruments that have come to my knowledge'.[216] While the organ is 'operose, complicated, and comprehensive',[217] the Theban harp nearly approaches the perfect instrument. Burney is clearly fascinated by this archaeological find and quotes a letter from James Bruce dated 20 October 1774:

This instrument is of a much more elegant form than the triangular Grecian harp . . . Besides that, the whole principles upon which the harp is constructed are rational and ingenious, the ornamental parts are likewise executed in the very best manner; the bottom and sides of the frame seem to be fineered, or inlaid, probably with ivory, tortoiseshell, and mother of pearl, the ordinary produce of the neighbouring seas and deserts. It would be even now impossible to finish an instrument with more taste and elegance.

Besides the elegance of its outward form, we must observe, likewise, how near it approached to a perfect instrument; for it wanted only two strings of having two octaves in compass.[218]

Burney devoted a considerable part of the first volume of his *History* to establishing Egypt as the origin of music, a nation whose inhabitants 'boasted a much higher antiquity than those of any other country'.[219] Educated men in eighteenth-century England were deeply interested in the evolution of music and the development of musical instruments. More than a form of antiquarianism, the quest for an explanation of music's evolution offered a paradigm for the growth of civilization and the possibility of locating Christianity within a *longue durée* that spanned an exotic Orient and a modern-day Europe. A paradigm such as this had potential for providing a resolution to national perplexity about the precedence of culture in a commercially driven society: music (like art) was in short understood as an index of civilization. 'In a

Society of more libertine and relaxed Principles', stated Dr Brown, 'the Corruption of Music would naturally arise, along with the Corruption of Manners; for the . . . Musicians, Bards, or Poets, would be the immediate Instruments of this Corruption. For being educated in a corrupt State they would be apt to debase their Art to vile and immoral Purposes.'[220]

But music, especially singing because it is linked to speech, served as a very special yardstick of civilization. As voyages of discovery opened up unfamiliar societies to the scrutiny of western eyes, language and its evolution was a subject of great interest. James Burnet, Lord Monboddo in his *Origin and Progress of Language*, trying to prove that language is not natural to man but is the fruit of art and of human industry, was interested in a perceived evolution from primitive cries into articulate speech.[221] Just as rhetorical gestures represented highly developed forms of controlling the civilized body, so song could be understood as a manifestation of spoken language open to inspection as a form of civilization. In Reynolds's painting spoken/sung and written language are both present in the foregrounded manuscripts. When the unfortunate Tahitian Omai (who had been brought to England in 1774 and whose English teacher was Fanny Burney's brother James, a sailor with Captain Cooke) was received at the Burney home on 14 December 1775, he was asked by Dr Burney to favour the company with a 'song of his own country'. What they heard was, in their own terms, the uncanny traces of an original and indestructible savagery bursting forth from this otherwise semi-civilized and Europeanized son of Nature. 'Nothing can be more *curious* or less *pleasing* than his singing voice,' says Fanny Burney, 'he seems to have none; and *tune* or *air* hardly seems to be aimed at; so queer, wild, strange a *rumbling* of sounds never did I before hear; and very contentedly can I go to the grave, if I never do again. His *song* is the only thing that is *savage* belonging to him.'[222] Fanny Burney was basing her judgement of Omai's performance on criteria established by Dr Burney and by less celebrated writers like John Brown, for whom music, dance, and poetry are the standard by which civilization can be measured:

But if we ascend a Step or two higher in the Scale of savage Life, we shall find this Chaos of Gesture, Voice, and Speech, rising into an agreeable Order and Proportion. The natural Love of a measured Melody, which Time and Experience produce, throws the Voice into Song, the Gesture into Dance, the Speech into Verse or Numbers. The addition of musical Instruments comes of Course. They are but Imitations of the human Voice, or of other natural Sounds, produced gradually by frequent Trial and Experiment.[223]

Reynolds's large-scale and splendid *St Cecilia* thus invites audiences to meditate upon the greatness of the artist who produced it and whose (eminently

civilized) name is inscribed close to the musical notation of ancient origin that he has depicted. It also contributes in a dramatic way to a discourse that would have been readily recognizable to his patron and to a circle of friends that included the Burneys. In this the inchoate and exotic sound of the savage and uncivilized world is tamed by the mystery of Egypt, the cradle of music. Figured as a female-headed instrument, Egypt is caught between the Raphaelesque cherub and the early Christian saint as depicted by an eighteenth-century painter in a progression from the ancient world, through the Renaissance, to Sir Watkin Williams-Wynn as exemplary of the most civilized point in the evolutionary scale. It is, however, the body of St Cecilia, dressed in her brilliant and exotic robes, upon which ultimately the eyes of the viewers in Sir Watkins Williams-Wynn's Music Room must have rested. More than the written text of music, more than the depicted instrument and the charming cherub, it is the performing female body upon which the narrative rests. The father of Richard Brinsley Sheridan, whose wife Reynolds portrayed as St Cecilia in the same year as he was at work on Sir Watkin Williams-Wynn's painting, had published a popular book on elocution in 1762. Sheridan is concerned with speech but there comes a point in his lecture when he turns to looks and gestures which, he proposes, are 'the handwriting of Nature'. This hand-writing, like Nature itself, carries marks of the divine original. Eyes and hands are the most important elements in this language.[224] Reynolds literally hand-wrote his signature (his own name and mark) onto his canvas close to the book in which music is imaged as captured in graphics. But the idea of 'writing' is more extensive and more pervasive. In representing St Cecilia seductively in performance, Reynolds was able to appeal to secular society in synthesizing ideas about unmediated genius—divine writing—and the celestial nature of music while insisting upon an evolutionary model which positioned modernity and painting as the means of accessing these forms of perfection. By emphasizing sight, moreover, through the strategy of a painterly visual tradition replete with baroque quotation and signature as text, materiality and painting stand between the particularity of the viewing subject and the transcendent subject the painting describes. Music as figuration of the feminine threatens loss of self. The St Cecilia story stages disempowerment and castration—the rejected marriage consummation, the broken instruments, the unheard music—but by making visible the transcendent, painting can also contain and secure the threatening seduction. Paint therefore surpasses and controls music while making use of music; Protestantism likewise surpasses the imagery of the Catholic saints it deploys; and eighteenth-century academic painting appropriates and goes beyond the stylistic conventions of the baroque which it mobilizes. Reynolds here moves beyond the

tensions between portrait and allegory which I explored in Chapter 2. One reason why there is no named sitter for St Cecilia must therefore be that no element of portraiture can be permitted to seep into the image, at least not if the semantic density of the image and the artist's own self-portrait therein are to survive. An important commission from a highly educated patron, Reynolds's *St Cecilia* should be regarded as the *tour de force* of a brilliant artist at the apogee of his career.

Notes

1. H. Walpole, *The Beauties: An Epistle to Mr. Eckhardt, the Painter* (London, 1746).
2. The Protestant Church, lacking the machinery of Roman Catholicism for canonization (and energetically repudiating it), makes contemporaries saints as a matter of popular opinion, collectively identifying individuals as saintly. The Book of Common Prayer recognizes them as historical personages. The relationship of Protestant culture to saintliness is generally enabling and unproblematic; when it comes to saints, however, it is, as one writer remarks, only possible to speak figuratively or by analogy (see D. Davie, *The Eighteenth-Century Hymn in England* (Cambridge, 1993), 55). In the context of what I shall discuss in this chapter saints may be regarded as a category of the semi-forbidden, acknowledged but prohibited. The standard work on 18th-cent. religion in England remains N. Sykes, *Church and State in England in the XVIIIth Century* (Cambridge, 1934), but see also I. Rivers, *Reason, Grace and Sentiment*, i: *Whichcote to Wesley* (Cambridge, 1991). For the 17th cent., see M. Aston, 'Gods, Saints, and Reformers: Portraiture and Protestant England', in L. Gent (ed.), *Albion's Classicism: The Visual Arts in Britain 1550–1660* (London, 1995) and C. J. Sommerville, *The Secularization of Early Modern England* (Oxford, 1992), especially ch. 7, 'The Secularization of Art'.
3. On Hogarth and religion, see R. Paulson, *Hogarth* (Cambridge, 1991), especially iii. 261 and D. Solkin, *Painting for Money: The Visual Arts and the Public Sphere in Eighteenth-Century England* (New Haven, 1993), ch. 5.
4. W. Hogarth, *A Burlesque on Kent's Altarpiece at St. Clement Danes Church* (Oct. 1725), see Paulson, *Hogarth*, i, pl. 38, Oct. 1725.
5. The event was recorded in a large group portrait by Agostino Masucci, now in the Scottish National Portrait Gallery, Edinburgh.
6. Described by J. C. D. Clark, *English Society 1688–1832* (Cambridge, 1985), 186. A more detailed account of the episode and a reproduction of the altarpiece which is now destroyed is to be found in I. Pears, *The Discovery of Painting* (London, 1988), 45–6; Paulson, *Hogarth*, i. 138–9 gives the definitive account but see also B. F. L. Clarke, *The Building of the Eighteenth-Century Church* (London, 1963), 163.
7. Paulson, *Hogarth*, i. 138, quoting the *Daily Post*.
8. *A Letter from a Parishioner of St. Clement Danes to . . . Edmund Ld. Bp. of London, Occasioned by his Ldsp's Causing the Picture over the Altar, to be Taken Down* (London, 1725), quoted in Pears, *Discovery of Painting*.
9. M. Postle, *Sir Joshua Reynolds: The Subject Pictures* (Cambridge, 1995), 13–14 and 313. Postle reproduces both paintings of Mrs Quarrington.
10. See p. 131.
11. RA 1790 (181). For details see A. Graves and W. V. Cronin, *A History of the Works of Sir J. Reynolds* (London, 1899–1901), i. 82–3. C. R. Leslie and T. Taylor, *Life and Times of Sir Joshua Reynolds* (London, 1865), state (ii. 548) that the artist's eyesight was failing by 1789.

12. See Revd J. Romney, *Memoirs of the Life and Works of George Romney* (London, 1830), 23, 53, 181; H. Ward and W. Roberts, *Romney: A Biographical and Critical Essay with a Catalogue raisonné of his Works* (London, 1904), 185.

13. Taken from *Gazeteer and New Daily Advertizer* for Monday, 6 June 1774, quoted by Malcolm Baker in H. Young (ed.), *The Genius of Wedgwood* (London, Victoria and Albert Museum, 1995), 123.

14. In 1771, religious and biblical subjects were exhibited by Barry, Edward Edwards, Hayman, Hone, John Joseph Kauffman, Rebecca, West, and Zucarelli. There were also engravings of religious subjects on display. The following year there were religious and biblical subjects by Bartolozzi, Edward Burch, Hayman, John Joseph Kauffman, Olivier, John Sanders, Samuel Wale, West, and 'a Lady'.

15. T. S. R. Boase, 'Macklin and Bowyer', *Journal of the Warburg and Courtauld Institutes*, 26 (1963), 163. For editions of the Bible in the 18th cent., see A. S. Herbert, *Historical Catalogue of Printed Editions of the English Bible, 1525–1961*, revised and expanded from T. H. Darlow and H. F. Moule's edn. of 1903 (London, 1968). This compendium lists 585 different published bibles between 1700 and 1800.

16. *Liberty: A Poem* (London, 1705).

17. Solkin, *Painting for Money*, 173.

18. Aston, 'Gods, Saints, and Reformers'.

19. R. Lonsdale (ed.), *The New Oxford Book of Eighteenth-Century Verse* (Oxford, 1984). The same is not true of the 17th cent., though it is notable that Sommerville, *Secularization*, is obliged to rely for art-historical references upon books published three or four decades ago.

20. L. Colley, *Britons: Forging the Nation 1707–1837* (London, 1992).

21. See V. Green, *A Review of the Polite Arts in France at the Time of their Establishment under Louis XIV, Compared with their Present State in England* (London, 1782), 38; J. Pye, *Patronage of British Art* (1845; London, 1970), 217–20; *Life and Anecdotes of Rt. Revd. Dr Thomas Newton, Dean of St. Pauls, Prefixed to a New Edition of his Works* (London, 1782).

22. See W. Carey, *Observations on the Probable Decline or Extinction of British Historical Painting, from the Effects of the Church Exclusion of Paintings, Respectfully Addressed to His Majesty, and to the Right Honourable the Members of Both Houses of Parliament* (London, 1825).

23. Thomas Wilson, *The Ornaments of Churches Considered, with a Particular View to the Late Decoration of the Parish Church of St. Margaret Westminster* (London, 1761), pp. iii, vi. The title-page of this work attributes 'the body of the work' to 'the learned W. Hole', even though Wilson is named as author.

24. For an excellent discussion of this topic see Deidre Lynch, 'Overloaded Portraits: The Excesses of Character and Countenance', in V. Kelly and D. von Mücke (eds.), *Body and Text in the Eighteenth Century* (Stanford, Calif., 1994), especially 116–20.

25. Wilson, *The Ornaments of Churches*, 24–5.

26. *The Choir and Lady Chapel, Salisbury Cathedral*, watercolour, 1797, Salisbury and South Wiltshire Museum, PD.121 127/1978. The watercolour also shows Reynolds's lost 1788 Resurrection window. For the history of this, see Postle, *Sir Joshua Reynolds.*, 222–3.

27. See the list at the end of Green, *Review of the Polite Arts*. For the apocalyptic paintings of West *et al.* see M. J. Paley, *The Apocalyptic Sublime* (London, 1986). For West's work at Windsor see J. D. Meyer, 'Benjamin West's Chapel of Revealed Religion: A Study in Eighteenth-Century Protestant Religious Art', *Art Bulletin*, 57 (1975). Clarke, *The Building of the Eighteenth-Century Church*, 163–8 lists a significant number of 18th-cent. altarpieces often with elaborate iconography incorporating biblical and royalist motifs. He states (p. 163), 'eighteenth-century churchmen liked to have an altar-piece'.

28. See N. Pevsner, *The Buildings of England* (Harmondsworth, 1951–74), currently undergoing revision.

29. The paintings represent St James, St Peter, and the Descent from the Cross. Williams's dates are 1727–91. The attribution is made in *St James's, Louth*, guidebook published in 1989.

30. See S. Piggott, *Ruins in a Landscape* (Edinburgh, 1976), 72–3.

31. *A Sermon Preach'd before the Societies for Reformation of Manners, at Salter's Hall, July 1st 1717 by Daniel Mayo, MA* (2nd edn. London, 1717).

32. T. Warton, *Verses on Sir Joshua Reynolds's Painted Window at New-College, Oxford* (2nd edn. corrected by Thomas Warton, London, 1783). For details of the New College commission see M. Postle, *Sir Joshua Reynolds: The Subject Pictures* (Cambridge, 1995), 168–81. Postle points out (p. 181) that Warton was actually a keen proponent of the 'Gothick' style the dismissal of which he celebrates.

33. Green, *Review of the Polite Arts*, 34.

34. S. T. Coleridge, *Biographia literaria* (1817), ed. G. Watson (London, 1971), 164–5.

35. See, e.g., Reynolds's design for Ledbury parish church still *in situ* as well as the New College designs. The two Cipriani paintings remain at Holkham, one on either side of the altar.

36. It was removed in the 1850s and now hangs in the NE transept. The Revd Peter Hammond of Lincoln has been helpful in providing information concerning Peters's work at Lincoln and I am grateful to him for sharing his very considerable knowledge of the cathedral in the 18th cent.

37. Francis Haskell's pioneering investigation into the collecting of Old Masters commences at this point. See F. Haskell, *Rediscoveries in Art* (London, 1976).

38. *The Woman of Fashion: A Poem: In a Letter from Lady Maria Modish to Lady Belinda Artless* (London, 1778).

39. See collection of 18th-cent. sale catalogues in the British Library at 7.805.e.5.

40. Green, *Review of the Polite Arts*, 41–2.

41. 13 Mar. 1795 and following four days, reprinted in Graves and Cronin, *Works of Sir Joshua Reynolds*, iv.

42. Pears, *Discovery of Painting*, 157. Walpole paid £630 for *The Doctors of the Church* before 1745. The prices paid for Reni's works soared as the century progressed (£2,000 in 1776, £3,500 in 1779). See G. Reitlinger, *The Economics of Taste* (New York, 1961), 426.

43. Reitlinger, *Economics of Taste*.

44. On Coke see A. W. Moore, *Norfolk and the Grand Tour* (Norfolk Museums Service, Fakenham, 1985), 34; Coke commissioned from Conca *The Vision of Aeneas in the Elysian Fields* in which he himself was depicted. See also *Sebastiano Conca 1680–1764* (Gaeta, Palazzo de Vio, July–Oct. 1981).

45. *A Guide to Burghley House, Northamptonshire Containing a Catalogue of All the Paintings and Antiquities* (Stamford, 1815) contains a biographical note on Peters on p. 247 and the statement: 'the child is represented entering into a world of bliss, with an air of ineffable simplicity'.

46. Denis Sutton, editorial 'Magick Land', *Apollo*, 99 (June 1974), 402. This number of *Apollo* which is largely devoted to articles by Brinsley Ford remains, however, a major source of information on 18th-cent. collecting in Italy.

47. There is still no satisfactory book on English collecting abroad. The series of articles in *Apollo*, 99 (June 1974) by Ford, will soon be usefully supplemented by the index to the Brinsley Ford Papers being prepared by the Mellon Centre, London. For general studies, see J. Black, *The British Abroad: The Grand Tour in the Eighteenth Century* (Stroud, 1992); the short

but interesting B. Skinner, *The Scots in Italy in the Eighteenth Century* (Edinburgh, Scottish National Portrait Gallery, 1966); L. Stainton, *English Artists in Rome* (GLC: Iveagh Bequest, Kenwood, 1974).

48. Copies after these artists are still at Burghley. See also Lady Victoria Manners, *Matthew William Peters RA* (London, 1913), 7.

49. *Gazzetta toscana*, 6 (30 Nov. 1771), 189, quoted Brinsley Ford Papers, Mellon Centre for Studies in British Art, London. Ford calculated that Peters arrived in Rome the first week of May 1762, stayed a year studying under Batoni and taking classes at the Life Drawing Academy, moved to Florence in May 1763, and left Italy in the autumn of 1765. He also spent some time in Parma perhaps in 1771 before returning to Florence. According to Ford, he returned to Venice for a year from 1 Mar. 1772 to 6 Mar. 1773. This is likely to be correct as Ford refers to official records (Note dei Forestieri, 759, 760) even though it conflicts with Lady Manners, who states (p. 7, based on his address in RA catalogue) that Peters was still in Rome in May 1774. She also asserts, on the authority of Walpole, that Peters returned from (presumably a further visit to) Rome in May 1776. The most reliable evidence of Peters's presence in Rome in 1775 is his letter to Romney giving advice to him about where to stay in Parma, Bologna, and Venice, now in the Pierpont Morgan Library (MA 3086 R-V Autogr. Misc. Artists).

50. He painted portraits of both men, see Manners, *Peters*, 21. Freemasonry was increasingly rational and respectable in the 18th cent., masons being charged in every country to be of the religion of the country or nation whatever it was. Stothard, Bartolozzi, Cosway, and other well-established artists were Freemasons. See M. K. M. Schuchard, 'Freemasonry, Secret Societies, and the Continuity of the Occult Traditions in English Literature', Ph.D. thesis (University of Texas at Austin, 1975). I am grateful to Dr Stephen Lloyd for drawing my attention to this thesis. Dr Lloyd's own work (*Richard and Maria Cosway: Regency Artists of Taste and Fashion* (Edinburgh, National Galleries of Scotland, 1995) is also a mine of information on this period. While the Catholic Relief Bill attracted little attention when passed, it generated opposition and led eventually to the Gordon Riots. For caricatures of the visit, see Gillray's *Grace before Meat or a Peep at Lord Petre's* (D. George, *Catalogue of Political and Personal Satires Preserved in the Department of Prints and Drawings in the British Museum*, v: *1771–1783* (London, 1978), no. 5489).

51. *Discovery of Painting*, 180.

52. Ibid. 179.

53. For an interesting discussion of the notion of legibility and the human face, see Lynch, 'Overloaded Portraits'.

54. J. Addison, 'A Letter from Italy to the Rt. Hon. Charles Lord Halifax' (1701), in *The Cabinet of Poetry* (London, 1818), ii. See also Addison's *Remarks on Several Parts of Italy* (London, 1705) (reissued fifty years later in Glasgow).

55. J. Richardson senior and junior, *An Account of the Statues, Bas-reliefs, Drawings and Pictures in Italy, &c* (London, 1722), ch. vi. The book comprises letters written from Richardson junior to his father and put together for publication with an introduction by the latter.

56. J. Barry, 'On Design', Lecture II, *Lectures on Painting by the Royal Academicians: Barry, Opie and Fuseli*, ed. R. Wornum (London, 1848), 100–3. There is an important account of Barry's views in J. Barrell, *The Political Theory of Painting from Reynolds to Hazlitt* (London, 1986), ch. ii.

57. See A. Potts, *Flesh and the Ideal: Winckelmann and the Origins of Art History* (London, 1994), 215.

58. F. Rehberg, *Drawings, Faithfully Copied from Nature, at Naples, and with Permission Dedicated to the Right Honourable Sir William Hamilton . . . by Frederick Rehberg. Historical Painter in his Prussian Majesty's Service at Rome, 1794, Published 12 October 1797 by S. W. Fores, No. 50, Piccadilly*

... *Lent out on the Plan of a Circulating Library (London, 1797)*. A further edition has the same title and date, without Fores's name but wih additional plates and the following inscription on the frontispiece: 'Fores's Correct Costume of Several Nations of Antiquity'.

59. Hester Lynch Piozzi, *Observations and Reflections Made in the Course of a Journey through France, Italy, and Germany* (Ann Arbor, 1967), 229.

60. Ibid. 327.

61. J. Walsh, C. Haydon, and S. Taylor (eds.), *The Church of England c. 1689–c.1833. From Toleration to Tractarianism*, (Cambridge 1993), 25–6.

62. Letter from J. Olmins, MS bound into back of BL copy of T. Wilson, *The Ornaments of Churches* (London, 1761) (BL 1124.k.16).

63. H. More, *An Estimate of the Religion of the Fashionable World* (2nd edn. London, 1741).

64. R. Porter, *English Society in the Eighteenth Century* (Harmondsworth, 1982), 186.

65. See E. G. W. Bill (ed.), *The Queen Anne Churches* (London, 1979).

66. See Clark, *English Society*, 166–90.

67. See M. J. Quinlan, *Victorian Prelude: A History of English Manners 1700–1830* (New York, 1941), ch. ii.

68. Walsh, Haydon, and Taylor (eds.), *The Church of England*, 56.

69. Colley, *Britons*, ch. 1.

70. Paulson, *Hogarth*.

71. See P. Wagner, *Eros Revived: Erotica of the Enlightenment in England and America* (London, 1988).

72. *The Female Rake: or, Modern Fine Lady: An Epistle from Libertina to Sylvia* (London, 1735).

73. This image belongs to *The Four Times of Day*, c.1736, oil on canvas, National Trust: Bearsted Collection, Upton House.

74. G. Fox, 'The Fashions of the World made Manifest; also a few words to the City of London' (1657), in G. Fox, *Gospel-Truth Demonstrated, in a Collection of Doctrinal Books, Given Forth by that Faithful Minister of Jesus Christ, George Fox* (London, 1706), 111.

75. S. Richardson, *Pamela: or, Virtue Rewarded* (1741), ed. P. Sabor (Harmondsworth, 1980), 505–6.

76. S. Richardson, *Clarissa: or, The History of a Young Lady* (1747–8), ed. A. Ross (Harmondsworth, 1985), 646. Both *Pamela* and *Clarissa* were immensely popular throughout the second half of the century, running into many editions.

77. A. Behn, *The History of the Nun: or, The Fair Vow-Breaker* (1689), in *Oronooko and Other Writings*, ed. P. Salzman (Oxford, 1994).

78. G. Bataille, *Les Larmes d'Éros* (1961), in *Œuvres complètes* (Paris, 1987), x. 607.

79. K. Nicholson, 'The Ideology of Female 'Virtue': The Vestal Virgin in French Eighteenth-Century Allegorical Painting', in J. Woodall (ed.), *Portraiture* (Manchester, 1997).

80. R. Jones, 'The Empire of Beauty: The Competition for Judgement in Mid-Eighteenth-Century England', Ph.D. thesis (University of York, 1995).

81. Barry, Lecture III, *Lectures on Painting*, 140. My italics.

82. *St James's Chronicle, or, British Evening Post* (17 Apr.–19 Apr. 1777), 2.

83. M. Olivier also exhibited at the same show a *Death of Cleopatra* and four family 'conversations' (English, French, Spanish, and Scotch). He was Michel-Berthélemy Ollivier (or Olivier) (1712–84), who was renowned for charming genre scenes and was responsible for the decoration of Château de l'Isle Adam for the prince de Conti. The same paintings seem to have been exhibited at the Salon in 1769 and a similar group in 1771. Diderot described his *Death of Cleopatra* as 'mauvais' (J. Seznec (ed.), *Diderot Salons* (Oxford, 1967), iv). I have found no reference to any religious works and the Witt Library only holds photographs of conversation pieces and portraits.

84. *Middlesex Journal* (25–8 Apr. 1772), no. 480. The detail has its origin in Poussin's *Massacre of the Innocents*, one version of which is in the Musée Condé, Chantilly.

85. *Morning Chronicle*, 4 May 1772. My italics.

86. The question also arises in relation to other media as Donald Davie's chapter on Watts's 'atrocity hymns' demonstrates. See Davie, *The Eighteenth-Century Hymn*, ch. 3.

87. In actual fact, most travellers merely listed what they saw and made few comments. The 'tours' that have found their way into print tend to be the atypical ones that contain personal observations. The Record Offices of the UK contain many more which do not.

88. A. Hemingway, 'Art Exhibitions as Leisure-Class Rituals in Early Nineteenth-Century London', in B. Allen (ed.), *Towards a Modern Art World,* Studies in British Art I (London, 1995).

89. In the version at Hampton Court many of the children were transformed into sacks. See F. Grossman, *Bruegel: The Paintings* (London, 1955), no. III.

90. See p. 77.

91. R. Leppert, *Music and Image: Domesticity, Ideology and Socio-cultural Formation in Eighteenth-century England* (Cambridge, 1988), 106.

92. L. Klein, *Shaftesbury and the Culture of Politeness: Moral Discourse and Cultural Politics in Early eighteenth-Century England* (Cambridge, 1994), 4.

93. The main sources for the life of Peters are the *DNB*; Manners, *Peters*; A. Crookshank and the Knight of Glin, *The Painters of Ireland c. 1660–1920* (London, 1978); these all draw upon *Freemason's Magazine* for 1794 and 1795 in which two articles on Peters appear. They are repeated in W. Dixon, *A History of Freemasonry in Lincolnshire* (Lincoln, 1894) and in the *Victoria History of the County of Leicester*, iii (1955).

94. E. K. Waterhouse, *Painting in Britain 1530–1790* (Harmondsworth, 1953), 201. The main source for knowledge of Peters in France is R.-R.-M. de Saint-Hilaire, 'M.-W. Peters 1742–1814', *Gazette des beaux-arts*, 4th ser. 6 (1911), 394–404. However, Susan Siegfried, who has conducted extensive research on Boilly, states (personal communication) that she has never come across a connection with Peters.

95. Waterhouse, *Painting in Britain*, 201–2.

96. W. Whitley, *Artists and their Friends in England 1700–1799* (London, 1928), i. 278–9.

97. J. E. Hodgson and F. A. Eaton, *The Royal Academy and its Members 1768–1830* (London, 1905), 130.

98. Quoted in Manners, *Peters*, 19.

99. Whitley, *Artists and their Friends* transcribes letters between Opie and Peters which suggest that the latter behaved with propriety.

100. A lay figure is a full-sized model used by artists. See ibid.

101. All the accounts in English of Peters's life go back to a detailed account in *Freemason's Magazine* for Oct. 1794. There was regular coverage concerning Peters in this magazine. Manners, *Peters* cites references.

102. For a discussion of the 19th-cent. development of this theme, see N. Penny, *Church Monuments in Romantic England* (London, 1977).

103. Whitley, *Artists and their Friends*, 70.

104. *Freemason's Magazine* (Oct. 1794), 261 suggests the order should be the Resurrection scene flanked on the left by the angel carrying the spirit of the child and on the right by the spirit arriving. The author of this article reports that prints of *An Angel Carrying* . . . 'were soon dispersed through Europe, and no print, we believe, from any picture of whatever master, had so rapid and universal a sale as what followed the publication from the plate we now mention'.

105. These engravings would have been beyond the means of any below the middling classes but it seems reasonable to suppose that they exercised an influence as powerful as that of the cheaper popular prints researched by T. Watt in *Cheap Print and Popular Piety 1550–1640* (Cambridge, 1991).

106. Peters worked in both crayon and oil and, as his work was widely engraved, so it was also widely copied. Caution is needed when attributing his work.

107. Tate Gallery, London, engraved W. Dickinson, 1824, and a head and torso only in an oval, reproduced in Manners, *Peters*, pl. ix. Robin Hamlyn of the Tate Gallery suggests there were several and that the Tate version is a variant of Lord Grosvenor's original. I am grateful to him for allowing me to see his catalogue entry in preparation.

108. See R. Halsband, *The Rape of the Lock and its Illustrations 1714–1723* (Oxford, 1980), 11. The illustrator closest to Peters is Beardsley who provided, in 1896, 'The Billet Doux', which shows Belinda in bed propped on pillows, her breasts revealed and wearing a very elaborate cap.

109. *The Woman of Fashion: A Poem: In a Letter from Lady Maria Modish to Lady Belinda Artless* (London, 1778).

110. Ibid. 8–9.

111. *Belinda: or, The Fair Fugitive: A Novel by Mrs. C—* (new edn. in 2 vols., London, 1789).

112. *Sylvia's Revenge: or, A Satyr against Man: In Answer to the Satyr against Woman* (12th edn. corrected, London, 1720).

113. *The Female Rake: or, Modern Fine Lady*, 3.

114. *The Adventures of Sylvia Hughes, Written by Herself* (London, 1761).

115. *The Entertaining Amour of Sylvander and Sylvia: A Fashionable Buck and a Delicate Edinburgh Belle* (Edinburgh, 1767).

116. Mrs Robinson, *Celadon and Lydia: A Tale*, dedicated to Her Grace the Duchess of Devonshire (London, 1777).

117. *Lydia: ou, Mémoires de Milord d'—, imité de l'anglais par M. de la Place* (London, 1772), i. 31.

118. See Wagner, *Eros Revived*.

119. I am grateful to Aileen Ribeiro for her observations on the headgear in these images.

120. Gaudenzio, *St James's Chronicle, or, British Evening Post* (17–19 Apr. 1777), 2.

121. A cap alleged to have been Maria Cosway's is reproduced in T. Wright, *Caricature History of the Georges: or, Annals of the House of Hanover* (London, 1876), 257. See also A. Ribeiro's contribution to Lloyd, *Richard and Maria Cosway*.

122. The attribution by Manners is, however, based on somewhat slender evidence, a pencilled name on the mount in the British Museum.

123. See Manners, *Peters*, 9. This is repeated in *Pictures in the Collection of J. Pierpont Morgan at Princes Gate and Dover House* (London, 1907), ii: *English School*. British Museum, 181 * b 10. I am grateful to William M. Griswold for information to the effect that the Peters paintings were among items dispersed from the Pierpont Morgan Collection earlier this century when, unfortunately, no records were kept.

124. Known from early photographs in the Pierpont Morgan Collection (see *Collection of J. Pierpont Morgan*) and from engravings.

125. Minutes of the RA Council, i (1768–84), 235 (recorded in Whitley, *Artists and their Friends*). It should, however, be noted that quotations generally were disallowed. Robin Hamlyn, who has searched Dryden for the source of the quotation, has been unable to locate it.

126. A comparable work, for example, is Vestier's *Grande Tête d'étude de femme couronnée de roses*, oil on canvas, dated 1789, Tours, Musée des Beaux Arts.

127. Reproduced in Manners, *Peters*, pl. ix.

128. See Postle, *Sir Joshua Reynolds*, ch. 2.

129. First published in Zurich, 1775–6. For the response to Lavater, see F. Price, 'Imagining Faces: The Late Eighteenth-Century Sentimental Heroine and the Legible, Universal Language of Physiognomy', *British Journal of Eighteenth-Century Studies*, 6: 1 (Spring 1983). On interpreting the scale of animality, the *locus classicus* is K. Figlio, 'The Metaphor of Organization: An Historiographical Perspective on the Bio-medical Sciences of the Early Nineteenth Century', *History of Science*, 14 (1976).

130. *The Natural History of Animals, Vegetables, and Minerals with the Theory of the Earth in General Translated from the French of Count de Buffon by W. Kenrick LLD and J. Murdoch* (London, 1775), ii, 69.

131. *The Task* (London, 1785), Book I, 'The Sofa'.

132. See, e.g., Christie's, 28 Feb. and 3 Mar. 1931 (148).

133. *Public Advertiser* (26 Apr. 1777), 2.

134. *Morning Chronicle* (26 Apr. 1777), 2. There may be lewd puns intended.

135. Walpole's statement is contained in a letter to Sir Horace Mann, 6 May 1770, quoted by Malcolm Baker in 'A Rage for Exhibitions', in Young (ed.), *The Genius of Wedgwood*.

136. See K. Shevelow, *Women and Print Culture: The Construction of Femininity in the Early Periodical* (London, 1989). On the growth of the print market and the development of new techniques like stipple and aquatint, see D. Alexander and R. T. Godfrey, *The Reproductive Print from Hogarth to Wilkie* (New Haven, 1980) and D. Alexander, 'Rembrandt and the Reproductive Print in Eighteenth-Century England', in C. White, D. Alexander, and E. D'Oench, *Rembrandt in Eighteenth-Century England* (New Haven, 1983).

137. Front page.

138. See Quinlan, *Victorian Prelude*, 62.

139. See, e.g., *A Sermon Preach'd at the Parish Church of St. James's Westminster on 21 May 1702, at the Funeral of Mr. John Cooper* (London, 1702).

140. Walsh, Haydon, and Taylor (eds.), *The Church of England*, 25.

141. See T. R. Preston, 'Biblical Criticism, Literature, and the Eighteenth-Century Reader', in I. Rivers (ed.), *Books and their Readers in Eighteenth-Century England* (New York, 1982).

142. *Sermons to Asses* (London, 1768) and *New Sermons to Asses* (London, 1773).

143. The Witt Library records two versions.

144. Private collection, reproduced in Leppert, *Music and Image*, 195.

145. Members of the Society of Dilettanti were portrayed by George Knapton in the 1740s in fancy dress which included allusions to the religion of Rome. The portrait of Francis Dashwood as a monk performing communion service before a nude statue of Venus is the most blatant of these. For a highly informative exploration of this topic see S. West, 'Libertinism and the Ideology of Male Friendship in the Portraits of the Society of Dilettanti', *Eighteenth-Century Life*, 16: no. 2 (May 1992).

146. Wagner, *Eros Revived*, among others, has argued in favour of this view but B. Kemp in *Sir Francis Dashwood: An Eighteenth Century Independent* (London, 1967) endeavours to refute the assertions.

147. Wagner, *Eros Revived*, ch. 2.

148. Romney, *Memoirs*, 90.

149. The lines are: 'So dreams the Patriot, who indignant draws │ The sword of vengeance in his Country's cause; │ Bright for his brows unfading honours bloom, │ Or kneeling Virgins weep around his tomb, │ So holy transports in the cloisters' shade │ Play round thy toilet

visionary maid! | Charm'd O'er thy bed celestial voices sing, | And seraphs hover on enamour'd wing.' E. Darwin, *The Temple of Nature: or, The Origin of Society: A Poem with Philosophical Notes* (London, 1803) (preface dated 1 Jan. 1802), canto iv i, 197.

150. For details of the life of de la Vallière, see W. H. Lewis, *Louis XIV: An Informal Portrait* (London, 1959). A further source of inspiration may have been Spanish 17th-cent. paintings such as Rubens's portrait of Ana Dorotea, daughter of Rudolf II, portrayed as a nun at the Convent of the Descalzas Reales, Madrid, *c*.1628, now in Apsley House, London.

151. Manners, *Peters*, 11.

152. One is by Peters.

153. Comprising 124 volumes. Moore's work is in vol. cvii (1807).

154. D. A. F. de Sade, *Justine: ou, Les Malheurs de la vertu* (1791; Paris, 1973).

155. For observations on the Leicester collection painting, see W. Carey, *A Descriptive Catalogue of a Collection of Paintings by British Artists in the Possession of Sir John Fleming Leicester, Bart* (London, 1819), no. 46. The images of Emma Hamilton have been variously identified with different subjects. For a file of up-to-date photographs, see National Portrait Gallery, Heinz Archive.

156. W. Hazlitt, 'Pictures at Burleigh House', from *New Monthly Magazine*, in *The Complete Works of William Hazlitt*, ed. P. P. Hare (London, 1932), x. 67.

157. See Revd Irvin Eller, *The History of Belvoir Castle* (London, 1841), 213. On p. 316 there is a description of Peters's *Girl and Jay* which hung in the Hunter's Dining Room ('There are much simplicity and nature in the expression of the head and the attitude of the girl'). It sounds as though this may have been a subject similar to those treated by Greuze. I have been unable to gain access to the picture collection at Belvoir. On Peters's meddling with the paintings at Belvoir, see *The Diary of Joseph Farington* (3 Oct. 1796), ed. K. Garlick and A. MacIntyre (New Haven, 1978), iii. 669; ix. 3485.

158. The portrait is in the possession of the Society of Dilettanti, London. I am indebted to B. Ford, 'Sir Watkin Williams-Wynn: A Welsh Mycenas', *Apollo* (June 1974), 435–9 for information on this collector.

159. See entry no. 95 in N. Penny (ed.), *Reynolds* (Royal Academy of Arts, London, 1986). Penny quotes memoranda for this Adam-designed house and reproduces a photograph of the interior of the Music Room as it is now as headquarters of the Distillers' Company.

160. Sale catalogue, *The Williams Wynn Chamber Organ* (Phillips, 21 Apr. 1995). The organ was bought by the National Museum of Wales, Cardiff. Eileen Harris will publish her findings in full in her forthcoming book on Adam as an interior designer to be published by Thames and Hudson in 1997 or 1998. I am grateful to Eileen Harris for her help. In her catalogue entry, she suggests that the source for Reynolds's *St Cecilia* is the frontispiece to *Tamerlane: An Opera Composed by Mr. Handel* (London, 1724), but since this frontispiece is clearly based upon the Mignard painting in the Louvre, it seems much more probable, as I argue in the following part of this chapter, that this was at least one source.

161. Personal communication.

162. *St Cecilia* is 279 × 160 cm compared to *Mrs Hale as Euphrosyne* which is 236 × 146 cm.

163. David Mannings, who is preparing a *catalogue raisonné* of Reynolds's *œuvre*, tells me he has not encountered any sitter's name identified with this painting.

164. This suggestion is made by Penny (ed.), *Reynolds*. Exhibited as *A Lady as St Cecilia*, the painting measures only 50 × 35.1 cm.

165. It is possible that these colours follow the colour scheme of the room, a suggestion made by the Los Angeles County Museum of Art in their accompanying notes.

166. Dated to 1735–45 by Chaucer Fine Arts with whom the painting was in 1989.
167. Kauffman's painting is in the Kunsthaus, Coire, illustrated by A. P. de Mirimonde, *Sainte-Cécile: Métamorphoses d'un thème musical* (Geneva, 1974), pl. 95. The pose continued to be popular, see e.g. *Portrait of a Lady Standing at her Harp* by Rose-Adelaide Ducreux, *c.*1790, New York: Metropolitan Museum.
168. These include works by Orazio Gentileschi, Sisto Badalocchio, and Benedetto Gennari. Possibly the most celebrated rendering after that of Raphael is the painting by Domenichino in the Louvre which shows St Cecilia half length playing a stringed instrument. A number of works are illustrated in the useful little account of the life of the saint by E. Poirée, *Sainte Cécile* (Paris, 1926); the most complete pictorial record is that offered in de Mirimonde, *Sainte-Cécile*. This work is divided into the following sections: St Cecilia with other saints; sacred conversations; St Cecilia in concert with the angels (at the organ); St Cecilia singing; St Cecilia playing the violin or viol; St Cecilia playing divers stringed instruments.
169. R. Rosenblum has rightly pointed out ('Reynolds in an International Milieu', in Penny (ed.), *Reynolds*, 43 *passim*) that the artist's relationship to European painting has yet to be properly evaluated.
170. Galerie de Pommersfelden, illustrated in de Mirimonde, *Sainte Cécile*, pl. 143.
171. Frost and Reed Galleries; location now unknown.
172. Leslie and Taylor, *Life and Times of Sir Joshua Reynolds*. Penny (ed.), *Reynolds* also suggests Domenichino's *David* as the source for the painting.
173. The Merlin harp was not Welsh but was named after its maker John Joseph Merlin. See *John Joseph Merlin. The Ingenious Mechanick* (GLC: Iveagh Bequest, Kenwood, 1985). Edward Jones went on to write *Musical and Poetick Relicks of the Welsh Bards* (London, 1784). His trade card is in the Victoria and Albert Museum.
174. I am grateful to Simon Shaw-Miller for several very illuminating conversations on the topic of St Cecilia's instruments and for his reading of an early draft of this section.
175. See S. Bernstein, 'Fear of Music? Nietzsche's Double Vision of the "Musical Feminine" ', in P. J. Burgard (ed.), *Nietzsche and the Feminine* (Charlottesville, Va., 1994). I am grateful to John Hayes for drawing this essay to my attention.
176. For an excellent consideration of the complexities of this relationship, see R. Leppert, *The Sight of Sound: Music, Representation and the History of the Body* (Berkeley and Los Angeles, 1993).
177. See Bernstein, 'Fear of Music?' for an illuminating discussion of this topic.
178. St Cecilia is relatively recent as a subject for representation by artists and seems, largely, to have been an invention of the Italian Renaissance. An account from this period is available in P. Toschi (ed.), *Sacre rappresentazioni toscane dei secoli XV e XVI* (Florence, 1979). The fullest discussion of the early cultural history of St Cecilia is to be found in a fascinating work by T. Connolly, *Mourning into Joy: Music, Raphael, and Saint Cecilia* (London, 1994). For Reynolds and his contemporaries, more significant would have been the publication in 1756–9 of the first edition of Alban Butler's *The Lives of the Fathers, Martyrs, and Other Principal Saints* (2nd edn. 1779, 3rd edn. 1798–1800). Also of interest is the publication in 1776 in Bologna of a splendid volume devoted to the history and mural decorations of the church of San Michele in Bosco near Bologna (*Il claustro di San Michele in Bosco di Bologna de' monaci Olivetani dipinto dal famoso Lodovico Carracci e da altri eccellenti maestri . . . descritto ed illustrato da Giampetro Cavazzoni Zanotti* (Bologna, 1776)).
179. A. Butler, *The Lives of the Saints* (London, 1756), 758.

180. See *Hall's Dictionary of Subjects and Symbols in Art* (London, 1974).

181. In F. Bastiano Castelletti, *La trionfatrice Cecilia vergine, e martire romana* (Florence, 1694), we read (p. 15): 'Sol di Cecilia e l'armonia discorde | Che rapita negiri alti, e lucenti | Tra gli angelici canti il canto mesce, | E gran dolcezza al paradiso accresce'. For the significance of Raphael's iconography, see Connolly, *Mourning into Joy*.

182. Bernstein, 'Fear of Music?', 119.

183. See E. Winternitz, *Musical Instruments and their Symbolism in Western Art* (London, 1967), 37.

184. Leppert, *Music and Image*, 147, 148–9; Leppert, *The Sight of Sound*, 67 passim.

185. Jones, 'The Empire of Beauty'.

186. Leppert, *Music and Image*, 174.

187. For this last point, see Winternitz, *Musical Instruments*, 48.

188. Leppert, *The Sight of Sound*, 26.

189. Ibid., p. xx.

190. Ibid. 66–7.

191. See, e.g., J. Mulliner, *A Testimony against Periwigs and Periwig-Making, and Playing on Instruments of Musick among Christians, or Any Other in the Days of the Gospel* (Northampton, 1677). For a discussion of Mulliner, see M. Pointon, *Hanging the Head: Portraiture and Social Formation in Eighteenth-century England* (New Haven, 1993).

192. Quoted in Bernstein, 'Fear of Music?', 114.

193. *Euterpe: or, Remarks on the Use and Abuse of Music, as a Part of Modern Education* (London, 1778), quoted in Leppert, *The Sight of Sound*, 69, where 'divesting' is misquoted as 'diverting'.

194. For music in 18th-cent. England see C. Hogwood and R. Luckett (eds.), *Music in Eighteenth-Century England* (Cambridge, 1983) and W. Weber, *The Rise of Musical Classics in Eighteenth-Century England* (Oxford, 1992).

195. Anon (James Gillray), satire on Lady Cecilia Johnston, see N. Penny (ed.), op. cit., p. 390, no. 204.

196. See W. H. Husk, *An Account of the Musical Celebrations on St. Cecilia's Day in the Sixteenth, Seventeenth, and Eighteenth Centuries* (London, 1857), ch. 3.

197. Vol. lxi.

198. J. Addison, 'An Ode for St. Cecilia's Day', in *The Poetical Works of Joseph Addison* (London, 1807), i. st. v.

199. I am indebted to the note in *The Poems of Alexander Pope*, ed. J. Butt (London, 1963), 139.

200. Leppert, *The Sight of Sound*, introd. and ch. i. For a vivid example of music become torture see Bosch's *The Garden of Earthly Delights*, Prado, Madrid. Bernstein explores the castration theme ('Fear of Music?') in the work of Nietzsche and Kleist.

201. A. Pope, 'Ode for Musick, on St. Cecilia's Day', in *Poems*, ed. Butt.

202. See Husk, *Account*, ch. 3.

203. 20 Apr. 1790. quoted in Graves and Cronin, *A History of the Works of Sir J. Reynolds*, i. 82–3.

204. Weber, *The Rise of Musical Classics*, 104.

205. See R. Smith, 'Intellectual Contexts for Handel's English Oratorios', in Hogwood and Luckett (eds.), *Music in Eighteenth-Century England*.

206. Weber, *The Rise of Musical Classics*, 289.

207. I am grateful to Paul Binski for his assistance with this part of the image. The engraved tickets for the Concert of Ancient Music contained images of old instruments and books of music manuscripts (UCLA, *Center and Clark Newsletter*, 26 (Fall 1995)).

208. The National Library of Wales owns the Williams-Wynn Memorial Collection, but accessioning at the time of the bequest in 1911 did not ensure a complete listing, as a conse-

quence of which it is extremely difficult to know precisely what Williams-Wynn's library contained. It does, however, appear to contain a number of 16th-cent. chronicles and it would not be surprising if it also included liturgical material. I am grateful to Robert Lacey, Assistant Librarian, for his help.

209. J. Hughes, *An Ode in Praise of Musick, Set for a Variety of Voices and Instruments by Mr. Philip Hart* (London, 1703).

210. D. Webb, *An Inquiry into the Beauties of Painting* (London, 1760), 53.

211. Ibid. 54.

212. Anon, *Raphael's St. Cecilia* (n.p., n.d.), BL 786.b.15, dated 1770 in BL catalogue, pp. 7–8.

213. *Public Advertiser*, 6 May 1790, quoted in Graves and Cronin, *A History of the Works of Sir J. Reynolds*, i. 82–3.

214. Mignard's *St Cecilia* in the Louvre is described by de Mirimonde (*Sainte-Cécile*, pl. 141) as 'souvent gravée' and 'utilisée par divers imitateurs'. Mentioned are Duflos, Chereau, Bouillard, and Tessari.

215. C. Burney, *A General History of Music* (London, 1776), i, facing p. 222.

216. Ibid. 225.

217. Ibid. iv. 436.

218. Ibid. i. 222.

219. Ibid. 199.

220. J. Brown, *A Dissertation on the Rise, Union and Power . . . of Poetry and Music* (London, 1763; New York, 1971), 45.

221. J. Burnet, Lord Monboddo, *Origin and Progress of Language*, 6 vols. (London, 1773–92).

222. F. Burney, *The Early Diaries of Frances Burney*, ed. A. R. Ellis (London, 1907). For an interesting analysis of the importance of linguistic practice in debates in this period, see the account of the imposter Psalmanzar in S.Stewart, *Crimes of Writing: Problems in the Containment of Representation* (1991), Durham NC and London, 1994, ch. 2.

223. Brown, *Dissertation*, 27–8.

224. T. Sheridan, *A Course of Lectures on Elocution* (London, 1762), 139–43 (a second edition appeared in 1798).

An Anthology of Wills Relating to Women's Property
1739–1760

A Note on the Wills included in this Anthology

The wills transcribed here concern the estates of women of means from the fairly
modest to the great. They represent a small section of women (unmarried, married,
and widowed) from the gentry and nobility. They have been selected primarily on the
basis of the textual representation of goods and effects personally owned; the listing
and defining of personal property rather than the status of the owner or the value
overall of the estate were, therefore, the criteria for choice. While many are long,
legally complex, and richly descriptive, a small selection of short and relatively terse
documents have been included by way of contrast. The wills are all court copies of
probated wills which were proved at the Prerogative Court of Canterbury and may be
found on microfilm in the Public Record Office in Chancery Lane, London. The
Prerogative Court of Canterbury sat in Doctor's Commons in London and was the
metropolitan probate court for the Southern Province and as such was the busiest and
most prestigious court. It had overriding jurisdiction in all England and sole jurisdic-
tion where the deceased had properties in two bishoprics or peculiars in the Southern
Province. It also dealt with individuals who resided abroad, or died at sea, or abroad,
with possessions in England. These cases are immediately identifiable in the following
anthology as in each case the testatrix dictated her will to a notary in The Hague and
the will is therefore written in the third person. These wills were translated from
Dutch into English for the Prerogative Court.

The interest of these documents for the purposes of this particular study lies chiefly
in the ways in which a human unit (which might be an individual woman but is more
likely to be a woman and her lawyer, a woman and her friend(s) and relatives, or any
combination of these) within the linguistic requirements of the legal system con-
structs an individualized narrative in order to represent with the greatest possible
clarity those things which are owned and which the testatrix intends to give away. All
references to real estate have been included and, while it is not part of the particular
concerns of this study, it is of interest to note here how many women did manage
estates. Since the moment of writing is, within this framework, the most significant
moment the wills have been arranged chronologically according to the date of the
signing of the will. There are, of course, many other aspects to wills that are of great
interest to historians (as for example with instructions for the arrangements of funer-
als and funerary monuments). In the interests of maintaining a manageable length, I
decided to concentrate solely on possessions and to exclude the passages concerning
funeral arrangements, executors, and formulaic legal and religious statements that

open and close the wills. Two wills are, however, given in their entirety as specimen cases: the Roman Catholic Dame Helena Clara Lunden (8 May 1736) and Dame Sara Humble (26 April 1737). The wills therefore in general open and close with (. . .). Within the text of the wills themselves almost every element of the text is transcribed; only in the case of frequent repetitions of standard legal formulations already established in the body of the will is the form <. . .> used to indicate an ellipse.

The Rt Honble Lucy Ann Countess Dowager of Bellomont,
 PROB 11/736, quire 274, fos. 193–4
Signed 11 August 1711
Proved 1 November 1744

(. . .) I give to my said mother one hundred pounds to buy her a ring as a token of my gratitude to her for her continued goodness to me I give to my brother Henry Earl of Grantham the sum of one hundred pounds to give to such poor persons as my said mother if she be living at the time of my decease or in case she shall dye before me then as Mrs Elizabeth Smith wife of Benjamin Smith Lieutenant in Major Generall Selwyns regiment shall direct and appoint the sum of one hundred pounds I give to ffrancis Annesley of the Inner Temple London esquire the sum of one hundred pounds all the said legacys to be paid as soon as may be after my decease all the rest and residue of my goods and my chattels real and personal and estate of what nature or kind soever I give to my daughter the Lady ffrances Cook but if she dyd before marriage or before she shall attain the age of twenty one years then I give the same to my three brothers the said Earl of Grantham Count Corneille de Rassan and Count William Mauritz de Rassan subject nevertheless to the payment of my debts and the legacies aforesaid I devise the Guardianship of my daughter unto my said mother (with whom I would have her continue and be educated) the most noble famous Duke of Ormond the said Henry Earl of Grantham and the said ffrancis Annesley and if my said mother should happen to dye before my daughter shall attain the age of twenty one years or be married I recommend the care of her person and education to the said Earl of Grantham with whom I would have her reside untill she be married.
codicil:
 I do hereby republish my last will above mentioned with the following Alterations only in case my daughter the Lady ffrancis Cooke shall happen to dye before her day of marriage or age of twenty one years my will is that in such case my honoured mother the Countess Dowager de Rassan and Anverkerke and her assigns shall have the <word illegible> and produce of all my estate during the term of her natural life subject to the legacies in my said will by me given and after her decease the above named Henry Earl of Grantham and William Mauritz de Rassan I <word illegible> and I do hereby direct that this codicill may be taken as part of my said will (. . .)

Rt Hon Lady Elizabeth Shirley, PROB 11/709, quire 108, fo. 98
Signed 10 March 1722/3 (*sic*)
Proved 10 April 1741

(. . .) I desire my servants may have their wages and mourning I give and bequeath to my sister the rt honble Lady Anna Elinora Shirley all the rest of my goods and chattles and whatever reversion shall appear that I have any claym to I give to my sister the rt honble Lady Anna Elinora Shirley and make her my executor <. . .>

I desire my executor to give to my sister the Right honble Lady Barbar Shirley the sum of 100 to buy her mourning with (. . .)

The Rt Hon. Elizabeth late Lady Dowager Folliott Baroness of
 Ballyshannon in the Kingdom of Ireland, PROB 11/729,
 quire 329, fos. 342–3
Signed 18 April 1728
Proved 7 November 1743

(. . .) I give and bequeath to my cousin Sr Andrew Thornhagh of Osborton in the County of Nottingham esquire the picture of my late husband my late Lord ffolliot drawn at length and now in a gilt frame and I also give unto my said cousin <. . .> my own picture drawn at length and my grandfather Thornhaghs picture and my late uncle John Thornhaghs picture all of which said pictures are now in my dwelling house in Cock street in the parish of St James Westminster in the county of Middlesex. Item I give and bequeath unto my loving ffriend Mrs Mary Mainwaring of Richmond in the county of Surrey spinster the sum of twenty pounds of lawful money of Great Britain to be paid to her by my executrix hereinafter named within one month next after my decease. Item I give and bequeath unto my servant woman Mary Wilbraham spinster twenty pounds of like lawfull money of Great Britain to be paid to her by my executrix hereinafter named immediately after my decease if she the said Mary Wilbraham shall be still living with me as my servant at the time of my decease and not otherwise. Item I give and bequeath to my servant George Storer ten pounds of like lawfull money <. . .> if the said George Storer shall be living wih me as my servant at the time of my decease and not otherwise. Item I give and devise unto my loving cousin Margaret Pudsey spinster daughter of my cousin Thomas Pudsey <. . .> all my real estate whatsoever and wheresoever with their and every of their appurtenances unto the said Margaret Pudsey her heirs and assigns forever and all the rest and residue of my goods chattels and personal estate whatsoever and wheresoever I give and devise unto my said cousin Margaret Pudsey she paying thereout my just debts, legacys and ffuneral expenses (. . .)

Lady Margareta Cecilia Munter Countess Dowager of Cadogan
 Lady of Zanen Raaphorst, PROB 11/782, quire 288, fos. 99–100
Signed 2 August 1728
Read 5 November 1749
Translated from Dutch and administered 6 September 1750

(. . .) I declare to have named to being heirs my eldest daughter my Lady Sarah
Cadogan spouse of my Lord Carolus Lenox Duke of Richmond and that in the only
legitimate portion belonging to her in the goods which I after my dead should may
leave and all my other goods as well ffief as <allodial ?> moveable and immoveable
goods whom I with my dead should leave to the disposition of my ffiefs having
obtained a grant of their Great Highnesses de States of Holland and Nesvrieslandt
date 17th September of this year 1726 I declare to my sole and general heiress to have
named and appoint my youngest daughter Lady Margareta Cadogan forthwith all the
same to do and act according to her will without any contradiction whatsoever and
whereas my said disposition in manner aforesaid not having been made because of any
discontent taken by me against my said eldest daughter as therefore not having the
least reason but to the contrary for to equal my said daughters reciprocally so with
relation to the goods possessed by late his excellency the Count of Cadogan my
husband as with relation to such goods as I upon my death shall leave and therefore to
better maintenance the love and peace between my said children so I declare by these
presents to be my plain will and desire that in case the immoveable goods which my
said daughter Lady Margareta Cadogan by virtue of these presents should inherit by
estimation to be done may amount more than the whole sum that my said eldest
daughter Lady Sara Cadogan or her said husband the Duke of Richmond or her child
or her children should have got or shall get still out of the goods of late the said his
excellency Count of Cadogan or otherwise my said daughter Lady Margaretta
Cadogan then and in no otherwise shall be obliged to pay in money to my daughter
the Duchess of Richmond in manner aforesaid might be profited save nevertheless
that then amongst the estimation of goods aforesaid be done not shall be understood
some moveable goods whether household goods, gold, silver jewels or else belonging
to my body which by me shall be leaved with the dead as all the bequeathing above by
this aforesaid to my said daughter Margareta Cadogan bequeathing above by this pre-
sents I declare by these presents to have named and appointed to executors of this my
last will and guardians of my heir or heirs underage John of Oorshot Treasurer of the
Rolls of the High Court with Peter Reynard (. . .)

Dame Susan Sacrelaire, PROB 11/732, quire 55, fos. 43–4
Signed 2 October 1728
Proved 27 February 1743

(. . .) The said testatrix disposing anew of her effects did leave by this present to the
poor of the Deaconry of the Walloon church at the Hague the sum of three hundred

fflorins once paid in the space of six weeks after death and then she the testatrix did declare name and appoint as she did by these presents name and constitute for her only and universal heiress Mrs Jane Alexander her daughter in all her goods as well moveable as immoveable actions and credits gold and silver coin'd and not coin'd cloaths linnen household and other ffurniture in any kingdom town country or place situate as well real as personal none excepted to be by her the said Jane Alexandre done with or disposed of in that manner she shall think proper (. . .)

The Hon. Lady Catherine Jones, PROB/11 702, quire 147, fos. 276–8
Signed 7 June 1730
Proved 13 May 1740

(. . .) I give and devise the picture of my dear ffriend Mrs Kendall which stands over the door of my bedchamber to Mrs Ann Muddiford now of Windsor if she shall be living at the time of my decease and if she shall happen not to be living at that time I give and devise the same to Mrs Oldfield and her sister & likewise give and devise the picture of Miss Squire deceased to Mrs Narcot her executrix and whereas I am seized of or otherwise well intitled unto the inheritance or equity of redemption of and in one equal undivided third part of my said late ffathers estate in Ireland to the money that shall arise from or by sale of such third part and being minded to dispose of it is my will and I do hereby give devise the same and all other my lands tenements and hereditaments in Ireland and Great Britain or elsewhere in possession reversion or remainder and all such sum and sums of money as shall or may arise from the sale or sales thereof or any part thereof unto Joseph Smith of the Privy Garden Whitehall in the county of Middlesex and James ffrazier of York Buildings in the said county esquires being both gentlemen whose great honesty I have experienced in my troublesome affairs their heirs and assigns for ever upon this special trust <. . .> that they <. . .> shall as soon as conveniently may be sell the same and every part thereof to the best purchaser or purchasers that can be had for the same. Item it is my will and I do hereby require and injoin my said trustees carefully to observe and perform everything that is required by my said dear ffathers last will and by a settlement to him made some time in the year 1708 so far as the same in any respect affects or regards my said third undivided part <. . .> it is also my will and I do desire that such of my said dear ffathers private debts which are not provided for by his said will as settlement or which shall not have been discharged before my decease shall be from the money arising from the sale of my estate be fully paid and satisfied. To my dear sister the countess of Kildare the sum of one thousand pounds provided she be living at the time of my decease and if she should happen at such time to be deceased I give and devise the said sum of one thousand pounds to ffrances the daughter of my niece Lady ffrances Hanbury Williams <. . .> to Lady Colliton the widow of Sir Theodore Colliton the sum of one hundred pounds as a small remembrance of her friendship to me & Thomas Read my godson son of Mrs Read who is daughter of Doctor Langford fifty

pounds to Mrs Mary Green of Westminster spinster one hundred guineas as a small token of my regard and gratitude to her to Mrs Braithwaite of Piccadilly spinster to whom I have always been obliged one hundred pounds to my good ffriend and old acquaintance Mrs Crawford now of Blackheath near Greenwich one hundred pounds and to her two daughters who are now unmarried ffifty pounds each and my godson William English grandson of my said ffriend Mrs Crawford fifty pounds to Mrs Angel Butler spinster my long acquaintance and ffriend one hundred pounds to Mr Henry Bury for his trouble in going through my dear ffathers publick accounts one hundred pounds to Jeffry ffrench of the Middle Temple London esquire ffifty guineas to Richard Bourdean son of my last servant Mary Bourdean deceased of whom I promised her on her death to take care the sum of ffour hundred pounds & I recomend him to be bred up to some good trade to which his genius shall turn under the care and direction of his uncle James Whitfield of Saint James street in the county of Middlesex peruke maker I give to my honest servant Samuel Memory thirty pounds to Mary Price my old and honest servant thirty pounds to my coachman the said William Bridges ten pounds and to each of my servants that shall be living with me at the time of my decease and not herein before mentioned one whole years wages over and above what at the time shall be due to them. Item whereas there hath been for many years a charity school maintained by subscription and other wise at Chelsea for the children of the invalides of Chelsea hospital and there is now a ffund of three hundred pounds for supporting the same it is my will and I do hereby give and devise to my said friends Joseph Smith and James ffrazier the sum of ffour hundred pounds upon trust that they <. . .> or the survivor of them shall and will pay and apply the same or the interest thereof in such manner as to them shall be thought expedient for the support and the maintenance of said school and I give and devise the sum of twenty pounds to the Reverend Mr Rothery the present chaplain of Chelsea College or the chaplin or chaplins who shall succeed him upon trust to lay out and apply the same in buying good religious books for the infirmary of Chelsea Hospital. Item I give to the rector or clergyman of the parish of Chelsea the sume of twenty pounds to be by him distributed amongst such poor parishioners of the parish as he shall in his judgement think the greatest objects of charity I give and devise unto the said Joseph Smith and James ffrazier the sum of fifty pounds to be by them payed and applyed as they <. . .> think fit to the relief of poor prisoners in this land and to Jeffry ffrench esqr the like sum of ffifty pounds to be by him paid and applyed as he shall think fit for the reliefe of poor prisoners in Ireland and I also give and devise unto the said Joseph Smith and James ffrazier the sume of one hundred pounds each for their care and trouble in the execution of the several trusts by me herby reposed in them and give and devise to Mrs Smith wife of the said Joseph Smith and to his young son ffrederick fifty guineas each which is an inconsiderable remembrance for the many obligations I owe to him and his ffamily and it is my will the said Joseph Smith and James ffrazier <. . .> shall from the money arising from the sale of my real estate pay and satisfie all and every the legacies and sums of money herintobefore mentioned (. . .)

The Rt. Hon. Ann Baroness Dowager Trevor, PROB 11/751,
 quire 367, fo. 318
Signed 3 August 1730
Proved 29 December 1746

(. . .) I give unto my son Sir John Bernard one hundred pounds my diamond strapp given me by Sir Robert Bernard his ffather and the great ffamily picture of Sir Robert Bernard now in the dining room at Peckham I give unto my daughter Anne Bernard one hundred pounds my diamond girdle buckle my pearl necklace my gold tweezer case with the chain and hook and other things thereon hanging my dressing plate now in Huntingtonshire a wrought bed that was my mothers with the damask to line it and my own picture at half length I give unto my daughter Mary Bernard one hundred pounds my diamond earrings my diamond buckles for my stays my lockett set with diamonds with her ffathers hairs a mohair bed that was my mothers and my own picture in little I give unto my said two daughters Anne and Mary Bernard all the household goods linnen and plate that was my mothers to be equally divided between them I give unto my daughter in law Anne Trevor two ffive pound peices of gold her ffathers picture in little and Mrs Prices picture I give to my daughter in law Mrs Cock two ffive pound pieces of gold and the picture of her sister Anne Trevor in little I give to my Daughter in Law Elizabeth Trevor two ffive pound pieces of gold and my daughter Anne Bernards picture in little I give unto my said two daughters Ann and Mary Bernard all the residue of my gold and silver meddals and other pieces of gold and silver which shall be found at the time of my death in my little iron trunk (except the six five pound pieces of gold before disposed of) to be equally divided between them and all my cloths and wearing apparel to be disposed of by them as they think fit. I give to my son Robert Trevor my diamond ring and all my other rings my grand-ffather Trevors picture and my own ffathers picture both set in gold I give unto my son Richard Trevor my gold watch and gold chain with all the things belonging to it (except the lockett set with diamonds before disposed of) and in case it shall please God that I shall die before the goods that were left me by the will of my late husband the Lord Trevor be removed from the house at Peckham in such case I give and bequeath the same unto my son in law Thomas Lord Trevor I give unto my servant Tabitha Gilbert ten pounds in case she be living with me at the time of my death I give unto all the servants that shall live with me at the time of my decease a years wages to each of them <. . .> and as to all the rest and residue of my household goods plate jewels money securities and all other my personal estate whatsoever I give and bequeath the same unto my said two sons Robert and Richard Trevor to be equally divided between them I give to my two daughters Anne and Mary Bernard my sticht quilt and pillow Beers of my own work and all my child bed linnen to be equally divided between them (. . .)

Dame Rebecca D'Oyly, PROB 11/751, quire 348, fos. 159–60
Signed 6 February 1734/5 (*sic*)
Proved 4 December 1746

(. . .) Having a power reserved to me in certain articles made on my marriage with the said Sr John D'Oyly baronet to give devise bequeath and dispose of my right title and interest in and to certain lands tenements and hereditaments lyeing and being within the parish of Lampon in the county of Gloucester and the manor lands tenements and hereditaments called or known by the name and names of Cold Aston Grove and Grove Mead and Burton Mead in the parish of Bourton in the water in the said county of Gloucester and also all that estate lands tenements and hereditaments near Whitney in the county of Oxford commonly called and known by the name Claywell to go therewith and singular my plate jewells rings and wearing apparrell after the decease of him the said John D'Oyly to such person or persons as I shall in and by my last will and testament or by any other deed or deeds writeing or writeings give devise bequeath or dispose of the same <. . .> I give devise and bequeath all my right title and interest in and to all and singular the aforesaid lands tenements hereditaments and premises with their and every of their appurtenances lyeing and being in the parish of Lampon in the County of Gloucester and also in and to all that the said Mannor Lands Tenements Hereditaments and premises with all and every their appurtenances called or known by the name or names of Cold Aston Grove and Groves Mead in the said County of Gloucester with all and every their rights members and appurtenances after the death of my said Dear Husband. To my dear son Thomas D'Oyly esquire to have and to hold to him the said Thomas d'Oyly Esquire his heirs executors administrators and assigns for ever I give devise and bequeath to my said dearly beloved husband Sr John D'Oyly Baronet in case he be liveing at the time of my decease all my right title and interest in and to the aforesaid estate called or known by the name of Claywell lyeing and being near Whitney in the county of Oxford his heirs executors adminis-trators and assigns for ever but in case I should survive him the said Sr John d'Oyly then and in such case I give devise and bequeath the said estate of Claywell with its appurtenances to my said dear son Thomas D'Oyly esq. his heirs executors admin-strators and assigns forever I give devise and bequeath to my dear son the Reverend Mr John D'Oyley all my right title and interest in and to the aforesaid Mead called or known by the name of Bourton Mead in the Parish of Bourton in the water in the said county of Gloucester after the death of my said dear husband Sr John D'Oyly to hold to him the said Mr. John D'Oyly his heirs executors administrators and assigns forever. I give devise and bequeath to such servant maid as shall be liveing with me at the time of my death all my wearing apparell I give and bequeath to the poor of Alscot in the county of Oxford the sum of ten pounds I give and bequeath to the poor of Chislehampton in the county of Oxford the sum of ten pound which three last men-tioned legacies I will shall be paid by my executor hereafter named within six months after my decease all the rest residue and remainder of my goods chattels and estate both real and personal together with my jewells rings and all other things that at the

time of my decease I shall anywise have right or as shall be in any power to dispose of I give devise and bequeath the same and every part and parcell thereof to my dear son Thomas D'Oyley his heirs executors adminstrators and assigns forever (. . .)

Dame Mary Charlton, PROB 11/715, quire 47, fos. 379–80
Signed 1 March 1735
Proved 23 February 1742

(. . .) Whereas the last will and testament of my late Uncle Edward Turner late Rector of Eynsbury in the county of Hungtington I had left me after the decease of my late dear mother Mary Carnes the great and small tythes of the two several townships of Caldecott and Weale in the said parish of Eynsbury helf under the Bishop of Ely for years. Item and whereas a codicil to the said will of my late uncle Edward Turner aforesaid date 7th March 1710 I became legally entitled after the decease of my said mother to a real estate of copy and freehold being the estates of my late Uncle John Turner situate lying and being in Nether Wintringham <. . .> now or late in the possession of one William King. Item and whereas by the last will and testament of my said late dear husband Sir ffrancis Charlton Barrt deceased <. . .> I had left me the sum of one thousand pounds and allso the copy and ffreehold estate and great and small tythes above mentioned and expressed and every part and parcel thereof I do thereby give and bequeath the same to my loving son Job Charlton esquire subject nevertheless to the payment of one thousand pounds which I am obliged to take up at interest for the discharging of a law suit between the corporation of Ludlow and my late husband and the placing out of my youngest son ffrancis Edward Charlton. Item I give and bequeath to my loving son ffrancis Edward Charlton the sum of one thousand pounds part of three thousand pounds that is now placed out at interest in the hands of Thomas Powys of Berwick esqr over and above the one thousand pounds which his late grandmother left him and is also placed out at interest in the hands of the said Thomas Powys I give and bequeath to my said son ffrancis Edward Charlton one freehold messuage or tenement in Broad Street Ludlow in which Mrs Elizabeth Dronburough doth now inhabit and dwell to hold unto my said son <. . .> his heirs and assigns until my eldest son Job Charlton do and shall well and truly pay or range to be paid unto my said son ffrances on his assigns the full and just sum of eighty pounds of good and lawful money of Great britain and from and after payment shall be made to my said son ffrancis Edward of his heirs or assigns of the said sum of eighty pounds by my said son Job his heirs or assigns I do hereby give and bequeathe the said Messuages or Tenement unto my said son Job Charlton from theretoforth to hold him and his heirs and assigns for ever. Item I give and bequeath unto my said son ffrancis one tenement in the Brandland in Ludlow aforesaid which Mr James Marsh doth now dwell but my will is that the said James Marsh shall hold and enjoy the said tenement during his natural life. Item I give and bequeath unto my loving daughter Emma Charlton the sum of one thousand pounds that is placed out at interest <. . .>

and I also give and devise to my said daughter Emma a japan cabinet, a silver lamp and tea kettle and all other plate whatsoever belonging to the said tea table (except two large waiters) and also all my rings and jewells I give to my said daughter. Item I give and bequeath to my son Job and my daughter Emma all my china ware to be equally divided between them. Item I give to the poor of the parish of Whittington five pounds. Item I give and bequeath all the rest and residue of my personal and real estate of what nature or kind soever as well plate as otherwise after payment of my debts and legacies as aforesaid unto my said son Job Charlton (. . .)

The Rt Hon Elizabeth Viscountess Dowager Irwin, PROB 11/754, quire 129, fos. 249–50
Signed 19 April 1736
Proved 18 May 1747

(. . .) I give and devise to my very good ffriend Sr Laurence Carter twenty guineas to be paid by my executor within three months after my decease. Item I give and devise to my dear son Bennet Noel and his heirs and assigns forever all that my annual rent charge or ffee farm rent of twenty pounds thirteen shillings and four pence issuing and payable out of the rectory and church of Ebrighton <ats?> Ebrighton <ats?> Erlington and out of the Glebe lands thereof in the county of Gloucester I also give and devise to my said son Bennet the sum of one thousand pounds to be paid him by my executor within twelve months next after my decease I also give and devise to my said son Bennet twelve silver hafted knives twelve silver hafted fforks twelve spoons four silver salts one old silver caster one pair of silver candlesticks and a Bohee tea pot and lamp silver these are at my house in London a trunk of linnen at Walcot marked for him and my oval picture by Cloysterman at Walcot. Item I give and devise unto my dear daughter Alice Noel the sum of two thousand pounds to be paid her by my executor within twelve months next after my decease I also give and devise to my said daughter Alice a Blackamoors head on onyx Lord Irwins little picture set in gold Lord Wissin Irwins picture set in gold a silver bason that I use my brother Christopher Sherards picture and trunk of linnen marked for her a brilliant diamond ring a silver eight square pallet I also give and devise to my said son Benet and to my said daughter Alice all the household goods and ffurniture of whatever kind soever of mine in London be equally divided between them plate and jewells only excepted. Item I give and devise to Elizabeth Grocoth ten pounds per annum to Elizabeth Rawson five pounds per annum to Charles Bynion five pounds per annum to Alexander Pitts five pounds per annum during their natural lives to Robert Crane ten pounds and to all and every of my servants at my decease I give and devise to each of them one years wages over and above what shall then be due to them. Item I give and devise to my cosen Mrs Elizabeth Langton twenty guineas and the silver ring and all the tea things and tea pot to it. Item I give and devise to my cosen Mrs Margaret Langton twenty guineas and my own <word illegible> silver cup my own porringer and spoon repeating watch

and old <word illegible>. Item I give and devise to my dear son Thomas Noel his executors administrators and assigns all my personal estate of what nature or kind or quality so ever he paying all my just debts legacies and ffuneral expences (. . .)

Dame Helena Clara Lunden, PROB 11/700, quire 15, fos. 117–18
Signed 8 May 1736
Proved 16 January 1739

IN THE NAME OF GOD AMEN. Be it known and manifest unto all and singular that this present Instrument of last will shall see or hear the same <. . .> that in the Year of our Lord <. . .> One thousand seven hundred and thirty six of the eight day of the month of may before Peter Gerard Royal Notary of the number of those of the City and secretary Office of antwerp and in the presence of the Witnesses hereunder named personally came and appeared Dame Helena Clara Lunden Dowager of the late Sir Charles John Baptist Perier de Coigners Knight and so forth living in this city unto me Notary walking and standing aged forty using and enjoying her memory and understanding and plain appeared who sayd and declared that considering the frailty and weakness of human nature and finding that nothing in this world is more certain than death and nothing more uncertain than the hour thereof hath therefore after mature deliberation not being constrained or misled by anybody so as she declared I made those and ordained as she doth by these presents this her last will and testament in the manner & form following. The said Lady and Testatrix willing and earnestly desiring that this her will may after her decease availle and take effect either as a Testament Codicill Gift or Bequest which men make in prospect of death or in such former as the same <word illegible> or may best availe attending to the Spiritual and Temporal laws alltho all the annuities be required by Law to be herein contained should not be herein observed and also notwithstanding any Municipal Cities or Land Laws to the contrary derogating from them all by these presents & likewise revoking and disavailling and in making voyd all former testaments, codicills, wills and bequests in prospect of death by hour before the sale hereof anyways made or passed and the said Gentelwoman the Testatrix now proceeding to the making of her Testament and <words illegible> first and before all things she Commits her Soul when ever the same shall depart out of her mortal Body in to the merciful hands of God to the prayers and interventions of the most holy king and Mary the Mother of God and all of the Heaven's host and her dead body to the wide earth raising her burying place in the Cathedrall Church of our blessed lady in that place ordering that she may be privately buryed in the Evening <. . .> shortly after her decease over and above the usual Masse there shall be sayd a thousand Masses of Rest for the Rest of her soul. Item the Testatrix order that the said Masses may be sayd and celebrated in the chapel of Our Lady in this Cathedrall. Item the Testatrix doth give and bequest by these presents to the building of this Cathedrall Churche. To the building of this cathedral churche the summe of one hundred guilders current money. Item the Testatrix doth give and

bequeath to the chappel of the honerable in this cathedral a like summe of one hundred guilders currant money to the chapel of the most holy Mother of God Mary in this said cathedral the said Testatrix orders that shortly after her death there shall be payd and distributed six hundred guilders exchange money <. . .> making two shillings in <word illegible> which shall be distributed among poor persons. Item the Testatrix doth give and bequeath to the Brotherhood of St Nicholas Tolentinas in the church of the Reverend Augustin ffathers in this place the summe of eight and twenty guilders current money once paid upon condition that the said brotherhood shall be obliged according to her interest and for the rest of her soul to celebrate a single mass in the choir. Item for testatrix doth give and bequeath the summe of ffourteen guilders current money on to pay to the Reverend Jesuit ffathers in the profession house in this place for which they shall be obliged to say or cause to be sayd a mass in the choir by the alter of the good deceassed for the rest of the soul of the testatrix willing and desiring that there shall be celebrated by the said reverend ffathers out of the said thousand masses one hundred masses of rest. Item the Testatrix doth give and bequeath to Helena Clavermans her chambermaid in case she shall live with her at the time of her decease and not otherwise the summe of two hundred guilders current money once payd. Here the Testatrix doth give and bequeath to each of her other servants the summe of sixty guilders. Item the Testatrix doth give and bequeath by way of prelogary by these presents to her nephew John ffrancis Michael Lunden and in case of his predecease to his lawfull child or childrens heir the Testatrixs Great house with the garden grounds and all the appurtenances called the Schier Brood situate and being upon the Dryhoeck in this place and now coming to the disposition of all and singular the estate which she shall leave at the time of her decease both moveable and immoveable real and personal goods and chattels for which purpose the Testatrix doth by these presents make use of the publick letters of grant by her obtained <. . .> of the sovereign Council of Brabant in the year of our Lord one thousand seven hundred and twenty all which estate which she shall leave at the time of her decease the Testatrix hath given granted devised and bequeathed as she doth by these presents to Mrs Maria Johanna Theresia Lunden Mrs Helena Clara Lunden wife of Lerois Van Colen Esqr <. . .> Mrs Susanna Hortentia Lunden nun in the cloyster in this place and John ffrancis Michael Lunden esquire the four children of her late brother William ffrancis Lunden esquire < . . .> one full moiety or half part thereof and to Mrs Helena Catharina Van Roosendael wife of Simon Joseph do <. . .> one full moiety or half part of the remaining moiety or half part of the estate which she shall leave at the time of her decease and likewise unto Mrs Maria Regina Theresia Josephina de Witte the other moiety or half part of the estate which the testatrix shall leave at the time of her decease upon this charge and condition nevertheless that her said Priere de Witte shall not dispose of the Estate which she shall inherit of her own Right until <word illegible> less sell Charge or alienate the same & till such time as she shall be in some approved state either spiritual or temporal shall have attained the age of ffive and twenty years for if it should happen that her said Priere should dye before she have attained the aforesaid age or such approved state in such case the Estate's will and

desire is that the share which the said Priere shall have inherited of her shall go rever-
tant and devolve and likewise be inherited to wit one moity of half part thereof by the
Children of the said late Brother William ffrancis Lunden and in the case of their or
any of their predecease to their lawfull issue by Representation and the remaining
Moity or half part thereof by the said <word illegible> Helena Catharina Van
Roosendael and in case of her predecease by the lawfull House of Representation the
said Gentlewoman the Testatrix Instituting and substituting in manner aforemen-
tioned their said <words illegible> respectively and in the case of their or any of their
predecease their lawfull issue by Representation and likewise nominating and appoint-
ing them for her Sole and universall heir with full right of Institution and Substitution
by there presents the Gentlewoman Testarix nominating and appointing for
Testamentary Guardian of the said Miss Maria Regina Theresia Josephina to wit
Simon Joseph de Renvele Esquire her loving Cousin with power of assumption and
subrogation in form and including the Chamber of <word illegible> of this City the
Gentlewoman the Testatrix expressly forbidding by these presents any sale either
public or of the voice of the Goods and moveable effects <. . .> her express Will and
desire is that all the sum shall be admirably divided among her aforementioned heirs.
Item the Testatrix declares by these presents to satisfy and approve the general <. . .>
letter by attorney by her made and passed the twenty fourth of may one thousand
seven hundred and thirty five before the Sheriffs of this city in favour of her nephew
John ffrancis Michael Lunden Esquire and also and whatsoever hath already done and
transacted <word illegible> thereof and all and whatsoever he shall do hereafter by
virtue thereof willing and desiring that her aforementioned heirs and every of them
shall satisfy and approve the same and observe and follow in every point the contents
of the said Letter of attorney without deviating therefrom in the least or contradict-
ing or molesting her attorney either in Law or otherwise much less to demand of him
any account of inventory and in case her heirs or any of them should do so In such
case the Testatrix declares to disinherit and deprive such heir or heirs of all whatsoev-
er they and each of them might enjoy from her by fortune hereof In which case the
Estate nominatees institutes and substitutes in such ones portion or portions her other
heirs who shall acqiesce to and perform the contents both of this her will and of the
aforementioned letter of attorney the Testatrix further willing and desiring that all
whatsoever she shall write or raise to be written and shall appear to be by her Signed
after the date thereof concerning the making of any Legacies pious works or any
other ordinance of Last will changing adding to or diminishing therefrom that all the
same & after her decease.

Dame Sarah Humble, PROB 11/700, quire 12, fos. 91–3
Signed 26 April 1737
Proved 15 Jan 1739

I Dame Sarah Humble of Thorpe Underwood in the County of Northampton –
widow do hereby revoke all former wills made by me and make this my last will as fol-

loweth (vizt) I devise the mannor of Thorpe Underwood and all other my messuages lands and hereditaments with their appurtenances in Thorpe Underwood Howell East Speaddon or alsowhere in the said county of Northampton to my son Sir William Humble for his life and after the determination of that estate to Christopher Tilson esquire and Joseph Ashton gentlemen and their heirs during the life of my said son in trust only to preserve the contingent remainders hereinafter limitted but to permitt my said son to receive the rents and profits thereof during his life and after his death I devise the same to the first son of the body of my said son lawfully begotten and the heirs of the Body of such first son and for want of such issue <word illegible> and sons of the Body of my said son lawfully begotten and heirs of their respective Bodys the eldest of them and the heirs of his body being always preffered and to take first and fore want of such heirs to all and every daughter and daughters of the Body of my said son lawfully begotten share and share alike as tennants in common, and not as joint tennants and the heirs of their bodys and for want of issue I devise the said promises to my daughter Mary Humble for her life and after the determination of that estate to the said Christopher Tilson and Joseph Ashton and their heirs during the life of my daughter. I trust only to preserve the contingent remainder hereinafter limitted but to permit my said daughter to receive the Rents and profits during her life and after her death. I devise the same to first son of the Body of my said Daughter lawfully begotten and the heirs of the Body of such first son and for want of such issue to the second and third son and every other son of the Body of my said Daughter lawfully begotten and the heirs of their respective Bodys and the heirs of their respective bodys the Eldest of them and their respective issue to be always preferred and to take first and for want of such issue to all and every the Daughter and daughters lawfully begotten share and share alike as tennants in common and not as joint tennants and the heirs of their Bodys and for want issue I devise the said Promises to my own right heirs. I give to my said daughter Mary Humble these goods and things following (vizt) my two smallest Indian cabinetts and an Indian chest of the same sort of Japan with the said two cabinetts a wrought Bed with all its bedding cloaths and everything belonging to it a green cloath bed with all its bedding and bedding cloathes and everything belonging to it and all the other ffurniture in the room where the same bed stands a chimney glass and a pier glass which stands in the last appartment fronting the park and the stove and grate and iron bath with tongs poker shovell and ffender which stands in the same appartment a straw coloured Indian quilt the servants bed with everything belonging to it in the garret next the park and all the other furniture in the said garret six green mohair chairs with walnutt tree frames and covers to them and green mohair hangings belonging to the study the marble sideboard and marble stool in the dining room and the six crimson and white walnutt tree chairs and the two white calamanto window curtains in the same room. Sir William Humble's picture two crimson china <word illegible> window curtains six black leather chairs and the great chair which are in the Great parlour and the stove and grate and what belongs to them which are in the same parlour a dozen of the best pewter plates and four of the middle sized & best pewter dishes all which goods and things are in my dwelling

house in Queens square except and of the said Indian cabinetts and the said Indian chest which are in my house at Thorpe Underwood aforesaid and I also give my said daughter these jewells following (vizt) a pair of diamond earrings with three drops to each of them and my solitair and girdle buckle my hoop ring and my br<r>illiant diamond ring and I give all the rest of my goods chatells and personall estate to my said son Sir William Humble and make him my sole executor here of in witness whereof I have hereunto set my hand and seal this six and twentieth day of april in the year one thousand seven hundred and thirty-seven and in the tenth year of the reign of his majesty king George the second signed, sealed and published by the said Testatrix: <Signed Sarah Humble> In the presence of us who have also subscribed our names as witnesses in her presence:
<signed>
Joseph Ashton
John Marke
Tho.Sagshaid
On the fifteenth day of January in the year of our Lord one thousand seven hundred and thirty nine power was granted to Edward Burton a Creditor of Dame Sarah Humble late of Thorpe Underwood in the County of Northampton – widow deceased to administer the goods chattels and credits of the said deceased according to the terms of her will for that Sir William Humble Baronet the son of the said deceased and sole executor and residuary legatee named in the said will hath renounced the Execution of the said will being first sworn duly to administer.

Charlotte Lady Dowager fforester, PROB 11/731, quire 36,
 fos. 287–8
Signed 10 May 1737
Proved 17 February 1743

(. . .) I give to my daughter Harriot fforester one thousand pounds and after payment thereof and of such debts as I shall owe at my death as also the expences of my ffu-neral I give and bequeath all the rest residue and remainder of my goods chattels and personal estate whatsoever and wheresoever unto my three children George Lord fforester, Carolina fforester and the said Harriot fforester equally to be divided between them share and share alike (. . .)

The Right Honourable Lady Baroness Dowager Bingley, PROB
 11/828, quire 74, fos. 223–4
Signed 25 July 1737
Proved 26 March 1757

(. . .) Item I give bequeath and devise unto my brother Henry Earl of Aylesford all the plate which his present majesty King George the Second was pleased to give me by a

grant of his privy seal the peices are as follows two eight square dishes four smaller twelve gilt plates which have my Lords arms and supporters upon them with a Barons coronet twelve gilt knives fforks and spoons which are marked with a cypher AR sixteen silver plates with the crown arms upon them GR twelve knives which are marked with only my own cypher EB and have a barons coronet twelve fforks twelve spoons two pair of silver candlesticks which are marked with a cypher GR all which I give to my brother as above mentioned and after his decease to his son Heneage ffinch now Lord Gernsey <. . .> Item I give and bequeath and devise unto my sister ffinch wife to my brother John ffinch my silver baskett that has a plate for the top with four silver branches belonging to it all which have been part of a large epargne <. . .> Item I give bequeath and devise to my dearest and only child Hariott the wife of George Fox esquire my diamond earrings and dropt and to her son after and also give her my japan cabinet with the two Indian pin cushing boxs upon it and my silver tea kettle lamp dish and milk pott all in the red case thereunto belonging and whereas I have a note of hand for the sum of ffive hundred pounds from my said daughter before she was married and Signed by her maiden name Harriet Benson which has not yet been paid I do hereby remitt the sum to my said dear daughter and all interest claim or demand whatsoever that might have been or may be made upon her by reason thereof and give the note to her to be cancelled torn or otherwise destroyed Item I give bequeath and devise unto Mrs Jane ffenay my dear Lords picture and my own and my Aunt Saviles picture and my princes wood strong box with brass's upon it that stands upon a walnutt tree frame Item I give and devise and bequeath to my nephew Mr Heneage Legge all the rest of my plate not herein before disposed of otherwise which I shall be possessed of at the time of my death and also the bond which I had from him and all interest due upon the same Item I give unto such of my servants as shall be living with me at the time of my death and who have been in my service two years before that time one whole years wages besides what shall be then due and owing to them respectively But to my servant Phillip Tallent if with me at the time of my death I give two years wages over and above what shall be then due and owing to him Item I give unto my servant Robert ffrancois and Anne ffrancis his wife over and above the said one years wages hereinbefore given to them the sum of twenty guineas apeice each if they are in my service at the time of my death and I give unto the said Ann ffrancis all my wearing apparell of what kind soever <. . .> I give and bequeath to my sister the Lady ffrances Bland my mothers picture and one dozen of my silver knives fforks and spoons Item I will that all my just debts which shall be owing at the time of my death shall be paid in the first place and as soon after my death as possible and all the rest and residue of my estate of what nature or kind soever not herein before devised after my debts legacies and ffuneral expences shall be discharged I give unto my dear daughter Hariett ffox (. . .)

Lady Ann Harvey, PROB 11/715, quire 17, fos. 131–2
Signed 11 November 1737
Proved 16 November 1739

(. . .) I hereby order direct and appoint my said executrix to pay the poor of the parish where I shall so happen to dye the same night after decease or so soon after as may be the sum of ffive pounds <. . .> first of all I will that all my just debts due and owing to any person or persons whatsoever shall be first discharged and paid and my ffuneral expences also I give and bequeath to my own servant Mrs Attow two hundred pounds of lawfull money of Great Britain and my gold watch. To my other servants <. . .> one hundred pounds of like lawfull money and all my wearing apparell as to silks wollen and linnen I give two thirds thereof to Mrs Atthow and one third thereof to Mrs Ewells also I give to the honble Mrs Elizabeth Courtenay wife of Rolland Courtenay esquire my granddaughter the sum of one hundred pounds to be put out at interest by my said granddaughter upon such security as to her shall seem meet in trust to and for the use and benefit of my black girl Lovey Longwell she the said Lovey Longwell may receive the interest therof as it shall yearly grow due and the said principal sum of the hundred pounds I order to be payd her whenever she shall marry to an advantage and to the good liking of my said granddaughter also I give and bequeath to my three servants Edward Rowley my coachmen Thomas Ginner and Samuel Gilbody twenty pounds of like lawfull money to each of them as shall be living with me at the time of my decease and not otherwise and to all the rest of my servants that shall be living with me at the time of my decease I give to them half a years wages over and above what shall be due to each of them for their respective wages also I give to Mrs Proory twenty pounds of like lawfull money also I give and bequeath unto the honble William Montague esquire brother to the right honble the Earl of Sandwich my grandson one hundred pounds to purchase a ring in remembrance of me also I give to Mrs Britton widow and niece to late Mr Harvey my gold tweezer case chain and hoof thereunto belonging also I give to mrs Elizabeth Pavallier ten guineas to buy her mourning with also I give to Lady Barbara North daughter of the Earl of Pembroke my amber tweezer case with King George the second and Queen Carolines picture with a diamond crown over it the which was given me by Lady Barbara Norths own mother the late Countess of Pembrok also I give to the Countess Dowager of Burlington my gold tooth pick case which has a Diamond button to open it by and a diamond upon the top of it also I give to Mrs Scrawen now wife of Thomas Scrawen of Surrey esquire my amber snuff box set in gold also I give to Master Edward Britton son of Mrs Britton my niece one hundred pounds of lawfull money of Great Britain also all my plate jewells ffamily pictures and china I give and bequeath my said granddaughter Mrs Elizabeth Courtenay all the rest and residue of my personal estate goods and chattels of what nature or kind soever I give devise and bequeath unto my dear granddaughter the said Mrs Elizabeth Courtenay (. . .)
codicil:

WHEREAS I the Right Honble the Lady Ann Harvey in and by my last will and Testament in writing by me formerly made and executed bearing the date the eleventh day of November which was in the year of our Lord one thousand seven hundred and thirty and seven did therein and thereby give and bequeathe unto the honble William Montague esquire my Grandson the sum of one hundred pounds to be payd in such manner as is therein specifyed now I the said Lady Ann Harvey do alter and seize nothing in my said will contained saving and except only such part thereof as shall and doth appear to be contradictory and repugnant to my mind and Intention herein after <words illegible> that is to say my mind and will now is and I do hereby give and bequeath the said sum of one hundred pounds (so given to the said William Montague esquire as aforesaid) to the Right Honble the Lady Elizabeth Hinchingbrook my daughter (. . .)

Dame Ann Saunders, PROB 11/702, quire 123, fo. 181
Signed 22 February 1738
Proved 12 April 1740

(. . .) I give unto my daughter the honble Mrs Anna Maria Egerton my coach & harness and also the sum of one hundred pounds and I give unto my granddaughters Henrietta Egerton and Ann Egerton the sum of seven hundred pounds apeice to be paid them at their respective ages of twenty one years or days of marriage which shall first happen. But if either of my said granddaughters shall dye in my life time or after my decease and before the said legacies shall become payable then I give the legacy of her so dying unto the survivor of them to be paid at her age of twenty one years or day of marriage which shall first happen or if both my said granddaughters shall dye before their said legacies shall become payable then I give the said legacies to my granddaughter Jane Nevell and I will that my Executor shall place the said severall legacies of seven hundred pounds each out at interest and apply the interest the rest toward the buying cloaths for my said granddaughters untill their legacies shall become payable. Item I give unto each of my said granddaughters a silver porringer and one pair of silver candlesticks and snuffers. Item I give unto my nephew Thomas Dartsquenart ten pounds and to my sister Mrs Barbara Bennett twenty pounds. Item I give to my nephew Charles Saunders John Bladwell and Lieutenant Willliam Bladwell ten pounds apeice for mourning. Item I give unto my neice Henrietta Heming ten pounds for mourning and my gold watch with the chain and two seals to it. Item I give unto Seth Jermy Esqr twenty pounds one hundred pounds and to Mrs Margaret ffarmer widow formerly my servant ten pounds also I give to my servant John Dooderidge and Ann Burk one years wages if living with me at the time of my death and all the residue of my goods and chattels & estate real and personall I give and devise unto my said granddaughter Jane Nevell wife of Thomas Nevell (. . .)

The Rt Hon Mary Viscountess Dowager Montaign, PROB 11/742,
quire 278, fos. 260–1
Signed 3 May 1738
Proved 31 October 1745

(. . .) I dispose thereof as followeth imprimis my will and desire is that all my just debts and ffuneral expences be first paid and satisfied whereas I have obtained a judgement in the court of common pleas at Westminster as of Hillary term in the sixth year of the reign of the late King George against Peter Dubison late of Wandsworth in the county of Surry callicot printer for the sum of one thousand six hundred and two pounds besides costs of suit now my will is that in case the said one thousand six hundred and two pounds and costs of sort shall not be paid to me in my lifetime then I give and bequeath the said judgement unto Richard Lurkin of West Grinstead in the county of Sussex gentleman his Executors and Administrators <. . .> for the said sum due to me upon the said judgement and all other sum or sums of money that shall become due to me thereupon and the full benefit and advantage of the said judgement. Item I give unto ffrancis Cowling my late coachman twenty five pounds a year during his natural life to be paid quarterly <. . .> I direct and appoint Robert Ashmall of Lincolns Inn in the county of Middlesex gentleman my executor hereafter named to place out at interest in his name the sum of eight hundred pounds upon government or upon some other good security as a sufficient ffund for serving the payment thereof during the natural life of the said ffrancis Cowling and after the decease of the said ffrancis Cowling I give direct and appoint the said Robert Ashmall to pay the said eight hundred pounds and the residue and remainder of all my personal estate in England (after the payment of my debts and legacies) unto such person or persons as I shall at any time hereafter direct and appoint by any note or writing whatsoever to be Signed by me and for want of such direction and appointment then to be disposed of by the said Robert Ashmall to such objects of charity and unto such person or persons and for such uses and purposes as he shall think fit and in that case the said Robert Ashmall shall not be accountable to any person or persons whomsoever for the doing therof and I give unto the said Robert Aspinall the sum of fifty pounds and a suit of mourning for his pains and trouble and due performance of this my last will and testament (. . .)

Rt. Hon. Frances Lady Colepeper, PROB 11/708, quire 83, fos. 323–4
Signed 31 August 1738
Proved 1st April 1741

(. . .) Item I give unto John Spencer Colepeper Esqr all my plate and jewells my stock on my ground and I declare upon my honour that I owe to Mr Stanhope nor my neece Stanhope not one farthing but as Stone Stepps is mine for my life so I have from time to time paid church poor suit tithes etc out of my own pocket I so desire that my neece Stanhope should have all the goods that my Lord bought of her ffather Sutton Stede

esq. Item I give and bequeath unto Mrs Ann Colepeper youngest daughter of my Brother William Colepeper Esqr the estate which was mortgaged to my dear John Lord Colepeper by my brother Mr Colepeper Esq which said estate lyss in the Parish of Shoreditch in the county of Middlesex and consists of ground rents let in two leases to Simon Griffots woolcomber – one lease thirteen pounds a year and the other eight pounds a year In all twenty one pounds a year and another lease was let to Jacob Brevinks carpenter at the yearly rent of thirty two pounds a year and is now in the hands of Mr John ffinch ironmonger in Clements Lane Lumber Street and a piece of ground lying in Long Alley unlet of ten pounds a year thieves have stole the material of the ground and sold them for fifteen pounds for their own use. Provided that the said Mrs Ann Colepeper gives up to her brother John Spencer Colepeper esq a full discharge for her portion paid her out of her ffathers estate which is six hundred pounds that by my giving her the above said estate she is fully satisfid as to her portion that is owing her from the said estate. Item I give unto Mrs Ann Colepeper my neece all my wearing apparel of linnen silk and woollen and my mahogony chest and my wallnut tree scrutore that is without a glass. I give and bequeath all my ground rents that was part of my portion unto John Spencer Colepeper esqr and his heirs eldest son of my brother William Colepeper esq which said ground rents are now or lately were in the hands of Simon Griffots two leases fourteen pounds a year and ten pounds a year called Kings Court eight pounds a year to Mr Anderson victualler two pound ffive shillings to John Loyd three pounds to Smith a draper in Smithfeilds lot in leafe to Dukes three pounds ten shillings to Ralison a baker White Cross Street all this is fforty pounds per ann. I give it to John Spencer Colepeper Esq and his heirs except & charge it with legacies <. . .> the manor of Godden with all the lands tenements rights priviledges and appurtenances to the same <. . .> lying and being in the parish of Tenterden in the county of Kent and now or late in the occupation of Jeremia Curtice <. . .> I do here hereby give bequeath and devise the said manor <. . .> unto the said John Spencer Colepeper to him and his heirs for ever provided he pays one hundred pounds unto his youngest sister Mrs Ann Colepeper in case I do not pay her in my lifetime as I hope to do which said hundred pounds I borrowed upon my nephews account and for his use. Item I give unto John Spencer Colepeper esq all my plate my jewells my linnen my pictures my father and my mother and my dear husbands my lords pictures and as I have made my house calld Stone Stepps <. . .> and which I now live and dwell in by a deed dated the <gap in MS.> of may 1727 I do now by this my last will and testament confirm the said deed made by me out of my great kindness and generosity unto Charles Stanhope esq and Cecilia his wife hoping that Stone Stepps is theirs by that deed from the time of my death so I recommend that the said Charles Stanhope and Cecilia his wife give the aforesaid unto their son Edwyn ffrancis Stanhope if he is deserving <. . .> and I declare upon my honour that I owe not one ffarthing to Mr Stanhope or to Mrs Stanhope which they very well know and I forgive all that they owe me I confirm the last will and testament of the right honble John Lord Colepeper my said dear husband in all points the said will dated ye <gap in MS.> 1710 and I confirm my marriage settlement dated y <gap in MS> 1709 in all points (. . .)

codicil:

Item I give and bequeath unto my dear neece Mrs Cecilia Stanhope wife of Charles Stanhope Esq all my wearing apparel linnen and woollen all the goods in my house call'd Stone Stepps excepting my plate and a trunk of linnen and some peices of old china which was my aunt ffrances ffroks and my best bedd of Indian quilting all which plate linnen and china I give <. . .> unto my said neece Stanhope All my horses my cows my sheep ffowles and all my stock upon my ground and my crop of corne or grass sanfoin or meadow hay whether on the ground or in the barn, all my china all my scrutours my mahogonie chest and chests of drawers all my tables and books are in the house my dumb waiter & the rest of my waiters that I dont other wise dispose of provided my said neece buries me at her own expence the charge of my funerall not to exceed fifty pounds.

Elizabeth Halpenn commonly called Lady Lawley, PROB 11/702,
 quire 144, fos. 249–50
Signed 27 January 1739
Proved 17 May 1740

(. . .) I give unto my husband Mark Halpenn one shilling. I give to the use of my melancholly daughter Judith Lady Dowager Coningsby Baroness of Clanbrazil in the kingdom of Ireland the sum of ffifty pounds a year during her natural life for her support and maintenance to arise and be paid out of the interest and produce of the money due to me upon mortgage of certain messuages tenements and their appurte-nances in Bond Yard or elsewhere in the parish of St Giles in the county of Middlesex whether the said money shall continue to stand out upon the said mortgage or shall happen to be paid and to be placed out from time to time upon any other security or securities <. . .> and after the decease of my said daughter I devise the said principal mortgage money to my son George Bateman Lawley Esq, his exrs adm & assignes. I give to my cousin John Twite and to his wife and to his daughter Elizabeth five pounds each for mourning and to Mrs Donaldson the sum of ffive pounds and to her husband the like sum of ffive pounds to buy them mourning. I give to Mrs Powell ffive pounds to be paid into her own hands separate from and exclusive of her husband and he to have nothing to do therewith but her receipt to be sufficient for the same. To Mr John Glass and his wife ten pounds between them for mourning <. . .> I give the rest and residue of my personal estate to my son George Bateman Lawley I give also to him and his heirs all my annuities for life and lives and I give unto my said son all my estates inheritance for and during his natural life & the remainder to his first and every other son in tail male successively remainder to my grandson John Bateman Perkins for life remainder to his first and every other son successively in tail male remainder to the daughters of my said son George Bateman Lawley in tail equally to be divided between them and for want of such daughter or daughters to my right heirs forever and I appoint my son George Bateman Lawley my sole executor of this my last will

and testament except only to the mortgage money due the son out of which my said daughter Lady Conningsby is to be supported as aforesaid upon reading over the above written will I devise my said estates of inheritance to my Grandson Thomas Bateman Perkin in remainder for life remainder to his sons successively in tail male which said remainder to the said Thomas and his sons are to take place next after the remainder to the sons of my other grandson John Bateman Perkin <. . .> so much thereof as shall not be disposed of by him in manner herein after mentioned to my said son and his assigns during the term of his natural life and case my said son shal have any child or children by present or any after taken wife then upon trust that the said Trustees do and shall after the decease of my said son or in his lifetime if he shall think fit pay the said trust money and the interest thereof to the only child to and among all and every or any one or more of the children of my said son or any issue of such child or children insuch proportions and at such times and in such manner and form as my said son shall by deed or will duly executed direct appoint and in default of such appointment or in case the present wife of my said son shall survive him then upon trust to pay the said trust money and the Interest thereof to the child and children of my said son who shall be living at his decease or born afterwards equally to be divided among them if more than one share and share alike and if any child or children of my said son shal die before him leaving some issue who shall survive my said son such issue to take the share which the parent or parents of such issue would have been entitled if living and in case of my said son shal survive his present wife and shall have no issue living at the time of his decease or born afterwards then my will and mind is that my said trustees do and shall pay the said trust money and all interest thereof from thenceforth to grow to the Executors or administrators of my said son and for part of his personal estate and in case my said son shall die in the lifetime of his present wife and shall have no issue living at the time of his decease or born afterwards then I give the said trust money and all interest from thenceforth to grow due for the same to my executors equally to be divided between them share and share alike provided and it is my will and mind that it shall and may be lawfull to and for my said Trustees from time to time as often as they shall think fit to call in the said trust money or any part thereof which shall be placed out at Interest and to sell dispose and transfer all and every or any Stocks ffunds Bonds or Securitys as aforesaid or on mortgage of Lands Tenements or hereditaments and further that my said Trustees shall and may deduct and default to themselves in the first place out of such Moneys as shall come to them or any of their hands all such Costs Charges Damages and Expences as they or any of them shall not be chargeable with or answerable for the said Trust Money otherwise than each person for what he shall respectively actually receive nor the one of them for the other of them or for the acts receipts and defaults of the other of them but each and every of them for his own acts receipts and defaults only not for any defective mortgage short ffund Bond or security in or upon which the said Trust money or any part thereof shall or may be placed by ffailure of any person or persons that may be employed under them or out of them in the Recipt of the Interest Dividend or proceed of the said Trust Money or any part thereof or of any Banker

with whom any Trust Money may be lodged for safe Custody or for any other invol-
untary loss whatsoever (. . .)

Honourable Sarah Montagu, PROB 11/700, quire 47, fos. 376–7
Signed 9 February 1739
Proved 23 February 1739

My desire is that you pay your sister out of my personall estate 9000 to be in full sat-
isfaction for 3000 I was to pay her by the indorsment and for half of 3000 she is intitled
to from H. Blacketts will and to be in full for her share of my personall estate and this
to stand good as a will till a will be made as it is my intention to do when I can have
proper assistance for that purpose I doubt not of your obedience herein . . .
give my nephew Rogers 100
Sarah Creagh 100
to Mr Harcousss children 100
to Edward Carter 50 (. . .)

Rt. Hon. Claude Margaret Gouijon Marchioness Dowager of
 Vannevelle, PROB 11/712, quire 264, fos. 246–7
Signed 13 June 1739
Proved 30 September 1741

(. . .) That my sister Elizabeth Mary Gouijon widow of Mr councellor Deberinglion
who lives in ffrance and in default of her daughter my neece who also lives there shall
enjoy by right of constitution all my estate which I have left there upon this condition
and charge and even that she will not object against paying to our dear cousin de
Chavanne Henrietta Mary de Ladnice the sum of five hundred livers a year during her
life and leave also all that I have in this country which is no great matter having always
lived from hand to mouth and having never laid up what knot doth spoil so she cannot
have but the choice of what will please her best of my cloathes and goods and in case
she dyes before me I leave the whole to my servants except a Quilted Marsallies coat
which I give to Mrs de Mirevour de Bivier and Mrs Barbine wife of our pastor my
eagles down to keep her warm in the winter and my amber necklace and bracelett as
to my frinds de la Salliotte who have not I wherewithal to do them good but poverty
<word illegible> I return to Mrs Passar the cups which she made me a present of to
Mrs de Sourcelle a silver snuff box gilt in the inside I give good Mrs de la Bruchardiene
one of my handsomest <cowys?> which were sent to me from France and my black
sattin cloak as for the remainder I desire that Mr de Cussey be my testamentory execu-
tor and give him a hundred fflorins of this place and my books and six small spoons
which my aunt Amprone has sent me from ffrance as to the rest they shall sell all my
goods and the little plate there is in order to bury me and the remainder as well my
linnen as my goods shall be for Dumas who has served me very well <. . .> also my

sister or my neice to pay her six hundred livre for her and her daughter I hope they will not refuse me this as they have all my estate it shall be for once paid. There shall also be given to the poor of our church twenty crowns to my landlady Mrs Ebers my straw coloured damask elbow chair as a token of my friendship I leave to my goddaughter a comb and ten crowns to buy her a small gold ring they must not forget to pay one crown for the bridge of <Loick?> according to custom in order that my will may subsist I leave my little picture in miniature to the sister of the Marquis de Tomars her father and my late husband were first cousins it will be a remembrance of their ffamily as for the great picture which is in my hall it is that of my elder sister and the other of my younger sister I desire that a case may be made for both of them and that they be sent to Mrs de la Colle near Mantz and let them be diverted to Mr Samvagett merchant at Mantz to be forwarded to her. She is my half sister and it is better that they should not go out of the ffamily or to my nephew <. . .> Lastly I hope that my good Mrs Dumas will make an auction of my fine cabinet and of all what I have to discharge what I have ordered which will not amount to above sixty crowns and the rest shall be for her for I pretend that she shall be the mistress and that the daughter shall only have what the mother thinks fit
codicil:
Dumas shall have a silver spoon and fork and her daughter as much the others shall be sold for I will not have the poor of our church forgotten and five crowns for the poor in the street I believe all this may be found they may possibly comand a quarter of my pension which will also help to pay I leave all my receipts to Mr Barbin (. . .)

Lady Elizabeth Wentworth, PROB 11/712, quire 248, fos. 116–17
Signed 19 June 1739
Proved 30 September 1741

(. . .) I give to the poor of each of the parishes of Empsall and Barrigh in the said county of York the sum of ten pounds and ten pounds to the poor of Horsham in the said county. I give to each and every of my servants who shall be living with me at my decease and shall then have served one year a years wages over and above what shall be due to them respectively I also give to my woman attending my own person at the time of my decease all my wearing apparel of what kind so ever all the rest and residue of my goods chattels and estate whatsoever and wheresoever I give and bequeath unto my executors hereinafter named upon the trust hereinafter expressed and declared <. . .> upon trust to turn all such part therof as shall not consist of ready money or be invested in securitys into ready money and place the same out at interest or mortgage in the publick funds and government securitys or East India bonds or South Sea bonds and in the first place pay out of the interest and increase thereof the yearly sum of seven pound free from all deductions for taxes or otherwise howsoever unto William Lucas an old servant of my husband and mine and during the term of his natural life on the ffeasts of St Michael the Archangell and the Annunciation of the

Blessed Virgin Mary in every year by even and equal portions <. . .> and upon further trust that all the interest and increase of the said trust estate after payment of the said yearly sum of seven pounds shall be added to and go to the increase the principal therof during the joynt natural lives of my son Sir Butler Cavendish Wentworth Baronet and Dame Bridget his now wife and upon this further trust that in case my said son <. . .> shall survive his present wife then my said executors <. . .> shall pay all the interest proffit and proceeds which shall from thenceforthe be made of or arise from the said trust estate <. . .> to my said son during the term of his natural life (. . .) codicils:
I leave to the Earl of Grantham my large aggatt snuff box to the Earl of Arran my watch and chain and also my mothers picture to Lord James Cavendish my brother my Japan Cabinett with a little enamelled picture
To Lady Amelia Butler three boxes of Japan lacker to Mrs Chandler a small picture of a Magdalene done by Solimene and two snuff boxes the one of cornelian and the other of berryl the family pictures not disposed of by will or codicil to remain with my executors the two men servants and ye two maid servants to have mourning given em and Mrs Loyd to provide for ye same and Mary Loyd to have ten guineas for mourning for herself (. . .)

Ann Countess Dowager of Winchelsea & Nottingham,

PROB 11/729, quire 326, fos. 321–2
Signed 27 July 1739
Proved 3 October 1743

(. . .) All my apparel I give to my servant Catherine Garratt and also to her and all other persons that shall be in my service one years wages above what shall be due unto them at the day of my death and after the payment of my debts ffuneral expences and the performance of the directions contained in the letter above mentioned I give and bequeath all the residue of my personal estate to my dear daughter the Duchess of Somerset in trust that she shall give unto my grandson Roger son of the late Sir Roger Mostyn and my dear daughter the Lady Essex his wife twelve hundred pound of lawfull money of Great Britain when he shall arrive at the age of one and twenty years and equally divide the remainder of my said estate amongst my grandchildren Ann Mary Bridget Charlotte and Elizabeth Mostyn or the survivors of them (. . .)
codicil:
(. . .) I do hereby give and bequeath unto my Grandson Roger Mostyn twelve hundred pounds <. . .> I do hereby give him three hundred pound more now subject to such disposition as the said legacy bequeathed to him in my will and I appropriate for the payment of the said sums or mortgage which I have upon Milton for fifteen hundred pound but charged with the payment of twenty pound a year quarterly without any deduction to Catherine Garrett during her life and whereas some doubt may arise about this payment of my servants wages my intention is that they should be paid the

whole quarter current at the day of my death besides the years wages I have given to each of them (. . .)

Dame Mary Jones, PROB 11/725, quire 119, fos. 185–7
Signed 13 November 1739
Proved 28 April 1743

(. . .) I give to my daughter Mary Howard wife of the Honble Major General Howard my gold repeating watch with all things thereto affixed (except the seals) I give to my grandson George Howard one hundred pounds to my granddaughter Mary Howard one hundred and fifty pounds to my granddaughter Katherine Howard and my grandson Thomas Jones one hundred pounds a piece and to my grandson Henry Howard fifty pounds I direct my executor to make up my share or interest in the old South Sea annuity stock the full sum of five hundred pounds stock in that kind if the same shall be less at my death and pay the interest dividend profit and proceed which from time to time during the joint lives of them the said Major General Howard and my said daughter his wife shall attend or be made out of ffive hundred pounds the said annuity stock whether left by me or made up as aforesaid or out of any ffund or security which shall come in here thereof unto the proper hands of my said daughter or to such person or persons as she shall from time to time in writing direct or appoint for separate use of my said daughter and wherewith her said husband notwithstanding her coverture is no ways to intermeddle nor is the same to be subject to his debts power or controul but the receipt or receipts of my said daughter <. . .> shall be sufficient discharge or discharges for the same and in case my said daughter shall survive her said husband then to pay assign and transfer the said five hundred pounds annuity stock and every other ffund and security which shall to me in lieu thereof or of any part thereof to my said daughter Mary Howard for her own use but if my said daughter shall dye in the lifetime of her said husband then upon trust to pay assign and transfer all the said ffunds and securities and the money arising therefrom and the interest dividend profit and proceeds <. . .> to and thereof which shall accrue or arise or be made from and after the death of my said daughter to and among such one or more children to be born or amongst all such children and if to more than one amongst such one of her children in such shares and proportions as my said daughter Mary Howard by any deed or goods or by her last will and testament <. . .> and my will and mind is that my said executor may from time to time alter or change any of the ffunds or securities in or upon which the said trust estate now is or at any time hereafter shall be placed and that he shall not be answerable for the defficiency of any ffund or security upon which the said trust estate <. . .> may be placed so that such <word illegible> and placing out be during the life of my said daughter Mary Howard with her consent in writing I hereto give my niece Elizabeth Bassett her mothers picture which I left in the possession of her brother my nephew Wentworth Harman esquire and if my dear sister Harman will accept the pictures which are in her possession I give them to her

all the rest and residue of my money effects and estate of what nature or kind soever after my debts funeral expenses and legacies are paid I give unto my son William Morton for his own use (. . .)

Elizabeth Baroness Howard of Effingham, PROB 11/715, quire 17, fos. 133–4

Signed 10 January 1740

Proved 22 January 1741

(. . .) In persuance of the powers and authoritys to me given and reserved in and by two several indentures tripartite the one bearing date on or about the sixteen day of July which was in the year of Our Lord Christ one thousand seven hundred and eighteen and made <. . .> between Sir Theophilus Napier then of Luton Hoo in the County of Bedford Baronet my former husband since deceased of the first part John Rotherham of the Parish of Saint Gyles in the ffields in the County of Middlesex Esqr. and Sir Henry Penrice of Offley in the County of Hertford Knight of the second part and me the said Elizabeth Lady Howard by the name of Dame Elizabeth Napier wife of the said Sir Theophilus Napier of the third part and the other bearing date of the sixth day of January which was in the year <. . .> 1721 and made or mentioned to be made between me the said Elizabeth Lady Howard by the name of Elizabeth Lady Napier of London Widow of the first part the said Sir Henry Penrice by the name of Sir Henry Penrice of Doctors Commons London Judge of the High Court of Admiralty Knight and the said John Rotherham by the name of John Rotherham of Grays Inn in the said County of Middlesex Esqr. of the second part and the right honble Thomas Lord Howard my late deceased husband of the third part and also in pursuance of the powers or authoritys to me given or reserved in and by a certain deed poll or writing of appointment executed by me previous to our marriage and the said Sir Conyers Darcy previous to our marriage and bearing date the eleventh day of September 1728 and of all of every power and powers authority and authoritys whatsoever to me in that behalf given or reserved and of all and every right in any wise me therunto enabling give devise limit direct and appoint all and every my mannors messuages ffarms land tenements hereditaments reversions and reall estate whatsoever and wheresoever with their appurtenances unto my said husband Sir Conyers Darcy his heirs and assigns for ever subject nevertheless to and charged and chargeable with the payment of the several sums of money after the decease of the said Conyers Darcy upon the contingencys hereinafter by me given and directed to be raised that is to say unto my sister ffrances Lady Somerville the sum of ffive hundred pounds unto my sister Mrs Anne Wyatt the sum of ffive hundred pounds and unto my goddaughter Anne Yonge daughter of Sir William Yonge Baronet the sum of five hundred pounds and I do hereby charge my mannors, lands tenements and hereditaments so given devised and appointed unto the said Sir Conyers Darcy and his heirs with the raising and paying the said several sums of money unto the said ffrancis Lady Sommerville Mary Rotherham Anne Wyatt and

Anne Yonge respectively immediately after the decease of the said Sir Conyers Darcy in case they shall be then living and not otherwise <. . .> and I give unto my servant Sarah Sibley the annuity or clear yearly sum of ten pounds for her life commencing from my decease and to be paid to her only in case she shall not so long continue in the service of the said Sir Conyers Darcy also I give to the Right Honble the Earl of Effingham the whole length picture of his ffather and also the half length picture of his mother and the two whole length pictures of my late lord and myself all which pictures are at Estwick and I do direct that the said Earl of Effingham shall have the use of the said pictures during his life and at his death I give the same unto his son the Right honble the Lord Howard and I do give all my goods chattells and personal estate whatsoever unto my said husband Sir Conyers Darcy (. . .)

Lady Eleanora Bertie, PROB 11/759, quire 3, fos. 23–4
Signed 21 January 1741
Proved 18 January 1747

(. . .) Whereas in and by one indenture of tripartite bearing date the twelfth day of June which was in the year of our Lord one thousand seven hundred and eleven made or mentioned to be made between my said late ffather then by the name and title of the most noble Robert Marquess of Lindsey Lord Great Chamberlain of England and one of her then majestys most honourable privy councell of the first part the right honourable Peregrine Bertie esquire commonly called Lord Willoughby son and heir apparent of the said Marquess of the second part and Peregrine Bertie eldest son of Peregrine Bertie of Cedney in the county of Lincoln esquire since deceased Sanwel Oldfield late of Boston in the County of Lincoln Esquire deceased John Vanburgh late of the City of Westminster Esqr deceased Peter Short late of East Keale in the said county of Lincoln esquire deceased and Robert Hardwick late of Scofflethorpe in the said county of Lincoln clerk deceased of the third part receiving a marriage settlement made on the marriage of the said Peregrine Lord Willoughby (afterwards Duke of Ancaster and now lately deceased) and certain powers therein contained he the said duke my said late ffather did (amongst other things) thereby direct the said Peregrine Bertie Samuel Oldfield John Vanburgh Peter Short and Robert Hardwick and the survivor and survivors of them and the heirs and assigns of such survivor to execute a power in the said marriage settlement contained for raising ten thousand pounds part of a sum of ffifteen thousand pounds for portions for the right honourable the lady Elizabeth Bertie and the said Eleanora Bertie (to wit) to each of us ffive thousand pounds to be payable at our respective days of marriage or within six months after the death of my said late ffather as in and by the said in part retified deed relation being thereunto had may more at large appear and whereas my said late ffather being dead many years ago the said sum of ffive thousand pounds is now become due and payable to me as aforesaid and at my will and pleasure to dispose of I do therefore give and bequeath one annuity or yearly payment of one hundred pounds to my said sister the

Lady Elizabeth Bertie for and during the term of her natural life to be raised and paid by my executrix hereinafter named out of the said sum of ffive thousand pounds and the interest and produce thereof and to be payable half yearly by equal portions from the time of my death the first payment to become due at six months after my decease. Item I give more to my said sister the Lady Elizabeth Bertie the sum of ffive hundred pounds to be paid within six months after my decease. Item I give to my mother in law her Grace the Duchess Dowager of Ancaster the sum of one hundred pounds to buy her mourning. Item I give to my sister the right honourable the Lady Louisa Carolina Bludworth the sum of one hundred pound to buy her mourning All the rest and residue of my goods chattels and personal estate whatsoever I give to my ffour neices the right honourable the Lady Mary Bertie Lady Albinia Bertie Lady Jane Bertie and Lady Caroline Bertie to be equally divided amongst them share and share alike (. . .)

Dame Margaret Bridges, PROB 11/716, quire 79, fos. 246–7
Signed 11 March 1741
Proved 15 March 1741

MEMORANDUM I leave to my grandson William Bridges my silver coffee pot and one pair of silver candlesticks snuffers and pan six silver hafted knives six silver spoons six silver fforks a pair of silver salts I leave to my granddaughter Margaret Bridges my silver teapot and lamp my diamond buckle and wedding ring I leave to my grand-daughter Elizabeth Bridges my silver canester and my triangular seal in gold I leave to my granddaughter Mary Bridges my silver milk pot my perle necklace and diamond cross I leave to my granddaughter Katherine Jane Bridges my silver saucepan and a gold medall I leave to my sister Bridges a hansom ring I leave to my nephew John Bridges a ring I leave to my niece Charlotte Baldwin a ring I leave to <crossed out> Pringle ten guineas I leave to my daughter Bridges a ring I leave to my servt Mary Nevell all my Waring cloths lining Laces & a silver paper castor & <words illegible> I leave to you & all my rings & table linnen & sheets & other little things yt you have a mind to & to bury me & this is my last desire from yr affect grandmother 1741.

The Hon. Katherine Digby, PROB 11/742, quire 269, fo. 186
Signed 20 March 1741
Proved 15 October 1745

(. . .) As for my worldly goods I dispose of them as follows whereas my ever honoured mother the Lady Jane Digby deceased did by her last will give me a legacy of one thousand pounds charged upon her mannor of Leigh in the county of Rutland one moiety of which legacy hath since been paid to me by me dear brother Wriothesly Digby now my will is that my executrix hereafter named out of the interest and proceed of the other moiety thereof shall pay to my old servant Elizabeth Willet the sum of six

pounds a year so long as she continues in the house and ffamily of my ever honoured ffather the Lord Digby and from and after his decease or in case she be removed at any time out of his ffamily then I give her the sum of fffifteen pounds yearly for her support and maintenance during her life the same to be paid quarterly by equal portions <. . .> my will is that my dear sister ffrances Digby shall have and receive the interest and produce of one thousand pounds to her own use and benefit during her life in case she shall so long continue sole and unmarried but from and after the death or marriage of my said sister which shall first happen my will is that the sum of one thousand shall be given unto and amongst such of the daughters or younger children of my dear sister Juliana Mackworth in such proportions as my said sister ffrances Digby shall direct or appoint and in default of any such direction to be equally divided among them share and share alike (. . .)

Rt. Hon Arethusa Viscountess Dowager Clifford, PROB 11/723, quire
 34, fos. 273–4
Signed 17 April 1741
Proved 12 February 1742

(. . .) I give to my granddaughter Arethusa Vernon ten of my East India Bonds each for one hundred pounds principal money my repeating watch chain and ornaments thereto and also all such silver plate as I shall have at my death I give to each of my four grandsons Henry Vernon ffrancis Vernon Charles Vernon and Richard Vernon five hundred pounds apiece I give to my niece Elizabeth Pulteney one hundred pounds I give to my servant Ward in case he be living with me at my death one hundred guineas. I give to every other of my servants who shall have lived with me for the space of one year before my death half a years wages over and above what shall be due to him her or them respectively at the time of my death and I also direct my executor to distribute one hundred pounds amongst such poor housekeepers in the parishes of Thorpe Egham and Staines in the county of Surrey as he shall think the greatest objects of charity and subject to the payment of my just debts and ffuneral expences and of all my legacies which I charge all my estate with the payment of I give devise and bequeath all my reall and personal estate whatsoever and wheresoever to my son in law James Vernon esq ffather of my said grandchildren and to his heirs and assigns for ever (. . .)

The Rt. Honble Elizabeth Lady Compton, PROB 11/723, quire 35,
 fos. 280–1
Signed 16 May 1741
Proved 1 February 1742

(. . .) Item I give and bequeath to my dear brother Charles Compton all my moneys mortgages assignments jewells plate ffurniture personal estate excepting those things which shall be here otherwise disposed of. Item I give to my brother James Earl of

Northampton a little picture in watercolours of my grandfather Northampton. Item I give to my niece and goddaughter Lady Anne Compton my large pearl necklace of thirty seven pearls and also my large pair of pearl drops I give to my niece Lady Charlotte Compton my little pendulum clock. Item I give to my sister Lady Jane Compton the locket with my mothers hair set round with diamonds I give my sister Lady Anne Rushout a picture of my brother Charles in enamelled. Item I give to my sister Lady Penelope Compton my tent-stitch-work carpet. Item I give to my sister and goddaughter Lady Margaret Compton one hundred pounds. I give to my sister Mrs Mary Compton my Japan Toylett. Item I give to my neice and Goddaughter Miss Jane Compton five hundred pounds. Item I give to my neice and Goddaughter Miss Elizabeth Rushout ffifty pounds. Item I give to my brother George Compton a picture of my dear nurse ffull half length. Item I give to the poor of the parish of Dainton ffifty pounds to be disposed of at the discretion of the Minister of each respective parish. Item I give to relieve poor prisoners out of Ludgate ffifty pounds that are in for debt not exceeding five pounds each Debtor. Item I give to my affectionate and faithfull servant Mary Green three hundred pounds as also if she be living with me at the time of my death all my wearing cloaths Laces Linnen. Item I give above what may be due to them at that time and Mourning to each one and every Legacy which I here have to be paid in one year after my decease. Item I do here by give and bequeath to my abovesaid dear brother Charles Compton all the remainder of my moneys goods and whatsoever I shall be possessed of at the time of my decease or anyways entitled to at that time (. . .)

Johanna Cecilia Hattingh, PROB 11/785, quire 49, fo. 385
Signed 30 December 1741
Translated from Dutch 3 October 1750
Proved 19 February 1750/1 (*sic*)

(. . .) She the appearer has desired that after her death a probate might be granted to her aforesaid executors of this her appointed administration of all and every her effects stocks goods and credits lying in the aforesaid Kingdom of Great Britain desiring further that act in fform hereof be delivered by me notary as being her last will concerning her effects stocks goods and credits in the said Kingdom of Great Britain (. . .)

Dame Mary Ann Nicolson otherwise Colyear, PROB 11/ 808, quire
 112, fo. 65
Signed 1742 (n.d.)
Translated 16 March 1754
Proved 19 April 1754

(. . .) She gives and bequeaths to Mrs Magdalen de Lambermou living at Olue a life

rent of one hundred and ffifty Dutch fflorins to be paid by her heir hereinafter named desiring that the said rent may be punctually paid every year till the said gentle-woman dies she likewise gives and bequeaths by way of institution to the most noble Lord Walter Philip Colyear General of ffoot Colonel of a scotch regiment of ffoot in the service of their High Mightynesses the States General of the United Provinces Governour of the City and Castle of Namur her most honoured ffather the sum of three pistoles once to be paid afterwards coming to the disposition of her real and per-sonal estate present and to come situate as well in Germany as elsewhere together with all her rights debts credits and actions present and to come nothing excepted or reserved she institutes for her universal and absolute heir therein the person of the said Lord George Nicolson her husband and after him his children and lawfull descendants who shall not profit by or demand anything thereout during his life on any account or pretence soever leaving him in case they offer to give him any trouble on account of this institution master and absolute heir to dispose of the whole as he shall think proper and further explaining her will if she declares that with regard to the children of the said Lord her husband she does not mean to put her estates in trust for them nor to bind the said husband so that he may not sell what he thinks proper out of the said estate and administer them as he shall think fit but only to assure to the said chil-dren the enjoyment of the residue of the said estate after her husbands death that no body but them may profit thereof (. . .)

Dame Elizabeth Hare, PROB 11/776, quire 46, fo. 402
Signed 1 December 1742
Proved 14 February 1749

(. . .) I give to my son Sir Thomas Hare his own picture in an oval fframe and the pic-tures of Dame Susan Hare late wife of Sir Ralph Hare and the two fflower pieces and fifteen pounds for mourning I give to Dame Rosamond Hare wife of the said Sir Thomas Hare ffifteen pounds for mourning I give to Elizabeth Hare and Mary Hare daughters of the said Sir Thomas Hare ten ten pounds each for mourning I give to my daughter Elizabeth wife of Sir Thomas Robinson the picture of Sir Ralph Hare and the picture of my late husband set with diamonds and ffifteen pounds for mourning I give the said Sir Thomas Robinson fifteen pounds for mourning I give to my sister Dame Ann Peyton the pictures of my late ffather and mother I give to my sister in law Algerina Dashwood her late husbands picture I give to my grandson Thomas Leigh ten pounds for mourning and the picture of his ffather and mother but if he dyes abroad I give the said pictures to my grandson Iane Leigh I give to the said Iane Leigh my gold watch and thirty pounds I give Ann the wife of Richard Dashwood esquire the picture of my Sister Ann Peyton I give to my niece Elizabeth Dashwood the picture of her ffather set with diamonds I give to Mrs Susannah Shiffin five guineas I give to Mrs Camilla Edwards her own picture I give to my waiting woman living with me at the time of my decease all my apparel be the same silk woollen or linnen I give

to my son George Hare fffity guineas <. . .> the rest of my goods I direct to be sold by my said executor and the money arising therefrom and also all the residue of my personal estate of what nature or kind soever after payment of my debts legacys and ffuneral expences I give to my said son George Hare and my daughter Sarah Hare to be equally divided between them (. . .)

codicil:

I give to the poor of Great Yarndon two guineas and to the poor of Little Yarndon one guinea.

codicil:

(. . .) whereas as my daughter Sarah Hare is dead since the making of my will I do hereby give to my son George Hare whom I have made my sole executor all the residue of my personal estate after payment of my debts legacy and ffuneral charges (. . .)

Dame Mary Fortescue, PROB 11/737, quire 13, fo. 97
Signed 26 January 1743
Proved 26 January 1744 (1745 ?) (*sic*)

(. . .) As to all my estate real and personal of what nature or kind which I shall be seized or possessed of or entitled unto at the time of my decease I give and bequeath the same unto my nephew Richard Huddleston of Sawston in the county of Cambridge Esqr. and to his heirs executors administrators and assigns for ever subject to the trust hereinafter mentioned and expressed that is to say in the first place to pay and discharge all my just debts and ffuneral expences. Then upon trust to pay unto my sister Mary Constantia Harding wife of Robert Harding clerk five pounds for mourning and upon further trust to pay unto my brother John Huddleston five pounds a year during his natural life and also to pay the sum of ten pounds to the poor of the parish where I shall be buried and as to my wearing apparell I order the same to be given unto my maid servant who shall live with me at my decease (. . .)

Rt. Hon. Ann Baroness Dowager of Gowran, PROB 11/736, quire 283, fos. 267–8
Signed 29 February 1743
Proved 7 December 1744

(. . .) I give and bequeath unto my younger son the honourable Richard ffitzpatrick esquire the sum of five hundred pounds <. . .> and also my large single stone brilliant diamond ring and I do hereby forgive him all such arrears as shall be due to me at the time of my decease of the interest of the money I gave him in order to make up the purchase money of the late Mr Arundells estate in Ireland which was bought for him and it is my will and meaning that my said executor do and shall immediately after my death acquit release and discharge my said younger son and his said estate of and from

the arrears of the said interest which shall be then due from him to me I give and bequeath to Mrs Hester Lucas living with me an annuity or yearly sum of fifty pounds to be paid unto her by my executor during the term of her natural life by two equal half yearly payments without making any deduction or abatement therout for or on account of any taxes charges or impositions whatsoever the first payment thereof to begin and to be made at the end of six calendar months next after my decease but in case my said Executor shall not choose to pay unto the said Hester Lucas the said annuity of fifty pounds during her life in manner aforesaid then and in such case I give and bequeath unto the said Hester Lucas the sum of six hundred pounds sterling which I desire her to lay out in the purchase of an annuity for her life I give and bequeath unto the said Hester Lucas the sum of twenty guineas <. . . > and to Mary Delany my woman an annnuity or yearly sum of ten pounds for and during her natural life to be paid to her by two equal and half yearly payments without making any deductions thereout for or on account of any taxes charges or impositions what-soever the first payment thereof to be made at the end of six calendar months next after my decease and I hereby charge all my real and personal estate of what nature or kind soever with the payment of the said two several annuities so by me given as afore-said I give and bequeath to every of my domestick servants both male and female that shall have been a year or longer in my service immediately before my decease one years wages over and above what shall be due to them from me and I give and bequeath to my eldest son the Right Honerable John Lord Baron of Gowran and his heirs Executors and Administrators all my real estate of what nature or kind soever and also the house situate in Grosvenor Square wherein I live with the stables out-houses Buildings and all and singular other appurtenances thereunto belonging together with all the pictures and household ffurniture therein and all the rest of my diamonds and jewells and all my plate and all the rest and residue of my goods and chattels personal estate and effects not by me hereinbefore otherwise disposed of (. . .)

The Most Noble Ann Dutchess Dowager of Cleveland and
 Southampton (late wife of Philip Southcote Esqr.), PROB 11/745,
 quire 76, fos. 227–8
Signed 6 June 1743
Proved 3 March 1745

(. . .) And whereas by two indentures of lease and release bearing unto respectively the twenty seventh and twenty eighth days of July which was in the year of our Lord one thousand seven hundred and twenty two and made or mentioned to be made between my said late husband the most noble Charles Duke of Cleveland and Southampton <. . .> (since decd) on the one part and the right honourable Henry Lord Conyngham and Thomas Pulteney esquire (both since deced) on the other part the said Charles Duke of Cleveland and Southampton for the consideration therein mentioned did

grant and convey unto the said Henry Lord Conyngham and Thomas Pulteney and to their heirs all that peice or parcel parcell of Ground parcell of the west side of the great square in St James ffield otherwise Poll Moll ffield now called St James Square in the parish of St. Martin in the Fields in the county of Middlesex containing in fromt fifty five foot in depth backwards two hundred foot ffronting the theretofore intended piazza there lying and going between the said intended piazza and the messuage and garden heretofore of Ralph Morris on the West and a certain street since called Kings Street <word illegible> Charles Street towards the north and other the ground thentofore of the Earl of saint <word illegible> and parcell of the said ffield called Poll Moll ffield on the north and the messuage or tenement erected and built thereon then thereuntofore and called or known by the name of Essexhouse and all and every the edifices outhouses and buildings on the said ground or any part thereof erected and built together with all its ways passages lights casements sellars priviledges and appur-tenances whatsoever were lately purchased by the said Duke of Cleveland and Southampton ffrancis Popham esquire. To hold to the said Henry Lord Conyngham and Thomas Pulteney and their heirs and assigns for and during the term of his natural life without impeachment or waste and from and after his decease to the use of the said Ann Dutchess of Cleveland and Southampton for and during the term of her natural life without impeachment of waste and from or after her decease to the use of the said Henry Lord Conyngham and Thomas Pulteney and their heirs. In trust for such and so many of the child and children of the body of the said Charles Duke of Cleveland and Southampton on the body of the said Dutchess begotten or to be begotten in such shares and proportions and for such estate or estates and under and subject to such provisoes and conditions as she the said dutchess by any deed or writing attested by three or more credible witnesses or by her last will and testament in writing attested aforesaid should direct limit or appoint and for want of such direc-tion limitation or appointment then in trust and for the benefit of the Lady Grace ffitzroy and the Lord Charles ffitzroy being two of the younger children of the body of the said Charles Duke of Cleveland and Southampton on the body of the said Dutchess begotten and of their heirs and assigns as tenants in common and not as joint tenants with a provisoe nevertheless that in case the eldest son and heir of the said Charles Duke of Cleveland and Southampton at the time of the death of the sur-vivor of them the said Duke and Dutchess should within one year after the death of such survivor be minded to become a purchaser of the said peice or parcell of ground messuage and premises for or at the sum of five thousand pounds that then they the said Henry Lord Conyngham and Thomas Pulteney and the survivor of them and the heirs of such survivor should on receipt of such sum of five thousand as aforesaid at the request and at the costs and charges of such eldest son and heir convey and assure or cause to be conveyed and assured to assigns for ever or to or for the use of such other person or persons as he should appoint and as councill should advise the said peice or parcell of ground messuage or tenement and all and singular other the premises or the said indentures of release before mentioned with their and every of their appurtenances discharged of the trusts thereby created for the benefit of the said

younger children as aforesaid and then and in such case such purchase money should be divided amongst such person or persons and in such shares and proportions as the said peice or parcell of ground and messuages or tenements and premises would have belonged to by virtue of the limitations or appointments in the said indenture of release before made thereof in case the same had not been conveyed or assured to such eldest son and heir or by his direction as lease and release relation being thereunto had may more fully appear And whereas the said Henry Lord Conyngham is since dead and the said Thomas Pulteney him survived and is also since dead now know all men by these present that in persuance of the powers herein before mentioned and of all and every other power or powers in me being do by this my last will and testament or this writing purporting to be my last will and testament direct limitt and appoint that the heir or heirs at law of the said Thomas Pulteney <. . .> shall from and after my decease stand seized of the said peice or parcell or ground <. . .> and all and singular other the premises in and by the said writed indentures of lease and release mentioned intended to be granted and conveyed as aforesaid and every part and parcell of them with their and every of their appurtenances in trust for Lady Ann Paddy youngest daughter of the said Charles late Duke of Cleveland and Southampton on my body begotten for and during the natural life of the said Lady Ann and from and after her decease then in trust for all and every the daughters of the said Lady Ann and their heirs as tenants in common and not as joint tenants and if there shall be but one daughter then in trust for her and her heirs and if there shall be no daughter of the said Lady Ann then in trust for the son of the said Lady Ann and their heirs or tenants in common and not as joint tenants I give and devise unto the right honourable George Henry Earl of Lichfield and the said Philip Southcote and their heirs all my real estate whatsoever. Item I give and devise unto the said Philip Southcote <. . .> all my personal estate whatsoever (. . .)

Lady Elizabeth Johanna Canzius otherwise Wylo, PROB 11/792,
 quire 31, fo. 249
Signed 12 July 1743
Translated 10 January 1752
Proved 7 February 1752

(. . .) Who signifying to have some effects in England and Great Britain has appointed and ordained the said her husband Mr Jan Wylo by these presents her sole executor and administrator of all such effects as she at her death might have in the aforesaid Kingdom of England and Great Britain granting to him full power and authority immediately after her the appearers death to govern to administer to sell and transferr all the said effects none of them excepted to receive the moneys and to give acquitances for the same she the Lady appearer desiring that after her death letters of administration in common fform might be granted on these presents (. . .)

Lady Elizabeth Harris, PROB 11/731, quire 40, fos. 321–2
Signed 12 July 1743
Proved 15 February 1743 (*sic*)

(. . .) ffirst I give and desire my son Harris to accept of my ffathers picture set in gold also my medal of my grandffather also my saphire ring with the velvet christening mantle and if he so likes it that he would choose from my books any one or two authors ffrench english from my books to keep for my sake I give to my son George William Harris all my books and china ware together with all my papers those alone excepted which may relate to my money matters in which my executors jointly must share I give to my goddaughter Ann ffreeman of London twenty guineas to my servant Jane Lawrence if living with me at the time of my death to Hannah Mayor if living with me at the time of my death ten pounds to my coachman in case he has lived with me three years at the time of my death ffive pounds and to the boy if having also lived with me three years three pounds all these sums to be paid them over and above what wages may be due to them at the time of my death. Also my will is that my body be raised early in the morning in the most private sort possible without escutcheons or any other manner of ornament whatsoever to the Cathedral church no upper bearers and for to carry my body to the grave six man servants my own son Harris and any servants belonging <. . .> to the ffamily giving to each for their troubles gloves silk hatbands and each five shillings. I desire a grave stone over my body with this inscription ingraved on it vizt. Here Lyeth the body of Lady Elizabeth Harris third daughter of Anthony Earl of Shaftesbury and of Lady Dorothy Manners his wife Daughter to John Earl of Rutland and Widow to James Harris esquire of the Close of Sarum (. . .)

The Lady Johanna Louise Godin, PROB 11/782, quire 294, fo. 295
Signed 31 August 1743
Proved 11 September 1750

(. . .) In regard of all such capital and stock which she at the time of her decease may have in the kingdom of England upon any publick ffunds or in upon or at the charge of any publick or private company or in any private mans hand standing out be the same ready moneys actions or shares bonds or obligations or any other sorts of writings obligatory or other effects may after her decease be entered and registered upon the name of the said Joseph Van der Muelen and that he may wholly and solely administer the same giving him particularly full power to receive all rents revenues dividends or interests or other rewards due and to grow due upon the same and also to sell alienate transfer and transport all and every one of the said effects none excepted nor reserved at his will and pleasure and as he shall find good at such prices and for such consideration and unto such persons also as he shall think fit and convenient (. . .)

Dame Rebecca Dixie, PROB 11/737, quire 10, fos. 75–6
Signed 29 September 1744
Proved 15 January 1744 (*sic*) (1744/5?)

I Dame Rebecca Dixie widow being of a sound and dispossessing mind memory and understanding do hereby make and declare this my last will and testament in manner and form following that is to say my body I desire may be wrapped up in linnen and laid in a thin oaken coffin covered with grey cloth and decently interred in a private manner in the churchyard of Clapham in the county of Surry in a vault made of brick to be covered with a marble stone encompassed with an iron rail with the inscription to be engraved thereon that is to say here lies the body of Dame Rebecca Dixie daughter of Sir Richard Atkins late of Clapham in the county of Surry Baronet with the day of the month and the year of my death to be added thereto. And I will that a sermon shall be preached at my ffuneral on the fourth verse of the twenty first chapter of Revelations and as to what worthy Estate it hath please God to bless me with in this life I dispose thereof as followeth. Imprimis I give and bequeath to my daughter Barbara Goodwin the sum of one hundred pounds my gold snuff box and all my books. Item I give and bequeath to my daughter ffrancis Dixie one hundred pounds. Item I give and bequeath to my daughter Bridget Bailey the sum of one hundred pounds and to my daughter Annabella Dixie the sum of one hundred pounds. Item I give and bequeath to my granddaughter Rebecca Dixie daughter of my late son Beaumont Dixie the sum of one hundred pounds. Item I give and bequeath unto my grandson Beaumont Dixie son of my said late son Beaumont Dixie the sum of five hundred pounds at his Age of twenty one years and my will is that the interest of the said principal sum of five hundred pounds be paid and applied to and for his education and maintenance during his minority and if he happens to die before he attains such age of twenty one years then I give the same unto my granddaughters the said Rebecca Dixie and <space in text> Dixie her sister or the survivor of them at her or their respective age of twenty one years but if both happen to die before they attain such age then I give and bequeath the same five hundred pounds to my daughter in law Elizabeth Dixie their mother. Item I give and bequeath to my son Wolston Dixie Baronet a broad peice of gold which his grandmother Dixie left at her death to his ffather. Item I give and bequeath to my daughter Elizabeth Dixie spinster one annuity or near yearly sum of twenty pounds to be paid and payable to her for and during the term of her natural life or until such time she shall receive the sum of seven hundred pounds that is now due and owing to her from one Richard Ryder <. . .> I give to my servant whose chief business is to attend my person and who shall be in my service at the time of my death the sum of five pounds for mourning and all my wearing apparell linnen and lace and one months wages over and above what shall be due to her at the time of my decease and board wages till after my burial. Item I give and bequeath to all and every other servant and servants that shall live with me at the time of my death the sum of five pounds apeice one months wages over and above what shall be due and owing to her or them and board wages till after my burial. Item I give and bequeath to the poor of the parish of Clapham aforesaid ten pounds. Item I give and

bequeath to the poor of the parish of Walcott in the county of Somerset where I now live the sum of five pounds. Item I give and bequeath to my great granddaughter Penelope Atkins my gold watch together with the chain seals and her ffathers picture in miniature set in gold with rubies and diamonds. Item I give and bequeath to my great grandson Sir Richard Atkins Baronet all my plate and jewells and one thousand pounds in money subject to the payment of the said annuity of twenty pounds a year to my said daughter Elizabeth Dixie in manner herein before set forth and I do herby charge the said sum of one thousand pounds with the payment thereof accordingly. Item all the rest residue and remainder of my goods chattells rights and credits what-soever and wheresoever my debts legacys and ffuneral expences being first paid and discharged I give and bequeath to my said great grandson Sir Richard Atkins.

The Honble Margaret Mugge, PROB 11/754, quire 103, fos. 39–40
Signed 21 November 1744
Proved 8 April 1747

(. . .) I give to the Right honourable the Lord Chedworth my brothers picture which I had of his ffather I also give the right honourable the Lady Shaftesbury my wrought bed. Item I give to Mrs Letitia Juge wife of Edward Juge of Brook Street in the parish of St George Hanover Square afore said gentlemen my tea table six china cups & six saucers my china tea pott and saucer my china sugar dish and cover my china slop-bason and saucer two china muggs and my six silver tea spoons my four large damask table cloths and nine damask napkins and my two little damask table cloths my velvett gown and pettycoat my ffrench brocaded handkercheif my two long laced hoods my black laced handkercheif my ffringed work pettycoat my white satten laced mantelett and pilgrim the same my velvett muffeles my emerald ring set round with rubys and diamonds my stone shoe buckles and my girdle buckle both set in silver my green earings with three white drops my garnett earings with three drops and all other my earrings and stones therto belonging my black broad small bead necklace my white ffrench necklace three rows my hook my white ivory ffann my gold stuff my little canvas ffire screen my two gold tassells my whiite sattin stumacher and my silk cover for the tea table and my book of receipt in cookery. Item I give to Miss Letitia Barbara Juge the daughter of the said Edward Juge my twezer case and chain to my watch and seals and my little amythist ring. Item I give to the said Edward Juge my gold watch but in case he shall happen to die in the lifetime of his daughter the said Letitia Barbara then I will and order the said watch to be delivered to her and immediately upon his death I give the said watch to her the said Letitia Barbara. Item I give to the said Edward Juge my green doublett stone ring. Item I give to Mrs Arbrough my landlady at Kensington a ring of one guinea value. Item I give to Mrs Hesse Nugent of Westminster six of my best shifts and two old fine ones six of my best cambrick tuckers four of my best holland aprons my two fflowered lawn aprons two broad hem'd cambrick aprons one flowered Lawn pinner and quoif six handsome mobbs

one suit of plain drest night cloaths two suits of my best night mobbs two of my best plain short hoods one pair of single fflowered lawn & ruffles one pair of double plain cambrick ruffles two pair of single fine cambrick ruffles two pair of coarse cambrick ruffles one double lawn handkerchief one single fflowered lawn handkercheif my coarsest singled edgd handkercheif three single coarse cambrick handkercheifs two fine cambrick pocket handkercheifs four new coarse cambrick handkercheifs two white dimity stomachers two dimity under pettycoats one dimity waist coat and one callico waistcoat one callico half sack work't and long dimity pettycoat two pair of cotton sleves one pair of fine holland sheets and six pillow cases one printed callico bed gown one pair of dimity pocketts two pair of my best cotton stockings one plaid gown one plaid pettycoat two new peices of plaid my white gown workt my tabby gown and tail and my fflowerd cotten gown my blue silk quilted petticoat and white silk quilted pettycoat my scarlet and black under pettycoat my best pair of stays my white silk stomacher and waist hoop my velvett mantelett and pilgrim and short hood two india silk handkercheifs two pair of new kid gloves my everlasting ffan and french muff my black enamelled gold ring one pair of worsted stockings my biggest pair of shoes my hair pormantua with a trunk at the <word illegible> my two large silver spoons and the sum of ten pounds in money. Item I give and forgive the same Mrs Hesse Nugent all moneys now due to me by virtue of her bond & jointly with Mrs Goles. Item all the rest residue and remainder of my ready money and securities for money and all my goods chattels and estates of what nature or kind soever whereof I shall be in any ways possessed or intitled unto at the time of my decease and not by me herein before given or disposed of after payment of my said just debts ffuneral expences and all charges touching the proving of or otherwise concerning this my will I give and devise unto the said Edward Juge (. . .)

Dame Ann Abdy, PROB 11/742, quire 288, fo. 337
Signed 26 December 1744
Proved 7 November 1745

(. . .) I give and bequeath unto my two nieces Philadelphia and Elizabeth Williams twenty pounds apeice to be paid them within six months next after my decease. Item I give and bequeath unto Mrs Mary Brand now residing at ffelix hall aforesaid ffive guineas for a ring. Item I give and bequeath unto Mr Isaac Lovett of Kelvedon afore-said ten pounds. Item I give all my wearing cloths and wearing linnen unto the woman servant who shall wait upon me at my decease and all the rest and residue of my goods chattels and personal estate whatsoever and wheresoever (after payment of my debts legacys and ffuneral charges) I give and bequeath unto John Williams esqr son of the late Sir John Williams deced & unto Miss Elizabeth Abdy one of the daughters of Sir Anthony Thomas Abdy Bart my late husband deceased equally to be divided between them share and share alike (. . .)

The Most Noble Sophia Dutchess Dowager of Kent, PROB 11/762,
 quire 183, fos. 312–14
Signed 28 January 1745
Proved 23 June 1748

(. . .) I give devise and bequeath my capital messuage called Rennants alias Rempingham and all my lands tenements and hereditaments situate lying and being in the parishes of Old Windsor and Egham and elsewhere in the county of Berks and Surrey which I Purchased of the Lord Viscount Weymouth and his trustees with their and every of their rights priviledges members and appurtenances unto my executors hereinafter named their executors admors and assigns for and during the term of two hundred years to commence immediately after my death and fully to be compleated and ended upon the trusts and to and for the ends interests and purposes and subject to the provisions and declarations hereinafter mentioned expressed and declared of and concerning the same and immediately from and after the end expiration or other sooner determination of the said term of two hundred years unto my mother the Countess Dowager of Portland and her assigns during her life and immediately after her decease unto my daughter the Lady Sophia Grey and the heirs of her body lawfully issuing and in default of such issue unto my sister the Lady Elizabeth Egerton wife of the honble and Right Reverend the Lord Bishop of Hereford her heirs and assigns for ever and my will and mind is and I do herby declare that the said messuage lands hereditaments and premises hereinbefore given and devised to my said executors for the said term of two hundred years are and were so given and devised to them upon trust and to the intent that my said executors or the survivor of them and executors and admors of such survivor shall and do by and out of the rent and profits of the premises comprized in the said term of two hundred years or by mortgage of the same premises or of a competent part thereof for all or any part of the said term or by all or any of the ways and means aforementioned raise and levy such sum and sums of money as will be sufficient to answer and pay so much and such part of my funeral expences the just debts I shall owe at the time of my death and the pecuniary legacies in and by this will given and bequeathed or on any codicil or writing under my hand hereafter to be given and bequeathed as my personal estate hereby given to my executors for that purpose shall fall short or be deficient to pay and shall and do apply and dispose of the money to be raised by and under the trusts of the said term of two hundred years in and for the supplying of the said deficiency accordingly and also upon trust that my said executors their executors and administrators shall and do permitt and suffer the residue and surplus of the rents and profitts of the premises comprized in the said term of two hundred years which shall not be applyed in and for the performance of the trusts of the said term to be had received and taken by the person and persons to whom the ffreehold and inheritance of the premises immediately on the determination of the said term of two hundred years shall for the time being belong or appertain provided always and my will is that when and as all the trusts hereinbefore declared of and concerning the said term of two hundred years

shall be executed and performed and the costs and charges of the trustees of the said term for the time being paid and satisfied then and from thenceforth the said term of two hundred years shall cease determine and be absolutely void and I give and bequeath all the household goods and furniture that I shall be possessed of at Old Windsor at the time of my death excepting plate and what may be hereafter mentioned to be otherwise disposed of unto my executors in trust to permitt the same to go with the house at Old Windsor for the benefitt of the person and persons who by virtue of this my will shall be intitled to the said house for the time being and I give and bequeath to the right honble John Lord Berkeley of Stratton my cousen the sum of fifty pounds and likewise to ffrancis Godolphin esqr my brother in law the sum of ffifty pounds to Emmanuel Burnett my cook the sum of ffifty pounds to Matthew Musgrave my butler the sume of fifty pounds to Elizabeth Crofts my woman the sum of one hundred pounds besides all which I give and bequeath to every servant that shall belong to me at the time of my decease having lived with me two years one years wages apeice I give and bequeath to Mrs Elizabeth Rivall who once lived with me the yearly sum of sixteen pounds to be paid her half yearly during her life I give and bequeath the sum of one hundred pounds to the poor of the parish of Old Windsor in Berks and likewise the sum of one hundred pounds to the poor of the parish of fflitton in Bedfordshire all to be distributed as my executors shall think fit I give and bequeath all my wearing apparel to Elizabeth Croft my woman I give and bequeath a fine japan drawing box which has the figure of a man fishing upon it to the Lady Marchioness Grey only as a mark of my kind regard for her I give and bequeath all my plate jewells money and securitys for money goods chattles and personal estate whatsoever (not herein otherwise specifically given and disposed of) unto my executors in trust in the first place to pay my funeral expences and all my just debts I shall owe at the time of my decease and afterwards the several legacies in and by this my will given and bequeathed and such other legacies as I shall by any codicil or writing under my hand hereafter give bequeath and dispose of and my will is and I do hereby direct that my said executors shall stand possessed of and interested in the surplus of my personal estate hereinbefore given and bequeathed to them and debts and such legacies as aforesaid in trust for my daughter Lady Sophia Grey until she shall attain her age of eighteen years or be married which shall first happen and then to consign and deliver over the same to her for her own use and benefitt and in the meantime to place out the money or securities for money or continue the same upon the publick funds or on government or real securitys at interest and do apply and dispose of the interest and yearly produce arising and to proceed from the same for and towards the maintenance or otherwise for the benefit and advantage of the said Lady Sophia Grey untill she shall attain her age of eighteen years or be married which shall first happen and then to consign and deliver over the same to her for her own use and benefitt provided always and my will is that if the said Lady Sophia Grey should dye under the age of eighteen years and unmarried then my said executors shall stand possessed of and interested in such surplus of my personal estate resulting as aforesaid to be disposed of in the manner following my diamond girdle buckle with my japan and dresden china to my

sister the Lady Viscount Limerick three dozen of my white silver plates to my brother the honourable William Bentinck my gilt large cup and cover to my brother the honble William Bentinck to whom I likewise give and bequeath all the residue and surplus of my personal estate (. . .)

Her Royal Highness the Princess Carolina, PROB 11/835, quire 5, fo. 40
Signed 18 April 1745
Proved 2 January 1758

I leave my sister Amalie all I have in possession and make her my sole executrix excepting these few legacies to my dear sister Anne an enamelled case and two bottles of the same sort, to my dear sister Mary my emerald set with diamonds and the brilliant drops hanging to it and my ruby ring with the Queens hair to my dear sister Louisa my diamond earings and also my rings to my brother William my enameled watch (. . .)

Dame Amy Kemp, PROB 11/745, quire 53, fo. 45
Signed 11 October 1745
Proved 18 February 1745 (*sic*)

(. . .) I give and bequeath to Philips Colman of Ipswich in the said county esqr and to Elizabeth his wife the sum of ffifty pounds each having already made the said Mr Colman a present of seven hundred pounds some time in the month of July last past as also a present of all my jewells to the said Mrs Colman I also give and bequeath to Martha the wife of Mr Dorrell Short the sum of ffifty pounds I give also and bequeath to Thomas Hodges of Ipswich aforesaid esquire and to the reverend Mr Thomas Bishop of the same town the sum of ffifty pounds each also I give and bequeath to the corporation lately erected for the relief of clergymens widows within the county of Suffolk the sum of one hundred pounds also I give and bequeath to the hospital school in Ipswich aforesaid the sum of two hundred and fforty pounds which I will shall be paid to the major part of the portmen of the said town of Ipswich and to be by them applyed towards the help of the said school all which legacys I will shall be paid by my executor hereinafter named within twelve months next after my decease <. . .> also I give to the poor of the parish of Kesgrave aforesaid the sum of ffive pounds to be distributed at the discretion of the minister of the said parish also I give to the minister who shall perform the duty of my funeral the sum of six guineas for a ring all the rest and residue of my estate as well real as personal of whatsoever nature or a tenure the same be I give devise and bequeath unto my brother Richard Phillips esquire and his heirs (. . .)

The Honble Lady Elizabeth Spelman, PROB 11/759, quire 27,
 fos. 211–12
Signed 2 November 1745
Proved 14 January 1747

(. . .) ffirst I give the right honourable James Hamilton Lord Viscount Limerick of the kingdom of Ireland the following pictures vizt the first picture of King Charles the second when a child Queen Ann of Bullen Henry Lord Hunsden Mary of Bullen his lady Henry Lord Leppington only son to Henry Earl of Monmouth but dyed before him Lady Herbet her first husband was the honourable Thomas Carey these last five are small paintings the large ffamily peice containing Robert Earl of Monmouth and his countess Henry Lord Carey afterwards Earl the honourable Thomas Carey and the Lady Philadelphia Carey their younger children this is a large fine painting Martha Countess of Monmouth wife to Earl Henry the Lady Ann Carey Countess of Clanbrazil the Lady Elizabeth Carey who dyed unmarried the Lady Martha Carey Countess of Middleton with that of John Earl of Middleton her husband the Lady Viscountess Mordant daughter to the honourable Thomas Carey these last six paintings are half lengths the Lady Elizabeth Spelman daughter to John Earl of Middleton and Martha his countess these two last paintings are quarter lengths. Item I give to the right honourable the Earl of Orrery a picture of the right honourable the Lady Martha Cranfield when a child afterwards Countess of Monmouth likewise a small picture of the right honourable Lady Margaret Cranfield who dyed unmarried both elder sisters to the right honourable Lady ffrances Cranfield afterwards Countess of Dorsett. Item I give to the right honourable the Lord Hardwick Lord High Chancellor of Great Britain one picture as directed for him on the back thereof. Item I give to my two cousins Mrs Ann and Mrs Elizabeth Byerley my bed of my own working with what work remains belonging thereto and my own picture in a red coat when a child the picture of the learned Sr Henry Spelman sitting in a chair and one of Philip Lord Wharton these three painting are half lengths a picture of Henry Earl of Monmouth two others of Lady Elizabeth Carey and Mrs Windsor these three last paintings are quarter lengths. Item I give Mrs Judith Corbett my large trunk inlaid with mother of pearl being the legacy left me by her uncles widow Mrs Bridgeman of Cavendish Square. Item I give to my cozen Mrs Inerson living in Grosvenor Street one hundred pounds to be paid her as soon as possible after my death. Item I give to Mr Thomas Morton of Chancery Lane London gentleman one hundred pounds for his trouble in the execution of this my will. Item I give to the poor of the parish where I shall happen to die twenty pounds to be paid to the overseers of the said parish for the use of the said poor. Item I give to Mrs Esther Le Cene three hundred pounds one hundred pounds thereof to be paid her as soon as possible after my death and the remaining two hundred pounds within three months after my death I likewise give her the whole ffurniture and goods of the room where she now lies. Item I give to my servant Catherine Lloyd one hundred and fifty pounds to be paid as soon as possible after my death if she be living with me then but not otherwise I likewise give her my walnut

tree cabinet together with the six leave screen standing in the parlour together with all my wearing linnen laces and all other wearing apparell. Item I give to my butler John ffletcher if living with me at my death twenty pounds to be paid to him as soon as possible after my death. Item I give to my servant Jane Evans if living with me at my death ten pounds to be paid to her as soon as possible after my death. Item I give to all my servants living with me at my death a years wages to each above what shall happen to be due to them for wages or otherwise to be paid them as soon as possible after my death together with a months board wages to each of them after the rate of ten shillings a week a peice lastly I appoint that after payment of debts legacys and ffuneral expences all that the rest residue and remainder of my ready money plate jewells household goods pictures watches chattels credits effects and personal estate whatsoever together with all my real estate be sold to the best advantage by my executor hereafter named and the moneys arising thereby be disposed of by my said executor with the advice of the rector of the parish where I shall dye to whom for his trouble therein I give twenty guineas to be disposed of to and amongst poor and distressed ffamilys and others according to their discretion not receiving relief from any parish or place whatsoever (. . .)

The Right Honourable Margaret Lady Baroness Clinton formerly
Margaret Fortescue, PROB 11/854, quire 141, fo. 355
Signed 29 April 1746
Proved 26 April 1760

(. . .) I give and bequeath unto my dear mother Lucy ffortescue her heirs executors and assigns all and singular my real and personal estate whatsoever and wheresoever of which I am now seized or possessed or intitled unto upon this condition that my said mother shall out of my said estate pay within one year after my decease the sum of one hundred pounds to my brother Lord Clinton and one hundred pounds to my sister Mrs Lucy Littleton and one hundred pounds to my brother Matthew ffortescue esquire and twenty pounds to my servant Elizabeth Marton if she is living at the time of my decease (. . .)

The Honble Anne Legge, PROB 11/752, quire 14, fo. 108
Signed 13 May 1746
Proved 8 Jan 1746 (*sic*) (1746/7?)

(. . .) I give and bequeath all and singular my goods chattels ready money plate household ffurniture and estate of what kind or nature soever after paying my just debts and legacys unto my dear and loving sister Elie Legge of the parish and county aforesaid spinster whom I do hereby make ordain constitute and appoint full and sole executrix of this my last will and testament (. . .)

The Honourable Margaret Tufton, PROB 11/840, quire 252, fo. 253
Signed 14 October 1746
Proved 8 August 1758

(. . .) Item I give and bequeath to my dear brother Willbraham Tufton the sum of five hundred pounds I likewise give to my said brother Willbraham Tufton one hundred guineas for mourning I leave to my dear sister Mary Tufton the sum of four hundred pounds, which I desire her to dispose of as I have given her directions. I give and bequeath all the rest and residue of my real and personal estate (after payment of my debts legacies and ffuneral expences) to my dear sister Mary Tufton (. . .)

Dame Dorothy Every, PROB 11/771, quire 181, fos. 4–5
Signed 11 December 1746
Proved 21 June 1749

(. . .) First I give and devise all my lands tenements and hereditaments whatsoever in the parish of Etwall in the county of Derby except my manor or reputed manor Hardwick with the rights members and appurtenances therto belonging unto my cousin Godfrey Meynell of Langley in the said county of Derby and the heirs of his body and for want of such issue I give and devise the same unto the Reverend Mr John Every second son of Sir Simon Every of Eggington in the said county of Derby baronet and to his heirs for ever and I give and devise all my lands tenements and hereditaments at Hanson Grange and Eggingon and all that my aforesaid manor or lordship of Hardwick in the said county of Derby and all my lands tenements and hereditaments at Houghton Conquest or elsewhere in the county of Bedford and all other my real estates whatsoever and wheresoever and also all my personal estate of kind or nature soever (except my cloths linnen wearing apparel and books as hereafter specifically devised) unto Henry Every esquire eldest son and heir aparent of the said Sir Simon Every and to his heirs executors administrators and assigns for evermore but nevertheless charged and chargeable with the payment of and I do expressly charge all my said real and personal estate devised to the said Henry Every as aforesaid with the payment of all the annuitys legacys gifts and bequests by me hereafter given and bequeathed and also with the payment of my debts. I give to the right honourable Isabella ffinch sister to the right honourable the Earl of Winchelsea and Nottingham one hundred pounds I give to the honourable Sir William Stanhope knight one hundred pounds and to his daughter Miss Elizabeth Stanhope fifty pounds I give to Mrs Fitzherbert of Derby widow twenty guineas for a ring I give to my cousin Mrs Dorothy Turner wife of Mr William Turner of the borough of Derby three hundred pounds I give to my cousin Mr ffrancis Meynell apothecary in Derby three hundred pounds I give to my god daughter Miss Mary Gretton six hundred and twenty pounds I give to Mrs Meynell of Langley aforesaid widow fifty pounds I give to Mrs Elinor Curson one hundred pounds I give to the aforesaid Godfrey Meynell esquire eight hundred pounds I give to my late servant Sarah now wife of Richard Ironmonger of the said borough of Derby fifty pounds to be paid her

in one month after my decease and I further give to the said Sarah Ironmonger a yearly annuity of ten pounds to be paid her yearly during her life without any manner of deduction for taxes or otherwise I give to Mrs Lydia Hodgkinson the elder of Derby an annuity of forty shillings to be paid her yearly during her life without any deduction for taxes or otherwise I give to my tennant Thomas Howe of <word illegible> close in Etwall fifty pounds I give to Mrs Ashby wife of Cornott Ashby three hundred pounds I give to Rowland Cotton of Etwell aforesaid esquire and his lady ffifty guineas apiece and to their daughter Miss Catherine Cotton six and twenty guineas I give to the Reverend Doctor Grey and his lady five guineas apiece and to their daughters Miss Mary Grey and Miss Sukey Grey ten guineas apiece for rings I give to Miss Mary Every and Miss Anne Every daughters of the said Sir Simon Every two hundred pounds apiece I give to Mr George Gretton of Jesus college in Cambridge my library of books I give to every of my domestick servants a years wages and mourning I give unto the said Miss Gretton one half of all my cloaths linnen and wearing apparel of what kind or nature soever and the other half thereof I give to the said Miss Mary Every and Miss Anne Every equally to be divided between them (. . .)
codicil:
(. . .) I do hereby give and bequeath unto Miss Catherine Cotton the sum of two hundred and seventy five guineas beside what I have given her in my said will and I do hereby expressly charge all my Lands tenements and real estate given and devised to Henry Every Esquire my executor in and by my last will with the payment thereof and my will and meanings is that this Codicil be and be adjudged to be part and parcel of my said last will and testament and that every thing here in contained and mentioned be faithfully and truly performed and that as full in every respect as if the same was devised and set down in my said last will and testament (. . .)

The Right Honble Elizabeth Lady Viscountess Dowager Harcourt,

 PROB 11/763, quire 204, fos. 117–18
Signed 13 February 1747
Proved 22 July 1748

(. . .) I give ffive pounds to the poor of the parish of Churchill aforesaid in the said county of Oxford and ffifty shillings to the poor of the parish of Sarsden in the same county and ffifty shillings to the poor of the village of Lynham in the same county I give to Simon Lord Viscount Harcourt my large brilliant diamond ring and his grandfathers the late Lord Viscount Harcourts picture with the diamond coronet and after his decease I give the said ring picture and coronet to his eldest son then living to the intent the same may go with the honour and heir loomes in the ffamily I give to my dear sister Martha Vernon all my dressing plate whatsoever all my wearing apparel and all my lace linnen all my china my tea kettle and lamp my tea spoons which I bought since I was a widow my two silver salts all my household linnen and all the ffurniture which I have bought all my pictures which I brought from Sarsden my sedan chair

with coats and hatts and the house it stands in the tea board which my sister Aislabie gave me the waiters which I bought the ffrench candlesticks which I also bought and my carpets and little bed all which things so given are for her own absolute use and disposal I give to my brother Sir Charles Vernon the picture of the late Chief Baron Walter and likewise the picture of my former husband the said Sir John Walter and my self drawn by Mr Doll I give to William Aislabie of Studley Hall in the county of York esquire and to Richard Lockwood the younger of Dews Hall in the county of Essex esquire ffifty pounds apeice for their trouble in the trust hereinafter mentioned and reposed in them. I give to my woman Mrs Anne Rock if living with me at my death ffifty pounds to be paid her a month after my decease all the rest and residue of my personal estate of what nature or kind soever which I shall dye possessed of or intitled to I give to the said William Aislabie and Richard Lockwood the younger and to the survivor of them and to the executor and administrator of such survivor in trust that the same be placed out by them at interest on real securitys or parliamentary ffunds and that the interest or dividends thereof may from time to time be duly paid to my said dear sister Martha Vernon during her natural life and I will and direct that after her decease my said trustees shall pay unto the governors of the bounty of Queen Anne for the augmentation of small vicarages the sum of two hundred pounds to be applyed to the augmentation of the vicarage of the parish of Churchill aforesaid which said sum of two hundred pounds shall be so paid as soon after her death as the said governours shall order the like sum out of their revenue to be added thereto for augmenting the said vicarage of Churchill and it is my will and desire that one moiety or half part of all the rest and residue of my said personal estate (after deducting the sum of two hundred pounds) shall be paid to such person or persons as my said sister Martha Vernon shall by her last will and testament direct or appoint and for want of such direction or appointment the said moiety to go to the executors or administrators of my said sister and I do will and direct that the other moiety or half part of my said estate from and after the death of my said sister shall be paid and delivered over to my brother Charles Vernon for his use and disposal (. . .)

The Rt Honble Lady Charlotte Scott, PROB 11/757, quire 264,
 fos. 58–9
Signed 17 June 1747
Proved 2 October 1747

(. . .) I give unto my loving nephew ffrancis Earl of Dalkeith my pearl necklace and earings with diamond tops and pearl drops. Item I give unto Lady Carolina Scott eldest daughter of my said nephew ffrancis Earl of Dalkeith the sume of ten thousand pounds to be paid to her at her age of twenty one years or day of marriage which shall first happen but in case she shall happen to dye before the same shall become payable as aforesaid then I give the said sume of ten thousand pounds to all and every other the daughter and daughters of the said Earl (if more than one) equally to be divided

between them and to be paid and payable to her or them at her or their respective age or ages of twenty one years or day or days of marriage which shall first happen and in case the said Earl of Dalkeith shall not have any daughter or daughters who shall live to attain the age or ages of twenty one years or who shall be married than I give the said sum of ten thousand pounds to be paid and payable to the second son of the said Earl by his present wife or to any other son he may direct and appoint to have and receive the same the said sume of ten thousand pounds to be paid and payable to such son upon his attaning his age of twenty one years. Item I give to the said Lady Caroline Scott my small pearl necklace of twelve rows of pearl and my pink colour diamond ring sett with small white diamonds on the shank and my white diamond in the shape of an heart which I use as a hook for my stays. Item I give unto Juliana Dutchess Dowager of Leeds my saphire ring with four little brilliants sett àt the ends. Item I give to the right honourable Ann <sic> Hollis Earl of Essex my large diamond ring sett round with small diamonds and in case he shall happen to dye in my lifetime then I give the same to his four sisters in manner following (that is to say) first to Lady Charlotte Capell and in case of her decease in my lifetime then to Lady Mary Capell daughter of William late Earl of Essex by Lady Jane daughter of the Earl of Clarendon and in case of both their deceases in my lifetime then to Lady Diana Capell one of the sisters of the said Ann Hollis Earl of Essex and in case she shall also happen to dye in my lifetime then to Lady Ann Capell his other sister. Item I give to the right honourable Caroline Countess of Dalkeith my white diamond ring sett in gold claws. Item I give unto the most noble Thomas Duke of Leeds my seal ring which hangs at my watch. Item I give to my loving neice Lady Jane Scott eldest daughter of my said brother in case she be unmarried at my death the sume of two thousand pounds to be paid to her at her age of twenty one years or day of marriage which shall first happen with the interest and produce thereof in the meantime but in case my said neice shall be married in my lifetime then I give her only the sume of ffive hundred pounds and do give the sum of fifteen hundred pounds the residue thereof to her brother the Earl of Dalkeith both the said legacys to be paid within twelve months after my decease. Item I give to my servant Elizabeth Adams the sume of one thousand pounds for her honesty and faithfull service to me for many years and for her better support by reason of her ill state of health and I give her also all my wearing apparell. Item I give unto all my domestick servants who shall be in my service at the time of my decease one years wages over and beside what shall be then respectively due to them all the rest residue and remainder of my estate of what nature or kind soever I give and bequeath unto my dear brother the Duke of Buccleuch (. . .)

Dame Eliza Dudley, PROB 11/776, quire 42, fos. 334–5
Signed 9 July 1747
Proved 9 February 1749

Whereas there are several arrears of moneys due to me for interest from Mr Joseph Biscoe as trustee for me persuant to some deed or conveyance executed by the late

Lady ffrederick Howard (my mother deceased) now I do hereby declare it is my desire and intent that in case of my death the debts due from me to the following persons shall and may be out of such moneys so due to me for interest as aforesaid be by the said Mr Biscoe or his assigns in the first place fully paid and satisfied (that is to say) twelve pounds fourteen shillings to Mr Paul Mowbray ten pounds to Mr Wootton attorney in Covent Garden and six pounds to Mrs Herring being moneys by me from them respectively borrowed and now justly due and unpaid and I further desire that the said Mr Mowbray Mr Wootton and Mrs Herring be also paid one year and half a years interest now due to them respectively and such interest as shall hereafter become due for the same and my further desire is that in case my servant Elizabeth Willows shall happen to survive me then that the residue and remainder of the said interest moneys shall go and be paid by my said trustee Mr Biscoe to her the said Elizabeth Willows for her own proper use and benefit but in case she shall happen to be dead in my lifetime then my desire is that the residue of the said moneys shall go and be paid to my son William Dudley and the interest and residue of whatsoever I have in my power to dispose of by will or otherwise, linnen wearing apparel or otherwise I likewise give to my said servant (. . .)

The Right Honble Lady Mary Petre, PROB 11/823, quire 174, fo. 92
Signed 10 September 1747
Proved 4 June 1756

(. . .) I give to my nephew John Petre esquire all the ffamily pictures at Bellhouse (excepting my own in my dressing room) upon condition that William Edmondson shall have the use of them during his lease of one and twenty years but if my nephew John Petre should dye before the above mentioned lease is expired I give the aforesaid pictures to William Edmondson with this proviso that he offers the ffamily pictures to Lord Petre for a valuable consideration Item I do give and devise to Lady Petre my little diamond heart ring that has her ffather's hair under it Item I give to Lady Shrewsbury my little mocco <mocha> stone set in gold Item I give to Lady Montague my cornelian seal with a head ingraved and set in gold Item I give to my brother Charles Radclyffes eldest son my mother and grandmothers two pictures in miniature Item I give and devise to my trusty William Edmondson the ffurniture at Bellhouse and all my goods chattels money arrears of my jointure plate linnen china rings earrings stock of husbandry and personal estate whatsoever and wheresoever to be held and enjoyed by the said William Edmondson subject only to the conditions above mentioned and as my dear late brother Charles Radcliffe commonly called Earl of Darwentwater has left me five thousand pounds sterling in his will I do here impower the said William Edmondson to demand it as his due for I leave it to him the said William Edmondson in recompense for the many obligations I have to him (. . .)

Dame Frances Chester, PROB 11/792, quire 7, fos. 51–2
Signed 24 October 1747
Proved 31 January 1752

(. . .) And whereas I have raised two several estates (part ffreehold and part copyhold lying within the mannor of Keol in the County of Stafford and within the mannor of Swinnerton in the said county of Stafford one or both of them) to be purchased surrounded and conveyed to persons in trust for me as I also have paid off and discharged one mortgage and security of Thomas Masseys of Nantwich in the county of Chester tallow chandler which likewise is by indenture bearing date on or about the eleventh day of November last assigned over to Christopher Horton of Catton in the county of Derby esquire in trust for me for the securing the sum of three hundred pounds and interest Now it is my mind and will and I do hereby direct will devise and require that my trustees in the said several purchases as also of all other my purchased estates and in the said assignment and security shall within three months next after my decease in case my Grandson Ralph Sneed doth before that time seal and execute unto the said Christopher Horton a trustee named for the purposes herein after willed and declared a good and sufficient security for the sum of two thousand pounds to carry interest at the rate of four pounds for one hundred pounds by the year shall severally convey and surrender the said several purchased estates to my said Grandson Ralph Sneyd <sic> and his heirs and assigns for ever to him his executors administrators or assigns the said security for the said sum of three hundred pounds but in case my said Grandson Ralph Sneyd shall neglect or refuse to give such security then I do hereby direct will and require my said trustees in the said Purchases to convey and surrender the said estates to my Grandaughter Honor Sneyd and to her heirs executors administrators for ever and to assign over said security for three hundred pounds unto her my said grandaughter her executors administrators and assigns and it is my will that if my said Grandson Ralph Sneyd shall seal and execute such a security for the said sum of two thousand pounds unto the said Christopher Horton his executors and administrators as before mentioned that such interest shall be yearly paid unto my said Grandaughter Honor Sneyd for and during her natural life or day of marriage which shall first happen and upon further trust that in case my said Grandaughter shall happen to marry then it is my will and I do direct that the said Christopher Horton his executors or administrators shall upon the day of such marriage assign over such security for the said sum of two thousand pounds unto such person with whom the said Honor Sneyd shall happen to marry having a proper settlement first made upon the said Honor Sneyd and the issue of such marriage suitable to the said portion or the circumstances of the person she shall marry with and it is my further mind and will that in case the said Honor Sneyd shall depart this natural life not having been marryed then I do hereby will direct and appoint that the said sum of two thousand pounds shall be paid to and equally divided betwixt my two Grandsons Edward Sneyd and William Sneyd I do hereby also give and bequeath unto the said Christopher Horton the further sum of two thousand pounds to be paid to him his executors and administrators within three

months next after my decease upon trust that the said Christopher Horton his executors and administrators shall immediately place out the same upon the best securtiy and at the highest interest he or they can get for the same and such yearly produce and interest pay unto my Grandaughter Ann Sneyd. And upon this further trust that in case the said Ann Sneyd shall happen to marry that then the said Christopher Horton his executors or administrators shall upon the day of such marriage assign over such security of securities which shall be had and taken for the said sum of two thousand pounds having first a proper settlement made upon the said Ann Sneyd and the issue of the person she shall marry with and it is my further mind that in case the said Ann Sneyd shall depart this natural life not having been married then I do hereby will and direct and appoint that the said last sum of two thousands shall also be paid to and equally divided betwixt my said two grandsons Edward Sneyd and William Sneyd and it is my further mind and will that neither the said Christopher Horton or his heirs executors and administrators shall be answerable for the ffailure of any security or securities which he or they or any of them shall take for the said several sums of two thousand pounds and two thousand pounds or any part of them or either of them provided the same shall from time to time be approved of them by the person and persons respectively who are to have the immediate benefit thereof his heir or their guardian or guardians. I give and bequeath unto my Grandaughter Mrs Horton wife of the said Christopher Horton the sum of one hundred pounds and to my son Edward Sneyd the like sum of one hundred pounds and to my kinswoman ffrances Harrison widow the sum of forty pounds to be paid to them respectively within six months next after my decease I give and bequeath unto my said Grandson Ralph Sneyd my best gold diamond ring and all my plate to Miss ffrances Horton eldest daughter of the said Mrs Horton the next best diamond gold ring to the said Honor Sneyd my gold watch and tweezer and two of my rings and all other my rings and jewells I give unto the said Ann Sneyd and it is my mind and will that in case my several estates reall and personal shall fall short (after payment of my funeral expences and just debts) to pay the several pecuniary lecacies I hereby given that such deficiency shall be borne by the pecuniary legatees in proportion to their respective legacies and not be made good out of the other legacies hereby given and I do hereby nominate and appoint the said Ralph Sneyd sole executor of this my last will and testament and give to him all the rest and residue of my personal estate not herein and hereby given (he distributing to and amongst the poor of Keol the sum of five pounds and to the poor of Catton aforesaid the sum of two pounds and ten shillings and the like sum to the poor of Lea Marston in the county of Warwick) (. . .)

Dame Frances Chester, PROB 11/771, quire 210, fos. 235–6
Signed 5 February 1748
Proved 19 July 1749

(. . .) And whereas I am intitled to the sum of one thousand pounds that was left me

by my uncle Charles Bagot esquire I do give and dispose thereof as followeth I do give the said sum of £1000 to my brother Sir Walter Wagstaffe Bagot Baronet in trust for my two young children ffrances Chester and Anthony Chester and to be paid them in manner following that is to say to my daughter ffrances Chester the sum of seven hundred pounds part thereof to be paid to her at the age of twenty ffive years or day of marriage provided she marry with the consent of my brother Sir Walter Wagstaffe Bagot baronet and her brother Sir Charles Bagot Chester baronet the interest of the said seven hundrd pounds in the meantime to be paid to her and her receipt for the same to be a sufficient discharge to my said brother and as to the three hundred pounds residue of the said one thousand pounds I do give to my son Anthony Chester to be paid to him by my said brother at his age of twenty ffive years or sooner for his advancement and preferment in the world if my said brother shall think proper the interest in the meantime to be applyed towards his maintenance and education and whereas the above one thousand pounds is now on a mortgage of Mr Parrotts estate I do hereby impower my said brother to call in the same and to place it out again on such security as he shall judge proper and most for the advantage and benefit of said two children <. . .> and if either my said children <. . .> should dye before his or her share of and in the said one thousand pounds should become payable then I do give her or his share so dying to the survivor and whereas there was due for the interest for the said £1000 whilst it remained in the said hands of my dear husband Sir John Chester the sum of one hundred seventy five pounds now I do dispose thereof as followeth I give thereout to my brother Sir Walter Wagstaffe Bagot baronet the sum of 50 gs and the remainder thereof being £122. 10s. od I give to my said brother in trust for my said son Anthony Chester to be paid and applied for the benefit of my said son in the same manner as the three hundred pounds I have before given him I give to my daughter ffrances Chester the silver coffee pott and 1 dozen of large spoons that have the arms of my uncle Bagot on them I give her all the tea spoons and my diamond sal-itare and little brilliant top earrings and my watch and seals and rings I also give her all my best laces Dresden work and fflourishing and all my cloaths that have any gold or silver in them I also give her everything that is in the trunk by my bedside (except the red damask chairs) I also give her what is in the trunk in the china closet and one ffive pound peice of gold I also give her the pictures that are between the windows in my dressing room except the large picture in a gold frame and all my japan the books that are on the shelves and in the escrutore in my dressing room I would have divided between my daughter ffrances and son Anthony Chester I give to my son Anthony Chester 1 dozen of silver spoons and one five pound peice of gold I give to my servant Ann Branton all my wearing apparel not before bequeathed I give to my servant John Negus a years wages over and above what is due to him and mourning I would have my other man servants wages paid up to June next when there will be a year due I would have my house maids wages made up a year from the time of her coming to live with me I give my cook a years wages over and above what shall be due to her the rest of my personal estate together with the arrears of my anny and the ffurniture of my house in Queens Square I give to my son Sir Charles Bagot Chester baronet he

paying thereout all my debts ffuneral charges and legacies <. . .> hereby requesting him to be kind to his brother and sister as their fortunes are small (. . .)
codicil:

(. . .) I am desirous of making the following alterations that is to say I desire my daughter ffrances Chester may have eight hundred pounds (part of the one thousand pounds) given by my aforementioned will to my brother Sir Walter Wagstaffe Bagot Baronet in trust for my two younger chidren paid to her and upon the conditions and at the time mentioned in my will and the remaining two hundred pounds I would have given to my son Anthony Chester <. . .> I have the sum of one hundred and seventy ffive pounds whilst it remained in the hands of my dear husband Sir John Chester and not my brother's legacy of ffifty gs. paid thereout But I do hereby give to my said brother Sir Walter Wagstaffe Bagot baronet the sum of one hundred pound and I do hereby in every other respect than above mentioned testify and confirm my said will of the 5th of ffeb 1748

Honble Dorothy Howard, PROB 11/858, quire 327, fo. 212
Signed 28 February 1748
Proved 11 August 1760

(. . .) I desire my dear brother Henry Bowes Howard Earl of Suffolk and Berkshire will accept of one hundred pounds with the pictures medals and copper coins in a little red trunk within my strong box as a poor but sincere mark of the entire love and affection I have for him wishing him and his ffamily all happiness in this life I give to my dear sister the Countess of Suffolk and Berkshire one hundred pounds with the diamond solitaire the amethyst drop crosse & ear rings to my niece the Viscountess Andover I give my diamond ring with five brilliants in it and my pearl necklace and my japan box painted red witin when the things are taken out of it and twenty guineas to my nephew the Lord Viscount Andover I give two pictures of the Royal ffamily of England and twenty guineas to my most dear nephew the honourable Thomas Howard I give my ffathers picture by Mr Cooper and all my other pictures not otherwise disposed of and all the plate inventoried and Signed by me my black cabinet painted within when the things are taken out of it and also twenty guineas to Lieutenant General Howard and his Lady I give twenty guineas apiece to my ffriend the Reverend Mr John Creyk I give thirty guineas to the right honourable the Lady Widdrington Erasmus Lewis esqr and the Reverend Mr Graham of Asted I give a mourning ring each to Mr Daniel Graham apothecary I give two guineas I also give thirty pounds to be disposed of in charity as my executrix shall think fit and as the rest of my estate is very inconsiderable and all my ffriends and near relations greatly provided for and I have a poor servant named Margaret White who in a course of years in sickness and in health has given me undeniable proofs of her honesty uncommon ffidelity and concern for me I am persuaded my friends and relations will not blame

me for bestowing upon my said servant all the residue of my estate I do therefore give devise and bequeath unto the said Margaret White all the rest residue and remainder of my goods cloaths moneys or securities for money chattels and effects and whatsoever other estate I shall dye possessed of or am entitled to after payment of my ffuneral expences debts and legacies (. . .)

The Most Noble Jane Dutchess of Atholl formerly Lannoy,
PROB 11/762, quire 169, fo. 193
Signed 29 May 1748
Proved 16 June 1748

(. . .) I do give and bequeath unto Lady Catherine Weemys sister to John Earl of Cranford my executor after named and appointed my rose diamond ring and my gold repeating watch and I give and bequeath unto my servant Eleanora Crispe if she shall be in my service at the time of my death all my wearing apparell and if not then to such other person as shall be my upper woman servant at the time of my death and also ten pounds ten shillings and all the rest residue and remainder (after the payment of my just and lawfull debts and ffuneral expences) of my estate real and personal whatsoever and wheresoever of what kind or nature soever I give devise and bequeath unto the said John Earl of Cranford his heirs and assigns forever (. . .)

The Rt. Honble Lady Ann Paul, PROB 11/773, quire 293, fos. 212–13
Signed 9 March 1748
Administered 6 September 1749

(. . .) First I give and bequeath unto all my servants that shall be with me at the time of my death a years wages over and above what shall be then due to them at the time of my decease. Item I give and bequeath unto my servant Joseph Bagaley seven pounds a year during his natural life. Item I give and bequeath unto Mary Ambross ten pounds during her natural life. Item I give and bequeath unto my dear brother the right honourable Lord George Bentinck one hundred pounds to buy some little triffle to remember me. Item I give unto my dear sister the right honourable Lady Amelia Catherine de Wassenaer de Harcromonde five hundred pounds. Item I give and bequeath unto my dear brother Ian Henry Monck esquire one hundred pounds to buy a ring or any other thing he likes to remember me by. Item I give and bequeath to my own chamber maid Mrs Hannah Vaughan for her great care of my late dear husband in his last sickness and for her great affection and fidelity to me ffifty pounds a year during her life and also the sum of two hundred pounds to be paid her in three months after my decease to dispose of as she pleases and also all my wearing apparel laces and linnen the ffurniture of my bed chamber and household linnen except the fine old damask linnen that was my mothers the pattern of boys turning a wine press. Item I give and bequeath unto my good ffriend Mr Peter Barbut the sum of ffifty pounds.

Item I give and bequeath unto Mr James Girardot of Greenwich one hundred pounds as a small mark of gratitude for all the trouble I have given him. Item I give and bequeath unto my dear neice and goddaughter Ann Monck my small pearl necklace of five rows and my rose diamond ear rings. Item all the rest residue and remainder of all my money goods chattels and other estate whatsoever wheresoever or of what kind or nature soever I give and bequeath unto the said Lord George Bentinck and James Girardot <. . .> upon this special trust that they <. . .> shall and do pay the rents issues Rights interest and produce thereof to my dear sister the right honourable Ann Isabella Monck during her life to her sole and separate use and if the said Lady Ann Isabella shall at any time during her life think proper to sell assign or dispose of all or any part of my said goods chattels or other estate whatsoever I do hereby direct and appoint the said Lord George Bentinck and the said James Girardot their executors and administrators to make such sale assignment of disposition of them or any part of them as the said Lady Ann Isabella shall direct any the money arising from such sale assignment or disposition of them or any part of them to put out on securities such as the said Lady Ann Isabella shall approve of and the interest and produce of such money so put out to pay to the said Lady Ann Isabella during her life to her sole and separate use and upon this further trust and confidence that they the said Lord George Bentinck and James Giradot their executors and administrators shall and do from and after the death of the said Lady Ann Isabella assign transfer and dispose of all my said money goods and other estate whatsoever to my two neices Elizabeth and Ann Monck daughters of the said Lady Ann Isabella equally to be divided between them share and share alike if my said two neices be both living at the time of the decease of the said Lady Ann Isabella and if there be but one out of my said neices living at the time of the decease of the said Lady Ann Isabella then the whole to be transferred and made over to such of my said two neices that shall be living at the time of decease and if my said two neices Lady Ann Isabella Elizabeth and Ann shall both die in the lifetime of the said Lady Ann Isabella I do hereby direct and appoint the said Lord George Bentinck and James Girardot their executors and administrators to transfer assign and make over all my said money goods chattels and other estate whatsoever to the said Lady Ann Isabella Monck to her sole and separate use and I do hereby give full and absolute power to the said Lady Ann Isabella Monck <. . .> to dispose thereof or any part thereof to such person or persons and in such proportions and manner as the said Lady Ann Isabella shall think fit (. . .)

Rt Honourable Mary Countess Dowager of Pembroke,
 PROB 11/773, quire 294 fos. 220–1
Signed 21 February 1749
Proved 19 September 1749

(. . .) My dear husband this letter is referred to in my will I wish you my sisters and all my ffriends all manner of worldly happiness <. . .> there is a year next Lady Day due

from my pension from the King also half a years rent of my jointure if Sir Everard ffaulkener has not already paid it to Mr Samuel Smith there is also a years rent due for my house in Saint James's Square these with the overplus arising from my jewels and whatever else you think proper to sell will I hope be much more than sufficient to pay my servants wages and tradesmens bills which I desire my be discharged first I desire my sister Page will accept of my emerald ear-rings set with little diamonds and rubies also my lapis lazuli snuff box I desire my sister Mordaunt will accept of my gold watch with the Queens picture also my <cabochon ?> etuie with all the trinkets belonging to it I desire my rich cloaths may be sold and the money divided equally between Katherine Peach and Elizabeth Saint that my other wearing apparel linnen and so forth may be equally divided between them with some share given to Elizabeth the chambermaid (. . .)

Dame Mary Abney, PROB 11/776, quire 35, fo. 283
Signed 7 August 1749
Proved 16 February 1749/50 (sic)

(. . .) Item I bequeath unto my son in law Jocelyn Pickard the sum of three thousand eight hundred sixty six pounds thirteen shillings and ffour pence which is the sum agreed upon he should receive the interest of during his natural life. This said sum I give to him to be paid in six or eight months after my decease apprehending he has no claim or demand on the estate of Sir Thomas Abney my late husband deceased or on my estate by virtue or in consequence of his marriage with one of my daughters Mary Pickard deceased or otherwise however or if he has then I declare the same to be in full satisfaction and discharge of all such demands however the same may arise. Item I also give to the afore said Jocelyn Pickard the further sum of one hundred and twenty three pounds six shillings and eight pence to be paid with the other which will make together the sum of ffour thousand pounds. Item I give and bequeath to Sir Thomas Abney the sum of one hundred pounds. Item I give to Elizabeth Ashurst widow ffifty pounds. Item I give to Thomas Ashurst esq and to Elizabeth Ashurst his wife to each the sum of ffity pounds. Item I give to Elizabeth Richier widow the sum of two hundred pounds and Sarah Ashurst her sister the sum of one hundred pounds and to Mr Archibald Maclane and Mrs Mary Maclane his wife each the sum of ffifty pounds. Item I give to the Revd Mr Samuel Price the sum of one hundred pounds. Item I give to the Revd Mr Thomas Gibbons Snr the sum of ffifty pounds and to the Reverend Mr Samuel Swashall the sum of twenty pounds. Item I give to my servant Joseph Parker the sum of one hundred pounds and to my servant Jane Davenport the sum of ffifty pounds Lastly I give all the rest of my effects of what kind or nature soever to my dear and only daughter Elizabeth Abney for ever (. . .)

The Right Honble Frances Viscountess Dowager Dillon in the
 Kingdom of Ireland, PROB 11/791, quire 305, fos. 39–40
Signed 11 August 1749
Proved 16 November 1751

(. . .) And whereas I am entitled to the sum of one thousand pounds and interest for the same charged upon the estate of the Right honourable Henry late Lord Viscount Dillon my late husband deceased now I give and bequeath the said sum of one thousand pounds and all interest that shall be due for the same to my nephew the honourable George Barnewall esquire to and for his own proper use and benefit I give and bequeath to Mrs Mary Shea who now lives with me the sum of one hundred and fifty pounds of lawful money of and in Great Britain and to Polly Shea the sum of one hundred pounds of like money and to the said Mary Shea the further sum of fifty pounds of like money but the said fifty pounds to be trust for and to the use of her niece Martha Orish I give to Patrick Plunkett the sum of fifty pounds of lawful money of Great Britain and to his eldest daughter ten pounds of like money I give to Elizabeth Dillon heretofore Tracy who formerly lived with me and is now the wife of Henry Dillon twenty pounds of lawful money of Great Britain to be paid to herself for her own separate use independent of her husband and her receipt alone shall be a sufficient discharge to my executor for the same I give to the aforesaid Mary Shea the ffurniture of the two rooms that she and Polly Shea lie in I will and direct that Mr Thomas Wall my steward in Ireland do settle all accounts depending between me and my tenants in Ireland and do collect and get in all rents and arrears of rents which shall be due to me from my said tenants and I do give to the said Mr Wall for his trouble therein and to be paid out of the said rents over and above his usual poundage and allowances the sum of one hundred pounds Irish money and I give to Mr Edward ffoley of Dublin to be paid out of the said rents the sum of ffifty pounds Irish money and I do likewise give to the said Mr Wall the further sum of two hundred and forty pounds Irish money to be by him paid and disposed of to such persons and for such uses as I shall signify to him by any letter or writing under my hand tho not attested by any witnesses which letter or writing I would not have Proved and my will is that the said Mr Wall shall not be accountable to anyone for the payment or distribution of the said two hundred and forty pounds I entirely trusting and relying on him therein I give to John Fitzgerald who formerly lived with me as a servant ten pounds of lawfull money of Great Britain and to each of my men and women servants ten pounds of like money I reserve to myself a power of making any codicil or addition to this my will either in my own handwriting or to be Signed by me and I do hereby give and bequeath all the rest residue and remainder of my goods chattels stock and annuitys in the public ffunds rights credits and estate whatsoever as well in the Kingdoms of Great Britain and Ireland as in any other country or dominion whatever to my said nephew the honourable George Barnewall esq to and for his own proper use and benefit (. . .)
codicil:

(. . .) I do hereby bequeath to my poor tenants in Connaught the sum of sixty pounds to be divided amongst them in such manner as Mr Thomas Wall my steward in that kingdom shall think proper I give to the poor of St Marys parish in Jervas Street Dublin the sum of ten pounds I give to the poor of North Audley Street London the sum of ten pounds I give to the gentlemen of the King of Portugals household in London the sum of ffifteen pounds I give to James ffitzgerald of Drumony the sum of ffifteen pounds I give to Mary Shea my woman the sum of ninety pounds over and above the sum of one hundred pounds bequeathed to her by my said will. I give to Mr Thomas Plunkett of Hammersmith the sum of ffifty pounds over and above what I have given him by my former will I give to Mrs Mary Plunkett wife to the said Mr Thomas Plunkett fforty pounds for her own separate use I give to Mr Mumford of South Audley Street twenty pounds I give to Mr Smith of Holborn twenty pounds I give to Mary Lanty ten pounds I give to Mrs Vaughan ten pounds I give to the widow Jordan twenty pounds I give to Dolly Ashburne ten pounds I do hereby revoke anul and make void to all intents and purposes the legacy of two hundred and forty pounds which I bequeathed by my said will to the said Thomas Wall in trust and I do hereby revoke all codicils made by me to my said will and I do ratify reaffirm and establish my said will except in so far as the same is altered by this codicil (. . .)

Dame Elizabeth Banastre, PROB 11/785, quire 3, fos. 25–6
Signed 31 May 1750
Proved 27 January 1750/1 (*sic*)

(. . .) I give and devise unto each of my daughters Jane Hamilton and Elizabeth Harcourt the sum of one hundred pounds and twenty pounds for mourning I also give and devise unto each of my grandchildren Alexander Hamilton Jane Cox Elizabeth Baldwyn Mary Clark Lady Abdy Elizabeth Torrel and Jane Harcourt the like sum of one hundred and twenty pounds for mourning I give to each of my grandsons William Clarke esq Sir Anthony Thos Abdy Bartt and Richard Dorrell esq the sum of twenty pounds for mourning I also give to each of my great grandchildren Elizabeth and Jane Baldwyn William Mary and Ann Clarke the sum of five guineas and the like sum of five guineas to such other great grandchildren as I may have at my death and to my god daughter Mrs Ann Baines the like sum of five guineas and also a gold seal with a head on it and a mourning ring with Mrs Ann Gladwins name on it (both which ring and seal were given me by Mrs Ann Baynes) also I give Mrs Mary Baynes Mrs ffarrant Mrs Collishaw Mrs Ben Mrs Grey and to Mrs ffield and Mrs Kent of Bulls Cross the sum of twenty shillings each and desire my executrix to give and dispose of the sum of twenty shillings each in charity to three such other persons as she shall think proper I give to my said grandson Alexander Hamilton the ffurniture of my room at Bulls Cross except my Japan cupboard my three carpets and beaurot which I give to my said granddaughter Lady Abdy I give and devise to my maid servant living with me at my death if at that time she shall have lived with me one year all my wearing

apparel of silk and woollen except my scarlet capuchin I leave to my man servant who
shall be living with me at my death (if at that time he shall have lived with me one
year) the sum of five pounds over and above what shall be then due to him for wages
I also give to my said children grandchildren great grandchildren and such other great
grandchildren as I may have at my death and to my brothers John and Walter Edwards
my sister Mrs Edwards of Bristol my nephew ffreeman my neice mis Edwards my
nephew and neice Sir Bourchier and Lady Wray Lord and Lady Middleton Mr
Alexander Ready and his wife the two ministers that shall attend at my ffuneral Mrs
Blackmore my cousin Stafford Doctor Terrick and Mr Robert Pardoe a gold ring each
also I give and devise unto my said granddaughter Jane Cox all that my share and inter-
est of and in the Hot Well at Bristol and of and in all other the leasehold messuages
and tenements with their appurtenances which came to me upon the death of my late
brother Joseph Edwards intestate to hold to her her executors administrators and
assigns for the residue of the term and interest which at the time of my death I shall
have therein also all the rest and residue of my estate and effects not hereinbefore dis-
posed of (my debts and legacies being first paid) I give and devise unto my said grand-
daughter Jane Cox (. . .)
codicil:
(. . .) my gold watch and chain I always promised it to Lady Abdy (being a good goer)
I hope she'll wear for my sake if Lane lives with me at my death I desire she may have
my chest of drawers that stands in the closet by my bedside in Chancery Lane all my
caps I wear days and nights drest and undrest six of my shifts my ruffles and stript
musling aprons which things I did not name in my will also my little prayer book
preparatory for the sacrament and all my night gowns and six neck handkerchiefs and
black under petticoats and black hoods (. . .)

Right Honourable Lady Barbara Leigh, PROB 11/813, quire 17,
 fos. 138-40
Signed 18 August 1750
Proved 18 January 1755

(. . .) And whereas I am as yet not able to judge of the amount of my personal estate
and tho' very desirous to testify my regard for my nearest relations and ffriends and
give several legacys among them yet I should mean them only as tokens of my love
and respect knowing what I could bequeath to their ample ffortunes would not make
any very considerable addition Therefore I hope I shall not be suspected of any disre-
gard for any of them when I give will and dispose of my effects in manner following.
First I give will and bequeath unto my neice the right honourable Lady Barbara
Montague the sum of ffive hundred pounds of lawful money of Great Britain to be
paid unto her by my executors hereinafter named and hereby appointed within six
months next after my decease Also I give unto Mrs ffrances Pearce the sum of one
hundred pounds of like lawful money <. . .> also I forgive discharge and release Mr

Charles Sale of and from the payment of all sums of money debts and demands what-
soever on special or simple contract that he shall owe me at the time of my decease
either in my own right or as executrix to my late husband deceased who I well know
intended the same Also I hereby give will and bequeath unto William Hayton of
Ivinghoe in the county of Bucks esquire and ffrancis Welles of Bosvile Court in the
county of Middlesex gentleman and to the executors, administrators and survivors of
them the sum of six hundred pounds of lawful money of Great Britain to be paid to
them by my executors hereinafter named within one month next after my decease out
of my personal estate In Trust and to the intent that they the said William Hayton and
ffrancis Welles or the executors or administrators or suvivors of them do immediate-
ly lay out and invest the said sum of six hundred pounds in the purchase of South Sea
annuitys or some other Government securitys and after deducting their reasonable
charges and expences in purchase thereof and in the execution of the said trust out of
the profits interest and dividends of the said stock pay unto Mary Thompson now
residing in almshouses at Watford in the county of Hertford for and during the term
of her natural life the yearly annuity or sum of six pounds of lawful money of Great
britain without any deductions unto whom I give the said annuity and direct the same
to be paid unto the said Mary Thompson by two half yearly payments <. . .> Also out
of the further profits interest and dividends of the said stock or government securities
to be purchased as aforesaid pay unto Mary Brinklow late my servant the yearly
annuity or sum of ten pounds of like lawful money <as with Mary Thompson> and
the residue and overplus of the said interest produce and dividends of the said stock
<. . .> from and after the payment of the said annuitys and from and after the death
of the said annuitants as they severally and respectively cease and determine and all
reasonable charges in the execution of the said trust are disburst allowed and paid I
will and direct to be paid transferred or otherwise assigned unto my executors or the
executors or administrators of the survivor of them for the use of and to be divided
and paid unto the person or persons to whom I give and shall be entitled unto the rest
and residue of my personal estate <. . .> Also I give the sum of fforty pounds of
lawful money unto my woman Henrietta York if living in my service at the time of
my decease payable within three months next after Also I give all my cloaths and
apparel whatsoever unto the said Henrietta York if living in my service at the time of
my decease Also I give unto my servant Mary Whitely the sum of thirty pounds of
like lawful money <payable as above> Also I give unto John ffranklin Steward in my
ffamily the sum of twenty pounds <payable as above> Also unto Robert Heywood
my servant the sum of ten pounds <payable as above> and to all and each and every
of my other menial servants both men and women that shall be living with me and in
my service at the time of my decease (not hereinbefore particularly named) I give five
pounds <payable as above> thinking these my several legacys will be of more service
to all and every my servants than mourning apparell at my ffuneral Also to the poor
inhabitants of the town of Leighton in the county of Bedford I give the sum of ten
pounds and desire it may be distributed in bread at the discretion of my executors
within fourteen days next after my decease And for my personal estate whatsoever and

wheresoever whereof I shall be possessed or entitled unto the time of my death or of what nature kind or sort soever the same doth may or shall consist wherein I have any controul or right of disposition not herein before given and bequeathed I fully freely absolutely and entirely give and bequeath the same and every part thereof unto my two neices vizt to the right honourable Lady ffrances wife of Sir Roger Burgoyne Baronet and the right honourable Lady Charlotte Johnstone wife of major James Johnstone daughters of my dear sister the Right honourable the Countess of Halifax deceased to be equally divided between them share and share alike, < . . .> And this my legacy and bequest of the share of my estate to my said neices I will shall be for their own several and respective sole and separate use and uses and not subject to the controul or lyable to any disposition whatsoever of their present husbands And my espress will and mind is that the interest and yearly produce only of the respective shares of the rest and residue of my said estate and effects so given to the Lady ffrances Burgoyne and Lady Charlotte Johnstone shall be paid to them during the lives of their husbands and in case my neices severally survive their respective husbands then the whole principal of such their respective shares shall be for their own uses and at my said neices respective disposalls But in case of the death of Lady ffrances Burgoyne before Sir Roger Burgoyne Then I give her share and interest so given and bequeathed unto her two daughers Miss ffrances and Miss Louisa Burgoyne equally to be divided between them share and share alike and in case either of the said children dye before it arrives to the age of eighteen years then the share of that child to go to the survivor of such children and for that purpose I only allow the interest of such child or childrens share to be paid for maintenance and education untill the share of such child or children becomes due and payable or so much thereof (yearly increasing the same) as my executors or the survivor of them shall think proper to allow but the share of the said Lady Charlotte Johnstone I will and direct in case of her death before her said husband Major Johnstone shall be intirely at her disposal to all or any of her children in such manner shares and parts as she by any will or writing under her hand shall direct which will writing and disposition Then to and amongst all and every here chidren that shall be living at the time of her decease share and share alike and the shares of him her or them dying before such child or children arrives to the age of eighteen years to go and be paid to the survivors or suvivor of them and I allow and direct the interest of such child's share to be paid towards its maintenance and education until the share of such child becomes payable or so much thereof as my executors of the survivor of them shall think proper (. . .)

codicil:

My affairs being now settled and not having time at present to alter my will makes me write this to give to Lady Barbara Montagu my neice five hundred pounds more than I left her in my will and to my servant Susan Burton eight pounds a year during her life to be paid out of what I have left Lady ffrances Burgoyne and Lady Charlotte Johnstone to be paid quarterly (. . .)

codicil:

I give at my death to Lord Scarbrough his Grandfather's Richard Earl of Scarbrough's

picture and his Grandmother's ffrancess Countess of Scarbrough's picture and his ffather's Thomas Earl of Scarbrough and his mother's ffrancess Countess of Scarbrough's pictures and his uncle the honble James Lumley's picture. I give to Mrs Eliza Bowes her brother Mr Bowes's picture and I give my sister Verney's picture to my neice the honble Miss Mary Leigh it is that that is in the parlor and I give to Mrs Jane Bowes my neice the honourable Mrs Bowes picture I give to my neice Lady Charlotte Johnston her mother's Mary Countess of Halifax's picture I give to Lady ffrances Ludlow my sister Lady Ann ffranklin's picture and to Lady Ann Sanderson my sister Lady Harriotte Lumley's picture and I give to Lady Ann Jekyll my emerald ring set round with diamonds and I give to Lady Betty Arther my ruby ring set round with diamonds (. . .)

Dame Mary Wrey, PROB 11/790, quire 296, fo. 372
Signed 4 July 1750
Administered 5 October 1751

(. . .) To whom my dear ffriend and beloved husband I give and bequeath and to his heirs or assigns as by my marriage settlement I am empowered to do in case I die without leaving any children the sum of four thousand pounds left me by my uncle John Schoppens and payable after the decease of my dear ffather with the following deductions that is to say the sum of twenty pound apiece to my much esteemed ffriends Mrs Elizabeth Watson and Mrs Diana Barker which I give them to purchase any small token for my remembrance and as I think it a real charity I give the sum of one hundred pounds to my cousin Elizabeth Swindell to be paid as likewise the afore-said two legacys by my said dear husband his heirs or assigns within twelve months after the said four thousand pounds are received and in case she is not living at that time to her child or children to be equally divided amongst them but if she does not leave any children to her own sisters in equal shares (. . .)

Dame Frances Gifford, PROB 11/794, quire 93, fo. 40
Signed 16 July 1750
Proved 10 April 1752

(. . .) I give and devise all and singular the rest and residue of my real and personal estate unto my dear sister Mary Lady Arundell her heirs and assigns forever Item I give and devise unto Mrs Mary Naish widow one annuity or yearly sum of twenty pounds during the term of her natural life Item I give and devise unto Mary Brandis my servant one annuity or yearly sum of thirty pounds during the term of her natural life and I do hereby direct that the said annuities be paid half yearly free from all taxes and deductions whatsoever the first payments to be made at the end of six months next after my decease Item I give and devise unto Mrs ffrances Wale one annuity or yearly

sum of six pounds during the term of her natural life to be paid in the same manner with the annuities before mentioned Item I give and devise unto the countess dowager of Litchfield to Lady Jenegan widow of Sir John Jenegan deceased and to Henry Beddingfield Barrt the sum of one hundred pounds apeice to be paid within six months after my decease Item I give and devise unto John Hamie son of John Hamie of Brinsome in Dorsetshire the sum of one hundred pounds to be paid him within six months after he shall have attained the age of one and twenty years (. . .)

The Lady Anna Margaretha Ittersum otherwise Des Marets,
 PROB 11/792, quire 14, fos. 111–12
Signed 22 December 1750
Translated 19 December 1751
Proved 15 January 1752

(. . .) she testatrix declared her only son and child Mr William Hendrick Verbrugge ruling magistrate of this city begotten in her former marriage with Mr Rutger Verbrugge when living councell in the high councill of Holland Sealand and Wostfriesland and all the ways her sole and universall heir of all her chattels none of them excepted as well present as to come where ever they might lay and specially also of the stock credits and presentations which she might leave in the Kingdom of England in the South Sea Company as elsewhere and declared him also executor of this her testament and last will. Lastly she declared the within to be her testament and last will desiring that the same shall be of full fforce and effect either as testament cod-icill donation in case of death or among the living under what ever denomination the same shall or may best subsist notwithstanding all the solemnitys of the law hereto required might not have been observed nevertheless leaving to enjoy the utmost benefit all with the exclusion of the managers of the orphans chamber and supreem guardians as well here as elsewhere where she shall happen to dye or her chattels shall lye not willing or desiring that they anywise shall trouble themselves therewith save their respect and reverence (. . .)

The Right Honourable Mary Viscountess Dowager Preston,
 PROB 11/843, quire 30, fos. 238–9
Signed 15 June 1751
Proved 18 June 1759

(. . .) I direct that the sum of twenty pounds shall be distributed amongst the poor of that parish whom my executrix shall esteem the most indigent and deserving also I give and bequeath unto each and every one of my cousins German (the sons and

daughters of my late Uncle the Reverend Mr Darcey Dalton deceased) that shall be living at the time of my death the sum of one hundred pounds and to each and every of the sons and daughters of my said cousins Germans whom I have represented in Baptism and who shall be living at my death the like sum of one hundred pounds and my intention is that the said legacies to my godchildren who shall be under age shall be paid by my executrix unto the ffather or mother of such godchild notwithstanding its infancy and that the receipt of such ffather or mother shall be a good discharge to my executrix for the same also I give and bequeath unto my sister in law the right honourable the Lady Widdrington in case she be living at the time of my death the sum of ffive hundred pounds part of the sum of one thousand three hundred and seventeen pounds ten shillings and six pence secured to me by bond bearing the date the ffifteenth day of June 1750 and to be paid to my executors or administrators within three months next after my decease and the remainder of the said sum of one thousand three hundred and seventeen pounds ten shillings and six pence I give to Mr ffrancis Charles Graham second son of the late Reverend Mr Charles Graham deceased if he lives to attain the age of two and twenty years and in that case the said Lady Widdrington shall dye in my lifetime then I give the whole of the said sum <. . .> to the said Mr ffrancis Charles Graham and I do direct that when and so soon as what I hereby give to the said Mr ffrancis Charles Graham shall be received upon the said bond that the same be placed out by my executrix in her own name in some of the publick funds or other good security carrying interest and that the interest thereof as well as the interest before it be so invested shall from time to time be paid and applyed for and towards the maintenance and education of the said ffrancis Charles Graham untill he shall attain his age of two and twenty years at which time I desire the same may be paid or the security in which it shall then be invested transferred to him but in case the said ffrancis Charles Graham shall happen to dye before his said age of two and twenty years my intention is that the said legacys thereby intended for him shall fall unto the residuum of my personal estate Also I give and bequeath unto my servant Mrs ffrances Byewater the sum of one hundred pounds and all my cloaths linnen and wearing apparel also I give and bequeath unto and every one of my other servants who shall be living with me at the time of my death and who shall then have lived in my service for the space of one whole year then next preceeding one years wages over and besides what I shall then owe them for wages or otherwise and as to the rest and residue of my plate jewells household goods ffurniture ready money securities and all other my personall estate whatsoever and wheresoever after my debts legacys and funeral charges are paid and satisfied I do hereby give and bequeath the same unto my much esteemed ffriend Mrs Lucy Skipwith as an acknowledgment of the happyness I have enjoyed in her long and sincere ffriendship also I give and devise unto the Lord Viscount Stanton George and his heirs a small ffee ffarm rent or other <word illegible> rent of ffour pounds a year or thereabout issuing out of part of his estate in the county of York and payable to me and my heirs (. . .)

Dame Barbara Ward, PROB 11/822, quire 126, fos. 196–7
Signed 12 February 1752
Proved 8 April 1756

(. . .) I give and devise to the said Sir Randall Ward my grandson and to his heirs for ever all my ffarm in Weston in the county of Suffolk with all the lands houses as they belong to the said ffarm as they are now in the occupation of my tenant William Brown I say all the lands as hired by him of me in the town of Weston or in any other town near it I say I give them all as they are now in my tenant Brown's occupation I give them all to my grandson Sir Randall Ward and to his heirs forever I also give him <. . .> all my manors of Weston or of any other town all my copyhold rents and ffree rents and all my ffines or any advantage whatsoever belonging to me out of my manors <. . .> I also give to my grandson Sir Randall Ward all my ffarm in Alburge in the county of Norfolk <. . .> with the two manors, that called Payns Manor and that called Waits Manor <. . .> I give all the lands houses outhouses as these are now in the occupation of my tenant John Burges <. . .> As to the estate that belong to me, the Kirby estate I do give that to my grandson <. . .> I give to my grandaughter Susan Ward fifty pounds to be paid ten months after my death. I give to my daughter Lady Ward a twenty shilling ring. I give to Sister Elisabeth Ward a guinea a year to be paid her as long as she lives. I give to the poorest in this parish of Saint Michael of Ple two guineas. I give to the poorest of people in Weston forty shillings, and a guinea to the poorest in Alburg, let this money be disposed of as Burges think proper and the 40s as Brown of Weston think fit. I give to Edger my servant five pounds if he be my servant at the time of my death. I give to Cathering Gordin five pounds if she be my servant at the time of my death. I give to Mary Judg five pounds if she be my servant at the time of my death I give my two maid servants all my wearing cloaths and wearing linnen, I do not mean household linnen. I give nephew Buxton and his brother Lenard Buxton each a ring and to nephew Warsham a ring. You may do as you think proper to give more rings to my own neices or not. I give to my grandson Sir Randall Ward all my plate, arrears of rent and all my ready money and all my household goods and ffurniture whatsoever <. . .>

The two ffarms in Plumsted which was in joynture to me I always desired my grand-son Sir Randall Ward should have the profits of them from the time of his brother Sir Edward Ward's death and his ffather's (. . .)

The Right Honble Letitia Cecil Countess of Exeter formerly
 Townshend and late Lady Burghley, PROB 11/822, quire 135,
 fo. 269
Signed 14 January 1753
Proved 13 May 1756

By this my will or writing in the nature of a will I give bequeath declare limit and appoint the yearly interest dividends rents and income of all the personal estate what-

soever which by the will of my said late ffather I have power to dispose of to my said husband the Lord Burghley and his assigns for and during the term of his natural life (. . .)

Dame Anna Maria Shaw, PROB 11/819, quire 328, fos. 335–6
Signed 24 May 1753
Proved 16 December 1755

(. . .) I impower my executor hereinafter named to give mourning rings to such of my relations and ffriends as he shall think fit I will that all my just debts and the charges of my ffuneral (to be performed in the manner before directed) to be paid in the first place I give to my grandson John Shaw all my plate my repeating watch gold chain and cornelian seal set in gold my single stone brilliant diamond ring and the hoop diamond ring which I usually wear my diamond girdle buckle and all such peices of gold as shall be found under a cover directed for my said grandson all which particulars I desire may be preserved for and delivered to my said grandson upon his attaining his age of twenty one years Item I give to Lady Shaw my daughter in Law my pearl necklace and pearl ear rings with the diamond bowes thereunto belonging and my diamond stay buckles Item I give to my son in law Peter Johns esquire two hundred pounds for mourning and to my sister Shaw ffifty pounds for mourning Item I give to my nephew John Williams esquire and my neice Charlotte Maria Williams his wife and to my nephew Thomas Byres esquire and my neice Elizabeth Byres his wife twenty pounds a peice for mourning Item I give to Edward Radcliffe esquire twenty guineas for a ring as a small acknowledgement of the many ffavours which I have received from him Item I give to my good ffriend Mrs Mary Bridges one annuity or yearly payment of one hundred pounds to be paid to her during her life free from all deductions whatsoever by four equal quarterly payments on the four most usual ffeasts or days for payment in the year (that is to say the annunciation of Blessed Virgin Mary the nativity of saint John the Baptist the ffeast of saint Michael the archangel and the Birth of our Lord Christ) the ffirst payment to be made on such of the said days of payment as shall next happen after my decease and in case a ffund for securing the one and punctual payment of the said annuity cannot be conveniently made out of my personal estate (which I devise may be done if it conveniently can be) Then I charge all my ffreehold mannors messuages Lands and hereditaments (Except such part thereof as I have hereinafter devised to the use of my said Grandson and the heirs of his body) with the payment thereof in the manner aforesaid Item I give to the same Mrs Bridges the following things vizt my new ring set with diamonds which I made in remembrance of my late dear daughter my silver saucepan engraved with my widows arms my yellow damask bed with the bedstead and ffeather bed curtains blanketts bolster pillows quilt and worked counterpain and the window curtains and chairs thereunto belonging and also my stone shoe buckles and sables tippett Item I give to Mrs Elizabeth Bridges ffifty pounds and to Mrs Sarah Marriott twenty pounds and to the Reverend Mr Christopher

Dodson ffifty pounds I give to Mrs Shaw the widow of Mr George Shaw one annuity or yearly payment of ten pounds during her life free from all deductions <. . .> Item I give to Mrs Mary Curtis of Eltham a like annuity of ten pounds during her life <. . .> but subject to this express condition in case the said Mary Curtis shall be put into the workhouse at Eltham contrary to my desire and intention then and in such case the said annuity to her shall from thenceforth utterly cease Item I give to ffrances Scoffield my maid who now immediately attends me all my cloaths wearing apparel and linnen except such of my laces or point as my son may choose to take in case he shall see fitt to take any of them and I further give to the said ffrances Scrofield <sic> the sum of thirty pounds Item I give to such of my menial or domestick servants (except the said ffrances Scofield) as shall have been one year or more in my service at the time of my death the amount of a years wages each and to such of them as shall not have been one year in my service the amount of half a years wages and I give to Richard Mason (who was formerly my coachman) ffifteen pounds in case he shall be living with me at the time of my death Item I give to such poor persons of the parish of Eltham as my executor shall judge to be the most proper objects thirty pounds to be distributed by him in such shares and proportions as he shall think fit Item I give to the poor of Ewerby Buskington and Haverholme in the county of Lincoln or to such poor persons in these place as my executor shall think fit the sum of ten pounds to be paid to or amongst such poor or poor persons in such proportions and manner as he shall likewise think fitt Item I give to such poor persons of Cavendish in the county of Suffolk as I have been used to give bread to the sum of seven pounds and to the poor of Brightwell three pounds and I leave the payment distribution and proportions of the two last mentioned sums to the discretion of my executor and all the rest and residue of my personal estate of every nature and kind (after the payment of my debts ffuneral charges and legacies) I give to my dear son Sir John Shaw for his own absolute use and I do hereby name and appoint him sole executor of this my will and whereas upon the death of Arthur Barnardiston the son of my late cousin Arthur Barnardiston deceased divers ffreehold manors messuages Lands tythes ffee ffarm rents and hereditaments in the Counties of Suffolk Cambridge and York and in the City of London lately descended and come to me and my said heires Charlotte Maria William and Elizabeth Byres as coheirs of Sir Samuel Barnardiston heretofore of Brightwell aforesaid or otherwise (that is to say) one full undivided moity half part thereof to me and my heirs and the other undivided moity to my said neices and their heirs as tenants in common but subject as to part thereof of the yearly value of eight hundred pounds of hereabouts to an estate for the life of Mary the widow of my said late cousin Arthur Barnardiston in jointure and all my revisionary estate and interest therein unto and to the use of my said grandson John Shaw and the heirs of his body lawfully begotten and for want of such issue I give and devise the same unto and to the use of my said son Sir John Shaw and his heirs and assigns and as to all the ffarm rents tythes and hereditaments whatsoever and wheresoever whereof I am owed or possessed of or in anyways entitled unto in possession reversion remainder or otherwise I give and devise the same unto and to the use of my said son Sir John Shaw his heirs and assigns

to hold the same to line and them to his and their own use for ever and I do hereby authorize and impower my said son in case the said estate hereby given to my said grandson shall by the death of the said jointress come into possession during his minority to take the care and arrangements thereof untill my said grandson shall attain his age of twenty one years and to make and grant such leases thereof or of any parts or part thereof to such person or persons for such terms or numbers of years and for such rents and upon such conditions as my said son shall think fit and also to place out or invest the rents and profits thereof or any parts thereof from time to time upon or in such of the publick ffunds or other securities for the benefit of the said estate and interest of my said grandson untill he shall attain his said age of twenty one years and lastly it is my will that my said son shall not be answerable or accountable for any involuntary loss or damage that may anyways happen to the said estate hereby devised to my said grandson or the rents and profits thereof or the securities in or upon which the same or any part thereof may happen to be placed out or invested and that it shall be lawfull for my said son to reimburse himself of the said rents and profits all such charges expences and damages as he shall be put unto or suffer for or by reason of any act or thing to be done or performed by him in pursuance of the powers hereby given to him touching the said estate hereby devised to my said grandson as aforesaid (. . .) codicil

I leave to my brother Paggen Shaw twenty guineas for a ring I leave to my gardener Alexr Christe if he lives with me at my death ten pounds over and above his wages and to Mr John Snell attorney at law twenty guineas for a ring

Dame Sarah Cotton, PROB 11/803, quire 225, fos. 270–1
Signed 18 June 1753
Proved 3 August 1753

(. . .) I give to Mrs Jane Hart grand-daughter to my late husband and wife of Thomas Hart of Warfield in Berkshire esquire the picture of my late husband Sir Robert Cotton set in gold I give to Mr John Hart esquire her son the sum of one hundred pounds I give to Thomas Bowdler esquire of Ashley in the county of Wilts my copy of my late husband Sir Robert Cotton's picture his picture of his wife Mrs Elizabeth Stuart Bowdler and the picture of the late John Cotton junior esquire brother to the said Mrs Bowdler I give to the said Mrs Elizabeth Stuart Bowdler another grand-daughter of my late husband a large shagreen case containing twelve knives and twelve forks with silver handles and twelve silver table spoons and a large seal set in gold with a mans head engraven on a stone and four small r's engraven at the bottom of the head in this manner rrrr I give to Miss Jenny Bowdler her daughter a small sha-green case containing twelve knives with silver handles and twelve silver forks I give to Miss Betty Bowdler another of her daughters two silver candlesticks and a cornish diamond seal with the crest of the Cotton arms engraven upon it I give to Mr John Bowdler her son my large silver soup dish I give to Miss ffrances Bowdler another of

her daughters a pair of silver candlesticks I give to Miss Henrietta Bowdler another of her daughters two silver ragout spoons I give to Miss ffrances Cotton another grandchild of my late husbands the sum of one hundred pounds I give to Miss Mary Cotton another grandchild of my late husbands the sum of one hundred pounds I give and bequeath the sum of four hundred pounds unto Mrs Elizabeth Jones of Steeple Gidding aforesaid unto Edmund Lloyd of town of Cardiff in the county of Glamorgan esquire and unto Jenkin Lloyd esquire his brother to the survivor or survivors of them their heirs or assigns upon special trust and confidence that they the survivor or survivors of them their heirs or assigns shall place the same out to interest or purchase any estate or estates in ffee or custom hold to the value thereof and shall apply the interest of the money so placed out or the rent issues or and profits of such estate or estates as shall be purchased therewith to the sole use and behoof of Barbara Robins who now boards with Mary Lewis of <word illegible> Major in the county of Glamorgan aforesaid during her natural life and from and after her decease to the use and behoof of such child or children of the said Barbara as shall be then living lawfully begotten and for want of such issue my will and meaning is that from and after the decease of the said Barbara Robins the said four hundred pounds with the interest thereof then due & the estate or the estates purchased therewith and rents issues and profits thereof then due shall by my said trustees the survivor or survivors of them their heirs or assigns be disposed of in manner following that is to say the one half part therof to the children of Mr William Clemson of New Street Horsely Town in Southwark skinner to be equally divided between them and the other half part thereof to Mrs Elizabeth Wilson now of Steeple Gidding aforesaid spinster and to Mr John Wilson of the Bath Sadler to be equally divided between them and I do hereby impower and give full authority to my said trustees the survivor of survivors of them their heirs or assigns to sell or dispose of the estate or estates if purchased as aforesaid and the money arising from such sales to be divided in manner following that is to say to divide equally the one half thereof between the children of the said Mr. William Clemson and the other half thereof between the said Mrs Elizabeth Wilson and the said Mr. John Wilson and in case any or either of them should die before this bequest becomes due leaving lawful issue I hereby order that the child or children be intitled to and receive the same share or moity such parent would have had if the parent had lived till this Bequest becomes due and only one of them shall leave a child or children as shall be alive at the time this bequest becomes due as a mark of gratitude to my said trustees I desire they would be pleased to accept the sum of five guineas I give to my nephew Mr Pierre Cornish the sum of ten guineas I give to Miss ffrances Cotton aforesaid as a further legacy my large silver gilt chalice with its cover and case two china plates two table cloaths and two napkins which were constantly used when the holy eucharist was celebrated at my house I give to my nephew Mr William Clemson aforesaid the sum of one hundred pounds and in case he dyes before this legacy becomes due I give the same to his children to be equally divided between them I give to the children of the said Mr William Clemson one hundred pounds which I order and direct to be paid to the Reverend Mr Nicholas Brett of Springgrove in the parish of

Wye in the county of Kent and I desire he will apply this sum to their use according
to his discretion either in placing them out apprentices in assisting them to set up in
any business at their respective times of marriage or when they shall attain their
respective age of twenty one years as he shall judge to be most for their advantage I
give to my cousin Elizabeth aforesaid the further sum of ten guineas and the use of
two silver candlesticks without any arms engraven on them a silver pepper box a silver
tea pot a silver poringer and cover a silver half pint mug a silver cream pot six silver
sugar tongs during the term of her natural life and from and after her decease I give
to the same unto Mr John Wilson aforesaid I give to Mrs Elizabeth Wilson aforesaid
my gold chaced watch and chain six silver table spoons and all my wearing apparel I
give to Thomas Taylor provided he lives with me at the time of my decease the sum
of two guineas I give to all and every of my yearly servants that shall live with me at
the time of my decease the sum of two guineas each I give to the Reverend Mr
Nicholas Brett aforesaid the picture of a young gentleman set in a black and gilt frame
with a glass before it and drawn by Mr Hussey I give all the rest of my goods chattels
and estate of what kind or wheresoever it is unto my nephew Mr John Wilson afore-
said (. . .)
codicil:
Whereas I have given to my neice Elizabeth Wilson by payment of the same to my
cousin Elizabeth Jones in full discharge of the shop goods which the said Elizabeth
Jones left with the said Elizabeth Wilson the full sum of three score pounds and
whereas I have since given to her the further sum of eight pounds I hereby order and
direct my executors to pay her the further sum of thirty two pounds in case I do not
live to pay the same to her myself and whereas I have given directions to Mr Edmund
Lloyd of Cardiff to look out for a purchase of ffreehold or customhold lands in Wales
to the amount of ffour hundred pounds which purchase I have directed him to make
in the name and for the use of Mrs Elizabeth Wilson aforesaid as soon after he has
received the three hundred pounds owing to me by Mr William Thomas of
Duffinfrood with the interest that shall be thereon due as conveniently may be I
hereby order my executors in case this purchase is not compleated during my life or
in case I do not otherwise give the said sum of four hundred pounds in my lifetime to
the said Elizabeth Wilson to pay into the hands of Mr Edmund Lloyd so much as with
the money the money he shall have of mine in his hands shall make up the said full
sum of four hundred pounds which I hereby direct the said Edmund Lloyd to pay to
the said Elizabeth Wilson for her sole and proper use.

Right Honourable Constantia Viscountess Dupplin, PROB 11/803,
 quire 201, fos. 76–7
Signed 20 June 1753
Proved 3 July 1753
(. . .) I am intitled to the ffee simple and inheritance of and in a certain estate in

Wiltshire and Herefordshire or elsewhere expectant on the death of my mother and which said estates were the jointure of my said mother and my said mother having contracted several debts It is my will and desire and I do so order and direct that as soon as conveniently can be after my said mother's decease such a sum of money be raised by sale or mortgage of the said estates so in jointure aforesaid as shall be sufficient and necessary for the payment and satisfaction of the just debts of my said mother and contracted before and at the time of my decease and which shall remain unsatisfied and owing at the time of the death of my said mother and also I do direct and order the raising in like manner upon the said estates in jointure as aforesaid such a sum and so much as shall be necessary for the payment and satisfaction of the following legacies to wit I give and bequeath to Mrs Jane Williamson the sum of ffive hundred pounds also I give to her son Adam Williamson the sum of ffour hundred pounds to be paid to him provided he attains his age of one and twenty years and in such case as soon as conveniently can be but if the said Adam Williamson shall dye before his said age of one and twenty years then and in such case I will that the said legacy of ffour hundred pounds be accounted lapsed also I give to Lieutenant James Money of his Majesty's own Regiment of ffoot commanded by Collonel Rich three hundred pounds also I give to the Reverend Mr Birt of Gloucestershire ffifty pounds also I give to Mr Thomas Rolt junior twenty pounds and to his sisters the misses Rolt thirty pounds each also I give to my servants Mrs Margown, my chambermaid Isabel Stanley, my man servant James Unick and Mrs Delaney my cook a years wages and as for and concerning the before mentioned legacy of ffive hundred pounds to Mrs Jane Williamson It is my will and order that the same shall be paid by my trustees and executors herein after named to such person or persons as the said Jane Williamson shall under her hand direct and appoint in trust for such person or persons to pay and apply the same to the use of the said Jane Williamson or in such other manner as she the said Jane Williamson shall direct and appoint and without any intervention or any ways intermeddling of her husband Major Williamson it being intended for her sole benefit and advantage And my express will and direction further is that the said sums so to be raised for the payment of the just debts of my mother and of the said several legacies before mentioned shall be looked upon and deemed as a lyen <sic> and incumbrance upon the said estates in Wiltshire and Herefordshire in jointure as aforesaid and I do hereby charge the said estates with the payment thereof accordingly and I do devise and bequeath the said estates in Wiltshire and Herefordshire so jointured as before mentioned but subjected by me as aforesaid unto my husband the Lord Viscount Dupplin for him the said Lord Viscount Dupplin to hold and enjoy the same and the rents issues and profits thereof for and during the term of his natural life hereby giving power to my said husband of granting leases of the said estates in the manner usually limited to tenants for life and from and after the decease of the said Lord Viscount Dupplin I do devise and bequeath the said estates in Wiltshire and Herefordshire subjected and charged by me as aforementioned together also with certain other estates in Wiltshire Herefordshire or elsewhere the ffee simple whereof I am intitled to and which were the estates of my deceased ffather John Kyrle Erule of

Whetham in the county of Wiltshire esquire (subject to such incumbrances as they are now subject) unto Susannah Washbourne Anne Washbourne late Anne Shepherd and Hester Soames widow which said Susannah Washbourne Anne Washbourne late Anne Shepherd and Hester Soames are the three surviving daughters of my aunt Washbourne deceased and to the survivors and survivor of them, for them the said Susannah Washbourne, Anne Washbourne late Shepherd and Hester Soames to enjoy the rents issues and profits of all and singular the before mentioned several estates for and during the term of their natural lives share and share alike and from after the decease of the survivor of them the said Susannah Washbourne, Anne Washbourne late Anne Shepherd and Hester Soames then and in such case I do hereby devise and bequeath all the said several before mentioned estates which were my said late father's as well those Jointured as otherwise (subject nevertheless to the several incumbrances before mentioned) and all my estate, right, title and interest therein unto the said James Money and his heirs for ever (. . .)
codicil:
Whereas I am desirous that a monument be erected to the memory of my late cousin John Kyrle esquire commonly called the Man of Ross it is my desire that the sum of two hundred pounds be applied for that purpose and the character of him by the late Mr Pope collected as my executors shall think proper from his writings inscribed thereon by way of epitaph But this matter of the epitaph to be wholly in the discretion of my executors also I give and bequeath the the Reverend Mr John Rolt the sum of ffifty pounds for the benefit and use of his son also I give to Miss ffrances Erule sister of Sir Michael Erule thirty pounds also I give to the three daughters of my cousin the said Baynton Rolt esquire <. . .> the sum of one hundred pounds each to be paid to them at their respective ages of one and twenty years and in case either of them dies before that age the share or shares of her or them so dying shall go to the survivors and survivor of them I do hereby charge the estates in Wiltshire and Herefordshire by the within will mentioned to my mother's jointure with the raising and the payment and the satisfaction of these several sums and the like manner as I have made the several legacies mentioned in the within till to be a lyen and charge upon those estates also I give the sum of eight hundred pounds to be paid and applied by my said executors in their discretion towards the releif of the poor of the several parishes of Calne in Wiltshire and of those or such of the parishes as they shall think proper where my estates lie in Herefordshire (. . .)

Dame Cecilia Garrard, PROB 11/803, quire 205, fos. 108–10
Signed 4 July 1753
Proved 10 July 1753

(. . .) As for the worldly estate wherewith it has pleased God to bless me, both real and personal, I beqeath the same, and all my interests and estates therein, to my dear niece Mrs Cecilia Stanhope, my heir at law (she being the only surviving child of my late

Brother Sutton Stede esquire and wife of Charles Stanhope esquire) and to their son Edwyn ffrancis Stanhope esquire and I do likewise nominate and appoint them joint executors to this my last will and testament upon trust that they will do and perform the several trusts therein named and required of them. And first, that in case they find it necessary, they sell so much of my lands in Norfolk, as may pay off the mortgage thereon according to the will and appointment of my late dear husband in his last will and testament, and if need so require, any other of my just debts and legacies herein after named, in case my arrearages of rent and moneys owing to me at the time of my decease should fall short and not amount to sufficient for that purpose. To my butler John ffoster if he be living with me at the time of my decease, I will and bequeath the sum of thirty pounds to be paid him within a year after my death, as also the last new horse I bought for him to ride on, with the bridle and saddle. Which horse and bridle and saddle It is my will he be put in immediate possession of, which legacy I appoint in consideration of the sobriety, honesty and diligence with which he has acquitted himself ever since he has been in my service. I also further appoint unto him the three pronged ffork I commonly eat with, and my smallest two handled silver cup which hold as near as I can guess about a pint or not so much. To my own maid Hannah Whitley I give and bequeath a legacy of twenty five pounds. Upon condition that her ffather will upon the payment thereof advance as much more to make her up the sum of ffifty pounds, towards her maintenance and support and to enable her with the greatest ease and comfort to get her bread by any way of life she shall choose to put herself into. I also appoint for her my spotted almareen sack, my last new purple and white wrapping cotten gown, and my black and white one, and one full suit of head cloaths, ruffles and handkerchief as shall be chose out for her, as fit and proper by my niece Stanhope. I also give her my silver watch. To my cook Sarah Taylor I give ffive guineas and a suit of my head cloaths, ruffles and a handkerchief as my niece Stanhope shall think proper, and one of my shifts, the grey gown or sack I used to wear commonly and one of my black stuff quilted pettycoats. To my tenant Bartlett's daughter Alice I appoint a pair of my stays and a piece of new cotten I lately bought to make her a gown, also a hoop and fforty shillings in money over and above the wages that may be due to her at the time of my death. To my gardener William ffoster I leave five pounds, and to his brother Thomas ffoster my ffootman three pounds. To my coachman I bequeath five guineas, and over and above all these several legacies to my servants I further appoint to each of them a decent suit of mourning, that is to the men a suit of black cloth, or dark grey trimmed with black and to each of my maidens a petticoat gown, or night gown of Norwich crape, or dark grey popplin. I also desire my three Livery servants may have their liveries at their own disposal, though the year for their wearing them should not be compleated at the time of my death. I also leave to every one of my servants to each a silver table spoon of the oldest fashioned make, marked with my ffather's arms. To Samuel Starling and his wife Margery I leave to each the sum of fifty shillings, and to Mary Beck widow of William Beck, I appoint the sum of two guineas. To my cousin Mrs Alathea Tavernor I bequeath the sum of thirty pounds, to be paid her within a year after my decease. And further I desire my said

cousin's acceptance of my grey and white flowered silk sack, that is fflowered in a sort of point pattern upon a striped black and white ground, six of my shifts marked C. G. 52, and further a suit of my last made plain muslin head cloaths, with ruffles and handkerchief and my fflowered velvet capuchin. To my cousin Mr William Tavernor her son, I bequeath twenty pounds and to my cousin John Hide the sum of ten pounds. To Mr William Clark Great Great Grandson of my Grandfather Sir William Clark, I will and bequeath the sum of three hundred pounds, to be paid him, or laid out for him a such time and in such proportions as to my executors shall appear most to his advantage but not absolutely to become due and payable to him untill he shall have compleated his twenty fifth year, and in the mean time I will that they shall pay him quarterly forty shillings, which will amount to eight pounds per annum untill the time of the principal's becoming due, and from thence to pay him the full interest of the whole three pounds at the rate of ffour per cent but if the said William should chance to dye before he attains his twenty fifth year, then the said principal sum of three hundred to remain with my executors for their sole use and benefit. To his two aunts the daughters of the Reverend Mr Clark late of Norfolk deceased I will and bequeath a legacy of ten pounds to each. To my God daughter Mrs Cecilia Bendish, I give and bequeath all the arrear of rent remaining due to me from the widow ffenn, now payable to me by quarterly payments by Mr Rayment, as by an agreement with me by him Signed will more fully appear. And also all such further arrears which are since become due to me from the said Mr Rayment on his own account for the small ffarm he occupies of mine in the parish of East Ham, late in the tenure and occupation of the above named widow ffenn. I likewise leave to my said God daughter Mrs Cecilia Bendish a mourning ring. From the desire I have to testify my respect to such of my late dear husband's relations, who have shewed any regard or civility to me I give and bequeath to Mrs Mary Lynn, widow of Thomas Lowth Lynn esquire, the sum of fffity pounds, and to Nicholas Garrard Lynn esquire her son, the like sum of fffity pounds, he being my late husband's Godson, and to my little God daughter, his daughter, I leave my diamond girdle buckle, and silver coffee pott to be delivered to the care and custody of her Grandmother the above Mrs Mary Lynn, untill she shall attain such an age, as they may become useful to her my said God daughter. I likewise bequeath to Nicholas Garrard Lynn esquire, the whole length picture of his cousin the late Mrs Cecilia Kerridge. To honest Mr William Swanton of Woolwich I appoint a legacy of ten pounds in token of my good will, he having always behaved both toward Sir Nicholas and myself with a grateful sense of all ffavours received. To the Reverend Mr Wade of East Ham, I bequeath the sum of ffive guineas and a mourning ring. To Mr Sedgewick my apothecary I will the sum of ffive pounds, and to Mrs Sedgewick his wife a mourning ring. To the poor widows and other necessitous persons belonging to the parish of East Ham I leave the sum of fffity pounds, to be distributed amongst them by my executors in such manner and proportion as they shall judge the greatest charity and do most good. To Burton a cooper at Barking I forgive the debt he owes me, as also I do forgive the remainder of a debt owing to me by Thomas Glanwill a shoemaker at West Ham. To my cousin Ralfe ffreke esquire of Hannington in the

county of Wilts I will and bequeath the pictures of his uncle Thomas ffreke and his Lady late of Stroaton in Dorsetshire, if it shall please him to accept them, and appoint where he would have them sent. But in case he should not chose to have them, then I leave them to my cousin Mrs Bythesea daughter of my cousin Mrs Mary Lear deceased. I also leave to her and her sister my cousin Elizabeth Phelps to each a mourning ring. To my God daughter Miss Speidell daughter of Thomas Speidell deceased I leave the sum of twenty pounds to become due and payable to her in case she attains the age of ffourteen, and then to be paid by my executor or executors or their heirs or executors, to her mother or guardian to be laid out and appropriated to her use as they shall advise and direct, with her approbation and consent, and this I leave her because I was prevailed on by importunity to be her God mother. To the widow of Mr Spicer who was son to Mrs Spicer that once lived with me as my woman I leave the pictures of Mrs Robson and Mrs Maynard the aunt and cousin of the said Mrs Spicer. To Thomas Bowdler esquire of Ashley near the Bath, I leave my small picture of Charles the ffirst, set round with small diamonds as a token of my esteem. To my cousins John Spencer Colepeper esquire and his sister Mrs Ann ffotherby wife of John ffotherby esquire, I leave to each a mourning ring of ffive pounds value, as I do also to my long much loved and much esteemed ffriend and acquaintance the Lady Rook now wife of the Reverend and honourable Doctor Moore. To my careful and skilled physician Doctor Tebb, and to his lady I leave to each a mourning ring, as an acknowledgement for the diligent and obliging care with which he has attended me in several dangerous fits of sickness. To my esteemed old acquaintance the daughter of my good tenant Mr Chamberlain, now wife of Mr Dyer, I bequeath a mourning ring, as a token of my kind remembrance and regard for her. To my late good neighbours Mr Royston and his lady I leave to each a mourning ring, which I beg them to accept of, as a token of my thanks and remembrance for their civility. To Mr John Howell and his lady I bequeath to each a mourning ring, as I do also to Mr Snell and his lady. And to all my kind obliging ffriends who have been so good to enquire after me in my late sickness, I leave to each a mourning ring as a token of my esteem, and acknowledgement of their ffriendly civility. My set of dressing plate, and such of my jewells which my dear niece Stanhope shall not want for her own use I willl and bequeath to her dear son Edwyn ffrancis Stanhope esquire for a present (if he so thinks fit) to his lady whenever he shall marry, but till then it is my desire my said niece may have the use of them if she so choses. And further I will and bequeath to him the said Edwyn ffrancis Stanhope and his heirs for ever all my lands and estates in Igbrough, Standford and Tottington in the county of Norfolk, with the manors, royalties and priviledges thereto belonging, and the perpetual advowson of Igbro, and all my estate and interests therein, he performing the before mentioned trusts according to my desire and appointment. And further that he thereout shall pay unto my much esteemed worthy nephew Charles Stanhope esquire his ffather, and to my dearest niece his mother, to each for their sole and separate use, the sum of ffive hundred pounds, and in the mean season untill it may be convenient for my said dear nephew Edwyn ffrancis Stanhope to raise these two said sums, he shall pay to each in like manner the interest of the said

two five hundred pounds at the rate of four pounds per cent in half yearly portions. And for all the rest and residue of my estate whether real or personal whatsoever or wheresoever I leave and bequeath it to the full and free disposal of my dearly beloved niece Cecilia Stanhope and her heirs (. . .)

The Most Noble Frances late Dutchess Dowager of Somerset,
 PROB 11/810, quire 211, fos. 80–2
Signed 13 December 1753
Proved 12 July 1754

(. . .) I bequeath to my aforesaid son in law Hugh Earl of Northumberland the sum of two hundred pounds to be paid out in some ring peice of plate or other token of remembrance as a small acknowledgement of his constant ffriendship toward me also I give and bequeath to him one picture of the inside of a cabinet painted by old ffranks the two pictures of Windsor castle and Syon House both painted by Caneletti and also an original picture of Peter the ffirst Emperor of Russia painted by Clinsted Item I give and bequeath to my dear daughter Elizabeth Countess of Northumberland Baronets Percy Ewall and singular the lands messuages gardens barns orchards outhouses and mansion house called Percy Lodge in the parish of Iver and county of Buckinghamshire during her natural life and at her decease to go to her second son the honourable Algernon Percy but in case he should not be alive at the time of her death then I desire it may descend to Lady Elizabeth Percy or any other younger child which she may hereafter have as she may judge it the most proper and I also give her all my plate except such as is hereafter disposed of by this my last will and testament I also give her the small enamell'd picture of her dear ffather set round with brilliant diamonds (and would intreat her at her own death to give it to her second son the honbl Algernon Percy) I also give her all my water colour'd and enamel'd pictures except what may be otherwise disposed of in my last will and testament or given away in my lifetime I give and bequeath to the honourable Hugh Percy commonly called Lord Warkworth the sum of two hundred pounds to be paid out in a ring or some other token to remember me by and that I give him no more is not that I have less affection for him than for his brother or sister but because all I have would be a trifle among the great estates which he will inherit I give and bequeath to Lady Elizabeth Percy my grand daughter the like sum of two hundred pounds my brilliant diamond earings with three drops my pearl necklace of several rows a gold snuff box with a peice of enammel on the top given me by Queen Caroline when I was one of the Ladys of her Bedchamber a picture in enamel of my Grandfather Thomas Lord Weymouth a picture of her Great Great Grandmother Elizabeth Countess of Northumberland one original picture of my late dear Lord her Grandfather painted by Richardson one picture of Lady Mary Brook with a garland in her head painted by Sir Godfrey Kneller and her ffathers and mothers pictures both done by Hoare I give and bequeath to my Grandson the honourable Algernon Percy the sum of two hundred pounds I give to

ffrancis Lord Brooke the sum of one hundred guineas to be laid out either in a ring or some peice of plate in remembrance of me and one gold lockett with his mother's hair I give to Henrietta Louisa Countess of Pomfret one picture of cattle with a man woman and boy bought for me at Brussels by Andrew Mitchell esquire To ffrances the wife of General Bigot now living in Holland I give and bequeath my largest silver tea kettle lamp and plate thereto belonging But if she should not be alive at the time of my decease I desire it may be given to her daughter who is my God daughter I give to my good ffriend Mrs Mary Seare (in case she survives me) my largest silver two handled cup and cover but if she dies before me the cup to belong to my dear daughter the Countess of Northumberland I give and bequeath to James Ramsden esquire my second sized silver coffee pott and one pair of the second sized silver candlesticks and one small seal cut upon a pebble set in gold with these three letters engraved upon the pebble F:B:H: in a cypher with some ashes of my dear son Ld Beauchamps hair within the urn which makes the handle of the seal I give and bequeath to John Cowslad esquire a pocket etuie set in gold which contained one knife with a gold blade one pair of scizzars with gold handles one gold pencil and one pair of compasses I also give him twenty pounds in money I give to William Scarrock esquire my silver standish one pair of candlesticks with my late dear Lords arms and mine join'd and twenty pounds in money I give and bequeath to Mrs Catherine Payne the sum of one hundred pounds with all my wearing apparel lace linnen of all sorts whatever and twenty pounds a year during her natural life if she is in my service at the time of my decease otherwise she shall be only entitled to ffifty pounds I give and bequeath to Mr Charles Prince all my landaus chariots and chaises with all my coach and saddle horses not otherwise hereafter disposed of by this will or codicil I also give him the saddle and ffurniture which he commonly rides with and all the common livery saddles I also give him thirty pounds a year during his natural life if he is in my service at the time of my decease otherwise he shall only be entitled to the sum of one hundred pounds I give and bequeath to Mr George Lomas the sum of one hundred pounds a year during his natural life to be paid to him at the yearly ffeast of Saint Thomas the apostle I also give him his choice of any two of my saddle horses with the saddle pistols and ffurniture which he commonly rides with I also give him the standing clock upon the great stairs at Percy Lodge Daniel Luare maker and the following plate the small silver cup which was my mother's with one handle and a cover a silver tankard old ffashion and a silver hand candlestick which I always use in sealing letters and of my quarto bibles printed by ffield and 4 volumes of sermons in octavo by Mr Mason also give him the book case with glass door and the drawers under it which stands in my closet at Percy Lodge and the map screen in my house in Downing Street I give to Mary Crook my old house maid six pounds yearly (which was her wages) during her natural life I give to Mr Evan Humphrys my servant ffifty pounds I give to Mr David Williams ten guineas to buy something in remembrance of me I give to Mr William Odell of Stamford twenty pounds yearly during his natural life I give and bequeath to all my servants who shall have lived with me twelve months before my decease one years wages besides what is due to them and desire that they be maintained and allowed to stay in my house one

month after my decease if they cannot otherwise provide for themselves before that time I give and bequeath to Samuel Streeting now at school at Stanwell the sum of ffour score pounds to place him as an apprentice with some reputable tradesman but in case I should live till he is so apprenticed I then leave him only ffifty pounds to be paid at the expiration of his apprenticeship I give and bequeath to my worthy ffriend Dr Le Couroyer the sum of twenty guineas to be laid out in what he pleases in remembrance of me I give and bequeath to Mrs Catherine Talbot a small picture of two hermitts on copper painted by old ffranks I give to Mrs Ann Hodge if she is alive at the time of my decease the sum of ffifteen pounds yearly during her natural life I give to Mr James Hardy (if he is alive at the time of my decease) the sum of ten pounds yearly during his natural life I give and bequeath to ten poor industrious housekeepers of the parish of Iver and county of Bucks ffive pounds each to be disposed of by the Earl of Northumberland George Task and Thomas Parr esquires It is also my intention that if the interest of such monies as I shall dye possessed of in the publick funds should not prove sufficient for the payment of my just debts annuities and legacies that the remainder of my personal estate not otherwise disposed of by this my last will shall be sold to make up such deficiency and desire that eight thousand pounds may be kept in the ffunds as a security to the annuitants as long as any such there shall remain alive and upon the decease of the longest liver I give and bequeath to the honourable Algernon Percy the sum of ffive thousand pounds and to his sister Lady Elizabeth Percy the sum of three thousand pounds pounds if they shall have attained the age of one and twenty years at that time or else to remain in the Earl of Northumberlands hands till they have attained to that age and if either of them shall dye before they have attained that age their proportion shall devolve to him to dispose of as he shall chuse without be accountable to any person whatsoever It is also my desire that my poor carcase may not be given into the hands of any surgeon to be opened or seen by any person but the women that constantly attend in my chamber till I am decently apparell'd to be put into my coffin (. . .)

Dame Henrietta Hatton, PROB 11/808, quire 107, fo. 30
Signed 5 March 1754
Proved 26 April 1754

(. . .) Item I give to my dear sister Mrs Ann Astry all my household goods and also my plate and jewells and household linnen and all ffurniture wheresoever they be except I leave a letter with this my will disposing of some particular things to this my last will I make my dear brother Doctor ffrancis Astry and my dear sister Mrs Ann Astry joint executors and desire them to pay all my just debts and legacies Item I give to Sir Thomas Hatton one hundred pounds Item I give to Mrs Mary Hatton one hundred pounds Item I give to the Reverend Mr Christiphor Hatton two hundred pounds Item I give to my kinsman Mr ffairmeadow Penystone three hundred pounds Item I give to my God daughter Miss Barbara Hervey fifty pound Item I give to my kinswoman

Dorothy Ward the daughter of my cousin William Astry the sum of fifty pound to all
the servants that live with me at the time of my death one years wages I give to Mrs
Susanna Hatton one hundred pound Item I give to my kinswoman Mrs Manden
twenty guineas Item I give to my sister Mrs Susana Astry ten pound for mourning I
give to the poor of the parish of Bassingbourne twenty pound to be distributed
amongst the poor housekeepers I give to the poor of the parish of Long Stanton the
sum of twenty pounds to the poor of the parish of Harlington ten pound I desire these
legacys may be paid in six months after my decease and I desire all arrears of rent and
money not before mentioned when the ffuneral charges are paid to be equally divided
between my two executors (. . .)

The Right Honourable Lady Anna Elinora Shirley, PROB 11/810,
 quire 211, fo. 75
Signed 7 April 1754
Proved 12 June 1754

(. . .) I give to the poor where I dye twenty pounds thirty pence to the poor where I
am buried I give to Mrs Elinor Curzon one of my executrix an hundred pound for a
diamond ring Item I give to my neice Pigot to take care of my sister Lady Barbara
Shirley who has the misfortune to be blind one thousand pounds Item I give to my
neice Digby daughter to my sister Cotes ffive hundred pounds Item I give to my
Nephew Captain Washington Shirley my house in Conduit Street and all my pictures
Item I give to my nephew Earll fferrers an hundred pounds for a diamond ring to wear
for my sake Item I give to my nephew Mr Robert Shirley a hundred pounds and all my
ffurniture and plate except what is disposed in this my will My nephew Mr Walter
Shirley I gave in my lifetime a living that I gott of the Earl of Clanrickord I appoint my
nephew James Cotes the < ? > executor with Mrs Elinor Curzon to take the trouble
of her I leave him all that I dye intitled to except what I have given in this my
will (. . .)

Dame Phyllis Langham, PROB 11/813, quire 17, fos. 137–8
Signed 15 June 1754
Proved 13 January 1755

(. . .) Imprimis I give and bequeath unto my good ffriends Thomas Clarck of Clements
Inn in the county of Middlesex gentleman Johnnathan Stanton gun smith of the parish
of Saint Andrew Holdborn [sic] London and my daughter Sarah Johnson now the wife
of John Johnson silk dyer of the parish of Saint George in the said county my execu-
tors hereinafter named and to the survivors or survivor of them all my South Sea
annuitys or other securitys for money by me lent and all my household goods plate
jewells my watch my gold equipage thereto belonging and linnen and all other my

personal estate whatsoever all my wearing apparel In Trust that they or the survivors or survivor of them do sell and dispose of all my said household goods plate jewells and linnen my wearing apparell within three calendar months next after my decease and out of the moneys arising thereby and all other my personal estate do in the first place pay all my just debts and ffuneral expences and also within one month after my decease do pay the pecuniary legacys hereinafter mentioned (that is to say) unto my loving brother Isaac Ball of the parish of Saint Ann in the Liberty of Westminster necklace maker the sum of twenty pounds for mourning and unto each of my servants living with me at the time of my death the sum of five pounds And I hereby appoint direct and request the said Thomas Clark Johnnathan Stanton and my daughter Sarah Johnson to retain to their own use the sum of ten pounds each which I hereby give and bequeath to them for their trouble in executing the several trusts and powers in them reposed by this my will and that my said executors do in the next place after payment of my said debts ffuneral expences and legacys aforesaid place and lay out the remainder of the monies arising by the sale of my household goods plate jewells and linnen and as above mentioned in Government Publick ffunds or securities and do out of the yearly interest dividends and produce of my other annuitys stock money and personal estate pay and apply for and towards the maintenance of my Grand daughter Phillis Windsor the yearly sum of fifteen pounds in such manner as my said trustees in their discretion shall think fit without any power controul direction or appointment of her ffather in law John Johnson untill she shall attain the age of twenty one years and when she shall attain the said age of twenty one years then my will and mind is that my said trustees or the survivor or survivors of them shall transfer or pay over unto my said Grand daughter Phillis Windsor the sum of five hundred pounds for her own use and benefit But if my said Grand daughter Phillis Windsor shall happen to dye before she shall attain the said age of twenty one years then I do hereby order and direct that my said trustees do and shall pay the said principal sum of five hundred pounds to my daughter Sarah Johnson and as to all the rest residue and remainder of the principal sum and sums of money South Sea stock and annuitys hereby vested in and the survivor or survivors of them and also such other stock or annuitys which shall be purchased by them in the public ffunds as before directed. I do hereby direct and order that my said trustees shall pay unto my daughter Phillis Moore the sum of fifteen pounds a year out of the interest dividends and produce of my south sea annuity stocks by equal half yearly payments during her natural life only and that her receipt alone shall be a sufficient discharge for my said trustees for the same and as to all the rest residue and remainder of the principal sum and sums of money south sea stock and annuitys hereby vested in my said trustees and the survivor or survivors of them and also all such other stock and Annuitys which shall be purchased by them as before directed I do hereby direct and order that my said trustees shall pay the interest dividends and produce of the whole thereof to my daughter Sarah Johnson by equal half yearly payments during her natural life for her own sole use and benefit exclusive of her now husband John Johnson silk dyer and that her receipt alone shall be a sufficient discharge to any said trustees for the same and I also do give and

bequeath to my Grand daughter Phillis Windsor for after the decease of her mother my daughter Sarah Johnson the said remainder of my principal money stock annuity and personal estate not herein before disposed of I give to my Grand daughter Phillis Windsor or her assigns for her own use and benefit and I do hereby give devise and bequeath unto my said Grand daughter Phillis Windsor the other moiety of all my principal money stock annuitys and personal estate whatsoever not herein before disposed for her own use and benefit forever (. . .)

Dame Martha Parker, PROB 11/819, quire 324, fo. 325
Signed 26 July 1754
Proved 15 December 1755

(. . .) I give and bequeath unto my honoured uncle John Strong esquire the sum of ten guineas for mourning and to my dear brother in law James Mundy esquire and to my dear sister Letitia Mundy the sum of ten guineas each for mourning also I give and bequeath to my two neices and god children Lucy and Emilia Strange my nephew and godson Matthew Strange and to my great nephew and godson John Nares the sum of ten guineas each also I give and bequeath to my brother in law John Parker esquire and my sister in law his wife and to my two sons in law Thomas Parker and George Parker the sum of ten guineas each for mourning also I give and bequeath to my cousin Robert Drew esquire the sum of ten guineas for mourning and to my cousin Sarah Roberts the like sum of ten guineas I desire my said dear husband to dispose of my jewells between my daughters at such times and in such manner and proportions as he shall think proper and as to all my bank annuities standing in the names of my trustees the right honourable Sir John Strange late Master of the Rolls deceased and of the said James Mundy and as to all other my personal estate and effects which are in my power to dispose of and are not hereinbefore disposed of I give and bequeath the same unto my said dear husband whom I nominate and appoint sole executor of this my will (. . .)

The Honourable Mary Viscountess Dowager Midleton,
 PROB 11/822, quire 145, fos. 345–6
Signed 13 May 1755
Proved 2 May 1756

(. . .) I will and direct that on the day of my ffuneral there be given to the poor of the parishes of Wandsworth Pepper-hara and Whitley in the said county of Surry the sum of ten pounds each parish to be distributed among the several poor persons in such proportion as the respective ministers of each parish shall think fit and they to give an account of such their distribution to my son George Lord Viscount Midleton I give to my grandson and godson the honourable George Brodrick and the heirs of his body

the town and lands of Lissinota, Startnemaddery and Gortefohey in the county of Limerick with their and every of their appurtenances and I direct the rents and profits thereof to be applied by his ffather during his minority for or towards his maintenance and education without any account to be given thereof and for default of issue of my said grandson I give the same town and lands <. . .> to the said George Lord Viscount Midleton I give to all my servants that shall be living with me at the time of my death one years wages over and above all moneys that shall be then due to them for wages or otherwise I give to the Lady Ann Capell the diamond ring that was left me by my late brother the Earl of Essex I give to Miss Mary Brodrick one hundred pounds To Mary Pick ffrances Mary Pick Isabella Capell Morrison and Charlotte Collet fifty pounds each all the said money legacys to be as money is current in England I give to Mrs Clarke and Nurse Thomas the yearly sum of ten pounds apiece during their respective natural lives I give to Mrs White and William Drew the yearly sum of five pounds a piece during their respective natural lives the said several yearly sums to be paid tax and exchange free on the two most usual ffeasts or days of payment <. . .> I give all my wearing apparel of what nature or kind soever to my own servant Susanna Pick I charge all my real and personal estate whatsoever not herein before disposed of with the payment of my debts and the debts of my said late husband which shall be due and owing at my decease and with my money legacies and the aforesaid yearly sums and subject thereto I give and devise the same to my son George Lord Viscount Midleton his heirs executors administrators and assigns respectively desiring but no ways obliging him either in laws or equity to dispose of the same real estate either in his lifetime or at his decease to or amongst his child or children some or one of them in such manner as he shall think fit (. . .)

Dame Margaret Conyers, PROB 11/835, quire 7, fos. 57–8
Signed 4 May 1756
Proved 27 January 1758

(. . .) I bequeath all and singular my messuages lands tenements and hereditaments with their and every of their appurtenances lying and being at Woodhall or Pinner in the Paris of Harrow on the Hill in the county of Middlesex and elsewhere in the Kingdom of Great Britain unto and to the use of John Waller of Saint Neots in the said county of Huntingdon gentleman and Mordicai Hilton of Ormond street in the parish of Saint George the Martyr in the county of Middlesex gentleman their heirs and assigns for ever in trust nevertheless to sell and dispose of the same as soon as conveniently may be after my decease and to pay and apply the money arising by sale thereof and also the rents and profits thereof till the time of such sales unto and amongst my daughters Henrietta Maria Wollascot wife of William Wollascot esquire Charlotta Gastaldi wife of the honourable John Baptist Gastaldi the right honourable Teresa Countess of Traquair wife of the right honourable Charles Earl of Traquair and Elizabeth Conyers to be equally divided amongst them I give and bequeath unto

the said Charles Earl of Traquair and to my said daughter the countess of Traquair the sum of one hundred pounds apeice for mourning I give to the said Willaim Wollascot esquire the sum of one hundred pounds for mourning I give to my said daughter Elizabeth Conyers the sum of two thousand pounds and half my plate and china and also all the ffurniture of my bedchamber dressing room and closet and also the ffurniture of her own bed chamber and dressing room at Great Stoughton aforesaid I give to my Lord and Lady ffingall the sum of one hundred pounds apeice for mourning I give to the said John Waller the sum of seven hundred pounds upon trust that the said John Walller shall and do in his own name from time to time put and place out the same seven hundred pounds upon government or other real security or securities at interest in such manner as he shall in his discretion think fit and shall and do apply and dispose of the yearly dividends interest and produce thereof as the same shall from time to time during the natural life of my said daughter Charlotta Gastaldi arise or be received unto the proper hands of her my said daughter Charlotta to and for her own sole and seperate use and benefit to the intent that the same may not be at the disposal of or subject or lyable to the controul debts or engagemts of her present husband but only at her own sole and seperate disposal and upon ffurther trust that the said John Waller shall and do from and after the decease of my said daughter Charlotta pay apply and dispose of the said sum of seven hundred pounds unto John and Charles the two sons of my said daughter Charlotta equally between them share and share alike and in case of the death of either of them the whole thereof to the survivor of them provided always nevertheless that in case my said daughter Charlotta shall survive her said husband then my said trustee shall pay the sum of ffive hundred pounds part of the said sum of seven hundred pounds to my said daughter Charlotta to and for her own use and benefit and the sum of two hundred pounds residue thereof equally between her said two sons and in case of the death of either of them Then and my will is that the receipt of my said daughter Charlotta alone under her hand for the yearly interest and procedure of the said seven hundred pounds trust money shall from time to time notwithstanding her coverture be a good and sufficient discharge to the person or persons paying the same for so much thereof for which such receipts shall be given I give to my daughter Margaret Conyers at Bangor ten pounds I give to Mrs Castle ten pounds I give to Mr Hughes and his wife two guineas a peice to buy each of them a ring I give to every one of my menial servants who shall be living with me at the time of my death ffive pounds a peice over and above their wages I give to the poor of the parish of Great Stoughton the sum of twenty pounds to be distributed amongst such poor ffamilys in Great Stoughton aforesaid and in such proportions as my executrix shall think fit I give all the rest of my plate gold watch rings jewells and china (not hereinbefore given or disposed of) unto my said daughter Henrietta Maria Wollascot I give and bequeath all the rest and residue of my goods chattels and personal estate whatsoever not hereby particularly given and disposed of unto the said John Waller In trust and to the intent and purpose that he shall apply and dispose thereof unto the proper hands of my said daughter Henrietta Maria Wollascot or of such person or persons as she my said daughter by any writing under her hand

whether she shall be <word illegible – married ?> or sole shall from time to time appoint for the sole proper peculiar use of her my said daughter and of such person or persons and in such a manner as she shall think proper and I do hereby make and constitute my said daughter Henrietta Maria Wollascot sole executrix of this my last will and testament and desire she will keep and preserve all family pictures which I am now possessed of or intitled to and not to sell or dispose of the same or any of them (. . .)

Lady Catherine Gardeman, PROB 11/828, quire 50, fos. 26–7
Signed 27 September 1756
Proved 16 February 1757

(. . .) Whereas my late dear deceased husband Baltazar Gardeman did by his will bearing date the fifteenth day of July in the year of our Lord one thousand seven hundred and thirty nine devise three thousand and nine hundred bank stock to me and Mr James Gaultier deceased In trust to pay the dividends thereof to my son Montague Baron (who is since deceased) during his life and after the death of my said son he gave and devised the said bank stock to such person and persons as I should name and appoint by my last will and testament for this and their proper and absolute use now I do by this my last will and testament in pursuance of and by virtue of the power and authority given to and vested in me in and by the said will of my said late husband and of all other powers and authoritys whatsoever me hereunto enabling give bequeath devise nominate and appoint the said three thousand and nine hundred pounds bank stock to my three grandsons John Baron Basil Baron and Nicholas Baron equally to be divided between them share and share alike Also I give and bequeath to my said grandson Basil Baron the further sum of two thousand pounds Also I give and bequeath to my son Nicholas Baron and Dorothy his wife the sum of one hundred pounds each for mourning Also I give and bequeath to my grand daughter Catherine Baron the sum of one thousand and ffive hundred pounds and to my grand daughter Mary Baron the sum of one thousand pounds. Also I give and bequeath to my goddaughter Mrs Catharine Elizabeth Loubier the sum of three hundred pounds and to my god daughters Catherine Jansen and Catherine Thornton the sum of two hundred pounds each Also I give and bequeath to Mrs ffrances Pothill and Baltazar Gardeman Cottiby the like sum of two hundred pounds each Also I give and bequeath to the right honourable Richard Edgecumb and his second son Commodore Edgecumb the sum of one hundred pounds each Also I give and bequeath to the governors of the charity for the relief of the widows of such clergymen as have or shall be possessed of some ecclesiastical benefice or curacy within the Arch Deaconrys of Sudbury and Suffolk or elsewhere in the said county of Suffolk the sum of one hundred pounds And I do hereby order and direct my executors hereinafter named to pay to the trustees or managers of the hospital for the poor ffrench refugees in London the like sum of one hundred pounds and to the trustees or managers of the charity schools of Grey Coat

Boys and Blue Coat Girls in Ipswich in the said county of Suffolk the sum of thirty pounds to be applied and disposed of for such pious and charitable intents and purposes as the said trustees and managers respectively shall think fit and my will is that the receipts of the respective treasurers of the said society for the time being shall be sufficient discharges to my executors for the same Also I give and bequeath to my kinsman Mr Montague Baron the sum of twenty guineas to Mrs Cottiby widow of the late Mr Rene Cottiby deceased the sum of ffifty guineas to the reverend Mr Bolton the sum of twelve guineas and to Mrs Dolastond of London widow and to the widow of the late Reverend Mr Joseph Raymond deceased ffive pounds each and to Mrs Cooper daughter of the late Reverend Mr Thom three pounds Also I give and bequeath to Mr Michael Lejay of Exchange Alley London gentleman the sum of ffifty pounds and to Mr Samuel Cooper of Coddenham the sum of twelve guineas Also I give and bequeath to my gardiner Samuel Jay the sum of ffifty shillings to my servant Mary Carey the sum of fforty pounds to my servant Sarah Blythe the sum of thirty pounds to my servant Samuel Turner the sum of twelve guineas and to Hannah Turner his wife the sum of ten pounds to my servant Sarah Goodwin the sum of ffive pounds all which legacys above mentioned I will shall be paid within two months next after my decease Also I give and bequeath to the said Mary Cary yearly and every year during the term of her natural life one annuity or yearly sum of twenty pounds and to the said Sarah Blyth yearly and every year during the term of her natural life one annuity or yearly sum of six pounds both which said annuitys I will shall be paid by ffour equal quarterly payments <. . .> and my will is that the said Mary Cary Sarah Blythe Samuel Turner Hannah Turner William Suss and Sarah Godwin or any of them shall have left or been discharged from my service before my death then the respective legacys or annuitys of such servants who shall have so left or been discharged from my service shall cease and not be paid at all Also I give and bequeath to my said grandson John Baron all my books desiring that he will dispose of those relating to divinity according to the directions which I shall leave for that purpose Also I give and bequeath to my said grand daughter Catherine Baron my gold watch with the chain and seal thereto appendant desiring that she will make a present of the watch which I formerly gave her to her sister Mary Baron Also I give and bequeath to the said Catherine Baron my japan cabbinet my great cup &c with stones my two Cocaa shele <coconut shell > cupps ornamented with silver two of my best purses my silver basket for sugar and my dressing plate and candlestick belonging to the same Also I give and bequeath unto my said grand daughter Mary Baron my silver cannister for tea my gilded salver and the images of the virgin Mary and our saviour in amber Also I give and bequeath to my said grandson Basil Baron my silver stand dish for ink and my largest silver coffee pott Also I give and bequeath to my said grandson Nicholas Baron my next largest silver coffee pott and my silver handle knife and ffork with the spoon in the shagreen case Also I give to Mrs Gaultier the picture of her grandmother and of her sister and her sisters husband Also my desire is that the picture of my said late husband Baltazar Gardeman may always remain at the vicarage house in Coddenham aforesaid to which living he hath been so great a benefactor Also I give and bequeath all my china ware

of every sort to my said grand son John Baron and my said grand daughters Catherine
Baron and Mary Baron equally to be divided between them Also I give and bequeath
my coach chariot and horses and all my silver plate pictures linnen and household ffur-
niture (not herein otherwise disposed of) and also all the liquors and ffewell which
shall be in or about my dwelling house in Coddenham aforesaid at the time of my
death unto my said grandson John Baron Also I give and bequeath unto my said
servant Hannah Turner such ffour of my shifts and such four of my said late husbands
shirts as my executors shall think properest for her Also I give two third parts of the
remainder of my own wearing linnen and apparell and of my said late husbands shirts
and other wearing linnen to my said servant Mary Cary and the other third part therof
to my said servant Sarah Blythe Also I give and bequeath to the poor of the said parish
of Coddenham the sum of ten pounds and to the poor of the parish of Barham in the
said county of Suffolk the sum of ffive pounds to be distributed amongst them at the
discretion of my executors Also I give and bequeath all the rest and residue of my per-
sonal estate and effects of every nature and sort <. . .> to my said grand sons John
Baron Basil Baron and Nicholas Baron equally to be divided between them share and
share alike (. . .)

The Right Honourable Anne Lady Dowager Arundel of Wardour,

PROB 11/833, quire 319, fos. 298–9

Signed 17 May 1757

Proved 2 November 1757

(. . .) Whereas I have been appointed sole Executrix of the last will and testament of
my late husband Henry Lord Arundel of Wardour and taken upon myself the burthen
of the execution thereof and notwithstanding my best endeavour and care I have not
been able to collect sufficient effects of my said husband to pay all his debts and as the
ffund for the payment of those debts has been considerably increased by a late event I
desire that my executors hereinafter named shall take care to see all my said husbands
just debts discharged as soon as conveniently may be without putting the creditors to
the trouble or the estate to the expence of carrying on the suit already commenced by
the creditors in the high court of chancery for the recovery of their debts also it is my
will that all my own particular debts and the expences of my ffuneral shall be paid
with all convenient speed. also I give to my brother in law Sir Robert Throckmorton
my executor hereinafter named the sum of one hundred guineas to be taken in the
first place after the payment of my debts and ffuneral expences for the trouble he shall
be at in the execution of this my will all the rest and residue of my estate and effects
whatsoever and wheresoever and of what nature and kind soever I give devise and
bequeath unto my said brother in law Sir Robert Throckmorton upon trust to pay
apply and dispose thereof unto and amongst such person or persons and for such uses
intents and purposes and in such manner and fform as I shall by any writing or writ-
ings under my hand purporting a codicil or codicils to this my will give devise limit

direct or appoint the same and for want of such gift <. . .> to pay three hundred guineas thereout unto and to the sole use and benefit of my sister Lady Mary Herbert and to the surplus thereof to pay the same unto and between my nephew and niece George Throckmorton esquire and Mrs Mary ffitzherbert son and daughter of my said brother in law Sir Robert Throckmorton (. . .)

codicil

(. . .) to Mr Edward Withy the sum of twenty pounds and to Mrs Jane Clerke formerly my servant the like sum of twenty pounds to Mary Duval my woman all my wearing apparell linnen and woollen and a years wages over and above the wages due to her at my death to Jemima West my cook and ffrancis Lee my butler each of them a years wages over and above the wages due to them at my death and to William Ridsdale my coachman Lucy Garget my housemaid and to Philip Norton my ffootman each of them half a years wages over and above the wages due to them at my death and to Mr John Jamart I give the sum of ten pounds I also give the sum of five pounds to the said Jemima West more than is above given her and I give bequeath and appoint three hundred guineas as mentioned in my said will unto and to the sole use and benefit of my sister Lady Mary Herbert and the residue of my estate and effects unto and between my nephew and neice George Throckmorton esquire and Mrs Mary ffitzherbert as mentioned also in my said will (. . .)

Dame Elizabeth Collett, PROB 11/835, quire 7, fo. 57
Signed 26 June 1757
Proved 31 January 1758

(. . .) I give unto my son James Collett the sum of fforty pounds and ten pounds more for mourning To my ffive grand children Timothy and Elizabeth Laugher Samuel John and Elizabeth Clayton the sum of ten pounds each for mourning to my loving brother Mr Nicholas Skinner twenty pounds for mourning I give unto my neice Susannah Skinner daughter of my said brother all my jewells that were my late honoured mothers I give unto the servants living with me at the time of my decease two guineas each and as to the land house and ffurniture left me by Mrs Mary Skinner my will is it should be sold and also my house in which I now live and lately purchased of William Green with the ffeilds to them belonging lying near the said houses with three acres in the marsh The house I lately fitted up and repaired with the ffurniture I give and bequeath to the Reverend Mr Timothy Jollie and ground belonging to it to him and his heirs forever and all the rest and residue of all and singular my monies securities for money stocks goods chattles and personal estates whatsoever that shall be and remain after my debts legacies and ffuneral charges shall be paid and satisfied I give and bequeath to my said brother Mr Nicholas Skinner and his heirs (. . .)

The Right Honourable Jane Viscountess Dowager Gage,
 PROB 11/833, quire 301, fos. 152–3
Signed 26 July 1757
Proved 17 October 1757

(. . .) I give and devise unto my dear son Charles Jermyn Bond esquire all that my mes-
suage or tenement situate and being at Saint Edmunds Bury in the county of Suffolk
with the coach houses stables offices out houses yards gardens and other the appurte-
nances thereto belonging and also all my estate right interest property claim and
demand in and to the same and likewise all the household goods pictures ffurniture
and all other things in and about the same And also the little ffield piece or parcel of
meadow or pasture at the end of the said garden with the appurtanances thereto
belonging to have and to hold the same unto the said Charles Jermyn Bond and the
heirs of his body lawfully issuing and for default of such issue I give and devise the
same unto Henry Bond merchant now or lately residing at Lisbon in the kingdom of
Portugal and the heirs of his body lawfully issuing and in default of such issue I give
and devise the same unto the heirs of the body of Mr James Bond late of Yorkshire
deceased who was brother of the said Henry Bond and in default of such issue I give
and devise the same unto Mrs Judith Bond of Huey near the city of Namur for the
term of her natural life and after her decease I give and devise the same unto my own
right heirs. I give and bequeath to Miss Charlotte Bond the sister of Sir Charles Bond
baronet five guineas for mourning and ten guineas to carry her to Wales if she should
go thither. I give and bequeath to Mrs Charlotte Bond of East Street near Red Lyon
Square and to Mrs Elizabeth Dunne of the same place the sum of ten guineas apeice
for mourning. I give and bequeath to Mary White, if she shall be living with me at my
death, the sum of twenty pounds over and above the wages that shall be due to her
and also all my cloaths except those that have gold or silver in them and likewise
except a white satin gown and petticoat all which I desire may be reserved for my said
son Charles Jermyn Bond and I do hereby give the same to him to make use of for
church stuff. I also give to the said Mary White all my wearing linnen laces and
blonds except the laces in the India chest in my bed chamber which I give and
bequeath to my said son Charles Jermyn Bond together with all my table and house-
hold linnen. I give and bequeath to the son of Henry Byard that lives with me, to
whom I lately stood god mother the sum of ten pounds for putting him to some trade
or business and I desire that the same may be paid to his ffather for that purpose and
that his ffathers receipt shall be a sufficient discharge for the same. I give and bequeath
to the said Henry Byard (if living with me at my decease) the sum of ten pounds over
and above the wages that shall be due to him at my death and to each of my other
maids the sum of five pounds besides the wages that shall be due to them at my
decease. I give and bequeath all the rest and residue of my goods chattles personal
estate and effects not by me hereinbefore otherwise disposed of unto my said son
Charles Jermyn Bond (. . .)

Lady Anna Van Lennep, PROB 11/844, quire 62, fo. 94
Signed 31 January 1758
Translated 6 December 1758
Proved 26 February 1759

(. . .) She <. . .> declared that having some effects stocks in the publick ffunds and other chattles and credits in the Kingdom of Great Britain hath by those present nominated and appointed her nephew Mr David de Neufville Van Lennep and Balthasar de Bruinas also dwelling here to be executors of this her last will and testament limitted to her said effects stocks in the publick ffunds and other chattles and credits and administrators of all such effects stocks in the publick ffunds and other chattles and credits as she at the time of her decease should have in the said Kingdom of Great Britain or that may in any ways belong unto her Ladyship in the said Kingdom giving unto them all such power and authority as can or may be given to testamentary executors in order immediately after her the testatrix's decease to cause all and singular the said effects stocks in the publick ffunds and other chattles and credits none excepted to be placed and transferred in the name of such person or persons as they shall think fit and proper and further to rule adminster sell <word illegible> charge and mortgage the same to receive the money arising thereby and give accquitances for the same (. . .)

The Right Honble Elizabeth Lady Viscountess Dowager Ashbrook,
 PROB 11/843, quire 44, fos. 346–8
Signed 27 November 1758
Proved 17 February 1759

(. . .) I give and bequeath to my two brothers the Reverend Doctor Tatton and Colonel Melville Tatton ffifty pounds apeice for mourning or to purchase rings as tokens of my affection and esteem for them Also I give to my old servant Mary Lynham three hundred pounds to be paid to her within six months after my decease Also I give and bequeath to my daughter Elizabeth fflower my watch with a blue enameled case with the steel chain and trinkets belonging to it and also my two bracelets one of her ffather my late lord Ashbrook and the other of her brother the present Lord Also I give to my daughter Mary fflower my ffinger rings of all sorts and also my dressing table and everything belonging to it And I do recommend it to my son William Lord Viscount Ashbrook to permit my said two daughters or either of them at his discretion to wear and have the use of my brilliant diamond earrings my seven brilliant roses for the stays my brilliant sprig for the hair and my brilliant diamond egret untill the marriage of my said son or daughters or either of them Also I give and bequeath to my said son my epagne and square silver tea table and also the old ffamily silver watch which belonged to <word illegible> Temple Also I give and bequeath all and every my household goods and ffurnitire and all other my earrings and trinkets to my said two daughters equally to be divided between them by my executors hereafter named my wearing apparel and wearing linnen except such as my daughters shall choose to keep for

themselves I give and bequeath to my said servant Mary Lynham And I desire my executors to give to my said daughters such of my books as they shall think most suitable and proper for them and the remaining part of them to my said son And as to the rest residue and remainder of my estate I direct that the same shall be applied towards the discharge of the debts and incumbrances affecting the estate of my said son devised to him by the will of my late Lord And I do hereby nominate constitute and appoint my said two brothers the Reverend Doctor William Tatton and Colonel Neville Tatton Executors of this my last will and testament And whereas my late Lord by his last will and testament in writing duly executed and published devised to me and my heirs and assigns for ever the reversion and remainder of his lands tenements hereditaments and estate after the determination of the particular estates devised limited and entailed upon my said son and daughters now it is my will and mind and I do hereby give and devise in case of the continuances mentioned in my said late Lord's will and that the said estates shall happen to descend and come to me for want of issue of my said son and daughters All my right title and interest of and in to all and every the said lands tenements hereditaments and real estate in the kingdoms of England and Ireland or elsewhere unto my said two brothers and the heirs of their respective bodys lawfully begotten But it is my will that in case whereof my said Brothers shall happen to dye without issue of his body lawfully begotten the part share and interest of such brother of and in the said lands tenements hereditaments and real estate shall go and belong to the surviving heirs of his body lawfully begotten But in the case of the death of both of my said brothers without such issue then I give and devise the same to John Spranger of the parish of Saint Paul Covent Garden in the County of Middlesex Gentleman his heirs and assigns in trust for my neice Catherine Neville (sister to the Right Honourable Lord Abergavenny) and her assigns for and during the term of her natural life without impeachment <. . .> and after the decease of the said Catherine Neville In trust for the heirs of the body of the said Catherine Neville lawfully begotten and their heirs and for default of such issue in trust for my nephew Henry (son of the said Lord Abergavenny) and his assigns for and during the term of his natural life <. . .> And I do hereby charge and make chargeable all and every the said lands tenements, hereditaments and real estate in the hands of the first person or persons aforesaid who shall come into and be in possession of the same by virtue of this my last will twelve compleat calendar months at least with the payment of the sum of ffive hundred pounds to the honourable Jane Ponsonby (widow of the honourable ffolliot Ponsonby) as a token of my ffriendship (. . .)

The Right Honble Lady Harriot Vane, PROB 11/843, quire 41, fo. 323
Signed 12 December 1758
Proved 22 January 1759

(. . .) I give my dear mother the Countess Dowager of Darlington ffive hundred pounds as a small token of my duty and affection to her I give to my dear brother ffredrick Vane twelve hundred pounds and to my dear brother Raby Vane one thou-

sand pounds and to my maid Dolly Sparling twenty five pounds and to my dear ffriend Mrs Ann Howard of Corby Castle in Cumberland my watch and chain ear rings rings and such trinkets and jewells as I shall be possessed of when I die all the rest residue and remainder of my estate I give unto my ffriend Joseph Creswicke esquire and appoint him executor of this my last will (. . .)

The Right Honble Ann Lady Viscountess Dowager Cobham,
 PROB 11/854, quire 140, fos. 346a–348
Signed 8 October 1759
Proved 9 April 1760

(. . .) ffirst I charge all that my messuages or tenements situate in Hanover Square in the Parish of Saint George Hanover Square in the County of Middlesex and in which I now live and also such part of the ground and offices lying behind and belonging to the same as is ffreehold with the appurtenances with the payment of a clear annuity of fforty pounds a year payable to my servant Mary Moore during the term of her natural life to who I give the same annuity and direct that it shall be paid to her by four equal quarterly payments <. . .> I give devise and bequeath the same messuage and premises unto Henrietta Jane Speed spinster and the heirs of her Body and for default of such issue I give and devise the same messuage and premises unto Henry Thrale of Southwark esquire his heirs and assigns for ever and Whereas some part of the ground lying behind my said house and of the offices built thereon is leasehold by the virtue of a lease from the City of London for a term of years in which there are several years yet to come and unexpired now I do hereby give and devise and bequeath the same ground and offices to the said Henrietta Jane Speed for and during so many years and such time and term of years which I shall at the time of my decease have to come in the same premises by virtue of the said lease subject nevertheless to the rents and covenants reserved in the same lease and As to all other my real and personal estate chargeable with my debts and ffuneral expences I dispose thereof as follows I give to Elizabeth Rand of Buckingham widow one yearly rent of twenty pounds of lawfull money during the term of her natural life to be issuing out of my messuage and farm at Lattenborough otherwise Loughborough in the county of Buckingham and to be paid to her by four equal quarterly payments <. . .> And I give and devise unto the same Henry Thrale in the Borough of Southwark the sum of ffive hundred pounds to be paid him by my executrix within six months after my decease upon trust that he the said Henry Thrale his executors and administrators do and shall with all convenient speed place out the same on Government or real securities in the name of him the said Henry Thrale his executors and administrators and that he the said Henry Thrale his executors and administrators do and shall stand and be possessed of the said sum of ffive hundred pounds when placed out as aforesaid upon trust to pay the dividends interest produce and proceed thereof unto Mrs Ann Gyfford the wife of Mr Anthony Gyfford for and during the term of her life <. . .> and immediately after the

decease of the said Mrs Gyfford then it is my will and I do hereby declare that the said Henry Thrale his executors and administrators shall stand and be possessed of the said sum of ffive hundred pounds in trust and for the benefit of Sarah Gyfford daughter of the said Mrs Gyfford her executors administrators and assigns and transfer the securities upon which the same shall be placed accordingly and I give to the said Mrs Gyfford my purse of old gold which it is my desire may be given to her daughter at her decease I also give to Mrs Gyfford if she pleases to have them the pictures of her mother and grandmother which are at my house at Stoke and of my own ffather and mother which are in the White Parlour at Stoke and I give to the Right Honourable the Countess of Westmoreland my diamond girdle buckle also I give Dame Jane Lambert widow of Sir Milton Lambert knight the use of my large pearl necklace for her life and after her decease the same to be returned to the said Henrietta Jane Speed Also I give to the said Dame Jane Lambert one hundred pounds Also I give to the right honourable George Greenville esquire the sum of ffive hundred pounds Also I give to Richard Berenger esquire the sum of ffive hundred pounds and to the said Henry Thrale the sum of two hundred pounds Also I give to Mr Rawlins my old harpsicord that is at Stoke and all my musick books Also I give to the right honourable Lady Hester Pitt ffifty pounds for a ring Also I give to Mrs Lucy ffortescue widow twenty guineas for a ring also I give to Mrs Ann Ascough wife of the Reverend Doctor Ascough twenty guineas for a ring Also I give to Lady Vanburgh twenty guineas for a ring Also I give to Mrs Hester Lyttleton twenty guineas for a ring Also I give to Mrs Mary Wood twenty guineas for a ring Also I give to Thomas Lambert of Sevenoake in the county of Kent esquire twenty guineas for a ring Also I give to my god daughter Ann the daughter of Thomas Rawlins which Ann is married the sum of twenty pounds Also I give to the poor of the parish of Stowe ten guineas and to the poor of the parish of Stoke ten guineas Also I give to my servant Jane Parker if she shall be living with me at the time of my decease the sum of ffifty pounds and to my servant James Squibb if he shall be living with me at the time of my decease the sum of one hundred pounds and to my servant Ingram Coombes if he shall be living with me at the time of my decease the sum of one hundred pounds and to my servant John Hillger if he shall be living with me at the time of my decease the sum of one hundred pounds and to my servant Richard Elme if he shall be living with me at the time of my decease the sum of twenty pounds and to my coachman William Yates if he shall be living with me at the time of my decease the sum of twenty pounds and to my own ffootman Thomas Davies if he shall be living with me at the time of my decease the sum of ten pounds and to each of my other servants who shall be living with me at the time of my decease at either of my houses in Stoke or Hanover Square one years wages over and above what will be due to them <. . .> And I desire my executrix to give my wearing apparel to the said Mary Moore and the chambermaid which shall be living with me at the time of my decease each such part share and proportion as my executrix shall think proper And subject to the payment of the several above mentioned legacies and of my debts and ffuneral expences I give devise and bequeath as well the said messuage ffarm in Lellenborough in the said county of Buckingham

charge and chargeable with the payment of the said annuity of twenty pounds a year to the said Elizabeth Rand for her life as also all other my real estate whatsoever and wheresoever and also all my ready money in the ffunds or on security arrears of rent live and dead stock on my ffarm household goods ffurniture jewells watches rings plate linnen books china pictures horses coaches and other carriages And also all other my personal estate of what nature or kind soever and wheresoever the same is or may be unto the said Henrietta Jane Speed sole executrix of this my last will <. . .> and I desire my executrix to burn all my letters and other private papers not appearing to be papers of business (. . .)
codicil
Besides the several legacies I have given by my will I give to the Reverend Mr Henry Duckworth vicar of Stoke the sum of twenty guineas for a ring and to Thomas Gray esquire the sum of twenty guineas for a ring (. . .)

Dame Gertruyd Noorthey, PROB 11/858, quire 333, fo. 274
Signed 14 February 1760
Translated (n.d.)
Proved 23 August 1760

(. . .) of all such effects and stocks in the publick ffunds and other chattels and credits whatsoever which she the said appearer shall or may have or which may any ways belong or appertain unto her at the time of her decease in the Kingdom of Great Britain She the said appearer giving and by these presents granting to her said executor and administrator all necessary power and authority and especially to administer the said effects and stocks to receive and give receipts for all dividends and interests due and payable thereon and also to sell and transfer all or part of the said effects and stocks to receive the moneys arising therefrom and give receipts for and generally to do all what an executor and administrator may do according to the law of England (. . .)

BIBLIOGRAPHY

1. Manuscript Sources

British Library, Additional MS 70238.
British Library, Additional MS 70270.
British Library, Additional MS 70348.
British Library, Additional MS 42071.
British Library, Additional MS, Althorp Papers, D15.
British Library, Strafford Papers, Additional MS 22,256.
British Library, Strafford Papers, Additional MS 22,265.
British Library, Letter from J. Olmins, MS (BL 1124.k.16).
British Museum Print Room, Whiteley Papers.
Hackney Archives Department, *The Origin of the Church of Christ of the Particular Baptist Denomination, Shore Place, Hackney,* 13 May 1798, D/E 232 MAR 2/1.
John Rylands University Library, MS R 71063 (616), Hester Thrale, *Daily Journal or the Gentleman's Complete Annual Accompt-Book,* 1757.
John Rylands Library, Rylands English MS 1122–1129.
National Art Library, V. & A., Garrard Ledgers, Microfilm.
North Yorkshire County Records Office, Chaloner Family Papers, MSS.
North Yorkshire County Records Office, Mary Chaloner's Account Book, MIC 1415 ZFM 84–9.
North Yorkshire County Records Office, MS MIC 1419 002029 ZFM.
Paul Mellon Centre for Studies in British Art, London, Brinsley Ford Papers.
Pierpont Morgan Library, MA 3086 R-V Autogr. Misc. Artists.
Portland MSS, Historical Manuscripts Commission, 14th Report (London, 1894).
Private Collection, Mary Moser Correspondence with Fuseli, MS (1770–1).
Private Collection, Mary Moser to Mrs Lloyd, unpublished and undated MS.
Royal Society of Arts, Dr. Templeman's transactions, MS.
Sheffield Archives, Wentworth Fitzwilliam Papers, NRA 1083.
Society of Antiquaries, MS, A List of the Members of the Society of Antiquaries of London.
Tate Gallery, Highmore Scrapbook.

2. Public Records Office, Probate—Wills Cited

11/700, quire 12, will proved 15 Jan. 1739, Dame Sarah Humble.
11/702, quire 144, will proved 17 May 1740, Elizabeth Halpenn (called Lady Lawley).
11/702, quire 147, will proved 13 May 1740, The Hon. Lady Catherine Jones.
11/708, quire 83, will proved 1 Apr. 1741, The Rt. Hon. Frances Lady Colepeper.
11/712, quire 248, will proved 30 Sept. 1741, Lady Elizabeth Wentworth.
11/712, quire 264, will proved 30 Sept. 1741, The Rt. Hon. Claude Margaret Gouijon, Marchioness Dowager of Vennevelles.

11/715, quire 17, will proved 16 Nov. 1739, Lady Ann Harvey.

11/715, quire 17, will proved 22 Jan. 1741, Elizabeth, Baroness Howard of Effingham.

11/723, quire 35, will proved 1 Feb. 1742, The Rt. Hon. Elizabeth Lady Compton.

11/725, quire 119, will proved 28 Apr. 1743, Dame Mary Jones.

11/731, quire 40, will proved 15 Feb. 1743, Lady Elizabeth Harris.

11/737, quire 10, will proved 15 Jan. 1744, Dame Rebecca Dixie.

11/751, quire 367, will proved 29 Dec. 1746, The Rt. Hon. Ann Baroness Dowager Trevor.

11/752, quire 14, will proved 8 Jan. 1746, The Hon. Anne Legge.

11/754, quire 103, will proved 8 Apr. 1747, The Hon. Margaret Mugge.

11/754, quire 129, will proved 18 May 1747, The Rt. Hon. Elizabeth Dowager Viscountess Irwin.

11/759, quire 27, will proved 14 Jan. 1747, The Hon. Lady Elizabeth Spelman.

11/763, quire 204, will proved 22 July 1748, The Rt. Hon. Elizabeth Lady Viscountess Harcourt.

11/771, quire 181, will proved 21 June 1749, Dame Dorothy Every.

11/771, quire 210, will proved 19 July 1749, Dame Frances Chester.

11/773, quire 293, will proved 6 Sept. 1749, The Rt. Hon. Lady Ann Paul.

11/776, quire 46, will proved 14 Feb. 1749, Dame Elizabeth Hare.

11/791, quire 305, will proved 16 Nov. 1751, The Rt. Hon. Frances Dowager Viscountess Dillon.

11/792, quire 7, will proved 31 Jan. 1752, Dame Frances Chester.

11/803, quire 201, will proved 3 July 1753, The Rt. Hon. Constantia Viscountess Dupplin.

11/803, quire 205, will proved 10 July 1753, Dame Cecelia Garrard.

11/803, quire 225 will proved 3 Aug. 1753, Dame Sarah Cotton.

11/810, quire 211, will proved 12 June 1754, The Rt. Hon Lady Anna Elinora Shirley.

11/810, quire 211, will proved 12 July 1754, Most Noble Frances Dowager Dutchess of Somerset.

11/813, quire 17, will proved 13 Jan. 1755, Dame Phyllis Langham.

11/813, quire 17, will proved 18 Jan. 1755, The Rt. Hon. Lady Barbara Leigh.

11/819, quire 328, will proved 16 Dec. 1755, Dame Anna Maria Shaw.

11/823, quire 174, will proved 4 June 1756, The Rt. Hon Lady Mary Petre.

11/828, quire 50, will proved 16 Feb. 1757, Lady Catherine Gardeman.

11/828, quire 74, will proved 26 Mar. 1757, The Rt. Hon. Dowager Baroness Bingley.

11/833, quire 30, will proved 17 Oct. 1757, The Rt. Hon. Jane Viscountess Dowager Gage.

11/835, quire 7, will proved 27 Jan. 1758, Dame Margaret Conyers.

11/835, quire 7, will proved 31 Jan. 1758, Dame Elizabeth Collett.

11/843, quire 30, will proved 18 June 1759, The Rt. Hon. Mary Dowager Countess Preston.

11/843, quire 44, will proved 17 Feb. 1759, The Rt. Hon. Elizabeth Lady Viscountess Dowager Ashbrook.

11/854, quire 140, will proved 9 Apr. 1760, The Rt. Hon, Ann Lady Viscountess Dowager Cobham.

11/858, quire 327, will proved 11 Aug. 1760, Hon. Dorothy Howard.

11/1342, quire 366, will proved 28 May 1800, Mary Grace.

11/1617, quire 283, will proved 5 June 1819, Mary Moser.

11/1617, quire 286, will proved 17 June 1819, Joseph Moser.

11/1702, quire 424, will proved 20 Aug. 1825, Anna Maria Duncombe.

3. Published Sources

ADDISON, J., *Remarks on Several Parts of Italy* (1705; Glasgow, 1755).

—— 'An Ode for St. Cecilia's Day', in *The Poetical Works of Joseph Addison* (London, 1807).

—— *The Cabinet of Poetry* (London, 1818).

The Adventures of Sylvia Hughes, Written by Herself (London, 1761).

AINSWORTH, R., *Thesaurus linguae Latinae compendiarius: or, A Compendious Dictionary of the Latin Tongue, Designed for the Use of the British Nations* (London, 1746).

ALEXANDER, D., 'Rembrandt and the Reproductive Print in Eighteenth-Century England', in C. White, D. Alexander, and E. D'Oench (eds.), *Rembrandt in Eighteenth-Century England* (New Haven, 1983).

—— 'Kauffman and the Print Market in Eighteenth-Century England', in W. W. Roworth (ed.), *Angelica Kauffman: A Continental Artist in Georgian England* (London, 1992).

—— and GODFREY, R. T., *The Reproductive Print from Hogarth to Wilkie* (New Haven, 1980).

Alexander's Feast: or, The Power of Musick: An Ode Wrote in Honour of St. Cecilia by Mr. Dryden (London, 1753).

ALLAN, D. G. C., *William Shipley: Founder of the Royal Society of Arts: A Biography with Documents* (London, 1968).

—— 'Studies in the Society's History and Archives: Artists and the Society in the Eighteenth Century', *Royal Society of Arts Journal*, 132 (1983–4).

ALLEN, B. (ed.), *Towards a Modern Art World* (London, 1995).

ALLEN, D. E., *The Naturalist in Britain: A Social History* (London, 1976).

ANDERSON, H., and SHEA, J. S. (eds.), *Studies in Criticism and Aesthetics 1660–1800: Essays in Honor of Samuel Holt Monk* (Minneapolis, 1967).

ANDERSON, J. (ed.), *Hume and the Heroic Portrait: Studies in Eighteenth-Century Imagery* (Oxford, 1986).

ANDREWS, M., *The Picturesque: Literary Sources and Documents* (Mountfield, 1994).

APPADURAI, A., *The Social Life of Things: Commodities in Cultural Perspective* (Cambridge, 1986).

ARCHER, M., *India and British Portraiture 1770–1825* (London, 1979).

ARENDT, H., *The Human Condition* (Chicago, 1958).

ARMSTRONG, J., *The Oeconomy of Love: A Poetical Essay* (1736; London, 1774).

The Artists' Repository and Drawing Magazine Exhibiting the Principles of the Polite Arts in their Various Branches (4th edn. London, 1788).

ASHDOWN, M., 'Elizabeth Elstob, the Learned Saxonist', *Modern Language Review*, 20: 2 (Apr. 1925).

ASTON, M., 'Gods, Saints and Reformers: Portraiture and Protestant England', in L. Gent (ed.), *Albion's Classicism: The Visual Arts in Britain 1550–1660* (London, 1995).

Athenaeum.

BAKER, M., 'Rysbrack's Terracotta Model of Lady Foley and her Daughter and the Foley Monument at Great Witley', *Stadel Jahrbuch*, NS 2 (1987).

BAKHTIN, M., *Rabelais and his World*, trans. H. Iswolsky (1968; Bloomington, Ind., 1984).

BALLARD, G., *Memoirs of Several Ladies of Great Britain Who Have Been Celebrated for their Writings or Skill in the Learned Languages, Arts and Sciences* (Oxford, 1752).

BARLOW, P., 'The Backside of Nature: The Clique, Hogarthianism and the Problem of Style in Victorian Painting', Ph.D. thesis (University of Sussex, 1990).

BARRELL, J., *The Political Theory of Painting from Reynolds to Hazlitt* (London, 1986).

—— (ed.), *Painting and the Politics of Culture: New Essays on British Art, 1700–1850* (Oxford, 1992).

BARRETT, C. (ed.), *Dairy and Letters of Madame d'Arblay* (London, 1781).

BARRY, J., 'On Design', in *Lectures on Painting by the Royal Academicians: Barry, Opie and Fuseli*, ed. R. Wornum (London, 1848).

BARTOLI, SANTI [Bellori, G. P.], *Admiranda Romanorum antiquitatum* (Rome, 1693).

BASTIANO CASTELLETTI, F., *La trionfatrice Cecilia vergine, e martire romana* (Florence, 1694).

BATAILLE, G., *Eroticism*, trans. M. Dalwood (1962; London, 1987).

—— *Œuvres complètes* (Paris, 1987).

BATTEN, C. L., Jr. (ed.), *Pleasurable Instruction: Form and Convention in Eighteenth-Century Travel Literature* (Berkeley and Los Angeles, 1978).

BAUDRILLARD, J., *For a Critique of the Political Economy of the Sign*, trans. C. Levin (St Louis, Miss., 1981).

BEER, G., 'Representing Women: Re-presenting the Past', in C. Belsey and J. Moore (eds.), *The Feminist Reader: Essays in Gender and the Politics of Literary Criticism* (London, 1989).

BEHN, A., *The History of the Nun: or, The Fair Vow-Breaker* (1689), in *Oronooko and Other Writings*, ed. P. Salzman (Oxford, 1994).

Belinda: or, The Fair Fugitive: A Novel by Mrs. C—— (London, 1789).

BELSEY, C., and MOORE, J. (eds.), *The Feminist Reader: Essays in Gender and the Politics of Literary Criticism* (London, 1989).

BENEDICT, B. M., 'The "Curious Attitude" in Eighteenth-Century Britain: Observing and Owning', *Eighteenth-Century Life*, 14 (Nov. 1990).

'Benedict, the Married Man', *The Road to Hymen Made Plain, Easy, and Delightful: In a New Collection of Familiar Letters, Pleasing Dialogues, and Verses* (London, 1790).

BÉNÉZIT, E., *Dictionnaire critique et documentaire des peintres* (3rd edn. Paris, 1976).

BENJAMIN, M. (ed.), *Science and Sensibility: Gender and Scientific Enquiry, 1780–1945* (London, 1991).

BERCHTOLD, L., *An Essay to Direct and Extend the Inquiries of Patriotic Travellers* (London, 1789).

BERG, M., 'Women's Consumption and the Industrial Classes of Eighteenth-century England', *Journal of Social History*, 30: 2 (Dec. 1996), forthcoming.

BERG, M., 'Women's Property and the Industrial Revolution', *Journal of Interdisciplinary History*, 24 (1993–4).

BERGER, H., Jr., 'Fictions of the Pose: Facing the Gaze in Early Modern Portaiture', *Representations*, 46 (Spring 1994).

BERGER, J., *Ways of Seeing* (London, 1972).

BERMINGHAM, A., *Landscape and Ideology: The English Rustic Tradition 1740–1860* (Berkeley and Los Angeles, 1987).

BERNSTEIN, S., 'Fear of Music? Nietzsche's Double Vision of the "Musical Feminine" ', in P. J. Burgard (ed.), *Nietzsche and the Feminine* (Charlottesville, Va., 1994).

BERRY, C., *The Idea of Luxury* (Cambridge, 1994).

BIDDLE, S., *Bolingbroke and Harley* (1973; London, 1975).

BIGNAMINI, I., and POSTLE, M., *The Artist's Model: Its Role in British Art from Lely to Etty*, Exhibition Catalogue (Nottingham, 1991).

BILL, E. G. W. (ed.), *The Queen Anne Churches* (London, 1979).

BLACK, J., *The British Abroad: The Grand Tour in the Eighteenth Century* (Stroud, 1992).

BLOOMFIELD, M. W. (ed.), *Allegory, Myth and Symbol* (Cambridge, Mass., 1981).

BLUM, C., 'Of Women and the Land', in J. Brewer and S. Staves (eds.), *Early Modern Conceptions of Property* (London, 1995).

BLUNT, A., *The Drawings of Nicolas Poussin* (New Haven, 1976).

BLUNT, W., and STERN, W. T., *The Art of Botanical Illustration* (rev. edn. London, 1994).

BOASE, T. S. R., 'Macklin and Bowyer', *Journal of the Warburg and Courtauld Institutes*, 26 (1963).

BONFIELD, L., 'Marriage Settlements and the "Rise of Great Estates": The Demographic Aspect', *Economic History Review*, 2nd ser. 32: 4 (1979).

BOUTET, C., *Traité de mignature pour apprendre aisément à peindre sans maître* (3rd edn. Paris, 1684).

BRADLEY, R., *The English Housewife in the Seventeenth and Eighteenth Centuries* (London, 1912).

BRAUDEL, F., 'The Structures of Everyday Life: The Limits of the Possible', in *Civilisation and Capitalism*, i, trans. S. Reynolds (1979; London, 1984).

—— 'The Perspective of the World', in *Civilisation and Capitalism*, iii, trans. S. Reynolds (1979; London, 1984).

BREMMER, J., and ROODENBERG, H. (eds.), *A Cultural History of Gesture from Antiquity to the Present Day* (Oxford, 1991).

BREWER, J., and PORTER, R. (eds.), *Consumption and the World of Goods*, i (London, 1993).

—— and STAVES, S. (eds.), *Early Modern Conceptions of Property* (London, 1995).

BROWN, G., *A New Treatise on Flower Painting: or, Every Lady her Own Drawing Master* (3rd edn. London, 1799).

BROWN, J., *A Dissertation on the Rise, Union and Power . . . of Poetry and Music* (London, 1763; New York, 1971).

BUCK, A., *Dress in Eighteenth-Century England* (London, 1979).

BUFFON, Count de, *The Natural History of Animals, Vegetables, and Minerals with the Theory of the Earth in General*, trans. W. Kenrick and J. Murdoch (London, 1775).

BURKE, E., *A Philosophical Enquiry into the Origin of our Ideas of the Sublime and the Beautiful with an Introductory Discourse Concerning Taste and Several Other Additions* (London, 1756).

BURNET, J., Lord MONBODDO, *Origin and Progress of Language* (London, 1773–92).

BURNEY, C., *A General History of Music* (London, 1776).

BURNEY, F., *The Early Diaries of Frances Burney*, ed. A. R. Ellis (London, 1907).

BUTLER, A., *The Lives of the Saints* (London, 1756).

—— *The Lives of the Fathers, Martyrs, and Other Principal Saints* (3rd edn. London, 1798–1800).

BYNG, Hon. J., *The Torrington Diaries* (London, 1935).

'CANDID', *Morning Chronicle*, (4, 5 May 1780).

CAREY, W., *A Descriptive Catalogue of a Collection of Paintings by British Artists in the Possession of Sir John Fleming Leicester, Bart* (London, 1819).

—— *Observations on the Probable Decline or Extinction of British Historical Painting, from the Effects of the Church Exclusion of Paintings . . .* (London, 1825).

A Catalogue of the Genuine Library, Prints, and Books of Prints, of an Illustrious Personage, Lately Deceased, Which Will Be Sold by Auction, on Wed. 9th June 1819 . . . by Mr. Christie at his Rooms in Pall Mall, 9–23 June (London, 1819).

A Catalogue of the Pictures, Sculptures, Models, Drawings, Prints, &c. Exhibited by the Society of Artists of Great Britain at the Great Room in Spring-Gardens, Charing Cross, May the 9th, 1761 (Being the Second Year of their Exhibition).

A Catalogue of the Pictures, Sculptures, Models, Drawings, Prints, &c. of the Present Artists. Exhibited in the Great Room of the Society for the Encouragement of Arts, Manufactures and Commerce, on the 21st April, 1760.

Catalogue of the Portraits and Pictures in the Different Houses Belonging to the Earl of Fife (n.p., 1798).

CAVAZZONI ZANOTTI, G., *Il claustro di San Michele in Bosco di Bologna de' monaci Olivetani dipinto dal famoso Lodovico Caracci e da altri eccellenti maestri* (Bologna, 1776).

Center and Clark Newsletter (UCLA), 26 (Fall 1995).

CERTEAU, M. DE, *The Practice of Everyday Life*, trans. S. Rendall (Berkeley and Los Angeles, 1988).

—— *The Writing of History*, trans. T. Conley (1975; New York, 1988).

CHALONER-SMITH, J., *British Mezzotint Portraits* (London, 1883).

CHARD, C., *Pleasure and Guilt on the Grand Tour* (forthcoming).

CHAZAL, G., 'Les "Attitudes" de Lady Hamilton', *Gazette des beaux-arts*, 6th ser. 94 (1979).

CLARK, J. C. D., *English Society 1688–1832* (Cambridge, 1985).

CLARKE, B. F. L., *The Building of the Eighteenth-Century Church* (London, 1963).

CLAY, C., 'Marriage, Inheritance, and the Rise of Large Estates in England, 1660–1815', *Economic History Review*, 2nd ser. 21 (1968).

CLIFFORD, J., 'On Ethnographic Allegory', in J. Clifford and G. E. Marcus (eds.), *Writing Culture: The Poetics and Politics of Ethnography* (Berkeley and Los Angeles, 1986).

—— and MARCUS, G. E. (eds.), *Writing Culture: The Poetics and Politics of Ethnography* (Berkeley and Los Angeles, 1986).

COLEMAN, J., 'Images of Assurance or Masks of Uncertainty: Joshua Reynolds and the Anglo-Irish Ascendancy, 1746–1789', M.Litt. thesis (Trinity College, Dublin, 1993).

COLERIDGE, S. T., *Biographia literaria*, ed. G. Watson (1965; London, 1971).

COLLEY, L., *Britons: Forging the Nation 1707–1837* (London, 1992).

COLOMINA, B. (ed.), *Sexuality and Space* (Princeton, 1992).

The Complete Peerage, iii (London, 1913).

CONNOLLY, T., *Mourning into Joy: Music, Raphael, and Saint Cecilia* (London, 1994).

COOPER, J. G., *Letters Concerning Taste* (1755; 3rd edn. London, 1757).

COPLEY, S., 'The Fine Arts in Eighteenth-Century Polite Culture', in J. Barrell (ed.), *Painting and the Politics of Culture: New Essays on British Art 1700–1850* (Oxford, 1992).

Country House Lighting 1660–1890, Temple Newsam Country House Studies 4 (Leeds, 1992).

COWPER, W., *The Task* (London, 1785).

CROOKSHANK, A., and the KNIGHT OF GLIN, *The Painters of Ireland c. 1660–1920* (London, 1978).

DARLOW, T. F., and MOULE, H. F., *Historical Catalogue of Printed Editions of the English Bible, 1525–1961*, rev. A. S. Herbert (1903; London, 1968).

DARWIN, E., *The Botanic Garden, Containing the Economy of Vegetation: A Poem with Philosophical Notes* (London, 1791).

—— *The Temple of Nature: or, The Origin of Society: A Poem with Philosophical Notes* (London, 1803).

DAVIDOFF, L., and HALL, C., *Family Fortunes: Men and Women of the English Middle Class* (London, 1987).

DAVIDSON REID, J. (ed.), *The Oxford Guide to Classical Mythology in the Arts 1300–1990s*, i (Oxford, 1993).

DAVIE, D., *The Eighteenth-Century Hymn in England* (Cambridge, 1993).

DEANE, S. (ed.), *Field Day Anthology of Irish Writing*, i (Derry, 1991).

DEFOE, D., *A Tour through the Whole Island of Great Britain*, ed. G. D. H. Cole (1724–63; London, 1935).

—— 'The Complete English Tradesman', *The Novels and Miscellaneous Works of Daniel De Foe [sic]*, xvii (Oxford, 1841).

DEMPSTER, T., *De Etruria regali libri* (Florence, 1723).

DERRIDA, J., *Dissemination*, trans. B. Johnson (1973; London, 1981).

—— *Memoirs for Paul de Man*, trans. C. Lindsay, J. Culler, and E. Cadava (New York, 1986).

—— *The Truth in Painting*, trans. G. Bennington and I. McLeod (Chicago, 1987).

DEUTSCH, O. E., 'Sir William Hamilton's Picture Gallery', *Burlington Magazine*, 82 (1943).

DIBDIN, T. F., *Reminiscences of a Literary Life* (London, 1836).

DIGGENS, K., 'The Influence of Reynolds and Gainsborough on Nineteenth-Century Portraiture', Ph.D. thesis (University of Manchester, 1995).

DIXON, W., *A History of Freemasonry in Lincolnshire* (Lincoln, 1894).

DOANE, M. A., 'Film and the Masquerade: Theorizing the Female Spectator', *Screen* (Sept.–Oct. 1982).

DOSSIE, R., *Memoirs of Agriculture and Other Oeconomical Arts* (London, 1782).

DOUGLAS, M., and ISHERWOOD, B., *The World of Goods: Towards an Anthropology of Consumption* (1978; London, 1979).

DOWNIE, J. A., *Robert Harley and the Press* (Cambridge, 1979).

DRUMMOND, J. C., and WILBRAHAM, A., *The Englishman's Food* (1939; London, 1991).

EALES, J., *Puritans and Roundheads: The Harleys of Brampton Bryan and the Outbreak of the English Civil War* (Cambridge, 1990).

EARLE, P., *The Making of the English Middle Class* (London, 1989).

Earwig or an Old Woman's Remarks on the Present Exhibition of Pictures of the Royal Academy Preceded by a Petit Mot Pour Rire, Instead of a Preface, Dedicated to Sir Joshua Reynolds, RA (London, 1781).

EHRET, G. D., 'A Memoir of Georg Dionysius Ehret . . . Written by Himself', *Proceedings of the Linnean Society* (1894–5).

EINBERG, E., ' "The Betts Family": A Lost Hogarth that Never Was and a Candidate for Slaughter', *Burlington Magazine* (July, 1983).

ELIAS, N., *The Civilizing Process: The History of Manners*, trans. E. Jephcott (1939; New York, 1978).

ELLER, Revd I., *The History of Belvoir Castle* (London, 1841).

ENGELL, J., 'The Modern Revival of Myth: Its Eighteenth-Century Origins', in M. W. Bloomfield (ed.), *Allegory, Myth and Symbol* (Cambridge, Mass., 1981).

The Entertaining Amour of Sylvander and Sylvia: A Fashionable Buck and a Delicate Edinburgh Belle (Edinburgh, 1767).

ERASMUS, *In Praise of Folly*, trans. B. Radice (London, 1971).

ERBEN, M., 'Editorial Introduction', special issue 'Auto/Biography in Sociology', *Sociology*, 27: 1 (Feb. 1993).

ERICKSON, A. L., 'Common Law *Versus* Common Practice: The Use of Marriage Settlements in Early Modern England', *Economic History Review*, 2nd ser. 43: 1 (1990).

—— 'Introduction', in A. Clark, *Working Life of Women in the Seventeenth Century* (1919; London, 1992).

—— *Women and Property in Early Modern England* (London, 1993).

'An Essay on the Passions of the Ancients', *London Chronicle* (22–4 Mar. 1774).

ESSEX, R., SIDNEY, P., and DAVISON, W., *Profitable Instructions: Describing what Special Observations Are to Be Taken by Travellers in All Nations* (London, 1633).

EURIPIDES, *The Bacchae and Other Plays*, trans. P. Vellacott (Harmondsworth, 1973).

Euterpe: or, Remarks on the Use and Abuse of Music, as a Part of Modern Education (London, 1778).

EVANS, J., *Pattern: A Study of Ornament in Western Europe 1180–1900* (Oxford, 1931).

—— *A History of the Society of Antiquaries* (Oxford, 1956).

EVELYN, J., *Memoires for My Grand-Son by John Evelyn*, transcribed and pref. Geoffrey Keynes (Oxford, 1926).

'Extracts from the Leeds Intelligencer 1763–1767', *Thoresby Society*, 33 (1930–2).

FABRICANT, C., 'Binding and Dressing Nature's Loose Tresses: The Ideology of Augustan Landscape Design', *Studies in Eighteenth-Century Culture*, 8 (1979).

—— 'The Literature of Domestic Tourism and the Public Consumption of Private Property', in F. Nussbaum and L. Brown (eds.), *The New Eighteenth Century: Theory. Politics. English Literature* (New York, 1987).

FARINGTON, J., *The Diary of Joseph Farington*, ed. K. Garlick and A. MacIntyre (New Haven, 1978).

FEINSTEIN, J., 'Mrs. Siddons, the Tragic Muse, and the Problems of As', *Journal of Aesthetics and Art Criticism*, 36: 3 (Spring 1978).

The Female Rake: or, Modern Fine Lady: An Epistle from Libertina to Sylvia (London, 1735).

FERRE, F. (ed.), *Natural Theology: Selections* (Indianapolis, 1963).

FIGLIO, K., 'The Metaphor of Organization: An Historiographical Perspective on the Bio–medical Sciences of the Early Nineteenth Century', *History of Science*, 14 (1976).

FINEMAN, J., 'The Structure of Allegorical Desire', in Stephen Greenblatt (ed.), *Allegory and Representation: Selected Papers from the English Institute, 1979–80* (Baltimore, 1981).

FISCHER-HOMBERGER, E., 'Hebammen und Hymen', in E. Fischer-Homberger, *Dies Krankheit Frau* (Bern, 1979).

FLAHERTY, G., *Shamanism and the Eighteenth Century* (Princeton, 1992).

FLETCHER, A., *Allegory: The Theory of a Symbolic Mode* (Ithaca, NY, 1964; 1965).

FORD, B., 'Sir Watkin Williams-Wynn: A Welsh Mycenas', *Apollo* (June 1974).

FOTHERGILL, B., *Sir William Hamilton, Envoy Extraordinary* (London, 1969).

FOX, G., 'The Fashions of the World Made Manifest; Also a Few Words to the City of London', in G. Fox, *Gospel-Truth Demonstrated, in a Collection of Doctrinal Books* (1657; London, 1706).

—— *Gospel-Truth Demonstrated, in a Collection of Doctrinal Books* (London, 1706).

FOX-GENOVESE, E., 'Placing Women's History in History', *New Left Review*, 133 (May–June 1982).

FRASER, F., *Beloved Emma* (London, 1986).

Freemason's Magazine.

FRIEDLÄNDER, W., 'Hymenaea', in M. Meiss (ed.), *De artibus opuscula XL: Essays in Honor of Erwin Panofsky* (New York, 1961).

—— and BLUNT, A., *The Drawings of Nicolas Poussin, A Catalogue raisonné* (London: Warburg Institute, 1953).

FURBER, R., CASTEELS, P., and FLETCHER, H., *Twelve Months of Flowers* (London, 1730).

GARBER, M., *Vested Interests: Cross Dressing and Cultural Anxiety* (1992; Harmondsworth, 1993).

Gazeteer and New Daily Advertiser.

Gazzetta Toscana.

GENT, L. (ed.), *Albion's Classicism: The Visual Arts in Britain 1550–1660* (London, 1995).

GENT, W., *The Infallible Guide to Travellers* (London, 1682).

Gentleman's Magazine.

GEORGE, M. D., *Catalogue of Political and Personal Satires Preserved in the Department of Prints and Drawings in the British Museum* (London, 1978).

GIDDENS, A., *The Constitution of Society* (Cambridge, 1984).

GILPIN, W., *Observations on the River Wye in the Summer of 1770*, in M. Andrews (ed.), *The Picturesque: Literary Sources and Documents* (Mountfield, 1994).

GIROUARD, M., 'The English Country House and the Country Town', in G. Jackson–Stops *et al.* (eds.), *The Fashioning and Functioning of the British Country House* (Washington, 1989).

GLASS, D. V., *Numbering the People: The Eighteenth-Century Population Controversy and the Development of Census and Vital Statistics in Britain* (Farnborough, 1973).

GOETHE, J. W., *Italian Journey*, trans. W. H. Auden and E. Mayer (1962; Harmondsworth, 1982).

GOLDSMITH, O., *The Vicar of Wakefield* (London, 1805).

GOMBRICH, E. H., 'Reynolds's Theory and Practice of Imitation: Three Ladies Adorning a Term of Hymen', *Norm and Form: Studies in the Art of the Renaissance* (Oxford, 1966).

GOMME, G. L. (ed.), 'English Topography', *Gentleman's Magazine Library* (London, 1893).

GOODY, J., *The Culture of Flowers* (Cambridge, 1993).

The Graces: A Poetical Epistle from a Gentleman to his Son (London, 1774).

GRAF, F., 'Gestures and Conventions: The Gestures of Roman Actors and Orators', in J. Bremmer and H. Roodenberg (eds.), *A Cultural History of Gesture from Antiquity to the Present Day* (Oxford, 1991).

GRAVES, A., *The Royal Academy of Arts: A Complete Dictionary of Contributors* (London, 1906).

—— and CRONIN, W., *A History of the Works of Sir J. Reynolds* (London, 1899–1901).

GRAVES, R., *The Spiritual Quixote: or, The Summer's Ramble of Mr. Geoffrey Wildgoose: A Comic Romance* (London, 1773).

Euphrosyne: or, Amusements on the Road to Life by the Author of The Spiritual Quixote (London, 1776).

GREEN, V., *A Review of the Polite Arts in France at the Time of their Establishment under Louis XVI, Compared with their Present State in England* (London, 1782).

GREENBERG, J., 'The Legal Status of English Woman in Early Eighteenth-Century Common Law and Equity', *Studies in Eighteenth-Century Culture*, 4 (1975).

GROSE, F., *The Antiquities of England and Wales, Antiquities of Scotland* (London, 1773–91).

GROSSMAN, F., *Bruegel: The Paintings* (London, 1955).

GUEST, H., 'A Double Lustre: Femininity and Sociable Commerce, 1730–1760', *Eighteenth-Century Studies*, 23: 4 (Summer 1990).

A Guide to Burghley House, Northamptonshire Containing a Catalogue of All the Paintings and Antiquities (Stamford, 1815).

HABAKKUK, H. J., 'English Landownership 1680–1740', *Economic History Review*, 10: 1 (1940).

—— 'Marriage Settlements in the Eighteenth Century', *Transactions of the Royal Historical Society*, 4th ser. 32 (1950).

HALL, J., *Dictionary of Subjects and Symbols in Art* (London, 1974).

HALSBAND, R., *The Rape of the Lock and its Illustrations 1714–1723* (Oxford, 1980).

HANCARVILLE, P. HUGUES D', *Receuil d'antiquités étrusques, grèques et romains* (Paris, 1766–7).

—— *Collection of Etruscan, Greek and Roman Antiquities from the Cabinet of the Honble Wm. Hamilton* (London, 1766–77).

HARRIS, B. J., and McNAMARA, J. A. (eds.), *Women and the Structure of Society* (Durham, NC, 1984).

HARRIS, E., *The Williams Wynn Chamber Organ*, Phillips Sale (21 Apr. 1995).

HARRIS, F., *A Passion for Government: The Life of Sarah Duchess of Marlborough* (Oxford, 1991).

—— 'Mary Black and the Portrait of Dr. Monsey', *Burlington Magazine*, 135 (Aug. 1993).

HARRIS, J., *Lexicon technicum: or, An Universal English Dictionary of Arts and Sciences: Explaining Not Only the Terms of Art, but the Arts Themselves* (1708–10; London, 1736).

HARRIS, J., 'English Country House Guides, 1740–1840', in J. Summerson (ed.), *Concerning Architecture: Essays on Architectural Writers and Writings Presented to Nicholas Pevsner* (London, 1968).

HASKELL, F., *Rediscoveries in Art* (London, 1976).

HAZLITT, W., 'On Going on a Journey', in *The Complete Works of William Hazlitt*, vol. viii, ed. P. P. Howe (London, 1931).

—— 'Pictures at Burleigh House', in *The Complete Works of William Hazlitt*, vol. x, ed. P. P. Howe (London, 1932).

HEAL, A., *The London Goldsmiths 1200–1800: A Record of the Names and Addresses of the Craftsmen, their Shop-Signs and Trade Cards* (Cambridge, 1935).

HEMBRY, P., *The English Spa 1560–1815: A Social History* (London, 1990).

HEMINGWAY, A., 'Art Exhibitions as Leisure-Class Rituals in Early Nineteenth-Century London', in B. Allen (ed.), *Towards a Modern Art World* (London, 1995).

HICKEY, W., *Memoirs*, ed. A. Spencer (London, 1913–25).

HILL, B., *Eighteenth-Century Women: An Anthology* (London, 1984).

—— *The First English Feminist: Reflections upon Marriage and Other Writings by Mary Astell* (Aldershot, 1986).

—— *The Republican Virago: The Life and Times of Catherine Macaulay, Historian* (Oxford, 1992).

—— *Women, Work and Sexual Politics in Eighteenth-Century England* (Oxford, 1989).

HILL, B. W., *Robert Harley: Speaker, Secretary of State and Premier Minister* (New Haven, 1988).

HILLES, F. W., *Portraits by Sir Joshua Reynolds* (London, 1952).

HODGSON, J. E., and EATON, F., *The Royal Academy and its Members 1768–1830* (London, 1905).

HOGWOOD, C., and LUCKETT, R. (eds.), *Music in Eighteenth-Century England* (Cambridge, 1983).

HUGHES, E., *North Country Life in the Eighteenth Century: The North-East, 1700–1750* (1952; London, 1969).

HUGHES, J., *An Ode in Praise of Musick, Set for a Variety of Voices and Instruments by Mr. Philip Hart* (London, 1703).

HUIZINGA, J., *Homo Ludens: A Study of the Play-Element in Culture* (1944; London, 1949).

HUSK, W. H., *An Account of the Musical Celebrations on St. Cecilia's Day in the Sixteenth, Seventeenth and Eighteenth Centuries* (London, 1857).

Hymen: A Poem (London, 1794).

IBBETSON, J., *Some Observations on Two Pamphlets* (London, 1755).

Iveagh Bequest, Kenwood, *Lady Hamilton in Relation to the Art of her Time*, Exhibition 18 July–16 Oct. (1972).

—— *John Joseph Merlin: The Ingenious Mechanick*, Exhibition (1985).

JACKSON-STOPS, G., 'A British Parnassus: Mythology and the Country House', in G. Jackson–Stops *et al.* (eds.), *The Fashioning and Functioning of the British Country House* (Washington, 1989).

—— *et al.* (eds.), *The Fashioning and Functioning of the British Country House* (Washington, 1989).

JAMES, J., *The History and Topography of Bradford* (London, 1841).

JANSEN, H. (trans.), *De l'allégorie ou traités sur cette matière, par Winckelmann, Addison, Sulzer etc.* (Paris, 1799).

JARDINE, A., 'Opaque Texts and Transparent Contexts: The Political Difference of Julia Kristeva', in N. K. Miller (ed.), *The Poetics of Gender* (New York, 1986).

JEPHSON, R., *The Count of Narbonne: A Tragedy* (4th edn. Dublin, 1782).

JEWELL, J., *The Tourist's Companion or the History and Antiquities of Harewood in Yorkshire* (Leeds, 1819).

JOHNSON, S., *Rasselas*, in *The Works of Samuel Johnson*, ed. G. J. Kolb, xvi (New Haven, 1990).

—— *Prose and Poetry*, ed. M. Wilson (1950; London, 1963).

JONES, E., *Musical and Poetick Relicks of the Welsh Bards* (London, 1784).

JONES, R., 'The Empire of Beauty: The Competition for Judgement in Mid-Eighteenth-Century England', Ph.D. thesis (University of York, 1995).

—— ' "Such Strange Unwonted Softness to Excuse": Judgement and Indulgence in Sir Joshua Reynolds's Portrait of Elizabeth Gunning, Duchess of Hamilton and Argyll', *Oxford Art Journal*, 18: 1 (1995).

The Joys of Hymen: or, The Conjugal Directory (London, 1768).

JUNE, J., *The Delights of Flower Painting: In Which is [sic] Laid Down the Fundamental Principles of that Delightful Art. To Which is Annexed a Curious Description of the Manner in Which Fifty of the Most Capital Flowers are now Finished by the Several Masters in that Branch* (2nd edn. London, 1756).

KELLY, V., and VON MÜCKE, D., *Body and Text in the Eighteenth Century* (Stanford, Calif., 1994).

KEMP, B., *Sir Francis Dashwood: An Eighteenth-Century Independent* (London, 1967).

KLEIN, L. E., *Shaftesbury and the Culture of Politeness: Moral Discourse and Cultural Politics in Early Eighteenth-Century England* (Cambridge, 1994).

KLONK, C., 'Science and the Perception of Nature: British Landscape Art in the Late Eighteenth and Early Nineteenth Century', Ph.D. thesis (University of Cambridge, 1992).

KRAMNICK, I., *Bolingbroke and his Circle: The Politics of Nostalgia in the Age of Walpole* (Cambridge, Mass., 1968).

LACAN, J., *The Four Fundamental Concepts of Psycho-Analysis*, trans. A. Sheridan (1973; London, 1987).

Lady Lever Art Gallery, Port Sunlight, *Catalogue of Foreign Paintings, Drawings, Miniatures, Tapestries, Post-Classical Sculpture and Prints* (Liverpool, 1983).

LANGFORD, P., *Public Life and the Propertied Englishman 1689–1798* (Oxford, 1991).

LECKY, W. E. H., *A History of Ireland in the Eighteenth Century* (London, 1892).

LEFEBVRE, H., *The Production of Space*, trans. D. Nicholson-Smith (1974; London, 1991).

LEMOINE-LUCCIONI, E., *La Robe: Essai psychanalytique sur le vêtement* (Paris, 1983).

LEMPRIÈRE, J. J., *A Classical Dictionary* (1792; London, 1839).

LEPPERT, R., *Music and Image: Domesticity, Ideology and Socio-cultural Formation in Eighteenth-Century England* (Cambridge, 1988).

—— *The Sight of Sound: Music, Representation and the History of the Body* (Berkeley and Los Angeles, 1993).

LESLIE, C. R., and TAYLOR, T., *Life and Times of Sir Joshua Reynolds: With Notices of Some of his Contemporaries* (London, 1865).

A Letter from a Parishioner of St. Clement Danes to . . . Edmund Ld. Bp, of London, Occasioned by his Ldsp's Causing the Picture over the Altar, to be Taken Down (London, 1725).

LEWIS, W. H., *Louis XIV: An Informal Portrait* (London, 1959).

Liberty: A Poem (London, 1705).

LICHTENSTEIN, J., *The Eloquence of Colour: Rhetoric and Painting in the French Classical Age*, trans. E. McVarish (1989; Berkeley and Los Angeles, 1993).

LINNAEUS, C., *Species plantarum* (Holmiae, 1753).

LLANOVER, Lady (ed.), *The Autobiography and Correspondence of Mary Granville, Mrs. Delany* (London, 1861).

LLOYD, S., *Richard and Maria Cosway: Regency Artists of Taste and Fashion* (Edinburgh: National Galleries of Scotland, 1995).

LOCKE, J., *Two Treatises of Government* (London, 1689).

London Chronicle.

LONSDALE, R. (ed.), *The New Oxford Book of Eighteenth-Century Verse* (Oxford, 1984).

Lydia: ou, Mémoires du Milord d' ——, *imité de l'anglais par M. de la Place* (London, 1772).

LYNCH, D., 'Overloaded Portraits: The Excesses of Character and Countenance', in V. Kelly and D. von Mücke (eds.), *Body and Text in the Eighteenth Century* (Stanford, Calif., 1994).

MacCANNELL, D., *The Tourist: A New Theory of the Leisure Class* (New York, 1976).

McINNES, A., *Robert Harley, Puritan Politician* (London, 1970).

McKENDRICK, N., BREWER, J., and PLUMB, J. H., *The Birth of a Consumer Society: The Commercialization of Eighteenth-Century England* (London, 1982).

MALONE, EDWARD, *The Works of Sir Joshua Reynolds, Knt. Late President of the Royal Academy . . . to Which is Prefixed an Account of the Life and Writings of the Author* (London, 1797).

MAN, T., *The Benefit of Procreation Together with Some Few Hints towards the Better Support of Whores and Bastards* (London, 1739).

MANDEVILLE, B., *The Fable of the Bees*, ed. P. Harth (1724; Harmondsworth, 1989).

MANNERS, Lady VICTORIA, *Matthew William Peters RA* (London, 1913).

—— 'Catherine Read: The "English Rosalba" ', *Connoisseur* (Dec., Jan., and Mar. 1931–2).

MARKHAM, S., *John Loveday of Caversham 1711–1740: The Life and Tours of an Eighteenth-Century Onlooker* (Salisbury, 1984).

Marriage Promoted in a Discourse of its Ancient and Modern Practice both under Heathen and Christian Common-Wealths: Together with their Laws and Encouragements for its Observance (London, 1690).

MAUSS, M., *The Gift: The Form and Reason for Exchange in Archaic Societies*, trans. W. D. Halls (1950; London, 1990).

MAXWELL, C., *Dublin under the Georges 1714–1830* (London, 1936).

MAYO, D., *A Sermon Preach'd before the Societies for Reformation of Manners, at Salter's Hall, July 1st 1717* (London, 1717).

MEISS, M. (ed.), *De artibus opuscula XL: Essays in Honor of Erwin Panofsky* (New York, 1961).

MEYER, J. D., 'Benjamin West's Chapel of Revealed Religion: A Study in Eighteenth-Century Protestant Religious Art', *Art Bulletin*, 57 (1975).

Middlesex Journal.

MILD, W., *Joseph Highmore of Holbein Row* (Ardomore, Pa., 1978).

—— 'Susannah Highmore's Literary Reputation', *Proceedings of the American Philosophical Society*, 122: 6 (1978).

MILLER, N. K. (ed.), *The Poetics of Gender* (New York, 1986).

MILTON, J., 'L'Allegro', in *Milton: Complete Poetry and Selected Prose*, ed. E. H. Visiak (London, 1952).

MIRIMONDE, A. P. de, *Sainte-Cécile: Métamorphose d'un thème musical* (Geneva, 1974).

MITCHELL, W. J. T., *On Narrative* (Chicago, 1981).

MOIR, E., *The Discovery of Britain: The English Tourists 1540–1840* (London, 1964).

MONTAGUE, J., *The Expression of the Passions: The Origin and Influence of Charles le Brun's Conférence sur l'expression générale et particulière* (London, 1994).

MONTFAUCON, B. de, *L'Antiquité expliquée, et représentée en figures* (Paris, 1719).

MOODY, T. W., and VAUGHAN, W. E. (eds.), *A New History of Ireland*, iv: *Eighteenth-Century Ireland 1691–1800* (Oxford, 1986).

MOORE, A. W., *Norfolk and the Grand Tour* (Fakenham, 1985).

MOORE, R. E., 'Reynolds and the Art of Characterization', in H. Anderson and J. S. Shea (eds.), *Studies in Criticism and Aesthetics 1660–1800: Essays in Honor of Samuel Holt Monk* (Minneapolis, 1967).

MORE, H., *An Estimate of the Religion of the Fashionable World* (2nd edn. London, 1741).

Morning Chronicle.

Morning Post.

Morning Post and Daily Advertiser.

MORRIS, C. (ed.), *The Journeys of Celia Fiennes* (London, 1969).

MORTIMER, Mr, *The Universal Director: or, The Nobleman and Gentleman's True Guide to the Masters and Professors of the Liberal and Polite Arts and Sciences . . .* (London, 1763).

MULLINER, J., *A Testimony against Periwigs and Periwig-Making, and Playing on Instruments of Musick among Christians, or Any Other in the Days of the Gospel* (Northampton, 1677).

MULVEY, L., *Visual and Other Pleasures* (London, 1989).

—— 'Visual Pleasure and Narrative Cinema', in *Visual and Other Pleasures* (London, 1989).

MYERS, S. H., *The Blue Stocking Circle: Women, Friendship and the Life of the Mind in Eighteenth-Century England* (Oxford, 1990).

New Sermons to Asses (London, 1773).

NEWTON, Revd T., *Life and Anecdotes of Rt. Revd. Dr. Thomas Newton, Dean of St. Pauls, Prefixed to a New Edition of his Works* (London, 1782).

NICHOLS, J., *Illustrations of the Literary History of the Eighteenth Century* (1817; London, 1966).

NICHOLSON, K., 'The Ideology of Female "Virtue": The Vestal Virgin in French Eighteenth-Century Allegorical Painting', in J. Woodall (ed.), *Portraiture* (Manchester, forthcoming).

NORTHCOTE, J., *Memoirs of Sir Joshua Reynolds, Knt.* (London, 1813).

NUSSBAUM, F., 'Heteroclites: The Gender of Character in the Scandalous Memoirs', in F. Nussbaum and L. Brown (eds.), *The New Eighteenth Century: Theory. Politics. English Literature*, (New York, 1987).

—— and BROWN, L. (eds.), *The New Eighteenth Century: Theory. Politics. English Literature* (New York, 1987).

OGILBY, J., *Britannia* (London, 1675).

OKIN, S. M., 'Patriarchy and Married Women's Property in England: Questions on Some Current Views', *Eighteenth-Century Studies*, 17: 2 (Winter 1983).

OULTON, W. C., *Authentic and Impartial Memoirs of her Late Majesty, Charlotte Queen of Britain and Ireland* (London, 1819).

OUSBY, I., *The Englishman's England: Taste, Travel and the Rise of Tourism* (Cambridge, 1990).

OVID, *The Metamorphoses of Ovid*, trans. M. M. Innes (1955; Harmondsworth, 1983).

Palazzo del Vio, Gaeta, *Sebastiano Conca 1680–1764*, Exhibition, July–Oct. 1981 (Gaeta, 1981).

PALEY, M. J., *The Apocalyptic Sublime* (London, 1986).

PARKER, R., and POLLOCK, G., *Old Mistresses: Women, Art and Ideology* (London, 1981).

The Parliamentary Register: or, History of the Proceedings and Debates of the House of Commons of Ireland, 1781–2 (2nd edn. Dublin, 1784).

PARSONS, J., *Human Physiognomy Explained in the Crounian Lectures on Muscular Motion for the Year MDCCXLVI Read before the Royal Society* (London, 1747).

PATERSON, D., *British Itinerary* (London, 1785).

PAULSON, R., *Hogarth*, iii (Cambridge, 1991).

PAYNE KNIGHT, R., *An Analytical Inquiry into the Principles of Taste* (London, 1805).

PEARS, I., *The Discovery of Painting* (London, 1988).

PENNY, N., *Church Monuments in Romantic England* (London, 1977).

—— (ed.), *Reynolds*, Exhibition Catalogue, Royal Academy of Arts (London, 1986).

PERRY, G., 'Women in Disguise: Likeness, the Grand Style and the Conventions of "Feminine" Portraiture in the Work of Sir Joshua Reynolds', in G. Perry and M. Rossington (eds.), *Femininity and Masculinity in Eighteenth-Century Art and Culture* (Manchester, 1994).

—— and ROSSINGTON, M. (eds.), *Femininity and Masculinity in Eighteenth-Century Art and Culture* (Manchester, 1994).

PERRY, R., *The Celebrated Mary Astell* (Chicago, 1986).

PEVSNER, N., *The Buildings of England* (Harmondsworth, 1951–74).

PIGGOTT, S., *Ruins in a Landscape: Essays in Antiquarianism* (Edinburgh, 1976).

PIOZZI, H. LYNCH, *Observations and Reflections Made in the Course of a Journey through France, Italy, and Germany* (Ann Arbor, 1967).

PLUCHE, Abbé, *Spectacle de la Nature or Nature Display'd Being Discourses on Such Particulars of Natural History as Were Thought Most Proper to Excite the Curiosity and Form the Minds of Youth*, trans. Mr Humphries (3rd edn. London, 1736).

POCOCKE, R., *The Travels through England of Dr. Richard Pococke . . . during 1750, 1751, and Later Years*, ed. J. J. Cartwright (Camden Society, NS 42, 1888).

A Poetical Epistle to Sir Joshua Reynolds (London, 1777).

POINTON, M., *Naked Authority: The Body in Western Painting 1830–1906* (Cambridge, 1990).

—— *Hanging the Head: Portraiture and Social Formation in Eighteenth-Century England* (New Haven, 1993).

POIRÉE, E., *Sainte Cécile* (Paris, 1926).

PONTE, A., 'Architecture and Phallocentrism in Richard Payne Knight's Theory', in B. Colomina (ed.), *Sexuality and Space* (Princeton, 1992).

POPE, A., 'Ode for Musick, on St. Cecilia's Day', in *The Poems of Alexander Pope*, ed. J. Butt (London, 1963).

—— *The Poems of Alexander Pope*, ed. J. Butt (London, 1963).

PORTER, R., *English Society in the Eighteenth Century* (Harmondsworth, 1982).

POSTLE, M., 'Reynolds, Shaftesbury, Van Dyck and Dobson: Sources for Garrick Between Tragedy and Comedy', *Apollo*, 132 (Nov. 1990).

—— *Sir Joshua Reynolds: The Subject Pictures* (Cambridge, 1995).

POTTS, A., *Flesh and the Ideal: Winckelmann and the Origins of Art History* (London, 1994).

PRATT, M. L., *Imperial Eyes: Travel Writing and Transculturation* (London, 1992).

PRESTON, T. R., 'Biblical Criticism, Literature, and the Eighteenth-Century Reader', in I. Rivers (ed.), *Books and their Readers in Eighteenth-Century England* (New York, 1982).

PRICE, F., 'Imagining Faces: The Late Eighteenth-Century Sentimental Heroine and the Legible, Universal Language of Physiognomy', *British Journal of Eighteenth-Century Studies*, 6: 1 (Spring 1983).

Public Advertiser.

PYE, J., *Patronage of British Art* (1845; London, 1970).

QUINLAN, M. J., *Victorian Prelude: A History of English Manners 1700–1830* (New York, 1941).

QUINTILIANUS, M. F., *The Institutio oratoria*, trans. H. E. Butler (London, 1920).

Raphael's St. Cecilia (n.p., 1770), BL 786.b.15.

RAVEN, J., 'Defending Conduct and Property: The London Press and the Luxury Debate', in J. Brewer and S. Staves (eds.), *Early Modern Conceptions of Property* (London, 1995).

—— *Judging New Wealth: Popular Publishing and Responses to Commerce in England, 1750–1800* (Oxford, 1992).

REDGRAVE, S., *A Dictionary of Artists of the English School* (1878; Bath, 1970).

REHBERG, F., *Drawings Faithfully Copied from Nature at Naples and with Permission Dedicated to the Right Honourable Sir William Hamilton . . . by . . . Frederick Rehberg. Historical Painter in his Prussian Majesty's Service at Rome, 1794, Fores's Correct Costume of Several Nations* (London, 1794).

—— *Drawings, Faithfully Copied From Nature, at Naples, and with Permission Dedicated to the Right Honourable Sir William Hamilton . . . by Frederick Rehberg. Historical Painter in His Prussian Majesty's Service at Rome, 1794, Published 12 October 1797 by S. W. Fores, No. 50, Piccadilly . . . Lent out on the Plan of a Circulating Library* (London, 1797).

REITLINGER, G., *The Economics of Taste* (New York, 1961).

REYNOLDS, Sir J., *Discourses on Art*, ed. R. Wark (London, 1975).

RICE, W. G. (ed.), *Literature as a Mode of Travel* (New York, 1963).

RICHARDSON, J., Sr., and RICHARDSON, J., Jr., *An Account of the Statues, Bas-reliefs, Drawings and Pictures in Italy, &c* (London, 1722).

RICHARDSON, S., *Pamela: or, Virtue Rewarded* (1740–1; Harmondsworth, 1980).

—— *Clarissa: or, The History of a Young Lady*, ed. A. Ross (1747–8; Harmondsworth, 1985).

RICOEUR, P., 'What is a Text? Explanation and Understanding', in *A Ricoeur Reader: Reflection and Imagination*, ed. M. J. Valdés (Hemel Hempstead, 1991).

RIVERS, I. (ed.), *Books and their Readers in Eighteenth-Century England* (New York, 1982).

—— *Reason, Grace and Sentiment*, i: *Whichcote to Wesley* (Cambridge, 1991).

RIZZO, B., *Companions without Vows: Relationships between Eighteenth-Century British Women* (Athens, Ga., 1994).

ROBINSON, J., *Wayward Women: A Guide to Women Travellers* (Oxford, 1990).

ROBINSON, Mrs, *Celadon and Lydia: A Tale* (London, 1777).

ROEBUCK, P., 'Post-Restoration Landownership: The Impact of the Abolition of Wardship', *Journal of British Studies*, 18: 1 (Fall 1978).

ROMNEY, Revd J., *Memoirs of the Life and Works of George Romney* (London, 1830).

ROSCOE, E. S., *Robert Harley, Earl of Oxford* (London, 1902).

ROSENBLUM, R., 'Reynolds in an International Milieu', in N. Penny (ed.), *Reynolds* (London, 1986).

ROSING, S., 'Mary Moser: The Discovery of an Extraordinary Woman and the Development of her Work', unpublished diss., Christie's and Royal Society of Arts (London, 1992).

ROUSSEAU, G. S., 'The Sorrows of Priapus: Anticlericalism, Homosocial Desire, and Richard Payne Knight', in R. Porter and G. S. Rousseau (eds.), *Sexual Underworlds of the Enlightenment* (Manchester, 1987).

ROWBOTHAM, S., *Hidden from History: Three Hundred Years of Women's Oppression and the Fight against it* (London, 1973).

ROWORTH, W. W., *Angelica Kauffman: A Continental Artist in Georgian England* (London, 1992).

SADE, D. A. F. de, *Justine: ou, Les Malheurs de la vertu* (1791; Paris, 1973).

SAINT-HILAIRE, R. R. M. de, 'M.-W. Peters 1742–1814', *Gazette des beaux-arts*, 4th ser. 6 (1911).

SANCHEZ, A. E. P,. and SAYRE, E. A. (eds.), *Goya and the Spirit of the Enlightenment* (London, 1989).

SAUNDERS, G., *Picturing Plants: An Analytical History of Botanical Illustration*, Exhibition Catalogue, Victoria and Albert Museum (London, 1995).

Savoy.

SAYER, J., *A Vindication of the Power of Society to Annull the Marriages of Minors* (n.p., 1755).

SCARISBRICK, D., *Jewellery in Britain 1066–1837: A Documentary, Social, Literary and Artistic Survey* (Norwich, 1994).

SCHADE, S., WAGNER, M., and WEIGEL, S. (eds.), *Allegorien und Geschlechter-differenz* (Vienna, 1994).

SCHAFFER, S., 'Natural Philosophy and Public Spectacle in the Eighteenth Century', *History of Science*, 21: 1 (1983).

SCHAMA, S., *The Embarrassment of Riches: An Interpretation of Dutch Culture in the Golden Age* (London, 1987).

—— 'Perishable Commodities: Dutch Still-Life Paintings and the Empire of Goods', in J. Brewer and R. Porter (eds.), *Consumption and the World of Goods* (London, 1993).

SCHIEBINGER, L., 'The Private Life of Plants: Sexual Politics in Carl Linnaeus and Erasmus Darwin', in M. Benjamin (ed.), *Science and Sensibility: Gender and Scientific Enquiry, 1780–1945* (London, 1991).

SCHIFF, G., *Johann Heinrich Füssli 1741–1825* (Zurich, 1973).

SCHIVELBUSCH, W., *The Railway Journey: The Industrialization of Time and Space in the Nineteenth Century* (Leamington Spa, 1977; 1986).

SCHLATTER, R., *Private Property: The History of an Idea* (London, 1951).

SCHOR, N., *Reading in Detail: Aesthetics and the Feminine* (New York, 1987).

SCHUCHARD, M. K. M., 'Freemasonry, Secret Societies, and the Continuity of the Occult Traditions in English Literature', Ph.D. thesis (University of Texas at Austin, 1975).

SECORD, A., 'Corresponding Interests: Artisans and Gentlemen in Nineteenth-Century Natural History', *British Journal of the History of Science*, 27 (1994).

SEKORA, J., *Luxury: The Concept in Western Thought, Eden to Smollett* (Baltimore, 1977).

SENNETT, R., *The Fall of Public Man* (1974; Cambridge, 1977).

A Sermon Preach'd at the Parish Church of St. James's Westminster on 21 May, 1702, at the Funeral of Mr. John Cooper (London, 1702).

Sermons to Asses (London, 1768).

SEZNEC, J. (ed.), *Diderot Salons* (Oxford, 1960–7).

SHAFTESBURY, A. ASHLEY COOPER, 3rd Earl of, 'A Notion of the Historical Draught or Tablature of the Judgement of Hercules, According to Prodicus', in *Characteristicks of Men, Manners, Opinions, Times* (1712; London, 1713–14).

SHEERAN, G., 'The Richardsons and their Garden at Bierley Hall', *Bradford Antiquary*, 3rd ser. 4 (1988–9).

SHERIDAN, T., *A Course of Lectures on Elocution* (London, 1762).

SHEVELOW, K., *Women and Print Culture: The Construction of Femininity in the Early Periodical* (London, 1989).

SHTEIR, A. B., 'Linnaeus' Daughters: Women and British Botany', in B. J. Harris and J. A. McNamara (eds.), *Women and the Structure of Society* (Durham, NC, 1984).

SKINNER, B., *The Scots in Italy in the Eighteenth Century* (Edinburgh, 1966).

SMILES, S., *The Image of Antiquity: Ancient Britain and the Romantic Imagination* (New Haven, 1994).

SMITH, J. T., *Nollekens and his Times*, ed. W. Whitten (1829; London, 1920).

SMITH, R., 'Intellectual Contexts for Handel's English Oratorios', in C. Hogwood and R. Luckett (eds.), *Music in Eighteenth-Century England* (Cambridge, 1983).

Society for the Encouragement of Arts, Manufactures and Commerce, *Premiums by the Society, Established at London, for the Encouragement of Arts, Manufactures, and Commerce* (London, 1758).

Society of Arts, *A Register of the Premiums and Bounties Given by the Society* (London, 1778).

Solkin, D. H., 'Great Pictures or Great Men? Reynolds, Male Portraiture and the Power of Art', *Oxford Art Journal*, 9: 2 (1986).

—— *Painting for Money: The Visual Arts and the Public Sphere in Eighteenth-Century England* (New Haven, 1993).

SOMMERVILLE, C. J., *The Secularization of Early Modern England* (Oxford, 1992).

SONTAG, S., *The Volcano Lover* (London, 1992).

SORANE D'ÉPHÈSE, *Maladies des femmes*, trans. P. Burgière, D. Gourevitch, and Y. Malinas, i (Paris, 1988).

SOWERBY, J., *An Easy Introduction to Drawing Flowers According to Nature by James Sowerby Originally Designed for the Use of his Pupils* (London, 1788).

SPENCER, N., *The Complete English Traveller: or, A New Survey and Description of England and Wales* (London, 1771).

STAINTON, L., *English Artists in Rome*, Exhibition, Kenwood (1974).

STANWORTH, K., ' "Pictures in Little": The Conversation Piece in England', Ph.D. thesis (University of Manchester, 1994).

STAVES, S., *Married Women's Separate Property in England 1660–1833* (Cambridge, Mass., 1990).

STEBBING, H., *A Dissertation on the Power of States to Deny Civil Protection to the Marriages of Minors* (London, 1755).

STERLING, C., *Still Life Painting from Antiquity to the Twentieth Century* (1952; New York, 1981).

STEWART, C. J., *A Catalogue of the Library Collected by Miss Richardson Currer at Eshton Hall* (London, for private circulation, 1833).

STEWART, S., *On Longing: Narratives of the Miniature, the Gigantic, the Souvenir, the Collection* (1984; Durham, 1993).

St. James Chronicle; or, British Evening Post.

STONE, L., *The Family, Sex and Marriage in England 1500–1800* (New York, 1977).

—— *Road to Divorce* (Oxford, 1992).

SUMMERSON, J. (ed.), *Concerning Architecture: Essays on Architectural Writers and Writings Presented to Nicholas Pevsner* (London, 1968).

SUTHERLAND, G. (ed.), *Essays in Honor of Robert Wark* (San Marino, Calif., 1992).

SUTTON, D., 'Magick Land', *Apollo*, 99 (June 1974).

SWEET, R. H., 'The Writing of Urban Histories in Eighteenth-Century England', Ph.D. thesis (University of Oxford, 1994).

SYKES, N., *Church and State in England in the XVIIIth Century* (Cambridge, 1934).

Sylvia's Revenge: or, A Satyr against Man. In Answer to the Satyr against Woman (12th edn. London, 1720).

SZÉPE, H. K., 'Desire in the Printed dream of Poliphilo', *Art History*, 19: 3 (Sept. 1996).

Tamerlane: An Opera Composed by Mr. Handel (London, 1724).

THORESBY, R., *Ducatus Leodiensis: or, The Topography of the Ancient and Populous Town and Parish of Leedes* (London, 1715).

TODOROV, S., *Symbolism and Interpretation*, trans. C. Porter (London, 1983).

TOMASELLI, SYLVANA, 'The Enlightenment Debate on Women', *History Workshop Journal,* 20 (Autumn 1985).

TOSCHI, P. (ed.), *Sacre rappresentazioni toscane dei secoli XV e XVI* (Florence, 1979).

TURNER, J. D., 'The Sexual Politics of Landscape: Images of Venus in Eighteenth-Century English Poetry and Landscape Gardening', *Studies in Eighteenth-Century Culture*, 11 (1982).

Universal Magazine.

VALDÉS, M. J. (ed.), *A Ricoeur Reader: Reflection and Imagination* (Hemel Hempstead, 1991).

VALE, M., *The Gentleman's Recreations: Accomplishments and Pastimes of the English Gentleman, 1580–1630* (Cambridge, 1977).

VEBLEN, T., *The Theory of the Leisure Class: An Economic Study of Institutions* (1925; London, 1957).

VICKERY, A., 'Women and the World of Goods: A Lancashire Consumer and her Possessions, 1751–81', in J. Brewer and R. Porter (eds.), *Consumption and the World of Goods*, i (London, 1993).

WAGNER, P., *Eros Revived: Erotica of the Enlightenment in England and America* (London, 1988).

—— 'The Discourse on Sex or Sex as Discourse: Eighteenth-Century Medical and Paramedical Erotica', in R. Porter and G. S. Rousseau (eds.), *Sexual Underworlds of the Enlightenment* (Manchester, 1987).

WALPOLE, H., *The Beauties: An Epistle to Mr. Eckhardt, the Painter* (London, 1746).

—— *The Duchess of Portland's Museum*, ed. W. S. Lewis (New York, 1936).

—— 'Notes by Horace Walpole', *Walpole Society* (1938–9).

WALSH, J., HAYDON, C., and TAYLOR, S. (eds.), *The Church of England c.1689–c.1833: From Toleration to Tractarianism* (Cambridge, 1993).

WARD, H., and ROBERTS, W., *Romney: A Biographical and Critical Essay with a Catalogue raisonné of his Works* (London, 1904).

WARNER, M., *Monuments and Maidens: The Allegory of the Female Form* (London, 1985).

WARTON, T., *Verses on Sir Joshua Reynolds's Painted Window at New-College, Oxford* (2nd edn. London, 1783).

WATERHOUSE, E. K., *Painting in Britain 1530–1790* (Harmondsworth, 1953).

—— *Reynolds* (London, 1941).

WATKIN, D., *The Royal Interiors of Regency England* (London, 1984).

WATKINS, C. T., *A Portable Cyclopaedia* (London, 1810).

WATT, T., *Cheap Print and Popular Piety 1550–1640* (Cambridge, 1991).

WEATHERILL, L., *Consumer Behaviour and Material Culture in Britain 1660–1760* (London, 1988).

WEBB, D., *An Inquiry into the Beauties of Painting* (London, 1760).

WEBER, W., *The Rise of Musical Classics in Eighteenth-Century England* (Oxford, 1992).

WEIGEL, S., 'Body and Image Space: Problems and Representability of a Female Dialectic of Enlightenment', *Australian Feminist Studies*, 11 (Autumn 1990).

WEST, S., 'Libertinism and the Ideology of Male Friendship in the Portraits of the Society of Dilettanti', *Eighteenth-Century Life*, 16: 2 (1992).

WHITE, C., ALEXANDER, D., and D'OENCH, E. (eds.), *Rembrandt in Eighteenth-Century England* (New Haven, 1983).

WHITE, H., 'The Value of Narrativity in the Representation of Reality', in W. J. T. Mitchell (ed.), *On Narrative* (1980; Chicago, 1981).

WHITLEY, W., *Artists and their Friends in England 1700–1799* (London, 1928).

WILLIAMS, R., *Marxism and Literature* (Oxford, 1978).

WILSON, T., *The Ornaments of Churches Considered, with a Particular View to the Late Decoration of the Parish Church of St. Margaret Westminster* (London, 1761).

WINCKELMANN, J. J., *Versuch einer Allegorie, besonders für die Kunst* (Dresden, 1766).

WIND, E., 'Humanitätsidee und heroisiertes Porträt in der englischen Kultur des 18. Jahrhunderts', in *England und die Antike,* ed. F. Saxl, Vorträge der Bibliothek Warburg 1930–1931, 9 (1932).

WINTERNITZ, E., *Musical Instruments and their Symbolism in Western Art* (London, 1967).

The Woman of Fashion: A Poem. In a Letter from Lady Maria Modish to Lady Belinda Artless (London, 1778).

WOOD, G. B., 'Bierley Hall', *Yorkshire Life Illustrated* (Oct. 1956).

WOODALL, J. (ed.), *Portraiture* (Manchester, forthcoming).

WORNUM, R. (ed.), *Lectures on Painting by the Royal Academicians: Barry, Opie and Fuseli* (London, 1848).

'Wretched Julia', 'Correspondence', *Morning Post and Daily Advertiser* (1 Mar. 1774).

WRIGHT, T., *Caricature History of the Georges: or, Annals of the House of Hanover* (London, 1876).

Yale Center for British Art, *'The Pursuit of Happiness': A View of Life in Georgian England,* Exhibition, Yale Center for British Art (New Haven, 19 Apr.–18 Sept. 1977).

YOUNG, A., *A Six Weeks' Tour through the Southern Counties of England* (London, 1768).

YOUNG, H. (ed.), *The Genius of Wedgwood*, Exhibition Catalogue, Victoria and Albert Museum (London, 1995).

ZOMCHICK, J. P., *Family and the Law in Eighteenth-Century Fiction* (Cambridge, 1993).

ZWEIG, M., 'Mary Moser', *Connoisseur Year Book* (1956).

INDEX

Abdy, Dame Ann 346
Abdy, Lady 365–6
Abdy, Sir Anthony Thomas, Bart. 365
Abergavenny, Lord 397
Abney, Dame Mary 363
Abney, Sir Thomas 363
Act of Toleration (1698) 233
Adam, Robert 179, 183, 186, 275
Addison, Joseph 243, 287
adultery 196, 236
Aeneas 215
Agar, Charles D' 57 n151
agronomy, agriculture 91, 106
Ainsworth, Robert:
 Thesaurus 209, 211
Aislabie, William 47, 115, 354
Alexander the Great 215
Alken, Henry:
 Flora at Play with Cupid (after Crewe) 149,
 Pl. 22
All Souls College Chapel, Oxford 235
Allan, D. G. C. 134, 145, 147
allegory 11, 64–7, 177, 285
 and portraits 5, 12, 59–61, 64–6, 69–70, 72–3, 80,
 82, 177, 284, 295
Amelia, Princess 164–5
anarchy 252
Ancaster, Dowager Duchess of 335
Anderdon, J. H. 140
Andover, Viscount 360
Andover, Viscountess 360
angels 230, 231, 242, 244, 248, 251, 257–8, 268, 272,
 284, 286
Anglicanism 242, 245–6
Anning, Miss 138
anthropology, anthropologists 8–9
antiquarian, antiquarianism 6, 90–1, 95, 97–8,
 100, 103, 106–10, 118, 120–1, 123–4, 246, 236,
 271, 289
Apollo, Apollonian 173, 186, 280
Apollo Belvedere 71, 190, 200–1
Appadurai, Arjun 8
archaeology, archaeologists 97, 123, 149
architecture, architects 79, 108–9, 162, 164, 181,
 246
Arendt, Hannah 126 n42
Armstrong, John:
 The Oeconomy of Love: A Poetical Essay 81–2
Arran, Earl of 331
artefacts 3, 6–7, 9–11, 16, 29–30, 32, 43–4, 244
 see also under specific artefacts

Arther, Lady Betty 369
Artists Repositiory, The 134–5, 138, 147
Arundell of Wardour, Dowager Lady Anne 393–4
Arundell of Wardour, Lord Henry 246, 393
Arundell, Mary, Lady 369
Ashbrook, Elizabeth, Dowager Viscountess 44,
 396–7
Ashbrook, William, Viscount 44, 396
Astell, Mary 40, 102, 233
Atholl, Jane, Duchess of (formerly Lannoy) 361
Atkins, Sir Richard, Bart. 344–5
Aubrey, John 106
Augusta, Princess 147
Austen, Jane 104–5, 115
 Pride and Prejudice 90, 261
Avebury, Wiltshire 118
Aylesford, Henry, Earl of 321–2
Aylsford, Countess of 37

Baccha 211, 213, 214, 218
bacchanal, bacchanalian, bacchic 70, 175, 179, 185,
 187–94, 196–7, 204, 211, 213, 215–16, 220, 286
Bacchante 187, 209, 219, 280
 A Bacchante (Kauffman) 218, Pl. 50
 A Bacchante (Reynolds) 177, 208, 209, Pl. 42
 A Bacchante (Wheatley) 211, Pl. 45
 A Bacchante (Woodforde) 190, Pl. 35
 Emma Hamilton (?) as a Bacchante (38x30.5)
 (Romney) 193, Pl. 37
 Emma Hamilton as a Bacchante c.1786 (Tate
 Gallery) (Romney) 208, 209, Pl. 41
 Emma Hamilton as a Bacchante c.1786 (151x119.5)
 (Romney) 209, Pl. 43
 Lady Hamilton as a Bacchante (Vigée–Lebrun)
 177, 209, 218, Pl. 44
 Reclining Bacchante (Bartolini) 190, Pl 36
 Self Portrait (?) as a Bacchante (Kauffman) 190,
 Pl. 34
Bacchus 186, 188, 209, 211, 215, 221
Bacon, John:
 design for Hymen candlesticks 66, Pl. 2
Badalocchio, Sisto 304 n168
Bagot, Sir Walter Wagstaffe, Bart. 359–60
Baker, Malcolm 267
Ball, Guy 181
Ballard, George:
 Memoirs of Several Ladies of Great Britain 103
Ballyshannon, Elizabeth, late Lady Dowager
 Folliott, Baroness of 309
Bampfylde, Miss 263
Banastre, Dame Elizabeth 365–6

Barbados 181
Barbauld, Anna 165 n 2
Barberini Vase (later known as Portland Vase) 36
Barlaston 176
Barnardiston, Sir Samuel 374
baroque 229, 237, 238, 276, 292, 294
Barry, James 85 n 51, 232, 243–4 , 249, 251, 266
Bartoli, Francesco 185, 238
Bartoli, Santi:
 Admiranda Romanorum antiquitatum 77, Pl. 7
Bartolini, Lorenzo:
 Reclining Bacchante 190, Pl 36
Bartolozzi, Francesco 272, 296 n 14, 298 n 50
 A Bacchante (after Kauffman) 218
 *The Spirit of a Child Arrived in the Presence of the
 Almighty* (after Peters) Pl. 55
Baskerville Printing Works 120
Bassano, Jacopo 238
Bataille, Georges 248
Batoni, Pompeo 238, 263, 298 n 49
Baudrillard, Jean 35–6
Beardsley, Aubrey 86 n 67
Beaufort, Elizabeth, Duchess of 147
beauty 60, 159, 194, 243–4
 and goodness 230
 and women 5, 248–50
Behn, Aphra 248
Bell, John (publisher):
 The Poets of Great Britain 270–1, 287–8
Bellomont, Lucy Ann, Dowager Countess of 308
Belvoir Castle 270, 272
Bentinck, Lady Margaret Cavendish 147
Bentinck, Lord George 361–2
Bentley, Joseph Clayton:
 Bierley Hall (after Cousen) Pl. 12
Benwell, Mary 139
Berchtold, L.:
 *An Essay to Direct and Extend the Inquiries of
 Patriotic Travellers* 105
Berg, Maxine 3
Bernard, Sir John 313
Bernard, Sir Robert 313
Bernstein, Susan 285
Berry, C. 26
Berry, duc de 202
Bertie, Emily 213
Bertie, Lady Eleanora 215, 334–5
Bertie, Lady Elizabeth 334–5
Bertie, Peregrine 334
Bestland, G.:
 *The Royal Academicians Assembled in their Council
 Chamber* (after Singleton) Pl. 18
Bewerley 115
bible, biblical texts 232–3, 250, 251, 257, 268,
 296 n 27
 see also religious imagery

Bierley Hall (near Bradford) 95–6, 110, 121, Pl. 12
Bigg, William Redmore 141
Billington, Elizabeth 231, 290–1
 Mrs Billington as St Cecilia (Reynolds) 273, 276,
 284, 288, Pl. 63
Bingley, Lady Elizabeth, Baroness Dowager
 321–2
Birmingham 94, 120
Bissett, Major G. M. 202
Black, Mary 139
Blackstone, Sir William 31
Blake, William 89
Bland, Lady Frances 322
Bludworth, Lady Louisa Carolina 335
Blue Stocking Circle 5, 165 n 2
Board of Agriculture 94, 125 n 11
Boase, T.S.R. 233
the body 29, 175, 248, 252, 286
 female 33–4, 72, 79, 82, 185, 196, 205, 208, 243–4,
 250, 263, 264, 266, 270
 male 244
Boilly, Louis-Léopold 254
Boltanski, Christian 30
Bolton Abbey 109–10
Bone, Henry 190
Boswell, James 79
botany, botanical 114, 123, 133, 146–8, 157–8, 161
 see also flower painting
Bourbon, duc de 202
Boydell, John 238
Boyle, Grace 32–3
Brackeridge, Revd. William 59
Bradbury, Revd Thomas:
 The Revd Thomas Bradbury (Grace) 139–40, Pl. 21
Brampton, Herefordshire 16–23
Braudel, Fernand 8, 21
Brewer, John 32
Bridges, Dame Margaret 335
Bridges, Mary 40
Bridlington 100, 111–13
Brighton 175
British Institution 204
British Museum, London 110
Brooke, Francis, Lord 384
Brown, G. 153–4
Brown, John 293
Brown, Peter 133
Bruce, James:
 The Theban Harp 292, Pl. 70
Bruegel, Jan and Rubens:
 *Garland of Flowers with the Virgin, Infant Jesus
 and Angels* 156
Bruegel, Pieter 251
Buccleuch, Duke of 355
Buffon, Comte de (Georges Louis Le Clerc):
 Natural History 266

Bunbury, Lady Sarah:
 Lady Sarah Bunbury Sacrificing to the Graces
 (Reynolds) 60, 71, 175, Pl. 25
Burch, Edward 296 n 14
Burghley 238, 257, 270, 272
Burghley, Lord 373
Burgoyne, Lady Frances 368
Burgoyne, Sir Roger, Bart. 368
Burke, Edmund:
 Enquiry 194
 *A Letter from a Distinguished English Commoner to
 a Peer in Ireland* 63
Burlington Magazine 67
Burlington, Dowager Countess of 323
Burlington, Richard Boyle, 3rd Earl of 77, 125 n 18
Burnet, James, Lord Monboddo 293
Burney, Charles 289
 A General History of Music 187–8, 280, 292,
 Pl. 32
Burney, E. F. 252, 268
 The Waltz 252, Pl. 56
Burney, Fanny 78, 167 n 23, 176, 215, 218, 220,
 293–4
 Cecilia 287
Burney, James 293–4
Bute, John Stuart, Earl of 147
Butler, Alban:
 Lives of the Saints 284
Butler, Lady Amelia 331
Buxton 105
Byng, John, Viscount Torrington:
 Torrington diaries 104–6, 108, 111
Byron, George Gordon:
 Don Juan 77

Cadogan, Charles, Baron of Oakley 310
Cadogan, Lady Margareta (daughter of Dowager
 Countess) 310
Cadogan, Lady Margareta Cecilia Munter,
 Dowager Countess of, Lady of Zanen
 Raaphorst 310
Cadogan, Lady Sarah 310
Calvinism 246
Camden, William 109, 118
Canaletto, Giovanni Antonio 47, 383
Canzius, Lady Elizabeth Joanna (otherwise Wylo)
 342
Capell, Lady Ann 355, 389
Capell, Lady Charlotte 355
Capell, Lady Diana 355
Capell, Lady Mary 355
card-playing 25, 100–1, 113, 119
Carey, William 234
Carolina, Princess 349
Caroline, Queen 43, 383
Carr, John 179

Carr, William 96
Carracci family 272
Carter, Elizabeth 165 n 2
Carwardine, Miss J. 139
Casteels, Peter 152
Castiglione, Baldassare 225 n 92
Catherine of Russia, Empress 94
Catholic Relief Bill 61, 83 n 11, 242
Catholicism 63, 229–31, 234, 237, 242, 246, 249,
 270–1, 272–3, 288
Cato 26
Cats, Jacob 65
Catton, Charles 161
Cavendish, Lord James 331
Cavendish, Lord Richard 64, 218
Certeau, Michel de 6, 8, 48
Chaloner, Anne, *see* Lascelles, Anne
Chaloner, Mary, *see* Hale, Mary
Chaloner, William 179, 181
Chambers, Sir William 138
Chard, Chloe 94
charity 24, 35, 118
Charles I, King 63
Charlotte, Queen 10, 146, 160–1
Charlton, Dame Mary 315–16
Charpin, Miss E. 139
chastity 74
Chatfield, Mrs 231
Chaucer, Geoffrey 287
Chedworth, Lord 41, 345
Chelsea Hospital, London 41
Chelsea Physick Garden, London 148
Chester, Dame Frances (will proved 19 July 1749)
 47, 358–60
Chester, Dame Frances (will proved 31 January
 1752) 357–8
Chester, Sir Charles 359
Chester, Sir John 260
children 4, 17, 19–24, 29, 179, 181, 195
 images of 69, 70, 141, 185, 190, 250, 257, 264,
 266, 276
 as models 244
Chipping Wycomb 121
Christie's 237
Chudleigh, Miss 181
Church of England 230
Churchill, Sarah, Duchess of Marlborough 8,
 34–5
Circe 284
Cipriani, Giovanni Battista 232, 236
Clanbrazil, Judith, Dowager Coningsby, Baroness
 of 37, 327–8
Clarges, Louisa, Lady 276
Clark, J. C. D. 246
class *see* social class
Claude Gellée (Le Lorrain) 222 n 31

Clegg's hat-making factory 120
Cleveland and Southampton, Ann, Dowager
 Duchess of 340–2
Cleveland and Southampton, Charles, Duke of
 340–2
Clifford, Arethusa, Dowager Viscountess 336
Clifford, James 64
Clinsted, Mr 47, 383
Clinton, Hugh Fortescue, 1st Earl of 351
Clinton, Margaret, Baroness (formerly Margaret
 Fortescue) 351
clothes, clothing, dress 2, 9, 27–9, 31, 33, 35, 38–9,
 41–2, 74, 173, 176, 179, 185, 201, 202, 204–5, 214,
 220, 247, 262–3, 276
Coade, manufactory 66
Cobbett , William 111
 Rural Rides 104
Cobham, Ann, Lady Dowager Viscountess 44,
 47, 398–400
Cockburn, Jane 33, 36
Coke, Thomas, First Earl of Leicester 238, 244
Coleman, John 80
Colepeper, Frances, Lady 45, 325–7
Colepeper, John, Lord 326
Colepeper, John Spencer 45, 325–6, 382
Coleridge, Samuel Taylor:
 Biographia literaria 236
collecting 229, 243, 297 n 47
collections 95, 232, 242, 244, 254, 272
 royal 110–11, 138
 sales of 36–7, 237, 238
collectors 37, 96, 111, 147, 237, 244, 273, 276
Collett, Dame Elizabeth 394
Colley, Linda 234, 246
Colliton, Lady 41, 311
Colliton, Sir Theodore 41, 311
Colonna, Francesco:
 Sacrifice to Priapus 69, Pl. 3
Colyear, Lord Walter Philip 338
commodities, commodity 10, 19–21, 24, 32, 144,
 146, 159, 242
 see also luxury
Compton, Lady Anne 337
Compton, Lady Charlotte 337
Compton, Lady Elizabeth 336–7
Compton, Lady Jane 337
Compton, Lady Margaret 337
Compton, Lady Penelope 337
Conca, Sebastiano 238
 St Apollonia Surrounded by Putti 276, Pl. 66
 St Cecilia 276, 291, 292, Pl. 69
Concert of Ancient Music 289
connoisseurs, connoisseurship 229, 233, 243, 246,
 250
consumption:
 of goods 3–5, 10–11, 24, 32, 35, 48, 146, 152, 244

Conyers, Dame Margaret 45, 389–91
Conyngham, Henry, Lord 340–2
Cook, Captain James 110, 293
Cooke, Lady Francis 308
Coombes, Dr (Keeper of the Hunterian
 Collection) 98, 100
Cooper, Samuel 47, 360
Copley, John Singleton 161
Copley, Stephen 13 n 22, 146
Corneille, Pierre:
 Antiochus, fils de Seleuchus 141
Correggio (Antonio Allegri) 237–8, 242, 243, 249,
 257, 268, 270, 272
corruption 3–4, 20, 229, 247, 252
Cortona, Pietro da 141, 238
Cosway, Maria, see Hadfield, Maria
Cosway, Richard 131, 134, 142, 237, 298 n 50
 A Group of Connoisseurs 73, Pl. 5
 A Lady and her Two Daughters in the Characters of
 Wisdom, Virtue and Beauty 6
Cotes, Francis 134, 266
Cotton, Dame Sarah 43, 47, 375–7
country:
 and city/town 4, 10, 18–21, 23–4, 27, 31
 histories 91
Courbet, Gustave 259
courtesans 178, 211, 215–16, 218, 219, 258
courtly love 248
Courtney, Elizabeth 39
Cousen, C.:
 Bierley Hall 95, Pl. 12
Coventry, Emily 213
Cowper, William:
 The Task 266
Cranford, John, Earl of 361
Crashaw, Richard 269
Crespi, Guiseppe Maria 188
Crewe, Emma:
 Flora at Play with Cupid 149, Pl. 22
Cries of London 27
critics 77, 250–1, 289
 see also reviewers
Cronin, W. V. 213
cross-dressing 74, 204–5
Cupid 81, 149–50
Currer, Frances Mary Richardson 96
Currer, John, see Richardson, John
Curwen, Christian 209

D'Oyly, Dame Rebecca 314–15
D'Oyly, John, Bart. 314
Dalkeith, Caroline, Countess of 355
Dalkeith, Francis, Earl of 354–5
Dance, Nathanial:
 Orpheus Lamenting the Loss of Eurydice 273
dance, dancing 185, 186, 193, 252

Darcy, Sir Conyers 333–4
Darlington, Dowager Countess of 397
Darwin, Erasmus:
 The Botanic Garden 148–52, 159, 165, Pls. 22, 22a,
 22b
 The Temple of Nature 270
Dashwood, Sir Francis 269
David, Jacques-Louis:
 Antiochus and Stratonice 141
Davidoff, Leonore 8, 244–6
Davies, Tom 81
Davison, W. 105
Dayes, Edward 104
death 7, 16, 22, 30, 33, 72
 see also wills
décor 47–8
decoration, decorative arts 133, 148, 150–1, 160,
 161, 162, 164–5
Defoe, Daniel 12 n1, 21, 104, 106
 Weekly Review 27
Delany, Mary 144
Della Porta, Giacomo 266
Dempster, Thomas:
 De Etruria regali 214, 218, Pl. 47
Derbyshire 91, 106
Derrida, Jacques 79, 159–60
Diana 69
Dibdin, Thomas Frognall 96
Dickinson, William:
 Lydia (after Peters) Pl. 60
 The Resurrection of a Pious Family (after Peters)
 Pl. 54
Diderot, Denis 300 n83
Dido 215
Diefendorf, Barbara B. 40
Digby, Katherine 335–6
Digby, Lady Jane 335–6
Dillon, Frances, Dowager Viscountess 364–5
Dillon, Henry, Viscount 364
Dionysus, Dionysiac 188, 280
divorce 59, 143, 179, 195–6, 218
Dixie, Dame Rebecca 344–5
Dolci, Carlo 244, 257, 272
Doll, Mr 47, 345
Dolte, William 47
Domenichino (Domenico Zampieri) 244
 David 279, 289
 Magdalen 237
 St Cecilia 279, 304 n168
Douglas, Mary 8
drama 6
 see also theatre
dress, *see* clothes, clothing
druids 96
Dryden, John 215, 264, 273
Dublin 63, 252

Dublin Society for Promoting Husbandry 145
Dudley, Dame Eliza 355–6
Duncombe, Anna Maria 139
Duncombe, John 139
Dundas, Charlotte 231
Dundas, Sir Thomas 231
Dunkarton, Robert:
 Belinda (after Peters) 259, Pl. 59
Dupplin, Constantia, Viscountess 377–9
Dupplin, Viscount 378
Dutch art 29, 133, 154, 157, 158
Dyce, Revd Alexander 133
Dyck, Sir Anthony van 56 n133

Earlom, Richard 133
Earwig 213
East India Company 26, 28
Eaton, Fred A. 254
Edinburgh Trustees Academy 143
education 139, 245
 and females 94, 96, 106, 118, 135
 and males 91
Edwards, Edward 296 n14
Effingham, Elizabeth, Dowager Baroness Howard
 of 45, 333–4
Effingham, 6th Baron, Earl Howard of 45, 334
Egerton, Lady Elizabeth 347
Eggington, Sir Simon Every of 352–3
Eglinton, Jane, Countess of 276
Egremont, Charles Wyndham, 2nd Earl of
 238
Egypt 292, 294
Ehret, Georg Dionysius 147
Einberg, Elizabeth 138
ekphrastic, ekphrastical 114, 272
Elias, Norbert 8
Eliot, George 268
Elizabeth, Princess 146, 161, 164–5
Ellis, Frances 142
Elstob, Elizabeth 102
emblems, emblematic 63, 65, 70, 175
emulation 5, 32
engravings 77, 131, 134, 138, 140, 150, 177, 183, 189,
 193, 196, 213, 230, 238, 254, 257–9, 263, 264,
 268, 272, 287, 288, Pls. 18, 19, 21, 22a, 29, 38–9,
 51, 65
Erasmus of Rotterdam 225 n84
Erickson, Amy 3, 10, 167 n25
erotic, eroticism 10, 77, 141, 165, 237, 243, 248,
 257–9, 262, 268, 270, 287
 see also sex
Eshton Hall, near Skipton 96
Essex, Lady Mostyn 331
etiquette books 186
euphemism 65
Euphrosyne 186, 189, 213–14

Euripides:
The Bacchae 188
Evans, Mrs 97
Evelyn, John 20–1, 41, 250
Every, Dame Dorothy 352–3
Exeter College, Oxford 252
Exeter, 5th Earl of 238
Exeter, 9th Earl of 238
Exeter, Letitia Cecil, *Countess of (formerly Townshend and late Lady Burghley)* 372

Fabricant, Carole 104–5
family, families 15–16, 22–32, 36–7, 43, 59, 96, 97, 100, 107, 139, 194, 237, 245–6, 247
 see also genealogy
fantasy 21, 121, 173,175, 178–9, 197, 198–9, 202, 205, 218, 246, 269
Farington, Joseph 146, 161
fashion 27, 162, 247
Fawkes, Francis 233
Feinstein, Joel 85 n50
feminine, femininity 5, 64, 71, 79, 80, 94, 102–3, 107, 213–4, 216, 244, 259, 262, 268
 ideals of 7, 229
 representation of 70
feminism, feminists 7–8, 71
fertility 23, 69–70
Festing, Michael 287
Fetherstonhaugh, Sir Harry 205
Fielding, Henry 105
 Amelia 195
Fiennes, Celia 90, 104–6, 108
Finch, Heneage (Lord Gernsey) 322
Fischer-Homberger, Esther 77
Fitzroy, Lady Grace 341
Fitzroy, Lord Charles 341
Flaxman, John 257
Fleming, Miss Jane (Countess Harrington) 205
Flemish art 29, 230, 237–8, 266, 271
Fletcher, Henry 152
Flora 149–50, 221
Florence 242, 257
flower painting 11, 131, 133, 146–64
Foley, Elizabeth, *see* Harley, Elizabeth
Foley, Thomas 15, 25
Fontenay, Jean Belin de 161
food 21, 27, 36
Ford, Brinsley 298 n49
Foreman, Mrs 36
Forester, Charlotte, Dowager Lady 321
Forester, George, Lord 321
Fortescue, Dame Mary 339
Foucault, Michel 107, 248
Foundling Hospital, London 224 n66, 233
Fox, George 247
frames 47, 48, 160, 162, 176, 183, 198

France 3, 13, 18, 63, 91, 161, 162, 164, 204, 254
 art 237
 music 286
Frederick Louis, Prince of Wales, 181, 232
Free Society 154
Freemason's Magazine or General and Complete Library 267
Freemasonry 149, 242, 254
Freud, Sigmund 248
 Beyond the Pleasure Principle 30
friendship 30, 40–1, 143
Frogmore House, Windsor 150, 152, 156, 160–1, 164–5
Furber, Robert 152
Fuseli, Henry 262
 Euphrosyne 186, Pl. 31
 Flora Attired by the Elements 150, Pl. 22a
 The Power of Fancy in Dreams (from Darwin, *The Temple of Nature*) 270, Pl. 61

Gage, Jane, Dowager Viscountess 39, 395
Gainsborough, Thomas 176, 276
Garber, Marjorie 204
Gardeman, Lady Catherine 45, 391–3
gardens 147–8, 158, 161, 162, 164
 garden gods 77
 landscape gardening 115
 and paintings 61, 77, 79–80, 149
Gardiner, Elizabeth, *see* Montgomery, Elizabeth
Gardiner, Luke (Lord Mountjoy, 1st Earl of Blessington) 10, 61, 63–4, 69, 79–80, 86 n55
Gardiner, William 79
Gargrave 96–7
Garrard, Dame Celilia 379–82
Garrards (jewellers) 32
Garrick, David 121, 181, 213, 261
Garthwaite, Anna Maria 164
Garzi, Luigi 238
gazeteers 106, 198
gender 5, 7, 48, 61, 64, 69, 71, 78, 102–3, 107, 113, 123–4, 135, 143, 175, 230, 243–5, 251–2
 boundaries 98, 100, 244
 differences 73
 roles and identities 2
 power relations 72
 and viewing 267, 270
genealogy; family history 43, 91, 97, 100, 107, 110, 120, 123
Gennari, Benedetto 304 n168
Genoa 270
genre paintings 254, 257, 258
genres 9–10, 29, 91, 95, 267, 273
 hierarchy of 133, 147
 and women 131, 133
 see also under specific genres

Gentileschi, Artemesia:
 Self-Portrait 134
Gentileschi, Orazio 304 n168
Gentleman's Magazine 195
George I, King 40
George II, King 321
George III, King 133, 147, 237
Giddens, Anthony 107
Gifford, Dame Frances 369–70
gifts, presents 21, 24, 33, 35–6, 40
Gilpin, William 91, 100, 114, 118, 120
glass 47, 162, 230, 232, 235, 236, 243, 245
Glorious Revolution 158
Gloucester, Duke of 242
Godin, Lady Joanna Louise 343
Goethe, Johann Wolfgang von 200–2
Goldsmith, Oliver 134
Gombrich, Prof Sir Ernst 67, 69, 71, 73–4, 77, 78,
 82
goods, *see* commodities
Gothic 115, 161, 236, 270
 Gothic novel 248
Gowran, Ann, Dowager Baroness 339–40
Gowran, John, 2nd Baron 340
Goya, Francisco de 86 n70
*The Graces: A Poetical Epistle from a Gentleman to his
 Son* 73
Grace, Mary 10–11, 131, 133–4, 138–145
 Antigonous, Seleucus and Stratonice 141
 A Ballad Singer 14
 Beggars 140
 Death of Sigismunda 141
 Pea-Pickers Cooking their Supper 141
 The Revd Thomas Bradbury 139–40, Pl. 21
 Self-Portrait 134, Pl. 19
Grace, Thomas 141
*Graces: A Poetical Epistle from a Gentleman to his
 Son, The* 73
Graham, Elizabeth 142–3
Graham, John 143
Grand Tour, Grand Tourists 59, 79, 91, 113, 238,
 263
Grantham, Henry d'Anverquerque, 1st Earl of
 308, 331
Grasmere 114
Graves, A. 213
Graves, Richard:
 Euphrosyne 150, 165, 173, 175, 189, 197, 214, 218,
 221, Pl. 33
Gray, Thomas 114
Green, Thomas 133
Green, Valentine 234, 236–7
Gregorian chant 286
Greuze, Jean-Baptiste 254, 264, 303 n157
Greville, Charles 205, 208–9, 211, 243
Grey, Marchioness 348

Grey, Lady Sophia 347–8
Griffith, Elizabeth 165 n2
Grignion, Charles:
 frontispiece to R. Graves *Euphrosyne, or
 Amusements on the Road of Life* (after Hoare)
 Pl. 33
 The Theban Harp (after Bruce) Pl. 70
Grose, Francis 110
Grosvenor Gallery, London 204
Grosvenor, Richard, 1st Baron 259
Grozer, J.:
 Death of Dido (after Reynolds) Pl. 48
Guercino, Il (Giovanni Francesco Barbieri) 190,
 238
Guido da Siena:
 St John 96
Guisborough 181

Habbick, Conradt 142
Hadfield, Maria (later Cosway) 131, 138, 142, 263
hair-styles, coiffure 262–3
Hale, Colonel John 179, 181, 215
Hale, Mary 12, 179, 181, 183–5, 199, 215, 216
 Mrs Hale as Euphrosyne (Reynolds) 60, 179,
 183–6, 189–90, 193–4, 196–8, 209, 213–16, 219,
 273, 275, 276, Pl. 29
Hall, Catherine 8, 244–6
Halliday, Lady Jane:
 Lady Jane Halliday (Reynolds) 223 n48
Halpenn, Elizabeth (Lady Lawley) 38, 39, 327–9
Hamilton, Emma 11, 177–8, 190, 193, 199–202,
 205–16, 243
 Emma Hamilton (Romney) 177, 232, 236, Pl. 52
 Emma Hamilton (?) as a Bacchante (38 × 30.5)
 (Romney) 193, Pl. 37
 Emma Hamilton as a Bacchante c.1786 (Tate
 Gallery) (Romney) 208, 209, Pl. 41
 Emma Hamilton as a Bacchante c.1786 (151×119.5)
 (Romney) 209, Pl. 43
 Emma Hamilton as St Cecilia (Romney) 232, 276,
 285, Pl. 64
 Emma Hamilton in the 'Attitude' of a Vestal Virgin
 (Rehberg) 271, Pl. 65
 Emma Hamilton performing her 'Attitudes'
 (Rehberg) 200, 271, Pls. 38–9
 Lady Hamilton as a Bacchante (Vigée-Lebrun)
 177, 209, 218, Pl. 44
Hamilton, Gavin:
 Priam Pleading with Achilles for the Body of Hector
 80
Hamilton, Sir William 10, 178, 201, 205, 208–9,
 243–4, 273
Hancarville, Pierre François Hugues d' 73
 Receuil d'antiquités étrusques, grèques, et romains
 77, 179, Pl. 6
Handel, George Frederick 215, 273, 289

Harcourt, Elizabeth, Dowager Viscountess 47, 353–4

Harcourt, Simon, Viscount 353

Harcromonde, Lady Amelia Catherine de Wassenaer de 361

Hardwicke Marriage Act, 1753 59, 195

Hardwicke, Lord Philip Yorke, 1st Earl of 46, 350

Hare, Dame Elizabeth 338–9

Hare, Dame Rosamond 338

Hare, Dame Sarah 338

Hare, Sir Thomas 338

Harewood House, Yorkshire 179, 205, Pls. 28, 30
 Music Room 10, 186, 196–9, 273, Pl. 26

Harley, Brilliana, Lady 18

Harley, Elizabeth 4, 15–29, 32, 34, 36, 38, 48

Harley, Robert 15–27

Harley, Sir Edward 15, 20, 24, 27

Harris, Eileen 275

Harris, Francis 8, 139

Harris, Lady Elizabeth 43, 343

Harrogate 118–19, 121

Harrow 104–5

Hart, Emma, see Hamilton, Emma

Harvey, Lady Ann 39, 323–4

Harward, Charlotte 142

Harwood, Francis 242

Hattingh, Joanna Cecilia 337

Hatton, Dame Henrietta 385–6

Havana 181

Haydon, C. 246

Hayman, Francis 232, 238

Hazlitt, William 105, 272

headgear 262–3

Heather, John 154

Hegel, Georg Wilhelm Friedrich 286–7

Hell Fire Club 269

Hemingway, Andrew 251

Herbert, Lady Mary 394

Hesse-Homberg, Frederick Joseph Louis, Landgrave of 146

Heysham 111

Hickey, William 213

Highmore, Susannah 139

Hinchingbrook, Lady Elizabeth 324

Historical Manuscripts Commission 15

historiography 10, 72, 176, 259

history, historical 2, 4, 7, 9, 26, 29, 30, 65, 69, 90, 94, 121, 199
 family histories, see genealogy
 history painting 61, 70, 78, 79, 134–5, 141, 197, 251

Hoare, Sir Richard Colt (?):
 frontispiece to Graves Euphrosyne, or Amusements on the Road of Life Pl. 33

Hoare, William 47, 383

Hodgkiss, Mary, see Grace, Mary

Hodgson, J. E. 254

Hogarth, William 176, 230, 235, 247
 After 78
 Before 78

Holkham Hall 236, 244

Holland 148, 152

Homer 70

homes, houses 16, 29, 31, 40, 66, 79–80, 104–5, 106, 108, 115, 118–19 , 238, 245, 272
 household management 23–4, 39, 41

Hone, Nathanial 296 n14

Houghton Hall 238

Houghton, J.:
 The Power of Fancy in Dreams (after Fuseli) Pl. 61

House of Commons, St Margaret's Westminster 234

Howard, Dorothy 360–1

Howard, Mary 39

Hudson, Thomas 134, 252

Huizinga, Johan 6

Humble, Dame Sarah 34, 319–21

Humble, Sir William 320–21

Hunter, Dr John:
 museum 98, 103

Hussey, Giles 47, 377

Hutchins, Martha 24–5, 28

Hymen 61, 66–7, 74, 77, 79, 81, 185

hymen 77–9, 81–2

Hymen: A Poem 59

Ilsley, Heneage 115

Incorporated Society of Arts 134

Ireland , Irish 18, 61, 63, 65, 95, 138, 142, 162

ironmongery 15

Irwin, Elizabeth, Dowager Viscountess 316–17

Isle of Wight 252

Italy 77
 art 157, 229–30, 237–8, 242–3, 248–9, 251, 266–7, 270–1
 music 286

Ittersum, Lady Anna Margaretha (Des Marets) 370

James III, King of England (James VIII of Scotland) 231

Jekyl, Lady Ann 369

Jenegan, Lady 370

Jephson, Robert 80

Jervais, Mr 232

jewellery 21, 28–29, 31–7, 41–5, 262

Johnson, Joseph 270

Johnson, Samuel 1, 121, 134, 159, 176, 269
 Rasselas 78, 157

Johnstone, Lady Charlotte 368–9

Jones, Dame Mary 39, 332–3

Jones, Edward 279
Jones, Lady Catherine 40–1, 311–12
Jones, Robert 5, 248, 285
Jones, William 173
Jordaens, Jacob 188
Jordan, Mrs Dora 263
journal-writing, journals 1–2, 11, 89, 124
Juno 69

Kant, Immanuel:
 Critique of Pure Reason 159
Kauffman, Angelica 131, 138, 186, 221
 A Bacchante 218, Pl. 50
 St Cecilia 276
 Self Portrait (?) as a Bacchante 190, Pl. 34
 Venus Showing Aeneas the Way to Carthage 215
Kauffman, John Joseph 296 n14
Keepsake literature 257
Kemp, Dame Amy 349
Kenmare, Viscount 63
Kent 254
Kent, Sophia, Dowager Duchess of 347–9
Kent, William 77, 230–1, 235, 280
Keppel, Augustus, 1st Viscount
 Commodore Keppel (Reynolds) 71
Keppel, George, 3rd Earl of Albemarle 181
Kildare, Emily, Countess of 40, 47–8, 311
Knapton, George 56 n144, 302 n145
Knaresborough 94, 118
Kneller, Sir Godfrey 47, 383
 Lord High Treasurer Harley 49 n6
 Lady Elizabeth Cromwell as St Cecilia 268, 276
Knight, Richard Payne 73, 91
 An Analytical Inquiry into the Principles of Taste
 30
Knight, Sir Charles John Baptist Pereir de
 Coigners 317
Knowlton, George 125 n18

Lacan, Jacques 198
Lairesse, Gérard de 141
Lake District 91
Lama, Giulia:
 Self-Portrait 134
Lambert, Dame Jane 44, 399
landscape 80, 114, 120, 197, 266
Langford's (auctioneers) 237
Langham, Dame Phyllis 38, 386–8
Langham, Dame Sarah 39
language 3, 7–8, 9, 11, 20, 22, 29, 71, 251, 252, 293
 and allegory 66
 antiquarian 107
 of wills 37, 39, 143
Lascelles, Anne 10, 179, 181, 183
Lascelles, Edward, Earl of Harewood 10, 179, 181,
 183

Lascelles, Edwin, Earl of Harewood 10, 179, 183,
 199, 205
Lavater, Johann Caspar 266
law, laws 3, 4, 25, 31, 34, 37, 41, 103, 179, 195
 see also wills
Le Brun, Charles 213 , 266, 270
 Ecce Homo 238
Le Grant, A:
 An Angel Carrying the Spirit of a Child (after
 Peters) Pl. 53
Ledbury 297 n35.
Leeds 94, 121
Leeds, Juliana, Dowager Duchess of 147, 355
Leeds, Thomas, Duke of 355
Legge, Anne 42–3, 351
Legge, Elizabeth 43, 351
Leicester, Sir John Fleming, Bart:
 Gallery 271
Leigh, Lady Barbara 366–9
leisure 33, 103, 196, 146, 164, 266
Lely, Sir Peter
 Susannah and the Elders 268
 Mary Magdalen 268
Lemoine-Luccioni, E. 185
Lennox, Charlotte 165 n2
Leppert, Richard 186, 252, 285–6, 288
Leslie, C. R. 176, 279
Lessing, Gotthold Ephraim 78, 235
letter-writing, letters 4, 11, 16–23, 30, 48, 72, 124,
 181, 195, 259
Lewis, Judith 138
Lewis, Lady Widdrington Erasmus 360
Leyser, Judith 157
libraries 15, 44–5, 95–6, 110, 114, 161, 229
Licensing Act 27
Lichfield 121
Lichfield, Dowager Countess of 370
Lichfield, George Henry, Earl of 343
Limerick, James Hamilton, Viscount 46, 350
Limerick, Viscountess 349
Lincoln Cathedral 236
Lindsey, Robert, Marquess of 334
Linnaeus, Carl von 148, 152, 165
Livy (Livius, Titus) 26
Lloyd, Mrs 195
Locke, John 3, 89, 235
London 16, 19–21, 27–8, 33, 91, 104, 111, 146, 176
 art market 238
 exhibitions 139, 197, 252, 267
 Hackney 141
 Homerton 141, 142
 Lincoln's Inn Fields 288
 St Mary Le Bow 142
 Spitalfields 162
London Chronicle 197–8
London Churches Act 246

London Gazette 27
Louis XIV, King 161, 270
Louth, Lincolnshire 235
Loutherbourg, P. J. de 235, 254
love 16, 18–20, 22, 30, 81
Ludlow, Lady Frances 369
Lunden, Dame Helena Clara 317–19
luxury 3–5, 20–21, 24, 26–8, 48, 148, 161, 162, 177,
 266, 268, 289
 trade 158
Lycurgus, King of Sparta 198
*Lydia: ou, Mémoires de Milord d'-imité de l'anglais
 par M. de la Place* 261–2
Lyon, Amy, *see* Emma Hamilton

Macaulay, Catherine 102, 165 n 2
MacCannell, Dean 104
McKendrick, Neil 32
Macklin, Thomas:
 Bible 232, 235
maenads 188, 193, 196, 214, 215, 218
Manchester Art Treasures exhibition 204
Manchester, George Montagu, Duke of 242
Mandeville, Bernard:
 The Fable of the Bees 26
Manners, Lady Victoria 254, 259
Mannings, David 202
Maratta, Carlo 238, 244, 272
Marlborough, Duchess of 261
marriage 7, 15–6, 22, 25, 33, 60, 63, 179, 195–7, 199,
 204–5, 216, 259, 261
 intermarriage 63
 and portraiture 59
 and property 34–5
 settlements 5, 34, 38, 40
Marsyas 186, 288
Martyn, John:
 Historia plantarium rariorum 148
masculine, masculinity 80, 82, 94–5, 102–3, 123,
 194, 213
masks 188
Matlock 111
Mauss, Marcel 8
Meissen porcelain manufactory 66
Melbourne, Lord 259
Mengs, Anton Raffael 235
metropolis 18, 235
 metropolitan life / culture 11, 19
 metropolitan public / society 23, 221, 251, 252
 see also country and city / town; London
mezzotint 133, 199, 225 n 80, 258
Midas 186
Middlesex Journal 250
Middleton, Clara Louisa 142
Middleton, Sarah 15
Midleton, George, Viscount 388–9

Midleton, Mary, Dowager Viscountess 388–9
Mignard, Pierre:
 St Cecilia 276, 291, 303 n 160, Pl. 67
Milan 244
Miller, Lady Anna 128 n 70
Millington, Sir Thomas 17
Milton, John 65, 185–6, 252, 288
Minerva 221
Minnelli, Liza 204
Mitchell, Andrew 47, 384
Mirth 186
Moir, Esther 103
Monck, Lady Ann Isabella 362
Monnoyer, Jean-Baptiste 161
Monsey, Messenger 139
Montagu, Elizabeth 147, 165 n 2
Montagu, Lady Mary Wortley 102
Montagu, Sarah 329
Montague, Lady Barbara 366, 368
Montaign, Mary, Dowager Viscountess 325–7
Montefiascone, Bishop 231
Montfaucon, Bernard de:
 L'Antiquité expliquée, et représentée en figures 77,
 179, 185, Pls. 8, 9
Montgomery sisters 67, 69, 71–2, 77–9
 Anne Montgomery (later Lady Townshend)
 61
 Barbara Montgomery 61
 Elizabeth Montgomery (later Mrs Gardiner) 12,
 61, 63, 67, 71–2; *Three Ladies Adorning a Term
 of Hymen* (Reynolds) 61–67, 69–74, 77–82,
 Pl. 1
Montgomery, Sir William 61
Moore, Edward 270
More, Hannah 165 n 2, 245–6
Morland, George 141
Morning Chronicle 66, 250, 267
Morning Post 146, 257
Mortimer, John Hamilton 134, 138, 235, 263
Moser, George Michael 133
Moser, Joseph 142–3
Moser, Juliet 142
Moser, Mary 10, 131–4, 137–9, 142–8, 150–2, 154–9,
 195
 The Mary Moser Room, Frogmore 131, 152,
 156, 160–5, Pl. 24
 Self-Portrait 134, Pl. 20
 Study of a Tulip 157–9, Pl. 23a
 Vase of Flowers 154, 159, 162, Pl. 23
Mostyn, Sir Roger 331
Mugge, Margaret 41–2, 345–6
Mun, Thomas:
 England's Treasure by Forreign Trade 26
Murillo, Bartholomé Esteban 272
 Madonna and Child and St Joseph 96
Murray, James 268

music 10, 186–7, 214–5, 270–3, 276, 284–9, 291–94
musical instruments 188–9, 252, 285, 288,
 304 n 168
 cymbals 186–7, 213, 215, 219
 guitar 285
 harp 230 , 275–6, 279–80, 284, 292
 harpischord 44, 285
 lutes 186, 285
 lyre 186, 196, 273, 280
 organ 230, 273, 275–6, 279–280, 284–5
 pipes 186, 280
 spinnet 285
 tambourine 189–90, 214–15, 218–19
 trumpet 186
Myers, S. H. 139
Mytens, Daniel 56 n 136
myth, mythology, mythological 7, 11–12, 65–6,
 69–74, 78–9, 82, 149, 151, 173–227

Napier, Sir Theophilus 333
Naples 190, 205, 208, 209, 244
nation 4
 nationalism, nationalistic 91, 229, 233
 nationhood 205
National Gallery, London 64
natural history 91, 98, 106, 107, 123, 147–8, 156
 see also botany
natural scientists 98
New College, Oxford 236
New Daily Advertizer 198
Newark 111
Nichols, John:
 Illustrations of the Literary History of the
 Eighteenth Century 96–7
Nicholson, Kate 248
Nicolson, Dame Mary Ann (otherwise Colyear)
 337–8
Nicolson, Lord George 338
Niddersdale 114, 119
Nodder, Frederick P.
 Meadia 152, Pl. 22*b*
Nollekens, Joseph 142–3, 160
Nollekens, Mary 142
Nonconformist church 141
Noorthey, Dame Gertruyd 400
Norfolk, Duchess of 147
North, Lady Barbara 323
North, Roger 285
Northampton 98
Northampton, James, Earl of 336–7
Northcote, James 63, 131, 213
 A Lady in the Character of St Catherine 231
Northumberland, Elizabeth, Countess of 383,
 384
Northumberland, Hugh, 18th Earl of 383, 385
Norton, Lady 113

Nostell 108–9
novels and stories 28, 48, 104, 105, 175, 259, 285
 Belinda: or, The Fair Fugitive 259
 Celadon and Lydia : A Tale 261
 Clarissa 248
 The Entertaining Amour of Sylvander and Sylvia
 261
 The Eustace Diamonds 36
 The Folly of Love: A New Satyr against Women
 261
 Lydia; or, Filial Piety 261
 Lydia: ou, Mémoires de Milord d'-imité de l'anglais
 par M. de la Place 261–2
 Pamela 31, 33, 35, 124, 247–8
 Pride and Prejudice 90, 261
 Sylvia's Revenge 261
 The Woman of Fashion: A Poem: In a Letter from
 Lady Maria Modish the Lady Belinda Artless
 259
nude, nakedness 173, 202, 262
 nudes 213
Nussbaum, Felicity 102

O'Neill, Mrs 264
Ogilby, John 106
Okin, Susan Moller 34
Old Windsor 348–9
Oldham 120
Olivier, Michel-Bertélemy 296 n 14
 The Massacre of the Innocents 250–1
 Death of Cleopatra 299 n 83
Olmins, Mr 235
Omai 254, 293
Opie, John 257
Ord, Mrs Elizabeth 147
Orient, orientalism 219, 266, 276, 292
ornament 133, 148, 164
Orpheus 188, 196, 273, 275, 280, 288
Orrery, John Boyle, 5th Earl of 46, 350
Osborton, Sir Andrew Thornhagh 309
Ossory, Lady 220
Oulton, W. C. 161
Ovid 70, 73–4, 150, 200
Oxford 113–14, 254, 288

Paddy, Lady Ann 342
Paley, William:
 Natural Theology 156
pamphlets 195
paradise 272
Paris 257
 Luxembourg Palace 61
 Salon 64
Parker, Dame Martha 388
Parker, Rozsika 133, 141
Parma 242, 257

Parmigianino (Girolamo Francesco Mazzola) 242, 249, 272
 Madonna 266
 Marriage of Catherine 238
Parsons, James:
 Passions 194
patrons, patronage 6, 10, 72–3, 160, 233, 238, 242, 254, 258, 264, 268, 272, 275
Paul, Lady Ann 43, 361–2
Paulson, Ronald 247
Pears, Ian 238, 242
Pembroke, Mary, Dowager Countess of 362–3
Penny, Nicholas 59, 222 n31
Penrice, Sir Henry 333
Pentheus 188, 218
Percy, Hugh (Lord Warkworth) 385
Percy, Lady Elizabeth 383, 385
Peters, Revd Matthew William 10, 150, 230, 242, 252, 254, 262
 An Angel Carrying the Spirit of a Child to Paradise 231, 238, 254, 257, Pl. 53
 Annunciation 236
 Belinda 259, 263, Pl. 59
 Hebe 263
 Love in her Eyes Sits Playing 263
 Lydia (Tate Gallery) 257, 262–3, Pl. 57,
 Lydia (British Museum) 264, Pl. 60
 The Resurrection of a Pious Family 238, 257, Pl. 54
 The Spirit of a Child Arrived in the Presence of the Almighty 238, 257, Pl. 55
 Sylvia 257–9, 262, Pl. 58
 The Three Holy Children 257
 A Woman in Bed 258, 267
Petre, Lady Mary 56 n132, 356
Petre, Robert Edward, 9th Baron 242, 246, 356
Pevsner, Nikolaus 235
Peyton, Dame Ann 338
Philadelphia 94
Pierpont Morgan Collection 254, 263–4
Pilkington, Matthew:
 Dictionary of Painters 151
pin-money 25, 34–5
Pindar, Peter (Dr Wolcot) 198, 254, 258
Pine, Robert Edge 134
Piozzi, Hester Thrale 1, 175–6, 244
Piroli, Thomas:
 Emma Hamilton performing her 'Attitudes' (after Rehberg) Pls. 38, 39
 Emma Hamilton in the 'Attitude' of a Vestal Virgin (after Rehberg) Pl. 65
Pitt, Lady Hester 399
Planta, Mr 110
Plantation House, near Guisborough 181, Pl. 27
Plato, platonic 9, 200, 230, 284
Playboy 259

Plumb, J. H. 32
Plutarch 141
 Lives 65
Pococke, Richard 105–6, 110
Poetical Epistle to Sir Joshua Reynolds, A 177–8, 198–9
poems, poetry 60, 80–2, 95, 104, 139, 157, 173, 185, 186, 195, 197, 198–9, 233–4, 247, 259, 261–2, 269, 270–2, 273, 287–8, 289, 290
Politan:
 Orfeo 188
Polite Arts 134, 145–6, 175
 politeness 11, 78, 82, 246, 252, 266, 268
Pollock, Griselda 133, 141
Pomfret, Henrietta Louisa, Countess of 384
Pope, Alexander 79, 288
 The Rape of the Lock 259
Porter, Roy 245–6
Portland Vase 36, 149
Portland, Duchess of 36–7, 105
Portland, Dowager Countess of 347
portraits 15, 29, 31, 44, 47, 59–82, 175–6, 178, 270
 bequests 41, 45, 309, 311, 313, 316, 320, 322, 323, 326, 330, 331, 332, 334, 337, 338, 343, 345, 350, 353–4, 356, 360, 368–9, 375, 377, 382, 383, 391, 392, 399
 family 45–7, 109; *see also under* bequests
 female 7, 59–61, 64, 79, 175, 177–9, 197–8, 214–5, 273, 284
 male 70, 200
 sittings 1, 2, 12
 see also under individual artists' works
portraiture 1, 11–2, 45–9, 59–82, 134–5, 138, 140, 173–221, 243, 263–4, 266
Postle, Martin 213, 231, 266
Pott, Bob 213
Pott, Emily 213, 215
Potts, Alex 244
Poussin, Nicolas 69, 77, 185, 219
 Landscape with a Snake 272
Powell, Mrs 39, 327
pregnancy 16–7
Presbyterians 16
presents, *see* gifts, presents
press 27
Preston, Mary, Dowager Viscountess 370–1
Priapus, Priapean 69, 73–4, 77, 185, 252, Pl. 3
Price, Uvedale 91, 114, 161
Price, William 161
prints, printing 36, 120, 267, 270
 see also engraving
private subscriptions 250
privatization:
 of art 242
Procaccini, Giulio Cesare 238
Proclamation Society 246

property 3, 30–6, 41, 95–6, 104, 142–3, 181–3,
 205
prostitution 59, 196, 215, 218
Protestantism 5, 41, 63, 156, 229–295
provincial life 103
 see also country and city / town
Public Advertiser 61, 266
Purcell, Henry 287
Puritans 15, 186

Quakers 147, 247, 286
Quarrington, Mrs 231
Quebec campaign 181
Quintilian (Quintillianus, Marcus Fabius) 193
quotation 64, 69, 71–2, 77, 79, 82, 97, 178, 264

railways 91
Ramsay, Allan 47, 56 n 143
Ranelagh House 40
Raphael (Raffaello Sanzio), Raphaelesque 37,
 222 n 31, 238, 242, 243, 244, 257, 272, 276, 294
 St Cecilia 285, 289–90
Rassan and Anverkerke, Dowager Countess de
 308
Rassan, Count Corneille de 308
Rassan, Count William Mauritz de 308
Ray, John:
 The Wisdom of God Manifested in the Works of
 Creation 156
Read, Catherine 138
Readshaw, Mrs 181
Rebecca, Biagio 232
Redgrave, Samuel 141
Reformation:
 pre-Reformation 236, 271
 post-Reformation 272
Rehberg, Frederick 244
 Emma Hamilton performing her 'Attitudes'
 engraved by T. Piroli 200, 271, Pls. 38, 39
 Emma Hamilton in the 'Attitude' of a Vestal Virgin
 engraved by T. Piroli 271, Pl. 65
religion 7, 8, 22, 31, 252
 see also under individual religions
religious imagery 5, 10, 230–95
Rembrandt Harmensz, van Rijn 9
Renaissance 74, 151, 250, 258, 294
Reni, Guido 238, 244, 257, 272, 290
reportage 91
representation:
 issues of and problems in 2–9, 22, 79, 91–4,
 102–3, 107, 111–13, 153–9, 194, 198–202, 230,
 233–6, 258–9, 276–85, 289–95
reviews, reviewers 61, 64, 65, 66–7, 154, 197–8,
 250–2, 258, 266–7
 see also critics
Revolution, 1688 15, 26

Reynolds, Sir Joshua 2, 6, 10–11, 147 157, 176–8,
 187, 199, 208, 214, 216, 237, 251, 257–8, 266, 273
 A Bacchante 177, 208, 209, Pl. 42
 Commodore Keppel 71
 Cupid as Link Boy 150
 Death of Dido 215 Pl. 48
 Discourses 67, 69, 194, 249
 Garrick between Tragedy and Comedy 78, 213–14
 The Infant Hercules 188
 The Ladies Waldegrave 215, 218–20, Pl. 49
 Lady Blake as Juno 69
 A Lady in the Character of St Cecilia 231, 273
 Lady Jane Halliday 223 n 48
 Lady Sarah Bunbury Sacrificing to the Graces 60,
 71, 175, Pl. 25
 Lady Worsley 202–5, 213, Pl. 40
 Mrs Billington as St Cecilia 231, 273, 276, 284, 288,
 291, Pl. 63
 Mrs Crewe as St Genevieve 231
 Mrs Hale as Euphrosyne 60, 179, 183–6, 189–90,
 193–4, 196–8, 209, 213–16, 219, 273, 275, 276,
 Pl. 29
 Mrs Quarrington as St Agnes 231, 276
 Mrs Sheridan in the Character of St Cecilia 231,
 273, 276, 280, 284, 294
 Muscipula 264, 266
 Portrait of a Lady in the Character of Miranda in
 'The Tempest' 67
 Robinetta 266
 St Cecilia (Los Angeles) 231, 273, 275, 276, 279,
 284, 288–95, Pls. 62, 62a
 stained glass design 236
 Thaïs 211–15, 218, 273, Pl. 46
 Three Ladies Adorning a Term of Hymen 61–7,
 69–74, 77–82, Pl. 1
rhetoric, rhetorical 16, 40, 48, 102, 124, 135, 250,
 287, 293
Richardson, Dorothy 10–11, 91–124, 145, 227 n 119,
 238, 271
 The Bit of a British Bridle Found at Silbury Hill
 98, Pl. 13
 Danesfield 115, Pl. 16
 Hack Fall near Ripon 91, Pl. 10
 Mr Yorke's Folly at Bewerley 115, Pl. 15
 Plan of Bridlington Quay 111, Pl. 14
 Richmond Friary 94, Pl 11
 St Patrick's Chapel near Heysham Pl. 17
Richardson, Dr Richard 10, 95–7
Richardson, Henry 10, 96
Richardson, John (Currer) 10, 113–14
Richardson, Jonathan 47, 243, 385
Richardson, Samuel:
 Clarissa: or, The History of a Young Lady 248
 Pamela: or, Virtue Rewarded 31, 33, 35, 124, 247–8
Richardson, William 10, 95–6
Richmond, Charles Lennox, Duke of 310

Richmond, Sarah, 2nd Duchess of 310
Ricoeur, Paul 102
Rigaud, 235
Robinson, Maria:
 Celadon and Lydia: A Tale 261
Robinson, Sir Thomas 338
Rocca, Michele (Il Parmigianino)
 St Cecilia 276, Pl. 68
Rochester Cathedral 235
Rockingham, Charles Watson Wentworth, 2nd
 Marquess of 108, 179
Roman Catholic Church, see Catholicism
Romano, Giulio 77
Rome 26, 231, 238, 242, 257
Romney, George 205, 208, 209, 216, 266, 270
 Emma Hamilton 177, 232, 236, Pl. 52
 Emma Hamilton (?) as a Bacchante (38×30.5) 193,
 Pl. 37
 Emma Hamilton as a Bacchante c.1786 (Tate
 Gallery) 208, 209, Pl. 41
 Emma Hamilton as a Bacchante c.1786 (151×119.5)
 209, Pl. 43
 Emma Hamilton as St Cecilia 232, 276, 285, Pl. 64
 The Head of a Lady in the Character of a Saint
 232
 A Magdalen 232
Rosenblum, Robert 64, 67
Rossiter, Charles:
 Teatime 190
Roundell, Eleanor 107
Roundell, Mary (née Richardson) 96, 107
Roundell, William 96, 98, 107, 113, 114, 115
Rowbotham, Sheila 8
Rowlandson, Thomas 252
Royal Academy 2, 60–1, 64–5, 67, 77, 81, 131, 133–4,
 145, 148, 160, 164, 183, 197–8, 202, 204, 211, 213,
 215, 218, 234, 243, 250–2, 254, 258, 264, 267–8,
 275, Pl. 18
Royal Botanical Gardens, Kew 147
Royal Society 95, 145
Royal Society of Arts 98, 123, 134, 145, 234
Rubens, Sir Peter Paul (and Bruegel):
 Nature Adorned by the Graces Pl. 4
Rubens, Sir Peter Paul 74, 188, 303 n150
 Life of Marie de' Medici 61
Rushout, Lady Anne 337
Rutland, Charles, 4th Duke of 254, 270, 272
Rutland, Mary Isabella, Duchess of 231

Sacchi, Andrea 238
Sacrelaire, Dame Susan 310–11
Sade, Marquis de 248
 Justine 271
saints, saintly 5, 229–30, 237, 242, 244, 249, 251, 258,
 268–9, 270, 272–3, 286
St Albans 111

St Anne 236
St Cecilia 139, 230–33, 236, 268, 272–95
 A Lady in the Character of St Cecilia (Reynolds)
 231, 273
 Mrs Billington as St Cecilia (Reynolds) 231, 273,
 276, 284, 288, 291, Pl. 63
 Mrs Sheridan in the Character of St. Cecilia
 (Reynolds) 273, 276
 St Cecilia (Conca) 276, 291, 292, Pl. 69
 St Cecilia (Domenichino) 279, 304 n168
 St Cecilia (Kauffman) 276
 St Cecilia (Mignard) 276, 291, 303 n160, Pl. 67
 St Cecilia (Raphael) 285, 289–90
 St Cecilia (Los Angeles) (Reynolds) 231, 273, 275,
 276, 279, 284, 288–95, Pls. 62, 62a
 St Cecilia (Rocca) 276, Pl. 68
St Clement's Dane, Strand, London 230, 280
St George 162
St George's, Hanover Square, London 181
St James's Square, London 9, 273, 292
St James's Chronicle 249, 262
St John 231
St Margaret's, Westminster 234
St Martin's Lane Academy 134
St Paul's Cathedral, London 234, 237
St Stephen's, Walbrook 235
Salisbury Cathedral 235–6
Salisbury, Anthony 133
Salvator, Rosa 205
Samuel, Richard 231
 Nine Living Muses of Great Britain 131
Sanders, John 296 n14
Sanderson, Lady Ann 369
Sardinian Embassy Chapel 235
Saunders, Dame Ann 324
Saunders, Gill 152
Saussure, Horace Benédict de 159
Sayer, Joseph 196
Sayer, R.:
 Emma Hamilton as a Bacchante (after Romney)
 193
Scarborough 101–2
Scarbrough, Lord 368
Scheemakers, Peter 129 n118
Schiebinger, Londa 148
Schivelbusch, W. 91
Schlatter, R., 12 n5
Schor, Naomi 157
Schweier, Rachel 142
Scotland 162
Scott, Lady Caroline 354–5
Scott, Lady Charlotte 354–5
Scott, Lady Jane 355
seduction 4, 215, 262, 270–1
Seghers, Daniel and Erasmus Quellinus II:
 Flower Piece with Madonna and Child 151

Sekora, John 26
Sennett, Richard 175
senses:
 sight 89–9, 120, 121, 123, 284
 sound 284
 see also music
Sentimental Magazine 268
servants 24, 31–2, 35, 39, 43, 109, 204, 245
 bequests to 43
 maids and journeys 100–102, 111
sex, sexual 65, 77–82, 157, 178, 197, 248, 215–16, 267,
 286, 288
 advice 81–2, 195
 dangers 186
 difference 60, 95, 148
 symbolism 285
 transgression 200, 204, 246, 272
 voyeurism 247
sexuality 7, 197, 214, 252, 285
Sèvres porcelain manufactory 66
Shackleton, Elizabeth 39
Shaftesbury, Anthony Ashley Cooper, 3rd Earl of
 213
 Judgement of Hercules 78
Shaftesbury, Lady 41, 345
Shakespeare, William 65, 252
 The Tempest 67
Shaw, Dame Anna Maria 40, 373–5
Shaw, Lady 373
Shaw, Sir John 374
Shebbeare, John:
 Lydia; or, Filial Piety 261
Sheffield 121
Shelburne, Henry Petty, Earl of 121
Sheldonian Theatre, Oxford 162
Sheridan, Mrs Elizabeth (née Linley) 165 n 2,
 231
 Mrs Sheridan in the Character of St Cecilia
 (Reynolds) 231, 273, 276, 280, 284, 294
Sheridan, Richard Brinsley 294
 The Rivals 261
Sheridan, Thomas 224
Shevelow, Katharine 5, 102
Shipley, William 98, 145
Shirley, Lady Anna Elinora 44, 309, 386
Shirley, Lady Barbara 309, 386
Shirley, Lady Elizabeth 309
shopping 19, 30
Shrewsbury, Lady 356
silk, silk-weaving 3, 26, 38, 43, 162, 164
Singleton, Henry:
 The Royal Academicians Assembled in their Council
 Chamber 131, Pl. 18
Slaughter, Stephen 138
slave trade 181
Sloane, Hans 95

Smith, Anker:
 Flora Attired by the Elements (after Fuseli) 150,
 Pl. 22a
Smith, John Raphael:
 A Bacchante (after Reynolds) 177, Pl. 42
 Hebe (after M. W. Peters) 263
 Love in her Eyes Sits Playing (after Peters) 263
 Sylvia (after Peters) 264
Smollett, Tobias 105
Sobieski, Clementina 230
social class 2–3, 11, 12, 13 n 23, 24, 33, 35–6, 101–2,
 104–5, 107, 113, 118, 124, 177, 246
 aristocracy 10, 38, 164
 gentry 1,10, 32, 38, 90, 139, 164, 175, 195, 270
 lower-classes 178
 middle classes 8, 32, 38, 91, 234, 244
social order 176, 196, 252
Societies for the Reformation of Manners 236
Society for the Promotion of Christian
 Knowledge 245–6
Society of Antiquaries 96–8, 107, 123, 145, 234
Society of Artists of Great Britain 134, 138, 140,
 183, 197–8
 see also Royal Academy
Society for the Encouragement of Arts
 Manufactures, and Commerce 135
 see also Royal Society of Arts
Society of Dilettanti 79, 94, 273, 302 n 145, 303 n 158
Society of Gentlemen 98
Soho Works, Birmingham 84, 120
Solander, Dr 110
Solkin, David 70, 194, 233
Somerset House 133–4, 138
Somerset, Frances, Dowager Duchess of 44, 46,
 383–5
Somerville, Anne Wyatt, Lady 333
Soranos of Ephesus 77
Spain:
 art 29, 133
Spelman, Lady Elizabeth 46, 350–1
Spelman, Sir Henry 56 n138
Spencer, N.:
 The Complete English Traveller 106
Spenser, Edmund:
 Faerie Queene 65
Spilsbury, John:
 The Revd Thomas Bradbury (after Grace) 140,
 Pl. 21
Stanhope, Sir William 352
Stanton, George, Viscount 371
Stark, Marianna 128 n70
Staves, Susan 25, 31
Stebbing, Henry D.D. 195–6
Stephenson, Elizabeth 264
Sterling, Charles 153, 159
Sterne, Laurence 79

Stewart, Susan 29, 34
Stone, Lawrence 34, 179, 195, 202
Stothard, Thomas 298 n50
Strafford, Anne 32–3, 36
Strafford, Sir Thomas Wentworth, Earl of, *see*
 Wentworth, Sir Thomas
Stratton, John, Lord 348
Streeter, Robert 162
Stuart, John, 3rd Earl of Bute 147
Stubbs, George 176
 Haymakers 262
Stukeley, William 106
Suffolk and Berkshire, Henry Bowes Howard,
 Earl of 360
Suffolk and Berkshire, Countess 360
Sunderland 113
Sussex, Duke of 160
Sweet, R. H. 90
Swift, Jonathan 40, 79

tambours 220–1
Tanjé, P.:
 St Cecilia (after Rocca) Pl. 68
Taylor, S. 246
Taylor, T. 176, 190, 279
Taylor, Tom:
 cavern 114–15
tea, tea-drinking 2, 26–7, 28, 105, 113, 119
text:
 in paintings 252, 258–9
 see also quotations
textile design 164
Thaïs 215, 219
 Thaïs (Reynolds) 211–15, 218, 273, Pl. 46
 Thaïs (Wheatley) 219, Pl. 51
theatre 8, 80, 102, 162, 186
 actors 193
 actresses 67, 71–2, 215–16, 263
Thornborough Moor 115, Pl. 16
Thornhill, Sir James 234
Thrale, Henry 1, 398–9
Thrale, Hester, *see* Piozzi, Hester Thrale
Throckmorton, Sir Robert 393
time 18, 29, 102–3, 107–8, 121
 time-frames 91, 97, 103
Tintoretto, school of:
 Deposition 236
Titian (Tiziano Vecellio) 242
 La Bella 258
Toddereck, Miss 139
Todorov, Stephen 65
Tollemache, Mrs 67
Tomars, Marquis de 45, 330
Tomaselli, Sylvana 4
topography 91, 94–5, 101, 114, 123–4
Tory 15, 246, 289

tours, touring 90–1, 98, 100–7, 114, 118, 123, 238
 see also Grand Tour; travel
town, *see* country and city/town
Towneley family 237
Towneley, Charles 73
 Gallery 77
transvestism, *see* cross-dressing
Traquair, Charles, Earl of 389–90
Traquair, Teresa, Countess of 389–90
travel 23, 98, 100, 104–6, 120–21
 writing 89–91, 94–8, 100–11, 114–15, 118–21, 123–4
Trevor, Ann, Dowager Baroness 47, 313
Trinity College, Cambridge 235
Trollope, Anthony:
 The Eustace Diamonds 36
Troy 70
 Helen of Troy 215, 219
Tufton, Margaret 352
Tunbridge Wells 23–5, 250
Turkey 158
Turner, Joseph Mallord William 104,
 The Choir and Lady Chapel, Salisbury Cathedral
 235–6

Universal Magazine 195

Vallière, Louise de la 270
Van der Gucht, Gérard 96
Van Huysum, Jacobus 133, 148, 151–2
Van Huysum, Jan 148
Van Huysum, Justus 148
Van Lennep, Lady Anna 396
Van Somer, Paul 56 n133
Vanderbank, Jan 56 n144
Vane, Lady Harriot 397
Vannevelle, Claude Margaret Goujon, Dowager
 Marchioness of 43, 45–6, 329–30
Vauxhall Gardens 164–5
veils, veiling, unveiling 74, 77–8, 198, 259, 263
Venice 242
Venus 80, 150, 186, 199, 215, 220
Verelst, Simon 133
Vernon, Sir Charles 354
Veronese, Paolo 272
Versailles 161
Vestier, Antoine 254, 264
Vickery, Amanda 32, 39
Victoria and Albert Museum, London 152, 279
Vien, Joseph-Marie 64
viewers, viewing 5, 66, 94, 104, 108–9, 114,
 197–200, 202, 259, 264, 267, 289, 291
Vigée-Lebrun, Marie-Louise Elizabeth 190, 202
 Lady Hamilton as a Bacchante 177, 209, 218,
 Pl. 44
Virginia 95
virginity 77–8, 81, 271, 284

virgins:
 vestal 175
virtu 36, 245
Voltaire, François Marie Arouet de 248

wages:
 of labourers 238
 of servants 25, 28–9
Wagner, Peter 88 n91, 247, 269–70
Wakefield, Priscilla:
 An Introduction to Botany 147
Waldegrave sisters (Horatia, Laura, Maria) 218
 The Ladies Waldegrave (Reynolds) 64, 215,
 218–20, Pl. 49
Wale, Samuel 232, 238, 296 n14
Wales 275
Walker, Robert 250
Walpole, Horace 65, 140, 154, 218, 220–1, 250,
 267
 *The Beauties: An Epistle to Mr Eckhardt, the
 Painter* 229, 249
 The Castle of Otranto 87 n83
 The Duchess of Portland's Museum 36–7
Walpole, Sir Robert 238
Walsh, J. 246
Walton, T.:
 Thaïs (after Wheatley) Pl. 51
Warburg, Aby; Warburgian 67
Ward, Dame Barbara 372
Ward, Sir Randall 372
Warren, Emily, *see* Potts, Emily
Warton, Thomas 236
Waterhouse, E. K. 254
Watson, James:
 Mrs Hale as Euphrosyne (after Reynolds) 183,
 Pl. 29
Weatherill, Lorna. 28, 48
Webb, Daniel 289–90
Webber, John 109, 110
Weber, Max 107
Weber, W. 289
Wedgwood tableware 94
Wedgwood, Josiah 176
Weemys, Lady Catherine 361
Wentworth, Thomas, 1st Earl of Strafford 63
Wentworth, Thomas, 3rd Earl of Strafford 108
Wentworth, Lady Elizabeth 330–1
Wentworth, Sir Butler Cavendish, Bart. 331
Wentworth, Woodhouse 108–9
West, Benjamin 109, 134, 141–3, 161, 232, 235–7
West, Elizabeth 142
Westmacott, Sir Richard 257
Westminster Abbey, London 234
Westmorland, Countess of 44, 399
Weymouth, Lady 37
Weymouth, Viscount 347

Wheatley, Francis 141
 A Bacchante 211, Pl. 45
 Thaïs 219, Pl. 51
Whig 179
Whitaker, Dr:
 History of Craven 97
White, Hayden 121
Whitley, William T. 254
Widdrington, Lady 371
Widdrington, Henry Francis, Lord 181
Wilberforce, William 246
Wilkes, John 269
Williams, Lady Frances Hanbury 40, 311
Williams, Raymond 104
Williams, William 236
Williams-Wynn, Sir Watkin 231, 273, 276, 279, 284,
 288–90, 292, 294
wills 2–3, 29, 35, 37–40, 47–8, 141–2, 183, 208, 245,
 307–400
Wilson, Dr Thomas 235, 245
Winchelsea & Nottingham, Ann, Dowager
 Countess 331–2
Winchester 288
 Cathedral 235
Winckelmann, Johann Joachim 65, 244
Wind, Edgar 69–71, 73, 79, 82
Windsor Castle 164
 Chapel of Revealed Religion 237
Winn, Rowland 108
Wissing, William 56 n142
witchcraft 236, 246
Witley Court, Worcesterhire 15, 25–6, 49 n5
Wollacot, Henrietta Maria 45
Wollstonecraft, Mary 94
Woodforde, Samuel:
 A Bacchante 190, Pl. 35
Worsley, Lady:
 Lady Worsley (Reynolds) 202–5, 213, Pl. 40
Worsley, Sir Richard 202, 204, 205
Wrey, Dame Mary 369
Wyatt, James 160
Wye Valley 91

York 121, 181, 330
Yorke, Mr 115
 Mr Yorke's Folly at Bewerley (Richardson) 115,
 Pl. 15
Yorkshire 94, 96, 106
Young, Arthur 94, 104–6
Yonge, Sir William, Bart 333

Zoffany, Johann 73–4, 131
Zuccarelli, Francesco 232
Zucchi, Antonio 186